Making Their Mark

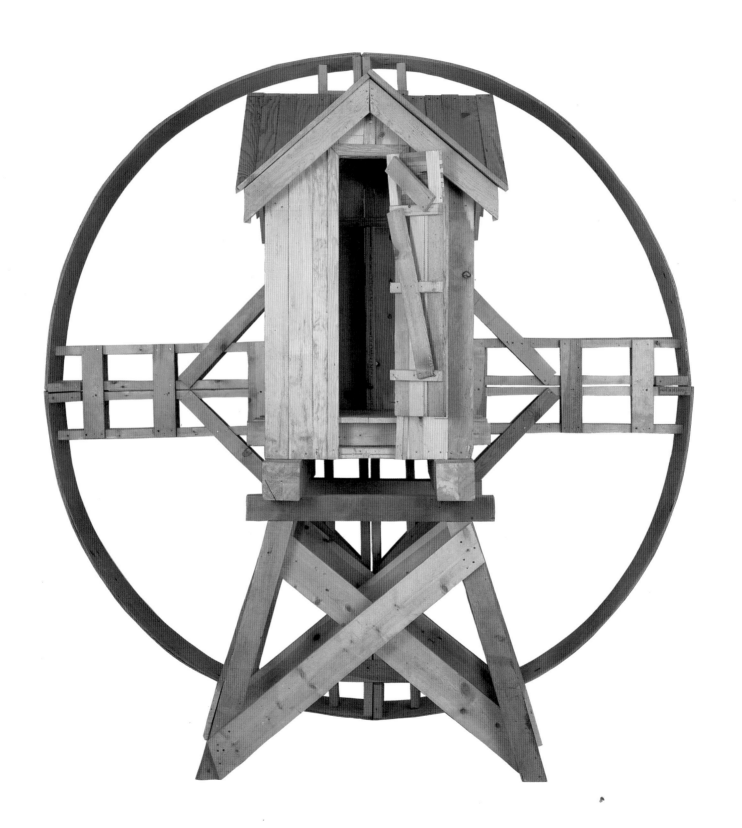

Randy Rosen, *Curator*

Catherine C. Brawer, *Associate Curator*

Making Their Mark

Women Artists Move into the Mainstream, 1970–85

Abbeville Press Publishers New York

The national tour of *Making Their Mark* and this publication have been made possible by **Maidenform, Inc.**

Exhibition Tour

Cincinnati Art Museum
February 22–April 2, 1989

New Orleans Museum of Art
May 6–June 18, 1989

Denver Art Museum
July 22 –September 10, 1989

Pennsylvania Academy of the Fine Arts,
Philadelphia
October 20–December 31, 1989

Editor: Nancy Grubb
Designer: Marc Zaref Design, New York
Production manager: Dana Cole
Artists' Biographies, Selected Group Exhibitions, and Public Collections compiled by Amy Handy
Exhibition organizer: Randy Rosen Arts Associates, New York

Front cover:

Jennifer Bartlett
2 Priory Walk, 1977
Baked enamel, silkscreen, and enamel on steel, 64 parts, each 12 x 12 in.; 103 x 103 in. overall
Philadelphia Museum of Art; Purchased, Adele Haas Turner and Beatrice Pastorius Turner Memorial Fund

Back cover and frontispiece:

Alice Aycock
Untitled (Shanty), 1978
Wood, shanty: 54 x 30 x 30 in.; base 45 x 36 x 42 in.; wheel diameter: 107½ in.
Whitney Museum of American Art, New York; Gift of Raymond J. Learsy

First edition

Library of Congress Cataloging-in-Publication Data

Making their mark: women artists move into the mainstream, 1970–85 / Randy Rosen, Catherine C. Brawer [compilers].
 p. cm.
Catalog of an exhibition to be held at the Cincinnati Art Museum and other museums, starting Feb. 22, 1989.
 Bibliography: p.
 Includes index.
 ISBN 0-89659-958-2. ISBN 0-89659-959-0 (pbk.)
 1. Art, American—Exhibitions. 2. Art, Modern—20th century—United States—Exhibitions. 3. Women artists—United States—Exhibitions. 4. Feminism and art—United States—Exhibitions. I. Rosen, Randy. II. Brawer, Catherine Coleman. III. Cincinnati Art Museum.
N6512.M27 1988
704'.042'0973074—dc 19 88-22261
 CIP

Contents

Randy Rosen

Moving into the Mainstream

The mainstream is an elusive venue, perhaps most aptly characterized by Heraclitus' observation, "It is not possible to step into the same river twice." Using the term *mainstream* to describe the center of activity in the contemporary art world suggests, first, that such a center exists, and second, that there is a clear consensus of opinion concerning its composition at any given moment. But inherent in the concept of *stream* is also the notion of fluidity, movement, change. The mainstream in art, like the art world itself, incorporates contradictory aspects, rendering literal definitions as slippery as a handful of water. Nonetheless, for the artist who must establish a reputation and earn a livelihood, understanding what the mainstream is and how it operates is more than a semantic exercise. Although an artist's sensibilities and style develop out of inner convictions, sometimes originating in a self-conscious challenge to what is currently acceptable in the mainstream, the very existence of the mainstream exerts continual pressure as a gauge of acceptance for both those in it and those rebelling against it.

Perhaps more important, participation in the mainstream affords the artist an opportunity to play a role in how the world is perceived and understood by one's contemporaries and, in some cases, by later generations. Whatever the long-term judgments of history turn out to be, artists in the mainstream make their mark on the visual and intellectual life of their own time. And, rightly or wrongly, the mainstream serves as a filtering mechanism—identifying, legitimizing, and propagating certain styles, world views, and interests. As the distillation of the values that a particular generation holds most significant, the mainstream also reflects which constituencies have a voice in shaping society's choices and actions. Being part of the mainstream, therefore, involves not only individual achievement but social power.

The artworks and essays in this book have been compiled as a picture of a unique period, 1970–85. It was unique for many reasons. But one of its most striking characteristics was the prominent and catalytic role played by so many women in redirecting and redefining the interest of mainstream art. As greater numbers of women artists moved center stage, they shaped the direction of contemporary art alongside their male colleagues. This visible leadership represented a radically new kind of participation, and it is the central nature of that participation, as much as the numbers, that marks the period as a breakthrough (though the permanence of that breakthrough will be legible only in the art history texts of the future). What occurred

1
Jennifer Bartlett
2 Priory Walk, 1977
Baked enamel, silkscreen, and enamel on steel,
64 parts, each 12 x 12 in.; 103 x 103 in. overall
Philadelphia Museum of Art; Purchased, Adele Haas
Turner and Beatrice Pastorius Turner Memorial Fund

from 1970 through 1985 was a phenomenon unique in American art history, and the artists represented here all took part in creating it. Either their careers emerged during this period or the style with which they are most identified matured during it. The core discussion has been deliberately confined to this sixteen-year framework, not to imply that all the obstacles confronting women artists as a group were eliminated in that time—they were not—but to focus attention on the breakthrough and change that occurred.

The notion of a mainstream is often thought to be a contemporary development. In writing about Clement Greenberg, the doyen of modernism whose critical benedictions defined and dominated thinking about art for several decades beginning in the 1940s, the critic Robert Storr called the idea of the mainstream "Greenberg's great invention and great fallacy."[1] But the concept of the mainstream in contemporary art and the structure of its support system can be said to have originated far earlier, with the publication in the sixteenth century of Giorgio Vasari's *Lives of the Artists*.

That, too, was a time of transition for the art world. Classical antiquities still provided the measure for both artist and collector, but attention was starting to shift to living artists. And a distinction was beginning to evolve between the professional artist, conduit for god-given truths (high art), and the artist-craftsman, whose decorative skills and functional output were relegated increasingly to minor standing (low art).[2] In this turbulent atmosphere Vasari set himself the task of defining a standard of excellence for contemporary Italian art, no doubt hoping to provide a guide for other artists and, in the process, to establish the precedence of his Florentine artistic heritage as the central model. Serving as a proto-modern art historian and critic, Vasari compiled his now-famous discussion of the artists and works he deemed to be the most important of his day. His undertaking, unique for its time, in effect established the idea of a mainstream in contemporary art. With the publication of a larger second edition in 1568, Vasari's canon spread throughout Europe. Not only his pantheon of male "genius" was accepted but also his view of art history as a series of progressive stylistic developments: both concepts survive in Western art scholarship and public myth to this day.[3]

Although *mainstream* suggests a broad base, from the outset Vasari's judgments, and the theories to which they were bound, were more exclusive than inclusive, reflecting a particular rather than a universal view. *Lives of the Artists*, written as a treatise on aesthetics and quality, created what amounted to a contemporary "star system"—Leonardo, Michelangelo, Raphael—and galvanized what until then had been random collecting into a market for contemporary art. The tension between a mainstream predicated on theories of aesthetic quality and a mainstream shaped by collecting activity and market economics soon established the basic countervailing tides of status quo and change. Fra Carlo Lodoli, born a century after publication of *Lives of the Artists*, managed (despite monastic vows of poverty) to indulge his passion for art by assembling a legendary collection of the early masters who had been praised but not prized by Vasari in his hieratic interpretation of art's development. Even in the seventeenth century Vasari's dicta held such sway that among the stacks of work that Lodoli foraged from the junk bins of local peddlers who collected the paintings and discards of old churches and noble houses were reportedly works by Bellini, Giorgione, Giotto, and Cimabue.[4]

The mainstream even then was not as stylistically monolithic as Vasari presented it. Many of its complexities were already in evidence: the tension between stylistic diversity and a dominant style against which all others are tested and evaluated; the dichotomy between fine art and functional art, between elitist and popular definitions of value; the presumed objectivity of art criticism and interpretation and its personal bias; the intrusion of economic issues such as supply and demand on perceptions of artistic quality.

Far more complex, though related, forces were at work between 1970 and 1985, when women artists entered the mainstream in unprecedented numbers. By then there had developed an extensive and sophisticated support system composed of museums, galleries, individual collectors, corporate collectors, art historians, the art press, alternative and cooperative exhibition spaces, art schools and universities, auctions, and government and private funding. Their relationship to one another, like tributaries feeding into a river, is both random and directed. No two art seasons produce quite the same combination of influences, and rarely are their forces exerted in equal strength. It is in their concerted effect that these forces constitute the composition of the mainstream, continually altering its level, currents, and periodically even its course. Although there are periods of stagnation when little seems to change, there are also times of turbulence when a flood of new styles, social values, critical theories, or market pressures alters the mainstream's mood and character.

By the late 1970s a virtual art industry had sprung up. The magnitude of this change is apparent in the gallery sector alone. "When I started there were about fifteen galleries in New York. Now there must be 515," artist-dealer Betty Parsons stated in a 1980 interview. "There were only about three or four galleries concentrating on the very contemporary area in 1946."[5] Confirmation of continued expansion can be seen in

Art in America's *Annual Guide to Galleries, Museums, and Artists:* 433 New York galleries were listed in the 1981–82 *Annual*; by 1985–86, 681 galleries were listed—an increase of 57.3%. The same escalation holds true cross-country: national listings jumped from 2,159 in the 1981–82 publication to 3,104 in 1985–86, a 43.8% gain.[6] Society at this time was becoming more visual at every level. The pervasiveness of advertising, television, and movies had democratized the arts in a larger sense, creating a broad-based, visually oriented audience for popular culture. Artists sometimes appropriated these mass-culture images and techniques and have recently blurred distinctions still further by challenging the sanctity of uniqueness, authorship, and originality. But the art world retains, in many ways, an elitist vision of the mainstream.

The identity of which styles are "in" and which are "out" can usually be agreed upon by those within the art community. This is not to say, however, that the mainstream is created by fiat or in the whispered conversations of a backroom cabal, although it sometimes appears that way when a particular group of artists seems to spring up on every front at once. And certainly the perception of art history as a lockstep march, with one style inevitably superseding its predecessor, assumes the dominance of one point of view. But who controls the decision-making power implied by such an assumption remains unclear, for power in the art world operates both informally and formally.

Anyone can have an opinion about art, but even at the informal level some opinions exert more authority than others. Because our society isolates art as a specialized activity, its explanation and validation have come to reside outside of intuitive "I like it, I don't like it" judgments, resting instead with art specialists: artists, curators, critics, collectors,

museum directors and trustees, art historians, and art dealers. Happenstance coalitions and shifting allegiances within this network of "validators" shape and reshape the mainstream. At a recent international exhibition attracting art world luminaries from many countries, curators, critics, collectors, and dealers could be seen huddled over cappuccino at bistros throughout the city, arguing the merits of the exhibition and theorizing about the future course of art. The impact of such social interactions on the mainstream—especially in facilitating access to it—should not be underestimated. The consensus that moves a new artist or style into the mainstream is as likely to begin with an exchange between artists swapping impressions of the Whitney Biennial, or with a curator and critic speculating on neglected mid-career artists, or with collectors discussing their discoveries with dealers, as it is to occur through any formally sanctioned channel.

Labels branding work by a group of artists as a style are generally attached after the fact, most often through gallery packaging or the organizing compulsions of art criticism. Before such labeling occurs, an informal process of winnowing new styles and intellectual directions begins among the artists themselves. This word-of-mouth selection (occasionally backed up by an artist-written essay or manifesto) percolates through other layers of the art world, such as dealers, critics, curators, and collectors. The fact that so many women artists worked in isolation, outside the social network, prior to the 1970s, blocked their primary access to the mainstream. With a chain of validation whose initial link is often wrought by the artistic community itself, those whose work is invisible to colleagues are likely to remain invisible.

Although initial access to the mainstream—getting one's foot in the door—still relies heavily on peer recognition, other points of entry

are gaining influence as a result of art's expanding base. Given the burgeoning number of artists in regional centers as well as in New York and Europe, galleries and collectors do more and more of the early fieldwork of discovery. Their continual quest for the new increasingly directs the mainstream, often leaving it to museums and critics to synthesize and anoint their discoveries. "If I mentioned the names of the last ten artists I bought to most critics," one major collector said, "they wouldn't know who I was talking about. By next year they'll all be writing about these same artists." By investing heavily in a single new artist or group of artists, some individual and corporate collectors in recent years have amassed such extensive holdings of contemporary art that they have been able to steer the entire art world's attention to their choices.[7]

The fugitive conjunctions of interest that link validators together on an informal basis assume more ritualized patterns in their formal expression. Here, two main sources feed the mainstream: those whose power is concentrated in ideas and information, such as artists, curators, critics, and art historians; and those exerting primarily economic power, such as galleries, collectors, museum trustees, and government and private funding sources.[8] Certain validators in each camp become institutionalized as particularly powerful forces on the mainstream. A substantial review by a well-known critic in the *New York Times*, an exhibition or acquisition by a prestigious museum, a catalog essay by a respected historian, or association with an established gallery can be a decisive turning point, elevating an artist or trend above the multitude clamoring for attention. If navigating the informal circuit is the first step toward achieving visibility, the second is generally a gallery exhibition. But not all galleries are created equal, at least in terms of their institutional power. Certain gal-

leries usually exhibit the most visible artists, and association with them can launch an artist onto the next stages of success: receiving retrospectives or solo exhibitions around the world, having work purchased by leading museums and collectors and sold at auction, and being the subject of art magazine articles and lavishly illustrated monographs.

While some galleries sustain their power for years, others emerge only briefly as forums for new styles, then disappear. Whatever its longevity, a gallery's influence on the mainstream seems to depend on certain characteristics, chief among them being a willingness to take risks in introducing a new style and to provide ongoing support to the group of artists that generated it. In a recent study analyzing the New York art world between 1940 and 1985, Diana Crane points to a connection between the influence exerted by a certain group of galleries and the level of their commitment to a particular style. Using a sample group identified only as "gatekeeper" galleries—each representing over five artists whose art had been purchased by the Museum of Modern Art, the Whitney Museum of American Art, and other New York museums—Crane found that such galleries "were also more likely to be the leaders in the sense that they had been the first to exhibit particular artists."[9] She also notes that despite the relative absence of interest in contemporary art at auctions prior to 1970, these same gatekeeper galleries represented the artists who did manage to reach the block. "Women were largely excluded from the auction market," she adds. "The few whose works were auctioned did not receive high prices."[10]

Women artists moving into the mainstream faced two major hurdles in winning validation in the marketplace. First, to exhibit in a gallery at all, a barrier crossed by significant numbers of women artists for the first time in the 1970s and '80s. Second, to gain a foothold within one of the leading galleries exerting the greatest influence and most sustained career support. A trend in this direction can be noted in information provided by ten such galleries in New York. Of the thirty-nine women artists currently represented by these galleries, seventeen joined the rosters in the 1970s, seventeen in the 1980s, and only five in the 1960s.[11]

Market success does not guarantee a place in history. But the visibility it makes possible can focus the attention of other segments of the validating chain—critics, curators, art historians—whose choices and commentaries create the cultural record. Recognition is a cumulative process involving various types of professional acknowledgment. The percentages of women artists who attained certain of those career markers between 1970 and 1985 are recorded by Ferris Olin and Catherine C. Brawer (see pages 203–36). What emerges is a picture of women slowly winning visibility within the validating network, a visibility that marks a critical break with past stereotypes and patterns.

"If you're an exceptionally gifted woman, the door is open," artist Grace Hartigan once noted. "What women are fighting for is the right to be as mediocre as men."[12] Hartigan was hardly espousing mediocrity; rather, she was pointing out that tokenism is not the same as full participation. Women had traditionally been omitted from the histories and discussions of major movements.[13] When discussed at all, they were shadowy figures at the edges of the action, recognized less as innovative than as oddities—the talented woman who is "an exception to the rule."[14]

For the greater part of Western art history, the absence of women from the pantheon of great artists was accepted as proof of their lesser skills. The scarcity of art by women in museum exhibitions and collections, galleries, art texts, reviews, and auctions perpetuated this perception. Then, in 1971, Linda Nochlin dismantled the time-honored assumption of women artists' innate inferiority in her classic article, "Why Have There Been No Great Women Artists?"[15] Rethinking the issue from a feminist perspective, she addressed the psychological, social, and economic impediments that had historically restrained women from pursuing art careers or, if they had pursued them, from excelling. Like other scholars then beginning to reassess art's standard interpretation, Nochlin looked beyond accepted conclusions to causes and circumstances.[16]

The marginalization of women took many forms. In addition to being passed over in the histories, art by women was critiqued with different standards and different language, implying in that differentiation an inherent inequality. The application of such separate standards was already evident in Vasari's *Lives of the Artists*. Commending sculptor Properzia de' Rossi's talents as so outstanding that "all men should praise her," Vasari then devotes as much discussion to her "delicate hands," her singing skills, and her disappointing love affair, concluding that one of her most ambitious projects was undertaken "as a relief to her ardent passion."[17] Even subtler has been the sidelining that gives full credit but undermines the impact of the artist as a generative force by depicting her as a "lone ranger," a gifted maverick working outside the mainstream (Louise Bourgeois, Alice Neel, Louise Nevelson, for example).[18] Marginalization for minority women artists has involved even more complicated barriers. "At the beginning of the seventies, one black woman artist told me she went to the Studio Museum in Harlem in 1969 and 1970 and hung around until she was told she would have a long wait, 'that there were all these black male artists who would have to get their chance first.'"[19] The psychic and profes-

sional toll that such marginalization and discrimination exacted on women artists trying to establish careers during the first six decades of this century becomes poignantly clear in Ellen G. Landau's essay, "Tough Choices: Becoming a Woman Artist, 1900–1970" (see pages 27–43).

The role of the avant-garde forms an undertow in any discussion of the mainstream. One of the ironies of twentieth-century art has been the metamorphosis of the avant-garde from its original position in opposition to established cultural values and traditions to its institutionalization by the very society it set out to criticize. In the late nineteenth and early twentieth centuries artists assumed an adversarial posture in response to the emergence of a consumer class that was transforming the values of art even as it expanded its audience. Art became identified with other commodities whose acquisition related to fashion, status, and profitable investment. The avant-garde rebelled against such materialism, inventing styles that challenged, rebuked, and baffled the new acquisitors. Although their relationship began in hostility, and there would be a time lag before this new class of art buyers could absorb the novel styles of the avant-garde, they shared a high regard for the idea of innovation, already part of the consumers' world view, both in their predilection for ever-changing fashion and their Darwinian faith in progress.

By the late 1960s innovation had been so thoroughly absorbed into the lifestyle of the twentieth-century middle class that the position of the avant-garde artist had changed from adversary to accomplice. This realignment of artist and audience hastened the diffusion of the modernist mainstream. Pluralist rather than linear, the new avant-garde was primed for diversity; and the result was a freewheeling experimentation with new subjects, styles, techniques, and materials that

further accustomed art audiences to novelty. By the late 1970s many not only accepted innovation, they were addicted to it. The appearance of more accessible styles and less perplexing subject matter also reduced the comprehension gap between art and spectator. The work of many women artists during the 1970s and '80s helped foster this reengagement between art and life by reemphasizing subjective and social concerns that had been outside the modernist visual lexicon. "Women made subject matter respectable again."[20] As members of a new pluralist avant-garde they enlarged the possibilities of art, helping to define a new mainstream that encompassed their work. For the first time in decades, ingrained notions of art history were challenged. Suddenly there was no dominant style. No discernible star system. Where women artists had been traditionally underrepresented in galleries and certainly within the stables of the larger galleries, the market's sudden appetite for new styles facilitated their breakthrough into the gallery structure.

These developments mirrored changes in the larger social sphere, itself under pressure from diverse groups calling for redefinition of the mainstream in all sectors of the culture. One of these groups was women. Underlying all the pressures for redefinition was a fundamental reassessment of authority and the centralization of power. Many of life's presumed "certainties" were coming to seem less certain. The shock of the Vietnam War, assassinations, Watergate, and the inequities revealed by the civil rights movement and the women's movement engendered disenchantment with existing values. The bombing of Cambodia and the tragic killings at Kent State University in 1970 exacerbated public distrust in authoritarian structures, such as government, business, science, the military, even the family. Once seen as protective or productive, these

institutions came to be viewed as destructive or, in the case of the divorce-torn family, as unreliable. The loss of faith in central institutions and in the whole idea of *centricity* was manifested not only in activism but also in a new reliance on the individual. This inherently pluralistic attitude nourished the narcissism of the "Me Generation," but it also encouraged tolerance for alternative viewpoints and reinforced efforts to dislodge established values, including those that dominated the art world.

At the vortex of the tumultuous transformation of the art world was the struggle to burst the bounds of modernism,[21] a concept that had supplied the basic interpretation of developments in art since Edouard Manet. Focusing on formal issues (color, line, space, shape, scale, etc.), modernism eventually had the effect of segregating art from life. Narrative, fantasy, eroticism, decoration, myth, political, social, and personal content largely vanished from mainstream art. In 1945 formalism's foremost spokesman, Clement Greenberg, said of Georgia O'Keeffe's highly personal and psychologically charged realism: "Her art has very little inherent value. . . . The greatest part of her work . . . has less to do with art than with private worship and the embellishment of private fetishes."[22] By the late 1960s modernism's explorations had so narrowed to visual grammar that when asked about the content of his Minimalist paintings, Frank Stella made his now-legendary comment: "What you see is what you see."[23]

Minimal and Conceptual art, the dominant incarnations of modernism at the time of Stella's remark, had distilled the visual down to a kind of "silence," with some versions of Conceptual art being no more than a typewritten page of instructions. It can be argued that Pop art, which came to prominence in the 1960s and seemed the antithesis of Minimalism, had served as the precursor for

the return to content that marked the 1970s.[24] But even though its iconography was legible and derived from everyday sources (comics, advertising, household products, and the media), Pop art remained tethered to modernist attitudes and a celebration (or parody) of the machine-made and industrial rather than to the more introspective interests that drove the 1970s.

The changes taking place in the nature of the avant-garde meshed with social upheaval, so that by 1970 the limitations of modernism as an expression of the new zeitgeist became apparent. A vanguard converged for an assault on the modernist position. This new, pluralist avant-garde was not a conjunction of like styles and ideas. Its participants shared little more than a conviction that modernist theory had reached a stalemate. What they confronted was not simply an alternative viewpoint open to mediation but a paradigm of institutionalized beliefs and methodologies built around a narrow definition of what was possible and acceptable in the practice of art.

Many abstract artists—both men and women—already within mainstream modes found themselves frustrated by the pressure to squeeze their broadening visions into the narrow confines of Minimalism. Touched by social and political upheavals on every front, they began rethinking their artistic commitments. The formalist separation between "what art is about" and "what life is about"—which characterized the Minimalist style that many were working in—seemed far removed from the emotionally charged larger context. Events pressed for a reconnection between art making and life, for a reengagement with subject matter. "Laying it on the line" personally took precedence over intellectuality. Equally alienated were those artists not in the mainstream—many of them women—whose work focused on social and political subject matter, psychological and personal narrative,

and specifically feminist content. Feminist artists had been insisting all along that "the personal is political," favoring styles rooted in direct experience over the formalist tradition. In this sense, their work presaged and prepared the way for a return of content to art. Many of them viewed analytical and abstract styles as irrelevant to portraying the world from the viewpoint of being a woman in it, citing such impersonal styles as part of art traditions bound up with patriarchal values and macho psychic drives that ignored or devalued women's contributions to civilization.

Whatever the individual motivations, the interests of both those in the mainstream and those outside of it began to fold into one another. A most notable overlap was the return of overt subject matter and implicit content in reaction to the austerities of Minimalist and Conceptual styles. Distinctions between abstraction and representation began to dissolve. Susan Rothenberg and Lois Lane were among those who formulated New Image painting, splicing the starkness of Minimalism with a pared-down representational imagery. Concern with the everyday realities of a woman's experience often found expression, however subtly, whether in the iconic house forms of a Jennifer Bartlett painting (plate 1) or an Alice Aycock sculpture (frontispiece) or buried below the abstractions of cups, beans, books, or legs in an Elizabeth Murray canvas (plates 20, 28). Nancy Graves, for one, continued to use the grammar of twentieth-century abstraction but integrated personal content by incorporating into her sculpture familiar objects such as pleated shades, fans, rigatoni, and zucchini (plate 2), cast in bronze.

Sometimes the interests of those extending the boundaries of abstraction and those stressing feminist concerns ran parallel in ways that were mutually reinforcing. The

abandonment of the industrial finish that had characterized Minimalism and the return to personal expressiveness and "handmadeness" aligned with the feminist agenda for eliminating distinctions between low and high art. Joyce Kozloff, Miriam Schapiro, and Valerie Jaudon reformulated a dormant decorative strain in modern art into styles that drew on abstraction and on a legacy of women's crafts (weaving, ceramics, knitting, quilting, etc.), as well as on non-Western, nonmodernist patterning, such as the Islamic.[25]

In "Righting the Balance" (see pages 45–49), Calvin Tomkins presents the new prominence of women artists as intricately bound up with a unique set of circumstances: the larger social changes taking place and the associated pressures from an ardent and vocal women's movement. Many women artists initiated and sustained organized endeavors to raise their own consciousness and to gain parity and acknowledgment as a group by bringing their case before the public through direct political action. Activism also manifested itself in the emergence of revisionist scholarship and exhibitions aimed at reassessing and restoring forgotten or neglected women artists.

Political activity came late to the art world. Probably its most visible moment was the mass meeting held at the Loeb Student Center at New York University on May 18, 1970, which brought together fifteen hundred members of the art community to protest the United States' invasion of Cambodia and the Kent State killings. A second meeting later led to the New York Art Strike, at which time more than five hundred artists staged a sit-in on the steps of the Metropolitan Museum of Art. Opposition to the Vietnam War had been voiced earlier by the Art Workers Coalition (AWC), with a female contingent of that group splintering off to form Women Artists in Revolution (WAR), which addressed the inequities confronting women in the art world.

2
Nancy Graves
Zeeg, 1983
Bronze with polychrome patina, 28½ x 14 x 11 in.
Private collection

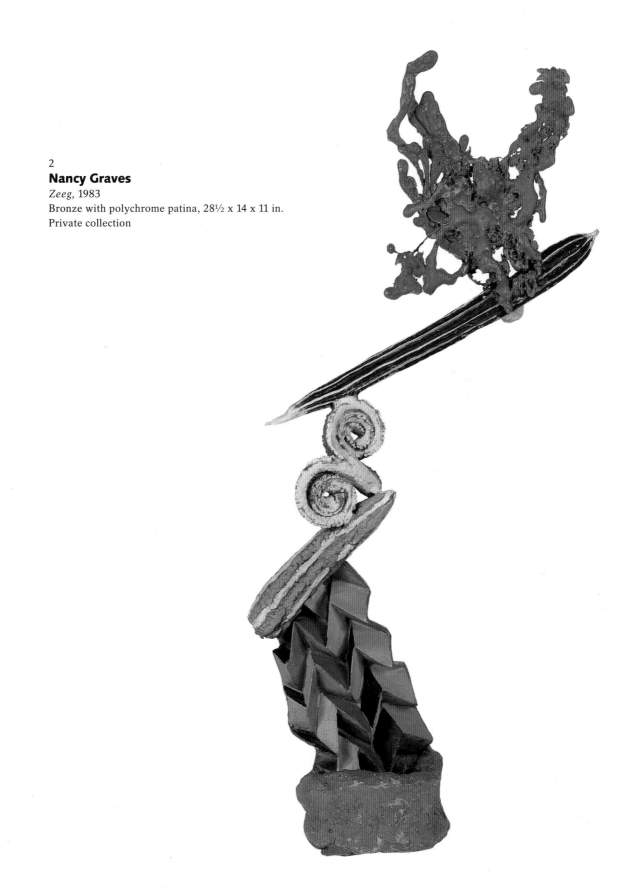

In May and June of 1970, WAR sent letters to the Museum of Modern Art protesting its policies and to the Whitney Museum of American Art protesting the low representation of women artists in its Annual (now Biennial), in which only 8 of the 143 artists were women. In September of the same year the Ad Hoc Committee of Women Artists was also formed, including some members of AWC. The Ad Hoc Committee, founded by artists Branda Miller, Poppy Johnson, and Faith Ringgold and critic Lucy Lippard, picketed the Whitney Museum, demanding a 50% representation of women in the Annual. Many minority women took part in these organizations, but they also developed groups that addressed their own specific needs, such as Artists for Black Liberation, which was formed in October 1970.[26] Strikes shutting down museums, marches, and letters of protest by women artists spread across the country and were particularly in evidence between 1970 and 1974.[27] The exclusion of women artists from the major *Art and Technology* exhibition mounted by the Los Angeles County Museum of Art in 1971 set off a storm of protest, resulting in the formation of the Los Angeles Council of Women and a front-page story in the *Los Angeles Times*. "Over a ten-year period *one* one-artist show out of 53 [at the museum] was devoted to a woman; less than one percent of all work on display at the museum at the time was by women; only 29 of 713 artists in group shows had been women."[28] The Corcoran Gallery of Art in Washington, D.C., was picketed a year later to protest the absence of women among the twenty-two participants in its Biennial. That protest led to the first National Conference on Women in the Visual Arts, hosted by the museum in 1972.

The escalation in protests was accompanied by a new phenomenon: exhibitions of art by women organized by women, both in traditional gallery spaces and in a growing number of so-called alternative spaces, a type of organization that has since become a permanent fixture in the art world and has often been responsible for bringing the art of "outsiders" to public attention.[29] Many early protest exhibitions were mounted in such temporary spaces. *Mod Donn Art, 11 Women Artists*, one of the first feminist shows, was installed in May 1970 at the Public Theater in lower Manhattan. One of the most influential of these consciousness-raising exhibitions, entitled *26 Contemporary Women Artists*, was held in 1971 at the Aldrich Museum of Contemporary Art in Ridgefield, Connecticut, and was curated by critic Lucy Lippard. A student project developed by the Feminist Art Program at the California Institute of the Arts resulted in the now-famous exhibition, *Womanhouse* (1972). Under the guidance of artists Judy Chicago and Miriam Schapiro, students converted a run-down mansion into a series of rooms built around women's experiences.[30] The exhibition served as a focal point for women's groups in the area and led, the following year, to the opening of the Woman's Building, which is an active force to this day.

The culmination of these early efforts, and perhaps the most compelling demonstration of centuries of art-world bias, was the revisionist exhibition *Women Artists: 1550–1950*, a monumental historical overview of paintings by women. The 1976 show presented striking evidence that there had been a large number of gifted women artists working throughout history. It was organized for the Los Angeles County Museum of Art by Linda Nochlin and Ann Sutherland Harris, whose exhibition catalog has since become standard classroom reading and a "corrective to all those pre-1970 art history texts of two- to fifty-thousand-year surveys of world art that failed to mention the work of a single woman."[31] Even earlier, in 1972, Ann Gabhart and Elizabeth Broun had organized the exhibition *Old Mistresses: Women Artists of the Past*. Their ironic title underscores "the unspoken assumption in our language that art is created by men. The reverential term 'Old Master' has no meaningful feminine equivalent." Indeed, "Old Mistresses" calls quite another image to mind.[32]

A moving excerpt from a letter sent by artist Eva Hesse to Ethelyn Honig in 1965 reveals the psychological burden that such "unspoken assumptions" placed on women artists:

> *I wonder if we are unique. I mean the minority we exemplify. The female struggle. . . . To me insurmountable to achieve an ultimate expression, requires the complete dedication seemingly only man can attain. A singleness of purpose no obstructions allowed seems a man's prerogative. His domain. A woman is sidetracked by all her feminine roles from menstrual periods to cleaning house to remaining pretty and "young" and having babies. If she refuses to stop there, she yet must cope with them. She's at a disadvantage from the beginning. . . . She also lacks conviction that she has the "right" to achievement. She also lacks the belief that her achievements are worthy. Therefore she has not the steadfastness necessary to carry ideas to the full. . . . There are handfuls that succeeded, but less when one separates the women from the women that assumed the masculine role. A fantastic strength is necessary and courage. I dwell on this all the time. My determination and will is strong but I am lacking so in self esteem that I never seem to overcome. Also competing all the time with a man with self-confidence in his work and who is successful also.[33]*

If the term *artist* has become relatively gender neutral, it is in no small measure due to the relentless protests, exhibition activity, and revisionist writings of feminist artists, critics, and art historians, which amounted to a prolonged consciousness-raising session. Many women artists who separate the success they have achieved in their careers from feminist activity acknowledge nonetheless that it generated a climate of acceptance that has benefited all women in the field.

If activism supplied the adrenaline that pumped life back into art, television, which had become a major cultural force by the late 1960s, provided the model for experimentation in unorthodox media such as video and performance. Part of the attraction of these forms was their immediacy, a direct connection with life that sidestepped the timebound stasis of traditional painting and sculpture. Many women were drawn to video and performance (see Judith E. Stein and Ann-Sargent Wooster, "Making Their Mark," pages 51–185). That neither was an established male turf made access easier, with performance proving especially appealing as a feminist forum for exorcising the stereotyped roles buried below the mundane rituals of everyday life. As a storytelling mode, performance lent itself readily to autobiography and narrative (plate 3), ritual and myth (plates 4, 7), parody (plate 6), and public protest (plate 5).

For a generation trying on new ways of seeing and acting, and for those women artists experimenting with new behavioral models and psychological identities, performance offered a transforming power. (This power can be understood by anyone who has ever made faces in front of a mirror.) Women's roles had traditionally been condensed into clichés by storytelling formats such as soap operas and pulp magazines. With performance art the stories and role fantasies were guided by women themselves, free from the

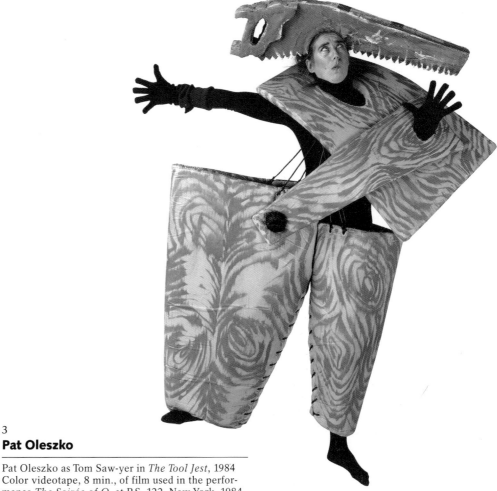

3
Pat Oleszko

Pat Oleszko as Tom Saw-yer in *The Tool Jest*, 1984
Color videotape, 8 min., of film used in the performance *The Soirée of O*, at P.S. 122, New York, 1984
Collection of the artist

"Even a frivolous costume can be seen as a political act," repeats a voice in the last scene of *The Soirée of O*. Using humor, her own body, and outrageous and ingeniously constructed costumes as vehicles to subvert authority and self-perceptions, Oleszko has developed a theatricality and absurdity in the tradition of Alfred Jarry's Pataphysics ("the science of reality as a joke of serious proportions"). Following a string of opening catcalls and wisecracks typical of the artist's events, *The Soirée of O* evolves through a series of vignettes, film sequences, and costume changes. As a wild-looking jester, Oleszko argues with an unseen companion over the difference between art that refers to life and art that, like the costumed Oleszko, *is* life. That is a difference Oleszko likes to obscure. She is almost always in eccentric costume, whether wearing her trademark domino-and-dice bracelets or transforming herself into Pat Kioski, a portable souvenir stand from which the audience can purchase postcards and posters after a performance.

4
Mary Beth Edelson

Woman Rising/Spirit, 1974
Black-and-white photograph and drawing from The
Woman Rising series
Private ritual performance in Outer Banks, North
Carolina, 1974
Courtesy of the artist

In 1973, as a way of overcoming cultural stereotypes
of women as powerless and passive, Mary Beth
Edelson began developing performances based on
the archetype of the Great Goddess, a symbol of
female power in many ancient societies. *Woman
Rising/Spirit* was part of Edelson's effort to connect
herself and other contemporary women with a posi-
tive female legacy. Using her own body as a surro-
gate for the goddess—and as symbolic of all women—
the artist performed and photographed a series of
private rituals in the Outer Banks of North Carolina.
Asking herself "How was goddess worship stamped
out, and when?" led to a period of intensive
research, which resulted in her famous performance:
*Proposals for Memorials to the 9,000,000 Women
Burned as Witches in the Christian Era* (1977). Each
member of the audience received the name of an
actual victim accused of witchcraft, which was later
chanted during the performance held at the A.I.R.
Gallery, New York, on Halloween Eve. The ritual
closed with a procession through Soho in which
participants carried candlelit pumpkins swinging
from five-foot poles, reenacting the way women in
the Middle Ages had lighted their paths through the
woods on the way to secret worship meetings.

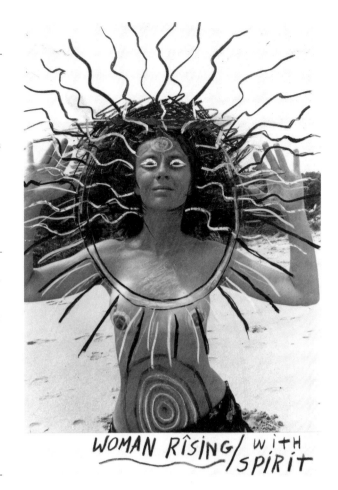

WOMAN RÎSING/ WÌTH SPÌRIT

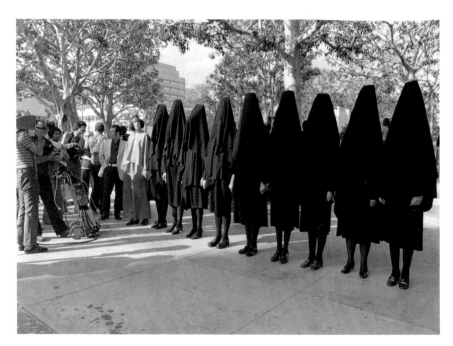

5
Suzanne Lacy and Leslie Labowitz

In Mourning and in Rage
Performance at Los Angeles City Hall, 1977

Suzanne Lacy and Leslie Labowitz view "the politi-
cal artist in present-day society as a model-maker as
well as an image-maker." *In Mourning and in Rage*,
evocative of ancient public rituals, was also a care-
fully orchestrated media event. The two Los Angeles
artists mobilized many local women's groups as part
of a performance protesting a series of vicious rape-
murders that had occurred in the city. The event,
which attracted national media coverage, called
attention to the high level of crime against women in
society and to the shoddy, often sensational media
coverage of such tragedies. A chorus raising a ban-
ner that read "In Memory of Our Sisters: Women
Fight Back" and a scarlet-robed warrior framed a
row of nine black-draped forms lining the steps of
City Hall. With their faces obscured by their mourn-
ful coverings, the nine stood as sentinels of sorrow
and reminders of recent and past victims.

proscriptions and restrictions of convention. Not surprisingly, "an overwhelming percentage of the work in this area has been by women."[34]

Performance dissolved high-low art boundaries, cross-breeding disciplines—theater, music, dance, video, painting—into a single presentation. The new fusion of art and mass culture that performance embodied found its apogee in the art of Laurie Anderson, who became something of a cult figure. Her performances (plate 139), theatrical multimedia events, dealt not only with autobiography and the insidious traps of stereotyping but also with the covert part played by language in reinforcing those stereotypes and in perpetuating patterns of behavior by individuals and social groups. *Americans on the Move*, which later became the first section of Anderson's *United States* performance, begins by exposing the frequent lack of genuine communication between men and women. A woman driving in the rain at night stops at a gas station for directions: "What follows is a false dialogue . . . in which Anderson's voice continually oscillates . . . between male and female. 'Hello, can you tell me where I am?' the woman asks. The male attendant answers over and over, 'You can read the signs. . . .' Communication grinds to a halt. A pioneer image appears on the screen (behind Anderson) throughout the 'dialogue.'"[35] Anderson's oscillations between male and female voices (like the androgynous outfits she wears) blur stereotypical identities, and the viewer, like the pioneer, enters unexplored territory.

Performance extended art beyond museum walls in a form inaccessible to ownership, and this aspect has often been cited as a link to Conceptual art.[36] But, in contrast to the cerebral nature of Conceptualism, performance was easily grasped and bypassed the elitist incomprehensibility of much twentieth-

century art. For many women artists who had long been working in obscurity and felt an urgent need to communicate in a direct voice, the opportunity to make an impact on the culture outside the art world and the close collaboration that performance allowed between artist and audience proved a perfect match.

The interactive and interdisciplinary aspects that appealed to so many women in performance were also present in public art. Large-scale collaborative undertakings involved the artist with architects, city planners, fabricators, and often with the community in which an artwork was to be placed. By the late 1970s a number of women artists had moved away from making autonomous objects for sale in galleries, shifting their emphasis to public projects. This shift reduced their visibility in the critically monitored gallery system but offered opportunities for integrating their art into the flow of life.

As greater numbers of women artists entered established galleries, museums, private and corporate collections, faculty positions, and art criticism, the social unrest of the 1960s and '70s was subsiding and the activist engine that had helped propel their entry was starting to slow down. At the same time, the postmodernist theoretical wars were starting to heat up. By the 1980s theories about art had become almost as central a subject as the art itself. Once the scaffolding of modernism collapsed, questions about the inherited assumptions of art history could be raised. Feminist scholarship was in the forefront of this process of rethinking. By the 1980s many of the early feminist issues had been absorbed into (and obscured by, according to some) a discourse that placed art and feminism within the larger framework of questions about society's power structure.[37]

"The modern age was dedicated to the cult of the male," claims Thomas McEvilley in "Redirecting the Gaze" (see pages 187–95).

He argues that women were relegated to a passive role: the object rather than the subject of "what has come to be called the male gaze." This passive position reflected women's status in the larger power structure. The 1970s and '80s represented a turning point, says McEvilley, when feminist artists began "redirecting the gaze."

With the spread of women's studies in the 1970s, some scholars turned their skills to the task of retrieving the lost achievements of women. Others dug deeper. Not unlike archaeologists sorting through the shards of a lost culture, these scholars began treating their own disciplines critically, extricating embedded and unchallenged premises—the "givens" and "norms" that constitute such disciplines as history, law, psychology, political science, sociology, literature, and art. Feminist reassessment of art scholarship occurred in two waves. The first grew directly out of efforts to achieve equity within the historical record and parity within the established art system. It introduced gender issues into art history, showing how alternative readings of inherited facts about art were possible using a different historical model, one that encompassed the experiences of women artists. Although most saw gender roles as culturally determined, some in the first wave were so-called essentialists. Arguing for an innate feminine sensibility—and, by extension, for a distinctly feminine aesthetic, content, and iconography—they saw the standard narrative of great masters, masterpieces, and movements as a purely patriarchal interpretation, missing its female counterpart. The second wave of feminist scholars and critics turned a spotlight on the cultural construction of knowledge. Theirs was a more theoretical approach, intersecting with inquiries into the nature of representation being pursued in such diverse fields as semiotics, psychoanalysis, linguistics, and the behavioral sci-

Martha Wilson and **Jacki Apple**

Transformation: Claudia
Performance with Anne Blevens at various locations
in New York, December 13, 1973

In a six-hour performance, Martha Wilson and Jacki
Apple posed as a composite fictitious persona,
Claudia—a symbol of the "powerful woman" as she
is stereotyped by fashion magazines, television,
advertising, and movies. The artists dined at New
York's posh Plaza Hotel and toured Soho galleries.
Observing the transformation that the Claudia guise
provoked in their own conversation and behavior
and in unsuspecting members of the public, who
viewed them as rich and powerful, the artists
became more sharply aware of the conflicts between
cultural stereotypes of women and feminist aspira-
tions. Their performance raised disturbing questions
for the artists: "Can a woman be 'feminine' and
powerful at the same time?" "Can a woman be pow-
erful without money?" "Is the powerful woman
desirable?"

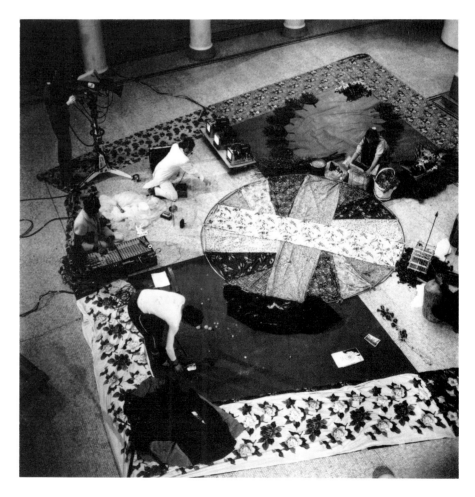

7

Tina Girouard

Pinwheel
Performance at the New Orleans Museum of Art,
with Mercedes Deshotel, John Geldersma, and
Gerard Murrell, 1977

Pinwheel suggests American Indian rituals and the religious textile paintings of Tibet. Using flowing lengths of silk fabric received from her mother-in-law years ago as a "gift of welcome" into the family, Girouard transformed a barren space into a symbolic universe. The fabric marked off four separate squares linked at their center by a pinwheel. Each quadrant connoted a different world—animal, mineral, vegetable, and other—in which four simultaneous performances occurred. As the mineral character picked up a piece of cobalt to render Copernicus's theory of the motion of planets, howls, grunts, and squeals could be heard from the animal world, in which a symbolic character and assorted four-legged creatures were playing out their fate. Girouard, a native of Louisiana, evoked an atmosphere as unpredictable as Mardi Gras, when the laws of the real world are suspended and a different state of consciousness reigns. Swirling the bright silk cloth overhead and spinning it and themselves into various patterns, the characters of the different worlds converged, their movements creating a mandala. The activity was played back on two video monitors, which revealed the creation of the mandala from very different perspectives, allowing the audience to experience a sense of life's simultaneity, incongruity, and complexity.

ences. Adapting analytical tools from these other fields, art criticism stretched beyond traditional formal analysis rooted solely in art's visual nature to address art's function within social, political, and cultural networks.

Feminist revision of art history began by questioning how much "objective" scholarship had been inadvertently distorted by the fact that its largely male formulators worked from male constructs of experience. If this were the case, how would that cultural construct of what is or is not valuable or moral or interesting have biased the choice of styles, subjects, artists, even ideas, considered worthy of attention? In her previously cited article, "Why Have There Been No Great Women Artists?" Linda Nochlin was one of the first to broach these issues. Published in a special *Artnews* publication on women artists in 1971, her article rigorously analyzed certain assumptions about Western art that had become so engrained that they passed for unchallenged fact. She concluded: "Art is not a free, autonomous activity of a super-endowed individual . . . but rather . . . occurs in a social situation, is an integral element of social structure, and is mediated and determined by specific and definable social institutions, be they art academies, systems of patronage, mythologies of the divine creator, artist as he-man or social outcast."[38]

What first-wave feminist critics and art historians such as Nochlin unearthed was far more than the fiction underlying the Romantic myth of "genius," or the inconsistencies pervading assumptions about the innate "masculine" or "feminine" sensibility, or even the crippling effects of cultural and institutional restrictions. By refusing to accept stereotypes, revisionists raised a larger question: how does a dominant group's perceptions about the world produce self-perpetuating networks of "fixed" values, traits, interpretations, and

norms, with everything different becoming "other" and hence substandard and marginalized? As long as art had been safely isolated from worldly concerns by focusing only on formal issues, the domination of a single style, a single group of artists, a single version of art history could be sustained. As soon as theory and criticism opened to include cultural, political, social, and psychological dimensions, alternative interpretations of art's function became not only visible but credible.

The toppling of modernism as an authoritarian system and the concomitant opening up of mainstream art can be seen as part of the period's overall questioning process and its dismantling of fixed conventions and structures. In art, challenges to the authority of modernism took varied forms. Eva Hesse's use of unorthodox sculptural materials such as fiberglass, cheesecloth, and rope for making art (plates 8, 31),[39] and her deconstruction of Minimalist perfectionism by the deliberate introduction of randomness and chaos into structure disrupted expectations about sculpture. Ida Applebroog's themes, played out in mini-dramas that borrow their serialized soap-opera format and cartoon style from popular culture, defied conventional forms of representation (plates 9, 119). Agnes Denes's permutations of a single theorem by Blaise Pascal into remarkably dissimilar visual solutions (plates 162–64) also challenged the legitimacy of fixed structures.

Dismantling fixed notions had been part of the agenda of the first wave of feminist scholarship. With the second wave, the focus shifted. Questions now centered on how the structure of knowledge and language relates to power in society. How do ideas about such things as giftedness, status, masculinity and femininity, good and bad art get formed and embedded? "Meaning . . . comes not from within, but from without," Kate Linker noted. "Nor is it fixed (natural? true?) but variable,

8
Eva Hesse
Untitled, 1968
Latex on wire mesh and plastic clothespin hook,
30 x 9 in.
Estate of the artist; courtesy Robert Miller Gallery,
New York

cultural, a historical formation."[40] The focus on how meaning is constructed—not only how we come to define the world but how that knowledge shapes attitudes and social interactions—placed questions about women's subordination within the broader scope of how difference generally is conveyed and marginalized in our society. Many saw the key representation of difference taking place through society's symbolic systems—language, art, movies, television, advertising. As vehicles for "the dominant forms of representing difference," such transmitters can convey and perpetuate meanings "justifying subordination in our social order."[41]

In "Women Artists Today: Revolution or Regression?" (see pages 197–202), Marcia Tucker presents the remaining obstacles to full participation by women in the art world as part of this larger issue of marginalization. Although acknowledging that women artists have achieved greater visibility since 1970, Tucker claims that the underlying repressive apparatus is essentially unaltered because "The women's movement was all practice and no theory." In her view, new ways of interpreting differences that are less polarizing and new definitions of meaning and value that are less linear are needed to enable those on the margins of power, including women, to move into the mainstream.

The increasing numbers of women artists who were breaking new ground during the 1970–85 period built into a critical mass. With so many "exceptions to the rule," individual achievements could no longer be so easily sidelined. But even as this critical mass pushed aside old stereotypes, reactionary pressures worked to keep them in place. "By 1976 (especially after the advent of Pattern Painting and the popularity of Decorative Art), women artists believed that they had more or less 'arrived' and so were wholly unprepared for being left out of the year's

major museum shows: The Museum of Modern Art's *Drawing Now* and the Guggenheim Museum's *Twentieth Century American Drawings: 3 Avant-Garde Generations*." Of the 45 artists included in the Modern's exhibition, only 5 were women: of the 29 artists showing 230 works at the Guggenheim, the only woman represented was Georgia O'Keeffe.[42] When the College Art Association (CAA) held its annual conference in New York in 1982, the Women's Caucus for Art, an offspring of the CAA, organized sixteen exhibitions at sixteen separate locations under the title *Views by Women*. They also enlisted the cooperation of about 150 galleries in holding simultaneous shows of work by women artists they represented. Observed Lawrence Alloway: "The critics were almost totally silent. There was nothing in *The Village Voice*, nothing in the *Soho News*, *The Nation* and *New York Magazine*. *The New York Times* and *Time* were united in ignoring this intensive sampling of women's art."[43]

The intellectual ferment of the pluralistic 1970s had made for a decentered, unstable art market in which the "star system" gave way to an emphasis on theoretical and artistic explorations. Modernism's clearly delineated mainstream had split into rivulets of new artists and new critical arguments; ideas long dammed up in the backwaters of the art world burst through. A number of influential galleries were established, but mostly the period's energy emanated from inside the studios and from critics trying to cull coherence from the chaos of creativity. A conservative backlash was already suggested by the Museum of Modern Art and Guggenheim exhibitions and by the response to the CAA effort, but few were prepared for the foreign invasion that brought pluralism to a standstill in the early 1980s. Market forces and their attendant star system reasserted themselves with the so-called Europeanization of the

American mainstream. Suddenly the art market rushed into a headlong embrace of Neo-Expressionism, a style with roots in the United States but deeper ones in the male-dominated European art scene. Helped along by a spate of museum and gallery exhibitions underwritten by various foreign governments, the Neo-Expressionists flooded the galleries, magazines, and museums.[44] Their success represented the return of a heroic style familiar to collectors as well as the reemergence of painting after years of nontraditional, and often noncollectable, experimental art forms.

For many artists, especially women artists and particularly those with explicitly feminist concerns, the sudden concentration of criticism, collecting, and gallery and museum exhibitions on a single style, and one in which few women were participants, threatened to reinstate the pre-1970s pattern of exclusion that many presumed had been overcome.[45] Whether the sudden prevalence of Neo-Expressionists in the early 1980s represented, as some suggest, a deliberate backlash to pluralism's free flow of ideas or merely a natural market inclination toward a single, easily promotable style, the mainstream's contraction affected the visibility of many women artists.

The pluralist impulse may have been stalled, but stopping it was something else again. Pluralism had altered the entire art support system. The number of collectors had grown, and their sophistication had increased. Contemporary art programs at museums, and the number of museums themselves, had expanded. Art publications had multiplied. University art departments had multiplied. The gallery system, which had been largely New York–based, by now extended its reach regionally and internationally. Alternative spaces had opened, further stretching the venues and audiences for art. Pressure from this expanded art system could already be

9
Ida Applebroog
Happy Birthday to Me, 1982
Acrylic and Rhoplex on canvas, 83 x 66½ in.
Ronald Feldman Fine Arts, New York

seen by the mid-1980s to be reversing the market's conservative trend with a new wave of pluralism. The women artists coming forward in this revivified pluralist mainstream included some of those who had achieved recognition in the 1970s, as well as a new generation of deconstructionists who were among the first to articulate feminist arguments within the postmodernist debate over meaning and representation that was still underway.[46]

If the sudden prominence of so many women artists as forces within the new pluralist avant-garde met with strong resistance, it was an acknowledgment of how deeply their breakthrough in the 1970s cut into established art world patterns, upsetting entrenched expectations, perceptions, and responses. The change that took place was more than a quantitative one. It involved a deep psychological adjustment for many women artists themselves (altering the learned habits of subsidiary or quasi-amateur status to those of full professional participation); for the art audience (relinquishing the image of the artist as a heroic male figure); and for the academic and commercial art establishments (who, in addition to letting go of the Vasarian myth of "genius," were forced to accept artists and styles traditionally outside the accepted pantheon). Most dramatically, the change restructured the demographic profile of artists who had access to, and influence on, the mainstream.

The recent use of the noun *mainstream* as a verb—exemplified by efforts on the part of educators "to mainstream" minority histories into their curricula—reflects a strong surge toward cultural pluralism and a response to pressure from groups traditionally outside the mainstream for greater representation in it. The tension between pluralism and a desire for singular clear-cut definitions of "good" and "bad" in contemporary art reflects simi-

lar struggles in dealing with the complexity and contradictions in the contemporary world as a whole. The new science of "Chaos" suggests that a nonlinear structure may actually provide a more accurate reading of our experience in a holistic sense than any one reductivist version of truth. The critical standards applied to art may also need rethinking, not in order to relinquish quality but to develop a system of parallel but equivalent measures that distinguish quality without suppressing art's diversity and broad participation in its mainstream.

Periodically the art world goes through episodes of fundamental readjustment. In the past these periods resolved themselves into a single direction and style that dominated thinking about art and art making until the next convulsion took place. The visibility of women artists between 1970 and 1985 resulted from just such a basic reassessment. This book and the exhibition it documents are not designed to provide a definitive overview of everything that occurred in the art world during that period; rather, the intention is to shed light on a particular development that has not been adequately recognized. While there have always been examples of exceptional women artists in the past, it has been possible to construct a history of mainstream art without women. In the future this will not be so, in large part because of the contributions made during the period celebrated here. Such a breakthrough seems to warrant both review and special acknowledgment.

It was tempting, and certainly would have been less hazardous, to concentrate on a few stellar figures. But such a narrow focus would have obscured the diversity and scope of individual effort actually involved. Instead, we have tried to reconstruct a sense of the period's pluralist character—its messiness and lack of any one dominant style—by bringing together a group of artists who represent

different aspects of concerns central to women then working in the art world. The selections presented here include many, but by no means all, of the artists who exerted an important influence. It is indicative of women's achievements during the period that no single book or exhibition could possibly encompass everyone who played a consequential role.

The single-sex focus of *Making Their Mark* is not intended to suggest in any way that a category of "women's art" exists. It does not. No single iconography, ideology, or stylistic direction defines the works included here. *Making Their Mark* contains examples of art with specifically political, social, and feminist content, and it contains works that derive from wholly different sources and intentions. What *does* unify this group of artists is their innovative contributions, their visibility, and their impact on mainstream art.

In the process of researching the exhibition and preparing this book our initial concept of the mainstream grew more complex. It became increasingly evident that entering the mainstream is not like arriving in Mecca; it's more like hovering over Atlantis, an illusory destination whose coordinates remain continually in flux. Much has changed. Much still needs changing. But as women artists move into the mainstream, they may yet prove Eva Hesse right. "The way to beat discrimination in art is by art," she said. "Excellence has no sex."[47]

Notes

1. Robert Storr, "Book Review: Five Collections of Essays on Abstract Expression," *Art Journal* 46 (Winter 1987): 325.

2. Vasari's theories were instrumental in glorifying the artist as a breed apart, a specially endowed superman. "Those who possess such gifts," he wrote, "are not mere men but rather mortal gods." Giorgio Vasari, *The Lives of the Painters, Sculptors and Architects*, ed. William Gaunt (London: Dent, Everyman's Library; New York: E. P. Dutton, paperback ed., 1970), p. xii.

3. Joseph Alsop, *The Rare Art Traditions: The History of Art Collecting and Its Linked Phenomena*, Bollingen Series 35 (Princeton, N.J.: Princeton University Press; New York: Harper and Row, 1982), pp. 110–15.

4. Ibid., pp. 115–17.

5. Betty Parsons, in *The Art Dealers: The Powers behind the Scene Tell How the Art World Really Works*, ed. Laura de Coppet and Alan Jones (New York: Clarkson N. Potter, 1984), p. 23. Parsons's was one of a series of interviews conducted by the editors between 1980 and 1982.

6. This information was provided by Steven Ansovin, director of *Art in America*'s *Annual Guide to Galleries, Museums, and Artists.*

7. The influence that such collectors now exert is typified by the Saatchi Collection, begun by Doris and Charles Saatchi in 1970. Their acquisitions are closely monitored by many in the art world as indicators of new directions in contemporary art. As critics and collectors follow their lead, the Saatchis' preferences for a particular artist or style can develop into a trend. Further enhancing the influence of their holdings was the opening in 1985 of the 30,000-square-foot museum to house the Saatchi Collection in London and, also in 1985, the publication of a four-volume catalog of the collection, which sells worldwide.

8. Although galleries sometimes mount pioneering and influential exhibitions, accompanied by scholarly catalogs that contribute significantly to the understanding of a period or the reputation of a particular artist, the gallery's function is essentially part of the art world's distribution system.

9. Diana Crane, *The Transformation of the Avant-Garde: The New York Art World, 1940–1985* (Chicago and London: University of Chicago Press, 1987), pp. 114–15.

10. Ibid., p. 116.

11. The following names of artists and the dates they joined the gallery were provided by the galleries. In one instance, Pace Gallery, the year represents the artist's first exhibition there: *Mary Boone Gallery*: Barbara Kruger (1987), Sherrie Levine (1987); *Leo Castelli Gallery*: Lee Bontecou (1960), Hanne Darboven (1973), Laura Grisi (1973), Mia Westerlund-Roosen (1977), Dianne Blell (1983); *Paula Cooper Gallery*: Lynda Benglis (1970), Jackie Winsor (1973), Jennifer Bartlett (1974), Elizabeth Murray (1976); *André Emmerich Gallery*: Helen Frankenthaler (1958), Ann Truitt (1963), Beverly Pepper (1975), Katherine Porter (1987), Dorothea Rockburne (1987); *Marlborough Gallery*: Barbara Hepworth (1960), Altoon Sultan (1975), Magdalena Abakanowicz (1987); *Robert Miller Gallery*: Janet Fish (1977), estate of Diane Arbus (1980), Louise Bourgeois (1981), Lee Krasner (1981), Alice Neel (1982), Jan Groover (1984), Martha Diamond (1986), estate of Eva Hesse (1987), Joan Mitchell (1987); *Pace Gallery*: Louise Nevelson (1964), Agnes Martin (1975); *Holly Solomon Gallery*: Judy Pfaff (1979), Melissa Miller (1983); *Sonnabend Gallery*: Hilla Becher (1972), Anne Poirier (1973), Erica Lennard (1979); *John Weber Gallery*: Nancy Holt (1971), Alice Aycock (1973), Barbara Kasten (1981), Susan Leopold (1986).

12. Grace Hartigan, in Eleanor Heartney, "How Wide Is the Gender Gap?" *Artnews* 86 (Summer 1987): 141.

13. H. W. Janson's *History of Art*, the standard textbook (first published in 1962; reprinted in 1969 and 1977), did not include any mention of Lee Krasner or Helen Frankenthaler, key figures in the Abstract Expressionist movement, until a third edition in 1986.

14. In a different context, historian Joan Kelly suggested that this kind of "typecasting" was inherent in the social structure: "Throughout historical time, women have been largely excluded from making war, wealth, laws, governments, art and science. Men, functioning in their capacity as historians, considered exactly those activities constitutive of civilization: hence, diplomatic history, economic history, constitutional history, and political and cultural history. Women figured chiefly as exceptions." Joan Kelly, *Women, History, and Theory: The Essays of Joan Kelly* (Chicago and London: University of Chicago Press, paperback ed., 1986), p. 2.

15. Linda Nochlin, "Why Are There No Great Women Artists?" in *Woman in Sexist Society: Studies in Power and Powerlessness*, ed. Vivian Gornick and Barbara Moran (New York: Basic Books, 1971), pp. 480–510; reprinted in *Artnews* 69 (January 1971) as "Why Have There Been No Great Women Artists?" It also is in the collection of essays *Art and Sexual Politics*, ed. Thomas B. Hess and Elizabeth C. Baker (New York and London: Collier Books, 1973).

16. Nochlin noted the particularly disastrous impact of the proscription against women drawing from the nude, which was in force for almost three hundred years. Forbidden to study from the human form, a basic element in the most prestigious types of painting, most women had to work in portraiture, still life, and landscape. Concentration on these genres, considered to require less skill, automatically categorized them as less gifted, however exceptional their talents.

17. Vasari, *Lives*, p. 326. Vasari briefly discussed several women among his nearly two hundred biographies, including Properzia de' Rossi, Sister Plautilla Nelli, Madonna Lucrezia, and Sofonisba Anguissola. Although none was presented as a major figure, Vasari did show sensitivity to the strictures placed on their development, commenting of Nelli: "She would have done marvellous things if, as men do, she had been able to study and learn to draw and work after living models." Quoted in Ann Sutherland Harris and Linda Nochlin, *Women Artists: 1550–1950* (Los Angeles: Los Angeles County Museum of Art; New York: Alfred A. Knopf, 1976), p. 21.

18. Louise Bourgeois remained an "outsider" even within the Surrealist circle. Robert Storr comments on Bourgeois's anger with the so-called father figures in her life, Marcel Duchamp and André Breton, noting that they were "dependent upon the support of a select group of rich women patrons. [Surrealism's] leaders demonstrated virtually no active interest in women

artists who did not in addition serve as economic or sexual providers." Quoted in Robert Storr, "Louise Bourgeois: Gender and Possession," *Art in America* 71 (April 1983): 134.

19. Corinne Robins, *The Pluralist Era: American Art, 1968–1981* (New York: Harper and Row, 1984), p. 47.

20. Nicholas Africano, in Kay Larson, "For the First Time Women Are Leading Not Following," *Artnews* 79 (October 1980): 69.

21. Modernism—the view that defined modern art for decades, shaping modern art texts and museum collections—was precisely delineated by Alfred H. Barr, Jr., director of the then recently established Museum of Modern Art, in *Cubism and Abstract Art* (New York: Museum of Modern Art, 1936; reprinted in paperback, 1974). A diagram on its cover depicted the history of modern art from 1890 to 1935, which became the standard model as further refined by Barr and later elaborated by the critic Clement Greenberg. Barr distinguished between "representational" and "nonrepresentational" art, with modernism being concerned primarily with the latter. Barr envisioned art as having an underlying natural order, to be revealed through a universal language of pure form. Greenberg's later formalist notions expanded on the purist theme, arguing for a completely autonomous art in which "subject matter and content become something to be avoided like the plague." See Clement Greenberg, "Avant-Garde and Kitsch," in *Art and Culture: Critical Essays* (Boston: Beacon Press, 1961; reprinted 1965), pp. 3–21, quote on p. 5.

Alternative interpretations vied with Barr's and Greenberg's, particularly those of Meyer Schapiro, who questioned distinctions between "representation" and "nonrepresentation" and argued for an inclusive critical model that addressed historical, social, and psychological influences. See Meyer Schapiro, "The Nature of Abstract Art," in *Modern Art: 19th and 20th Centuries* (London: Chatto and Windus, 1978), pp. 185–226; and Meyer Schapiro, "The Social Bases of Art" (1936), in *Social Realism: Art as a Weapon*, ed. David Shapiro (New York: Frederick Ungar Publishing Co., 1973), pp. 118–27. Barr's and Schapiro's concepts were formulated in the 1930s, a period rife with political controversy and pressures for a "people's art," which challenged the values of

traditional art criticism. The shadows of these early arguments over the nature and function of art remain visible behind the debates of the 1970s and '80s.

22. Clement Greenberg, in Peter G. Ziv, "Clement Greenberg: A Critic's Forty-Year Challenge to the Art World," *Art and Antiques*, September 1987, p. 57.

23. Frank Stella, in William S. Rubin, *Frank Stella* (New York: Museum of Modern Art, 1970), p. 42.

24. Connections can be made, for example, between the antiart, antielitist Duchampian strain in some Pop art and the postmodernist criticism of "originality." The arguments of the 1970s over "high" art and "low" art are foreshadowed in Claes Oldenburg's use of such craft-associated elements as fabrics and papier-mâché. On an iconographic level, Elizabeth Murray's early cartoon style and Vija Celmins's oversize comb sculptures bear visual affinities to Pop art but grew out of other motivations.

25. In a coauthored article, Valerie Jaudon and Joyce Kozloff traced the pejorative connotation of decorative art: "The prejudice against the decorative has a long history and is based on hierarchies—fine art above decorative art, Western art above non-Western art, men's art above woman's art. ("Art Hysterical Notions of Progress and Culture," *Heresies* 4 [Winter 1977–78]: 38.) Pattern and Decoration, a style that rose to prominence in the mid-1970s, answered a growing desire to bridge the gap between "high" and "low" art and was liberating for men as well as women. Kim McConnell, Brad Davis, Robert Kushner, Tony Robbins, and Robert Zakanitch were directly identified with aspects of this decorative development. But it surfaced in work by others as well: Frank Stella's Exotic Birds series, Lucas Samaras's stitched brocade and metallic polyester wall pieces, Alan Shields's stitched canvases, and George Sugarman's exuberantly colored sculptures, to cite a few.

26. Robins, *Pluralist Era*, pp. 57–58.

27. An overview of the organizations, protests, and exhibitions of the period can be found in the special issue of *Artnews* entitled "Where Are the Great Men Artists?" October 1980. See also Lawrence Alloway, "Women's Art in the '70s," *Art in America* 64 (May–June 1976): 64–72; and Robins, *Pluralist Era*, pp. 1–75.

28. Lucy Lippard, *From the Center: Feminist Essays on Women's Art* (New York: E. P. Dutton, 1976), p. 98.

29. One of the longest surviving of these spaces, A.I.R. (an acronym for "artists in residence"), opened September 17, 1972, in a renovated machine shop on Wooster Street in New York. A cooperative gallery founded with twenty members, A.I.R. was organized by Barbara Zucker and Susan Williams. Corinne Robins reports a comment revealing some of the attitudes and expectations operating in 1972: "The male art world turned out in large numbers, one man telling Barbara Zucker, 'Okay you did it: You found 20 good women artists, but that's it.'" (Corinne Robins, "Artists in Residence: The First Five Years," *Womanart*, Winter 1977–78, p. 6.) In 1973 Soho 20 opened in New York, and the Committee for the Visual Arts, organized by Irving Sandler and Trudie Grace, eventually led to Artists Space, another alternative gallery devoted to showing unaffiliated artists. Also in 1973, Artemesia and ARC formed in Chicago, and Womanspace Gallery opened in the Woman's Building in Los Angeles.

30. *Miriam Schapiro, Femmages 1971–1985* (Brentwood, Calif.: Brentwood Gallery, 1985).

31. Robins, *Pluralist Era*, p. 57. According to Grace Glueck ("Women Artists 1980," *Artnews* 79 [October 1980]: 60), the exhibition grew out of demands made by women artists picketing the Los Angeles County Museum of Art in 1970, although the show's greatest stimulus was Nochlin's famous essay, "Why Have There Been No Great Women Artists?"

32. Ann Gabhardt and Elizabeth Broun, *Bulletin* (Walters Art Gallery) 24 (April 1972).

33. Eva Hesse, in Lucy R. Lippard, *Eva Hesse* (New York: New York University Press, 1976), p. 205.

34. Mary Jane Jacob, introduction, in *The Amazing Decade: Women and Performance Art in America, 1970–1980*, ed. Moira Roth (Los Angeles: Astro Artz, 1983), p. 13.

35. Craig Owens, "Sex and Language in Between," in *Laurie Anderson, Works from 1969 to 1983* (Philadelphia: Institute of Contemporary Art, University of Pennsylvania, 1983), p. 53.

36. Often cited as an extension of 1960s Happenings or as a by-product of Conceptual art,

performance actually has deeper roots. In this century it has been tied to efforts for political and social change, as in the Dadaist performances in Europe after World War I and the "Living Newspapers" acted out in the streets and factories of Russia in the 1920s. A fascinating summary of early performances can be found in *The Art of Performance: A Critical Anthology*, ed. Gregory Battcock and Robert Nickas (New York: E. P. Dutton, 1984), pp. 3–23; and in Rosalee Goldberg, *Performance: Live Art 1909 to the Present* (New York: Harry N. Abrams, 1979), p. 115.

37. Critics Lucy Lippard and Craig Owens have each commented on the trend toward assimilation: "If this happens, we shall find ourselves back where we started within another decade, with a few more women known in the art world, with the same old system clouding the issues, and with those women not included beginning to wonder why. The worst thing that could happen at this time would be a false sense of victory." (Lippard, "The Women Artists' Movement—What Next?" [1975] in *From the Center*, p. 141.) Noting points of conjunction between the feminist critique of art and the postmodernist critique, Owens speculated that "postmodernism may be another masculine invention engineered to exclude women." (Thalia Gouma-Peterson and Patricia Mathews, "The Feminist Critique of Art History," *Art Bulletin* 69 [September 1987]: 326–57; Owens quote, p. 350. The *Art Bulletin* article provides an important overview of the integration of feminist criticism into art and art history.)

38. Nochlin, "Why Have There Been No Great Women Artists?" *Artnews*, p. 32.

39. Lippard, *Eva Hesse*, p. 132. "She wanted to make art that could surprise, and she was canny enough to know that if it looks beautiful at first glance, a second glance may not be necessary. . . . Getting away from the pretty had been a preoccupation of hers since she left art school. The eroticism, the humor, the new materials, were all means to that end."

40. Kate Linker (discussing the work of Louise Lawler), "Eluding Definition," *Artforum* 23 (December 1984): 67.

41. Mary Kelly, "No Essential Femininity: A Conversation between Mary Kelly and Paul Smith," *Parachute*, no. 26 (Spring 1982): 35.

42. Robins, *Pluralist Era*, p. 70.

43. Lawrence Alloway, "Where Were You on the Week of the 23rd?" *Village Voice*, March 2, 1982.

44. The West German government was particularly energetic in promoting its star painters—Georg Baselitz, Jörg Immendorff, Anselm Kiefer, Markus Lüpertz, and A. R. Penck—by funding international and American museum exhibitions in which they were showcased. Joseph Beuys's large solo exhibition at the Guggenheim Museum in November 1979 generated a media event and a full feature in the *New York Times Magazine. Masters of German Expressionism 1909–1937*, another government-aided effort also mounted at the Guggenheim, in 1981, provided a backdrop to the growing popularity of the Neo-Expressionists, by implication placing the new style within the lineage of twentieth-century European art movements and suggesting its eminence as part of a logical series of progressive developments. *Zeitgeist*, 1982 (one of the year's most talked-about exhibitions), opened in Berlin; it included examples of Neo-Expressionism from eight countries. Only one woman, Susan Rothenberg, was represented in it. Documenta, a recurring exhibition considered by many to be a barometer of the contemporary art world, offered another strong platform for the Neo-Expressionists in 1982. By 1983, *Expressions: New Art from Germany*, organized by the St. Louis Art Museum, was touring the United States. There were no works by women in that exhibition, a trend also notable in the flood of imports from Italy (Sandro Chia, Francesco Clemente, Enzo Cucchi); France (Jean-Charles Blais, Gérard Garouste); and Britain (Richard Deacon, Anish Kapoor, Bill Woodrow).

45. Of the forty-three artists in the 1985 Carnegie International, only four were women (Dara Birnbaum, Jenny Holzer, Susan Rothenberg, Cindy Sherman); thirteen were Neo-Expressionists. Many of the women artists who attained visibility during this resurgence of heroic painting were, interestingly enough, nonpainters involved with electronic media or photography.

46. As a term, *postmodernism* is multivalent, covering everything from stylistic challenges to modernism to theoretical arguments for cultural transformation. For an overview of many of the key issues involved in the postmodernist discussion, see the anthology *Art after Modernism: Rethinking Representation*, ed. Brian Wallis (New York: New Museum of Contemporary Art; Boston: David Godine, 1984).

47. Hesse, in Lippard, *Eva Hesse*, p. 205.

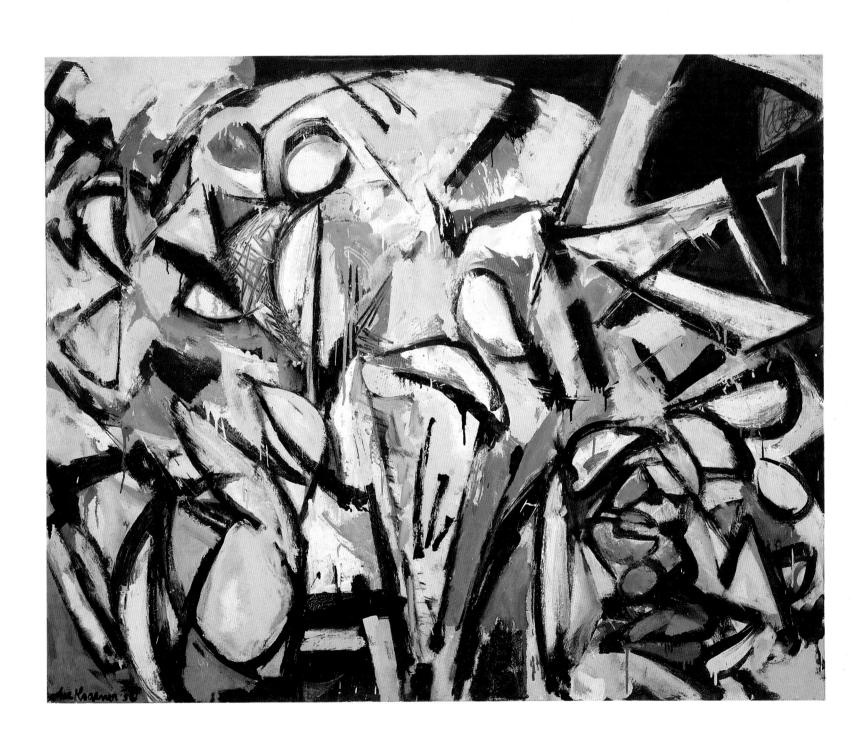

Ellen G. Landau

Tough Choices:
Becoming a Woman Artist, 1900–1970

10
Lee Krasner
Easter Lilies, 1956
Oil on cotton duck, 48¼ x 60⅛ in.
Private collection; courtesy Robert Miller Gallery,
New York

Prior to the women's movement of the 1970s, women artists in America were, more often than not, forced throughout their careers into making tough personal and professional choices in order to achieve even a modicum of success. Indeed, during the first seven decades of this century the trials and tribulations of becoming a woman artist in America changed hardly at all; patterns were set at the beginning of the 1900s that continued with surprisingly few variations throughout the prefeminist years. Close examination of the biographies of American women who succeeded in art during this period reveals that most exhibited aggressiveness, determination, and rebelliousness from childhood on. These characteristics are vividly apparent in the lives of Marguerite Thompson Zorach and Georgia O'Keeffe, women who made their mark on the art world of the 1910s and '20s.[1]

Even after working in Paris and having her paintings accepted into several prestigious Salons, Marguerite Thompson (plate 11) still had to contend with a family so opposed to her becoming an artist (and so horrified by her interest in radical modern movements) that they tried to hide her paints. Continuing to rebel against her parents' wishes, Thompson moved to New York to marry the sculptor William Zorach, whom she had met abroad. At first better known (and perhaps more

talented) than he—her work was exhibited in the 1913 Armory Show, and she was the only woman represented in the landmark Forum Exhibition held three years later—Marguerite Zorach eventually chose to submerge her own career in that of her husband. "She always said that I had a depth of feeling and an original creativeness that was beyond hers," he later wrote.[2] (This situation was to be repeated almost identically twenty or so years later in the relationship of Lee Krasner and Jackson Pollock. Krasner recalled that in the early 1940s: "He was the important thing. I couldn't do enough for him." As Krasner became more involved with Pollock, she admitted that her own work began to seem "irrelevant."[3])

Marguerite Zorach found it increasingly difficult to concentrate on art after the birth of her two children. Unfortunately, her resulting decision to switch from painting to embroidering pictures in woolen yarns seriously damaged her artistic reputation, in effect downgrading it to amateur status. The fact that Zorach devised the preliminary designs for many of her husband's reliefs, although readily acknowledged in his memoirs, has never been mentioned in studies of his work.[4] But (as would be true of Krasner and Pollock later on) Marguerite Zorach continued throughout her life to serve as catalyst for

27

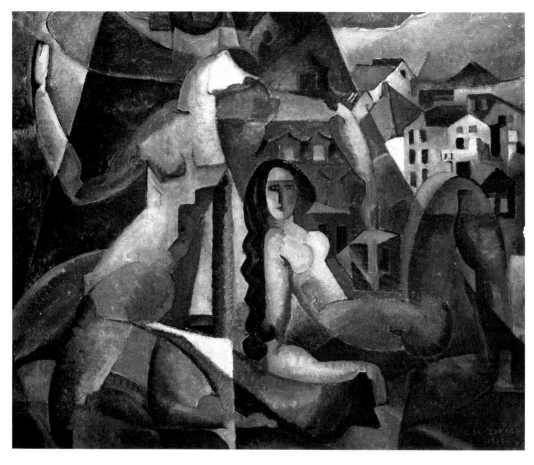

11
Marguerite Zorach
Sailing (Wind and Sea), 1919
Oil on canvas, 25 x 30 in.
Private collection; courtesy Kraushaar Galleries,
New York

her husband's innovations.

The dynamics of the relationship between Georgia O'Keeffe (plate 12) and Alfred Stieglitz were very different, although she was denigrated by some as merely an extension of her husband's genius.[5] An undeniable factor in O'Keeffe's success was Stieglitz's role not only as a mentor who constantly encouraged her to extend herself but also as an active promoter of her career in his role as a dealer. There were drawbacks to the relationship, however. Stieglitz's series of intimate photographs of her generated a tabloid notoriety that did great psychological and critical damage to O'Keeffe, ultimately causing her to adopt a radically austere public persona in self-defense.[6]

Even more harmful was Stieglitz's often-expressed conviction that women experienced life in a way that was "spiritually distinct" from men's experience. He claimed, for instance, that "Woman feels the world differently than Man feels it. . . . The Woman receives the world through her womb. That is the seat of her deepest feeling."[7] His pontifications along these lines encouraged others to interpret O'Keeffe's work accordingly. For example, in 1922 a writer for *Vanity Fair* stated: "There is no stroke laid by her brush whatever it is she may paint, that is not curiously, arrestingly female in quality. Essence of very womanhood permeates [O'Keeffe's] pictures."[8] This type of criticism intensified O'Keeffe's difficulties in being accepted as an equal by her male peers at Stieglitz's gallery, "291." ("The men like to put me down as the best woman painter," she once remarked. "I think I'm one of the best painters."[9]) It also stimulated the erotic interpretations of O'Keeffe's flower paintings of the 1920s and '30s, interpretations that she vehemently rejected throughout her life, particularly after the championing of "vaginal iconography" by militant feminists.

12
Georgia O'Keeffe
Morning Glory with Black, c. 1926
Oil on canvas, 35¹³/₁₆ x 39⅝ in.
The Cleveland Museum of Art; Bequest of Leonard
C. Hanna, Jr.

Similar discriminatory language has pervaded subsequent reviews of work by many women artists. Feminine terminology—especially adjectives such as *intuitive*, *lyrical* (which Helen Frankenthaler has blasted as "that loaded word"[10]), *sensitive*, *delicate*, *tender*—has been much overused. Frankenthaler, one of the principal heirs to the "macho" Abstract Expressionist tradition, found herself criticized for painting works that were "too soft" and, at the same time, for saying "in bold and aggressive (read 'non-feminine') terms: 'My name is Helen Frankenthaler—and goddam it, I know how to paint just as well as the boys.'"[11]

Returning to the 1920s, the decade of O'Keeffe's and Zorach's development, we should note as well the increased participation of women in other art activities. Many became art teachers and others assumed the role of patron, most prominently, Lillie Bliss in New York, Gertrude Stein in Paris, and the Cone sisters of Baltimore. In 1920 Katherine Dreier and the avant-garde French artist Marcel Duchamp formed the Société Anonyme, an unprecedented organization that collected radical new art and organized traveling exhibitions. Sculptor Gertrude Vanderbilt Whitney's founding of the Whitney Studio Club in 1918 in New York, in conjunction with her friend Juliana Force, led to the establishment thirteen years later of the Whitney Museum of American Art.

By the early 1930s the number of women associated with the arts had dramatically increased. The WPA, a work-relief organization formed to help artists survive the Depression, had a profound impact on women in the art world because of its gender-blind hiring practices.[12] Its influence was especially strong in New York, where many of the planners and administrators of the local Fine Arts Projects of the WPA were women, including Juliana Force, Audrey McMahon, and

Berenice Abbott. Many women artists—Krasner, Elizabeth Olds, and Helen Lundeberg among them—were appointed to supervise their male and female peers in the execution of major projects, and many served as executives in the Artists Union, which was formed to lobby for WPA artists' rights.[13] There was a collegial atmosphere during this period that helped encourage the more general acceptance of women. As critic Clement Greenberg has noted, worldly success for any American artist was such a remote possibility during the Depression that it seemed to be "totally beside the point"[14]; men had nothing to lose (economically, at least) by admitting women into their poverty-stricken ranks.

Despite the paucity of financial resources, artists who survived the period remember it fondly: "You put things on the line," Krasner recalled about her WPA days. Krasner, Alice Neel, Louise Nevelson, I. Rice Pereira, and many others launched their careers under the auspices of New Deal patronage. Some female artists who specifically addressed "women's issues" in their art were encouraged to continue doing so (albeit in a benign rather than militant fashion); witness Lucienne Bloch's prominently publicized mural *The Cycle of a Woman's Life*, painted in 1935 for the New York Women's House of Detention.

By the late 1930s there were also two other key venues for female participation in the New York art world: the Hans Hofmann School of Fine Arts and the American Abstract Artists organization. At the Hofmann School the latest, most radical modernist theories were taught to artists in this country for the first time. Some Americans, including Louise Nevelson, had traveled to Germany to study with Hofmann before his school opened in New York in 1934. Nevelson briefly continued her studies with him here; Krasner, Perle Fine, Lillian Kiesler, Rae Kaiser Eames,

and Mercedes Carles Matter were among the other women who attended the school in the 1930s and early '40s. (Frankenthaler, Nell Blaine, Jane Freilicher, and others went there in the following decade.) Many, including Nevelson and Krasner, have recalled Hofmann's blunt male chauvinism: Hofmann once told Krasner that one of her works was "so good you would not believe it was done by a woman."[15] Nonetheless, his classes supported the advancement of many female artists.

The American Abstract Artists (AAA) group was set up to counteract widespread Depression-era animosity toward nonobjective art, particularly from the WPA and the Artists Union. (Abstract artists were outsiders during this period, whatever their sex.) In addition to offering its members an opportunity to exhibit, the AAA took a strongly theoretical approach, with many position papers written to accompany its exhibitions. Women members played a key role in articulating these statements of policy.[16] The AAA encompassed an unusual number of couples who shared equal responsibility in the organization and equal visibility in its shows. Rosalind Bengelsdorf and Byron Browne, Gertrude Glass and Balcomb Greene, Susie Frelinghuysen and George L. K. Morris, Esphyr Slobodkina and Ilya Bolotowsky were all active, as were women *not* attached to men in the group, including Krasner, Pereira, and Charmion von Wiegand.

No one in the AAA was more deeply committed to the abstract cause than Alice Trumbull Mason (plate 13). More patrician than her colleagues, many of whom were first- or second-generation Americans, Mason was descended from the colonial governor of Connecticut, whose son, John Trumbull, was a famous painter of the Revolutionary War. Rejecting the genteel life of her family, she devoted herself to promoting nonobjec-

tive art. "Were it not for Alice Trumbull Mason," the Abstract Expressionist painter Ad Reinhardt was later to comment, "we would not be here, nor in such strength."[17] Her work prefigured the Minimalism of the 1960s and '70s, but her self-effacing modesty[18]; her family problems (her husband was away at sea most of the time, leaving Alice to raise their two children alone); her rather acerbic personality; and her alcoholism and recurring depressions all contributed to the eclipse of Mason's reputation after the heyday of the AAA (1936–42).

Questioning whether Mason's gender had affected her style at all, *Time* critic Robert Hughes once wrote: "What sex is Alice Mason's painting? . . . I might answer platonic."[19] If that same question had been raised about her art, Louise Nevelson (plate 14) would probably have answered it very differently. "My whole life is feminine," she once commented. "I work from an entirely different point of view. My work is the creation of a feminine mind—there is no doubt." Continuing this idea, she explained, "The feminine mind is positive and not the same as a man's. . . . My work is delicate; it may look strong, but it is delicate. True strength is delicate."[20]

After enduring an unsatisfying marriage for a decade, Nevelson left her husband and temporarily gave up her son in order to become an artist. It was not to be an easy process. "For forty years," Nevelson recalled, "I wanted to kill myself. I just wasn't hitting it quite right . . . the frustrations, the anger." She maintained that she survived because "I recognized that I had the equipment to fulfill my life, and I believed in what I was doing. Every breath I took was that."[21] Nevelson's self-destructive desperation was tempered somewhat in the early 1940s by the love and sustenance provided by art dealer Karl Nierendorf. From the day in 1941 when Nevelson pushed her way in to see him until

13
Alice Trumbull Mason
Brown Shapes White, 1941
Oil on board, 24 x 31¾ in.
Philadelphia Museum of Art; A. E. Gallatin
Collection

14
Louise Nevelson
Dawn's Wedding Chapel II, 1959
Painted wood, 115⅞ x 83½ x 10½ in.
Whitney Museum of American Art, New York; Gift
of Howard and Jean Lipman Foundation, Inc.

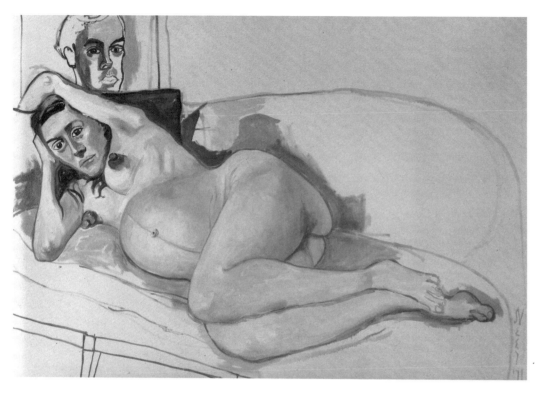

15
Alice Neel
Pregnant Woman, 1971
Oil on canvas, 40 x 60 in.
Courtesy Robert Miller Gallery, New York

his death six years later, Nierendorf encouraged her both spiritually and financially, as Stieglitz had done with O'Keeffe. His support enabled Nevelson to develop her distinctive mural-size assemblages, in which she recorded her childhood obsession with collecting, made personal sense out of her family's immersion in the lumber business, and finally came to terms with her mother's failed hopes and expectations.[22]

Though she eventually became the doyenne of American sculptors, Nevelson had a difficult time being accepted when she first began to show. Partly this was due to the general climate in the 1940s: many of the gains that women had made through the WPA vanished in the face of New York's suddenly more ambitious, market-oriented, and male-dominated art community. (This was true despite the fact that many of the important dealers of the period, such as Betty Parsons and Peggy Guggenheim, were female.) "We learned the artist is a woman, in time to check our enthusiasm," read a review of Nevelson's work in a 1941 issue of *Cue* magazine. "Had it been otherwise," the critic continued, "we might have hailed these sculptural expressions as by a truly great figure among moderns."[23]

The woman artist most severely affected by the changed climate of the war and immediate postwar years was Lee Krasner (plate 10). "I was not the average woman married to the average painter," she once noted wryly. "I was married to Jackson Pollock. The context is bigger and even if I was not personally dominated by Pollock, the whole art world was."[24] Her independent development prior to meeting Pollock and her own contributions to the genesis of early Abstract Expressionism were ignored during the 1940s and '50s, as Krasner was increasingly patronized by both artists and critics as "the wife who also paints."

Krasner's friends from the Hofmann

School and the American Abstract Artists had considered her the more talented of the two when she first began to go out with Pollock. Admittedly "bowled over" by him, she immediately recognized his radicality as being comparable to that of the great European innovators, and she willingly relegated her own career to subsidiary status to proselytize for Pollock. Only recently, in the spirit of revisionism resulting from the feminist "questioning of the litany," have many who were close to Krasner and Pollock acknowledged his dependence on her—sometimes aesthetically, always practically. (When asked if Pollock had studied with him, Hofmann had to say no, but he often qualified his statement with the observation that Pollock *was* "a student of my student, Lee Krasner."[25]) Her accomplishments in the course of some forty years were not really recognized until it was virtually too late: Krasner's single major American retrospective took place in 1983, the year before she died.

In her later years Krasner repeatedly remarked, "My painting is so autobiographical, if anyone can take the trouble to read it."[26] A concern with personal history is also evident in work by two of Krasner's colleagues, Alice Neel and Louise Bourgeois. They, too, emerged in the 1940s and they, too, remained almost invisible in the art world until some thirty years later. Their works bear further witness to the search by many women for catharsis and compensation through painting and sculpture.

Considered a role model by many feminists in her last decade or so, Neel (plate 15) remained a loner afflicted with "a profound timidity" until very late in life. She once recalled, however: "I was born believing in feminism. I was born believing in art. My mother used to say, 'I don't know what you expect to do in the world, you're only a girl.' But if anything, that made me more anx-

ious to do something."[27] Neel's worst nightmare, she once announced, was that she had turned into someone who was conventional and bourgeois.[28] Neel credited her belated success to the fact that she had finally learned how to defend herself in a man's world. Long before, one of her WPA cronies had dubbed her "the woman who paints like a man." "I always painted like a woman," she countered, "but don't paint like a woman is supposed to paint."[29] Focusing without embarrassment on women's pregnant stomachs or men's genitalia, Neel usually presented her sitters in unheroic or vulnerable moments in order to reveal, in her words, "not only what shows, but what doesn't show."[30]

Neel's obstinate refusal to soften her approach to portraiture no doubt delayed her acceptance. In the 1970s she told Eleanor Munro: "For all I know, my human images originate in terror. (Maybe I need to exorcise something.)"[31] Her difficult pictures certainly mirror her difficult life. By her own account, Neel was a bored and morbid child, and an early marriage to Cuban painter Carlos Enriquez made her even more unhappy. Her first-born daughter died from diphtheria, and Neel lost custody of her second daughter when she and Enriquez were divorced. She never remarried, but Neel did bear two sons by different fathers within two years. However traumatic her life was, Neel found: "The minute I sat in front of a canvas I was happy. Because it was a world and I could do what I liked in it."[32] Neel's personality seems to have encompassed a paradoxical combination of physical and mental fragility with an inexhaustible determination to succeed. Having experienced her first mild nervous breakdown as a teenager, she attempted suicide several times, almost bringing it off after Enriquez took her daughter away.

Neel's hypersensitivity and that of her female colleagues and predecessors—Alice

Trumbull Mason's depressions and alcohol addiction (later exacerbated by the loss of her grown son at sea); Nevelson's never acted upon desire to do away with herself; and O'Keeffe's habit of taking to bed with nervous exhaustion after every one of her solo exhibitions during Stieglitz's lifetime[33]—all form another pattern whose implications should not be ignored. Work was not always enough to satisfy these women, and it often took a high psychic toll. Neel voiced this problem when she told an interviewer, "I would leave myself behind and enter the painting and the sitter," but afterward she would often find herself feeling "like an empty house with no self."[34]

This very image of a faceless, selfless woman trapped in the empty shell of a house is most poignantly expressed in the Femme Maison series by Louise Bourgeois (plate 16). Although Bourgeois had created these drawings before 1950, there was little awareness of their haunting imagery until critic Lucy Lippard chose one as the cover image for her 1976 book, *From the Center*. Bourgeois has attributed her need to make sculpture to a desire to create "a past that I could not do without. And not only recreating the past: also controlling it."[35] Speaking about her years of working in relative obscurity, Bourgeois confessed to Eleanor Munro: "I had the feeling that the art scene belonged to the men, and that I was in some way invading their domain. Therefore my work was done but hidden away. I felt more comfortable hiding it."[36]

Although she is now renowned for the disturbing and often violent sexuality of her work, Bourgeois has characterized herself as inhibited and "not courageous." Her marriage in the late 1930s to American art historian Robert Goldwater (a man her father did not like) enabled Bourgeois to escape her French family's tapestry-weaving business, a place

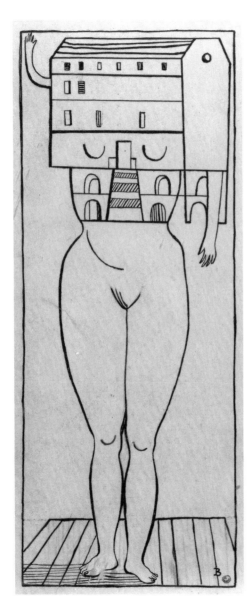

16
Louise Bourgeois
Femme Maison, 1947
Ink on paper, 9⅛ x 3⅝ in.
Courtesy Robert Miller Gallery, New York

where she says she was always "trying to be good and [was] absolutely disgusted with the world."[37] Her disgust derived, in part, from the fact that her father had installed his mistress in the household as Louise's governess—a situation her mother had to endure quietly.

After Bourgeois moved with Goldwater to New York, she began to use her artistic talents psychotherapeutically. Conceiving woman as victim and sex object, man as predator and oppressor, she created not only the Femme Maison pieces but also a group of idiosyncratic totems and a series of Femme Couteau sculptures. These "woman-knives" can be read as simultaneously penile and labial. "The fact that this woman is wrapped indicates that she is frightened," Bourgeois said in reference to one of her Femmes Couteaux. "She has to protect; it's a giveaway. Actually the knife is not an aggressive knife, it's a defensive knife. It has the shape of a penis because in her imagination she experienced the penis as a weapon. So she steals a weapon in order to defend herself."[38]

Bourgeois can be seen as a direct predecessor of many later women artists whose imagery has been explicitly sexual, celebrating or exploring gender differentiation. However, the fact that the roots of Bourgeois's iconography are clearly psychological rather than political distinguishes her approach. For instance, Bourgeois's womblike Lairs—hanging cocoon forms of mesh-covered latex—were inspired by her desire to enfold her mother within a protective love. The resultant image is very different from the heraldic and decorative vaginal icons made by Judy Chicago (plate 107), for example.

Although Bourgeois was well connected in the New York art world of the 1940s, through her own contacts at the Art Students League and through those of her husband (she was also a close friend of Marcel Duchamp's and knew many of the Surrealist émigrés), she

chose not to play a visible role in the burgeoning art scene during that or the following decade.[39] Krasner and Nevelson did try but ran up against the discriminatory attitudes of their male colleagues. For example, women were initially excluded from such networking venues as The Club.[40] "The men did not really include me as an artist at all," Nevelson recalled about those days. "I was a good chick. I'd sing for them at the Cedar, but I wasn't on their level."[41] (One of them told Nevelson, "You've got to have balls to be a sculptor."[42]) At the height of its importance in the early 1950s, Krasner refused to go to the Cedar Bar because her husband's friends who hung out there delighted in goading him to drink too much. She herself suffered many slights from these same colleagues. Barnett Newman (who once said to Krasner, "We don't need dames"[43]) called their house to ask Pollock to endorse the famous January 1951 petition of the "Irascible 18" painters, a protest against the antiabstract exhibition policies of the Metropolitan Museum of Art. It apparently never occurred to Newman that Krasner might also have wanted to sign.[44] Bourgeois signed the sculptors' petition, but only one woman painter—Hedda Sterne—was included in the photograph of the "18" that was published in *Life* magazine.

Sterne, whose semiabstract canvases were far less adventurous than Krasner's, had been singled out by *Life* the previous year as "one of our most promising young painters."[45] Having fled her native Bucharest, Sterne arrived in the United States in 1941; she later married the cartoonist Saul Steinberg. Through Jean Arp, whom she had known in Europe, Sterne came to the attention of Peggy Guggenheim, but it was through her affiliation with the Betty Parsons Gallery that she met Pollock, Newman, Mark Rothko, Robert Motherwell, and Clyfford Still. Parsons, only after Pollock's insistence, grudg-

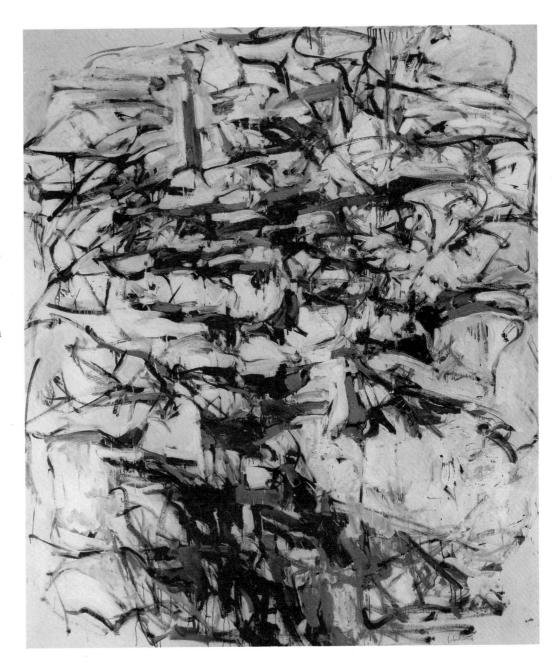

17

Joan Mitchell

Hemlock, 1956
Oil on canvas, 91 x 80 in.
Whitney Museum of American Art, New York;
Purchase, with funds from the Friends of Whitney
Museum of American Art

ingly gave Krasner a solo show in 1951. It was probably Parsons's more sustained and enthusiastic support of Sterne that led to Sterne's being taken more seriously. Krasner always complained that her own exclusion from the photo of the "Irascible 18" was a major setback to her career.

By the mid-1950s, with the development of a "second generation" of Abstract Expressionists, women artists seemed to find the road to recognition more accessible. Willem de Kooning's young wife, Elaine Fried de Kooning, was one of a number of female painters making the Tenth Street scene, and she was also actively involved in writing criticism for Thomas B. Hess, the editor of *Artnews* magazine. Like so many other young artists of the 1950s she emulated de Kooning's smear and spatter style, but she applied it to portraits and to often brutal (and certainly "unfeminine") sporting and bullfight subjects. Elaine de Kooning, who has described her impetus to succeed as a reaction to her own mother's antifeminism,[46] had met her husband the previous decade (before he became famous), and for a number of years she followed him to such major centers of artistic ferment as North Carolina's Black Mountain College. They eventually separated in the early 1960s but were never divorced; in recent years she has returned to take care of him.

Though certainly influenced by her husband, Elaine de Kooning established her own reputation, bolstered by her inclusion in *Talent 1950*, a landmark exhibition curated by Clement Greenberg and Meyer Schapiro for the Samuel Kootz Gallery.[47] Also included in that show were the realists Jane Freilicher and Nell Blaine and the abstractionists Helen Frankenthaler, Grace Hartigan, and Joan Mitchell, who was one of the most energetic and restless of the *Talent 1950* group. Mitchell's ambitions had also developed in

reaction to parental treatment (her father, a doctor, was disappointed that she had not been a son, and he frequently taunted her by saying, "You can't do anything as well as I because you are a woman"[48]). By her own admission, Mitchell was unwilling to "fight for her rights," and she never achieved the prominence of some of her peers. Like Bourgeois, Mitchell was convinced that, as a female painter, she could "never be in the major competition."[49] She effectively removed herself from contention when she relocated to France in 1968 to live with the Canadian painter Jean-Paul Riopelle. (Unmarried, they stayed together for more than twenty years, she keeping house and raising his children.) Mitchell has continued to create fluid and emotional Abstract Expressionist compositions (plate 17) influenced by the rural landscape of Vetheuil, her home. In painting these, she has eschewed the egotism typically associated with the Abstract Expressionist movement: instead, painting to her is "a way of forgetting oneself."[50]

The two most prominent female second-generation Abstract Expressionists were Grace Hartigan and Helen Frankenthaler. Hartigan—whose marriage to fellow gestural painter Harry Jackson (an artist now known primarily for his cowboy subjects) was witnessed by the Pollocks[51]—has recalled that in the 1940s and '50s she did not think much about being "a woman artist." Rather, she says, she thought primarily about how difficult it was to paint.[52] The fact that she exhibited for a while as George Hartigan has been viewed by some critics as an attempt to achieve success by masking her sex. (The same questions have revolved around Gertrude Glass Greene's use of the name Peter—which was actually derived from Petra, a childhood nickname—and Leonore Krasner's adoption of the less specific Lee.) Denying that her motivation was gender

camouflage, Hartigan has explained her short-lived name change as an homage to two nineteenth-century women she considered role models, George Sand and George Eliot; numerous paintings of this period, such as *Grand Street Brides* (plate 18), attest to her feminine interests.

Hartigan recalls being sympathetically treated by her male peers primarily because they realized that anyone willing to live in such poverty had to be truly committed to art.[53] Frankenthaler's situation was somewhat different. The ambitious and privileged daughter of a wealthy family (her father was a New York State supreme court justice[54]), Frankenthaler learned early how to parlay into her own success the contacts she was able to make. Her first was with Mexican artist Rufino Tamayo, a teacher at Dalton; next came Paul Feeley, her professor at Bennington; and most important for her career was her five-year relationship with critic Clement Greenberg. Greenberg sent her to Hofmann's summer school, introduced her to important New York School painters, took her to Long Island to watch Pollock paint. Eventually, she was to marry the youngest of the Abstract Expressionist pioneers, Robert Motherwell. But these contacts were obviously not all it took to establish Frankenthaler's place in the history of art, nor would her mastery of anyone else's language and technique have secured her preeminent position. Her modifications of Pollock's late staining technique were truly innovative (plate 19). "She was a bridge between Pollock and what was possible" is how fellow color-field painter Kenneth Noland summed up her contribution.[55] By the early 1960s Frankenthaler had been featured numerous times in such widely circulated periodicals as *Look*, *Life*, and *Time*, resulting in a national prominence enjoyed by few of her female predecessors or peers, and her status was assured by the end

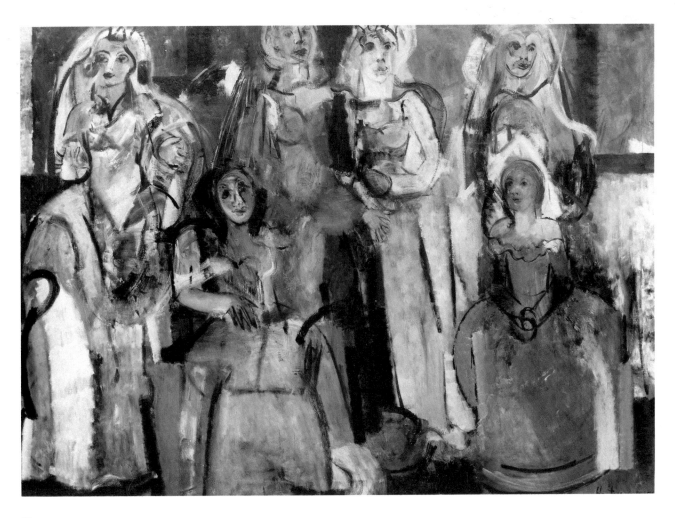

18
Grace Hartigan
Grand Street Brides, 1954
Oil on canvas, 72 x 102½ in.
Whitney Museum of American Art, New York; Gift
of an anonymous donor

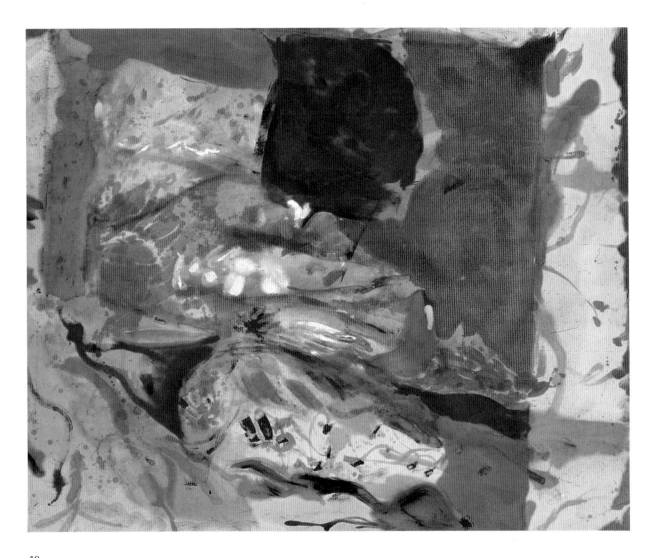

19
Helen Frankenthaler
Lorelei, 1957
Oil on canvas, 70¾ x 87 in.
The Brooklyn Museum; Gift of Alan D. Emil

of that decade when she was given a full-scale retrospective by the Whitney Museum of American Art.[56]

The situation for other women artists in the 1960s was somewhat less stellar, although this was the period when Krasner, Neel, Nevelson, and Bourgeois finally began to achieve some recognition. With the exception of Yvonne Rainer, who made significant contributions to dance, no new women artists rose to prominence within the more recent Pop and Minimalist movements. This is not to say, however, that there were no women producing strong work in those styles.

One of the women artists peripherally associated with Minimalism was Agnes Martin. As early as 1959 Martin's paintings were sharing the new-found respect being accorded the compositions of Rothko and Newman, whose understated pictures were beginning to seem more appealing to many than the explosive canvases of de Kooning and Pollock. Martin's matte black and white tones were lauded for remaining—like Newman's stripes—"on the surface plane."[57] Temporarily relocated from the Southwest to New York during this period, Martin lived in the section of downtown Manhattan known as Coenties Slip. There she shared ideas with other "hot" young abstract painters such as Ellsworth Kelly and Jack Youngerman. She also lived within walking distance of Pop artists James Rosenquist and Robert Indiana; working nearby were Newman, Jasper Johns, and Robert Rauschenberg. Martin's own inclinations leaned more toward Newman's classically austere style, although her impetus toward sublimity seems to have been less mystically derived and was achieved with even sparser means: her paintings were often no more than pencilled grids on canvas.

Recognized by then–New York Times critic Hilton Kramer as an artist all too easy to "mistake as minor or marginal" because

of the restraint of her works,[58] Martin (like Mason) had to endure such adjectives as humble, low-key, and self-effacing. Her own rare statements have reinforced this view, whether she intended them to or not. Martin has confessed, for instance, that "the establishment of the perfect state is not mine to do," adding, "I do not represent it very well in my work."[59] Similarly controlled and restricted, and similarly difficult to assess, are the more literal and at the same time optically stimulating canvases of Jo Baer. Somewhat younger, Baer emerged about five years after Martin's debut and she has been more closely associated by the critics with the Minimalist style, although Baer herself has tried with "recalcitrance" to maintain an autonomous stance.[60] Like Martin, Baer has been best understood and most admired by her fellow artists.

Even in so brief an overview of women's participation in American art prior to 1970, certain factors become evident. First, the importance of influential male support for the achievement of even a modicum of mainstream success by many of these women is a factor that cannot be denied. Romantic entanglements with prominent artists, dealers, and critics had a key impact on the careers of a majority of the artists discussed. Moreover, the attitude toward help from male members of the art world evinced by most of the women working actively between 1910 and 1969 was generally much more positive than is probably the case today, when many women turn instead to each other for support. For instance, AAA member von Wiegand told critic Avis Berman: "Men always helped me because I would always pick out the male artists I admired and try to become friends with them. I met David Burliuk, went to Joseph Stella for criticism, and Mondrian made me. They were all extensions of my father, whom I liked and could always turn to for help."[61]

Similarly, Neel remarked to Pat Hills: "When I was in my studio, I didn't give a damn what sex I was. Nor did I feel I couldn't learn from any male artists either. I thought art is art."[62] Mitchell and O'Keeffe have both pointed out that the only people who encouraged them were men.[63] Although the husbands and lovers of these women were sometimes ambivalent toward their careers (this was true of Pollock and de Kooning[64]), most were more strongly committed (Stieglitz, Greene, Nierendorf, Greenberg), and in virtually all cases the entrée into the art world offered by these men proved critical to the women's success.

Once many of these artists began to show their works, they were frequently treated shamefully by curators and dealers. Parsons, for example, summarily dropped Krasner when Pollock left her gallery, and Greenberg made it very difficult for Mitchell to obtain representation.[65] The sympathetic Abstract Expressionist sculptor Ibram Lassaw has noted that before the early 1970s many galleries (even those run by women) were less than enthusiastic about taking on female artists or giving them solo shows, primarily because collectors considered work by women to be a weak financial investment.[66]

Part of the "feminine mystique" of the 1950s—which persisted into the following decade—was the widespread belief that domesticity and family obligations would prevent women's total dedication to their careers. Women artists often had to play double roles and to prove themselves in ways not demanded of men, who could more easily integrate their personal and professional lives. Some women ultimately chose to give up having children (O'Keeffe, Krasner[67]); others had to temporarily or permanently relinquish their parental roles (Neel, Nevelson, Hartigan). Nevelson recalled feeling "strangled" by her family situation in the late 1930s. A similar complaint had been voiced a few years

earlier by Mason in a 1934 letter to her sister: "Maybe you think intellectual life is not the real thing—but damn it—just caring for babies isn't either. I am chafing to get back to painting."[68] Von Wiegand has also remembered resenting the time and energy her children took; looking back, she concluded, "Marriage diminishes an artist."[69] In the 1950s Hartigan found it impossible to be a single mother and simultaneously succeed as a painter in the East Village. She determined that the only solution was to send her twelve-year-old son to live with his father, and the boy was so resentful that he never spoke to her again.[70]

As we have seen, once women artists did manage to achieve recognition either through individual exhibitions or through inclusion in important group shows, they often encountered condescension from critics, especially those writing for popular newspapers and magazines. Early in the century a flippant reviewer of the Armory Show joked: "In the 'study' by Marguerite Zorach, you see at once that the lady is feeling very, very bad. She is portraying her emotions after a day's shopping. The pale yellow eyes and the purple lips of her subject indicate that the digestive organs are not functioning properly."[71] (In all fairness, it must be noted that the male artists represented in that show attracted similar mockery.) In the same vein, Henry McBride wrote in his January 1943 review of *31 Women*, a group show at Peggy Guggenheim's Art of This Century, that there were "more women than men among New York neurotics. Obviously women ought to excell at Surrealism. At all events, they do."[72] More recently, "And Mr. Kenneth Does Her Hair" was the unfortunate title of a *New York Times* article about Krasner; "Alice in Mondrianland" was used to headline a notice of one of Mason's shows.[73] Women artists have frequently been disparaged in print as "girls" or "ladies," and the use of obviously "feminine"

(sometimes even uterine) words intended to deprecate the art produced by just about every artist under consideration here can also be taken as a subtle form of discrimination. Typically overshadowed in the history books by their husbands, lovers, and male colleagues, women artists have also had their works incorrectly labeled as derivative.

No collective path to success can be defined for those women artists who began their careers prior to the past two decades. As witnessed by their own autobiographical comments, many achieved some prominence simply because they were more single-minded than others in pursuing a career in art. Most of these older women have been loath to accept the label of "woman artist." Even though a number of them admit that they found their way into the mainstream eased by the effects of the women's movement, few have openly embraced it, choosing, as Neel put it, not to "fight the fight in the streets."[74]

By 1970, as consciousness of the contributions made by women to all areas of American culture and society became more widespread, younger female artists began to encounter significantly fewer gender-related career obstacles. Women in all walks of life now had more options available to them and were being taken more seriously in whatever they chose to do. Both official and unofficial structures for mutual support rapidly fell into place, easing the feelings of alienation expressed by so many of the women discussed in this essay. Female artists were no longer doomed to work in relative isolation and to have their work belittled or ignored; new possibilities for women energized the entire scene. In retrospect, the achievements of women artists in prefeminist America— achievements that were previously considered peripheral at best—must now be seen as part of the historical mainstream.

Notes

1. Before O'Keeffe and Zorach, there were women associated with the Ashcan School, the art movement that dominated the New York scene c. 1905–12. These women were either wives, daughters, or students of the men in the group, and they adopted a subordinate role. Marjorie Organ, for instance, always deferred to her husband, Robert Henri, as "The Boss" in public. See Charlotte Streifer Rubinstein, *American Women Artists: From Early Indian Times to the Present* (New York: Avon, 1982), pp. 165–69.

2. William Zorach, *Art Is My Life* (New York: World Publishing, 1967), p. 189.

3. Lee Krasner, in John Gruen, *The Party's Over Now: Reminiscences of the '50s—New York's Artists, Writers, Musicians and Their Friends* (New York: Viking Press, 1972), p. 230.

4. Her contributions to his work were first documented in Roberta K. Tarbell, *Marguerite Zorach: The Early Years, 1908–1920* (Washington, D.C.: National Collection of Fine Arts; Smithsonian Institution Press, 1973).

5. Sue Davidson Lowe, *Stieglitz: A Memoir/Biography* (New York: Farrar Straus Giroux, 1983), p. 258.

6. Ibid., p. 242. Laurie Lisle, in *Portrait of an Artist: A Biography of Georgia O'Keeffe* (Albuquerque: University of New Mexico, 1986), p. 129, points out that O'Keeffe's works were labeled the female counterpart of D. H. Lawrence's erotic novel, *Lady Chatterley's Lover*. Lisle cites a *New York Times* critic who wrote of O'Keeffe in 1927, "She reveals woman as an elementary being, closer to the earth than men, suffering pain with passionate ecstasy and enjoying love with beyond good-and-evil delight."

7. Dorothy Norman, *Alfred Stieglitz: An American Seer* (New York: Random House, 1973), p. 137.

8. Paul Rosenfeld, "The Paintings of O'Keeffe," *Vanity Fair* 19 (October 1922): 112. Earlier, in 1917, a reviewer for the *Christian Science Monitor* had written that O'Keeffe "has found expression in delicate veiled symbolism for 'what every woman knows,' but women have heretofore kept to themselves." Others perpetuating this interpretation of O'Keeffe include Marsden Hartley (*Adventures in the Arts*, 1921); Henry McBride (*New York Herald*, February 4, 1923); Lewis Mumford (*New Republic*, March 2, 1927); and Helen Appleton Read (*Vogue*, June 15, 1928).

9. O'Keeffe, in Lisle, *O'Keeffe*, p. 130.

10. Helen Frankenthaler, in Henry Geldzahler, "An Interview with Helen Frankenthaler," *Artforum* 4 (October 1965): 38.

11. An unidentified writer made this comment in *Time*, March 28, 1969. Rozsika Parker and Griselda Pollock discuss the critical treatment of Frankenthaler at some length in *Old Mistresses: Woman, Art and Ideology* (New York: Pantheon Books, 1981), pp. 145–51.

12. Karal Ann Marling and Helen A. Harrison, *Seven American Women: The Depression Decade* (Poughkeepsie, N.Y.: Vassar College Art Gallery, 1976). Marling and Harrison quote Elizabeth Olds's comment: "I was aware of no discrimination between men and women on the Project. We were all just artists. . . . One of the great things about the WPA was that it allowed men and women to work as artists." In my own interview with Lee Krasner (New York City, February 25, 1980), she similarly recalled no evidence of favoritism toward men by the WPA. (Note: Some of the other quotes by Krasner in this essay were taken from this interview as well as seven other interviews I conducted with Krasner between 1978 and 1980.)

13. See Ellen G. Landau, "Lee Krasner's Early Career, Part One: 'Pushing in Different Directions,'" *Arts Magazine* 56 (October 1981): 110–22. At one point Krasner supervised William Baziotes and Jackson Pollock on a WPA project, and she was assigned to complete a mural begun by Willem de Kooning. Krasner was asked to serve on the executive committee of the Artists Union in 1939. She resigned after realizing that those controlling the board were primarily Communist Party members who advocated a Stalinist position with which she could not agree.

14. Clement Greenberg, "The Late Thirties in New York," in *Art and Culture: Critical Essays* (Boston: Beacon Press, 1961), p. 231.

15. Dolores Holmes, transcript of tape-recorded interview with Lee Krasner, Summer 1971, pp. 3–4, Archives of American Art, Smithsonian Institution, Washington, D.C. Krasner commented to Holmes that she "got a cold shower before [she] had a chance to receive the warmth of the compliment." Nevelson frequently recalled attending a party at Hofmann's studio where he made the following toast: "To art—only the men have wings." See, for example, Cindy Nemser, *Art Talk: Conversations with Twelve Women Artists* (New York: Charles Scribner's Sons, 1975), p. 238.

16. Susan Carol Larsen, "The American Abstract Artists Group: A History and Evaluation of Its Impact upon American Art," Ph.D. dissertation, Northwestern University, 1975. The first AAA Annual, issued in 1938, included "The New Realism" by Rosalind Bengelsdorf and "Concerning Plastic Significance" by Alice Mason. Bengelsdorf not only wrote in AAA annuals but also delivered the only lecture on Cubism (September 23, 1936) allowed by the Marxist- and Social Realist–oriented Artists Union. Unfortunately, after her marriage to Byron Browne she downgraded her artistic activity to part-time status.

17. Ad Reinhardt, at an evening session of The Club during the 1960s; quoted by Marilyn Brown in *Alice Trumbull Mason/Emily Mason: Two Generations of Abstract Painting* (New Orleans: Art Department Gallery, Newcombe College, Tulane University, 1982), p. 8.

18. Mason once told Dore Ashton, "I think there are no 'qualities or advantages' in my work which are peculiarly mine"; quoted by Brown, in *Mason*, p. 11. See the interview with Mason conducted by Dore Ashton on June 23, 1953, Archives of American Art.

19. Robert Hughes, "Rediscovered—Women Painters," *Time*, January 10, 1977, p. 60.

20. Louise Nevelson, in Edward Albee, "Louise Nevelson: The Sum and the Parts," introduction to *Louise Nevelson: Atmospheres and Environments* (New York: Whitney Museum of American Art; Clarkson N. Potter, 1980), p. 25.

21. Louise Nevelson, in Betsy von Furstenberg, "Louise Nevelson: A Monumental Life," *Cleveland Plain Dealer*, July 27, 1980. Nevelson also told von Furstenberg: "I have been so lonely for long periods of my life that if a rat walked in, I would have welcomed it. I don't think I

realized the price that would be demanded of me for what I wanted."

22. See Laurie J. Wilson, "Louise Nevelson: Iconography and Sources," Ph.D. dissertation, City University of New York, 1978.

23. *Cue*, October 4, 1941, p. 16; quoted in Arnold B. Glimcher, *Louise Nevelson* (New York: Praeger, 1972), p. 71, and in Elsa Honig Fine, *Women and Art* (Montclair, N.J., and London: Allanheld and Schram/Prior, 1978), p. 201.

24. Lee Krasner, in Roberta Brandes Gratz, "Daily Close-Up—After Pollock," *New York Post*, December 6, 1973.

25. Fritz Bultman, interview with author, New York City, February 27, 1979. Those who knew Krasner and Pollock in the 1940s mostly remember their relationship as being mutually supportive, although as John Bernard Myers remarked, not many people really understood the true nature of what was between them (Myers, interview with author, New York City, January 18, 1979). Ethel Baziotes and May Rosenberg, the wives of William and Harold, have both pointed out that during this period Krasner was "remarkably sure of herself," and, in Mrs. Baziotes's words, Jackson and Lee soon became "psychologically embedded with each other" (interviews with Baziotes and Rosenberg, New York City, February 21, 1980, and February 22, 1980, respectively).

26. Lee Krasner, in Cindy Nemser, "A Conversation with Lee Krasner," *Arts Magazine* 47 (April 1973): 48.

27. Alice Neel, in Barbaralee Diamonstein, "Alice Neel," in *Inside New York's Art World* (New York: Rizzoli, 1979), p. 261. See Diana Loercher, "Alice Neel, American Portraitist," *Christian Science Monitor*, March 4, 1974, p. F6, for Neel's description of herself as timid.

28. Ann Sutherland Harris, *Alice Neel* (Los Angeles: Loyola Marymount College, 1983), p. 6.

29. Neel, in Diamonstein, "Neel," p. 258.

30. Ibid., p. 254.

31. Alice Neel, in Eleanor Munro, *Originals: American Women Artists* (New York: Simon and Schuster, 1979), p. 120.

32. Alice Neel, in Patricia Hills, "Alice by Alice," in *Alice Neel* (New York: Harry N. Abrams, 1983), p. 11.

33. Lisle, *O'Keeffe*, p. 214.

34. Neel, in Loercher, "Neel," p. F6.

35. Louise Bourgeois, in Munro, *Originals*, p. 165.

36. Ibid., p. 156.

37. Louise Bourgeois, in Lucy Lippard, "Louise Bourgeois: From the Inside Out," in *From the Center: Feminist Essays on Women's Art* (New York: E. P. Dutton, 1976), p. 239.

38. Louise Bourgeois, in Lynn F. Miller and Sally S. Swenson, *Lives and Works: Talks with Women Artists* (Metuchen, N.J.: Scarecrow Press, 1981), p. 10. Bourgeois told Munro (*Originals*, p. 166): "Women are losers . . . they are beggars in spite of Women's Lib. Because our fate is conditioned by our gifts. That is a very cruel thing. If you have no gift, only a third-rate education, no manners, no self-restraint, then what are you going to do with your life? So it is a serious matter, life. It is often tragic."

39. Bourgeois has recalled that the attitude of the Surrealists toward her was condescending. "Of course, for them I was just a girl and women were not to be taken seriously anyway." See Barbara Rose, "Sex, Rage and Louise Bourgeois," *Vogue*, September 1987, p. 824. Krasner has recalled that the Surrealists treated their own women like dolls or mannequins, even to the point of choosing their clothes. She has stated that, to some extent, this attitude rubbed off on the Abstract Expressionists (interview with author, New York City, February 21, 1980).

40. The sculptor Philip Pavia seems to have unofficially controlled the membership of The Club. Joan Mitchell has recalled being thrilled that Pavia let her join. See Cindy Nemser, "An Afternoon with Joan Mitchell," *Feminist Art Journal* 3 (Spring 1974): 24.

41. Louise Nevelson, in Roy Bongartz, "'I Don't Want to Waste Time,' Says Louise Nevelson at 70," *New York Times Magazine*, January 24, 1971.

42. Louise Nevelson (taped conversation with Diana MacKown), *Dawns + Dusks* (New York: Charles Scribner's Sons, 1976), p. 69; quoted in Rubinstein, *American Women Artists*, p. 269.

43. Krasner, interview with author, New York City, February 25, 1980.

44. See "The Met and Modernism," *Life*, January 15, 1951, p. 34. Krasner related this story a number of times. See, for instance, Cindy Nemser, "The Indomitable Lee Krasner, *Feminist Art Journal* 4 (Spring 1975): 8.

45. "19 Young American Artists," *Life*, March 20, 1950. *Life* chose the artists it featured from 450 names submitted by people from thirty-eight states. Sterne was among three women cited: the others were Honoré Sharrer and Aleta Cornelius. Of the nineteen, who were considered representative of the best art being done in the country at that time, only Sterne and Theodoros Stamos gained any future recognition.

46. Munro, *Originals*, p. 251.

47. Characterized by Thomas B. Hess as one of the most provocative exhibitions of younger artists he had ever seen, *Talent 1950* also boosted or launched the careers of a number of male painters, including Robert Rauschenberg and Larry Rivers. For discussion of *Talent 1950*, see Hess, "Seeing the Young New Yorkers," *Artnews* 49 (May 1950): 23, and Phyllis Rosenzweig, *The Fifties: Aspects of Painting in New York* (Washington, D.C.: Hirshhorn Museum and Sculpture Garden; Smithsonian Institution Press, 1980), pp. 16 and 30.

48. Nemser, "Afternoon with Joan Mitchell," p. 24.

49. Joan Mitchell, in Marcia Tucker, *Joan Mitchell* (New York: Whitney Museum of American Art, 1974), p. 7.

50. Joan Mitchell, in Yves Michaud, "Conversation with Joan Mitchell, January 12, 1986," in *Joan Mitchell: New Paintings* (New York: Xavier Fourcade, 1986), n.p.

51. Grace Hartigan, interview with author, Baltimore, 1978.

52. Nemser, *Art Talk*, p. 150. Nemser and Hartigan discuss her name change on p. 151.

53. Hartigan told Nemser (*Art Talk*, p. 152): "Once the men saw how serious my work was they respected it. They were also touched by the fact that I was so poor. They weren't used to young women going into that life. I lived like the men."

54. Frankenthaler told Munro (*Originals*, p. 211), "I was a special child and I felt myself to be. Also, I received special attention from the outside. . . . I had the genes . . . intelligence . . .

talent . . . the 'gift.' Who knows what it is really? But it was a positive thing. The condition was my destiny."

55. Kenneth Noland, in James McC. Truitt, "Art-Arid D.C. Harbors Touted 'New' Painters," *Washington Post*, December 21, 1961, p. A20. Noland commented: "We [he and Morris Louis] were interested in Pollock but could gain no lead to him. He was too personal. But Frankenthaler showed us a way—a way to think about, and use, color."

56. *Life* featured Frankenthaler in a 1957 article, "Women Artists in Ascendance"; *Time* did so in 1957, "The Younger Generation," and in 1960, "The Vocal Girls"; and *Look* followed suit in 1960 in "Women of American Art." Eugene Goossen, in his 1969 catalog essay accompanying Frankenthaler's Whitney retrospective, wrote on page 8 that the recent history of art would have been "radically different without her presence."

57. See B[arbara] B[utler], "Agnes Martin," *Arts Magazine* 34 (January 1960): 50–51, and Rosenzweig, *The Fifties*, pp. 25–26 and 33, for a discussion of Martin in the late 1950s.

58. Hilton Kramer, "An Intimist of the Grid," *New York Times*, March 18, 1973.

59. Agnes Martin, in Carter Ratcliff, "Agnes Martin and the Artificial Infinite," *Artnews* 72 (May 1973): 27; quoted from unpublished manuscripts by Martin at the Institute of Contemporary Art, University of Pennsylvania, Philadelphia.

60. Lucy Lippard, "Jo Baer: Color at the Edge," in *From the Center*, pp. 172–80.

61. Charmion von Wiegand, in Avis Berman, "A Decade of Progress, but Could a Female Chardin Make a Living?" *Artnews* 79 (October 1980): 76.

62. Neel, in Hills, *Neel*, p. 129.

63. See Munro, *Originals*, p. 246, for Mitchell's comment, and Lisle, *O'Keeffe*, p. 354, for O'Keeffe's.

64. Pollock's attitude toward Krasner as a painter in her own right is a topic hotly debated by those who knew them. Usually marshaled as evidence of his support is a comment Pollock made in a letter to Alfonso Ossorio dated June 7, 1951. At that time, Pollock wrote, "Lee is doing some of her best painting—it has a fresh-ness and a bigness that she didn't get before—I think she will have a handsome show." (See Francis V. O'Connor and Eugene Victor Thaw, eds., *Jackson Pollock: A Catalogue Raisonné of Paintings, Drawings and Other Works* [New Haven and London: Yale University Press, 1978], vol. 4, p. 261.) My interviews with Ossorio (East Hampton, N.Y., July 17, 1979); John Bernard Myers (New York City, January 18, 1979); Ethel Baziotes (New York City, February 21, 1980); and Betty Parsons (New York City, May 2, 1979) led me to believe Pollock was sympathetic. On the other hand, my interviews with Ibram Lassaw (The Springs, N.Y., July 17, 1979); Fritz Bultman (New York City, February 27, 1979); Reuben Kadish (New York City, May 2, 1979); and Grace Hartigan (Baltimore, 1978) yielded an opposing view. Willem de Kooning's indifference to his wife as an artist is well known.

65. See Nemser, "Afternoon with Mitchell," p. 24, for Greenberg's negative role in her career. Greenberg planned to give Krasner a show in the early 1960s, but she canceled it after he tried to dictate to her how she should paint the works to be included in it. Alice Neel recalled to Munro (*Originals*, p. 130) that she once asked Henry Geldzahler, curator of twentieth-century art at the Metropolitan Museum of Art, why she was not included in any shows. "He looked at me and guess what he said? 'Oh, so now you want to get professional?' "

66. See Brown, *Mason*, p. 11, for Lassaw's comments.

67. According to Lisle, *O'Keeffe*, p. 106, between 1916 and 1923 O'Keeffe did want to have a child. Stieglitz finally talked her out of it; he was appalled by the dementia that childbirth had caused in Kitty, his daughter from an earlier marriage. He also persuaded O'Keeffe that motherhood would be detrimental to her art. (See also Lowe, *Stieglitz*, pp. 248–49.) According to Krasner, both she and Pollock believed that parenthood would be too distracting for two working painters. Pollock, however, was apparently fascinated by the idea of having children. See Francine du Plessix and Cleve Gray, "Who Was Jackson Pollock?" *Art in America* 55 (May–June 1967): 54.

68. Mason, in Brown, *Mason*, p. 13.

69. Von Wiegand, in Berman, "Progress," p. 76.

70. Nemser, *Art Talk*, p. 153.

71. New York *American*, February 23, 1913; quoted in Tarbell, *Zorach*, p. 36.

72. Henry McBride, "Women Surrealists," *New York Sun*, January 1943. See Melvin Paul Lader, "Peggy Guggenheim's Art of This Century: The Surrealist Milieu and the American Avant-garde," Ph.D. dissertation, University of Delaware, 1981.

73. Both were written by a woman, Grace Glueck. The article on Krasner appeared on March 17, 1968, and the one on Mason on June 7, 1973.

74. Neel, in Miller and Swenson, *Lives and Works*, p. 129. It is interesting to note that O'Keeffe was persuaded by her friend Anita Pollitzer to address the 1926 convention of the National Woman's Party. Her speech exhorted women to take control of their own lives.

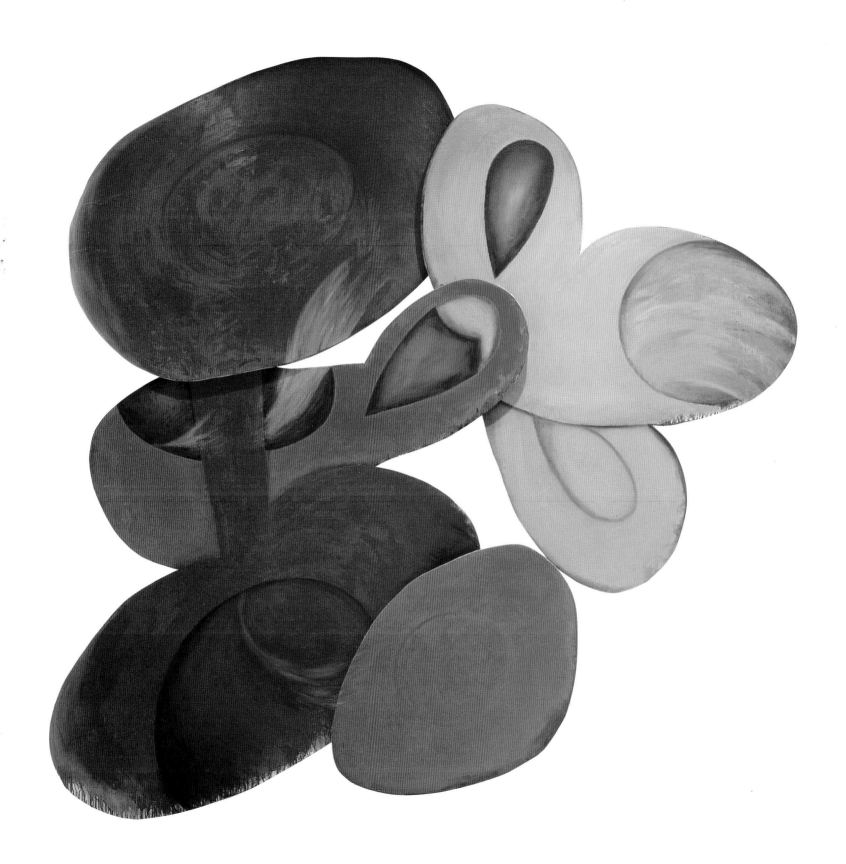

Calvin Tomkins

Righting the Balance

At a certain point during the 1970s it suddenly occurred to me that half the interesting new artists in America were women. This was such a startling realization—nothing like it had ever happened in the history of art—that I wondered why more wasn't being made of it. Women artists had not achieved overnight parity with men, of course; an enormous imbalance still remained, and many of the barriers that women in the visual arts have always faced were still intact. But something had happened. Susan Rothenberg, Jennifer Bartlett, Lynda Benglis, Jackie Winsor, Elizabeth Murray, Mary Miss, Lois Lane, Joyce Kozloff, Valerie Jaudon, Nancy Graves, Audrey Flack, Alice Aycock, and others were showing their work at major New York galleries. Their shows were being reviewed with exactly the same degree of verbal incompetence that our critics brought to bear on men's shows, and more important, their work was being bought by collectors here and abroad. How did this come about? Were these women so phenomenally gifted that their talent simply swept aside the obstacles? Or had changes in society and in cultural attitudes made possible a kind of acceptance that these same women could not have won twenty years earlier? The answers to these questions are both simple and complex, and at this point highly tentative. Statistics will play little part in what I have to say here, because I don't trust them—least of all in such slippery areas of investigation as the "woman question" and the art market.

The practice of art is not an isolated or a mystical undertaking. Art is conditioned and to a large extent defined by the social and cultural context in which it takes place, and the most obvious fact about the emergence of so many women artists in the period from 1970 through 1985 is that it coincides with the development of the feminist movement in this country. In that sense it reflects the gains that women have made in other sectors of the economy—more women executives, lawyers, doctors, politicians, telephone linepersons, and so forth. Nothing changes until there is pressure for change, and in the early 1970s women began pressing hard for changes in the male-oriented New York art world.

Even before that, however, art schools around the country had been enrolling female students who were not willing to accept the status quo. When Jennifer Bartlett entered the graduate program at Yale University's School of Art and Architecture in 1963, it was still possible for male students to think they were paying her a compliment when they said you'd never know her paintings had been done by a woman. Bartlett's response was to adopt "a completely macho attitude of my

20
Elizabeth Murray
Duck Foot, 1983
Oil on canvas, 129 x 132 in.
Sue and David Workman

own—I just started building huge stretchers that interfered with the people working near me." At most art schools then it was taken for granted that the women students were not going to go out and become practicing artists, even if their work showed more promise than the men's. Jack Tworkov, who had succeeded Josef Albers as head of the art department at Yale, actually begged them not to try; Lynda Benglis remembers Tworkov's telling them that his wife was an artist and his sister was an artist, and that it was just too difficult—there were too many obstacles. Bartlett, Benglis, Elizabeth Murray, Nancy Graves, and others of their generation reacted quite angrily to this sort of talk; it made them all the more determined to buck the system when they came to New York.

Rising expectations were the norm among young artists in the 1970s—men as well as women. The media had made Pop art a household term, and the Scull sale in 1973 had confirmed its value as a status commodity—the record prices paid at that auction for paintings by Robert Rauschenberg, Jasper Johns, Andy Warhol, and others received widespread press coverage and established a new scale of values for advanced contemporary work. For the first time, it became possible for a young man or woman to consider a career in art as a viable profession, rather than a romantic calling. The New York art world of the 1970s, moreover, was opening up in all sorts of new ways. There was no longer a single mainstream. Abstract Expressionism had been the dominant style of the 1950s; Pop and Minimalism had taken over in the 1960s. In the 1970s, though, the buzz word was "pluralism." Process art, body art, performance art, earth art, video art, New Image painting, and a host of other experiments vied with the remnants of Minimalism and Conceptualism in a period that seemed to lack a formal center and a sense of direction. Every-

thing was expanding. There were more galleries, more group shows, and more opportunities to present work outside Manhattan. There were also the new "alternative spaces" —nonprofit galleries such as The Clocktower, Artists Space, P.S. 1, and The Kitchen, which seemed to be as open to women as to men. At Artists Space, although there was no policy to this effect, about 40% of the work shown during the 1970s was by women.

Pattern and Decoration, the movement that got going in the early 1970s and reached its peak of popularity about 1979, drew much of its energy from the feminist movement. One of the interesting things about P & D was that Miriam Schapiro, Joyce Kozloff, and other militant feminists involved in its early development were quite willing to accept men on equal terms as colleagues. Brad Davis, Robert Zakanitch, Robert Kushner, and Kim McConnell took quite a risk in choosing to work with bright-colored fabrics and design motifs taken from Near Eastern decorative-arts traditions; the Minimalist aesthetic was still strong in the early 1970s, and "decorative" was still a pejorative term. "We used to get together and talk," Kozloff recalls, "and among ourselves there was a feeling of total equality with the men. The art world was not so marketplace oriented in the 1970s as it is now—there wasn't so much money around. We really did help each other. Some of the critics even got interested in the issues of the women's movement. And there were a lot of women curators in the museums by this time. We really created a sort of old-girls' network."

The notion of an old-girl's network, intriguing as it sounds, seems applicable only to the Pattern and Decoration artists. Although a surprisingly large number of commercial galleries in the 1970s were run by women, few of them made a conscious effort to show work by women artists. "I just don't think in those terms," said Paula Cooper, whose stable

includes Lynda Benglis, Jennifer Bartlett, Elizabeth Murray, and Jackie Winsor. How did she happen to select these women? "I'd known Lynda for years, and one day she showed me her work, and I liked it. Jennifer came to the gallery to see a Joel Shapiro show in 1970; she invited me to visit her studio, and I did, but it was quite a while before I started to show her. I met Elizabeth through Jennifer, and I saw her work develop in any number of group shows before she came here. Jackie Winsor—somebody told me about her, and I went to look at the work. That's the way it usually happens, with men as well as with women. There wasn't any difference." Miani Johnson said more or less the same thing about the women she showed at the Willard Gallery—Susan Rothenberg, Lois Lane, Judith Shea, and Joan Thorne. They came to her attention the same way the men did, often by another artist's recommendation. "I sort of regret the fact that I didn't have any great awareness of these issues earlier," she told me. "It was purely fortuitous that I showed a lot of women."

The Holly Solomon Gallery, which was the strongest promoter of Pattern and Decoration, represented only one of the movement's women artists, Valerie Jaudon, who moved subsequently to Sidney Janis. Some galleries with woman directors showed no women at all, while some that were run by men, such as the Robert Miller Gallery on Fifty-seventh Street, made women their strong suit. "For us it seemed like a great opportunity," said Miller, who represents Louise Bourgeois, Joan Mitchell, Jan Groover, and Martha Diamond as well as the estates of Alice Neel, Eva Hesse, Diane Arbus, and Lee Krasner. "It was very high quality work, and it was available." Miller feels that Lee Krasner is still undervalued. Although in her last years Krasner was finally recognized as a major, first-generation Abstract Expressionist whose work could

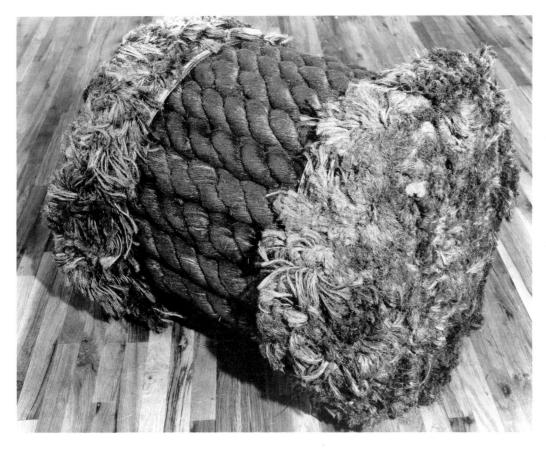

21
Jackie Winsor
Chunk Piece, 1970
Hemp, diameter: 28 in.; length: 36 in.
Michele Amateau and Albert Alhadeff

be judged on the same level as that of her husband, Jackson Pollock, her prices have remained significantly lower than those of Pollock, Kline, Rothko, and de Kooning. Most dealers say that the price differential between male and female artists is rapidly disappearing, however, and that it does not apply to the work of younger artists. Pat Hearn, whose influential East Village gallery opened in 1982, has never considered pricing her women artists below the men. "That probably did exist at one time," she told me, "but not here."

The fact that a relatively large number of women broke into the New York gallery system in the 1970s cannot really be pinned down to any specific cause. Some very talented and ambitious women appeared on the scene at a moment when the art world was opening up, partly as the result of pressure by militant feminists. The system responded, more or less unwittingly, to changes in the cultural climate.

Similarly, the change for the worse that seems to have made it more difficult for younger women artists to be recognized in the 1980s is a reflection of the social backlash that affected the feminist movement as a whole. The art world of the early 1980s was marked by a return to macho, male-dominated painting on a heroic scale. Neo-Expressionism, as the new style was called, thrilled a whole new echelon of novice collectors—the Reagan-era tycoons who had made a ton of money very quickly in such manly pursuits as corporate takeovers and arbitrage. Neo-Expressionism was just the ticket for these types. It was an international movement, with strong positions in Germany and Italy. The pictures were big, loud, and easy to understand; the artists, who behaved like rock stars and attracted no end of publicity as a result, were names that you could drop in almost any company and get a response; and the prices tripled and quadrupled in a very short time, proving the buyer's investment savvy. A lot of these new buyers were really speculators, in the art market as on Wall Street. They looked at track records and projected performance futures. "I'd never buy a woman artist," one of them told Miani Johnson. "They quit in mid-career to have babies." (Actually, as Holly Solomon has observed: "One very important thing has happened in the last ten years. Women used to have to make a big decision at about the age of thirty, whether to have children or not. Now they can wait until they're forty or forty-five. So those all-important work years from thirty to forty, when men artists usually come into their own, are now available to women.")

The period from 1980 to 1985 was a discouraging one for many women artists. Although they made up nearly 40% of the professional artist population in the United States (according to U.S. census figures), they were still very far behind their male counterparts in gallery representation, in museum showings and in the permanent collections of major museums, and in earning capacity—a recent National Endowment for the Arts survey showed that their average annual income

22

Joyce Kozloff

Untitled (Buffalo Architectural Themes), left to right: #6: window, Martin House; #7: City Hall lobby, Vars Building; #4: window, Heath House; #9: City Hall auditorium; #2: Calumet Building, City Hall lobby, 1984
Series of 5 watercolors from tiles at Humboldt Hospital subway station, Buffalo. All are from lower level except #9, which is from upper level.
Each 9½ x 6 in.; 14 x 43 in. overall (framed)
Albright-Knox Art Gallery, Buffalo; Charles W. Goodyear Fund, 1984

23

View from upper level of the Humboldt Hospital subway station, Buffalo, 1984, with hand-painted ceramic-tile-and-glass mosaic (36 x 114 ft.) by Joyce Kozloff

from art was $5,700, compared with $13,000 for men. "The art world is not interested in women any more," Joyce Kozloff said recently. "It's much harder for a woman to be recognized now. I'm doing all right, but I'm worried about the next generation—the gains we made are not being carried over." But the younger women have one advantage whose importance should not be overlooked: they have Kozloff's generation of women artists as role models. There have usually been one or two notable women artists in any given period —Georgia O'Keeffe and Agnes Martin, Rosa Bonheur, Mary Cassatt—but in the past these figures were so exceptional in their motivation or tenacity that you could hardly use them as guides. This is no longer the case. The artists presented here, whose work encompasses such a wide range of approaches and options, will serve as a major resource for those who come later.

Recent art world developments suggest that the climate is changing once again. The Neo-Expressionist wave has lost its momentum in the last couple of years, and the even newer geometric abstraction and "appropriation" styles do not show any great staying power. Certain women artists, meanwhile, have been exploring the peripheries of the so-called mainstream (which is really no more than what the influential galleries happen to be pushing). Kozloff, Mary Miss, Jennifer Bartlett, Nancy Holt, Alice Aycock, and others have been doing important work in the new form of public art that involves collaboration with architects, landscape designers, contractors, city planners, and municipal authorities. These artists and their male colleagues are not interested in making large, "site-specific" works for federal or corporate plazas. Rather, they become involved in all aspects of the design and articulation of the public space itself—parks, playgrounds, traffic intersections, gardens, waterfront areas, and

even—in Holt's case—a garbage dump on the Jersey meadows. At least half the artists doing this kind of public art are women. Mary Miss says she got into environmental work of this kind in the 1970s because the gallery system seemed so closed to women. "I really think we have a natural aptitude for the sort of cooperation and accommodation that's required," Miss told me, "for working with what exists rather than imposing a sculptural statement."

Women are also prominent in photography, in video art, and in what is now being called "media art," which uses video and other high-tech means to address social and political issues. The media artists' work sometimes seems like a conscious challenge to the bully-boy, paint-on-canvas heroics of Julian Schnabel and other prominent male art stars—a recent Barbara Kruger image showed a little girl admiring the desperately flexed bicep of an even smaller boy, with a caption across the center reading "We don't need another hero." Their work also seemed until recently to be far removed from the mainstream, but in 1987 both Kruger and Sherrie Levine joined the previously all-male Mary Boone Gallery, one of the hottest stables in town, so perhaps the stream is branching out and becoming more diffuse.

The Guerrilla Girls, bless their hearts, have revived the militant feminism that went out of the art world in the late 1970s. This group, whose anonymous members wear gorilla masks for their public appearances, arose in direct response to the Museum of Modern Art's 1984 *International Survey of Painting and Sculpture*, which included only fourteen women among the one hundred sixty-five artists represented. In their eye-catching posters and in lectures around the country, they present statistical evidence of the blatant underrepresentation of women in museum shows and collections, in commercial galleries, and

in critical reviews, and they do so with considerable wit and effectiveness. A new wave of feminist activism may be building up as the decade draws to a close. In spite of the backlash in the late 1970s, the feminist movement shows signs of regaining its forward momentum.

Long-range changes in attitudes and expectations are the most important ones, of course, and they are usually irrevocable. For American women artists, the changes that have taken place in our society over the last two decades make it very clear that the past can no longer be taken as a guide to the future.

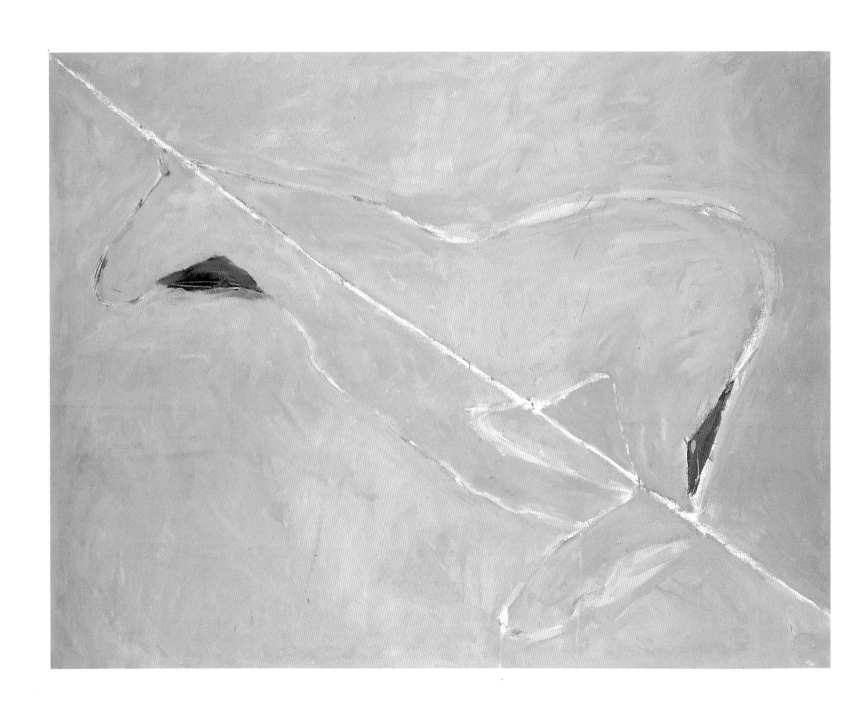

Judith E. Stein
Ann-Sargent Wooster on Video

Making Their Mark

Speaking to an assembly of Barnard College students seventy-three years ago, the American painter Cecilia Beaux addressed the situation of women artists. Directing her remarks to the future, she commented: "There should be no sex in Art. . . . I am pointing, I know, to a millennium at least in the women's view if I predict an hour when the term 'Women in Art' will be as strange sounding a topic as 'Men in Art' would be now."[1]

Nearly three-quarters of a century later, there is still nothing strange about a talk on women in art. But times *have* changed. Although we have not reached the millennium referred to by Beaux, we have accomplished some radical alterations in the public's consciousness of women artists. Beaux, who lived during the first flowering of American feminism, continually confronted the widespread belief that women were incapable of being artists at all; and she and her contemporaries were accustomed to discussions that isolated women's artistic achievements.

Such isolation is more debatable today. How, in fact, can we justify a single-sex art exhibition? Have we not long passed the point where women's artistic abilities were in question? And do we not share Beaux's belief that the sex of an artist should be immaterial in assessing excellence? To answer yes to the last two questions is not to relinquish respon-

sibility for the first. One rationale for *Making Their Mark* is that its restriction to one gender deepens our understanding of the recent past. Another is that it sharpens our awareness that even though excellence knows no sex, the fact of having been born a woman was no hindrance; indeed, as will be seen, the experience of growing up female has empowered a multitude of artists who have changed the shape of art and art history.

Extending the Boundaries of Abstraction

American art of the 1960s can be characterized as a succession of extremes, from the accessible object orientation of Pop to the ethereal cerebrations of Conceptual art; from the exuberant and unkempt antiestablishmentism of Fluxus to the formal austerity of color-field painting and Minimalist abstraction. This alternating current of inherited possibilities energized the 1970s, even as many artists reached back to the aesthetic discourses of the earlier Abstract Expressionist generation, which gave weight and value to the expression of self.

In the 1950s the Abstract Expressionists had redefined the previously European determination of abstraction in purely American

24
Susan Rothenberg
Diagonal, 1975
Acrylic and tempera on canvas, 46 x 60 in.
Stefan T. Edlis

terms. In the 1960s heirs of the New York School eschewed the painterly issues of expressionism in favor of hard-edge abstraction or work in other media entirely. Jasper Johns was one of the few major artists who retooled the gestural surfaces of 1950s abstraction to create a new, representational style. He was a notable influence on the artists of the 1970s who quietly returned to painting despite critical proclamations of its demise. These new painters, not at all committed to the suppression of self that had been a hallmark of the formalist 1960s, felt a kinship with the self-reflective 1950s. They freely reaffirmed emotional content and completely revamped the modernist categorizations of abstraction and representation. Sharing the painters' desire for expressive substance and their verve for deconstructing art historical givens, sculptors went on to dismantle the conventional boundaries separating painting and sculpture and to use a variety of untraditional materials.

The bellwether exhibition documenting the new sensibility in painting was *New Image Painting*, curated by Richard Marshall at the Whitney Museum of American Art in 1979. In his catalog essay Marshall discussed how important the idea of engaging the psychology of the viewer was to the work of Jennifer Bartlett, Susan Rothenberg, Lois Lane, and Robert Moskowitz.[1] A decade later, it has become increasingly clear that women artists participated significantly in this "repsychologizing of abstract painting."[2] Among the sculptors who formulated an expressionist response to the reductive aesthetics of Minimalism, a notable portion were likewise women, including Eva Hesse, Lynda Benglis, Jackie Winsor, and Jackie Ferrara.[3] This is not to say that the artists themselves have made gender an issue in their art. In fact, some of the women artists who came to prominence in the 1970s prefer not to show in single-sex

25
Susan Rothenberg
Mist from the Chest, 1983
Oil on canvas, 78 x 89 in. (framed)
Milwaukee Art Museum; Gift of Friends of Art

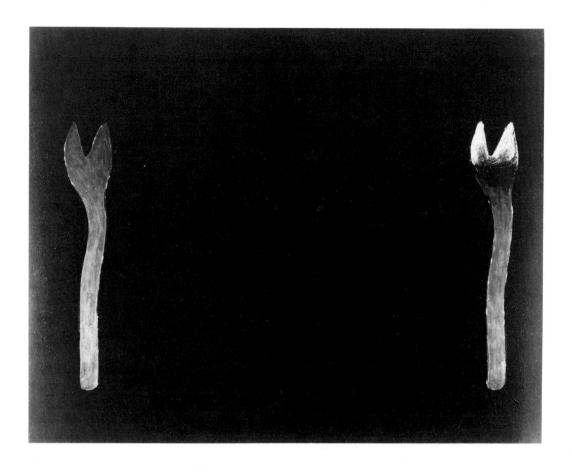

26
Lois Lane
Mardi Gras, 1976
Oil on canvas, 72 x 96 in.
Miani Johnson

exhibitions or those in which they are the sole female included.

Now internationally celebrated as a principal determinator of the new nature of American painting, Rothenberg jolted the New York art world in 1975 with her solo show of large, intense canvases of schematic horses. A native of Buffalo, Rothenberg had been introduced to art at the Albright-Knox Art Gallery prior to her studies during the 1960s at Cornell and George Washington universities. Her early heroes were Jasper Johns and Lucas Samaras. In 1969 she moved to New York and entered the diverse community of creative people who formed the city's interdisciplinary avant-garde. After a phase of making process art with funky materials and a series of geometric pattern paintings, she hit upon the horse as subject. Regarding her choice of this highly connotative image, the artist has revealed: "The horse was a way of not doing people, yet it was a symbol of people, a self-

portrait, really."[4] *Diagonal* (plate 24), like Rothenberg's other paintings of the mid-1970s, is part abstraction, part representation. Frozen flat against a richly gestural field, the speeding animal is slivered by the insistent diagonal. Playing with the formal implications of this fragmentation, Rothenberg coaxed the composition to yield several sympathetic triangles.

In the 1980s Rothenberg worked more directly with the human form. Her earlier focus on figure-ground relationships became a concern for what she termed "the atmosphere of the surfaces, the 'weather,'"[5] when she switched from acrylic to oil. In the visceral *Mist from the Chest* (plate 25), a brutish specter inhabits an aqueous realm. Here expressionist means serve a subjective content: "I'm totally motivated by psychology—but the whole . . . experience of painting, is to solve and channel and tame and define what the experience is, so it becomes a very eyeball and

hand and brainy experience with the given that it is already psychologically charged."[6]

Lois Lane also employs minimal images and maximal content, playing both ends of the abstraction-representation dichotomy against the middle. After earning her M.F.A. from Yale in 1971, Lane moved to New York and worked as an assistant to Jasper Johns. Her later penchant for doubling images and for floating iconic objects against a flat, painterly field likely relates to his example.

Mardi Gras (plate 26) presents two nearly identical plant forms deployed at either edge of a neutral black ground. Common to many of her paintings of this period, this central split is, as she describes it, "deflected by the closeness in color value, [and] furthered by one's inability to focus on both forms at once."[7] Lane's evocative images usually originate in drawings inspired by dreams, memories, or magazine photos. In discussing the iconography of a painting closely related to

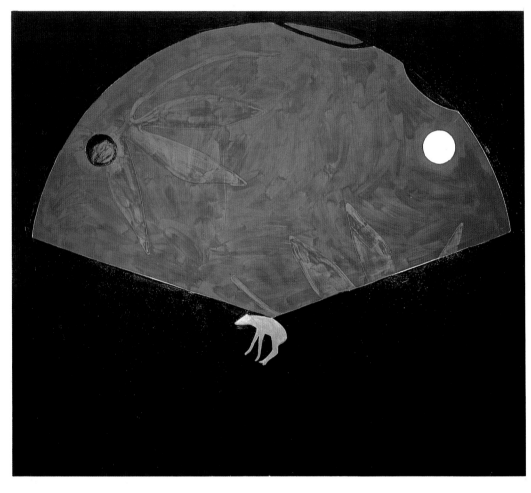

27
Lois Lane
Untitled, 1978
Oil, gesso, and graphite on canvas, 84 x 96 in.
Ellen and Ellis Kern

Mardi Gras, critic Jeff Perrone noted that her shapes "are as difficult to describe as they are memorable" and characterized them as "branches, blood corpuscles, worms, even wrenches or labia."[8]

Intrigued by the implication of hidden activity, Lane often employs emblematic images with both accessible and covert content. The ambiguous germinating sprouts of *Mardi Gras* seem to have acquired their quirky coloration under cover of darkness. Fans and masks, both devices for concealment, are found in many of her paintings and drawings. Although she does not work in series, she does gravitate to such iconic shapes as clothing, animals, flowers, and hands, which continually reappear in her 1970s work. In the large-scale *Untitled* (plate 27), Lane employs the archetypal feminine image of the fan coupled with an enigmatic, pendant dog.

Elizabeth Murray earned her M.F.A. from Mills College in Oakland, California, in 1964; three years later she moved to New York. Her early paintings, energized by the model of Robert Rauschenberg, Claes Oldenburg, and Jasper Johns, are representational. Tellingly, in this work, which predated her signature style by a decade, she lavished thick paint on shaped canvases collaged with soft, sewn fabric forms and furniture fragments. Pop-inspired comic-strip characters also appeared, and another body of work from this period consisted of artist's books that were both painted and embroidered.

In 1971 Murray switched from acrylics to oils. A subsequent group of gridded, small-scale paintings ranges in imagery from goofy kidney-bean shapes to sequential stick figures narrating such disparate moments as friends cavorting in the snow and Madame Cézanne in a rocking chair. After passing through the mid-1970s with an overtly abstract phase of biomorphic shapes and grandly increased scale, Murray evolved a fresh and personal

content built on her dual fondness for art historical allusion and domestic realities. Emotionally expressive and vividly colored, her savvy and spirited style engendered much critical interest in the late 1970s. By 1980 Murray no longer used a rectangular support, favoring instead an assemblage of shaped canvases.

Duck Foot (plate 20) is characteristic of her unique approach. A topsy-turvy scene of flying saucers and cups plays itself out with a cast of large, curiously shaped canvases. This loose confederation of panels sports both illusory and actual negative spaces. Here Murray personalized and made literal the fractured figure-ground relationships of Cubism. A tornado of painterly energy animates her suggestively figurative inanimate objects.

Murray has deftly skirted the polarity of representation and abstraction by planting one foot in each camp. Regarding her favored motif of the cup, she has described it as "an extremely female symbol. It can be seen as an encasement for the female genitals. It is a male symbol too: the winner of an athletic event gets a cup. I also find the cup—as an object—a beautiful image in itself. Handle, saucer, cup—three circular shapes."[9] Other domestic fittings abound in her work of the 1980s. In *Leg* (plate 28), she used her canny sleight of hand to pun visually on the dual use of the word *leg* to signify both limb and furniture part. With barely a leg to stand on, Murray's stick figure is conflated with a cubistically tilted table, both recalling themes from her earliest paintings.

Katherine Porter is an expressionist painter who has likewise confronted emotional realities with global implications. An abstractionist, she has developed a potent visual language to communicate her passionate commitment to social justice. Having studied at Colorado College and at Boston University,

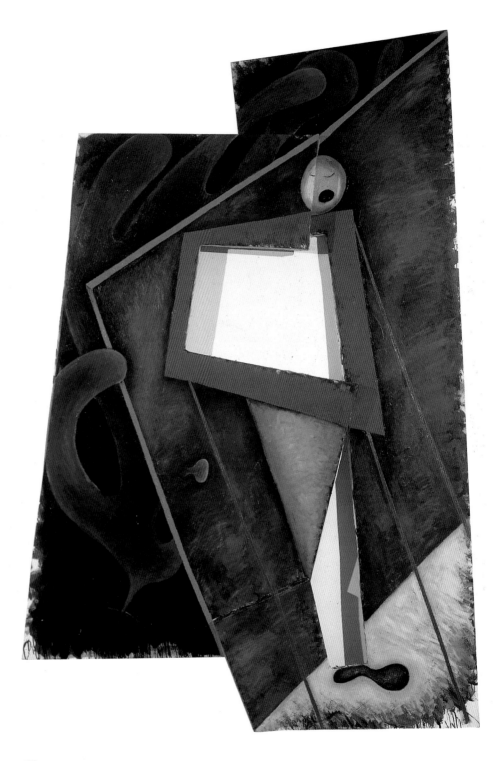

28
Elizabeth Murray
Leg, 1984
Oil on canvas, 2 parts, 117 x 82 in. overall
Mr. and Mrs. Graham Gund

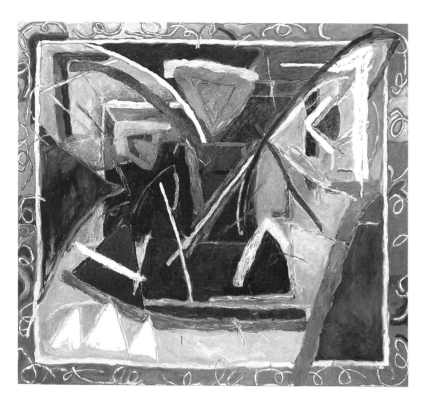

29
Katherine Porter
When Alexander the Great Wept by the River Bank Because There Were No More Worlds to Conquer, His Distress Rested on Nothing More Substantial Than the Ignorance of His Map Maker, 1977
Oil on canvas, 84 x 92½ in. (framed)

Denver Art Museum; Purchased with funds from National Endowment for the Arts Purchase Fund, Dayton Hudson Foundation, and Target Stores

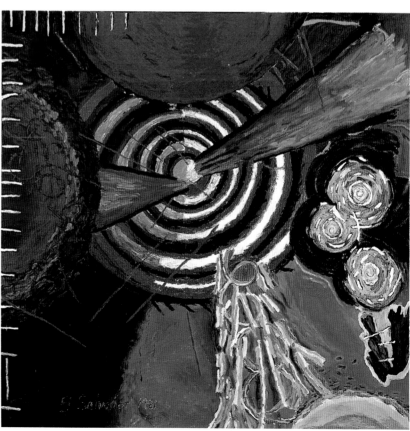

30
Katherine Porter
El Salvador, 1981
Oil on canvas, 90 x 90 in. (framed)
Jane and David Davis

31
Eva Hesse
Tori, 1969
Fiberglass on wire mesh, 9 parts, each 30–47 x
12½–17 x 10¼–15 in.
Steven Robinson

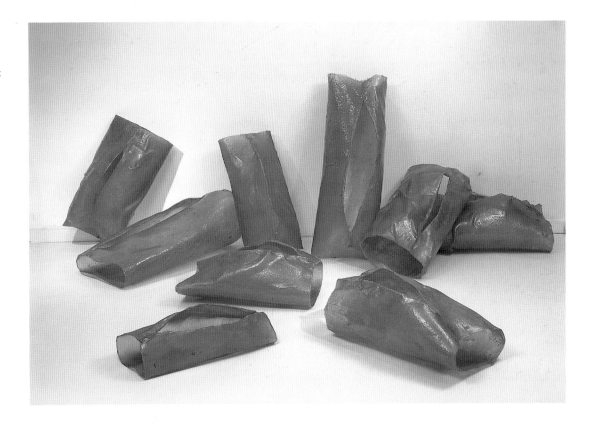

Porter spent a decade in Boston from 1962 to 1972; she then lived in New Mexico for four years before settling in Maine. In the early 1960s she made painterly landscapes, influenced in part by her teacher, Fairfield Porter (no relation). The grid entered her work in 1966, after Frank Stella's work awakened her to its formal potentials. In New Mexico during the 1970s Porter began to alter and personalize the grid format. This early signature device provides the covert compositional structure for *When Alexander the Great Wept by the River Bank . . .* (plate 29). Alluding to the perils of imperialism, its title derives from a phrase in Richard Barnet and Ronald E. Muller's 1974 book, *Global Reach*, which addressed the repercussions of actions by multinational corporations on the Third World. Balancing order and license, she juggled geometric shapes and squiggly lines, confining the latter to an intensely colored border.

Porter works with a modernist vocabulary of evocative forms and rich colors. Her paintings explode with a gestural language of shapes abstracted from such natural forces as sun flares, tornados, windstorms, and cloudbursts; and her expressionist style seems to harness their kinetic energies. In the 1970s she found many of her subjects in the brutal realities of post-Allende Chile and the war in Vietnam. Boldly theatrical, these compositions acknowledge the example of the Mexican muralists, who had also developed powerful visual strategies to express moral outrage.

El Salvador (plate 30) is one of a series of paintings from the early 1980s that addresses the oppressive regime of that Central American country. Porter juxtaposed shapes that embody containment, like the central target, and others that burst free, resembling a megaphone or ear trumpet—apt metaphors for her need to speak out and be heard on

matters of conscience. A looping line of barbed wire, a favored motif, snakes across the canvas. Porter's interest in allusive devices is evident in the toothy, nearly deconstructed grid partially framing the composition. It recalls her own stylistic history while also evoking a sinister radar screen or navigational chart.

Rothenberg, Lane, Murray, and Porter chose painting as the arena in which to transform and expand the nature of abstraction. Of the sculptors who were crucial in doing the same in the 1970s, one died before the decade had barely begun. Eva Hesse's brief but enormously influential career ended in May 1970, with her death from a brain tumor at age thirty-four. Hesse's 1972 memorial exhibition at the Guggenheim Museum in New York, the first retrospective of a woman artist ever mounted by that institution, made the breadth of her legacy vividly apparent. Here

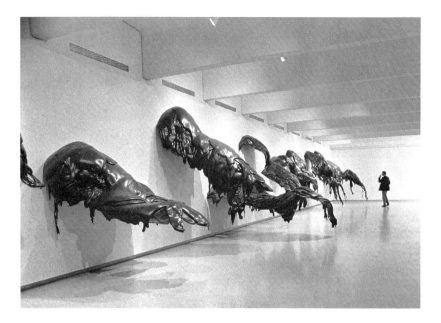

32
Lynda Benglis
Adhesive Products, 1971
Iron oxide and black-pigmented polyurethane,
9 parts, 13½ x 80 x 15 ft. overall
Installation at Walker Art Center, Minneapolis, 1971

was a catalytic body of work that drew upon the visceral expressionism of the 1950s and the reductive sensibility of the 1960s, an oeuvre that both epitomized and transcended its time. In her search for an authentic, original art, Hesse appropriated such unexpected materials as latex and fiberglass. Employing the then-current mode of serial and modular forms, she fabricated "ugly," powerfully unsettling pieces that challenged and redefined the nature of sculpture.

Hesse was born to Jewish parents in Hamburg, Germany, and fled with her family to the United States in 1939. Raised in New York, she attended such city-based art institutions as the Pratt Institute and Cooper Union before entering the Yale University School of Art and Architecture in 1957. As a teenager she had her work published in *Seventeen* magazine, a forum for talented young women that gave similar encouragement to her contemporaries Yvonne Jacquette and Sylvia Plath.

Hesse's preeminent position in American art of the twentieth century rests on her mature work produced between 1966 and 1970. Two of her late pieces exemplify the power and originality of her vision, manifesting Hesse's masterful balancing of randomness and order. With deadpan humor, Hesse suspended five irregular latex segments from an ordinary household clothespin hook in *Untitled* (plate 8). While its modular format is a familiar device of the 1960s, the mottled coloration and wavery edges are not typical of Minimalism. *Tori* (plate 31) is composed of nine independent units of fiberglass on wire mesh, arranged in arbitrary configurations on the floor. The complex visual allusions of the swollen and split rectangles are reinforced by the multiple meanings of the word *tori* in the diverse vocabularies of geometry, botany, and anatomy.

Five years younger than Hesse, Louisiana-

33
Lynda Benglis
Modern Art No. 1, 1970–74
Bronze and aluminum, 2 parts, each 12 x
42¾ x 30 in.
Collection, The Museum of Modern Art, New York;
Gift of J. Frederic Byers III

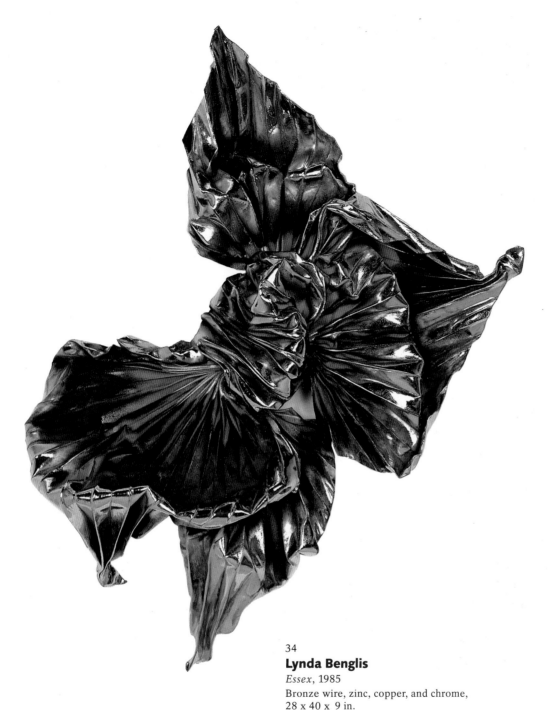

34
Lynda Benglis
Essex, 1985
Bronze wire, zinc, copper, and chrome,
28 x 40 x 9 in.
Dr. and Mrs. Robert J. Freedman, Jr.

born Lynda Benglis is likewise known for pioneering with new materials and for working in the conceptual gulf between painting and sculpture. Along with their colleagues Alan Saret, Richard Serra, and Keith Sonnier, the two followed the lead of the Abstract Expressionists and challenged the tradition of easel painting by working directly on and with the walls, floors, and environs of the gallery.

Six years after receiving her B.F.A. from Newcomb College in New Orleans, Benglis had her first solo show in New York, in 1970. In one early series she took the technique of stained-canvas painting favored by Helen Frankenthaler and others one step further: she poured pigmented latex directly onto the floor, treating paint as a sculptural form. Another series of freely formed pieces employed polyurethane foam, which even when dry still looks fluid. The nine "molten" segments of *Adhesive Products* (plate 32) were created by spilling the viscous medium across a temporary armature of undulating chicken wire and polyurethane sheeting. Mindful of the precedent of Oldenburg's supple sculptures and motivated by a desire to "soften the hard-edged world,"[10] Benglis has frequently worked with the polarity of hard and soft.

An early feminist, Benglis gleaned from the women's movement her own permission to break boundaries: "What interested me about the feminist movement was the fact that there really is emphasis on the 'taboo.'"[11] In 1973 she tested the outer limits of taste with a series of audacious self-portraits in the guise of such stereotypes as pinup girl and porno queen. She had conceived these purposely controversial photographs, in part, to mock "sexuality, machoism and feminism," as well as "the art-star system, and the way artists use themselves, their persona, to sell the work."[12]

In the 1970s Benglis made metal casts of

35
Burnt Piece on fire. This was the last and riskiest of six stages in its construction, during which the work might have exploded despite its five layers of mesh and six-inch-thick concrete structure.

36
Jackie Winsor

Burnt Piece, 1977–78
Concrete, burnt wood, and wire, 36 x 36 x 36 in.
Private collection, New York

the forms engendered by her earlier foam "pour" pieces. With *Modern Art No. 1* (plate 33), a two-part work of bronze and aluminum, viewers must confront the incongruity of untraditional and organically suggestive shapes presented in the most conventional of sculptural materials. In 1971 Benglis initiated an ongoing series of knots. A richly allusive image, it makes uncustomary sculptural references to embroidery and rope craft, and also brings to mind the colorful southern expression of anger, "I'm gonna jerk a knot in you." *Essex* (plate 34), a recent and elegant variation, retains an impression of fabric: its fluted metallic surfaces read as pleats, and its bouffant sections fan out like the cape of a toreador doing a *paso doble*.

Like her contemporaries Hesse and Benglis, Jackie Winsor began making art in the 1960s, during a period strongly shaped by the reductive aesthetics of Minimalism. After earning her M.F.A. from Douglass College, Rutgers University, in 1967, she settled in New York. One of her early series resembled 1930s Surrealist sculpture, and another explored such process-oriented materials as rubber, latex, and polyester resin. Winsor's mature work concentrated on the simple forms of sphere, cube, and triangle. While retaining the Minimalist's instinct for geometry, symmetry, and restraint, she was to transform those elements by her own distinctive methods and materials.

Winsor's way of working has always been labor intensive. Her 1970s sculptures incorporate rope, lath, tree trunks, hemp, cement, bricks, wood dowels, and sheet rock, and required such repetitive actions as binding, winding, nailing, and coiling. The obsessive quality of this handwork imparts a fetishistic personality to many of her pieces. Responding to a question about her art historical affections, Winsor expressed interest in "archeological items, especially those where it's

difficult to reconstruct what their function was or why they took on this or that particular shape."[13] *Chunk Piece* (plate 21) was made by amassing yard-long lengths of coiled hemp, bound at both ends of a cylindrical pile. Winsor coaxed each edge to unravel, revealing the enormous number of individual filaments required to form one dense, chunky mass. The fact that the sculpture sits directly on the floor enhances its allusiveness.

During the 1970s Winsor focused on the manipulation and transformation of primary forms. At first she used only one material in each piece, then gradually shifted to integrating two materials by some sort of repetitive action. Subsequently she worked with laminated woods. That process of layering shapes Winsor's content: "What my work is about is putting things together. . . . I'm interested in what is holding things together."[14] The fabrication of *Burnt Piece* (plate 36)—an evocative cube of alternating registers of concrete, burnt wood, and wire mesh—informs its meaning. After extensive research into the technical challenges of its manufacture, Winsor set the piece on fire (plate 35): "[*Burnt Piece*] . . . was filled with uncertainty. I never knew until the very last minute if it would explode during the firing or crack when cooling, and I was never able to see how the piece would look until the moment of completion."[15]

Having worked in both abstraction and representation, Nancy Graves is not at all constrained by the traditional boundary between them, and she has blithely ignored other boundaries as well, such as the one separating art and science. Graves was a frequent visitor to the art and natural science museum in her native Pittsfield, Massachusetts, where her father served as director. The launching of Sputnik I in 1957, the year she entered Vassar College, spurred her scientific interests. After completing her M.F.A. at Yale, she painted and lived abroad before returning to New

York in 1966. She was only twenty-nine when the Whitney Museum exhibited her life-size, highly naturalistic camels, which grabbed the attention of critics and public alike.

No artist before her had chosen to explore the boundaries between the natural and the constructed by investigating the conceptual gap between sculpture and taxidermy. Innovative and adventuresome, Graves mined subsequent subjects from such fields as anatomy, biology, anthropology, and archaeology. The fetishistic *Bone Finger* (plate 37)—a 1971 hanging sculpture of steel, acrylic, and gauze—annexes the power and appearance of tribal art with simulated ritual objects arranged in artful and magical configurations.

For the next several years Graves shifted away from sculpture, concentrating instead on paintings, drawings, prints, and films. (The subject matter of the three major films she made between 1971 and 1974 includes camels, exotic birds, and the surface of the moon.) Working from such starting points as topographical charts and orbital photos of Antarctica, she imaginatively recreated these highly technical sources, making them over by hand with varying degrees of verisimilitude. Their distinctive style rejects any a priori distinctions between abstract forms and recognizable images.

When Graves returned to three-dimensional forms in the late 1970s, she chose to experiment with bronze, the most traditional of sculptural media. Her preference for direct casting, in which the object is destroyed in the process of being "remade" in metal, reflects her abiding interest in redoing nature by hand. It is in the joining and coloring that she is free to create dazzlingly new sculptural forms. In collaboration with the Tallix Foundry, which casts and then welds the pieces under her direction, Graves has pioneered in creating new polychrome patinas with baked enamel and poured acrylic.

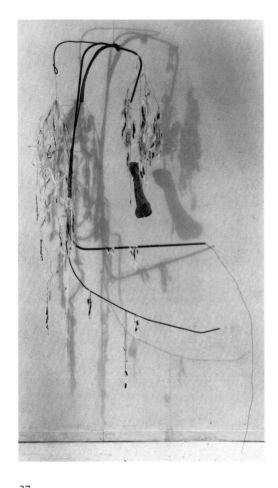

37
Nancy Graves
Bone Finger, 1971
Steel, acrylic, and gauze, 114 x 60 x 12 in.
Private collection; courtesy M. Knoedler and
Company, Inc., New York

Through the casting process Graves has replicated such natural and manmade components as exotic flowers, delicate plants, dried fish, noodles, industrial tools, packing material, farm machinery, and lampshades. She has then welded these into incongruous combinations, artfully creating new relationships of scale, content, and form that could not exist if the elements were real. In *Zeeg* (plate 2), she cantilevered her assemblage into a whimsical and exuberant form, which bears a sassy resemblance to Picasso's influential painted sculpture of 1914, *Glass of Absinthe*. The flirtatious angle of the open fan in *Tarot* (plate 38) lends a mysterious and figurative air to the otherwise abstract sculpture. Color, a significant element in both works, is imaginative, high-keyed, and sensuous.

Like Nancy Graves, Vija Celmins uses nature as a starting point. In her re-creations of the heavens and earth, Celmins prods the viewer into an expanded awareness of both her sources and the process of artistic vision. Having emigrated from Latvia to Indianapolis at age ten, Celmins eventually moved to California, where she received her M.F.A. from UCLA in 1965. After a year in California, she relinquished an Abstract Expressionist style and began to paint life-size images of household objects. Her subject matter gradually shifted from these Pop-related themes to remembered matériel of World War II and to views of the freeway developed from her own photos. In the mid- to late 1960s she made sculpture as well, including a small house with scenes of calamity depicted on its walls. Its lift-off roof revealed a fur-lined interior, an homage to Surrealist Méret Oppenheim's fur-lined teacup.

In 1968 Celmins's preferred medium changed from paint to graphite on paper with a series based on satellite photographs of the lunar surface. By choosing drawing as her primary means of expression, Celmins conferred a new importance on what was then a devalued medium. In the 1970s drawing became the major expressive vehicle for Celmins, Agnes Denes, Dottie Attie, and a number of other women who accorded new status to the medium. Celmins used her own photographs of the ocean, taken from the Venice pier, as catalysts for a major series of drawings. These snapshots provided her with certain givens—namely, a fixed point of view and a "found" composition. Working within these parameters, Celmins has reinvented the surface of the sea with thousands of tiny, precise marks. In *Ocean: 7 Steps #1* (plate 39), she paces the viewer through seven versions of the same image, each one executed with a progressively softer, and hence darker, lead.

The nature of perception itself is one of her themes in *Desert-Galaxy* (plate 41), in which she paired drawings of the celestial Coma Bernices with a close-up detail of the desert floor. Her meticulous pointillist technique here unites such polar opposites of scale as a distant star and a grain of sand. The contemplative *To Fix the Image in Memory* (plate 40) also encompasses two elements: a stone and the bronze re-creation of a stone. By presenting this juxtaposition Celmins invites the viewer to consider the nature of reality and the process of art making.

Margaret Wharton is a sculptor who also reveals aspects of the art process in her work. Because her raw material is restricted to ordinary wooden chairs, the viewer can summon up a mental image of her starting point. Chairs convey a strong human presence, through the implication of use and through the punned resemblance to the human body of a chair's arms, legs, back, and seat. Wharton engages this predetermined form and content in a visual and conceptual dialogue, enacting astonishing transformations. In capitalizing on the figural references of chairs, Wharton shares affinities with such

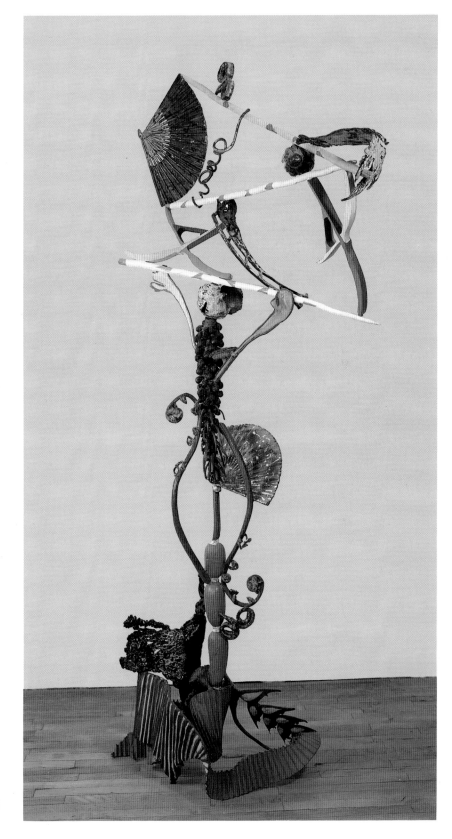

38

Nancy Graves

Tarot, 1984

Bronze with polychrome patina and enamel,
88 x 49 x 20 in.

Private collection; courtesy M. Knoedler and
Company, Inc., New York

39
Vija Celmins
Ocean: 7 Steps #1 (detail), 1972–73
Graphite on acrylic-sprayed paper, 12⅝ x 99¼ in.
Whitney Museum of American Art, New York;
Purchase, with funds from Mr. and Mrs. Joshua A.
Gollin

40
Vija Celmins
To Fix the Image in Memory, 1977–82
Stone and painted bronze, 2 parts, each 3¼ x 1¾ x
3¼ in.
David McKee Gallery, New York

41
Vija Celmins
Desert-Galaxy, 1974
Graphite on acrylic-sprayed paper, 17½ x 38 in.
Collection of the artist

artists as Judith Shea, Mimi Smith, Harmony Hammond, Maureen Connor, and Barry Ledoux, who use the associative content of clothing to address the human condition.

In 1973 Wharton was one of the founders of Artemisia, Chicago's first women's cooperative art gallery. Two years later she earned her M.F.A. from the School of the Art Institute of Chicago, where she had been particularly encouraged by the support of such faculty as Ray Yoshida, Jenny Snider, and Ree Morton. Wharton was aware of the precedent of Claes Oldenburg's garments when she made her first sculptures, welded metal articles of clothing. Another early series of small, enigmatic seaweed boxes was informed by the example of Lucas Samaras's menacing boxes. In turning to the wooden chair as the basis of her art in 1975, Wharton chose to explore an iconography approached earlier by such sculptors as Barbara Zucker, Joel Shapiro, Scott Burton, and Richard Artschwager.

Her highly original vision has yielded inexhaustible variations on the subject. She begins each sculpture by disassembling the chair—cutting, slicing, peeling, and dicing the wood as demanded by her conception. While metamorphosing into people, animals, and multifarious abstractions, no chair ever strays so far from its original form that it can't be traced back to it. In *Mocking Bird* (plate 42), a telephone chair has become a fanciful bird with toelike talons. Wharton has striped the body with gold pigment and represented the feathery wingspan with thin cross sections of the chair fanned out like a series of stop-action photos. In *Eiffel Tower* (plate 43), a vintage high chair is extended like a telescope through four progressively etherealized stages, getting lighter and smaller as it towers upward. Like Joyce Kozloff and Heide Fasnacht, Wharton occasionally recycles her art: the year prior to the creation of *Eiffel*

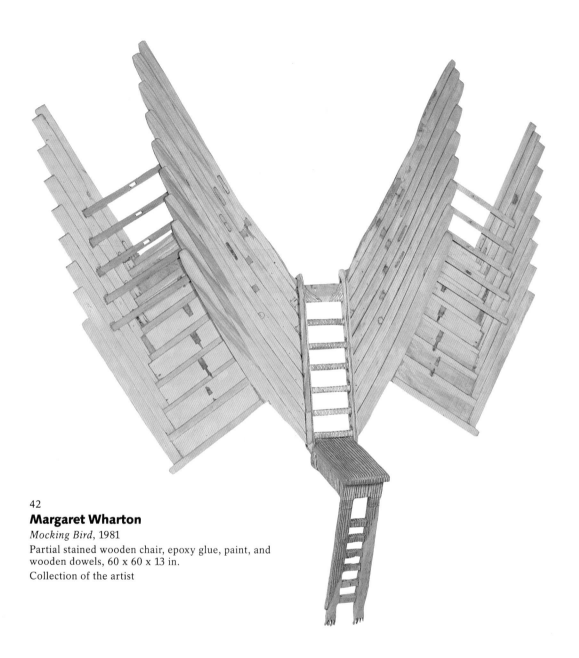

42
Margaret Wharton
Mocking Bird, 1981
Partial stained wooden chair, epoxy glue, paint, and wooden dowels, 60 x 60 x 13 in.
Collection of the artist

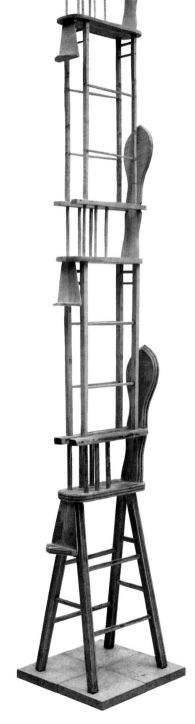

43
Margaret Wharton
Eiffel Tower, 1979
Partial stained wooden high chair, epoxy glue, and wooden dowels on concrete base, 98 x 17 x 17 in.
Mr. and Mrs. Charles M. Diker

Tower, she used the high chair for a site installation in her New York gallery.

Video

Today a great deal of controversy surrounds video art. Is it a form of avant-garde film or an expanded version of kinetic painting and sculpture; a tool for political activism and communication or a subset of broadcast television? Although arguments can be made for each of these positions, clearly video is all of these things and more. When video art began in the 1960s, its diverse practitioners—who included painters and sculptors, kinetic artists, filmmakers, performers, and social and political activists—were drawn to video art for different reasons, but they found themselves united by their common fascination with this new art material. In the early years, when the art world was smaller and more communal, the distinctions between media and genres were less pronounced, and each group served as the audience for the others.

With few exceptions, video is not by nature or common practice a wholly abstract medium. At its most abstract, it is closer to Piet Mondrian's and Wassily Kandinsky's paintings of the early 1910s, in which forms became highly simplified but still remained readable as horse and rider, tree or mountain. Broadcast television, with its appearance of realism and verisimilitude, can be considered as the constant backdrop for video art, and all of the early experiments with video deconstructed and abstracted television by manipulating it electronically and conceptually. The artistic appropriation of what are normally considered flaws in television, such as feedback and vertical roll; the use of the underscan button as a compositional device; and the development of colorizers and synthesizers to shape the television image to the artist's vision all challenged the realism of broadcast television, giving it a personal, often expressionist content. Although the content of their work varies, all of the artists in this section are directly linked to the early years of video art, when artists first experimented with seeing television in a new way.

The broad genre of video art that includes such diverse forms as installations, documentaries, image-processed work, and experimental narratives owes its origins to the expansion of sculpture during the 1960s. One of the lesser-known sources of the period's development of a new sculptural language was a deep involvement with kinetic, electronic, industrial, and technological art forms. Sculptors such as Jean Tinguely, Otto Piene, Keith Sonnier, Hans Haacke, and Bruce Nauman and groups such as Experiments in Art and Technology (E.A.T.) began to make sculptural machines using light, sound, electricity, and sometimes television.

Although television was still a relatively new medium, it had been around long enough for obsolescent television sets to have been discarded as junk. By 1960 they had become a kind of urban waste, like the other industrial discards that were attracting sculptors who inhabited urban manufacturing districts. Nam June Paik, who is generally given credit for producing the first video art, started by using television sets as altered Ready-mades. Several of his early sculptures used feedback and other devices, such as magnets, to disrupt the set's function and reveal the machinery behind the picture. Paik was also one of the first in America to use television sets sculpturally, making performance costumes and structures out of them for his collaborator, the cellist and later impresario of the avant-garde, Charlotte Moorman.

The introduction of low-cost portable video equipment in 1968 stimulated artists who immediately saw its potential as a new art form. Steina Vasulka recalls: "You have to understand those early years; they were so unbelievably intense. . . . This was the '60s revolution.' We didn't have the division in the early times. We all knew we were interested in different things, like video synthesis and electronic video, which was definitely different from the community access–type video, but we didn't see ourselves in opposite camps. We were all struggling together and we were all using the same tools."[1]

In the early years (1968–74) many people saw video as a radical political tool for enfranchising the previously disenfranchised by giving them access to television. Others during this time, including many artists and critics, also saw it as expanded painting or sculpture. Most would have agreed with Paik that video was the art of the future: "As collage technique replaced oil paint, so the cathode ray tube will replace canvas."[2] Video artists complicated their quest for an identity by artificially isolating their work from the tradition of avant-garde film, with which it was, in fact, closely aligned. Video art was generally treated as an outgrowth of the visual arts, largely because many of its practitioners had crossed over from traditional art forms. The early single-channel works and installations were usually shown in art galleries and museums, as well as in alternative viewing spaces such as The Kitchen, Anthology Film Archives, the Raindance Foundation, and Global Village (all in New York City) and Video Free America in San Francisco. Because of limited access to editing equipment in the early years and because of the period's emphasis on the process of making art, many of the early tapes are about duration—the camera was left on as long as the tape lasted, usually an hour. As Rosalind Krauss has pointed out in her important critical essay "Video: The Aesthetics of Narcissism," the instant-replay capacity was seductive, and many artists—including Lynda Benglis, Joan Jonas, Richard Serra, William Wegman, and

Nancy Holt—began to construct private performances, using the television screen as a mirror. Influenced by ideas about self-referentiality and concepts of political enfranchisement, others saw beyond television's capacity to function as a picture frame or a small stage and constructed work that addresses the nature of the medium. They were assisted by hands-on information demystifying how television works, which was published in *Radical Software* and *Guerrilla Television*.

Paik's experiments dovetailed with the art world's interest in process and materials. The colorizer-synthesizer he developed with Shuya Abe—along with those simultaneously invented by Stephen Beck, Peter Campus, Bill and Louise Etra, Woody and Steina Vasulka, and others—could produce Fauve colors and electronically induced stacks of intermingled forms. This technical breakthrough led to the separate genre of image-processed work. Woody Vasulka has pointed out that image processing began as "an alternative industrial subculture . . . based on individuals . . . in the same way that art is based on individuals."[3] These "electronic tool designers" built low-cost systems that could be used at the Television Labs at the PBS stations of WGBH, Boston, WNET, New York City, and KQED-TV, San Francisco; at the Experimental Television Center—first in Binghamton, New York, and later in Owego, New York—headed by Ralph Hocking and Sherry Miller; at the Art Institute of Chicago through a program headed by Dan Sandin; and elsewhere. Computers have since been added to the original systems, extending their range. It would be wrong to think that image-processing equipment produces machine art. Like brand-name art materials, it is no more than a tool whose results vary according to the artist. Compare, for example, the work of Barbara Buckner, Sara Hornbacher, and Doris Chase, three video artists who have produced work at the Experi-

mental Television Center. Image processing by artists has shaped the look of broadcast television, inspiring the development of the elaborate special-effects generators that now decorate television news and sports. That sophisticated equipment has, in turn, allowed the creation of high-tech videotapes such as those by Mary Lucier, Dara Birnbaum, Joan Jonas, Max Almy, and others.

"Another challenge to video artists," critic and filmmaker Lizzie Borden has pointed out, "has been to develop ideas about editing that do not imitate those of film. There is no literal frame in video as there is in film, but rather visual phrasing, which is a more gestural way of reading images."[4] Two important early works took an innovative structural approach to this problem, with memorable results. Joan Jonas used the "flaw" of vertical roll in making a videotape of her performance *Organic Honey's Visual Telepathy* (1972). (Vertical roll results when the frequency sent to the set is out of synchronization with the frequency with which it is interpreted, causing an unstable, rolling image.) Jonas played with the roll, making it look as if she were being pulled down and out of the picture or giving the illusion that she was jumping over the roll. The sense that the rolling bar marks the frame of the pictures is "intensified by the soundtrack on which she is heard banging a spoon against a mirror or clapping pieces of wood together to mark the moment when the roll strikes the bottom of a monitor, making it sound solid and material."[5] *Vertical Roll* (1972), a nineteen-and-a-half-minute black-and-white videotape, was produced by rescanning the monitor during the performance.

Nancy Holt has described her introduction to video as follows: "The first time I had contact with video was in 1969 when Peter Campus rented a video camera and came over. There was a tremendous sense of discovery because it was so accessible and so Bob

[Smithson] and I immediately did a work of art, *East Coast, West Coast*. We invited a large group of people over to our loft that night including Richard Serra, Michael Heizer, Nancy Graves, and Keith Sonnier to see it. It is very unusual when you discover a medium, make a work of art, and show it in the same day. That broke the ice and gave me a sense of what it was about. I was always very clear about what were film ideas and what were video ideas."[6] Holt says that she would never make a videotape about nature like her film *Pine Barrens* because the scale of the monitor seems wrong to her. Video seems psychological and immediate and more about real time, whereas film is more artificial.

Holt's *Underscan* (1974) is another important early tape that uses a structuring device unique to video. Pushing the underscanning button on a video monitor compresses the picture so that the edges can be seen precisely, making a black border around the picture. Holt used two types of underscanned images: one caused by pushing the button halfway in, which compressed the vertical sides of the picture, thereby elongating the images, and the other by pushing the button all the way in, which reduced the whole picture. She used this device in displaying photographs of her Aunt Ethel's house in New Bedford, Massachusetts. Holt has explained her reason for making the tape as follows: "I was fascinated how you could change an image by pushing a little button—fascinated by what happened with an image. [Also] I always wanted to do something with stills."[7] The idea for the tape came to her while visiting her aunt's house during her aunt's hospitalization for a cancer operation. Holt decided to make "a portrait of someone where you never saw the person . . . touching someone with them never being there. I thought about the cyclical nature of time and how it is reflected in the film and video process through editing."[8] Each photo-

44
Steina Vasulka
Somersault, 1982
Color videotape, 5 min.
Collection of the artist; courtesy Electronic Arts
Intermix, New York

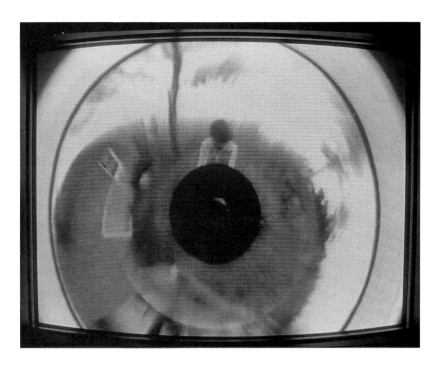

graph is seen three times: regular, contracted, and somewhat elongated as it is subtly transformed through underscanning. The voice-over is Holt reading her aunt's letters. She noticed that certain topics were repeated, a repetition that is mirrored formally by the tripling of each image. Although most early video projects were informal, Holt became increasingly concerned with taking a more professional approach. *Underscan* was done on now-obsolete black-and-white equipment, but it was carefully planned for the camera and produced by Carlotta Schoolman, one of the people most experienced with video in the art world.

It is hard to imagine how video art would have developed without the contribution of Steina Vasulka. She was born in Iceland and was a member of the Iceland Symphony Orchestra before coming to America in 1964. Seven years later she and her husband and frequent collaborator, Woody, founded The Kitchen, originally called the Electronic Kitchen, a much-needed screening and performance space for artist-produced electronic media. Starting in 1969 the Vasulkas concentrated on exploring the unique plastic properties of the new electronic medium. Woody stated: "There is a certain behavior of the electronic image that is unique. . . . It's liquid, it's shapeable, it's clay, it's an art material, it exists independently."[9] The Vasulkas began to have specialized video equipment designed for them, and from 1971 to 1974 they produced a series of highly abstract tapes that looked like modern abstract painting but which they perceived as manifestations of electromagnetic energy. Indeed, much of their early work involves conceptual demonstrations of the various kaleidoscopic patterns that can be produced by manipulating the video signal. As Lucinda Furlong has pointed out: "They began to think of these manifestations as a kind of language, and their work with video hardware as a 'dialogue with the tool and the image, so we would not perceive an image separately. . . . We would rather make a tool and dialogue with it.'"[10] The Vasulkas moved to Buffalo in 1974, and in 1976 worked with Jeffrey Schier to build "the Vasulka Imaging system," a computer-run digital video system that allowed them to create images using mathematical logic systems.

In the early days the Vasulkas exhibited both together and separately.[11] After moving to Santa Fe, New Mexico, in 1980 they began to respond to their new environment by producing work that was about landscape and machines. In *Somersault* (plate 44), Steina Vasulka used a mirrored ball to create alternating effects of concavity and convexity. Her manipulations of the ball yielded images of mythic proportions, suggesting Alice's journey down the rabbit hole, young Arthur's attempts to free the sword from the stone, and the giant in *Jack and the Beanstalk*. *Rest* opens with a section of a hammock abstracted into a fan shape set against a tree whose top repeats its curve. Through a series of changes in which the tree and hammock are digitalized and seen in different positions, the tape concludes with the hammock-fan shape at the top of the screen and the tree at the bottom, mirroring their original placement.

More than any other aspect of video,

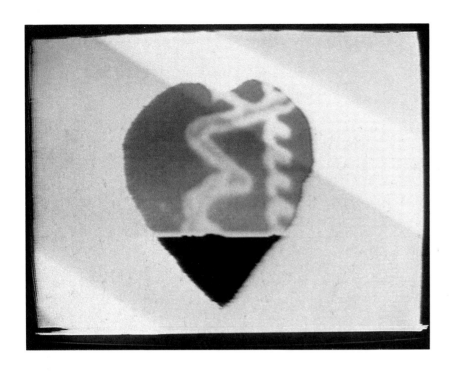

45
Barbara Buckner
Hearts, 1979–81
Color videotape, 12 min. (silent)
Collection of the artist; courtesy Electronic Arts
Intermix, New York

image processing has responded to early modern painting by artists such as Wassily Kandinsky, Kasimir Malevich, Arthur Dove, Georgia O'Keeffe, and others whose heightened sensitivity to the symbolic meanings of color and form led to the development of abstraction. In video the colorizer-synthesizer makes it possible to layer objects in a dense, transparent collage of interpenetrating forms, which become one translucent substance. This stacking dissolves the boundaries of an object, giving it roughly the appearance of a freely drawn line in painting or the bleeding of two colors in watercolor. The distortions caused in videos by technological pyrotechnics parallel expressionist distortions of form. Today's video artists have become conscious of the meaning inherent in such distortions, and one attraction of image processing is that it enables them to render spiritual and emotional metamorphoses both graphically and kinetically.

A desire to create an electronic poetics led Barbara Buckner to begin working in video. She felt that "the video image expressed a metaphoric identity emerging from its organic structure, yet had a universal quality drawing on the traditions of poetry, painting and music. There were always two central concerns—exploring the medium with the tools that were available and expressing inner states of being and becoming."[12] Buckner became interested in video and computers while taking film and television courses and an experimental video course with Bill Etra at New York University. In 1973 she bought Etra's synthesizer and "began to use that in combination with other tools to moderate feedback" in order to create what "looked like spiralling energy fields of jewels intercut with a molten metal—square structure."[13] With her first residency at the Experimental Television Center in 1976 she began to work in color. In *Hearts* (plate 45), Buckner's longest early work, spectacular permutations of a heart icon are coupled with an electronically altered landscape to stress the potency of wordless, soundless visual communication. Buckner says, "In *Hearts* I am trying to express the integration of emotional energy over a period of time. It is a cycle that continues, beginning slowly, and then transforming. . . . The heart is the centralized icon not only of emotional energy but also the seat of consciousness, the heart-center that informs the whole psyche, which I depicted as a magnetic landscape. The heart issues forth many kinds of energy within that landscape."[14]

Reviving Representation

Although various modernist abstract modes have periodically gained ascendancy over figuration in the twentieth century, representational painting has always reasserted itself. In the 1970s, when the dominant aesthetic swung away from nonobjective Minimalism, painters and sculptors accorded new attention to figures and still lifes. Traditionally, still lifes had occupied a low position in the hierarchy of academic art because they required the mere arrangement of objects and lacked the sublime content of history painting and landscape. In the nineteenth century still lifes were the province of "accomplished" women and were little valued as a serious art form. In the twentieth century such artists as Georgia O'Keeffe and Charles Demuth, in the 1920s, and Nell Blaine and Jane Wilson, in the 1950s, used the genre as a major vehicle for their talents. Still lifes received another boost in the 1970s, achieving a new probity and unprecedented importance in the work of such artists as Audrey Flack and Janet Fish.

Audrey Flack, a pioneer of Photorealism, has always been a maverick. A student at New York's Cooper Union and at Yale in the early 1950s, she was taught to paint as an Abstract Expressionist. But her determination to work with representational images led her to study anatomy with Robert Beverly Hale at the Art Students League. She first exhibited as a figurative expressionist in the late 1950s but gradually eliminated the gestural brushwork from her canvases. An active member of an informal circle of realist painters that included Dorothy and Philip Pearlstein and Sidney Tillim, Flack broke with them in 1964 when she made a painting that clearly derived from a photograph. Flack's indifference to "good taste" and her disregard for the taboo against the revelation of photographic sources would place her in the forefront of

46
Audrey Flack
Queen, 1975–76
Oil over acrylic on canvas, 80 x 80 in.
Private collection; courtesy Louis K. Meisel Gallery, New York

what soon would be termed Photorealism or Super-realism.

In a sense, all art addresses the issue of how the artist and the audience see. Flack was to confront the related matter of how vision is altered by the camera. In 1970 she began focusing on the visual characteristics of reproductions, using airbrush techniques to recreate their glossy, immaculate surfaces and the photographic depth of field. Her luxurious, high-keyed colors took their cues from the luminous intensity of projected slides. She developed a special technique of restricting herself to three base colors and spray mixing all others directly on the canvas. Shifting from her 1960s images of political events and tourist sights, Flack did a series of ecclesiastical subjects, most notably the resplendent weeping madonna by the Spanish Baroque sculptor Luisa Roldan. In the mid-1970s Flack turned her attention to narrative still life, revitalizing traditional iconography with autobiographical elements and a feminist's historical sensibility.

The large-scale *Queen* (plate 46) was part of Flack's Gray Border series, its name originating from the frame within the frame that defined the median spatial plane of the compositions. Scattered across a reflective surface are the universal female metaphors of flower and fruit, such accessories as perfume vials and makeup pots, and the personal memento of a jar of model airplane paint. Flack juxtaposed double locket photos of the artist's mother and herself as a young girl with the stylized gaming images of the flat queen of hearts and the squat, rounded queen, chess's most mobile playing piece.

In *Wheel of Fortune (Vanitas)* (plate 47), Flack confronted the tradition of *vanitas* images meant to demonstrate the futility of human endeavor. Reminders of mortality are embodied in the hourglass, skull, calendar, and candle stub. The Tarot card and the die

47
Audrey Flack
Wheel of Fortune (Vanitas), 1977–78
Oil over acrylic on canvas, 96 x 96 in.
Louis K. and Susan Pear Meisel

evoke elements of chance, and the lipstick, mirror, and baubles symbolize vainglorious pursuits. Written on the frame are quotes from the well-known poem *Invictus* by W. E. Henley: "I am the master of my fate: I am the captain of my soul." In this painting, based on her own photograph, Flack presented herself as both participant and observer, achieving a highly complex layering of reality and illusion by incorporating a glistening silver ball that reflects an image of the artist holding her camera.

During the 1960s the Vietnam War and the civil rights movement motivated many to an art of social protest. For the artist Faith Ringgold, who is both black and female, the 1970s provided a climate that encouraged the extension of her political concerns to include issues of gender. Ringgold was born in 1930 in Harlem, the neighborhood with the world's largest population of blacks living outside Africa. She studied art at City College, New York, under Yasuo Kuniyoshi and Robert Gwathmey, earning both her B.S. and M.A. there in the 1950s. Moving on from traditional landscape subjects, in 1963 she turned to the civil rights movement for her themes, employing a Cubist-derived style of representation. The following year she began to use the image of the American flag as a vehicle for social commentary, and for the rest of the decade she continued to address the bitter realities of racial prejudice in America. Ringgold reinforced her focus on Afro-American life by adopting African design motifs, noting with pride Cubism's debt to African art.[1] Concurrently, her early feminist consciousness prompted her exploration of such chilling subjects as slave rape.

Disheartened by the difficulty of hauling her large stretched canvases up and down fourteen flights of stairs, in 1972 she began painting her images on cloth and framed them with fabric tankas. Delighting in her new, soft

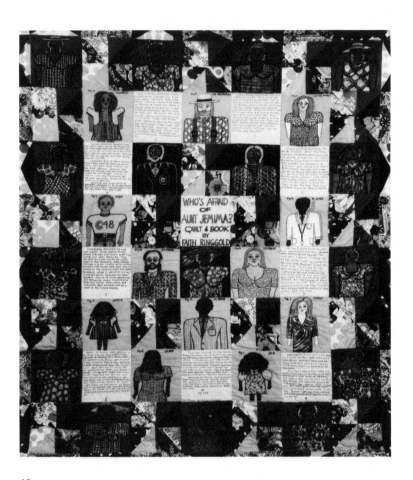

48
Faith Ringgold
Who's Afraid of Aunt Jemima?, 1983
Dyed, painted, and pieced fabric, 90 x 80 in.
Frederick N. Collins

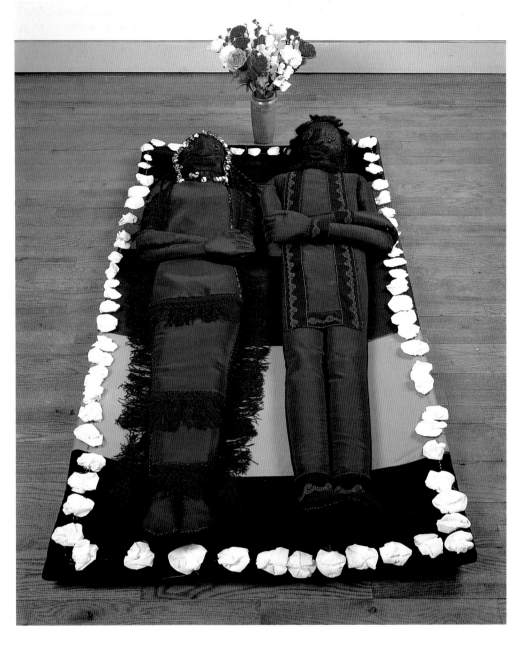

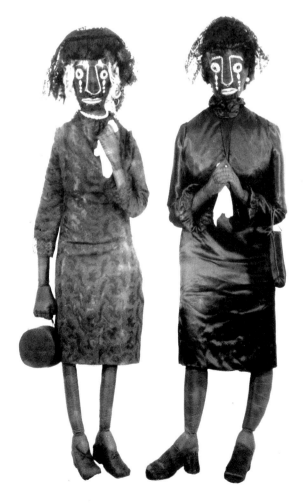

50

Faith Ringgold

Nana and Moma, from *The Wake and Resurrection of the Bicentennial Negro*, 1976

Mixed media, *Nana*: 67 x 16 x 11 in.; *Moma*: 62 x 16 x 11 in.

Bernice Steinbaum Gallery, New York

49

Faith Ringgold

Bena and Buba, from *The Wake and Resurrection of the Bicentennial Negro*, 1976

Mixed media, *Bena*: 65 x 14 x 7 in.; *Buba*: 71 x 16 x 7 in.; flowers and vase: 18 x 12 x 12 in.; cooling pad: 70 x 36 x 2 in.

Bernice Steinbaum Gallery, New York

materials, which allied her to the traditional sphere of women's work, she began to collaborate with her mother, Willi Posey, a fashion designer and dressmaker who died in 1981. In tribute to her mother, Ringgold subsequently created *Who's Afraid of Aunt Jemima?* (plate 48). This unusual quilt combines written black dialect, traditional patterns, and embroidered portraits to tell the fanciful story of the family of Aunt Jemima, depicting her as a successful and beautiful black businesswoman. The artist made the jump from two to three dimensions with a series of beaded, fringed, and embroidered portraits of women and children of her acquaintance; Posey fashioned bodies and clothes for these African-inspired masks. In 1974 Ringgold first combined paintings and masks in installations and gradually shifted to audience-participation performance pieces, with skits occasionally written and acted out by her two daughters, Barbara Wallace and the writer Michele Wallace.

Arguably the most ambitious and compelling work from this period is *The Wake and Resurrection of the Bicentennial Negro* (plates 49, 50). Executed in 1976, a year marked by public celebrations of patriotism, *The Wake* focuses on events in the private life of contemporary black citizens. The funereal tableau uses five masked figures and four life-size soft sculptures to portray the tale of death and resurrection. Ringgold's original performance piece for *The Wake* employed eight actresses and actors accompanied by a sound track with music ranging from that of Aretha Franklin and Billie Holiday to the choir of Harlem's Abyssinian Baptist Church. The moving narrative recounted Buba's death from a heroin overdose and his wife Bena's demise from grief. The performance concluded with their miraculous return to life, which Ringgold presented as a testament to maternal love, embodied by the

51
Joan Brown
After the Alcatraz Swim #3, 1976
Enamel on canvas, 96 x 78 in. (framed)
Stanley Shenker

52
Joan Brown
New Year's Eve #2, 1973
Enamel and oil on canvas, 72 x 84 in.
Allan Frumkin Gallery, New York

character Moma. Regarding her political intentions, Ringgold has commented: "I was trying to point up what happened to us in the 200 years of our country, and the resurrection was meant to say, let it not happen again; let us not have the same story to tell in another 200 years."[2]

Californian Joan Brown had her first solo gallery exhibition in 1957 at the age of nineteen. Although Abstract Expressionism was then the predominant national art mode, many artists in San Francisco, Chicago, and New York were using the gestural strategies of action painting to address representational forms. Brown gained early recognition as a Bay Area figurative expressionist. From her mentor Elmer Bischoff she learned an emotive style, an interest in large scale, and a visual respect for her immediate surroundings. These characteristics have abided in varying degrees through several phases of her art.

The 1960s were a decade of transition for the highly acclaimed young artist, during which time her work changed from the characteristic Bay Area style of thickly brushed, expressionistic still lifes and figures to a more thinly painted, crisper-edged, more personal repertoire of images. She studied Oriental art and spent several years in isolation before reemerging in 1971. Her ensuing canvases encompassed both conscious and instinctive self-portraits, based on actual and imagined travels, environments, and situations. Her flat, opaque surfaces reflected Brown's new respect for Henri Rousseau, especially in her fondness for stark, frontal figures who inhabit quirky, unperspectival spaces. She now preferred oil-base enamel paints, using some colors straight from the can and mixing others. The large-scale *New Year's Eve #2* (plate 52) describes a humorous pas-de-deux between a red-gowned woman and a skeleton in top hat and tuxedo. Against the foil of the

San Francisco skyline, the sinister, high-stepping couple evokes the medieval image of Death and the Maiden, an allegory about fleeting beauty and the swift passage of time.

After the Alcatraz Swim #3 (plate 51) is an autobiographical work that includes representations of the artist as both participant and spectator, a tactic also used by Audrey Flack. Brown, an enthusiastic amateur competitive swimmer, participated in a perilous swim near the infamous island prison. She and a group of others nearly drowned in the treacherous wake of a passing freighter. In this one of three canvases that Brown painted around this event, the impassive artist sits in stiff repose, wearing a dress with a repeating ship motif; behind her is depicted the rescue of the overwhelmed swimmers. The shape of the crescent-shaped waves reappears in a more controlled form in the butterfly patterns in the flooring. Interestingly, Brown disclaims any specific decorative impulse that might align her with the Pattern and Decoration artists, her 1970s contemporaries who consciously chose ornamental motifs and materials as a way of breaking down the distinctions between high and low art.[3]

Janet Fish, who like Joan Brown was born in 1938, grew up in New England and Bermuda. Both she and her sister Alida Fish, a photographer, took inspiration from the example of their mother, sculptor Florence Fish, and their grandfather Clark Voorhees, an Impressionist painter. Fish was one of a diverse group of talented young artists attending the Yale University School of Art and Architecture during the early 1960s, which included Nancy Graves, Jennifer Bartlett, Brice Marden, Chuck Close, Richard Serra, Rackstraw Downes, and Sylvia Plimack Mangold. After a brief Abstract Expressionist phase at school and a period of painting gestural landscapes and portraits, in the late 1960s Fish came to concentrate on the depic-

tion of objects. She now addressed close-up images of fruits and vegetables, depicted in random formation on tabletops or swathed in cellophane packaging. Their relatively large scale owed more to action painting than it did to the modest size of the traditional still life.

These explorations of the play of light on plastic wrap led Fish into her well-known studies of translucent, liquid-filled containers, which she began in 1971. Initially she worked with multiple examples of the same object, delineating the similarity and dissimilarity of the units as defined by light. *August and the Red Glass* (plate 54) is indicative of the growing complexity of her compositions, as she brings the viewer in close to examine various tumblers and goblets enlivened by the late summer sun. The reflections and refractions are here translated into sensuously painted, high-keyed color, dispersed across an active gestural surface. Regarding her aesthetic concerns at this period, Fish has commented: "My primary subject is light [and] the manner in which it transforms appearances, altering color and atmosphere, shattering and reordering forms."[4] Her content here is perception itself and the evocative associations of the still-life genre, namely the passage of time and the intimations of human experience.

Gradually Fish began to nudge the viewer back away from her closely observed compositions, allowing landscape elements and flowers to appear along with the still life. Light is no longer her principal subject. *Kara* (plate 53), one of her first paintings to include the figure, juxtaposes an object-cluttered tabletop with a fashionably dressed teenager seated in thoughtful repose. Although haphazardly arranged, the props were purposefully chosen. The layers of meaning of *Kara* derive from its contrasting components, the dark winter garb and the vivacious flowers, the meditative young woman and the accoutrements of flummery.

In 1967, at the age of twenty-one, Catherine Murphy graduated from New York's Pratt Institute without any specific stylistic commitment, save an interest in figuration. "In a way, I escaped school without being taught anything concrete, and that was very good."[5] Murphy's early style was directly influenced by the work of Fairfield Porter and Jane Wilson, two New York School expressionists who painted what they saw around them. Her first solo exhibition, in 1972, like that of Janet Fish's the previous year, was at a New York cooperative gallery. These alternative spaces offered young artists working with representational imagery the chance to show work that went against the grain of the still predominating abstract modes.

View from the Backyard: Lexington (plate 56) was painted by the artist looking out from her parents' Massachusetts home. The restricted vision of this orderly lower-middle-class neighborhood, inhabited by a lone figure whose back is turned, is representative of Murphy's visual interest in "artless" subject matter, meticulously recorded in a style free from any trace of brushstrokes. Murphy has continually valued the chance configurations of what she can see from the vantage point of her home. The small-scale *View of the World Trade Center from Rose Garden* (plate 57) is a masterful rendering of the prosaic plantings, parking lots, and structures of Jersey City, New Jersey. In the far distance can be glimpsed an intriguing sliver of the Hudson River and the Manhattan shoreline, punctuated by the looming World Trade Center.

When the artist turns her considerable observational skills on herself, as in *Self-Portrait with Pansy* (plate 55), the results transcend the simple transcription of reality. She depicted herself in the process of painting, scrutinizing her own reflection. Just as we share the constricted space of her room, we

53
Janet Fish
Kara, 1983
Oil on canvas, 70¼ x 60½ in.
The Museum of Fine Arts, Houston; Museum purchase with funds provided by the Museum Collectors

54
Janet Fish
August and the Red Glass, 1976
Oil on canvas, 72 x 60 in.
Virginia Museum of Fine Arts, Richmond; Gift of The Sydney and Frances Lewis Foundation

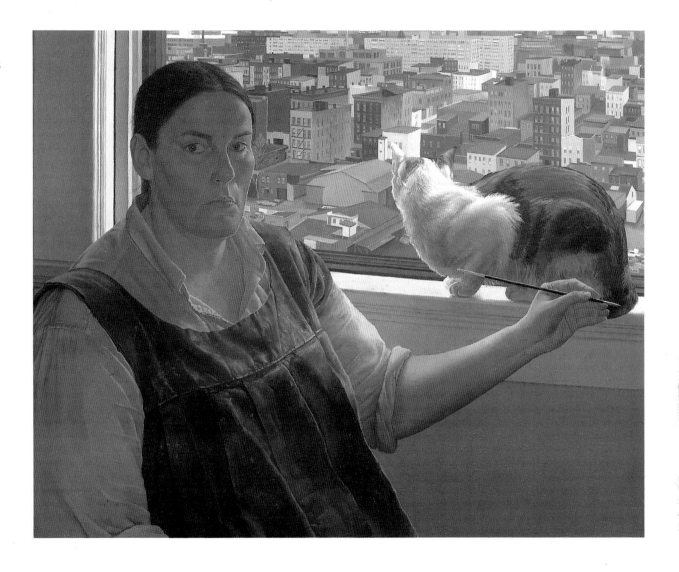

55
Catherine Murphy
Self-Portrait with Pansy, 1975
Oil on canvas, 21 x 26 in.
Mr. and Mrs. Graham Gund

also see what the cat sees, a high-rise view of an urban landscape. A canny composer, whose sophisticated content belies her professed claim to "just paint what I see,"[6] Murphy used the window as a boundary between interior and exterior, playing off the inactive yet observant feline against the sedentary creator.

Artists addressing the human condition in the 1980s have used a variety of fresh strategies. Some, like Judy Rifka, have appropriated pop culture images and devised novel materials and methods to alter their figural subject matter dramatically. Others have banished the figure per se. Judith Shea has brilliantly exploited the potential of body

garments to convey the lives of their wearers. Cheryl Laemmle has commandeered the plant and animal inhabitants of her childhood memories to act out her lyrical scenarios. In the fictional narratives of photographer Laurie Simmons, dolls mimic and dramatize mortal behavior. Photographer Sandy Skoglund's concern for human content has strongly relied on the sinister implications of her brightly colored animals. These two camera-artists have exerted a directorial control over the content and composition of each image, constructing props and posing models just as Audrey Flack had carefully assembled and arranged the objects for her still lifes.

Judy Rifka likes to think of herself as a cross-media artist, who has worked in such spheres as oil paint, video, and artist's books. Born in New York in 1945, she studied at Hunter College and at the New York Studio School with Philip Guston. In the early 1970s she made abstract paintings on bare plywood and exhibited at the Bykert Gallery, which also represented Minimalists Dorothea Rockburne and Jo Baer. Rifka was included in the unusual 1975 Whitney Biennial, restricted to those who had not yet had solo exhibitions in New York. Some of the other notable young artists introduced that year were Ross Bleckner, Scott Burton, Robert Kushner, Judy

57
Catherine Murphy
View of the World Trade Center from Rose Garden,
1976
Oil on canvas, 37 x 29 in.
Hirshhorn Museum and Sculpture Garden,
Smithsonian Institution, Washington, D.C.; Museum
Purchase, 1976

56
Catherine Murphy
View from the Backyard: Lexington, 1972–73
Oil on canvas, 35 x 40 in. (framed)
Whitney Museum of American Art, New York;
Purchase, with funds from the Neysa McMein
Purchase Award

Pfaff, Barbara Schwartz, and Alexis Smith. By 1980, when she was part of the Collaborative Projects group, Rifka's videos were included in the *Times Square Show*, an underground exhibition of postmodern and political art. Her new style was urban and figurative, and she recalls borrowing freely from the slap-dash energy of street art: "There, on rock and roll club handbills, was press type used expressionistically, unceremoniously, cheaply. . . . It took kids to really implement the artists' concepts in a free-wheeling way."[7]

An inventive artist, Rifka adapted the transparent acetate sheets she used in her videos to create images for her paintings. She has, for example, push-pinned overlapping layers of loosely drawn images directly to the wall or transferred combinations of them onto her canvas by using an opaque projector. With the instincts of an action painter, she courts chance configurations and unpremeditated juxtapositions. In *Square Dress* (plate 59), a dancer, seen from above, is set off against an exuberant field of abstract color patches and architecturally evocative lines and circles. Segments of the athletic composition push forward into the viewer's space because Rifka has affixed additional canvas forms onto the surface plane. The heaving foreground of waves in *Beach II* (plate 58) was created by stretching the canvas across strewn lumber. Rifka's two other signature techniques are also evident here: the unpainted brown linen canvas retains an active role in the painting's coloration; and the thick black lines were painted on another fabric before being cut and collaged onto the irregular surface.

Before she earned her B.F.A. degree in sculpture, Philadelphia-born Judith Shea studied fashion design. Her expertise and interest in clothing construction strongly shaped the direction of her art. Shea's flat, Minimalist sculpture of the 1970s suggested

58
Judy Rifka
Beach II, 1984
Oil on linen and wood, 74½ x 89 in.
Brooke Alexander, New York

unassembled pattern pieces. Working with such dressy stuffs as organza and taffeta, she implied a figural presence by emphasizing the profile of sleeves or the curve of a neckline. The red cotton organdy of *Inaugural Ball* (plate 61) has been cut to resemble a floor-length, form-fitting sheath. Fabricated during the first year of President Reagan's term of office, the silhouette's bright color and conservative lines convey a rich associational content. Although her spare, Minimalist aesthetic was quite distinct from the decorative sensibility of such Pattern and Decoration artists as Miriam Schapiro and Joyce Kozloff, Shea nonetheless shared their concern for reversing the art world's low regard for fabric as an artistic medium. In all her work Shea has courted a delicate balance between the formal presence of her images and their implication of narrative content.

The Young One (plate 60) exemplifies the expansion of Shea's art from low relief to fully three-dimensional forms. She used white industrial felt to create a youthful, animated bodice that calls to mind both the subtle modeling of Egyptian statuary and the simplified volumes of a traditional dressmaker's dummy. New references to classical art appeared in her work following a trip to Greece in 1983: "I found a whole vocabulary of formal compositions of figures. . . . I couldn't get over the integration of forms, both figural and architectural, with story and emotion."[8] The statuesque garment in Shea's *Untitled Drawing* embodies the stylized forms of early Greek sculpture. With a bare suggestion of an exterior landscape, Shea created a provocative tableau by placing this tailored form at an angle to the rigid vertical of the truncated column.

Sculptor Judith Shea has harnessed the expressive potential of clothing's form and content to address the human condition; photographer Laurie Simmons has used the potent metaphor of dolls toward a similar

59
Judy Rifka
Square Dress, 1982
Oil on linen, 51 x 64½ in.
Dr. and Mrs. Jack Eisert

61
Judith Shea
Inaugural Ball, 1980
Cotton organdy, 67 x 24 x 1½ in.
Jack and Maryon Adelaar

60
Judith Shea
The Young One, 1981
Wool felt, 19 x 28 x 8½ in.
Private collection, Washington, D.C.

62
Laurie Simmons
Arms Up/Pyramid, 1982
Color photograph, 39 x 29 in.
Private collection; courtesy Metro Pictures, New York

end. Just as Shea has used the devalued arena of fashion, so Simmons has gone against the grain of conventional practice by elevating child's play, and the play of little girls, at that, to the realm of art. The vintage articulated figurines favored by Simmons participate in the widespread 1980s nostalgia for the fashions and designs of the 1950s. Yet her feminist intent distinguishes her from the "image scavengers" with whom she has been grouped. Simmons has orchestrated her scenarios to confront the complex issues of gender stereotypes in the past and in the present. The imagery in *Arms Up/Pyramid* (plate 62) derives from the common fantasies of adolescent girls who dream of becoming dancers. Here a bevy of *en pointe* toy ballerinas match themselves against a photo of a corps de ballet. In turning their backs to the picture plane, they implicate the presence of an audience capable of judging the viewer as well.

To be likened to a doll may be intended as a compliment for a woman but it has had devastating effects on men. Political analysts cite Alice Roosevelt's unflattering comparison of presidential candidate Thomas Dewey to the vapid male figure atop the traditional wedding cake as a factor in his 1948 election loss to Harry S. Truman. By creating contexts for the female version of such pop culture images, Simmons has brought to the surface the negative dimensions of being "a doll." In the large-scale color photograph *Red Library #2* (plate 63), the doll woman in her comfortable, upper-middle-class home recalls the futuristically lobotomized helpmates in the film *The Stepford Wives*. Color coordinated with her rosy environment, Simmons's stultified heroine is both a part of and separate from her art- and book-filled home.

Simmons's contemporary, Sandy Skoglund, also stages her photographs, manipulating scale and scenarios with unsettling effectiveness. Skoglund earned her M.F.A. in painting at the University of Iowa, along with Ana Mendieta. After moving to New York in 1972, she became involved with post-Minimalist Conceptual art, doing process and performance art. She worked as a documentary filmmaker and taught herself photography. Following a period of drawing from set-up still lifes, she began to record them with her camera. In 1979 she began to create and photograph room-size environments, consciously annexing the legerdemain of commercial photographers in large-scale prints. The first of the six she did in 1980 was *Radioactive Cats* (plate 65).

In this humorous and horrific scene, an aging couple in a grimly impoverished interior is inundated by mutant green cats, whose lurid coloration reverberates against the neutralized environment. These voracious animals infest every surface in a quest for nonexistent food. This science-fiction fantasy is rendered believable by the veristic nature of photography, which simply records "the truth." Skoglund sculpted the plaster cats herself and readied the set by painting everything in the tiny room a mottled gray. The artist also prepared a version of the tableau as a separate installation, allowing her audience to see both the photograph and a portion of the thing photographed.

Revenge of the Goldfish (plate 64) describes a preposterous invasion by a school of 140 ceramic goldfish. As in a biblical scourge, there are fish everywhere—on the bed, in the dresser, in the air. These aggressive beasties ripple and writhe suggestively as they insinuate themselves into the lives of a quiescent boy and his sleeping mother. Skoglund has commented: "I'm interested in using animals to express a variety of human emotions, and I'm interested in movement. The way fish move: sinuous, swishy, sensual, movey. I wanted to activate the whole space using that brushstroke, if you will."[9] The garish high-

63
Laurie Simmons
Red Library #2, 1983
Color photograph, 48½ x 38¼ in.
Collection of the artist; courtesy Metro Pictures,
New York

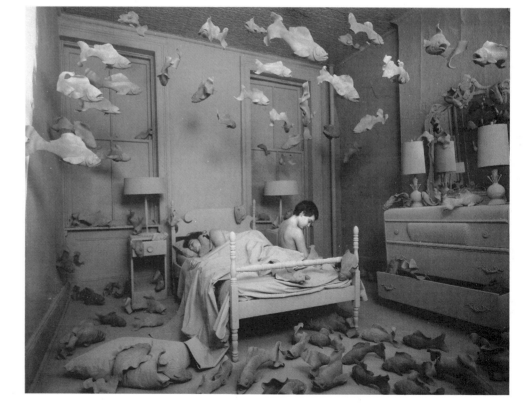

64
Sandy Skoglund
Revenge of the Goldfish, 1981
Cibachrome, 30 x 40 in.
Collection of the artist

65
Sandy Skoglund
Radioactive Cats, 1980
Cibachrome, 30 x 40 in.
Collection of the artist

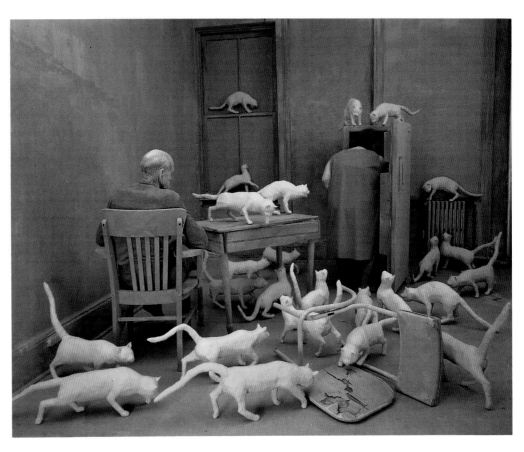

66
Cheryl Laemmle
Two Sisters, 1984
Oil on canvas with painted wood,
73 x 84 in. (framed)
A. G. Rosen

keyed orange of the in-bred, bubble-eyed pets is played off against the room's pervasive blue, the two complementary colors lending each other mutual encouragement.

Cheryl Laemmle, who was born in Minnesota in 1947, had a common girlhood wish to own a horse. In lieu of actual pets, she drew images of the animal companions she desired. After two years of diverse employment as a janitor and factory worker following her graduation from college in 1974, she went to Washington State University for a master's degree in painting. Her graduate thesis show used simian iconography to address issues of good and evil. Animal subjects had engaged her from the outset, and after she moved to New York in 1978, she continued to work with images of monkeys, which sometimes were used as stand-ins for the artist herself. An important early installation, *The Girl with a Curl* (1980), consisted of large Masonite cutouts of animals and an evocative stone castle. One of Laemmle's frequent themes is the transformation of childhood experience, played out with fanciful personae rendered in a precise, representational style.

In *Two Sisters* (plate 66), Laemmle set up a visionary narrative within an expansive twilight landscape. The two birchwood figures have a dual presence as metamorphosed people and anthropomorphized plants. Randomly delineated knotholes read as surrealistic eyes. The dynamics of the figures' relationship is hinted at by their different sizes, by the painting's title, and by the steadying gesture of the smaller one. The transformative power of children's (and the viewer's) imaginations is suggested by the rocky configuration on which they perch as riders. Tendrils of flowering wisteria encircle the imagined mount and the smaller sister, as the two seem to live out a youthful fantasy of "riding off into the sunset."

67
Cheryl Laemmle
August, 1985, from the American Decoy series
Oil on canvas, 85 x 80 in. (framed)
Eli Broad Family Foundation

Birds serve as human surrogates and omens in *August* (plate 67). But as in all of Laemmle's work, reality is elusive and made up of enigmatic layers of significance. Two wooden decoys are set against a dramatic, cloud-streaked sky, bordered by a sepulchral compartment containing a small dead bird. The bright target displayed on the breast of the eyeless, more colorful lure is echoed in the circular carvings on its spherical pedestal. The poignant trophies of dead game and wild birds that bedeck its chest like medals are metaphors for the thoughtless destruction of the environment.

Video

Women artists working in the early 1970s often emphasized masking and unmasking, trying on new or lost personae, male alter egos, and the physical and psychological masks of race. Although often personal and cathartic at base, this work aimed at identifying previous concepts of gender and liberating women from them, especially those that diminished women and reinforced their sense of otherness. According to one analysis of gender, women either subscribed to the cultural conventions of femininity or became outlaws or wildwomen. Many performances explored the politics of being an outsider, destroying the image of a "respectable" woman with aberrant acts designed to challenge the status quo. Also, by breaking down the image of femininity that spelled both privilege and vulnerability, women performance artists called attention to its limitations in order to forge a broader, stronger, and more productive definition of self. Many of these activities were staged in the streets, in part because "the streets" had become the arena of visible political protest. Also, the expression "take back the streets" had a particular meaning to women because it was

there that they had been most vulnerable to verbal and physical assault.

Video served an important role in this odyssey. Video is naturally figurative—the human figure has always been the basis of broadcast television. Early experimental uses of video frequently involved talking heads, letting women have their say, often for the first time. Video allowed women to mirror themselves, leading directly to the self-reflexivity of postmodernism. In feminist performances, video functioned in several ways. It could be situated in the performance area as an alternative perspective or as an aside to the events on stage. It was often used to render an ephemeral art form permanent, either through documentation of an actual performance or through re-creation of a performance for the camera. By the late 1970s and early '80s the messy, spontaneous, and autobiographical aspects of performance had become more sophisticated. Artists such as Yvonne Rainer, Joan Jonas, and Doris Chase began to treat broader themes, substituting narrative poetry for autobiography and ritual.

California was a center of feminist performance in the early 1970s. Judy Chicago and Miriam Schapiro organized the Feminist Art Program, first at Fresno State and later at the California Institute of the Arts, where performance was taught in the classroom. Chicago later explained: "Performance can be fueled by rage in a way painting and sculpture can't. The women at Fresno did performances with almost no skills, but they were powerful performances because they came out of authentic feelings."[1] In 1973 the Woman's Building opened in Los Angeles, housing Womanspace (a women's gallery) and the Feminist Studio Workshop. The work produced under the aegis of these organizations emphasized a woman's consciousness and the artist's experience as woman; many artists were more overtly political in their concern,

emphasizing women's social and economic position in the world. Shortly after the opening of the Woman's Building, Nancy Buchanan, Eleanor Antin (see pages 136–38), Pauline Oliveros, and Barbara T. Smith were invited to participate in workshops and performances there, which proved to be turning points in their careers.

Since 1971 Nancy Buchanan has been deeply involved with performance and with the feminist movement in southern California. While attending the University of California at Irvine she helped to establish F-Space Gallery in Santa Ana, the site of many performances. After moving to Los Angeles she became a founding member of Grandview Gallery, a feminist cooperative, and of Double X, a nonprofit organization of women in the arts whose members regularly challenged notions of acceptable contemporary art and frequently attacked "the art establishment as biased, sexist and insensitive to the needs of women."[2] Many early performances were arrived at spontaneously and intuitively, but most of Buchanan's performances were more highly structured. Working from a script, she built her performances so that they moved from autobiography to more general political issues and often examined male and female roles.

Originally a painter and sculptor, Barbara T. Smith began concentrating on performance when it first developed in Los Angeles in the late 1960s, and she became an influential figure in the Los Angeles performance community. Her work examines the structures of everyday life, often in a ritualistic manner. Smith has pointed out that she and the other artists were drawn to performance art because it offered opportunities for expression not open elsewhere:

The art context provides areas and ways for the artist to be and do things

which could never be believed or permitted in ordinary life. It is precisely the dilemma which often makes the viewer's discomfort with performance art, and created a persistent desire to continue doing performance on the part of the artist.

For me my art accomplishes my own liberation. It makes me stronger. For others it acts as art does, a confrontation they must face on their own terms. I am pointing to things that are real, which people may or may not like to face.[3]

Many of Smith's early performances focused on issues of nurture, with food often presented during the performance as both form and symbol. While not specifically feminist, her work featured women and women's issues, and it expanded in the 1970s to include issues of sexual politics and spirituality.

Buchanan and Smith collaborated on several performances that critically and symbolically examined the meaning of love relationships. Their mutual involvement with symbols and ritual fuels the intimate table-top performance *With Love from A to B* (plate 68), performed for video at the College Art Association annual meeting in 1976. A later version was done on cable television. The camera tightly frames two sets of hands (theirs) on a slightly wrinkled white tablecloth. Acting out the progress of a one-sided love affair, one set of hands offers the other small gifts—rings, flowers, pictures, a glass of wine, etc.—symbolic of the usual presents and activities that accompany the courtship phase of a romance. In poignant, minute gestures, the other set of hands rejects the love tokens, driving the giver to suicide.

Rachel Rosenthal has focused on performance art since 1975. Born in Paris, she moved to New York in the 1940s. She studied engraving with William Stanley Hayter and

68
Nancy Buchanan and **Barbara T. Smith**
With Love from A to B, 1977
Color videotape, 10 min., adapted from fixed-camera performance for video at College Art Association, Los Angeles, 1976
Collection of the artists

worked in the New York theater; later she became a member of the Merce Cunningham Dance Company. Her involvement with the French theatrical avant-garde (the Absurdists and Antonin Artaud) and her friendships with Robert Rauschenberg, Jasper Johns, and John Cage led her to form in 1956 an improvisational theater group in Los Angeles known as the Instant Theatre, which lasted for over ten years. The group performed primarily for art audiences rather than for conventional theater audiences. In 1971 Rosenthal's life altered when she was introduced to feminism and feminist art. Two years later, taking as her motto "the personal is political," she became involved with Womanspace and started experimenting with performance.[4] She discovered there were profound differences between theater and performance: "In theatre you mostly work from or with a text, in performance you squeeze out yourself, you dredge it up from the unconscious. It is a process of giving it form from the inner to the outer. The process cannot be frivolous, but must be deep, a deep commitment to yourself."[5]

Rosenthal's one-woman performances, which are often accompanied by flamboyant props, costumes, and slides, expand from autobiographical issues to encompass sexual politics, often centering on the politics of the body. *Charm* (1977) examines the hypocrisy of her Parisian childhood, during which her family ignored the growing horror of World War II. Performing in a set recalling her Parisian home, Rosenthal delicately nibbled French pastries while she and her family were surrounded by grotesquely masked characters, who represented ugliness, cruelty, and sadism, as in a medieval morality play. Gradually their qualities were transferred to Rosenthal, and her manner became bestial. In *The Death Show* (1978) Rosenthal used her own battles with bulge coupled with her mother's death to address symbolically "the hundreds of little deaths that occur in our lives."[6] Having recently lost a great deal of weight, Rosenthal contrasted her present self with her former overweight self, personified as "The Fat Vampire." The performance ended with her slashing a photograph of her earlier fat self.[7] Similar issues of catharsis and change were addressed in *The Arousing (Shock, Thunder)* (1979), in which she created a series of self-portraits using video, props, and a dramatic monologue. In this "Hexagram in Five Parts," Rosenthal changed from a bandaged and masked figure to a mustached and bearded male alter ego; finally, she danced on the stage as herself and destroyed the bandages in a spectacular explosion.

Rosenthal often explores alter egos of both genders. In *Traps* (plate 69) she alternated between the persona of a bald warrior, a burnoose-clad monk, and (briefly) a charming hostess, thus weaving together personal memories and fears into a more general evocation and condemnation of the horrors of war. Rosenthal says of her performances, "If you put all my performances together, then you will have my life done in the form of an art work."[8]

Most performance art was done by younger women. Since Rosenthal began doing performances at a later age than most, she often centered them on the issues of older women, daring to explore the persona of the crone and the witch. By dealing with this subject matter and presenting her body as a vehicle or medium of her art, Rosenthal was one of the first to demonstrate the physical worth of older women. Her performances charted new ground and redrew the female form.

Linda Montano's performance work began with two different kinds of public street performances in the early 1970s. In one, she dressed as a motionless nunlike figure and sat or lay in public places; in the other, she dressed in a chicken costume and danced wildly in the streets. In her internal battle between wild humor and an involvement with trance meditation, hypnosis, and altered states of being, the spiritual component won, resulting in some extraordinary works that challenge the definition of art and focus on the nexus of art and life.

In response to the unexpected death of her ex-husband, Mitchell Payne, in 1978 Montano created three performances and a videotape which meld Catholicism and Eastern religions into private rituals that, like all funerary customs, combine remembrance with an exorcism of grief. The first performance was small and private and ended with Montano's playing the chord organ for thirty-three minutes to mark the years Mitchell had lived. The second performance, at LAICA in Los Angeles, was more like a memorial service. Minetter Lehman showed slides of Payne's photographs and talked about his work as a photographer, then Montano again played the organ. The third version, which is the basis of the videotape *Mitchell's Death* (plate 70), was performed at the Center for Music Experiment, University of California, San Diego. The piece is structured around a cruciform shape, with Al Rossi on the left playing an Indian sruti box and Pauline Oliveros on the right playing a Japanese gong, representing Hinduism and Buddhism, respectively, and forming two arms of the cross. A video monitor placed next to Oliveros shows Montano in white face slowly applying acupuncture needles to her face. Montano then stands at the lectern with her white face pierced with the needles (light and shadow rendering her as the other axis of the cross) and chants "the story of Mitchell's death I had written after I had come back from his funeral in Kansas."[9] In a keening monotone she describes her feelings of guilt about her separation from her husband: "Did I do it? My fault? Was he despondent? Lonely? Miss me too much?"

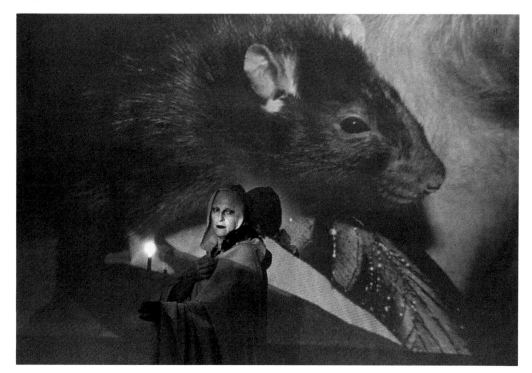

69
Rachel Rosenthal
Traps, 1982
Color videotape from performance at Espace DBD,
Los Angeles, 1981
Included in *The Performance World of Rachel
Rosenthal*, 1987
Color videotape, 15:38 min. (entire tape)
Collection of the artist

70
Linda Montano
Mitchell's Death, 1978
Black-and-white videotape, 22 min., from
performance at University of California, San Diego,
Center for Music Experiment, 1978
Collection of the artist

Adrian Piper
Funk Lessons, 1983
Color videotape, 18:30 min., from performance at
University of California, Berkeley, 1983
Sam Samore

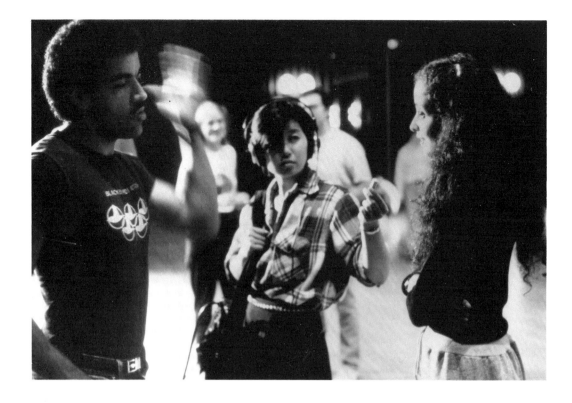

She details every aspect of her journey, including a visit to the crematorium chamber where Payne's body was being prepared. "I pull the sheet down, shocked by black stitches, autopsy . . . ask him how he is? How did it happen? Why? . . . I remember the Tibetan Book of the Dead and whisper in his ear. Don't be afraid, Mitchell, It's ok pups, go on. Don't be scared. . . . I can't get my eyes off of him." Autobiographical material is a frequent source for performance art. Montano makes it clear that the performance had a different aspect for her. She said of the performance, "It was mourning, not art."[10]

Adrian Piper first studied sculpture, primarily at the School of Visual Arts in New York, and later received a Ph.D. in philosophy from Harvard University. The dynamics of human relations is the basis for her interest in both philosophy and performance. She says philosophy "siphons off abstractions,"[11] allowing her to be more concrete in her performances. In her early street performance

work Piper made herself look mutilated or distorted in some way: wearing clothes smeared with rancid butter, dried food, or wet paint in stores, subways, and buses; blowing gum bubbles at the Metropolitan Museum of Art and letting the gum from the burst bubbles stay on her face; playing tape-recorded burps in the library. The denial of civilized behavior in these early street performances helped Piper deconstruct conventional roles and experience the social dynamics of the taboo area of being an "outlaw" or wild-woman. Although she was often frightened and threatened during these performances, Piper says that her personality became stronger and more flexible as a result of altering her appearance and that these works gave her the courage to state her wants and desires and not to back down in the face of authority.

Stressing the political connection between art and life, in the performances and videotape of *Funk Lessons I–IV* (1983–85) Piper confronts aspects of black working-class

culture that have been suppressed and marginalized. In a two-year series of large public performances (with as many as sixty people) and small private performances, she directly engaged people on the frontiers of their senses—using hearing and movement to challenge previously held conceptions about themselves and about race and in the process redefining their sense of their own bodies. Piper has written that her goal is "to restructure people's social identities, by making accessible to them a common medium of communication—Funk music and dance—that has been largely inaccessible to white culture, and has consequently exacerbated the xenophobic fear, hostility and incomprehension that generally characterizes the reaction of White to Black popular culture in this society."[12]

Piper's methodology as seen in her videotape *Funk Lessons* (plate 71) is at once didactic, remedial, and subversive. The performances are structured as a series of dance lessons in which Piper breaks down the forms of

black social dancing. She explains and demonstrates each dance step or body movement.

The audience repeats the gestures she has demonstrated. Because of their participatory nature the dance lessons demolish the barrier between us and them—viewer and viewed—by replacing watching with doing. They also supply an occasion for Piper to "lecture" on the meaning of black music and dance structures, in the way that Joseph Beuys used to give lectures on art as a form of performance art. Piper uses the lecture format not only to supply information, mirroring her activities as a college teacher, but also to erase what she sees as the false dichotomy between high and low culture. In a final reversal of the usual figure-ground relationship in art, the members of the audience are physically transformed as the evening concludes with them all practicing the new steps. Piper is black, and many of her performances and videotapes deal with issues of race and otherness in our society. She specializes in "exposing the distances between people and the alienation that exists in our lives—personally, politically, emotionally."[13]

Joan Jonas is one of the longest-enduring performance and video artists. She was important in developing new approaches to television and has continued to produce work that is complex, innovative, and provocative. Jonas came to performance with a background in art history, sculpture, and dance. Her early performances often used sound, language, and dance to explore the meaning of space. Mirrors were a prominent feature of these early performances. During the performance mirrors were used by the performers to "check" their bodies in a self-reflexive narcissistic gesture in which the mirror image is revealed only to the performer. The performers would also shield their bodies with mirrors at various times, replacing their bodies with the audience's own image reflected in the mirror.

In 1972 the purchase of a mask with a doll's face gave Jonas an erotic, vulgar alter ego, Organic Honey. With the performances based on this character her characteristic performance style began to take shape. For the first time Jonas used video to expand the performance and to comment on various ways of seeing and representation. She has explained that she was drawn to video because: "At first I saw the monitor/projector as an ongoing mirror. Watching myself I tried to alter the image using objects, costumes, and masks, moving through various identities (the sorcerer, the floozie, the howling dog). Narcissism was a habit. Every move was for the monitor."[14]

In a later version of the same performance, *Organic Honey's Vertical Roll*, she added a new element to the performance: a video monitor with rolling vertical black stripes, which used television in a new way both visually and structurally. Jonas comments: "Space was always a primary concern, and in considering the space of the monitor I then dealt with its box-like structure, positioning it in relation to myself. I tried to climb into the box, attempting to turn the illusion of flatness to one of depth. . . . Video is a device extending the boundaries of my interior dialogue to include the audience. The perception is of a double reality: me as image and as performer. I think of the work in terms of imagist poetry; disparate elements juxtaposed . . . alchemy."[15]

One characteristic of Jonas's performances and videotapes is the production of drawings during the performance. For her, drawing is a separate visual language that expands and layers her vocabulary of images. Jonas says: "In *Organic Honey* I called the drawings 'drawings for the monitor.' I drew while looking at the monitor instead of at what I was drawing. The audience also saw the result on the monitor. From then on, I used drawings in all my pieces. They derived from an interaction with the technology, with the content of the work, and the rhythm and gesture of the performance."[16]

In 1976 Jonas began using fairy tales and similar narratives as the basis of her performances. These were distinguished from her earlier video by the appearance of consistent characters and by the fact that the stories were never enacted but became a backdrop against which she presented images and events. The results resembled free association, superimposed upon a narrative or a dream landscape littered with symbols drawn literally from the text in the form of drawings made during the performance. Several of the performances—*Upside Down and Backwards*, *Double Lunar Dogs*, and *Volcano Saga*—evolved into videotapes, which use the same stories and images as the performances but are independent artworks based on the space, movement, and special effects that are integral to television. As Jonas puts it, they take "you into a space you wouldn't otherwise be in."[17] *Double Lunar Dogs* (plate 72), loosely based on Robert Heinlein's novel *Universe*, takes place on a spaceship that has been traveling for hundreds of years. "You, the travelers, were born here and will die here." Most of the ship dwellers accept their present life, but a few of them, including Jonas, question the solipsism of their way of life. Jill Kroesen and Jonas play different aspects of the same "double lunar dog," a sort of Gemini configuration. They are joined by David Warrilow as the ship's captain and Spalding Gray as a slightly mad wizard-scientist. Everything is tightly compacted, part memory, part story, part archetypal dream. Great rolling seas and scenes of the Southwest countryside and Indian ruins representing freedom and escape appear, turn into spinning walls, and vanish. The tape is partially a meditation on the meaning of change, loss, and

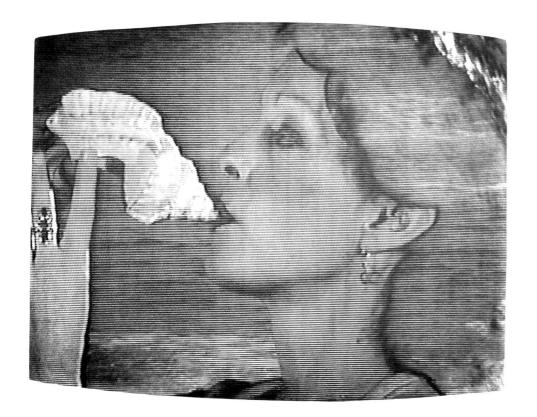

72
Joan Jonas
Double Lunar Dogs, 1984
Color videotape, 25 min., from performance premiered at University Art Museum, University of California, Berkeley, 1980
Collection of the artist; courtesy Electronic Arts Intermix, New York

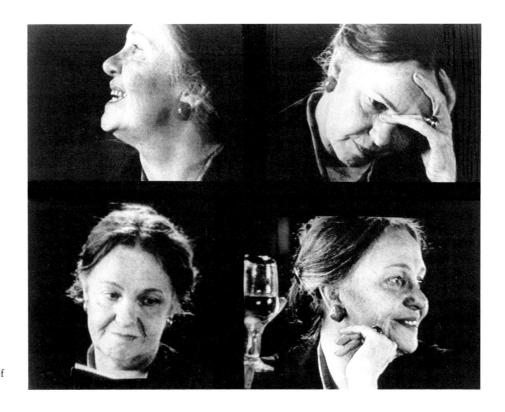

73
Doris Chase
Table for One, 1985
Color videotape, 28 min.
Circulating Film and Video Library, The Museum of Modern Art, New York

74
Joan Logue
David Hockney, from *30 Second Spots: Paris*, 1984
Color videotape, 12:30 min. (entire tape)
Collection of the artist

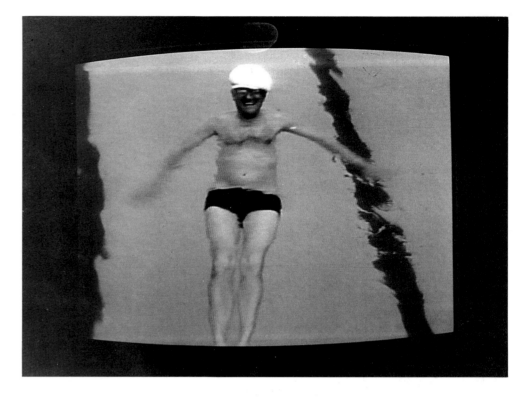

growing older. Jonas's message is very clearly that you can't go home again. But, through technology, memories and dreams can take on a more permanent form, and video plays a central role in contemporary society by making it possible to capture memories and keep them always available.

Doris Chase began as a painter in Seattle, then switched to making sculpture, first in wood and later large-scale pieces in steel. In 1968 choreographer Mary Staton asked her to create large kinetic sculptures to be moved by dancers in a multimedia production for the Seattle opera. A film record of the performance began Chase's interest in filming and videotaping dance; in both processes the forms of the dance are abstracted and elaborated on through the use of special effects. In the early 1970s she began to use image-processing equipment at WNET's Television Lab in New York City and at the Experimental Television Center in Binghamton, New York. "I wanted to take the form and pull and

push it in many areas that I couldn't possibly do in the theatre or with sculpture."[18] Chase was attracted to special effects in film and video because she could "use them the same way I'd use a paintbrush to create an Impressionist painting."[19] She felt that "by diffusing images, I can create a dreamlike effect; I can draw the viewer right into the work; I create tension, just as I would in painting."[20] These video dance tapes were some of the most widely seen pieces of early video art, reaching out to a great diversity of audiences.

In the late 1970s Chase began to use language for the first time in her video *Concept Series*, which combines the abstract elements she was familiar with from painting and dance with drama in order to examine and communicate a broader range of emotions. Working with storytellers and poets such as Thulani Davis, Jessica Hagedorn, Le Nagrin, and Bonnie Greer and performers such as Ruth Maleczech, Claudia Bruce, Laura Simms, and others, Chase examined emotional and

economic security; relationships with men, family, other women, aging; illness and death—all from a feminist point of view. The result was a new kind of electronic theater.

In the mid-1980s a desire to reach out to an even broader audience led Chase to write and produce her latest project, *By Herself*, a series of videotapes featuring major actresses such as Geraldine Page, Anne Jackson, Luise Rainer, and Roberta Wallach. Chase's intent in this series was to give women dynamic role models and to show that the older actress is still an exciting force in the acting field. In *Table for One* (plate 73) we hear an interior voice-over monologue by a successful older woman, played by Geraldine Page, who is dining alone in an elegant restaurant. She selects a table with her back to the wall where she can observe others in the restaurant. The woman has just ended a thirty-year marriage, and in the beginning she broods on the awkwardness of being a single woman in a world of couples, "an appendage without a

body." She ponders aging and concludes, "The only thing that grows better with age is cheese." By the end of dinner her thinking has gone full circle, and she decides that she is "just coming into prime time" and toasts herself "cheers . . . to me."

Joan Logue was a pioneer in the field of video art, learning to use the medium soon after it became available to artists with Sony's introduction of the portable video camera in 1965. As a still photographer she immediately recognized the new medium's potential for expressing more fully the personality of the sitter in living, real-time portraits. Logue decided to use the format of the television commercial, the thirty-second spot, as the time frame for her video portraits. In these expanded photographs the camera is focused for thirty seconds on her subjects in their native environment. Since 1973 she has completed over four hundred video portraits of artists, families, lovers, and street people, including Merce Cunningham, Ann Halprin, John Cage, Starr Sutherland, David Hockney, Laurie Anderson, Arnie Zane, and Bill T. Jones. The *30 Second Spots* (plate 74) go beyond the realm of art to produce a new form of television. The portraits are intended to replace commercials, reversing the usual structure of television by turning the watchers into the watched. They have appeared on television in Europe, where television programming is more flexible. Logue's portraits of artists, which she calls ads for artists, are more complex and often use surreal special effects to encapsulate each subject's artistic expression in a thirty-second video miniature.

75
Mary Frank
Night-Head, 1971
Clay, 20 x 19 x 19 in.
Suzanne and Maurice Vanderwoude

Responding to Nature

By proclaiming "We won't play nature to your culture," Barbara Kruger's 1983 work (plate 130) boldly declares independence from the typecasting that associates women with elemental nature and men with culture and civilization. Yet other feminist voices have espoused the notion that woman's reproductive powers link her more closely to the "life force" of the universe. Whether or not they shared this view of woman as intuitively in harmony with Mother Nature, a significant number of women artists of the 1970s turned to nature for the form and substance of their art.

In a 1978 article on six women artists who were working with the landscape, critic April Kingsley proposed that their art differed in "intent and content" from that of their male counterparts. Discussing Alice Aycock, Mary Miss, Michelle Stuart, and Nancy Holt, among others, Kingsley noted that they exemplify a "rapport with their site and their materials, rather than a victory over them," and described their environmental projects as "private places made for interiorizing values and universal experiences."[1] In comparison, she found that the earthworks of male artists tended to be public objects that externalized societal values. Although exceptions exist, Kingsley's characterization of landscape art by women as "intensely human statements" is a helpful clue to the connections among a disparate group of artists.

In Cynthia Ozick's novella about a golem the heroine fashions a woman out of raw earth, animating her by blowing air gently into her nostril. The primordial clay women made by Mary Frank are similarly enlivened by the artist's generative powers. Mary Frank and her mother, the painter Eleonore Lockspeiser, emigrated to New York from London when she was seven. As a talented teenager, she

studied dance with Martha Graham and drawing with Max Beckmann and Hans Hofmann. Married at seventeen to the photographer Robert Frank, from whom she was later divorced, Mary Frank was the mother of two children by the time she was twenty-one.

During the 1950s she worked on small figurative sculptures in wax and some larger pieces in wood. Early friendships with such artists as Jackie Ferrara and the figurative expressionists Jan Muller, Robert Beauchamp, and Lester Johnson provided support for her figural interests, which ran counter to the nonobjective imagery of Abstract Expressionism. In the 1960s she worked with plaster, but by 1970 her principal medium had shifted to clay, which she both modeled and carved. Mary Frank delighted in the malleability and mutability of clay, cannily exploiting it to pun on the capacity of flesh to stretch and change. Attracted by its versatility and expressive potential, Mary Frank made clay her principal medium, rejecting its designation as a material traditionally relegated to the decorative arts.

Her early pieces were restricted by the size of her kiln. *Night-Head* (plate 75) is constructed from cut and shaped slabs set at right angles, with the fluttery impress of the artist's fingers punctuating the joins. A woman's dark silhouette falls across two interior planes, as if embodying what the modeled half-head was dreaming. This visionary head derives its sensual power from the earthy, warm tones of the medium and from clay's tendency to form visceral folds and fissures. In the early 1970s Mary Frank discovered that she could create larger figures by building and firing them in sections. The shardlike components that constitute the reclining *Woman* (plate 76) range from generalized curving planes to specifically modeled details. The discontinuous terrain of this archetypal woman is enlivened with the imprint of plant and animal forms

and animated by the spontaneous marks of its maker. The viewer who circles this figural landscape, moving from the well of her abdomen to the natural bridge of her upraised arms, comes away with an indelible image of erotic joy.

The natural world evoked in Mary Frank's sculpture is ancient and generic, belonging to all times and all places. By contrast, Clyde Connell's sculpture maintains a continuing dialogue with her specific environment, taking inspiration from the sounds and materials of the Louisiana swamps and bayous. Like her contemporary Alma W. Thomas, Connell was in her late seventies before she was given a major museum exhibition. Born on a Louisiana plantation in 1901 and raised by black servants, she developed a deep affinity for southern black and native American culture. In the 1930s and '40s Connell served as a volunteer at a church school for blacks. When her husband retired in 1959, they moved to a more rural area of the state. Here she began to concentrate on her art.

As an artist Connell is largely self-taught, having done figurative painting before coming to sculpture. In the 1950s she made frequent trips to New York for her volunteer work and took the opportunity to visit the city's museums and galleries. Her influences encompass the major figures of modernism as well as her native habitat. Speaking about the origins of a series of sculptures she did in 1971–73, she has noted: "The philosophy and works of two architects, [Paolo] Solari and [Frederick] Kiesler, combined with a particular interest in watching the wasps and dirt dobbers build their sculptural homes, began to affect my use of materials."[2] In describing the predominant motivations behind Connell's work of the 1970s, curator Charlotte Moser has cited "feminist art theory, the rising status of craft materials, and a sense of almost pantheistic mysticism."[3]

77
Clyde Connell
Guardian Post III, 1976
Wood, paper, metal, and glue, 84 x 14 x 14 in.
Alexandria Museum of Art, Alexandria, Louisiana

76
Mary Frank
Woman, 1975
Clay, 22 x 92 x 16 in.
Private collection

Guardian Post III (plate 77) is one of a series entitled Posts and Gates, begun in 1969. A center core of Louisiana lumber is embossed with a rich, textural papier-mâché of Connell's own invention, made from ordinary household materials. As in many of the artist's sculptures, the rusty stains of embedded nails mottle the skin with a pattern of lights and darks. The figural presence implied in Connell's work of the early 1970s was replaced by an architectural one by the end of the decade, as she shifted from singular, totemic forms to configurations of structural elements.

The bench in the enveloping sanctuary of *Mantis and Man in Time and Space* (plate 78) was intended to be used. Connell has here returned to a figural form, creating a curious, benign bench-being with a straight back and outstretched arms. Sitting on it brings the viewer face-to-face with a triptych of stone sculptures that represents the racial variety of the world's people. Recalling the genesis of this work in her response to the devastating famines and civil wars going on in the world, Connell has said: "I felt the need to make a place where you could sit and think about some of the problems the world needs to try and solve."[4]

For environmental sculptor Mary Miss, as for Connell in *Mantis and Man in Time and Space*, the participation of the viewer is a major aspect of each work. Born in New York in 1944, Miss was the child of a career army officer and his wife. She grew up in the West and spent a year exploring modern and medieval ruins in Germany. After study at the University of California at Santa Barbara and the Maryland Institute, she moved back to New York in 1968. Her sculpture shifted from spare, conceptual pieces that addressed the physical properties of specific materials to site works that situated the observer within a space defined and controlled by Miss. One

78
Clyde Connell
Mantis and Man in Time and Space, 1983
Mixed media, 79 x 37 x 45 in.
Gayle and Andrew Camden

notable example was the 1973 single-file arrangement of five short plank fences, each punctured in descending order with a circular cutout. Viewers trekked across a wintry urban landfill to peer through these barriers, lined up fifty feet apart. Standing outdoors before this untitled sculpture, the critic Lucy Lippard found the experience "telescopic" and felt herself drawn into "an immense *interior* space."[5]

Characteristic of both her environmental sculptures and her occasional indoor pieces is a love of fine carpentry. The well-crafted layers of Miss's untitled wall relief of 1977 (plate 79) refer to architectural elements such as walls, doors, shutters, grilles, and, provocatively, a medieval portcullis. Such overt and veiled associations are typical of her sculpture. Her referents—frequently borrowed from archaeology and engineering—are mined from memories or culled through research: ". . . what I do as an artist in the studio is to think and read. I am always looking at images, reading, absorbing things. [I usually] have about three tables of books that I am currently using."[6]

As a sculptor of earthworks, Miss collaborates directly with the terrain, as do her contemporaries Alice Aycock, Harriet Feigenbaum, Richard Fleischner, George Trakas, and Jody Pinto. Like the works of her colleagues, Miss's signature projects have no commodity value. Not only can they not be bought or sold, many exist only for a relatively short time before they succumb to the elements. Her ambitious *Perimeters/Pavilions/Decoys* of 1977–78, which art historian Ronald J. Onorato has called "central to our understanding of 1970s sculptural attitudes,"[7] remained on the grounds of New York's Nassau County Museum of Fine Arts for only a year. By contrast, *Field Rotation* (plate 80) is a permanent installation on the campus of Governors State University, Park Forest

79
Mary Miss
Untitled, 1977
Wood, 108 x 114 x 12 in.
Solomon R. Guggenheim Museum, New York; Theodoron Purchase Award, through funds contributed by Mr. and Mrs. Irving Rossi, Mr. and Mrs. Sidney Singer, The Theodoron Foundation, and The Walter Foundation, 1977

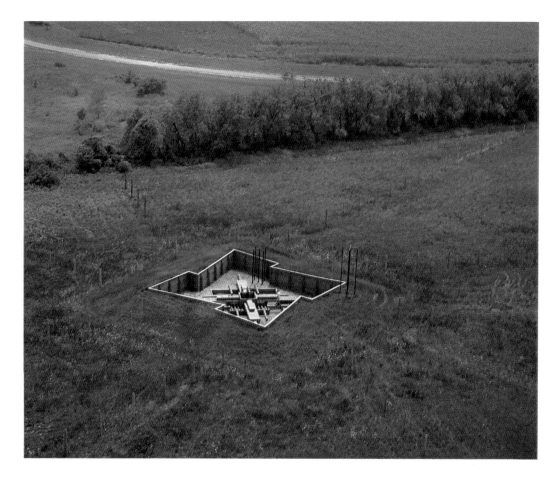

South, Illinois. While its evocative title may call to mind crop rotation, from an aerial view its central image resembles a stilled pinwheel or an American Indian medicine wheel.

At the center of an open field, Miss created a multilevel walled pit, embedded in a sloping mound of earth. Long files of posts radiate from the elevated hub, punctuating the flat grassy plain with lines of approach for the viewer-participant. The constituent towers, platforms, and barriers derive in part from such local vernacular structures as corrals and grain elevators. Other components evoke such nonmidwestern sources as docks, piers, and observatories. This multiplicity of visual and experiential references is reflected in critic Kate Linker's description of *Field Rotation* as "at once fortress and garden,

sanctuary and pleasurable retreat."[8]

Nancy Holt moved to New York in 1960, the year she earned her B.S. from Tufts University. In the 1960s she worked with super-eight films, video, concrete poetry, and photography. She first visited the American Southwest in 1968, in the company of sculptors Michael Heizer and Robert Smithson: "As soon as I got to the desert, I connected with the place."[9] During the next several years Holt did several outdoor pieces. For *Buried Poems* of 1969–71—related in spirit to Agnes Denes's 1968 outdoor performance piece *Rice/Tree/Burial*—she created verses for specific individuals and interred the verses in vacuum containers at sites in Florida, New Jersey, and Utah; each recipient was given a retrieval instruction booklet. The

permanent installation *Missoula Ranch Locators* (1972) consists of eight steel pipes used to partition the vista. Any kid who has ever looked at the world through an empty paper-towel roll is familiar with a "locator," a simple device that frames and isolates whatever it is pointed at. Four monumental locators constitute Holt's most notable project of the 1970s, *Sun Tunnels* (plates 81, 82).

On a forty-acre site in the Great Basin Desert in northwestern Utah, which she purchased for the purpose, the artist situated four specially constructed concrete tunnels. Each of the twenty-two-ton components rests on a buried concrete foundation. The open "x" of their placement was precisely determined to align with the rising and setting of the sun during the summer and winter

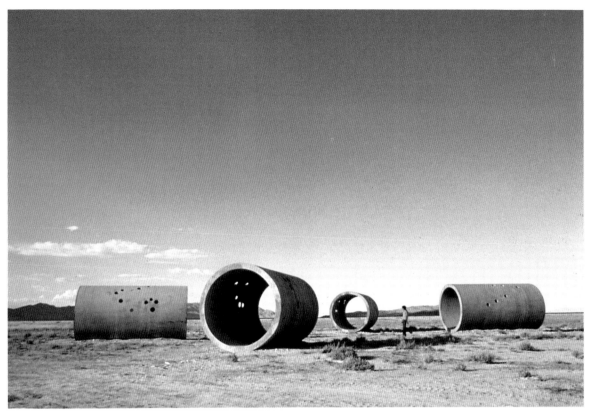

81, 82
Nancy Holt
Sun Tunnels, Great Basin Desert, Utah, 1973–76
4 tunnels, each 18 ft. long x 9 ft. 4 in. diameter; each
axis 86 ft. long
Color photographs, plate 81: 16 x 16 in.; plate 82:
30 x 40 in.
John Weber Gallery, New York

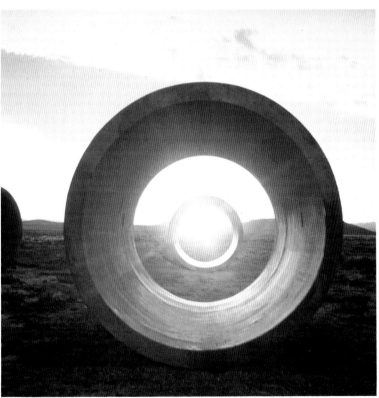

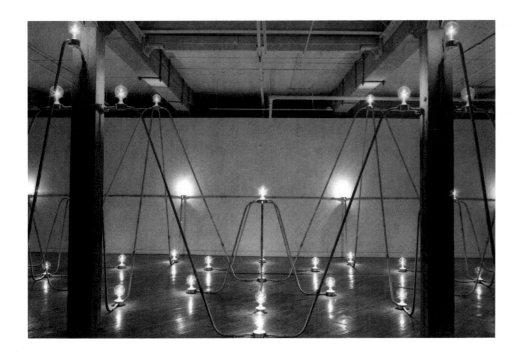

83
Nancy Holt
Electrical System II: Bellman Circuit, 1982
¾-in. steel conduit, sockets, and 72 light bulbs, 9½ x 55 x 24 ft.
Installation at David Bellman Gallery, Toronto, 1982

solstices. Holes cut through the upper half of each locator duplicate the configurations of four constellations—Draco, Perseus, Columba, and Capricorn. As Holt has described them: "The sizes of the holes vary relative to the magnitude of the stars to which they correspond. During the day, the sun shines through the holes, casting a changing pattern of pointed ellipses and circles of light on the bottom half of each tunnel. On nights when the moon is more than a quarter full, moonlight shines through the holes, casting its own paler pattern."[10] Thus the visitor who travels to this remote but not inaccessible site and takes shelter inside the human-scale tunnels encounters an artwork continually altered by the changing light. It is a testament to its power that an obviously artist-made structure is able to intensify each viewer's experience of the surrounding natural world.

In the 1980s Holt courted the edge between art and life by fabricating sculpture that focused attention on "normally hidden structural and functional elements such as electrical, plumbing, and drainage systems."[11]

Electrical System II: Bellman Circuit (plate 83), an elegant, luminous gallery installation, permitted viewers to wander through an orderly network of conduits and sockets that mimicked the configurations of concealed circuitry.

Michelle Stuart's evocative work, informed by the disciplines of geology, ecology, and archaeology, presents the viewer with poetic evidence of the passage of time. Born in California to parents who had emigrated from Australia, Stuart was early introduced to natural history at Los Angeles's La Brea Tar Pits. She often accompanied her father, a water-rights engineer, on working trips to the inland deserts of southern California. Pursuing her interest in the culture and archaeology of Mexico, she spent a year there following high school and worked for a short time as an assistant to the Mexican muralist Diego Rivera. During and after art school she worked as a cartographer, doing typographical drawings for the Army Corps of Engineers. Her artwork in the 1960s consisted of plaster relief sculpture and figurative draw-

ings. By 1966 she had settled in New York. A political activist, Stuart noted the correspondence between her social and aesthetic concerns in an 1980 interview: "In a certain sense I am a product of the 1960s. I think that a great deal of work that happened in the seventies is an organic development of the sixties."[12]

Stuart's 1968 series of sequential drawings of the craters of the moon was stimulated by the first NASA satellite photos. Like her contemporaries Vija Celmins and Nancy Graves, who were also inspired by these aerial photographs of the lunar landscape, Stuart was keenly aware of the moon as a female symbol and planetary influence. Turning to Mother Earth in the 1970s, she shifted her technique from on-site rubbings of the ground, executed with pencil or graphite stick on scrolls of muslin-backed paper, to studio-worked surfaces, created by pounding powdered rocks and soil into the paper support. In 1975, as one of the first individuals to participate in Artpark, Lewiston, New York, Stuart created a major environmental installation using the

84

Michelle Stuart

Niagara Gorge Path Relocated, 1975

Red Queenston shale from gorge site on rag paper
mounted on muslin, 460 ft. x 5 ft. 2 in.

Temporary installation along the Niagara River,
commissioned by Art Park, Lewiston, New York

85

Michelle Stuart

Passages: Mesa Verde, 1977–79

Scroll: earth from Mesa Verde, Colorado, on rag
paper mounted on muslin; stacks: earth from Mesa
Verde on handmade paper; and 2 Kodacolor C-prints
Scroll: 108 x 59 in.; 11 stacks of varying sizes;
C-prints: 14 x 17 in.

Collection of the artist; courtesy Max Protetch
Gallery, New York

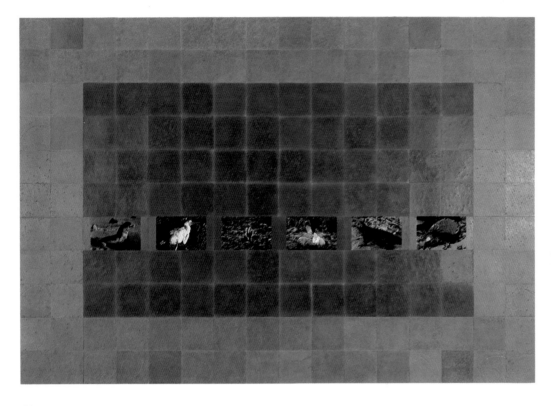

86

Michelle Stuart

Islas Incantadas: Seymour Island Cycle (for C.D.)
(Charles Darwin), 1981–82

6 black-and-white photographs, earth from Seymour
Island, Galapagos Islands, Ecuador, mounted on rag
paper, 121 x 176 in.

Collection of the artist; courtesy Max Protetch
Gallery, New York

latter method. The 460-foot scroll of drawings
that constituted *Niagara Gorge Path
Relocated* (plate 84) spilt down the cliff to the
water's edge, miming the flow of Niagara
Falls, which was originally situated at this site
twelve thousand years ago. The drawings, left
in place to disintegrate slowly, were created
with pulverized red Queenston shale, a
native rock.

Stuart is an inveterate keeper of journals.
In the 1970s she compiled rock drawings
within artist's books and also incorporated
book forms into several works. *Passages:
Mesa Verde* (plate 85) takes its name from an
archaeological excavation in Colorado. It con-
sists of a long paper scroll pigmented with soil
from the location, masonrylike stacks of dos-
siers with earth-rubbed sheets, and photo-
graphs of the site's ancient stonework dwell-
ings, detailing two windows. For Stuart, the
work addresses passages "in the grand sense,
a transition from one state to another, a cor-
ridor to the harmony of place and time."[13]
The cycle of natural history is the subject of
Islas Encantadas: Seymour Island Cycle
(plate 86), which is dedicated to Charles Dar-
win. Here a strip of photos of the extinct
Galapagos turtle and the booby, a marine
iguana, a sea lion, and a view of the terrain is
isolated like an island in a sea of gridded
squares.

The career of Cuban-born Ana Mendieta
was abruptly cut short by her death in 1985
at the age of thirty-six. Having emigrated to
the United States with her older sister in 1961,
she grew up in foster homes and orphanages,
displaced from her parents and her homeland.
Before settling in New York in 1978, Men-
dieta lived in the Midwest and studied art at
the University of Iowa. From the start, her art
addressed women's experience and often used
her own body as a medium. One notable
example of 1973 was triggered by a brutal
series of campus rapes. Mendieta's jolting,

87
Ana Mendieta
Untitled, no. 259, from the Silueta (Silhouette)
series, 1976
Color photograph, 13¼ x 20 in.
Documentation of earth-body sculpture with flowers
on sand, Oaxaca, Mexico
Raquel Oti Mendieta

88
Ana Mendieta
Untitled, no. 401, from the Arbol de la Vida/Silueta
(Tree of Life/Silhouette) series, 1977
Color photograph, 13¼ x 20 in.
Documentation of earth-body sculpture with gunpow-
der and fire on tree trunk, at Old Man's Creek, Iowa
City, Iowa
Ignacio C. Mendieta

photo-documented performance piece was
staged in the artist's apartment, where invited
viewers were shocked to encounter her pros-
trate and partially dressed body amidst the
splattered disarray of a low table.

Mendieta dispensed with a live audience
for another significant instance of her body
art, recorded in the untitled color photograph
(plate 177) from the Arbol de la Vida/Silueta
series. With arms upraised like a primeval
goddess, the artist posed her nude, mud-
covered body against the warm-toned bark of
an enormous tree. This incantatory effigy has
affinities with Mary Frank's clay figures
(plates 75, 76) and Deborah Butterfield's mud
and twig horses (plate 89). In another work
from this series (plate 88), Mendieta outlined
the shadowy presence of her body with gun-
powder on a fallen log, and set it aflame. Her
use of fire as a rite of exorcism and purifica-
tion, as well as her contemporaneous use of
flowers (plate 87), was influenced by the folk
traditions of Mexico, which she visited on sev-
eral occasions. During the late 1970s her
photo-documented sitework was introduced
in New York through the cooperative galleries
112 Greene Street and A.I.R., where How-
ardena Pindell, Nancy Spero, and Sylvia
Sleigh also showed.

Mendieta's signature Silueta series
(1973–80), numbering about two hundred
works, constituted, in her words, "a dialogue
between the landscape and the female body
(based on my own silhouette)."[14] Having
experienced a ruptured adolescence as a
parentless emigrant, she regarded her earth-
body sculptures as a "return to the maternal
source" and as a way of reestablishing
"the bonds that united me to the universe."
These earthbound, solitary women were
incised in sand, carved into hillsides, and, as
in *La Concha de Venus (The Conch of Venus)*,
molded out of mud and clay. They are primi-
tive in the authentic meaning of the term—of

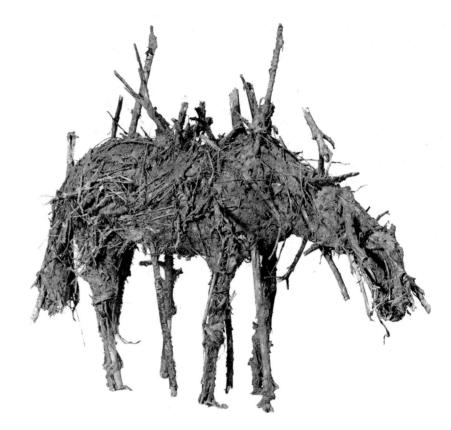

89
Deborah Butterfield
Small Horse, 1977
Mud and sticks over steel, 32 x 32 x 8 in.
Private collection

or pertaining to an earliest or original stage. According to archaeological evidence, rock carvings and goddess figurines were among the first artworks ever made. According to Greek myth, the first artist was a woman, Dibutade, and the first image, a silhouette.

For Mendieta, the female form provided an inexhaustible iconographic source, further explored in low-relief floor pieces in the 1980s. For sculptor Deborah Butterfield, the horse plays a similar role. In all of her work, she subjugates disparate materials to convey an overriding equestrian presence. Precedents for the thematic focus and ambitious scale of Butterfield's sculptures can be found in Nancy Graves's veristic camels and Anne Arnold's animal sculpture. Since her California girlhood Butterfield has been interested in horses. As an undergraduate at the University of California at Davis in the early 1970s, she was a ceramicist, at one point making a series of clay riding saddles. She came to depict horses, as did her contemporary Susan Rothenberg, as a way of creating a symbolic self-

portrait: "I first used the horse images as a metaphorical substitute for myself—it was a way of doing a self-portrait one step removed from the specificity of Deborah Butterfield."[15]

Her first life-size horse sculptures are highly realistic, made of plaster over a steel armature. Butterfield made a deliberate choice to depict mares: "The only horse sculpture I'd ever seen was very masculine. . . . The horse was essentially a tank or a vehicle of war. . . . No knight or soldier would ever be caught riding a mare into battle, it was just not done. And what I wanted to do . . . this was during the Vietnam War, I tried to make this small reference to the war . . . [with] this big sculpture that was very powerful and strong, and yet, very feminine and capable of procreation rather than just destruction."[16]

In 1976 the artist broke through to her mature work when she switched to natural materials and allowed the process of creation to be part of the viewer's experience. These hulking, atavistic animals hover between

abstraction and representation. Using daubed mud and clotted configurations of protruding twigs and branches (plate 89), she communicated the horse's physical essence, its haunch, its girth, its downstretched head.

A resident of Bozeman, Montana, since 1977, Butterfield has continued to find the horse a potent vehicle for expression. Its interior structure became more of a visible presence after 1979, when the artist began to work with such found objects as barbed wire, pipes, fencing, and corrugated metal. The placid, erect *Horse #6–82* (plate 91) and the seated *Horse #9–82* (plate 90) were both constructed from the scrap metal of a crushed aluminum trailer. In each, ribbons of buckled, silvery metal shine against matte, tar-splattered surfaces, banding and articulating the jagged, equine volumes. All of Butterfield's horses are jarring when first encountered. They confront the viewer with the complexity of their formal sculptural presence, the specific personality of each animal, and the inner core of meaning, which "isn't about

90
Deborah Butterfield
Horse #9-82, 1982
Aluminum, steel, and tar, 39 x 92 x 60 in.
Ethan and Sherry Wagner

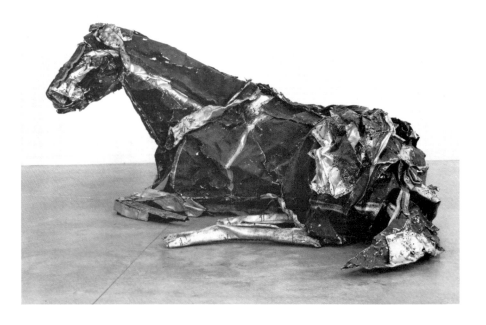

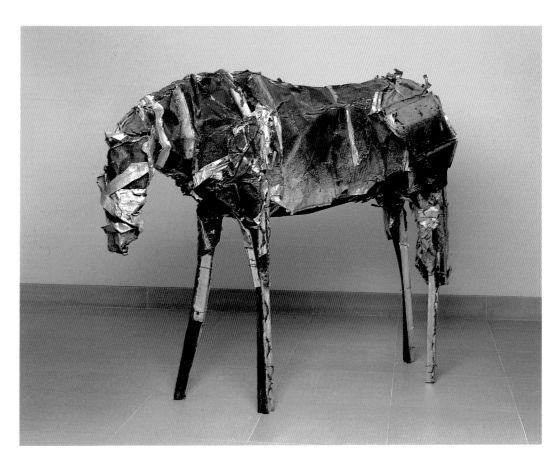

91
Deborah Butterfield
Horse #6-82, 1982
Steel, sheet aluminum, wire, and tar, 76 x 108 x 41 in.
Dallas Museum of Art; Foundation for the Arts Collection, Edward S. Marcus Fund

92
Sylvia Plimack Mangold
Study for Ruler Reflection, 1976
Acrylic, ink, and pencil on paper, 39¾ x 29¾ in.
Collection of the artist

93
Sylvia Plimack Mangold
January 1977, 1977
Acrylic on canvas, 60 x 72 in. (framed)
Collection of the artist

horses at all,"[17] according to the artist.

Sculpture based on the natural world both represents and inhabits real space, but the two-dimensional medium of painting deals with space by implication alone. Sylvia Plimack Mangold is a painter who has taken illusionism as her subject matter, rendering naturalistic space while simultaneously calling attention to the artificial boundaries of representation. She attended the High School of Music and Art and Cooper Union in New York before entering the Yale University School of Art and Architecture in 1959. In the late 1950s and '60s Yale functioned as a magnet for a disparate group of talented young

artists; among Plimack's close associates there were Sol LeWitt, Eva Hesse, and Robert Mangold, whom she married in 1961.

By 1965 the artist had isolated the floor as a source for painted imagery: "At first I was painting a chair on that floor. Then I became interested in painting the floor itself, so I removed the object. The floor to me was rich in detail, sensuous. It contained a lot; scuffmarks, wood grain, knotholes—a whole story seemed to unfold."[18] In 1972 she began to include depictions of sunlight cast from unseen windows. The following year she added mirrors. In *Study for Ruler Reflection* (plate 92) Mangold augmented the humble

subject of the floor with the theme of appearance. The exact rendition of the floorboards in the room is played off against their seeming distortion in the mirror's reflection. Coincident in placement with the receding lines of the flooring, the ruler alludes to issues of scale as well as to the illusionistic nature of Renaissance perspective. In a subsequent painting of an interior, *January 1977* (plate 93), Mangold triply referred to the signification of boundaries. The artist delimited the field encompassed by the actual frame by surrounding a rectangle with eye-fooling painted masking tape. Within this haven from the void, we see a window-pierced wall, through which is visi-

94

Sylvia Plimack Mangold

Schunnemunk Mountain, 1979

Oil on canvas, 60 x 80⅛ in.

Dallas Museum of Art; General Acquisitions Fund
and a gift of The 500, Inc.

ble a snowy landscape, bleached in sunlight. She delighted in multiple planes, stepping us from the literal flatness of the unadorned canvas, past the grid of the window frame, and on through to the distant fence and remote mountain. By the end of the 1970s Mangold had begun to confront the exterior landscape directly, switching from acrylic to oil and loosening her handling of the paint.

Like the landscape and still-life painter Jane Freilicher, who is older, and the younger Catherine Murphy, Mangold enjoys painting the scenes visible from her studio: "Everything I paint is some extension of my life. I use what I see around me. I don't go searching for a subject."[19] *Schunnemunk Mountain* (plate 94), a nocturnal view of New York's Hudson River Valley, twinkles with the faint illumination of distant habitation. Here and in subsequent paintings, the artist took on the transitional moments of the day, when the scant natural light transforms the sky into an inky expanse of purple, navy, and cobalt. These fluent, near-abstract landscapes, again banded by simulated tape, direct us to consider not only nature but also the nature of the artist's vision. As Miss did with her locators, Mangold isolates a particular panorama, enclosing and defining it.

The mediating presence of the artist as an intervening force between nature and the viewer is keenly sensed in the work of Jennifer Bartlett. Landscape is seen through the continually changing lens of her style, whether systematized patterns of dots, closely observed renderings, or painterly showers of brushstrokes. Bartlett attended Mills College in Oakland, California, with Elizabeth Murray before moving east to study at Yale in the early 1960s. Jack Tworkov, then head of the art school, gave her early encouragement and support. After moving to New York in 1968 she experimented briefly with process art before devising a novel painting system for herself.

This highly personal mode involved the mathematically determined placement of enamel-hobby-paint dots on modules of enameled steel plates. Imprinted with a graph pattern prior to being painted, the square aggregates are themselves arranged in a grid, spaced one inch apart. Initially Bartlett limited herself to a palette of red, yellow, blue, green, and black, expanding to the full range of available colors in 1974. While her systematized format had much in common with the geometrical structures of Minimalism, her methods and materials related to the conceptual underpinnings and nontraditional substances of process art. But her narrative inclinations; representational, if stylized imagery; decorative aesthetic; and stylistic inclusivity set her apart from her contemporaries.

Bartlett continued to use metallic supports, modular grids, and formulaic images well into the 1970s. *Rhapsody* (1975–76)—her epic, 153-foot exegesis on the texts of "tree," "mountain," "house," and "ocean"—fulfilled the artist's wish to make a painting "that had everything in it."[20] Described by *New York Times* critic John Russell as "the most ambitious single work of art that has come my way since I started to live in New York,"[21] *Rhapsody* is a tour-de-force compendium of art. Balancing the four representational themes are three abstract ones—circles, triangles, and squares, the latter echoed by the basic compositional unit. Across 988 of these enameled plates Bartlett painted every manner of dotted, ruled, or freehand line, using a stylistic vocabulary borrowed from Impressionism, pointillism, and Abstract Expressionism, to cite just a few of her sources.

Following this encyclopedic undertaking, Bartlett focused on individual themes, such as the house, an image that first appeared in her work in 1969. In *2 Priory Walk* (plate 1), whose title derives from a street address, the

iconic dwelling is presented threefold: emerging from the center of a turbulent, expressionist landscape; set off against a blue field bordered by serendipitous drizzles of paint; and picked out by color changes from an all-over pattern of dots. Although a similarity in content has been noted between Bartlett's houses and the figurative alter egos of sculptor Joel Shapiro,[22] they also share an affinity with the woman-house metaphor as used by Louise Bourgeois (plate 16), Miriam Schapiro (plate 108), and Alice Aycock (frontispiece).

A voracious reader and the author of an autobiographical novel, the wordwise Bartlett chooses her series titles with an ear for prepositions—At the Lake, Up the Creek, and In the Garden. The naturalistic landscape visible in this last cycle was inspired by the overgrown backyard greenery and fetid pool of a southern French house she lived in during the winter of 1979–80. She made approximately two hundred drawings of it on site and worked from photographs for such subsequent paintings as *In the Garden No. 201* (plate 95). Here Bartlett used the diptych format, the compositional device that "is to painting of the '80s what the grid was to painting of the '70s," in the analysis of Marcia Tucker.[23] It permits the artist to present the same landscape vista from two different viewpoints. Despite the accessibility of the imagery and the rich, van Gogh–like paint handling, there is a muffled and remote aspect to her meaning in this work: "I think basically my work is pretty abstract in content,"[24] she has acknowledged. In the mid-1980s Bartlett initiated a series of large-scale installations of painting and sculpture. In *Sea Wall* (plate 96), for example, iconic images of houses and boats are present in both two- and three-dimensional versions.

Louisa Chase attended Yale the decade after Bartlett was there. Gaining early recog-

95

Jennifer Bartlett

In the Garden No. 201, 1983

Oil on canvas, 2 parts, each 84 x 72 in.; 84 x 144 in.
overall

J. Barrett Gallery, Toledo, Ohio

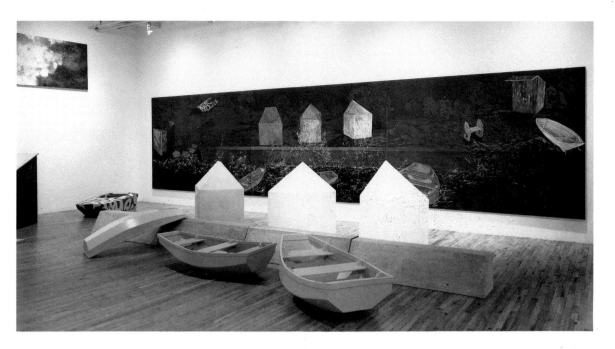

96
Jennifer Bartlett
Sea Wall (detail), 1985
Oil on canvas with mixed-media objects, 3 parts,
each 84 x 123 in.; 7 ft. x 30 ft. 9 in. overall
Courtesy Paula Cooper Gallery, New York

nition as an artist, Chase had her first New York exhibition at the prestigious alternative gallery Artists Space, in 1975, the year she obtained her M.F.A. degree. During the next several years her work changed formally and iconographically, evolving from three-dimensional wooden floor pieces to wall paintings, and from a more abstract vocabulary of gestural marks to figurative and landscape imagery. An abiding expressionist, Chase would retain her early definition of content as pertaining to the art-making process itself, returning to a more abstract mode in the second half of the 1980s.

In her large paintings of the late 1970s and early '80s Chase gravitated toward romantic images of nature's unbridled power, presenting sublime landscape elements as metaphors for emotional states. Like Joan Brown, the artist cast herself in the dual roles of observer and participant: she both joins the viewer as an awed onlooker, transported by the majesty and terror of such natural forces as waves, waterfalls, and thunderstorms, and is present symbolically in the midst of the picture, represented by emblematic figurative fragments. The hand that cups raindrops in *Storm* (plate 97) is the artist's hand, experiencing the sensations of the downpour. Chase further introduced herself here by identifying the tempest's unleashed force with the exercise of her creative powers. In a later journal entry regarding a related painting of a storm, she observed: "During the [marking] process I do become the storm—lost—yet not lost. An amazing feeling of losing myself yet remaining totally conscious."[25]

Storm's outsized fern, an exemplary beneficiary of nature's largess, is tinged a lighter tint on its growing tip. Although Chase sometimes uses naturalistic coloration—blue for water, green for plants—her palette serves not realist but emotional and decorative ends. Massed against a luminous pink sky, the flowerlike rainclouds unleash their contents on a diagonal, a favored compositional format of the artist's. In *White Water* (plate 98), the churning expanse is represented by an activated impasto surface. An upraised hand pushes up in an archetypal gesture of drowning. As in other works executed at this time, elements of drawing as well as direct and metaphoric signs of the process of painting take on a more prominent role in Chase's content. The vehicle she used to express the sensations of creation is an image of an inundating wave: "The physicality of the work, of the gesture, is so much closer to the uncontrollability of the feeling than a symbolic depiction."[26]

This physicality of surface, a hallmark of the Abstract Expressionists, is a key factor in the work of Chase's contemporary Melissa Miller. If Chase seems to refer to the Deluge in her work, comparing the emotions of creation with an overwhelming flood, then Miller attends to the earth's antediluvian creatures, using animal surrogates to address the human condition. Unlike Deborah Butterfield, who chooses to concentrate on the allusive image of the horse, Miller depicts a range of domesticated and wild beasts, including gorillas, lions, baboons, sheep, peacocks, zebras, and lizards. Although she is aware of such European predecessors as Sir Edwin Landseer and Rosa Bonheur, who painted large-scale pictures of animals, Miller has forged her own approach, informed as much by Western art as by examples from Persia and Japan.

Miller studied art in Texas and participated in the Yale University Summer School of Music and Art prior to earning her B.F.A. in drawing from the University of New Mexico in 1974. The following year she moved to a small ranch near Austin, where she worked initially on depicting the central Texas landscape. Within a few years her pictures began to focus on vignettes of local inhabitants and barnyard animals in natural settings. Miller made a conscious decision to work as a regionalist artist, in the spirit of Thomas Hart Benton and the Canadian painter Emily Carr. By 1981 she no longer painted human figures and concentrated entirely on animals, both familiar and exotic.

An arctic environment of majestic icebergs and frigid waters provides the authentic habitat for the creatures in *Northern Lights* (plate 99). Just as we marvel at the flashing luminosity of the aurora borealis, so too do five polar bears, who halt their nocturnal perambulations to sniff the air and assess the beauty of the sky. A lone hare balances upright on its hind paws, the better to assimi-

97
Louisa Chase
Storm, 1981
Oil on canvas, 90 x 120 in.
Denver Art Museum; Purchased with funds from National Endowment for the Arts Matching Fund and Alliance for Contemporary Art

98
Louisa Chase
White Water, 1983
Oil on canvas, 48 x 60 in.
Marcia and Marvin Naiman

99
Melissa Miller
Northern Lights, 1982
Oil on linen, 66 x 74 in.
Private collection; courtesy Texas Gallery, Houston

100
Melissa Miller
Salmon Run, 1984
Oil on linen, 90 x 60 in.
Shirley and Thomas J. Davis, Jr.

late the spellbinding sight. For anyone who has ever come upon a deer stopped to survey the landscape, it is easy to suspend disbelief and join the artist in spying on the stilled beholders.

Miller is a bold and dramatic colorist. In *Northern Lights* the lurid tones of the light show stain the icy crags and fleck the shaggy creatures. Color is applied with lively, paint-ladened strokes that read as physical approximations of the choppy pools and patchy fur. Sensuous, expressionist surfaces are also a feature of *Salmon Run* (plate 100), a complex allegory of survival. Miller draws us close to observe the dramatic confrontation of two natural phenomena—the salmons' desperate upstream struggle to return to their breeding grounds and the feeding behavior of brown bears. These instinctual beasts are not real villains, nor are the balletic fish genuine victims. Like Walt Whitman, who admired animals for what they did not have in common with humans, Miller here seems to invite us to "stand and look at them long and long."[27]

Video

Beginning in the late 1960s and early '70s there was a renewed interest in nature that was expressed variously as earthworks, process art, and the back-to-the-land and ecology movements. Added to this was the feminist concern with reclaiming woman's history, the time when women were worshiped as fertility and earth goddesses and when religion, if not society, was matriarchal. Some works dealt with building onto or into the land, as in the art of Ana Mendieta, Nancy Holt, Mary Miss, and Alice Aycock; others—including Donna Henes, Mary Beth Edelson, Carolee Schneemann, Meredith Monk, Betsy Damon, and Barbara T. Smith—recreated the forms of the great goddess in public and private ritual performances. Photography, film, and

video served as important adjuncts to these temporal and temporary artworks, often providing the only trace of their existence. By the end of the 1970s the need for rituals rooted in primitive cultures had waned. Yet the underlying need that had provoked the initial activity remained, and images of nature continued to be seen as containing spiritual beauty. Just as televised sports coverage has changed how sports are seen, so has wild-life programming shaped our perception of nature. By bringing outstanding footage of exotic creatures into our living rooms, it has caused us to see wild life both compassionately and as art objects. It has also called attention to its potential destruction by political, technological, and ecological disasters.

In the 1980s artists expanded the technology of television to evoke paradise lost in ways that resembled the mourning over the passing of the wilderness expressed in paintings of the late nineteenth century. Video installations (with two or more monitors and two or more channels or programs, often set in a sculptural form) by Shigeko Kubota, Mary Lucier, Rita Myers, and Tomiyo Sasaki recreate nature. The installation has proved to be an especially viable form for work concerned with nature because expanding the images into space and time asserts the physical presence of the absent landscape being evoked. These installations, which are often furnished with natural props and sculpture—uprooted trees, banks of lava, or tumbled rocks—take video, a process that essentially miniaturizes its subjects, and expand it to produce a dynamic sculptural environment that theatrically creates an oasis of nature, a vest-pocket garden that keeps our contact with nature alive. Just as nineteenth-century landscape painting was an important agent in preserving the wilderness because it supplied a context for viewing the landscape, thus giving it value, so these installations enhance con-

temporary appreciation of natural resources.

Shigeko Kubota graduated from Tokyo University with a degree in sculpture. Inspired by John Cage after seeing him perform "chance-operation/happening" with David Tudor, Kubota came to America in 1964 and became involved with the avant-garde Fluxus group, which included Yoko Ono, George Maciunas, Alan Kaprow, Ay-O, and Nam June Paik. That same year she became the vice-chairwoman of the extremely prolific New York Fluxus organization, whose members produced performances, environmental artworks, and diverse printed materials. Feminist historians have agreed on the importance of diaries as women's literature, and Kubota extended this genre into the electronic age. In 1972 she made the first of her ongoing video diaries, *Europe on a Half-Inch a Day*, the same year that the first Women's Video Festival was held at The Kitchen in the Mercer Arts Center.[1] She described the experience of making the tape: "I travel alone with my portapak on my back, as Vietnamese women do with their baby. I like Video because it is heavy. Portapak and I traveled all over Europe, Navaho land and Japan without male accompany. Portapak tear down my shoulder, backbone and waist. I felt like a Soviet woman, working on the Siberian Railway."[2]

In 1972 Kubota continued exploring the artistic potential of the television medium by using the newly developed image-processing machines such as the Paik/Abe Rutt/Etra synthesizers at the Artist's Television Laboratory at WNET's Television Lab in New York City and at the Experimental Television Center, Binghamton, New York. These machines allowed her to alter the color and form of her images, further manipulating them and making them uniquely her own. In 1974 Kubota became the video curator at the Anthology Film Archives, New York City, an institution

devoted to experimental film and video, where she was an early and vocal champion of video art.

Kubota's early work is divided into two phases: a series of installations and other work dealing with Duchamp, and Duchampian ideas about art and landscape. By the 1960s Duchamp had become almost a mythological figure, not only to Fluxus-influenced artists and musicians but also to the whole art world. If Americans practiced ancestor worship, Duchamp would have been the most likely candidate at this time. It would even be easy to make a case for laying the use of video as an art material at Duchamp's door. A chance meeting with Duchamp on the way to Buffalo for the opening of Merce Cunningham's "Walk Around Time" was the catalyst for Kubota's decade-long obsession with Duchamp. This led to five Duchampian sculptures, which, Kubota says, "manifest a video dialogue with death and reincarnation."[3]

Kubota traveled extensively through western America in 1976 and videotaped the mountains of Washington, Idaho, Montana, and Wyoming and the deserts and canyons of Utah, Arizona, and New Mexico. She was impressed by the mountains, describing them as "a visual storm of perceptual complexity in a setting of almost incomprehensible mass and volume."[4] She found herself wanting to make a tribute to ancient sculptural works such as Stonehenge, the pyramids, Peru's Nazca lines. She said, "I want to create a fusion of art and life, Asia and America, Duchampiana [*sic*] modernism and Lévi-Strauss savagism, cool form and hot video."[5]

In the four-channel video installation *Three Mountains* (plate 101), Kubota abandoned Duchamp to recreate the experience, or more exactly the perception of the experience, of the western landscape. The installation consists of three truncated pyramidal

plywood forms set on the floor. Holes are carved into the surfaces of two of the sculptures. The holes are lined with mirrors, and each is set with a video monitor so they glitter like the facets of a crystal. The third sculpture is shaped like a geometricized version of a volcanic cone.[6] It is plain on the outside, but the central cavity is lined with mirrors and set with a video monitor. The four channels of video that could be seen on the monitors showed footage of: 1. a Grand Canyon helicopter trip; 2. a drive on Echo Cliff, Arizona; 3. a Taos sunset and mirage; and 4. a Teton sunset. Kubota has described the sculpture as a mediation between nature and technology, time and space, reality and perception that is unique to the modern era. "My mountains exist in fractured and extended time and space. My vanishing point is reversed, located behind your brain. Then, distorted by mirrors and angles, it vanishes in many points at once. Lines of perspective stretch on and on, crossing at steep angles, sharp, like cold thin mountain air."[7]

Mary Lucier came to video via performance and photography. Her work of the early 1970s dealt with process, especially the process by which the sun burned the tube of the video camera, producing a natural overlay of halations that sometimes recalled Robert Delaunay's corona paintings. She recently commented that she had been attracted to video because "the monitor became a phenomenal additional prop in performance and in installation work . . . sculpture, photography and performance took me right into video. It felt completely natural and you could structure time and images in space like architecture."[8]

Lucier has also said: "The celebration of beauty may be the most radical act of the eighties. War and politics, violence and ugliness are popular subjects now, but to deal with beauty is to be viewed with suspicion."[9]

101
Shigeko Kubota
Three Mountains, 1976–79
4-channel video installation with 3 mountains, constructed of plywood and plastic mirrors, containing 7 monitors; *Mountain I:* 38 x 17 in. at top and 59 x 59 in. at base; *Mountains II* and *III:* 67 x 21 in. at top and 100 x 60 in. at base; 4 color videotapes, each 30 min.
Single-channel composite videotape included in *Video Installations*, 1970–86
Color videotape, 11:25 min. (entire tape)
Collection of the artist; courtesy Electronic Arts Intermix, New York

102, 103
Mary Lucier
Ohio at Giverny, 1983
2-channel video installation with 7 monitors; 2
color videotapes, each 18:30 min.
Collection of the artist

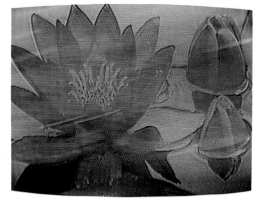

104
Mary Lucier
Ohio at Giverny, 1983
8 x 23 x 14½ ft. (curved wall)
Installation at Whitney Museum of American Art,
New York

In the early 1980s her work began to focus on the poetic, lyrical, and metaphorical aspects of nature. In the two-channel *Ohio at Giverny* (plates 102, 103), Lucier fully realized her vision of combining the act of seeing with the act of remembering, of combining technology with nature, metaphor with reality. The installation (plate 104) consists of a graceful staggered arc of seven monitors, ranging in size from seven to twenty-one inches, mounted in a concave screen suggesting the bowed shape of the arbors in Monet's garden at Giverny. (The two-channel installation has also been synthesized into a single-channel tape, *Ohio to Giverny: Memory of Light*.) Ostensibly, this is a study of that garden, but Lucier gives us something closer to great poetry than a documentary. In her hands the television screen becomes a magic window extending the range of our eyes and visually evoking the haunting patterns of memory. Lucier combined the poppy-dotted fields, flower-drenched arbors, and floating water lilies of Monet's world with boiling clouds and goblets of light. A medieval French town is cross-referenced with its American

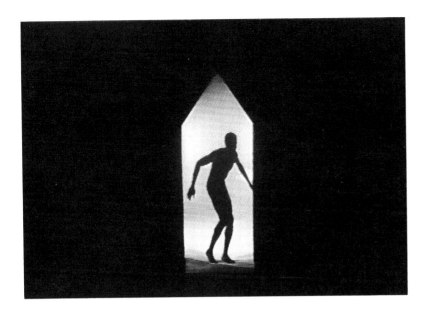

105
Rita Myers
In the Planet of the Eye, 1984
Color videotape, 5 min.
Collection of the artist; courtesy Electronic Arts
Intermix, New York

equivalent, Lucier's own native landscape of Bucyrus, Ohio, represented by a Victorian house and grounds. With scenes of a graveyard and sounds of war she also suggests that the world of visual splendor she has created is a paradise lost. Collaborator-composer Earl Howard added layers of music and sound that subtly code the pictures and define their meanings. The sound of a train even without the physical presence of a train suggests a journey, making more explicit the meaning of the changing images.

Other of Lucier's installations use technology and sculpture to bring nature indoors as an urban oasis. In these installations sculptural forms establish the site of the "garden," which is seen on inset monitors. In *Wintergarden* six geometric shapes in assorted dusty pastels were grouped together in an abstract rock pile; the monitors set into them showed parallel and interlaced images of an urban landscape coupled with a Japanese formal garden. A moving finale contrasts interior and exterior space, intimate and public space, as geometric patterns of architecture become a great spinning diadem of skyscraper tops juxtaposed with close-ups of flowers buzzing with insects.

Lucier describes her work as cinematic sculpture. "I saw [video] as a medium in which I could deal with all these things— senses of structure, pictures, time and narrative. It's natural for me to organize things three dimensionally; the TV box gives arrangements in time, while the installation format allows me to arrange in space, and broaden the whole scope of the work. The main thing is that the internal images and the form resonate, echo each other to create a third entity which is the whole piece."[10]

Rita Myers came to video with a background in Minimalism, Conceptualism, and performance. Her work combines a study of perception with mythological and metaphoric themes, often set in theatrical environments evoking landscapes or gardens. Beginning with the video installations *Barricade to Blue* (1977) and *Dancing in the Land Where the Children Are the Light* (1981), Myers has created magical alternative worlds with their own landscapes and mythologies, where the viewer is encouraged to move around and explore, to become an active participant in Myers's structure. *In the Planet of the Eye* is a series of works including three separate video installations and one autonomous

single-channel tape. The series takes "as its raw material the common archetypes of mythic reality and using the underlying logic of myth as its formal structure . . . portrays cyclic and transformational states of being. It is concerned with the survival of primordial themes as the foundation of images of reality."[11] Myers's explorations of myth are rooted in a close examination of nature. In the single-channel *In the Planet of the Eye* (plate 105) she created a mysterious mythic ritual that evokes all creation myths. The tape uses an evocative vocabulary of geometric symbols drawn from the tarot and alchemy; ritual gestures; small sculptures of animals, houses, and bones; and landscapes grouped around a solo performer.[12]

In Myers's latest installations, *The Allure of the Concentric* (1985) and *Rift/Rise* (1986), the presence of nature has become dominant as video has been used to fashion a dialogue between technology and the natural landscape. In *The Allure of the Concentric*, the culmination of *In the Planet of the Eye*, the viewer enters the space through metal gates. Across the room are clustered three metal towers; in the center of the room three whole trees, complete with their root balls, hang

106
Tomiyo Sasaki
The Creatures of the Enchanted Isles, 1984
Single-channel study for 5-channel video installation
with 20 monitors; color videotape, 25 min.
Collection of the artist

over a black, square pool of water. Water continually drips from the trees into the pool, forming concentric rings. Four monitors showing scenes of mountains, streams, and the flora and fauna of the western landscape rest on the floor, surrounded by stones. Myers has created a meditative environment, an urban oasis, suggesting that although the natural landscape may still exist (the videotape is proof of that), it is more an object of dream and memory and a source of imagination and renewal than a reality, at least for the urban viewers of the installation. The artist is a pilgrim whose quest has yielded these spectacular vistas.

Trained as a painter and a sculptor at the San Francisco Art Institute, Tomiyo Sasaki found herself dissatisfied with the limitations of traditional art media. She added real food and clutter to her life-size, bulbous papier-mâché figures, and in painting she forbade herself to use brushes, using her hands and her fingers instead. In 1971 she turned to video. From the beginning she approached the medium conceptually and began to explore the aesthetics of distortion by using repetitive editing to disrupt, reorder, and abstract real-time recording. It was not until

1980 that she began to work with nature. It had been ten years since her brother died, and she wanted to do something to remember him. She recalled that as children they had spent a great deal of time outdoors together and had kept logs of the birds they saw in their apple orchards. Besides, she adds, he looked a bit like a Rockhopper penguin. Thus began her far-flung journeys to the Falkland Islands, Africa, the Galapagos Islands, and most recently India and Japan.

Sasaki minimizes the hardships of the trips necessary to produce her raw footage, yet in all ways she functions as a heroic wild-life filmmaker, traveling to distant locations to "capture" the natural life of these birds and animals firsthand. Her footage requires the same patience, trained eye, and intimacy with her subject as the material that appears on a television nature program, our primary source of contact with nature today. Instead of assembling her material so it appears to be a continuous narrative, as a wild-life filmmaker does, Sasaki takes the same kind of raw material, the same bits of information, and repeats them. The isolation of the creatures' gestures into short, repeated units introduces an element of choreography to their natural

movements and often emphasizes their resemblance to human behavior. A diagram of them would reveal that the artist's attention to detail is so great that the gestures become rhythmic patterns on a grid. But, when seen in an installation, the repetitions give the creatures an almost three-dimensional or holographic appearance, which is enhanced by being surrounded by the sculptural rectangle of the monitor. In the five-channel, twenty-monitor installation of *The Creatures of the Enchanted Isles* (plate 106), Sasaki arranged her monitors on a raked bank of volcanic rock in three zones approximating the location of the animals. The marine iguanas, crabs, and seals are on the lowest tier. The land birds occupy the middle zone, and the huge tortoise that the Galapagos Islands are famous for appears in the uppermost register, in a space equivalent to the calderas of volcanos that are their favored home. The effect of Sasaki's installation lies somewhere between a conceptual schematization or abstraction of nature, a technological zoo, and an intimate and loving presentation of these creatures that allows them to be continually reborn before our eyes.

Art with an Agenda

According to conventional art history, artists' characteristic styles of expression are determined by three considerations: their unique nature as individuals, the geographic area they work in, and their historical era. Gender had been ignored as an influential factor until the 1970s, when the feminist art historian Linda Nochlin suggested: "The fact that a given woman happens to be a woman rather than a man counts for something; it is a more or less significant variable in the creation of a work of art, like being an American, being poor, or being born in 1900."[1] As a result of the women's movement, many artists became newly aware of what it meant to be female: the consciousness of sex discrimination, of the trivialization of women's work, and of being perceived as a sex object did indeed count for something.

The principal theorists of feminist art were Judy Chicago and Miriam Schapiro, who cofounded the Feminist Art Program at the California Institute of the Arts in 1971. Implementing the movement's epiphany that "the personal is the political," they participated in group consciousness-raising with their students, helping them to "build their artmaking out of their experiences as women."[2] Chicago transmitted feminist content via centralized imagery, the incorporation of explicit texts, and her choice of such gender-identified media as embroidery and china painting. Her 1975 autobiography, *Through the Flower*, and her collaborative chef d'oeuvre, *The Dinner Party* (plate 107), are likely the most widely known markers of the feminist art movement in America.

Miriam Schapiro was forty-eight years old when she consciously began to mine her female experience for the content of her art. Born in Toronto, Schapiro moved with her family to New York when she was fourteen.

107

Judy Chicago

The Dinner Party, 1974–79
Painted porcelain and needlework, 48 x 48 x 48 ft.
ACA Galleries, New York

Conceived by the artist as "a symbolic history of women in Western Civilization," *The Dinner Party* was constructed over the course of five years in a collaboration that involved more than four hundred people. The triangular table, 48 feet on each side, is set with thirty-nine places, each representing a historic or legendary woman. Individual settings include a painted or sculpted porcelain plate and an ornamental needlework runner executed in a style and imagery related to the woman honored. The table rests on a white tile floor inscribed in gold with 999 women's names, including such surprising discoveries as a native American chief and warrior, Elizabeth Talbot, and an Elizabethan architect, Louyse Bourgeois.

Early interested in being an artist, she enrolled at Hunter College as an art major, transferring to the State University of Iowa, Iowa City, in 1943, where she earned her B.A., M.A., and M.F.A. degrees. In 1952 Schapiro and her husband, the painter Paul Brach, settled back in New York. In the 1960s Schapiro's paintings had evolved from centralized figural compositions with a self-referencing, symbolic content to computer-generated, hard-edge abstractions. All this changed when, after taking a teaching position in California, she embraced the new women's movement: "Feminism taught me not to worry about what I was 'allowed' or 'not allowed' to do as a serious artist."[3]

The pivotal expression of her fresh viewpoint was *The Doll House* (plate 108), which she worked on with artist Sherry Brody as part of their contribution to the collaborative exhibition *Womanhouse* (1972). Spurred by the subversive intent "to challenge the limits of what 'art' could be," the artists chose the inconsequential form of the dollhouse, equating the 'frivolous' task of its interior decoration with their highest artistic aims. Adapting the symbol of the house as woman, they peeled away the surface to reveal a private habitat "patterned after fantasies of faith, fear and anguish."[4]

Following her return to New York, Schapiro extended her interest in the decorative beyond the feminist community, joining with painter Robert Zakanitch in 1975 to convene a group of artists to discuss their then-radical involvement with pattern and decoration. The monumental *Barcelona Fan* (plate 109)—in which she combined acrylic paint and sheer, lush fabric collaged onto a fan-shaped canvas—exemplifies her "femmage"[5] aesthetic, reflecting women's domestic culture in both form and content. This dual concern is also evident in *Wonderland* (plate 110), which Schapiro made with vintage

108
Miriam Schapiro, in collaboration with
Sherry Brody
The Doll House, 1972
Mixed media, 48 x 41½ x 8 in.
Miriam Schapiro; courtesy Bernice Steinbaum
Gallery, New York

109
Miriam Schapiro
Barcelona Fan, 1979
Acrylic and fabric collage on canvas, 72 x 144 in.
Howard Kalka and Steven M. Jacobson

110
Miriam Schapiro
Wonderland, 1983
Acrylic and fabric collage on canvas, 90 x 144 in.
(framed)
Bernice Steinbaum Gallery, New York

Australian needlework. Crocheted aprons, doilies, quilt blocks, and handkerchiefs are anchored in and against a complex geometric space augmented with brushstrokes. The feminist content is conveyed not only by the use of fabric, the decorative patterning, and the collaboration with the anonymous needleworkers but also by the central embroidered image of a housewife who curtsies beneath the caption "Welcome to Our Home."

Growing up in Los Angeles in the 1930s, Betye Saar was early aware of Simon Rodia's unique folk-art construction, the Watts Towers, made of such devalued and discarded materials as broken glass and crockery. Her subsequent work with nonart materials was shaped by this early influence and by her respect for crafts. As the daughter of a widowed and working mother, she often did hobby projects to entertain herself and her family. Saar has noted that her early experience with "making things for other people, to give them pleasure, . . . has a lot to do with why I make art."[6]

During the twenty-one years between her graduation from UCLA in 1949 and her inclusion in the 1970 Whitney Sculpture Annual, Saar raised a family, attended graduate school, and worked as a professional designer and printmaker. She began to construct boxes after seeing a 1968 show of Joseph Cornell's, which awakened her to the visual and thematic potential of juxtaposed found objects.

Impassioned by the civil rights movement, Saar began to assemble material that confronted derogatory racial images. Using artifacts documenting such characterizations as Jim Crow, Uncle Tom, and Little Black Sambo and such cultural conventions as pickaninnies and golliwogs, she turned the tables on those cruel untruths by fabricating new and ironic contexts for them. In *Imitation of Life* (plate 111), Saar used the shallow and deep surfaces of a tin box to address the

realities and myths of slavery by contrasting an image of a downtrodden black mother and child with a wide-eyed mammy figurine resting on a sinister pedestal of teeth. The niche behind this Aunt Jemima stereotype is papered with stark historical notices of slave auctions.

Like many other feminists in the 1970s, Saar actively reclaimed women's history by searching out her cultural and actual foremothers. The legendary blues singer of the 1920s, Bessie Smith, is the subject of a two-part assemblage (plate 112). Saar's own mother and grandmother are the focus of *Veil of Tears* (plate 113), a mixed-media construction in a silverware box. Such evocative family memorabilia as kid gloves, handkerchiefs, jewelry, and photos are combined to form a nostalgic portrait of past lives. In these assemblages Saar collaborates with the pre-existing content of the found objects: "Each item I collect has a certain energy that carries over into its new use."[7] In the late 1970s Saar extended the concept and scale of her constructions to include room-size installations. Fostering an abiding interest in the occult, she sought her subjects in ancestral memories, personal experiences, dreams, and feelings. An aura of mysterious ritual pervades the installation *Indigo Mercy* (plate 114), an altar-like construction alluding to the art of Africa and New Guinea. Some of Saar's viewers have been so moved by this work that, unbidden, they leave notes and offerings in its half-opened drawers.

Like Betye Saar, Alexis Smith is a Los Angeles artist who harvests found objects for their associative content. Smith forages materials at swap meets, for example, retrieving the passé trappings of pop culture that she later combines with found texts. Smith, who changed her first name to that of a 1940s film star when she was seventeen, has long been intrigued by the myths of Hollywood and the American dream. In the three years following

111
Betye Saar
Imitation of Life, 1975
Assemblage, 8¼ x 7 x 4 in.
Collection of the artist

112
Betye Saar
Bessie Smith Box, 1974
Assemblage, 14¾ x 20 x 2½ in. (open)
Monique Knowlton

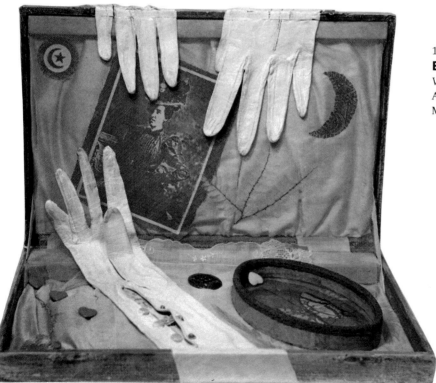

113
Betye Saar
Veil of Tears, 1976
Assemblage, 9½ x 13½ x 9½ in. (open)
Mr. and Mrs. Alvin P. Johnson

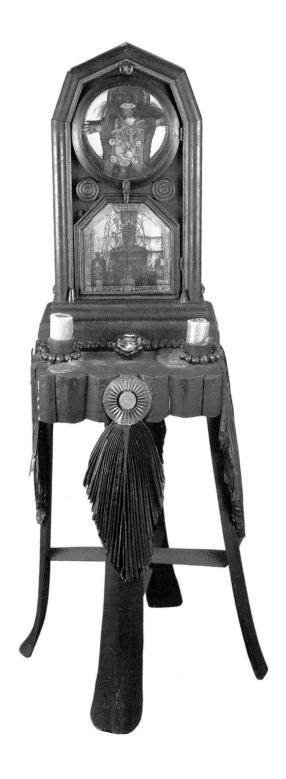

114
Betye Saar
Indigo Mercy, 1975
Assemblage, 41¾ x 18½ x 17½ in.
The Studio Museum in Harlem, New York; Gift of
Nzingha Society, Inc.

the receipt of her B.A. from the University of California at Irvine in 1970, she made artist's books. Housed in richly bedecked folders, her unbound, tactile pages are full of whimsically organized mixed-media collages.

In the spare and tidy wall installations that followed, Smith relinquished this early impressionistic format in favor of neatly counterpoised texts and pictures spread across sequential panels. With parodic intent, she paired such items as dated film stills, ads, and plastic curios with written passages from such diverse sources as H. G. Wells, Jorge Luis Borges, Yukio Mishima, Thomas Mann, and Raymond Chandler. An underlying theme of sexual politics surfaces in *The Red Shoes* (plate 115), based on a 1950s film by Michael Powell, which in turn was taken from a Hans Christian Andersen fairy tale. Across thirteen sheets of regimented typing paper unfolds a complex cautionary tale deploying playing cards, pipe-cleaner figures, and a serendipitous *Time* cover photo of the actress Alexis Smith dancing in red shoes. Spiked with autobiographical references, *The Red Shoes* is a modern parable about the irreconcilable conflict between a woman's career and her happiness.

The ironic and unintended humor of a vintage *Life* cover is artfully revitalized in Smith's mixed-media collage *Wild Life* (plate 116), one of her Jane series from the 1980s. To the artist, "Jane" is everywoman, a cultural archetype encompassing Jane Doe, Tarzan's Jane, Calamity Jane, and numerous authors and actresses. The mink-embellished image of the pouty starlet Jane Greer in *Wild Life* is accompanied by the deadpan caption: "Jane lives in Bel-Air with her poodle, two goats, and an actor."

Nancy Spero was shaped by world events a generation before Alexis Smith. She has pursued a highly individualistic career, eschewing in her mature work both the mate-

115
Alexis Smith

The Red Shoes, 1975

Mixed-media collage, 2 parts: left: 7 sheets, each 11 x 8½ in.; 13½ x 63 in. overall (framed); right: 6 sheets, each 11 x 8½ in.; 13½ x 54½ in. overall (framed)

The Grinstein Family

116
Alexis Smith

Wild Life, 1985

Mixed-media collage, 11 x 9¼ in.

Santa Barbara Museum of Art, Santa Barbara, California; Gift of Bruce Murkoff

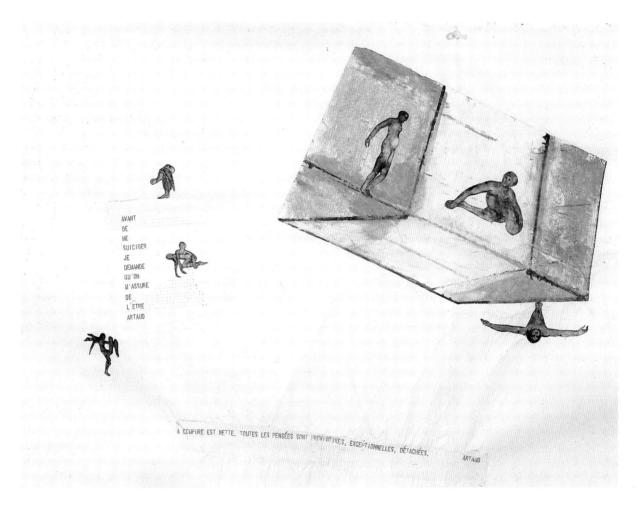

AVANT
DE
ME
SUICIDER
JE
DEMANDE
QU'ON
M'ASSURE
DE
L'ÊTRE
ARTAUD

A COUPURE EST NETTE, TOUTES LES PENSÉES SONT PROVISOIRES, EXCEPTIONNELLES, DÉTACHÉES.

ARTAUD

117
Nancy Spero
Codex Artaud XXIV (detail), 1972
Painting, typewriting, and collage on paper, 24½ x
114¼ in.
Collection of the artist; courtesy Josh Baer Gallery,
New York

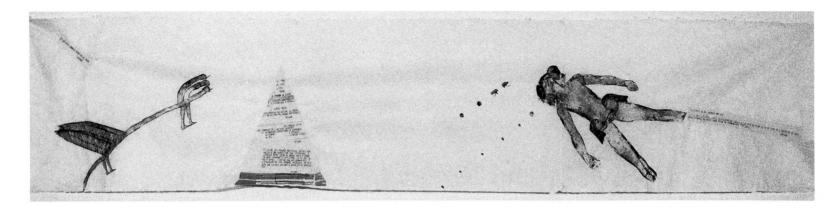

118
Nancy Spero
Codex Artaud XXIII, 1972
Painting, typewriting, and collage on paper, 24½ x 116 in.
Collection of the artist; courtesy Josh Baer Gallery, New York

rials and subjects of traditional art in favor of highly personal methods and political themes. The artist earned her B.F.A. from the School of the Art Institute of Chicago before studying art in Paris in 1949–50. In the early 1950s she lived in New York and Chicago, then after Spero and the painter Leon Golub were married, they lived abroad from 1956 to 1964 (the year 1958 was spent in Bloomington, Indiana). During this European sojourn Spero produced a series she calls "black paintings"—dark, expressionistic figures of lovers and mothers and children.

After returning to New York in 1964, Spero jettisoned oil painting in favor of working on paper, a lesser medium in the traditional hierarchy of the art world: "I needed to get away from that damn studio. By now I figured out the relationship between sex and power and I was angry. I now turned to making shocking art."[8] Prompted by America's intervention in the Vietnam conflict, she con-

fronted the obscenity of war with such searing images as bombardiers defecating their deadly payloads and phallic angels spewing destruction. Her next body of work grew out of the deep frustration she felt at the artist's untenable position in a bourgeois society. As a vehicle for her enraged sense of isolation as a woman and as an artist, Spero chose the writings of the French Surrealist poet and playwright Antonin Artaud, whose anguished letters to the editor of a French literary journal expressed his fury at the injustices of the prevailing system. Spero first exhibited eleven of the thirty-four components of her Codex Artaud series in 1973 at New York's A.I.R. Gallery, the women's cooperative she had helped found the previous year.

Beginning in 1969 Spero collaged her own stamped images with hand-printed bits of Artaud's text in translation. Then, shifting to French for the quotations, she expanded to a

scroll format, using segments of rice and tracing paper pasted together. A detail of the 1972 *Codex Artaud XXIV* (plate 117) rawly depicts the acrobatic contortions of sexual union, the participants' mouths stretched into screams. Other searing metaphors for the relationship of the artist to the world appear in *Codex Artaud XXIII* (plate 118), showing a winged fantasy creature with multiple heads and thrust-out tongues. The artist has noted of herself: "I am the angry person sticking out her tongue. I chose to use Artaud because he is the angry person sticking out his tongue . . . [which is] an act of defiance."[9] This spleenful series showing women as victims of what the artist has called "internalized psychological states" was a prelude to Spero's later work of the 1970s, which focused on images of women as victims of manmade war and violence.[10]

The strongly cinematic element in Spero's unfurled codices encourages viewers to pace

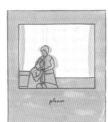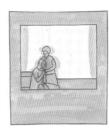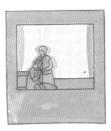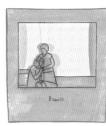

119

Ida Applebroog

I Can't, 1981

Ink and Rhoplex on vellum, 7 parts: 10½ x 9½ in.
(6); 9 x 9½ in. (1)

Cincinnati Art Museum; Gift of the RSM Co.

out the scroll's linear footage, looking and reading. A similar visual strategy propels the audience into the work of Ida Applebroog, whose images and terse narratives unfold across multiple tableaux, prompting viewers to follow along in time and space. Before she decided to study fine arts at the Art Institute of Chicago in the mid- to late 1960s, Applebroog worked in advertising as a graphic designer in her native New York. Critics have seen the impress of this vocational experience on the simple, distilled images of her mature art, whose serial format also reveals aesthetic vestiges of the Minimalist sculptures she made while living in southern California from 1968 to 1974.

In the period between her 1979 return to New York and her solo show there in 1980, Applebroog relinquished her use of modular abstractions reminiscent of early sculptures by Eva Hesse and developed a singular style for rendering the human body. Using ink on Rhoplex-sealed vellum, she employed linear, cartoon-derived figures in ordinary domestic

settings. She cut out areas in each panel of this serial work so that stark shadows are cast when the works are hung. Succinct subtitles provide ambiguous keys to the plots of these silent dramas. Her favored framing devices, such as proscenium curtains or half-drawn window shades, seem to implicate the viewer as a voyeur.

Applebroog found her unsettling themes in the theater of everyday life, in sterile relationships, alienation, and gratuitous violence. In *I Can't* (plate 119), the main, repeated scene shows two women in a barren interior, the standing one comforting her seated companion. Are they relatives, friends, or lovers? The cryptic phrases "I can't" and "please" augment the portentous calm, which erupts in the final panel with the shocking disjuncture of an abduction at gunpoint, captioned with the alarmingly bland cliché, "Let's all kiss Mommy goodbye."

In the years before she had a gallery affiliation, Applebroog, like Eleanor Antin, took the distribution of her work into her own

hands by using the United States Postal Service. She produced books of photographs of her serial paintings and mailed them to hundreds of people in the art world. Receipt of these enigmatic "performances," as Applebroog called them, implicated the recipient as a silent observer-performer in the disrupted narratives. In many of Applebroog's paintings of the early 1980s detailing alienated and isolated people, there is an emotional undercurrent akin to that in the work of Edward Hopper. A woman sits alone with a cocktail in the upper corner of *Happy Birthday to Me* (plate 9). Is she the lonely celebrant implied by the title, or does she represent the central figure's palpable fear of abandonment?

In the 1970s many people concerned with the historic representation of women in art gave deep consideration to the issue of the viewer's gaze and the attendant objectification of the female subject. Painter Joan Semmel wrenched control of the traditionally male spectator's view of the nude by depict-

ing herself looking down at her unclothed body, uniquely conflating artist, model, and viewer. Sylvia Sleigh chose a different tack: she reversed the convention of woman as sex object by posing men as sensuous and compliant odalisques.

Sleigh was trained in realist portraiture at the Brighton School of Art in Sussex, England. She emigrated to America in 1961 with her husband, critic Lawrence Alloway. An early and active feminist, Sleigh joined the women's cooperative A.I.R. Gallery in the early 1970s, where she showed lushly colored paintings of nude young men. Witty and audacious, *The Turkish Bath* (plate 120) is a tour-de-force reversal of such erotic chestnuts as Jean Auguste Dominique Ingres's painting of the same title and Titian's *Venus of Urbino*. Here Sleigh utilized a ploy of the women's movement: switching the gender in a context to reveal the sexism inherent in the original.[11] Against the foil of a richly patterned rug, analogous to those in the contemporary work of Joyce Kozloff, Sleigh depicts four nude art critics—the seated Scott Burton, John Perreault, and Carter Ratcliff, plus the recumbent Alloway—together with two views of her frequent model, the regally maned Paul Rosano.

Sleigh's portrait subjects are nearly always individuals who are important in her life: "I hardly ever paint people unless I'm rather in love with them. . . . You see, they sit for five hours, or months perhaps, and if you don't like your subject, how awful."[12] *A.I.R. Group Portrait* (plate 121) is Sleigh's affectionate record of the twenty-one members of her women's cooperative gallery. To document this feminist phenomenon of the 1970s Sleigh chose the time-honored format of an artists' group portrait. Depicted in a disarming, nearly pre-Raphaelite manner are such diverse personalities as the radiant, septuagenarian avant-gardist Sari Dienes, seated at left, and

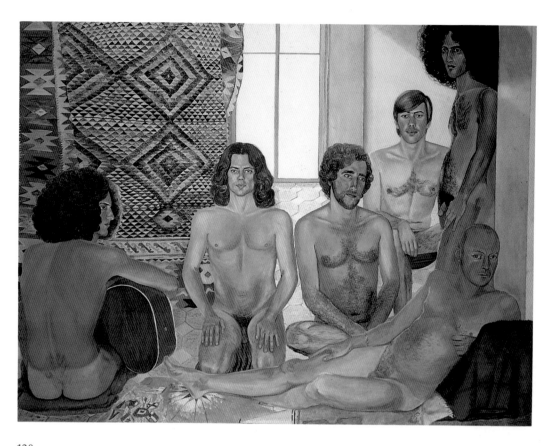

120
Sylvia Sleigh
The Turkish Bath, 1973
Oil on canvas, 76½ x 102½ in. (framed)
Collection of the artist

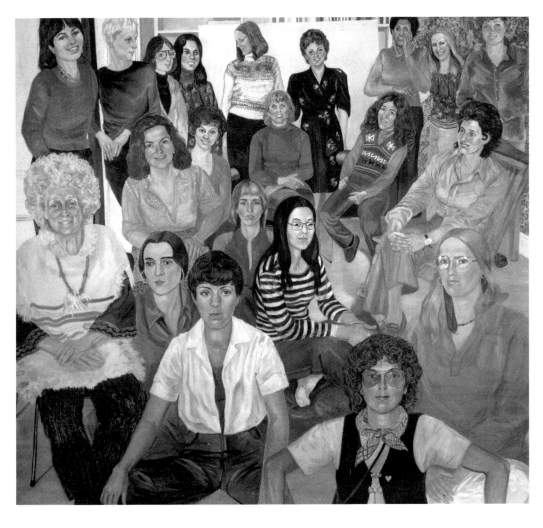

121

Sylvia Sleigh

A.I.R. Group Portrait, 1977
Oil on canvas, 75½ x 82½ in. (framed)
Collection of the artist

Top row, left to right: Daria Darosh, Nancy Spero, Dottie Attie, Mary Grigoriades, Blythe Bohnen, Loretta Dunkleman, Howardena Pindell, Sylvia Sleigh, Patsy Norvell
Second row, left to right: Sari Dienes, Anne Healy, Agnes Denes, Laurace James, Rachel bas' Cohain, Louise Kramer
Bottom, clockwise from Kazuko (in striped shirt): Dona Byars, Mary Beth Edelson, Maude Boltz, Pat Lasch, Clover Vail

the lanky and reflective Nancy Spero, leaning against the wall behind her.

One early 1970s reaction against the impersonal aesthetics of the 1960s was body art, an offspring of both Minimalism and Conceptual art whose ancestry can be traced back to Dada events of the 1920s. Practitioners such as Bruce Nauman, Vito Acconci, and Dennis Oppenheim pared down their media to their own physical beings, literalizing the pun in the axiom "I am, therefore I art." The lineage of body art and its sibling, performance art, can also be traced to the Happenings of the late 1950s, where artists interacted with their materials before an audience. Carolee Schneemann was an important bridge between the early Happenings and the body art and performance art of the 1970s (plate 180). Harnessing the art historical associations of female nudity by presenting her own body "as a source of varying emotive power," she mindfully manipulated society's designation of woman as sex object.[13]

Hannah Wilke, too, has used her own nudity as a tool. If anyone were going to objectify her, she, as a sculptor, would do it first and utilize the process as a vehicle for her art. Since 1960 she has been concerned, by her own account, "with the creation of a formal imagery that is specifically female. . . . Its content has always related to my own body and feelings, reflecting pleasure as well as pain, the ambiguity and complexity of emotions."[14] To accomplish this she has favored the metaphor of vaginal iconography and the actuality of her own body. Following her undergraduate and graduate study at Philadelphia's Tyler School of Art, in 1961, Wilke made a series of genital-shaped terra-cotta boxes, intending to create a "positive image to wipe out the prejudices, aggression and fear"[15] that society associates with the epithets derived from women's genitalia. The subject of female sexuality has rarely been

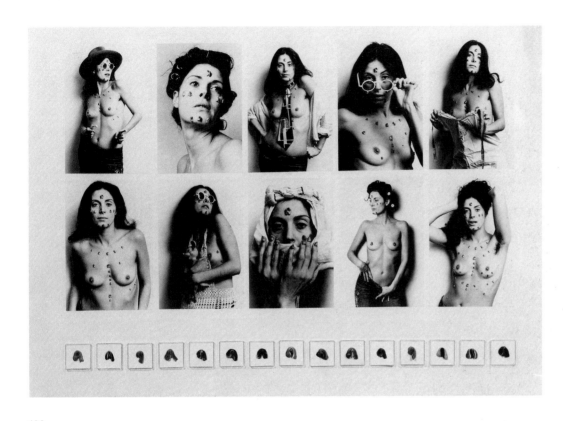

122

Hannah Wilke

S.O.S.—Starification Object Series, 1974–82
10 black-and-white photographs with 15 chewing-
gum sculptures in Plexiglas cases mounted on
ragboard, from a series originally made for *S.O.S.
Mastication Box* and used in an exhibition-
performance at The Clocktower, January 1, 1975
41 x 58 in. overall (framed)
Collection of the artist

confronted in art, and Wilke's choice of
diminutive scale and clay materials did not
facilitate its visibility. Commenting on a
1966 showing of this early work, she later
observed: "Nobody noticed them. If you do
little things and you're a woman, you're
doomed to craft-world obscurity."[16]

Wilke switched media and in the mid-
1970s further explored the taboo subject of
feminine sexual imagery with a series of
poured-latex wall sculptures. *Rosebud* (plate
123), whose title evokes the associative sexu-
ality of flowers as well as the lost object of
desire in *Citizen Kane*, is a quivering lozenge
of multilayered flesh-tinted rubber, fastened
together with grommets. *Rosebud*'s daring
somatic references still retain the potential to
shock, and Wilke has noted: "Claes Olden-
burg once said to me, 'They'll eventually
accept baked potatoes, but I don't know if
they'll ever, ever be able to accept your mak-
ing female genitals—although visually they
look very similar.'"[17]

In the humorous and audacious *S.O.S.—
Starification Object Series* (plate 122), her
dual methods of metaphor and actuality are
joined. During the performance documented
by *S.O.S.*, a primarily nude Wilke enacted a
variety of male and female roles, aided by
props such as hats, ties, and aprons. As both
artist and model she cunningly ornamented
her upper torso with dainty vulvas sculpted
from morsels of chewing gum. Wilke's sen-
sitivity toward language and the interaction of
words and images is evident in the highly
referential title of this work, which alludes to
Third World scarring rites, the negative
aspects of stardom, and an emergency plea
for assistance. The artist's first performance to
be documented in photographic stills was
Super-T-Art (plate 179). In this outrageous
yet moving series, Wilke effected the gradual
transformation of the artist from draped
supplicant in high heels to crucified Christ

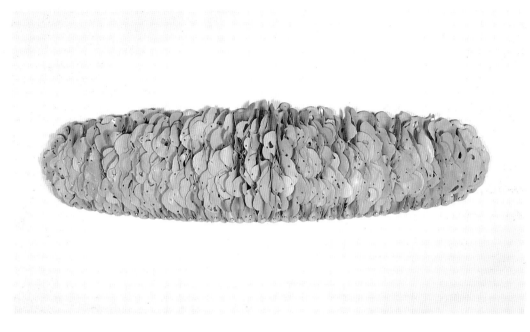

123
Hannah Wilke
Rosebud, 1976
Latex, rubber, and snaps, 24 x 92 x 8 in.
Collection of the artist

in a loincloth. Her unclothed body fluctuates between readings of nude and naked, embodying the inherent conceptual tension between an image of a beautiful woman and that of a spiritual martyr. By using herself as the victim, Wilke artfully addressed the latent sensuality of such male icons of suffering as Saint Sebastian.

Eleanor Antin is an artist whose provocative and complex oeuvre dissolves the boundaries between several genres and media. Best known as a pioneer of performance art, she is also a video artist, a filmmaker, a painter, and a sculptor, as well as a trained actress and a one-time poet. Antin's first projects in the 1960s were conceptual explorations of the nature of human reality; she was a figurative artist who deleted the figure—an early portrait series, for example, defined people by the objects they might use.

Between 1971 and 1973 Antin produced a highly inventive work entitled *100 Boots* (plate 124), consisting of a series of photographic postcards documenting the picaresque adventures of one hundred empty rubber boots. Using the United States Postal Service as a distribution system, Antin sent the postcards out unsolicited to one thousand people.[18] Seeing a museum installation of the full cycle of *100 Boots* cannot duplicate the sly seduction of the original presentation, when each component was separated from the next by real time in the recipient's life. Antin spun out her tale at intervals ranging from three days to five weeks, depending on what she took to be the "internal necessities" of the narrative.[19] We track the antics of "100 Boots"—the protagonists of her fictional biography—as they start out in the California suburbs (Antin had moved from New York to California in the late 1960s), commit their first crime, go to war, and eventually end up at New York's Museum of Modern Art.

Antin was one of the principal figures in

125
Eleanor Antin as the Ballerina, from the black-and-white videotape *Caught in the Act*, 1973
Courtesy Ronald Feldman Fine Arts, New York

124
Eleanor Antin
100 Boots on the Way to Church, from *100 Boots*, 1971–73
Black-and-white postcard, 4½ x 7 in.
Wadsworth Atheneum, Hartford, Connecticut;
The Sol LeWitt Collection

1970s body art and performance. *Carving: A Traditional Sculpture* used her own body as the medium for a subtractive sculpture: as the artist "carved" off ten pounds over a period of thirty-seven days of dieting, she took 148 sequential photographs documenting the process. As a performance artist Antin is best known for her ongoing series of events in which she takes on the female personae of the Ballerina (plate 125), the Black Movie Star, and the Nurse and the male character of the King. Serving as writer, director, and actor, Antin has embodied these personalities in performance pieces, video, and film during the past fifteen years. She has also played out their stories in sculptures, drawings, and paper dolls. Regarding the process of self-transformation in this work, Antin has commented: "I . . . have an overall system. This sort of psychological system within which I work . . . three selves and a color, black. And everything I do is about inventing and discovering myself using that system as an armature."[20] Because she chooses to address the issues of feminine stereotypes, gender boundaries, and racial definitions, Antin's work has profound social implications and is at heart deeply political.

A feminist artist of a younger generation, Cindy Sherman has used photography to fashion the conceptual undercurrents of performance and body art into a new likeness. Born in northern New Jersey and raised on Long Island, she spent a fair portion of her girlhood watching TV, drawing, and playing dress-up. She recalls that even at the State University of New York at Buffalo, where she studied art from 1972 to 1976: "I had all this makeup. I just wanted to see how transformed I could look. It was like painting in a way."[21] Uninspired by college painting courses, Sherman took up photography in 1975, and in response to a class assignment to do a serial work, she began documenting herself in different guises.

Untitled (plate 126), one of Sherman's earliest works, was done when she was twenty-one years old. With minimal props and maximal command of makeup, lighting, and facial gestures, she tapped into the psychic sources behind male and female archetypes.

When she settled in New York in 1977 Sherman was attracted by the energy and intelligence of Conceptual and performance art, especially those projects that used photography: "Probably the most impressive things to me were the ads that Lynda Benglis, Robert Morris and Eleanor Antin did, where they used themselves in a kind of joke about advertising."[22] In Sherman's Untitled Film Still series, she served as photographer, actor, director, wardrobe mistress, and makeup artist. Her summary poses distill cinematic plots within a single frame. Working in black and white, in a variety of indoor and outdoor locations, Sherman revitalized such clichés as the earnest but apprehensive ingenue (plate 127) and the worldly, self-absorbed sophisticate (plate 128).

In the color work that Sherman began in 1980, she enlarged the scale, backlit the settings, and increased the subtlety of her female characterizations. As her photographs evolved from costumed melodramas into evocative studies of contemporary women, she explored the edge between art and commerce. It was only a matter of time before Sherman was approached by dress designers who requested her to use their wares in her staged situations. She began shooting the group that includes *Untitled* (plate 129) as an advertising assignment for French *Vogue*, but early on felt a friction between the manufacturer's expectations of "cute funny pictures" and her own creative interests: "I really started to make fun of, not really of the clothes, but much more of fashion."[23] This troubling presentation of haute couture, worn by a passively posed, disheveled model with a

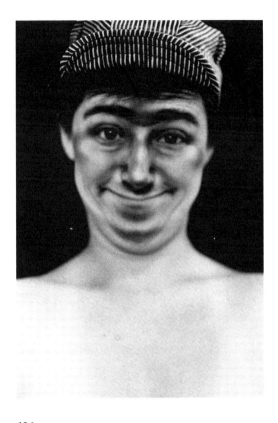

126
Cindy Sherman
Untitled, 1975
Black-and-white photograph, 20 x 16 in.
Metro Pictures, New York

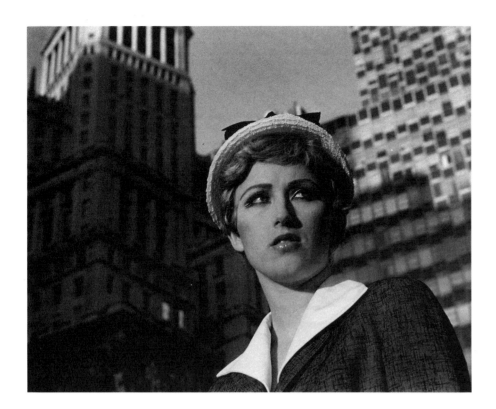

127
Cindy Sherman
Untitled Film Still, 1978
Black-and-white photograph, 8 x 10 in.
Carol and Arthur A. Goldberg

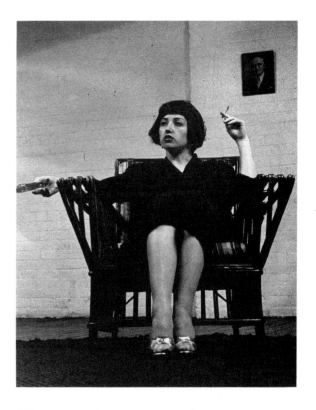

128
Cindy Sherman
Untitled Film Still, 1978
Black-and-white photograph, 10 x 8 in.
David Wirtz

disquieting leer, reflects the artist's deepening concern with creating "art that makes you think critically about the world."[24]

Sherman's command of photography to deflate the sexism and consumerism of contemporary society is paralleled in the work of Barbara Kruger, nine years her senior. Interpreting her own work in the 1980s as "a series of attempts to ruin certain representations,"[25] Kruger has come to this postmodernist political position from more conventional feminist sensibilities. In 1966 Kruger studied at the Parsons School of Design in New York, working with photographer Diane Arbus and graphic designer and

artist Marvin Israel. Needing a job, Kruger presented her portfolio to Condé Nast Publications and was hired as a graphic designer and picture editor; the expertise she acquired as *Mademoiselle*'s chief designer would be tapped for her art a decade later. Her initial career as an artist began after seeing a 1969 show of woven hangings by Magdalena Abakanowicz, which influenced her choice of fiber-related craft techniques traditionally associated with "woman's work."[26] For example, Kruger's *Homage to Gunta Stozel* (1972), a circular stitched and fringed wall piece, paid tribute to a woman weaver of the Bauhaus school.[27]

The mid-1970s was a time of transition for Kruger. She read widely and studied film and later would write film and television criticism for *Artforum* magazine. The year following her inclusion in the 1973 Whitney Biennial she gave her first poetry reading, emceed by poet and rock star Patti Smith. In 1975 she scrapped her soft materials and spent a year painting abstractions before she stopped making art entirely. When she resumed working, it was as a photographer. Given her interest in writing, it is not surprising that she soon began to incorporate words into her art. Her new mode—large-scale black and white images reshot from scavenged photos and

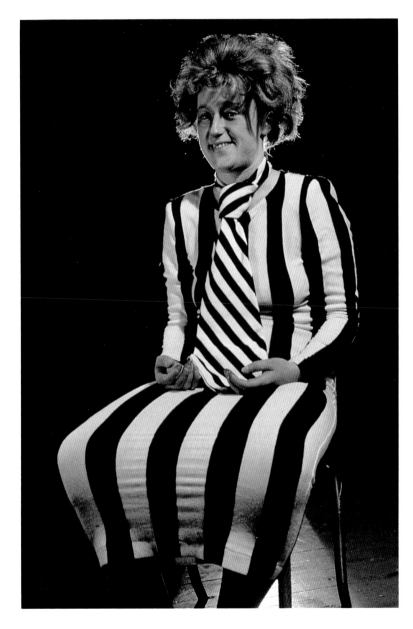

129
Cindy Sherman
Untitled, 1984
Color photograph, 71 x 48½ in.
Metro Pictures, New York

interpolated with a written message—debuted in New York at the alternative space P.S. 1 and was shown at the 1983 Whitney Biennial. These signature works are encased in attention-drawing red enamel frames that emphasize the purposeful packaging of the work as a commodity.

Kruger's feminist politics were now manifest in the content of her art rather than in the form. On a literal level *Untitled (We Have Received Orders Not to Move)* (plate 183) momentarily immobilizes the viewer who takes the time to read its simple declarative statement. Its arresting impact intensifies as it becomes clear that the collective "we," defined by a woman's voice, encompasses the pinned model, the artist, and the female spectators subject to masculine control. Artificially determined gender roles are dramatically addressed in *Untitled (We Won't Play Nature to Your Culture)* (plate 130). Kruger here implements the feminist rejection of the dichotomy of superior "culture" and inferior "nature"—the latter long associated with woman's physical, domestic, and emotional life.

When Judy Chicago, Miriam Schapiro, Eleanor Antin, Nancy Spero, Alexis Smith, Ida Applebroog, and Barbara Kruger paired their images with text, it was to help reveal the subtext of their content. Jenny Holzer extended the use of language in art to another dimension by presenting words alone; for the viewer, looking and reading became one and the same act. Born in Gallipolis, Ohio, in 1950, Holzer grew up considering herself an artist. In college her early paintings were abstract: "I could do a pretty good third-generation stripe painting, but so what?"[28] In graduate school at the Rhode Island School of Design in the mid-1970s, she came closer to discovering her own voice in anonymous public projects at the beach or in Providence and in collecting captioned diagrams. On moving to New York to participate in the Whitney

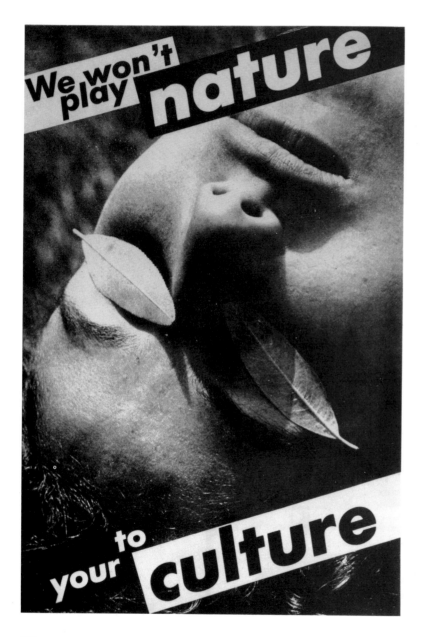

130
Barbara Kruger
Untitled (We Won't Play Nature to Your Culture),
1983
Black-and-white photograph, 73 x 49 in. (framed)
John Weber Gallery, New York

Museum's Independent Study Program in 1976–77, she realized that she loved captions even more than diagrams. Her desire to use language as her medium, to do public pieces in an urban environment, and "to be very explicit about things"[29] culminated in the Truisms, begun in 1977.

These flatly worded one-liners—"Abuse of power comes as no surprise," "Starvation is nature's way," "Romantic love was invented to manipulate women," "Sex differences are here to stay"—were Holzer's highly condensed renditions of the profundities she had gleaned through extensive readings during the Whitney program. Some seemed to reflect a male point of view, others a woman's perspective. Truisms made their debut in anonymous offset posters that she wheat-pasted on walls in downtown New York. They may seem brash and assaultive in her later electronic signs (plate 182) placed in museums, but one must imagine the initial impact of these seemingly official notices when encountered unexpectedly by someone walking through the city. In the 1980s Holzer went further in her bypass of traditional systems of art distribution by putting Truisms on T-shirts, hats, and the large Spectacolor board in Times Square (plate 131). In response to criticism that the diverse attitudes in Truisms canceled each other out, Holzer filled her next series, Inflammatory Essays (plate 132), with "hot, flaming, nasty things . . . [that] need to have an underground format for immediacy."[30] Each of these explosive broadsides—presented in a standardized format of one hundred words, twenty lines long—tackles a universal issue such as torture, poverty, or freedom. The calculated extremism of her statements in the Essays provokes her audience to clarify their own positions in regard to the expressed views. As a second-generation feminist, she has produced art that has less to do with what Holzer calls the "women's-lot" themes of the

131

Excerpt from Jenny Holzer's Survival series, on the
Spectacolor board, Times Square, New York,
1985–86

*DON'T TALK DOWN TO ME. DON'T
BE POLITE TO ME. DON'T
TRY TO MAKE ME FEEL NICE.
DON'T RELAX. I'LL CUT THE
SMILE OFF YOUR FACE. YOU
THINK I DON'T KNOW WHAT'S
GOING ON. YOU THINK I'M
AFRAID TO REACT. THE JOKE'S
ON YOU. I'M BIDING MY TIME,
LOOKING FOR THE SPOT. YOU
THINK NO ONE CAN REACH YOU,
NO ONE CAN HAVE WHAT YOU
HAVE. I'VE BEEN PLANNING
WHILE YOU'RE PLAYING. I'VE
BEEN SAVING WHILE YOU'RE
SPENDING. THE GAME IS
ALMOST OVER SO IT'S
TIME YOU ACKNOWLEDGE ME.
DO YOU WANT TO FALL NOT
EVER KNOWING WHO TOOK YOU?*

132
Jenny Holzer
Inflammatory Essays (detail), 1980–84
Ink on colored paper, 20 parts, each 17 x 17 in.

initial movement and more to do with global
politics.[31]

In scrutinizing the mythologies of woman-
hood, several first-generation feminists found
it useful to confiscate a male identity, as did
Eleanor Antin, who cross-dressed as a king;
Hannah Wilke, who transformed herself into
a Christ-like martyr in *Super-T-Art*; and
Nancy Spero, who adopted Artaud's mas-
culine voice to express her own experience as
an artist. Sherrie Levine has extended these
strategies to a new realm. In confronting the
myths of artistic greatness, creativity, and
originality, she has borrowed not the persona
but the product of male artists: "A lot of
what my work has been about since the
beginning has been realizing the difficulties of
situating myself in the art world as a woman,
because the art world is so much an arena for
the celebration of male desire."[32]

Levine was born in 1947 in the anthracite
coal country of Pennsylvania, not far from
the birthplace of Franz Kline. At the Univer-
sity of Wisconsin she did Minimalist paintings
as an undergraduate and studied photo-
printmaking in graduate school. Levine main-
tains that she had a sense of being "outside
the mainstream of the art world," which fos-
tered her reliance on secondary sources of
information and influenced her fondness for
the reproductive "surface and finish" of the
art books and magazines she consulted.[33]
After brief stays in Boston and Berkeley, she
moved to New York in 1975. The young art-
ists she soon met, including two graduates
from the California Institute of the Arts,
David Salle and Matt Mullican, often dis-
cussed questions of representation and mean-
ing that had long intrigued her.

Levine's 1976 tempera drawing series,
Sons and Lovers, which made use of the coin-
derived profile heads of Kennedy, Lincoln,
and Washington, was an early example
of postmodernist image scavenging, in which

signs are wrested away from their original context and significance. The iconoclasm of her next work, the re-photography of photographic masterworks, catapulted her into the heroic boxing arena of masculine art history. If Oedipal issues had partially influenced Cézanne's desire "to redo Poussin after nature," then Levine's jump into the ring with the fathers of the medium was likewise informed by a wish to establish the probity of her own vision as a woman.[34] Her redoing of pictures by Edward Weston, Eliot Porter, and Walker Evans (plate 133) brought to consciousness the unintended alteration of the authentic prints when seen in book reproductions. The antecedents for Levine's acts of appropriation include Marcel Duchamp's transformation of a ready-made plumbing fixture and bottle rack into sculpture by a mere change of context and Andy Warhol's faithful simulation of the commercial packaging of Brillo boxes and Campbell's soups.

How the reproductive processes of book illustration modify the original art forms part of the subtext of Levine's *After Henri Matisse* (plate 134), a watercolor replica of a Matisse traced from a small-scale reproduction. She professes to make an honest woman of herself by frankly confronting the status of art as a marketable and duplicable commodity. With the Matisse watercolor and with a recent series of generic casein-and-wax stripe paintings (plate 135), derived from the example of such reductivists as Brice Marden and Blinky Palermo, Levine has reintroduced her own hand into the art-making process. Regarding these complexly subversive representations, she has commented: "The discomfort that you feel in the face of something that's not quite original is for me the subject matter."[35]

Video

All video art, regardless of its form, is a radical political art form. Although independent

133
Sherrie Levine
After Walker Evans, 1981
Black-and-white C-print, 20 x 16 in. (framed)
Collection of the artist; courtesy Mary Boone Gallery, New York

134
Sherrie Levine
After Henri Matisse, 1983
Watercolor on paper, 19½ x 15½ in. (framed)
Harvey and Florence Isaacs

135
Sherrie Levine
Untitled (Broad Stripe #8), 1985
Casein and wax on wood, 24 x 20 in.
Marianne and Sheldon B. Lubar

video is less expensive to produce than broadcast television, it is still extremely expensive (especially now that video art is supposed to have the finish of broadcast television), and it does not produce a saleable object. Although video art parallels and imitates broadcast television in terms of its tools and materials, the fact that it represents a private voice or vision means that it will always remain in opposition to broadcast television as a challenge to the status quo. In an age when VCRs have become standard home furnishings and compact video cameras are used to make home movies, it is difficult to recapture the excitement surrounding the introduction of the first low-cost, portable video equipment ($1,500 to $2,000 for a portable recorder, black-and-white camera, and monitor) in America in the late 1960s. From the beginning video had a political component. Most of the early video publications, such as *Radical Software*, *Guerrilla Television*, and the *Spaghetti City Video Manual*, devoted themselves to explaining the media technically, showing how a camera worked and how to wire various machines together.

Early video art developed in a time of generally heightened political consciousness that corresponded with the liberation movements of women, blacks, gays, and Native Americans. Video was an important tool for women in challenging and changing their status in society. Central to its use in feminist and political contexts was the importance of video as an accessible communication device. Lucy Lippard has identified women's concerns at this time as constituting an exploration of taboos—"rape, violence against women, incest, prostitution, agism and media distortion."[1] According to the feminist critique of media, women have historically been seen as other—the object of men's desire—and in this role they have been used to sell products in television advertisements. A critique of such

media representation of women remains at the heart of much video produced by women. Those who produced feminist video addressed this issue initially by making women the subject of their work. By "asserting the validity of women's existence and experiences, by challenging accepted ideas about those experiences, or by a combination of both strategies,"[2] videotapes by women sought to redefine and empower women in relationship to media and the culture. Julie Gustafson's documentary *The Politics of Intimacy* (1972–73) is an important marker of change. In it a group of women of various ages and races discuss sex roles and relationships. Edited to give the appearance of a consciousness-raising group, the interviews are significant in that they give women a voice on subjects that had been previously taboo. By the end of the 1970s this type of "realist" work had branched into two different directions. On the one hand, women artists took a more analytical approach to video through performance and experimental narrative; on the other hand, Tami Gold, Mon Valley Media, Julie Gustafson, Third World Newsreel, the Long Bow Group, and others began to produce more formal documentaries on subjects related to women, such as the unionization of nurses, nuclear disarmament, pollution, and women steelworkers.

The development of postmodernism is directly related to the emergence of feminist art in the late 1960s and early '70s. Women called for a new, nonhierarchical theory of culture that identified high art, photography, and electronic and print media as equivalent subjects of art, thus breaking down the barriers between the "once fundamental distinctions—original/copy, authentic/inauthentic, function/ornament."[3] Many artists began to use appropriated images, including off-the-air footage from television, in the way an earlier generation might have used a live model or a

landscape as subject. Their goal was to deconstruct television, making it their subject. In analyzing the political structures of society as they affected women, many women began to dissect video's function as a disseminator of information.

From her earliest work Martha Rosler has sought to give a voice to the powerless, to question the status quo, and to right injustice by revealing it. Her earliest political work was a series of photomontages about the Vietnam War, in which she "put war scenes into American interiors—American boys in their bedrooms with missiles and riots outside the windows or Vietnamese women and children in an American living room—the images (there was no text) were trying to say: The war abroad, the war at home."[4] Having been trained as a painter, she returned to painting in graduate school before embarking on her characteristic political work. Her Conceptual and book works, mail pieces, photographs, performances, and videos approach the issues of motherhood, domesticity, sex, and career, which grew out of a climate of feminism, an interest in alternative forms of art, and her own experiences as a single parent in New York and California.

Rosler identified food as a central issue in women's lives and did a number of works in different media on that topic. She has commented: "Food is the art of womanhood. . . . It is an art product, but one that is made for the delectation of others and which disappears. . . . I also saw food in relationship to class differentiation."[5] Her three postcard-novels from 1978—*A Budding Gourmet*, *McTowersMaid*, *Tijuana Maid*—trace the role that class imposes on women's relationship to food. The first is about an aspiring bourgeois who takes gourmet cooking lessons. The second is about a working-class "countercultural" fast-food worker, and the third is about an illegal alien. Rosler sees attitudes

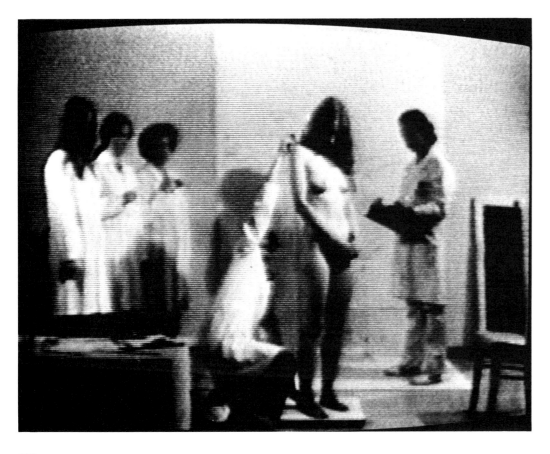

136
Martha Rosler
Vital Statistics of a Citizen, Simply Obtained, 1977
Color videotape, 39:20 min., from performance
premiered at University of California, San Diego,
1973
Collection of the artist; courtesy Electronic Arts
Intermix, New York

about the body as being essential to the oppression of women, and she is central to the group of women artists, many of them clustered around Suzanne Lacy and the Woman's Building in Los Angeles, who question the objectification of women and deconstruct femininity. In a live performance and later videotape, *Vital Statistics of a Citizen, Simply Obtained* (plate 136), Rosler created a situation in which a woman was literally objectified: stripped, asked about such things as her race, and physically measured by a male examiner. In a second section the now-naked subject (Rosler) breaks six eggs into a bowl and with the help of other women is dressed in different clothing. In the final section a recitation of crimes against women is juxtaposed with historical black-and-white photographs of women being measured, which were the source of the first section. The piece has a decidedly Orwellian cast, which communicates the oppression of women on a visceral level. In both the performance and the videotape the woman is nude, but in the videotape Rosler diminishes the scopophilia of this situation by using a long shot, which places the woman beyond the reach of a voyeur. There is a deliberate directness and simplicity in Rosler's work. She has commented: "I never want the viewer to forget that my videotapes are just something someone has made. The main effort of most of mass media is to get you to succumb to magic and lose your critical ability. Since my primary aim is to get you to fight with the material and to think critically, I need to make them realize that I'm not offering entertainment. I want the work to be more of an irritant."[6]

Margia C. Kramer in her video installations, single-channel tapes, and publications examines the political and social forms of manipulation under the surface of American society. She works like an investigative re-

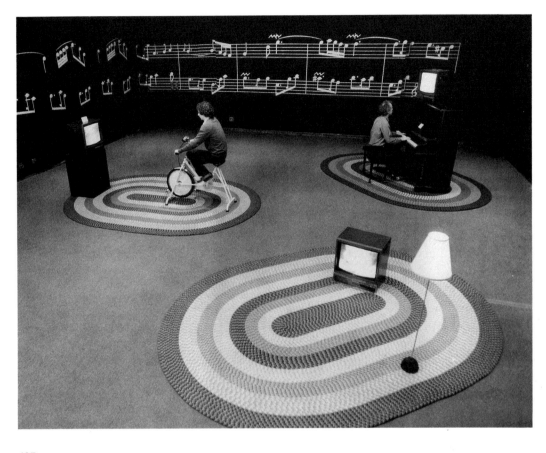

137
Margia C. Kramer
Progress (Memory), 1983–84
3-channel video installation at Whitney Museum of
American Art, New York, 1984, with exercycle,
upright piano and bench, 3 braided rugs, and black
walls with white-painted calligraphy; 3 color
videotapes, 36, 20, and 15 min.
Collection of the artist

porter, presenting previously hidden material
in the hope that the exposure of concealed
facts will change the viewer from a passive
receiver to an active participant. Her strat-
egies combine an innovative approach to
documentary with more aesthetic structures.

Kramer's three-channel video installation,
Progress (Memory) (plate 137), deals with
"the distribution and control of information
through advanced technology,"[7] specifically
the computer. Kramer set her dialogue with
the computer society in a homey electronic
cottage whose black walls are striped with
wrap-around musical staffs. At the entrance
to the room a floor lamp and a monitor rest
on a braided rug, forming a cosy tableau.
Images of a baby learning to do various things
alternate with the words USER FRIENDLY on
the monitor. An upright piano stands in one
corner of the room. When a viewer sits on the
piano stool, a musical composition that can
only be watched, not heard, appears on a
monitor atop the piano. Across the room an
exercycle faces another monitor. Peddling the
cycle turns on *Progress and Access*, a series of
taped interviews dealing with the impact of
the computer revolution on people's lives,
concluding with a set of interviews with the
editors of *Reset* magazine, who discuss "the
potential for radical, progressive change when
computers are used by grass roots organiza-
tions."[8] The fact that the tape plays only as
long as someone peddles asserts the impor-
tance of the viewer's own activism in expos-
ing this information. The presence of the baby
and the music contrasts a natural, pre-
technological world with that of the com-
puter—the human needs versus the needs of
the machine—demonstrating the alienation
produced by technological advances. Kramer
also suggests that if we avail ourselves of the
possibility to work at home that advanced
technology supplies, we will doom ourselves
to acute isolation. She quotes Ivan Illich to

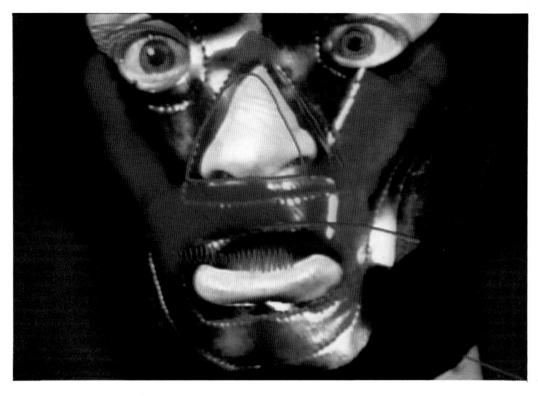

138
Lyn Blumenthal and **Carole Ann
Klonarides**, in collaboration with
Ed Paschke
Arcade, 1984
Color videotape, 11:00 min.
Collection of the artists; courtesy Video Data Bank,
Chicago

this effect: "The machine-like behavior of people chained to electronics constitutes a degradation of their well being and dignity."[9]

Lyn Blumenthal was the founding director of Video Data Bank in Chicago in 1976 and codirected this important video distribution and resource center until her death in 1988. Her work examines the politics of media in various ways. As Hal Foster has pointed out, in certain kinds of socially conscious postmodern art, "the artist becomes a manipulator of signs more than a producer of art objects, and the viewer an active reader of messages rather than passive contemplator of the aesthetic or consumer of the spectacular."[10] In *Arcade* (plate 138), Blumenthal, in collaboration with Carole Ann Klonarides and the painter Ed Paschke, fashioned a complex collage, weaving together gritty, nighttime scenes of Chicago with off-the-air footage. News footage of John Hinckley's attempted assassination of President Reagan is intercut with clips from Hinckley's favorite movies, such as Robert de Niro in *Taxi Driver* and Charles Bronson in *Death Wish*, movies he said influenced his actions. Scenes of a circus with a woman being raised up and down in the air by her long black hair also appear, along with a recurring bird's-eye view of people gathered around a television outdoors at night, as if it were a fireplace. Using a computerized "paint box," Paschke added swirls and squiggles of color over the pictures, uniting the different kinds of images. While asking viewers to question the acceptability of watching violence as a form of amusement, Blumenthal, Klonarides, and Paschke also underline its attractions with the tape's jazzy graphics and astute editing, set to a disco beat. Klonarides is a curator and independent video producer. Together with Michael Owen (at MICA TV), she produced many innovative documentaries about artists, including Cindy Sherman and Laurie Simmons.

Laurie Anderson
United States, Part II
Performance at the Orpheum Theatre, New York,
October 1980

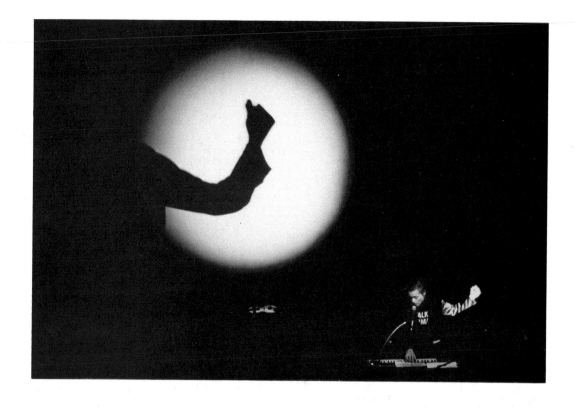

Laurie Anderson is best known as a performance artist who made the transition from the art world to the commercial world, from performing on street corners and in alternative spaces to having a record on the pop charts and a contract with Warner Bros. Records. Her most characteristic work combines spoken and sung narratives with film, slides, music, and unconventional and electronic sounds. Anderson came from a large musical family and practiced the violin steadily until 1969. She studied art history as an undergraduate and received an M.F.A. in sculpture before becoming involved with performance art and new music in the early 1970s. She likes to joke that the material for the "dream series . . . came out of falling asleep in art history classes and mixing those dreams with what was on the screen."[11] Anderson began working at a time when the dematerialization of the art object was stressed and artists were concerned with expanding the boundaries of

art. In *Dearreader* (1975), she showed a series of photographs coupled with texts at the Holly Soloman Gallery in New York. An unusual feature of the show was the presence of a large jukebox in the room: viewers could play her artworks or songs just as they would play a pop song. From the beginning Anderson espoused the radical idea that art should be widely available to people. She has said: "There's no way that I can edit out my political ideas from my work. My idea with making things like records satisfied me because as a performance artist I produce no real physical objects. And a record . . . it's skinny, it's small and it's cheap, and it's exactly the piece and everybody gets exactly the same thing and it's affordable."[12] She carried this search for new ways to disseminate art and information to the point that she literally gave away her work by binding a record of *Let X = X* into the February 1982 issue of *Artforum* magazine.

With the 1979 multimedia performance *Americans on the Move*, in which transportation is used as a metaphor for communication, Anderson began work on a project that evolved into the seven-hour, two-night operatic performance *United States, Parts I–IV*. In content the performance resembled Walt Whitman's and Willa Cather's tales of America and the more recent talking stories of Jack Kerouac, William Burroughs, Spalding Gray, Yvonne Rainer, and Eric Bogosian. True stories, autobiography, newspaper stories, and other elements were woven into disjunctive song monologues that were performed in front of a multimedia backdrop or a large-scale high-tech collage that illustrated the stories.

Anderson has made music videos of two of the songs, *O Superman* and *Sharkey's Day*, which both deal specifically with the alienation engendered by technology. In *O Superman* she transforms herself into a robotlike

140
Dara Birnbaum
Technology/Transformation: Wonder Woman, 1978
Color videotape, 5:36 min.
Collection of the artist; courtesy Electronic Arts
Intermix, New York

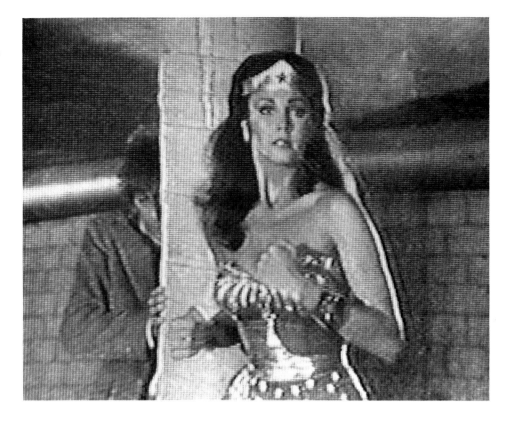

creature by using a vocoder, which renders her voice as electronic chords, and by placing lights inside her mouth. Images of her illuminated body alternate on the monitor with the silhouette of an arm in different positions within a lighted circle (plate 139). This changing "sign" fills the frame and is keyed to the different sections of the song; in the transportation section, for example, the arm makes wiperlike motions. To the accompaniment of an electronic "ah" sound, part baby cry and part sexual sigh, Anderson describes a personal but also universal quest for comfort and nurture in the modern world. *Sharkey's Day* presents feelings of alienation and powerlessness in a gentler way. Scenes of Anderson performing in makeup that transforms her face into three floating white circles are followed by computer graphics of a playground in outer space, with figures whizzing around a multicolored skeletal space city.

Anderson's deep involvement with tech-

nology points to the evolution of her work, in part, from the electronic sculpture of the 1960s and the expanded or multimedia sculpture of the late 1960s and early '70s. She develops her work by treating electronic equipment as a versatile art material, like paint or clay. "Because tools will teach you things. I want to control the technology I use. And not just set them on automatic."[13] Technology remains a male province, and the act of women working in electronic media continues to be a radical one, simply because most people in and out of the media do not believe women can do it. Anderson points out that traditional notions of masculinity and femininity are more firmly entrenched in Europe: "In Germany, I'm some sort of a freak because they figure a woman can't do technological things. Then something breaks and I know how to fix it, and they go, 'Oh, OK. Fix it.'"[14]

Dara Birnbaum—unlike earlier video art-

ists who worked within the traditions of painting, sculpture, and performance—has approached broadcast television as a Readymade, making it the subject of her art. Having come to video in 1978 with degrees in architecture and painting, she has blended an analysis of the medium's structure (and an appreciation of its beauty) with a feminist perspective. *Technology/Transformation: Wonder Woman* (plate 140), one of her earliest pieces, repeats small units of footage from the television program "Wonder Woman," with the Wonder Woman in Discoland Band singing "Wonder Woman in Discoland" on the sound track; the repetition of imagery intensifies Wonder Woman's importance as an icon of female power. One of the early artists to work successfully with appropriation, Birnbaum combined Pop art and Dada subject matter with a formal structure. Benjamin Buchloh has commented: "In this rigorous reduction of the syntax, grammar, vocabulary and genres

of the language of commercial television does Birnbaum's work follow the procedures of deconstruction as they were developed in the context of modernist collage and montage work, and the effects of her application of these high art strategies are stunning: revealing to the viewer that the apparatus of television conveys its ideological message as much by its formal strategies and its technique as by its manifest subject matter."[15]

For the installation *PM Magazine* (plate 141), Birnbaum appropriated the introduction to the prime-time TV show "PM Magazine." A video monitor is set in a large photographic panel of a woman at a computer keyboard. The tape on the monitor combines footage from the TV show with a television commercial for Wang computers that features a woman using a home computer. A slowly spinning ice skater, baton twirlers, a man and a woman swinging a small child between them, a bowler, and other figures symbolic of the good life in America perform on a rolling road that brings their "acts" from background to foreground before they vanish. The image of a young girl with an ice-cream cone is emphasized. Birnbaum borrowed and transformed these figures through the use of state-of-the-art television technology—pausing, isolating, and framing the figure with freeze-frames, slow motion, mats, wipes, and dissolves. The figures are intercut with a slow-motion version of the woman at the keyboard, whose touch on the keys produces rainbows. The narcissistic child eating the ice-cream cone, centered on personal pleasure, embodies the seduction and alienation central to broadcast television. The woman at the terminal symbolizes the woman worker, whether office worker or homemaker, but she also points to a more ancient archetype, the goddesses of creation that figure prominently in ancient mythology.

Sara Hornbacher describes herself as "a visual artist who works in electronic imaging media." She began making art during the period of Conceptualism, producing site-specific multimedia sculptures. Concurrently she worked with film and video at the Center for Media Studies at the State University of New York at Buffalo, studying with Hollis Frampton, Paul Sharits, and Woody Vasulka, and began working at the Experimental Television Center in Owego, New York, in 1976. Hornbacher's early work concentrated on images indigenous to the machine, such as the raster pattern: the matrix of scan lines that forms the television image. Increasingly, in her prints, installations, and single-channel works, she has concentrated on the social and political ramifications of representation. Hornbacher points out that video artists were among the first to use appropriated images—images "borrowed" from broadcast television by taping them off the air.

In *Writing Degree Z* (plate 142), Hornbacher used image processing to abstract and interpret snippets of *The Shape of Things to Come*, *The Day the Earth Stood Still*, *1984*, and other movies taped off the air, combining them with pulsating, distorted still images. She wove everything together in a haunting and elusive collage that provokes awareness of the fallibility of the early modern belief in technological progress; the crescendo of militarism in the twentieth century, and other issues. She subjects all of her images to electronic processing, using computers, colorizers, synthesizers, and sequencers to transform them into the same visual substance, giving them a gritty, tactile appearance like Man Ray's photographs of dust breeding on Marcel Duchamp's *Large Glass*. While using the materials of television, Hornbacher denies our expectations of the medium. Her postmodernist deconstruction of images and her use of short, disjunctive sequences deny the passivity of television and the acceptance of the status quo, calling instead for an art that is political and aesthetic but never comfortable.

San Francisco–based Max Almy works both in the commercial and the art world, using the technology of broadcast television in ways that comment on the medium and on society. Her *Leaving the 20th Century* and *Perfect Leader* use lavish special effects to sketch a scenario of the future that is part prediction and part cautionary tale.

In *Perfect Leader* (1983) Almy explored the synthesis and packaging of a political candidate through the techniques of advertising and market research. On the screen a male figure goes through a series of costume changes, each symbolic of a different male persona. This piecework construction is augmented by the kind of graphics often used on television to explain upheavals in the world economy. Accompanying these images are the throbbing lyrics: "We need a perfect leader. We want a perfect leader." The music gives a kind of collective urgency to something that is really a manufactured product. At the end a voice-over says: "OK, What do we got? Not bad. Let's give this one the final test." A television screen is placed over the candidate. The voice-over concludes, "We have a leader."

Leaving the 20th Century (plate 143) also has an Orwellian slant. A male sleeper with electrodes on his temples is awakened first by a woman's voice and then by the morning news, both of which appear on a television set implanted in his forehead. Later, a man and a woman stand side by side while a voice-over details why they left the twentieth century: "He left because there was nothing good on television. She left because she was over-educated and the government canceled her funding. He left because he was no longer entertained. She left because she had grown up with no real belief in the future and she was oddly curious." They "leave" by some

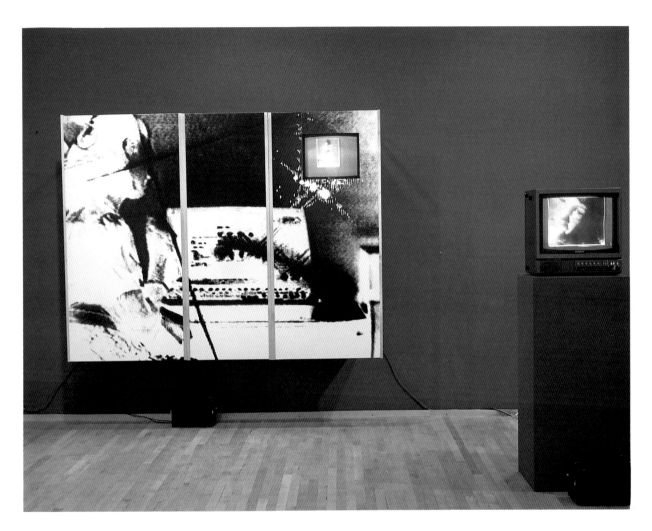

141

Dara Birnbaum

PM Magazine, 1982

Video installation with bromide enlargements,
speed-rail suspension system, painted walls, and
lights; installation: 71 x 95 x 20⅛ in.; single-channel
color videotape, 5:40 min.

Museum of Contemporary Art, Chicago; Gift of
Joseph and Jory Shapiro, Mr. and Mrs. E. A.
Bergman, and Mrs. Robert B. Mayer

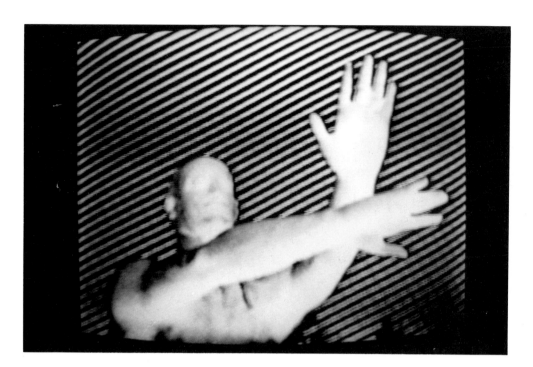

142
Sara Hornbacher
Writing Degree Z, 1985
Color videotape, 5 min.
Collection of the artist

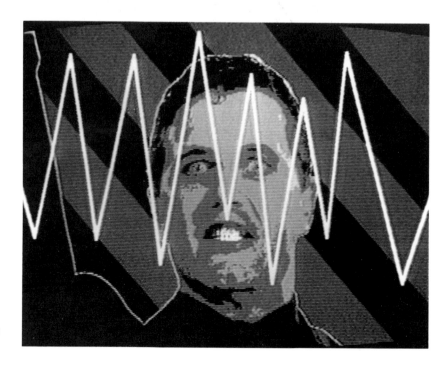

143
Max Almy
Leaving the 20th Century, 1983
Color videotape, 10:40 min.
Collection of the artist; courtesy Electronic Arts
Intermix, New York

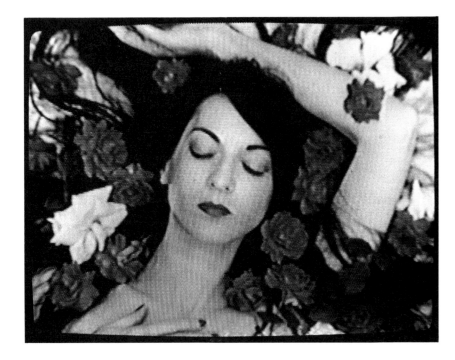

144
Cecilia Condit
Possibly in Michigan, 1983
Color videotape, 11:40 min.
Collection of the artist; courtesy Electronic Arts
Intermix, New York

kind of time machine that deposits them in the future, having been altered beyond recognition by their journey. Almy uses state-of-the-art technology to sketch the bleak future that can be extrapolated from the current technological society.

Cecilia Condit came to video from photography. Her photographs expanded until they became mosaic walls of photographs before she realized that she needed a more complex form to communicate her distinctive view of the world. Her tapes *Beneath the Skin* (1981) and *Possibly in Michigan* (plate 144) address women's preoccupation with romance, revealing the sado-masochistic conflict that underlies it. Threaded throughout are touches of the gothic, which suggest the nineteenth-century preoccupation with the madwoman in the attic, a motif that spoke directly of women's conflict with the sexual stereotyping of the period. In both tapes Condit deconstructed the plot of a classic woman's romance: instead of progressing to marriage, her heroine progresses to murder. By thus questioning women's traditional expectations, Condit calls on the viewer to reexamine past assumptions.

Possibly in Michigan is a macabre and fragmented tale of shopping malls, a menacing Prince Charming, and cannibalism. Commenting on the traditional roles of the sexes in fairy tales, it provides some unusual twists on common themes. The tape opens with two women, linked by their mutual love of violence and perfume, wandering through a deserted shopping mall. A masked male consort joins them as they browse. Reality is given a weird torque when the women describe in sing-song voices how their strange Aunt Kate killed her poodle trying to dry it in a microwave, pointing to the covert violence involved in housework. Back at home in their suburban bungalow, the two women are menaced by a man whose image fluctuates between being the ideal Prince Charming and a variety of monsters. Dreamlike fragments that show a woman running in a garden, a greedy dog, and Sleeping Beauty crossed with a lusty vampire reveal the inner life of the women. The prince says: "You have two choices. I will eat you now, or I will eat you later." The women sing, "Love shouldn't cost an arm and a leg." Reversing *Little Red Riding Hood* and *Goldilocks*, the women end up in the kitchen of a suburban villa butchering and cooking their assailant-victim with the glee of the witches in *Macbeth* and the aplomb of Julia Child. In a prosy finale full of irony, the remains of their crime are packed into two large plastic garbage bags and picked up by a garbage truck. The revenge fantasy that concludes this tape empowers the women, but in the process Condit gives the women masculine qualities that would be denounced in a man—thus revealing how tricky it can be to revise sexual politics.

Rediscovering Decorative Traditions

From the mid-1960s to the early 1970s, the cool and austere aesthetics of Minimalism dominated the American art world. This reductivist spirit favored the unadorned, pure object or painting, purged of references to anything outside of its own reality. Lush, sensual patterns and decorative values were regarded as "weak" and "female." In fact, for much of the twentieth century the description of art as "merely decorative" has been a pejorative that not even the great master Henri Matisse could fully evade. A confluence of factors helped change this negative valuation in the mid-1970s, when artists began to create frankly decorative paintings and sculpture. In society at large, many reversals of prejudice were in progress: the gains of the civil rights movement buoyed the proclamation that "black is beautiful"; following the 1969 Stonewall rebellion, a new pride among gays and lesbians resulted in a wider acceptance of alternative lifestyles; and the women's movement triggered a new consciousness of negative gender stereotypes, fostering revaluation of all matters pertaining to women.

In 1975 a group of New York artists met informally with critic Amy Goldin to discuss the aesthetic and political implications of the new decorativeness. Valerie Jaudon, Joyce Kozloff, Robert Kushner, Miriam Schapiro, and Robert Zakanitch were among those who had each independently gravitated toward an art of sensuous colors, repetitious patterns, and vernacular sources. Their common interest in decoration and ornament challenged received definitions of aesthetic "significance" and the traditional hierarchical distinction between the superior fine arts and the inferior decorative arts or crafts. By embracing such devalued materials and techniques as mosaics,

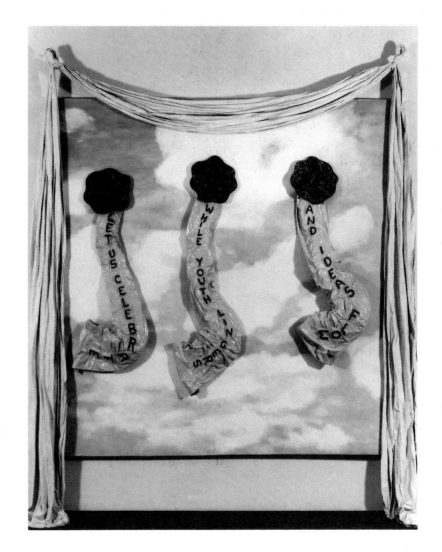

145
Ree Morton
Let Us Celebrate While Youth Lingers and Ideas Flow, 1975
Celastic, wood, and paint on canvas, 96 x 72 in.
Pennsylvania Academy of the Fine Arts, Philadelphia; Academy Purchase Fund, 1988

weaving, fabric, needlework, and wallpaper, this group encouraged a wide variety of 1970s artists.

A flamboyant affection for pattern and ornament was but one manifestation of Ree Morton's disdain for Minimalist restraint. In the seven years between receiving her M.F.A. from Tyler School of Art in 1970 and her death in an automobile accident at the age of forty-one, Morton produced a powerful and strangely original body of work, which continues to exert a strong and far-reaching influence in the art world. Her insistence on content and narrative, albeit ambiguous, distinguished her quirky and provocative environmental installations of the early 1970s. Combining enigmatic dotted drawings with such organic and primitive materials as branches, tree stumps, and stretched rawhide, she addressed such issues as the shifting boundaries between painting and sculpture and the nature of artifice.

Let Us Celebrate While Youth Lingers and Ideas Flow (plate 145) is a festively painted wall tableau made of Celastic, a plastic cloth that temporarily becomes malleable when dipped in acetone. Swaggered proscenium curtains frame three out-size, festooned medallions arrested in mid-journey across a picture-perfect sky. The undulating text of the title disports itself lengthwise down each animated streamer. Florid and grandly ironic, it pits present pleasures against future decline.

Regional Piece Number 6 (plate 146), done during the artist's teaching residence at the University of California, San Diego, is one of a series of paired oil paintings of "seasets and sunscapes"[1] made up of vast ocean vistas and counterpart paintings of closeup underwater views of fish in profile. Theatrically draped with Celastic swags, it is a complexly interwoven presentation of deadpan kitsch and unabashedly romantic sentiments. In her notebooks Morton sketched a possible instal-

146
Ree Morton
Regional Piece Number 6, 1976
Oil on Masonite with Celastic drapery, 2 parts, each 16 x 49¾ in.
Private collection, New York

lation that placed works in the series against a decorative foil of brightly patterned wallpaper. Morton's casting of such humble motifs as bows, banners, flowers, and ribbons in the central role of her art loosely allied her with the heterogeneous group of artists who were mining decoration to expand the purview of art in the 1970s.

In 1978 Joyce Kozloff and Valerie Jaudon coauthored a germinal article entitled "Art Hysterical Notions of Progress and Culture," documenting the art historical bias against the "decorative."[2] Text excerpts from a multitude of sources revealed a broad cultural snobbery, as exemplified by Adolph Loos, who wrote in his 1908 treatise, *Ornament Is Crime*, that "no ornament can any longer be made today by anyone who lives on our cultural level. . . . We [Westerners] have outgrown ornament; we have fought our way through to freedom from ornament."[3] For both Kozloff and Jaudon, it was a consciousness of the political and ideological implications of what came to be called the Pattern and Decoration movement that reinforced their aesthetic interest in the decorative.

Kozloff's fascination with architectural details dates from her first solo show in New York, held in 1970, which contained a series of acrylic canvases inspired by the structure of antique temples. Following a summer spent in Mexico in 1973, during which she made numerous sketches of pre-Columbian design motifs, she felt a growing identification with the anonymous female artisans who crafted much of the country's weavings and ceramics. Concurrently she became increasingly conscious of the political and social content of non-Western pattern and ornament. A political activist and feminist, Kozloff then decided to focus her art on the form and content of Third-World decorative arts. *Tent-Roof-Floor-Carpet, Zenmour* (plate 147), once part of a diptych, is an acrylic painting inspired by

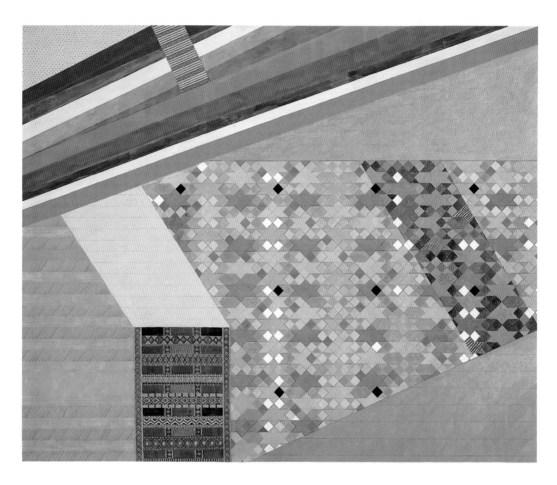

147
Joyce Kozloff
Tent-Roof-Floor-Carpet, Zenmour, 1975
Acrylic on canvas, 78 x 96 in.
Dr. and Mrs. David Peretz

North African Berber textiles. Among the Zenmour tribe, women weave rugs such as the two that Kozloff replicated. The composition juxtaposes her favored motif of Islamic star patterns with skewed and straight registers of thinly washed colors.

By 1978 the artist's involvement with the realm of crafts had expanded to the materials themselves. She now painted on clay, not canvas. When Kozloff first began working on tiles, she raided her kitchen for cookie cutters to shape them. The working methods she evolved were analogous to her sources: "Crafts rely on labor-intensive processes, and I've made that kind of process part of my work and imposed it on the viewer as well."[4] Kozloff's major projects of the 1980s have been in the realm of public art, a logical arena for artists committed to the democratization of art. When commissioned in 1983 to create a 2,000-square-foot mural for Buffalo's Humboldt Hospital subway station (plates 22, 23), she began by researching the city's indigenous design traditions. The artist felt strongly that the audience of daily subway users should be provided with rich and complex images that could be encompassed only over a period of time. Her completed tile and mosaic installation incorporates motifs borrowed from Louis Sullivan's newly restored Prudential Building, a Buffalo landmark, as well as decorative patterns from Seneca Indian jewelry.

Both Kozloff and Valerie Jaudon have challenged themselves to create art that rebuts the traditional low status of the decorative arts in our society. While Kozloff has annexed the exact patterns and materials of her sources, Jaudon has preferred to invent her ornament-inspired abstract designs and to retain oil paint on canvas as her preferred medium. The complex mathematical structuring of patterns also holds interest for the artist. Born in Mississippi in 1945, Valerie Jaudon studied art

148
Valerie Jaudon
Yazoo City, 1975
Oil on canvas, 72 x 72 in.
The Aldrich Museum of Contemporary Art, Ridgefield, Connecticut

149
Valerie Jaudon
Pantherburn, 1979
Oil on canvas, 96 x 72 in.
Collection of the artist

both here and abroad. The changes in her work since her first solo exhibition in New York in 1977 have evolved from painterly concerns. Like most of the artists identified with the Pattern and Decoration movement, Jaudon had to confront the grid, the compositional tool that is the underlying framework not only of most decoration but also of 1960s Minimalism. She chose to retain this austere scaffolding, augmenting it with a form and content undreamed of in the preceding formalist decade. *Yazoo City* (plate 148), one of her first oil paintings, is a square grid interlaced with symmetrical circles and diagonals that are likely derived from Celtic and Islamic sources. The intricately patterned surface juxtaposes bare white canvas with black segments of richly textured brushstrokes. *Pantherburn* (plate 149), worked with lustrous metallic pigments, strikes an elaborate architectural chord. It derives its magisterial presence from a towering schema of interwoven arches and shapes reminiscent of the springing of a vault.

Cynthia Carlson attended the School of the Art Institute of Chicago with several of the artists who would later become known as "The Hairy Who." While never herself an Imagist, she did share her contemporaries' enthusiasm for naive or Outsider art, which often featured repetitious patterns and decorative elements. After moving to New York to study at the Pratt Institute, Carlson gradually distanced herself from the Chicago-accented Surrealism of her early 1970s paintings. She had begun with landscapes turning into repeated forms, and by 1972 these evolved into depictions of the repeated forms themselves. As an abstractionist, she lavished on paint with a pastry tube, creating luscious delineations of her grid compositions. *Cozy Hang* (plate 150) is representative of this work, with its pastel tonalities and its puckery pattern of orderly paint blobs.

150
Cynthia Carlson
Cozy Hang, 1976
Oil on canvas, 60 x 48 in.
Denver Art Museum

In 1976 Carlson's animated squiggles bolted from their canvas-and-paper supports and were henceforth found affixed to the gallery walls themselves. Arguably the best-known and most highly regarded of these impermanent, site-specific installations was *Homage to the Academy Building* (plate 152), a room-size environment of three-dimensional "wallpaper" inspired by and situated in the Victorian architectural landmark of the Pennsylvania Academy of the Fine Arts. *Untitled* (plate 151), a wall of twelve individual bronze floral units, began as a similar temporary installation of paint wriggles for the Hayden Gallery at the Massachusetts Institute of Technology in 1981. To render it both permanent and portable, Carlson cast it in metal.

Judy Pfaff is an artist who, like Carlson, moved from easel painting to room-size installations. After receiving her M.F.A. from Yale in 1973, Pfaff abandoned her earlier involvement with painting in favor of ambitious panoramas of dynamic three-dimensional elements projected from the floor, ceiling, and walls (plate 154). An energetic expressionist, Pfaff surrounds her viewer with a bracing splash of exuberant forms and colors. She works intuitively, discovering her forms in the process of creation. Walking into one of her environments is like entering an Abstract Expressionist canvas and encountering showers of unpremeditated gestures that record direct encounters between the artist and her materials. Early on she used linear images in jazzy, punk colors. Reeds, wires, and plastic tubing were cut and spliced in jerky, animated rhythms. Gradually she dropped the figurative references and worked more abstractly, with subjects as far-ranging as war and the undersea world. *Voodoo* (plate 153) and *Stage Fright* (plate 155) are indicative of Pfaff's work in the 1980s, when she countered the ephemeral existence of her site-specific

151

Cynthia Carlson

Untitled, 1983

Bronze, 12 parts, each approximately 15 x 9 x
2½ in.; wall installation: approximately 10 x 8 ft.

Museum of Contemporary Art, Chicago; Promised
gift of Dr. Helen Herrick

152

Cynthia Carlson

Homage to the Academy Building, 1979

Mixed-media installation at the Pennsylvania
Academy of the Fine Arts, Philadelphia, 1979

153
Judy Pfaff
Voodoo, 1981
Contact-paper collage on Mylar, 98 x 60 in. (framed)
Albright-Knox Art Gallery, Buffalo; Edmund Hayes
Fund, 1983

154
Judy Pfaff
3-D (detail), 1983
Mixed media, 12 x 22 x 35 ft.
Installation at Holly Solomon Gallery, New York,
1983

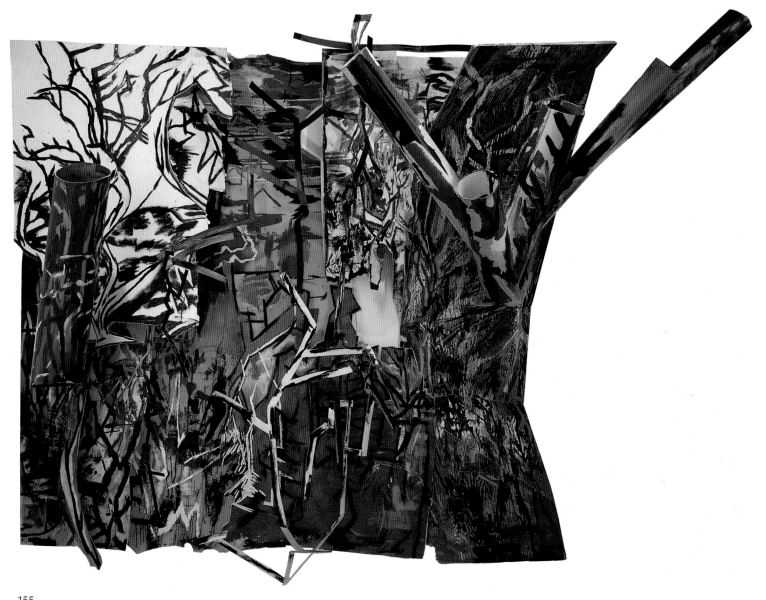

155
Judy Pfaff
Stage Fright, 1983
Mixed-media wall relief, 85 x 102½ x 29 in.
Holly Solomon Gallery, New York

sculpture by periodically creating wall-mounted reliefs.

Like Morton and Carlson, Pfaff has significantly contributed to one of the principal aesthetic changes of the 1970s—namely, the blurring of distinctions between painting and sculpture. All three came to regard paint as an integral component of three-dimensional form. Morton and Pfaff were also important to the integration of theater into the art world of the 1970s. Morton's arcane narratives and ritualistic installations were not unlike the Happenings of the late 1950s, minus the artist's actual participation. Pfaff's expressionist environments are likewise progenies of the Happenings. It is as if each artist cast the spectator as actor to complete the intention of her piece by physically passing through it.

At the time Philadelphia-born Howardena Pindell attended Yale's graduate school of fine arts in 1965–67, she was painting urban landscapes and skeletal forms. Influenced by her work at Yale with Josef Albers and by her admiration for Ad Reinhardt, she subsequently worked abstractly, focusing on closely related colors. After moving to New York she did curatorial work at the Museum of Modern Art, maintaining a dual career for twelve years. Pindell was early attracted to the women's movement after being denied an exhibition at an emerging black art institution because she was a woman and because she painted abstractions, not political subjects. In 1972 she helped found A.I.R. Gallery, conceived as a forum unfettered by dogma.

Pindell continued to explore delicate and nuanced color and light in the early 1970s, shifting her technique from staining canvases to spraying pigments through a random pattern of holes punched into paper stencils. Reluctant to discard the circular byproducts of her templates, she saved and numbered them. At times she scattered this confetti to create richly textured surfaces, mixed with thread or

156

Howardena Pindell
Untitled (No. 5) (detail), 1975
Pen and ink on punched paper, mounted on graph paper, 34 x 44 in.
Collection of the artist

hair and dusted with pigments. In *Untitled (No. 5)* (plate 156), Pindell regimented the randomly numbered dots by following the orderly format of the underlying graph paper. The serendipitous positioning of sparse and dense numbers mottles the surface with subtle lights and shadows. In *Feast Day of Iemanja II, December 31* (plate 157), a pieced and sewn unstretched canvas, the artist extended her investigations of repetitive circular shapes and forms. Its meditative presence derives in part from the complex multilayer construction of dots of paint and embedded paper, with passages of sprayed powders and crystal glitter.

Neither Pindell nor Yvonne Jacquette was allied with the Pattern and Decoration painters of the 1970s, although their work bears affinities with them. Jacquette, like Alma W. Thomas, began with the landscape, translated into a richly complex weave of pigment flecks and cross-hatchings. But unlike the older artist's style of abstract impressionism, Jacquette's mode has been to retain representation, balancing the painterly abstractions of vision with a keen sense of place.

Jacquette was born in Pittsburgh in 1934 and as a teenager received encouragement for her artistic talents by having work published in *Seventeen* magazine. After attending the Rhode Island School of Design in the mid-1950s, she moved to New York and supported herself by drafting architectural drawings. Her early paintings were of interiors and cityscapes executed in acrylic in a straightforward, realistic style. A series of images of the intricate pressed-tin ceiling in her home was the first manifestation of her interest in angled vision, a fascination that has led her from ground-based cloud studies to airborne views of rural and urban landscapes. In the early 1970s Jacquette switched to oil for the richer color it afforded. She did plein-air city views while living in New York and country

157
Howardena Pindell
Feast Day of Iemanja II, December 31, 1980
Acrylic, dye, paper, powder, thread, and glitter on sewn canvas, 84 x 102 in.
The Studio Museum in Harlem, New York; Gift of Diane and Steven M. Jacobson

158
Yvonne Jacquette
Telegraph Hill II, 1984
Oil on canvas, 77¾ x 105 in.
John H. Scully

159
Yvonne Jacquette
Ferry near Battery Park, Dusk, 1981
Oil on canvas, 76 x 62 in.
PaineWebber Group, Inc., New York

scenes during her summers in Maine. After working with pastels for a print exhibition, she evolved her now-characteristic manner of conveying a sense of place with a vibrant, mosaiclike pattern of individual brushstrokes.

The focus of Jacquette's mature work has been the aerial landscape, as if she had taken to heart Gertrude Stein's insightful reminder: "One must not forget that the earth seen from an airplane is more splendid than the earth seen from an automobile."[5] Committed to the specifics of time and place, Jacquette works from notational drawings made while aloft in a single-engine plane. Night vision, or the optical effects of artificial illumination, is explored in both *Ferry near Battery Park, Dusk* (plate 159) and *Telegraph Hill II* (plate 158). In these nocturnal views she maximized her dark tonal range by systematically juxtaposing matte and shiny strokes across the canvas. While the vibrant, agitated strokes read as abstract color patterns up close, at a distance they communicate the shimmery path of the Staten Island Ferry and the jittery pulse of San Francisco.

Exploring Structures and Systems

When historians point to a revival of content in the art of the 1970s, they generally refer to the resurgence of emotive themes, the subjective, psychological currents that had all but disappeared during the 1960s. But there are other dimensions to the content of 1970s art that can be said to have survived from the 1960s. One of the most viable sources was Conceptual art, in which the underlying idea or thought system becomes the principal determinant of the form of a given work. Unlike their 1960s predecessors, who often practiced what Duchamp had earlier termed the "visual indifference" of Conceptual art, artists working with a conceptual scaffolding in the 1970s were as concerned with aesthetic issues as they were with the intellectual structure of meaning.[1]

Of all the underlying conceptual systems used by artists in the past twenty years, mathematics may be the most pervasive. The classical definition of beauty in the West is based on the Greek system of mathematical proportions. The nearly magical power and seductive authority of numerical relationships are ingrained in our culture, from the Egyptian pyramids and Greek temples to the invention of one-point perspective during the Renaissance. For several American artists working in the 1970s, the elegance and beauty of mathematics provided an inexhaustible conceptual structure for their art.

Dorothea Rockburne has said of herself that she reads mathematical texts the way other people read novels. The Quebec-born artist studied at North Carolina's legendary Black Mountain College in the 1950s, where she first became entranced with the artistic applications of numerical theories. Attracted by the potential of math to predetermine certain relationships of part to part and of part

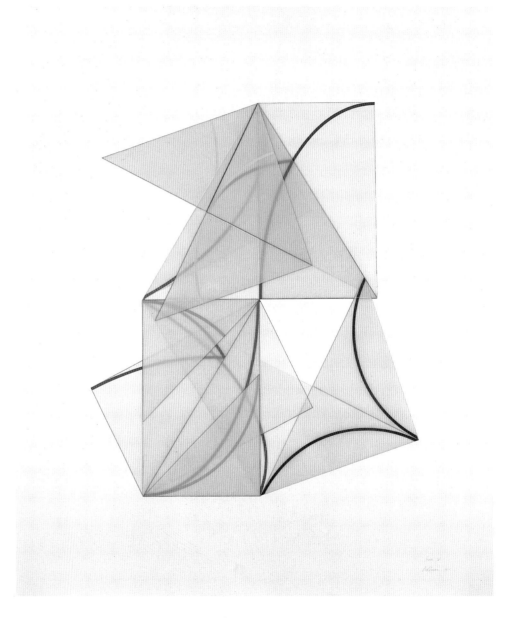

160
Dorothea Rockburne
Arena IV, 1978
Vellum, colored pencil, varnish, glue, and ragboard,
54½ x 47 in.
Michael McCarthy

to whole, Rockburne subsequently studied Boolean algebra, set theory, the golden section, the Fibonacci series, and related concepts in logic that formed the conceptual underpinning of her early work. The philosophers Edmund Husserl and Ludwig Wittgenstein were of particular interest to her at the time of her first solo exhibition in New York in 1970. The spare elegance of her meditative abstractions is the product of a balancing of elements: "In working, I've always tried to keep things in a system of checks and balances, so that every voice should be in the same modulation. . . . Neither paper, nor concept, nor the inspiring emotions should seem to have a stronger accent."[2]

Throughout her career Rockburne has been among the pioneers in the deconstruction of the medium of drawing, helping to redefine it with her methods of creation and choice of unusual materials. Her initial work on paper employed cup grease, crude oil, tar, and carbon. In *Drawing Which Makes Itself* (1973), she introduced the fold as a fundamental operation. Works in the Arena series (plate 160), so named because their color was inspired by Giotto's Arena Chapel frescoes in Padua, also embody mathematically determined relationships of part to part, now augmented by arcing curves of color drawn on translucent vellum. *White Angel #2* (plate 161) extends her reductivist vision in pristine white with a visual vocabulary of active verbs: cutting, folding, flipping, tacking, layering, covering, and exposing the paper of the drawing. Geometry remains its underlying structure.

Giving concrete visual form to the theoretical concepts of mathematics is just one of the ways Agnes Denes has demonstrated her genius for orchestrating the synergy of art and science. Born in Budapest and raised in Sweden, Denes emigrated to the United States as a teenager. Although she studied art

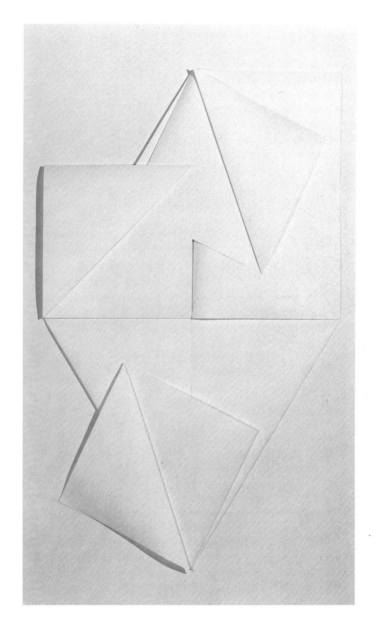

161
Dorothea Rockburne
White Angel #2, 1981
Rives BFK paper on mattboard with glue and blue pencil, 70 x 46 in.
Virginia Museum of Fine Arts, Richmond; Gift of The Sydney and Frances Lewis Foundation

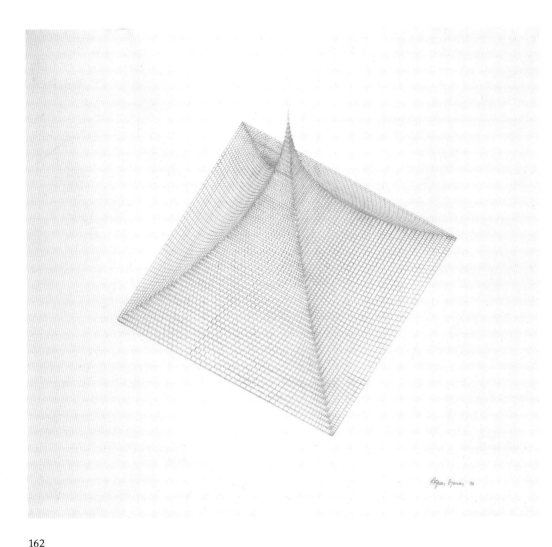

162
Agnes Denes
*Probability Pyramid in Perspective—Study for
Crystal Pyramid*, 1982
Silver ink on silk vellum, 36 x 39 in.
Collection of the artist

at New York's New School for Social Research and attended Columbia University, she regards herself as self-taught: for every project she conceives, she reads extensively in the relevant scientific or philosophical fields. In the past two decades her desire to abstract reality by drawing on the content and structure of science has fostered her intellectual investigations into such areas as linguistics, symbolic logic, set theory, typography, radiology, archaeology, crystallography, astronomy, physics, biology, cytology, genetics, and comparative anatomy.

Denes began her artistic career as an abstract painter, starting as an expressionist and moving on to hard-edge compositions prior to abandoning the medium altogether in 1967. A visionary artist of enormous range, Denes has, for example, executed a series of monoprints from X rays of such masterworks as Vincent van Gogh's self-portrait and Pablo Picasso's *Demoiselles d'Avignon*, in 1970–72. In penetrating and presenting the unseen layers of pigment, she revealed the hidden pattern of the artist's thinking process. Her best-known undertaking in rendering visible the invisible structure of thought is a group of drawings, the Pyramid series. With *Pascal's Triangle II* (1973), Denes became the first person to give visual form to the abstract mathematical theory of probability. She began by plotting a spiraling number system representing the relative probability of accidental repetition of chance occurrences. Having revealed the inherent logic of its structure, in her subsequent work she eliminated the network of numbers that had determined it and replaced the numbers with rectangular stones, thus realizing a graceful, dynamic, and flexible pyramid. Some of the ingenious pyramidal variations Denes has envisioned include a crystal edifice, seen from a bird's-eye view (plate 162); a stone mosaic "restless" pyramid displaying a uniquely curved

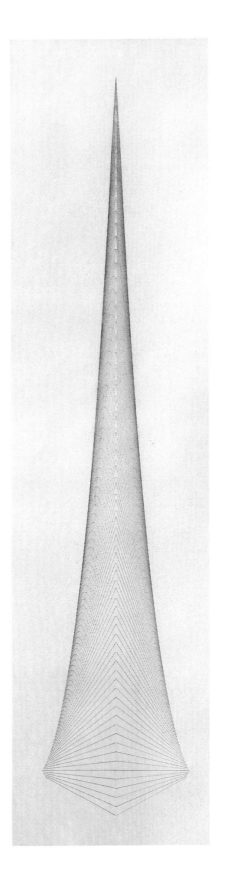

163
Agnes Denes
Systems of Logic/Logic of Systems, Studies for Steel-Cable Structure in Red, Black, and Silver, 1976
Ink on Mylar, 108 x 30½ in.
Collection of the artist

profile; a towering steel-cable "system of logic" (plate 163); an egg-shaped, self-supporting city dwelling; and a "monument to being earthbound," which incorporates a hovering miraculous teardrop (plate 164).

Recently Denes has been commissioned to build some of these large-scale symbolic structures. Her abiding interest in what she calls "public art with a conscience" was early evidenced in the 1968 outdoor performance piece *Rice/Tree/Burial,* in which she enacted three ritual gestures to symbolize life processes and the dialectics of thought. The continuity of her concern for the environment is evident in her 1982 public sculpture, *Wheatfield—A Confrontation* (plate 165). In lower Manhattan, within two blocks of Wall Street, Denes and assistants hand-planted two acres of wheat and faithfully maintained it for four months. That temporarily vacant plot of land worth several billion dollars yielded a harvest of nearly one thousand pounds of edible grain, representing the first crop grown in that earth since the era of the Indians. The project called attention, in a grass-roots fashion, "to our misplaced priorities and deteriorating human values."[3]

Jackie Ferrara is a sculptor who, like Denes, is concerned with the underlying logic of pyramidal forms but prefers to leave their content open-ended. Ferrara has been living and working as an artist in New York since 1951; in the early 1950s she took classes at the New School for Social Research and worked in ceramics. For her first solo exhibition in New York, in 1961, she showed small bronze figures that she had cast in Italy during a year abroad. An expressionist in the 1960s, Ferrara favored fetishistic combinations of flax, rope, feathers, and fur, hung from the ceiling. Her sculpture underwent a dramatic change of form, material, and installation after she spent a year renovating her loft in 1972.

She began to work with wood pyramids set

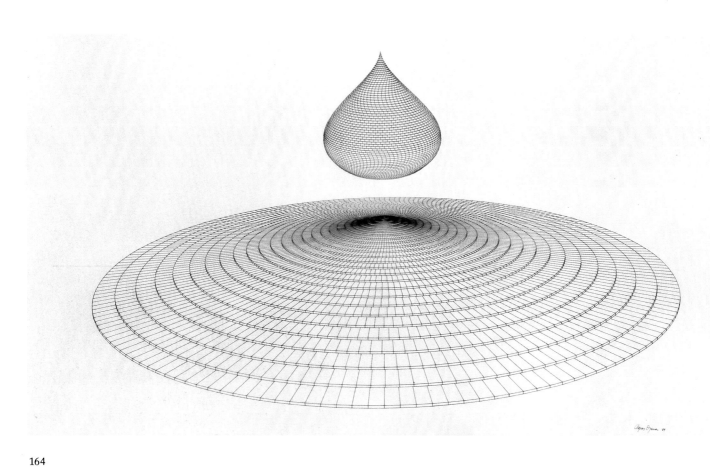

164

Agnes Denes

Teardrop-Monument to Being Earthbound (Top Free Floating), 1984
Ink on Mylar, 46 x 80 in.
Collection of the artist

165
Agnes Denes
Wheatfield—A Confrontation, 1982
Two acres of wheat planted and harvested, Battery
Park landfill, New York, 1982
Color photograph, 16 x 20 in.
Collection of the artist

166
Jackie Ferrara
A121 Curved Pyramid, 1973
Wolmanized fir, 35 x 60 x 18 in.
Collection of the artist; courtesy Max
Protetch Gallery, New York

167
Jackie Ferrara
A207 Recall, 1980
Pine, 76½ x 37½ x 37½ in.
Max Protetch Gallery, New York

168
Jackie Ferrara
A207 Recall, 1980
Pencil on paper, 2 sheets, 17 x 44 in. overall
Collection of the artist; courtesy Max Protetch
Gallery, New York

on the floor. The unadorned blocks and simple geometry of Ferrara's *A121 Curved Pyramid* (plate 166) reflect her new preference for neutral materials and systematic forms. Her initial pyramids and steps, fitting easily within the context of sculpture, have gradually evolved into increasingly complex, ordered, and elegant constructions with loosely fitting architectonic identities. She begins all of her work with a graph-paper diagram based on a predetermined set of proportions: "It's like a scientist in the lab. I set myself a problem and then solve it. . . . When the solution comes out in three dimensions, it's always interesting and surprising to me."[4] In *A207 Recall* (plates 167, 168), Ferrara

glued small modules of pine together to create an artfully awry profile, suggestive of an eccentric chimney. Indicative of her concern for both exterior and interior spaces, she weaves into her surface a pattern of visual caesuras that only partially reveals a covert inner chamber. Like her colleagues Alice Aycock and Mary Miss, Ferrara invests her architectural structures with a strong emotional content.

The structuring systems used by Rockburne, Denes, and Ferrara derive from mathematics. Alice Aycock, by contrast, bases her forms on the logic of the imagination. While Ferrara avoids specific historical allusions in her work, Aycock revels in conjuring

the past. The rich associative content of her sculpture is often nurtured by fanciful titles and accompanying texts that refer to history, literature, and personal fantasy. Aycock settled in New York in 1968, the year she received her B.A. from Douglass College, Rutgers University; she earned an M.F.A. degree from Hunter College three years later. In the early 1970s Aycock concentrated on installations, notable for their ambitious scale and simple materials. Her viewers were obliged to confront potentially dangerous situations as they wandered through mazes, crawled through openings, or inched their way across precariously high ledges. *Untitled (Shanty)* (frontispiece) uses the rough-hewn

169
Alice Aycock
One Hundred Small Rooms (Part II), 1984
Pencil on Mylar, 36 x 54 in.
George and Salina Muellich

170
Alice Aycock

A Salutation to the Wonderful Pig of Knowledge,
1984

Steel, copper, brass, aluminum, Formica, wood,
Plexiglas, and motorized LED parts, 82 x 112 x 139
in.

Collection of the artist; courtesy John Weber
Gallery, New York

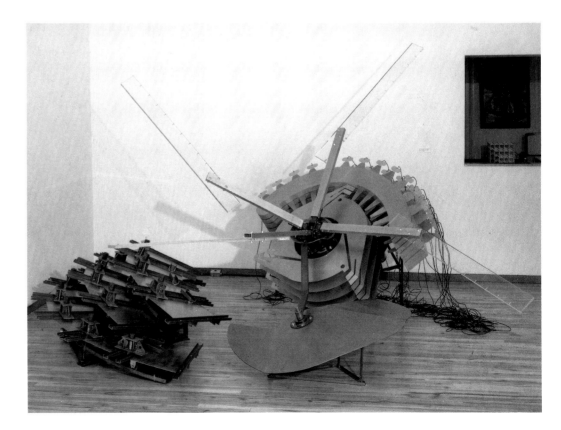

wood of the early pieces. The format of a house raised on a platform, with an open door on one side and an encompassing wheel on the other, returns the viewer to the role of a nonparticipating spectator, who may circle round the piece but not enter it. This highly evocative image was inspired in part by the preindustrial technology of the waterwheel and by the configuration of a medieval wheelhouse. Open to a figurative interpretation, as are the iconic dwellings of Louise Bourgeois, Miriam Schapiro, and Jennifer Bartlett, *Untitled (Shanty)* can be viewed as a fanciful descendant of Leonardo's *Man as the Measure of All Things*. The wood structure pictured at the center of *One Hundred Small Rooms (Part II)* (plate 169), built for a short-term installation in Houston, was inspired by a Roman attack fortress and by Aycock's fantasy of the American dream of the picket fence.

By the end of the 1970s Aycock had moved on from wood to metal materials and motorized components. Her "blade machines" of the early 1980s return the aura of danger to her work and extend her fascination with technology into the realm of personal fantasy. The domestic sphere furnished one stimulus for these works: at about that time Aycock acquired a Cuisinart and was acutely impressed with its Shiva-like role as "both a creator and destroyer."[5] *A Salutation to the Wonderful Pig of Knowledge* (plate 170), a blade machine of 1984, takes its title from a chapter heading in Aycock's novel-in-progress. Her highly personal vision of the implementation of technology evokes thoughts of the nineteenth-century author Mary Shelley. In envisioning Frankenstein's monster, a creature both seductive and terrifying, Shelley gave palpable form to widely held hopes and fears for the future of science. Many of Aycock's sculptures court the same fine edge between creation and destruction.

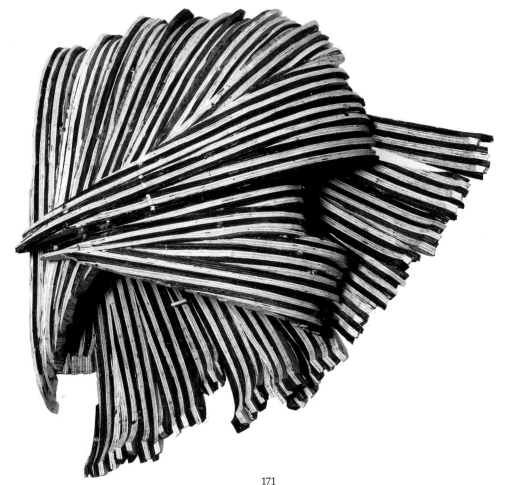

171
Heide Fasnacht
Pell Mell II, 1985
Wood and India ink, 58⅝ x 20¼ x 50½ in.
Columbus Museum of Art, Columbus, Ohio;
Purchased with funds made available from the
Awards in the Visual Arts Program

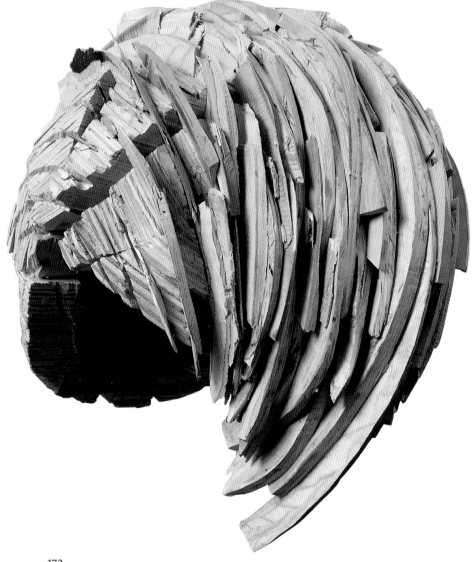

172
Heide Fasnacht
Portrait, 1985
Wood and various paints, 27½ x 21 x 30 in.
Diane and Steven M. Jacobson

Like Ferrara and Aycock, Heide Fasnacht builds systematic structures out of wood, a resonant material for sculptural constructions. Having studied at the Rhode Island School of Design, she moved to New York in 1974. Following course work at Hunter College and a subsequent M.F.A. at New York University, Fasnacht concentrated on large-scale installations. Her initial shift toward discrete objects evolved when she built exaggerated wall reliefs based on drawings that, in turn, were linear schematics of an installation entitled *Storm Windows*.

When Fasnacht's outdoor work *Twain* was smashed by vandals in 1980, the damaged shards evolved, phoenixlike, into a new body of work. This wall series, each element of which incorporates a sample of her previous art, is loosely figural and fabricated of laminated wood. Like much of the other work she did in the 1980s, *Portrait* (plate 172) is, in her words, "very much about heads, about the embryonic stage when the cranium is a crust for the brain and the face is a simple opening."[6] Curved like a talon yet gaily painted, *Portrait* is a bundle of double messages; it suggests both poles of such pairs as closed and open, abstract and figurative, freedom and control. Fasnacht's pieces belly out from the wall with an assertive thrust derived from body language. *Pell Mell II* (plate 171), with its muscular bands of concentric wood rings alternately stained with India ink, can be read as a sassy hand on a hip or a violently swiveled head. The raw splintery surfaces and curved volumes of Fasnacht's sculpture register the active presence of a fearsome will, whirling and shaping each piece like a force of nature.

In Alma W. Thomas's ordered vision of the world, she abstracted the color, shape, and movement of natural phenomena. At the age of eighty-one, Thomas had her first exhibition in a major museum, a retrospective that

173
Alma W. Thomas
Antares, 1972
Acrylic on canvas, 65¾ x 56½ in.
National Museum of American Art, Smithsonian Institution, Washington, D.C.; Bequest of Alma W. Thomas

174
Alma W. Thomas
Babbling Brook and Whistling Poplar Trees Symphony, 1976
Acrylic on canvas, 72 x 52 in.
Mr. and Mrs. Gilbert H. Kinney

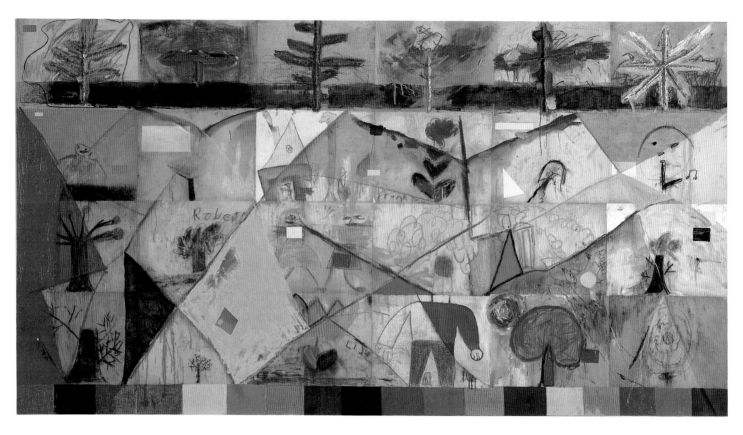

175
Joan Snyder
Sweet Cathy's Song (for Cathy Elzea), 1978
Mixed media, including children's drawings, papier-
mâché, chalk, and oil on canvas, 77¾ x 144 in.
Collection, The Museum of Modern Art, New York;
Gift of the Louis and Bessie Adler Foundation, Inc.,
Seymour M. Klein, President

appeared at New York's Whitney Museum and at the Corcoran Gallery of Art in Washington, D.C. Forty-eight years earlier she had been the first Howard University student to graduate with a degree in fine arts. But it was not until 1960, following her retirement from full-time teaching, that she was able to devote herself fully to painting. Associated for geographical and stylistic reasons with such Washington Color School painters as Gene Davis, Kenneth Noland, and Morris Louis, Thomas consistently charted her own course, unaffected by the currents of fashion. Guided by Impressionist and pointillist precursors, Thomas devised a systematic mosaic-like application of paint based on the direct observations of nature, especially light.

For Thomas, her "geometric designs—angles, curves and circles . . . all illustrate [her] impressions of nature in action."[7] This personal method, which systematically transformed her visual experience into abstract patterns, is seen to great advantage in *Babbling Brook and Whistling Poplar Trees Symphony* (plate 174). Here Thomas suppressed naturalistic details to extract a rhythmic, geometric infrastructure, using a range of blues and browns to convey the sensory equivalent of sound. *Antares* (plate 173), a densely patterned composition of vivid reds, takes its name from the brightest star in the southern sky. When she died a few years later, at age eighty-seven, Thomas was still painting at full strength.

Thomas used the stroke as a unit of pictorial construction; Pat Steir and her contemporary Joan Snyder use the mark as a content-laden formal language. Steir's expressionist gestures reference the history of painterly style. For Snyder, gestures are a record of emotional realities. Snyder took her first art course during her senior year at Douglass College, Rutgers University, in 1962. Her initial approach was expressionist, a mode to which she has been true for twenty-five years. In the 1960s she made painterly symbolic landscapes and a group of flatly painted and collaged female figures.

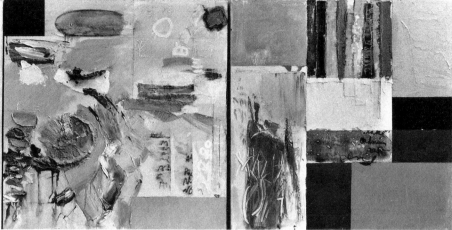

176
Joan Snyder
Small Symphony for Women #1, 1974
Oil and acrylic on canvas, 3 parts, each 24 x 24 in.;
24 x 72 in. overall
Suellen Snyder

Another, more abstract body of work used colors, shapes, and materials to convey a strong content of female sexuality. Snyder began her highly acclaimed series of expressionist Stroke Paintings in 1969, triggered by a pivotal, semiabstract landscape she painted that year. In these powerfully visceral canvases, stacks of showery paint strokes in an open-grid format seem transformed into raw pulses of emotion.

Snyder redefined her content in 1972, when she distanced herself from purely formal concerns and focused intently on the issues of the burgeoning women's movement. Paintings with overtly feminist themes now appeared, based in part on her 1960s iconography of fleshy female shapes. The sensuous, expressionistic gestures of the Stroke Paintings were often joined by handwritten texts and collage. Snyder used the tripartite structure of *Small Symphony for Women #1* (plate 176) to play out, in a musical fashion, three variations on the theme of female sensibility. The first square spells out "political ideas, dreams, colors, materials, angers, rage."[8] The second is an iconographic directory of signature words, images, and strokes. For Snyder, the final square recapitulates the others, offering "a resolve, a crescendo" of her intentions.

Snyder's feminism manifested itself in both content and form. Her interest in children's art derives from her intent to break down the hierarchies that elevate the work of trained artists above those who are not. The principal field of *Sweet Cathy's Song (for Cathy Elzea)* (plate 175) is made up of orderly rows of children's crayon drawings, forming a content-rich foil for her painted counterpoint of zigzagged colors and lines. Its four gridded registers permit the unfolding of distinct visual narratives. The bottom color bar encodes some of Snyder's symbolic associations, as in yellow for house, red for passion, pink for flesh. In the past decade Snyder's surfaces have become increasingly sculptural and she has returned to the landscape themes of her early work.

Notes

1. Cecilia Beaux, in Elizabeth Graham Bailey, "The Cecilia Beaux Papers," *Archives of American Art Journal* 13, no. 4 (1973): 18.

Extending the Boundaries of Abstraction: Stein
(pages 51–67)

1. Richard Marshall, *New Image Painting* (New York: Whitney Museum of American Art, 1979), pp. 9, 12.

2. Roberta Smith, "Motion Pictures," in *Elizabeth Murray: Paintings and Drawings* (New York: Harry N. Abrams, 1987), p. 9.

3. Robert Pincus-Witten, "Winsor Knots: The Sculpture of Jackie Winsor," *Arts Magazine* 51 (June 1977): 130.

4. Susan Rothenberg, in Grace Glueck, "Susan Rothenberg: New Outlook for a Visionary Artist," *New York Times Magazine*, July 22, 1984, p. 20.

5. Susan Rothenberg, in Peter Schjeldahl, "Putting Painting Back on Its Feet," *Vanity Fair* 46 (August 1983): 85.

6. Susan Rothenberg, in Jeremy Lewison, "Form and Expression in Susan Rothenberg's Prints," in *Susan Rothenberg, The Prints* (Philadelphia: Peter Maxwell, 1987), p. 10.

7. Lois Lane, "Statement," in Richard Marshall, *New Image Painting* (New York: Whitney Museum of American Art, 1978), p. 44.

8. Jeff Perrone, "Review," *Artforum* 16 (December 1977): 61.

9. Elizabeth Murray, in Paul Gardner, "Elizabeth Murray Shapes Up," *Artnews* 83 (September 1984): 55.

10. Lynda Benglis, in Linda L. Cathcart, *Extensions* (Houston: Contemporary Arts Museum, 1980), p. 18.

11. "Interview: Lynda Benglis," *Ocular* 4 (Summer 1979): 34.

12. Ibid., p. 32.

13. Jackie Winsor, in John Gruen, "Jackie Winsor: Eloquence of a 'Yankee Pioneer,'" *Artnews* 78 (March 1979): 60.

14. Ibid., p. 59.

15. Jackie Winsor, *Jackie Winsor* (New York: Museum of Modern Art, 1979), p. 29.

Extending the Boundaries of Abstraction: Wooster (pages 67–70)

1. Steina Vasulka, in Lucinda Furlong, "Tracking Video Art: 'Image Processing' as a Genre," *Art Journal* 45 (Fall 1985): 233.

2. Nam June Paik, in *Video in Technology*, ed. Judson Rosebush (Syracuse, N.Y.: Everson Museum, 1974).

3. Woody Vasulka, in Furlong, "Tracking Video Art."

4. Lizzie Borden, "Directions in Video Art," in *Video Art* (Philadelphia: Institute of Contemporary Art, 1975), p. 83.

5. Ibid., p. 84.

6. Nancy Holt, telephone conversation with author, January 1988.

7. Ibid.

8. Ibid.

9. Woody Vasulka, in Furlong, "Tracking Video Art," p. 236.

10. Furlong, ibid.

11. Steina Vasulka showed an award-winning tape of "close-ups of her mouth, twitching and grimacing in accompaniment to the Beatles' 'Let It Be'" at the first Women's Video Festival at The Kitchen in 1972. Shigeko Kubota described the tape in "Women's Video in the U.S. and Japan," in *The New Television*, ed. Douglas Davis and Allison Simmons (New York: Electronic Arts Intermix; Cambridge: MIT Press, 1977), p. 98.

12. Barbara Buckner, in Marita Sturken, "An Interview with Barbara Buckner," *Afterimage*, May 1985, p. 6.

13. Ibid., p. 7.

14. Ibid.

Reviving Representation: Stein (pages 71–88)

1. Lucy Lippard, "Faith Ringgold Flying Her Own Flag," *Ms.* 5 (July 1976): 36.

2. Faith Ringgold, in Grace Glueck, "An Artist Who Turns Cloth into Social Commentary," *New York Times*, July 29, 1984.

3. Joan Brown, in conversation with Kate Horsfield, in "Joan Brown," *Profile* 2 (May 1982): 21.

4. Janet Fish, in *Real, Really Real, Super Real: Directions in Contemporary American Realism* (San Antonio: San Antonio Museum of Art, 1981), p. 72.

5. Catherine Murphy, in John Gruen, "Catherine Murphy: The Rise of a Cult Figure," *Artnews* 77 (December 1978): 55.

6. Ibid., p. 57.

7. Judy Rifka, in Barbara Moynehan, "Judy Rifka," *Flash Art*, no. 108 (Summer 1982): 64.

8. Judith Shea, "Sculptors' Interviews," *Art in America* 73 (November 1985): 135.

9. Sandy Skoglund, in Jerry Tallmer, "The Goldfish Are on the Move," *New York Post*, January 7, 1981.

Reviving Representation: Wooster
(pages 88–96)

1. Judy Chicago, in Moira Roth, "Autobiography, Theater, Mysticism and Politics: Women's Performance Art in Southern California," in *Performance Anthology: Source Book for a Decade of California Performance Art*, ed. Carl E. Loeffler and Darlene Tong (San Francisco: Contemporary Arts Press, 1980), p. 466.

2. Linda Frye Burnham, "Performance Art in Southern California: An Overview," in *Performance Anthology*, p. 413.

3. Barbara Smith, in "Interview with Barbara Smith by Moira Roth," in *Barbara Smith* (San Diego: University of California, San Diego, 1974); reprinted in *Performance Anthology*, p. 118.

4. Moira Roth, ed., *The Amazing Decade: Women and Performance Art in America, 1970–1980* (Los Angeles: Astro Artz, 1983), p. 126.

5. Rachel Rosenthal, interview with Eelka Lampe, June 8, 1985; quoted in Eelka Lampe, "Rachel Rosenthal: Creating Her Selves," *Drama Review* 32 (Spring 1988): 170.

6. Jack Burnham, in *Performance Anthology*, pp. 404–6.

7. Roth, in *Performance Anthology*, p. 472.

8. Rachel Rosenthal, in *Performance Anthology*; reprinted from Jim Moisan, "Rachel Rosenthal," *LAICA Journal*, January 1979.

9. Linda Montano, in *Performance Anthology*, p. 324; reprinted from Moira Roth, "Matters of Life and Death: Linda Montano Interviewed by Moira Roth," *High Performance* 1 (December 1978): 2–3, 6–7.

10. Ibid.

11. Adrian Piper, in Roth, *Amazing Decade*, p. 122.

12. Adrian Piper, unpublished manuscript, "Notes on *Funk I–IV*," p. 7.

13. Roth, *Amazing Decade*, p. 122.

14. Joan Jonas, in *Video Art*, ed. Ira Schneider and Beryl Korot (New York: Harcourt Brace Jovanovich, 1976), p. 73.

15. Ibid.

16. Joan Jonas, *Joan Jonas Scripts and Descriptions 1968–1982*, ed. Douglas Crimp (Berkeley: University Art Museum, University of California, Berkeley; Eindhoven: Stedelijk Van Abbemuseum, 1983), p. 138.

17. Ibid., p. 124.

18. Doris Chase, interviewed in *Doris Chase: Portrait of an Artist*, a videotape by Robin Schazenbach, 1985.

19. Doris Chase, in Rob Edelman, "Doris Chase," *Sightlines*, Spring–Summer 1986, p. 27.

20. Ibid.

Responding to Nature: Stein (pages 97–116)

1. April Kingsley, "Six Women at Work in the Landscape," *Arts Magazine* 52 (April 1978): 108.

2. Clyde Connell, "Artist's Statement," in *Clyde Connell* (Shreveport: Louisiana State University Library, 1973), n.p.

3. Charlotte Moser, "Totems and Swamp Songs," in *An Exhibition of Works by Clyde Connell* (Tyler, Tex.: Tyler Museum of Art, 1979), n.p.

4. Clyde Connell, in Jamey Gambrell, "Essay," in *Awards in the Visual Arts 5* (Winston-Salem, N.C.: Southeastern Center for Contemporary Art, 1984), p. 14.

5. Lucy R. Lippard, "Mary Miss: An Extremely Clear Situation," in *From the Center: Feminist Essays on Women's Art* (New York: E. P. Dutton, 1976), p. 212.

6. Mary Miss, in "Round Table Discussions," in Hugh M. Davies and Ronald J. Onorato, *Sitings* (La Jolla, Calif.: La Jolla Museum of Contemporary Art, 1986), p. 107.

7. Ronald J. Onorato, "Battlefields and Gardens: The Illusive Spaces of Mary Miss," in *Sitings*, p. 81.

8. Kate Linker, "Mary Miss," in *Mary Miss* (London: Institute of Contemporary Arts, 1983), p. 139. Linker here cites the title as *Rotating Field*.

9. Nancy Holt, "Sun Tunnels," *Artforum* 15 (April 1977): 34.

10. Ibid., p. 32.

11. Nancy Holt, in Ronny H. Cohen, "'Cityside Sculpture,' Visual Arts, Ontario," *Artforum* 21 (January 1983): 83.

12. Michelle Stuart, in conversation with Kate Horsfield, in "Michelle Stuart," *Profile* 3 (May 1983): 4.

13. Michelle Stuart, in Elizabeth Duvert, "With Stone, Star and Earth: The Presence of the Archaic in the Landscape Visions of Georgia O'Keeffe, Nancy Holt, and Michelle Stuart," in Vera Norwood and Janice Monk, eds., *The Desert Is No Lady* (New Haven, Conn., and London: Yale University Press, 1987), p. 220.

14. This and the following unattributed quotations in the text are from a statement by Ana Mendieta in John Perreault, "Earth and Fire: Mendieta's Body of Work," in *Ana Mendieta: A Retrospective* (New York: New Museum of Contemporary Art, 1987), p. 10.

15. Deborah Butterfield, in *Deborah Butterfield* (Winston-Salem, N.C.: Southeastern Center for Contemporary Art, 1983), n.p.

16. Deborah Butterfield, in *Deborah Butterfield* (Providence: Rhode Island School of Design Museum of Art, 1981), n.p.

17. Deborah Butterfield, in Graham W. J. Beal, "Eight Horsepower," in *Viewpoints: Deborah Butterfield: Sculpture* (Minneapolis: Walker Art Center, 1982), n.p.

18. Sylvia Plimack Mangold, in Margaret Mathews, "Sylvia Plimack Mangold," *American Artist* 48 (March 1984): 84.

19. Mangold, ibid., p. 55.

20. Jennifer Bartlett, in Calvin Tomkins, "Getting Everything In," *New Yorker*, April 15, 1985, p. 61.

21. John Russell, quoted ibid., p. 62.

22. Marge Goldwater, "Jennifer Bartlett: On Land and at Sea," in *Jennifer Bartlett* (Minneapolis: Walker Art Center; New York: Abbeville Press, 1985), p. 39.

23. Marcia Tucker, "An Iconography of Recent Figurative Painting," *Artforum* 20 (Summer 1982): 70.

24. Jennifer Bartlett, in Nan Robertson, "In the Garden with Jennifer Bartlett," *Artnews* 82 (November 1983): 75.

25. Louisa Chase, journal entry for February 20, 1984, in *Louisa Chase* (New York: Robert Miller Gallery, 1984), n.p.

26. Ibid.

27. Walt Whitman, "Animals" [excerpted from *Song of Myself*], in *The Pocket Book of Modern Verse* (New York: Washington Square Press, 1961), p. 24.

Responding to Nature: Wooster (pages 116–21)

1. The first Women's Video Festival was organized by Susan Milano with Shridbar Bapat. Tapes included work by Milano, Steina Vasulka, Jackie Cassen, "Lesbian Mothers" by David Sasser, and Queer Blue Light Video. The festival concluded a live video and dance performance by Elsa Tambellini and Judith Scott. The second annual Women's Video Festival (1973) was enlarged to include fifty-seven artists and featured women working in electronic synthesis. Shigeko Kubota, "Women's Video in the U.S. and Japan," in *The New Television*, ed. Douglas Davis and Allison Simmons (New York: Electronic Arts Intermix; Cambridge: MIT Press, 1977), pp. 98–99.

2. Shigeko Kubota, in *Video Art*, ed. Ira Schneider and Beryl Korot (New York: Harcourt Brace Jovanovich, 1976), p. 83.

3. Shigeko Kubota, *Video Sculptures* (Berlin: Daadgalerie; Essen: Museum Folkwang; Zurich: Kunsthaus, 1982), p. 13.

4. Ibid., p. 37.

5. Ibid., p. 35.

6. Kubota directly identifies the volcano form with her body, saying, "Mountain-womb/My womb is a volcano." Ibid., p. 37.

7. Ibid.

8. Mary Lucier, in Sue Graze, *Mary Lucier, Wilderness* (Dallas: Dallas Museum of Art, 1987), p. 1.

9. Mary Lucier, in Ann-Sargent Wooster, "Video Installations," *Videography*, September 1984, pp. 79–85.

10. Lucier, in Graze, *Lucier*, p. 1.

11. Artist's statement, in *Rita Myers* (Richmond: Anderson Gallery, Virginia Commonwealth University, 1985), n.p.

12. Artist's statement, program notes for *The Allure of the Concentric*, Whitney Museum of American Art, New York, September 28–November 3, 1985.

Art with an Agenda: Stein (pages 122–43)

1. Linda Nochlin, "The Twentieth Century: Issues, Problems, Controversies," in *Women Artists: 1550–1950* (Los Angeles: Los Angeles County Museum of Art; New York: Random House, 1976), pp. 58–59.

2. Miriam Schapiro and Judy Chicago, in Linda Nochlin, "Feminism and Formal Innovation in the Work of Miriam Schapiro," *Miriam Schapiro, A Retrospective, 1953–1980* (Wooster, Ohio: College of Wooster, 1980), p. 21.

3. Miriam Schapiro, in Avis Berman, "Women Artists 1980: A Decade of Progress, But Could a Female Chardin Make a Living?" *Artnews* 79 (October 1980): 74.

4. Miriam Schapiro, in *Miriam Schapiro* (St. Louis: Brentwood Gallery, 1985), n.p.

5. Melissa Meyer and Miriam Schapiro, "Waste Not/Want Not, An Inquiry into What Women Saved and Assembled, Femmage," *Heresies* 4 (Winter 1977–78): 66–69. See also Norma Broude, "Miriam Schapiro and 'Femmage': Reflections on the Conflict between Decoration and Abstraction in Twentieth-Century Art," in Norma Broude and Mary D. Garrard, eds., *Feminism and Art History: Questioning the Litany* (New York: Harper and Row, 1982), pp. 315–29.

6. Betye Saar, in Eleanor Munro, *Originals: American Women Artists* (New York: Simon and Schuster, 1979), p. 356.

7. Betye Saar, in Peter Clothier, "The Other Side of the Past," *Betye Saar* (Los Angeles: Museum of Contemporary Art, 1984), p. 16; quoted from Grace Glueck, "Betye Saar, Artist Inspired by the Occult," *New York Times*, February 16, 1978.

8. Nancy Spero, in Elaine King, "The Black Paris Paintings," in *Nancy Spero: The Black Paris Paintings 1959–1966* (Pittsburgh: Carnegie-Mellon University, 1985), p. 13.

9. Nancy Spero, "Nancy Spero Interviewed by Tamar Garb," *Artscribe*, no. 64 (Summer 1987): 61.

10. Nancy Spero, "Dialogue: An Exchange of Ideas between Dena Shottenkirk and Nancy Spero," *Arts Magazine* 61 (May 1987): 34.

11. A similar tactic was used by Miriam Schapiro and Sherry Brody in their *Doll House* (plate 108), where the woman artist's studio is equipped with a male nude model.

12. Sylvia Sleigh, interviewed by Gerrit Henry, "The Artist and the Face: A Modern American Sampling," *Art in America* 63 (January 1975): 39.

13. Carolee Schneemann's 1968 statement is quoted in Lucy R. Lippard, "The Pains and Pleasures of Rebirth: Women's Body Art," *Art in America* 64 (May 1976): 76.

14. Hannah Wilke's statement, made in conjunction with her 1977 Ontario performance, *Intercourse with. . . ,* is quoted in Lowery Sims, "Body Politics: Hannah Wilke and Kaylynn Sullivan," in *Art and Ideology* (New York: New Museum of Contemporary Art, 1984), p. 45.

15. Ibid.

16. Hannah Wilke, *New York*, February 11, 1974.

17. Hannah Wilke, in Gerrit Henry, "Views from the Studio," *Artnews* 75 (May 1976): 35.

18. The series included in this exhibition was the one sent to artist Sol LeWitt.

19. Eleanor Antin, *Matrix 34* (Hartford, Conn.: Wadsworth Atheneum, 1977), n.p.

20. Eleanor Antin, in conversation with Nancy Bowen, in "Eleanor Antin," *Profile* 1 (May 1981): 11.

21. Cindy Sherman, in Gerald Marzorati, "Imitation of Life," *Artnews* 82 (September 1983): 84–85.

22. Cindy Sherman, in Andy Grundberg, "The 80s Seen through a Post-Modern Lens," *New York Times*, July 5, 1987, p. 29.

23. Cindy Sherman, in Sandy Nairne, Geoff Dunlop, and John Wyver, *State of the Art: Ideas and Images in the 1980s* (London: Chatto and Windus in collaboration with Channel Four Television Co., 1987), p. 136.

24. Sherman, in Grundberg, "The 80s Seen through a Postmodern Lens," p. 25.

25. Barbara Kruger, in Carol Squiers, "Diversionary (Syn)tactics," *Artnews* 86 (February 1987): 79.

26. Ibid., p. 81.

27. Along with a group of fiber works by women artists, including a related hanging piece by Jackie Ferrara, this 1972 piece is reproduced in Elizabeth Weatherford, "Crafts for Art's Sake," *Ms.* 1 (May 1973): 30.

28. Jenny Holzer, in Bruce Ferguson, "Wordsmith: An Interview with Jenny Holzer," in *Jenny Holzer: Signs* (Des Moines: Des Moines Art Center, 1986), p. 66.

29. Ibid., p. 67.

30. Ibid., p. 69.

31. Ibid., p. 72.

32. Sherrie Levine, in Jeanne Siegel, "After Sherrie Levine," *Arts Magazine* 59 (June 1985): 142.

33. Ibid., p. 141.

34. The metaphor of a woman artist's playful yet serious pugnacity was early employed by Judy Chicago, who posed in satin trunks and boxing gloves for a 1968 ad in *Artforum*.

35. Sherrie Levine, in "Sherrie Levine Plays with Paul Taylor," *Flash Art*, no. 135 (Summer 1987): 56.

Art with an Agenda: Wooster (pages 143–54)

1. Lucy R. Lippard, *Get the Message? A Decade of Art for Social Change* (New York: E. P. Dutton, 1984), p. 135.

2. Martha Gever, "Video Politics: Early Feminist Projects," *Afterimage* 11 (Summer 1983): 25.

3. Craig Owens, "The Discourse of Others: Feminists and Postmodernism," in *The Anti-Aesthetic: Essays on Postmodern Culture*, ed.

Hal Foster (Port Townsend, Wash.: Bay Press, 1983), p. 77.

4. Martha Gever, "An Interview with Martha Rosler," *Afterimage* 9 (October 1981): 11.

5. Rosler, ibid.

6. Ibid., p. 14.

7. Margia Kramer, program notes, Anthology Video Program, Anthology Film Archives, New York, May 8, 1986.

8. Ibid.

9. Quoted in the program notes for Kramer's installation of *Progress (Memory)* at the Whitney Museum of American Art, New York, March 13–April 8, 1984.

10. Hal Foster, "Subversive Signs," in *Recodings: Art, Spectacle, Cultural Politics* (Seattle: Bay Press, 1985), p. 100.

11. Laurie Anderson, in Moira Roth, ed. *The Amazing Decade: Women and Performance Art in America, 1970–1980* (Los Angeles: Astro Artz, 1983), p. 74.

12. Laurie Anderson, in Rob La Frenais, "An Interview with Laurie Anderson," in *The Art of Performance: A Critical Anthology*, ed. Gregory Battcock and Robert Nickas (New York: E. P. Dutton, 1984), p. 259.

13. Ibid., p. 265.

14. Ibid.

15. Benjamin H. D. Buchloh, "From Gadget Video to Agit Video: Some Notes on Four Recent Video Works," *Art Journal* 45 (Fall 1985): 222.

Rediscovering Decorative Traditions: Stein
(pages 155–67)

1. Ree Morton, in Allan Schwartzman and Kathleen Thomas, "Ree Morton, A Critical Overview," in *Ree Morton: Retrospective, 1971–1977* (New York: New Museum of Contemporary Art, 1980), p. 58.

2. Valerie Jaudon and Joyce Kozloff, "Art Hysterical Notions of Progress and Culture," *Heresies* 4 (Winter 1977–78): 38–42.

3. Ibid., pp. 40 and 39.

4. Joyce Kozloff, in Hayden Herrera, "A Conversation with the Artist," in *Joyce Kozloff:*

Visionary Ornament (Boston: Boston University Art Gallery, 1986), p. 28.

5. *Gertrude Stein on Picasso*, ed. Edward Burns (New York: Liveright Publishing Corp., 1977), p. 76.

Exploring Structures and Systems: Stein (pages 168–81)

1. Ellen Johnson quotes this phrase of Duchamp's in her discussion of Conceptual art in *Modern Art and the Object* (New York: Harper and Row, 1976), p. 39.

2. Dorothea Rockburne, in Roberta Olson, "An Interview with Dorothea Rockburne," *Art in America* 66 (November–December 1978): 144.

3. Agnes Denes, "Wheatfield—A Confrontation, The Philosophy" (unpublished statement), Summer 1982.

4. Jackie Ferrara, in Phil Patton, "Jackie Ferrara: Sculpture the Mind Can Use," *Artnews* 81 (March 1982): 109–10.

5. Alice Aycock, quoted in Maurice Poirier, "The Ghost in the Machine," *Artnews* 85 (October 1986): 84.

6. Heide Fasnacht, in Steven Henry Madoff, "Sculpture Unbound," *Artnews* 85 (November 1986): 107.

7. Alma W. Thomas, *Alma Thomas: Recent Paintings 1975–1976* (New York: Martha Jackson West, 1976), n.p.

8. Joan Snyder, in Hayden Herrera, *Joan Snyder: Seven Years of Work* (Purchase, N.Y.: Neuberger Museum, 1978), p. 24.

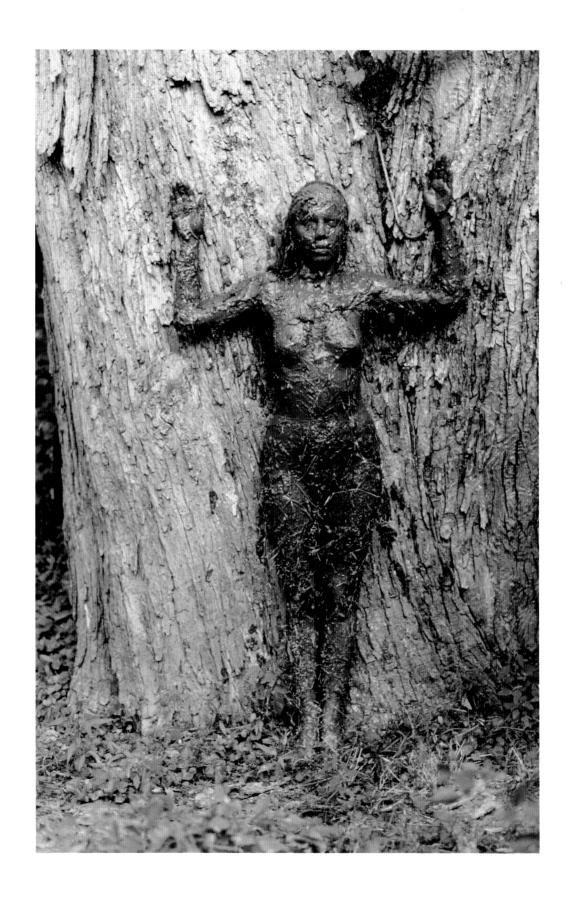

Thomas McEvilley

Redirecting the Gaze

177
Ana Mendieta
Arbol de la Vida, no. 294, from the Arbol de la Vida/Silueta (Tree of Life/Silhouette) series, 1977
Color photograph, 20 x 13¼ in.
Documentation of earth-body sculpture with artist, tree trunk, and mud, at Old Man's Creek, Iowa City, Iowa
Hans Breder

One day in 1970 fifty thousand women marched down Fifth Avenue in New York (plate 178). It is said to have been the biggest women's gathering since suffrage days, a little more than half a century before. The 1970 event was more a critique of that half-century than an homage and commemoration of the suffrage amendment. Why, it implicitly asked, had fifty years passed without significant correction of the deficiencies of women's roles in American society? In 1923, four years after the Nineteenth Amendment acknowledged American women's right to vote, the United States Senate had begun discussing the Equal Rights Amendment. Now almost fifty years had passed without action on it. There was a sense that the ice was breaking at last or that the dam of frustration had burst. In the same year, 1970, the Senate revived its hearings on the ERA—hearings that had ended in 1956.

The mood was spreading beyond politics into the culture at large. Women's studies programs began to be established in American universities, sponsoring attempts to see history as a history of women as much as of men, and to understand culture without the intervention of a specifically masculine point of view. The fine arts also felt the impact of women's claims upon cultural roles that had long been closed to them. In the watershed year, 1970, a group called Women Artists in

Revolution (WAR) protested the unequal gender proportions in the Whitney Museum's annual survey exhibitions. Another group, called Women in the Arts, demonstrated against unequal representation in exhibitions at both the Whitney and the Museum of Modern Art. Two years later, in 1972, women members of the College Art Association formed the Women's Caucus on Art, which in 1974 left the association and became an explicitly feminist organization.

In the art world as elsewhere these events protested not only the male-dominated power structure of the present and its threatening influence on the future, but also its distortions of the past. New lines of research by feminist art historians began to reveal that there had been important women artists in Europe and America for centuries, but that their contributions had been excluded from the record. H. W. Janson's *History of Art*, the standard college textbook, did not at that time mention a single woman artist. The great thirteenth-century cosmographer Hildegard of Bingen was not mentioned; nor was the sixteenth-century painter Sofonisba Anguissola, whom Michelangelo praised and Vasari—in that more enlightened age—wrote about. The powerful and active women portrayed by Artemisia Gentileschi (1593–1652) were not seen; the Mannerist self-portraits of the Flemish artist

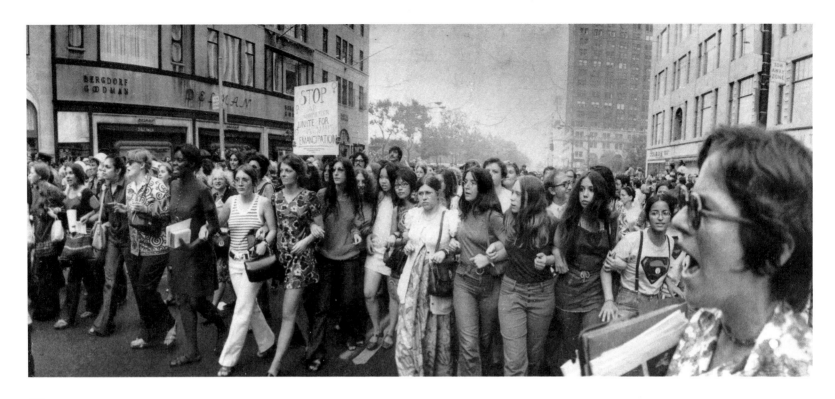

178
March down Fifth Avenue, August 26, 1970

Clara Peeters (1594–?), the Neoclassical goddesses of Angelica Kauffman (1741–1807) and Elizabeth Vigée-Lebrun (1755–1842), even the Impressionist masterpieces of Mary Cassatt (1844–1926) and Berthe Morisot (1841–1895) were as invisible as if they had never existed. The modern age was dedicated to the cult of the male.

Western social mores, of course, had long given a preferred place to men in cultural activities. But the fiction that art was inherently and exclusively a domain of men was fully locked into place by an ideology that arose in the early Romantic period—that is, in the late eighteenth century. At that time the

emerging middle class set itself off from the traditional courtly class by projecting an opposite claim to privilege. The aristocratic claim to divine right was countered by the bourgeois claim of personal achievement. This emphasis on individuality was then co-opted, in the age of the Napoleonic wars, into a mystical-prophetic view of history that was fully articulated around 1810 in G.W.F. Hegel's philosophy of spirit. In this view, as elaborated by Hegel's contemporaries and successors (Schnaase, Schelling, Schiller, the Schlegels, and others), the artist came to be seen as the forward edge of history's advance toward pure spirit. He was a solitary hero

whose quest for hyper-truths took him out on a metaphysical razor's edge. His work was more than personal self-expression: it was a voyage of discovery marking a trail of spiritual attainment that would lead humanity to higher planes. Art was viewed as a glimpse into the beyond—a glimpse that could only be attained through personal heroism and peril. In the Romantic tradition—which laid the foundations of the modern practice of art history—it was believed that somehow human destiny in the broadest sense depended on the mighty adventure of the artist piercing into the unknown beyond.

This value system remained relatively

unquestioned throughout the nineteenth century and most of the twentieth. It was inherently sexist. It excluded women from the most serious resonances of the role of the artist because that role was confused with the (traditionally military) role of the hero. Our culture, unlike some others, had no significant tradition of female heroes—no Antigones or Medeas who take matters into their own hands and remake them in their own image. As long as the artist's role was associated with that of the hero, it would remain a primarily masculine domain.

This ideology, reading man as active and woman as passive, assigned to women the role of the model rather than the artist. Art became an expression of what, in recent discourse on psychology and art, has come to be called the male gaze—the gaze of a conquering hero who sees the world as a passive domain lying ready for his possession. Women appeared as objectified for the delectation of that gaze—often naked, helpless, coquettish, contextualized as possessions. Woman, in short, was the object, not the subject. She responded to the manipulations of the male observer, posing as whatever he wanted. When representational art, with its mythos of artist and model, was temporarily eclipsed by abstract art early in this century, the situation grew even more sexist. Early abstractionists, following the Romantic ideology, felt themselves keenly to be heroes and shapers of destiny. But the sexism of this belief was heightened by the fact that their arena of conquest had shifted to a world of pure form that was more or less the opposite of the world of nature, materiality, and everyday experience. Women were associated, in the prevailing ideology, precisely with the domains of nature and domesticity that the heroic conquerors of pure form had to leave behind, like fighter pilots in World War II movies kissing their weeping girlfriends goodbye.

By the late 1960s various events—including the Vietnam War, the civil rights movement, the student rebellions (especially those in Paris in May 1968), and headlong nuclear proliferation—had exposed disquieting ethical deficiencies in this ideology. The transcendentalist view of art—the view that art has less to do with this world than with a hypothetical beyond—began to be seen as dangerously asocial, if not outright antisocial. The conquest of realms of pure form seemed slight consolation for losing this world here and now. The artist as hero seemed sadly lacking in real effectiveness beyond the ability to whip up a transient froth of emotions. By excluding political and social meanings, the emphasis on pure form had eliminated art—especially the abstract art of the 1950s and '60s—as a possible force for social change. By the 1970s the exclusion of meanings from art seemed truly to have rendered it meaningless. Abstract art seemed to have been involved, however unintentionally, in a repressive cultural structure that endangered, instead of promoted, the survival of civilization.

It was this same wave of realization that broadened the base of the women's movement and sent it flooding down Fifth Avenue. In order to break out of the passive role imposed by a patriarchal ideology, activist women had to take an adversary role. To break into a new, more open structure they would have to expose, controvert, and subvert those hidden ideologies that perpetuated archaic patterns of male power and authority at a time when the world was clearly threatened by them. The cause of feminist art in the 1970s, in other words, went beyond the already massive project of evening up the gender score; it involved a kind of critique of society and—still in keeping with the traditional view of woman as bound to the world of nature—an implied custodianship of the earth in response to growing ecological dan-

gers. Whether women have aesthetic tendencies that are innately different from those of men is simply unknown and may remain so; but clearly, granted the surrounding political situation, feminist artists had to set themselves off from the inherited artistic modes in very deliberate ways. A number of strategies to accomplish this emerged.

Some artists continued to employ the traditional male-heroic genre of the easel painting but adapted it to various more or less subversive purposes. Miriam Schapiro, for example (who refers to her work as "femmage"), introduced imagery reminiscent of the traditional female domain of the home, such as wallpaper patterns, and returned emphasis from the art of pure form to the crafts orientation of earlier societies (plates 108–10). Catherine Murphy (plates 55–57), Janet Fish (plates 53, 54), and others made realist or hyper-realist paintings of everyday domestic subjects, tacitly rejecting the otherworldliness of the male art of the abstract sublime. Vija Celmins, in her hyper-detailed pencil drawings of the ocean surface (plate 39); Michelle Stuart, in her incorporations of leaves and earth into her paintings (plates 84–86); Ann McCoy, in her colored pencil depictions of undersea scenes; and Melissa Miller, in her portrayals of animals in the wild away from human sensibility (plates 99–100), stepped part way out of (male-dominated) culture, making (traditionally female) nature the subject of their work. By applying the tools of culture—for example, artistic methods and media—directly to nature, they implicitly rejected the patriarchal distinction between nature and culture, which was based on the transcendentalist idea that history's course aims not at an integration into this world but at an attainment of the sublime. Subverting the male emphasis on pure form and transcendence of personality, Linda Montano (plate 70), Eleanor Antin (plate 125), and others opened their perfor-

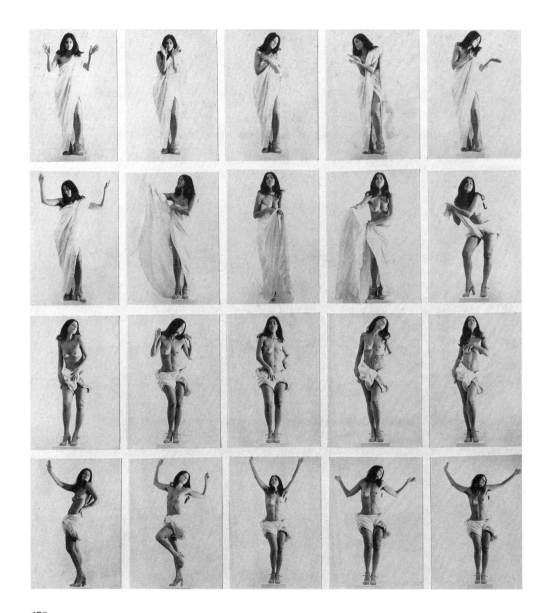

179
Hannah Wilke
Hannah Wilke: Super-T-Art, 1974–76
20 black-and-white silver-print photographs, 40 x 30
in. overall (framed)
From the series Soup and Tart, performed at The
Kitchen, New York, 1974
Collection of the artist

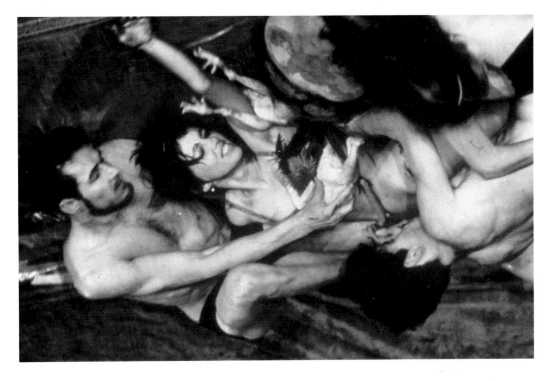

180
Carolee Schneemann
Meat Joy
Performance at Judson Church, New York, 1964

mance art to autobiographical and personal elements. These developments altered the media they occurred in, making the art audience more aware of the decorative nature of abstract art and opening performance to elements of everyday personality as opposed to male performance's emphasis on the special ordeal and the shattering of convention (as in the work of Chris Burden and Vito Acconci).

But the attempt on the part of feminist artists to discover a woman-centered aesthetic was a difficult act of self-knowing in a society where self-knowledge had not seemed the prerogative of women and where women's self-image had been radically distorted by the male gaze. Even more radical and sweeping strategies were required to truly redirect the gaze and regain access to a theoretically unmediated female selfhood. Two major strategies arose, which define the situation as much by their difference as by their shared goal. The first of these to appear, and the dominant strategy throughout the 1970s, was the redirection of attention to ages and cultures when women had not been subservient, as a means of research toward finding a female face and self for the present. From the male-dominated linear model of history, with its idea of progress and its emphasis on national states and their wars and empires, some women's (and some men's) gazes shifted toward an earlier age in which female archetypes ruled. The religious stereotype of the Earth Mother or Great Goddess was brought into the foreground as a corrective to the long dominance of the stereotype of the transcendent and warlike sky god (such as Zeus or Yaweh), which came to be seen as symbolic of bombs and missiles raining from the sky.

This approach was radical in that rather than attempting to modify the outlines of art history as they had been known it vaulted over them altogether. The patriarchal nature of art historiography made it seem worthless,

What big muscles you have!

My lordship My lancelot My crusader for peace with dignity My Chairman of the board My guardian of culture My professor of desire My host with the most My Dagwood My Rambo My Popeye My pimp My doctor My banker My lawyer My landlord My soldier of fortune My provider My better half My wunderkind My quarterback My the charts My great artist My baby mogul My sugar daddy My ticket to ride My jack of all trades My leader of the pack My capo My pope My stickman My ayatollah My daddy

181
Barbara Kruger
What Big Muscles You Have!, 1985
Vinyl lettering on Plexiglas, 60 x 80 in.
Centre Georges Pompidou, Paris

an artificial boundary to be leapt over into a much vaster arena. Art of this tendency based itself on the evidence of cultures that had preceded the development of the national state by thousands of years and that have been popularly known as matriarchal. Anthropologists have cautioned that there is no unequivocal evidence of an ancient matriarchy—that is, a society in which political decisions were made entirely by women rulers. Nevertheless, there is unequivocal evidence of societies (such as Çatal Huyuk, which flourished around 6000 B.C. in Asia Minor) whose archaeological remains feature mature females in iconic poses that do not suggest allegiance to any male masters. Such cultures seem to have worshiped goddesses more vigorously than gods, who were subservient to their female counterparts, and to have involved a sense of the timelessness of culture as opposed to the idea, which has dominated modern European thought, that history is driven by a force of progress—an idea that promoted the unlimited self-assertion of the state and brought with it the consequences of war and devastation. A matriarchal aesthetic (as some feminist authors have called it) was seen as involving a nonlinear or circular idea of history, a noncompetitive, nonhierarchical structure, a communal or shared expressiveness, and a ritual, often therapeutic intention. Masculine repressiveness would be abjured, and sexuality—especially female sexuality—would be presented as an object of reverence.

In the 1970s this approach to art, with its rejection not only of accustomed media and genres but of the schema of art history as a whole, seemed to mark an epochal turning point. There was a prophetic feeling in the air that a major shift of cultural ages was occurring or about to occur. This feeling was optimistically heralded in works such as Mary Beth Edelson's wry telephone-operator–like

182
Jenny Holzer
Untitled, with selections from Truisms, 1984
Electronic LED sign, 5½ x 30½ x 6 in.
Stefan T. Edlis

announcement of the end of the age of male dominance, *Your Five Thousand Years Are Up* (1977). It was a ritual performance in which eleven women acted out, through chants and movements, a transition from mourning the repression of women to celebrating the end of the patriarchal era.

The evocation of modern identities for ancient goddesses and of modern forms of fertility rites based, however loosely, on those from goddess-worshiping cultures informed widespread genres of feminist art of the 1970s. In ancient societies ritual had both a bonding and a therapeutic function, and many, perhaps most, artworks were manufactured as ritual accoutrements. Much

women's art of the 1970s and '80s featured the revival of these intentions. While this work might be expected in time to reenter the framework of received art history by some mode of mediation with it, it served, in its moment, a transitional function of freeing the work of women seeking a content of their own into areas where few male artists felt either inclined or empowered to tread. The artists whose works are briefly mentioned here do not necessarily share a single feminist orientation; nor do these observations account for the full range of contributions made by women artists to the art of the 1970s. Still, the works mentioned here, however individual, share the quality of suggest-

ing elements of prepatriarchal rite.

Many women artists eschewed painting—especially abstract painting—as a domain polluted by long saturation with male dominant values, and developed their themes in performance. Edelson (plate 4), Carolee Schneemann (plate 180), Ana Mendieta (plate 177), Hannah Wilke (plates 122, 179), and other women artists presented their own bodies as instantiations of ancient goddesses. Much women's art of this type relates to what in feminist literary criticism is called "writing the body." As against the male assertion of abstract painting or modernist literature as essentially otherworldly endeavors aimed at immaterial realities, these and other women

artists restored focus to the reality of the body and with it to social and personal realities.

Sometimes elements drawn directly from the ancient goddess religions were revived: the multibreasted torso of the goddess Artemis as worshiped in the Asian Greek city of Ephesus (which was used by the performance group called, ironically, The Waitresses); the vagina-covered clay figurines of fourth-millennium B.C. Mesopotamia (echoed in certain of Wilke's works in which she has presented her body covered with vaginal symbols); the ancient connection between goddesses and serpent rites (seen as early as 1963 in Schneemann's *Eye Body*). Under the auspices of the revived goddesses the genre of ritual performance art unfolded. Artists such as Schneemann, Donna Henes, and Betye Saar integrated into their performances elements of shamanism (a profession that may have belonged to women before it was taken over by men). Henes's solstitial and equinoctial rites marked off stages of the ancient agricultural calendar. Montano, Rachel Rosenthal (plate 69), and Nina Wise explored the effects of the drumming stage of shamanic performance.

Elements of ancient goddess culture were not evoked exclusively in performance. For example, images such as that of Sheela, the Celtic goddess of fertility and sexuality who is commonly portrayed displaying her vagina, are found in Nancy Spero's hand-pressed prints. Mary Frank's ceramic sculptures of women (plates 75, 76) evoke the ancient tradition of the goddess as ceramic vessel, whether intuitively or with fully conscious intention. Many other artists created objects or installations that suggest or imply the accoutrements or locations of ancient rites. Faith Ringgold's neoprimitive masks and feather fetishes have sometimes been accumulated into major installations such as her *Fam-*

ily of Women (1973). Saar's *Spiritcatcher* (1976–77) and *Indigo Mercy* (plate 114) allude to a type of primitive magical object. Nancy Holt's *Sun Tunnels* (plates 81, 82) were constructed on the religio-astronomical principles that governed many ancient ritual places. Judy Chicago's communal project of the mid-1970s, *The Dinner Party* (plate 107), presented an altarlike table for a rite of communion among famous women from all ages, with vaginal icons as the overriding image (in both the triangular shape of the table and the individual place settings). Women painters and sculptors have also contributed to this iconography. Clyde Connell (plate 78), Jackie Ferrara (plates 166, 167), and others have sculpted representations of the idea of ritual centrality. Some of the installation works of Nancy Graves and Eva Hesse fetishized the space so the viewer seems to be gazing into an area once ritualized, now abandoned, perhaps to be brought into ritual life again.

The Great Goddess or body-writing approach had an unquestioned power that arrested the attention of the art world. An approach to art history from outside its usual purview had established new positions from which to view its limitations. Still, as the 1970s unfolded, other artists took different approaches to the question of feminine identity and self-knowledge. As the approaches ramified, inner tensions grew among the artists. Some felt that the Great Goddess archetype did not subvert but on the contrary strengthened the sexist ideology in which femaleness was associated with instinctual drives, the earth, and the unconscious. To emphasize and affirm this cliché was a bold reversal of values, but without a correspondingly bold alteration of concepts. The female body was still being presented as a signifier of a primal oneness that preceded cultural accomplishment, rather than as a cultural

object mediated by discourses, patriarchal and otherwise, that still needed analysis. Other strategies arose that were less concerned with reintegrating art into a female religious milieu and more concerned with reversing the sexist procedures of art history in particular and society in general. Sylvia Sleigh's paintings of male nudes reversed the tradition of the male gaze and converted her male models to passive receptivity (plate 120). Sherrie Levine, in her appropriations of male masterpieces, parodied heroic ideas of originality and conquest (plates 133, 134). Images of violence against women—traditional in such subjects as the Rape of Europa, the Rape of the Sabine Women, and so on—were seen with new awareness of their unacceptability in works such as Joan Snyder's *Resurrection* (1977) and other paintings in which she has depicted rape victims. The blithe image of the buxom wench being dragged into the forest was made bitterly real and unbearable in Suzanne Lacy's 1977 performance work *Three Weeks in May* (with assistance from Barbara Cohen, Melissa Hoffman, Leslie Labowitz, and Jill Soderholm), in which rape as an ongoing social practice was documented and protested.

A significant group of artists turned their attention to the ways imagery of women has been manipulated to naturalize and perpetuate their subservience. Their work uses as material the iconographies of the contemporary media systems that ratify male authority. Often under the influence of structuralist and poststructuralist thought, mostly from France, they set about taking apart or deconstructing the communications codes by which unspoken assumptions of male supremacy have been held in place. These artists, while for the most part rejecting the traditional male-assertive field of painting, have turned not to performance but to industrial or technological media, prominently including photography

and video. Cindy Sherman has photographed herself in various costumes and settings reminiscent of the male stereotypes of women, especially in the movies (plates 127, 128). The distorting effect of the male gaze is focused into a concentrated essence in these works. Barbara Kruger, rather than making her own photographs, has combined found media imagery involving the male gaze and its various hidden projections of personal power with brief texts of her own devising (plates 130, 181, 183). Sometimes by reinforcement of the thrust of the image, sometimes by controversion of it, and sometimes by oblique wry comment, these texts force on the viewer an awareness of the process whereby concepts such as womanness—and power-supporting concepts in general—are created and maintained. Jenny Holzer has adopted various media of advertisement and power, including the poster and the light sign—a medium associated with both advertisement and presentations of the official news of the patriarchal state—to present messages that subvert the conventional pronouncements that the media themselves lead one to expect (plates 131, 132, 182). Dara Birnbaum's videotapes, often incorporating found television footage, lead the viewer to formulate critiques of media icons, especially those involving the depiction of women (plate 140).

The goddess-revival approach and the media-analysis approach are the two great strategies of feminist art to date, and there is a disturbing tension between them that has recently seemed to harden into an ideological polarization. Feminist artists and critics who emphasize deconstruction of the social means of constructing identity have expressed the misgiving that the work of goddess-reviving artists, with its emphasis on the depiction of the female body, may be complicit with the male gaze and with the long tradition of

patriarchal exploitation of the female image. Goddess-reviving artists, on the other hand, have expressed the misgiving that the deconstructivists, with their emphasis on language, analysis, and French philosophy, may be complicit with the male emphasis on intellectual mediation of experience—that they are, as one such artist put it, "phallicized by their conceptual rigor."

Yet it can be argued that both these strategies are necessary and that their difference is more complementary than contradictory. The goddess-reviving artists are reacting to the fact that for millennia the female body has been culturally colonized by the patriarchal order; they are trying, in effect, to take their bodies back. The deconstructivists are reacting to the equally long and thorough patriarchal colonization of the female mind; they are trying, in effect, to take their minds back. Clearly the two projects are equally necessary and drive toward the same end. And clearly the accomplishments of both are related.

Both approaches have, in different ways, reclaimed art's ancient connection with therapy—both personal and public—and given art an explicit social force and meaning that it lacked through the long hegemony of transcendentalist abstraction. The various feminist approaches, together, have managed to establish and validate strong counterpositions to a set of cultural presuppositions and prejudices that had long been dominant. The adversarial power of art has been reestablished after long quiescence. Content and meaning are again elevated, as in the art of premodern cultures, over the innately depoliticizing obsession with pure form. Ways have been shown for the art of the future to shape culture rather than submit to a passive coverup for a dominant ideology.

But the story is by no means over. Troubling questions remain. The project of expos-

ing and subverting the inherited and entrenched aesthetic of the male gaze implies that there is an authentic female gaze that will emerge once bondage to the male gaze has ended. Yet many of these modes of specifically women's art have the disadvantage that in them femaleness is still being defined in relation to maleness, albeit in a newly aggressive relation based on contrast rather than on submission. Granted the political situation that prevailed around 1970, this strategy was inevitable. But it is not to be inferred that any of these modes is necessarily an expression of an essential femaleness. They may be partial and limited steps toward a possible clearing of the field in which both genders might express themselves outside of enforced clichés—but such an ideal moment does not seem imminent.

As against the optimistic heralding of a new age in the late 1960s and the '70s, there are signs of regression in the air today. While women artists clearly gained ground in the 1970s, the 1980s have seen losses in the proportion of women exhibited in major galleries and museums, along with changes widely misunderstood as a return to male myths of hyper-self-expressiveness. Heroic aura, however diminished in critical credibility, still holds the market in thrall. The museums in their turn have proved slow to redirect themselves. Sitting on treasure houses of male-heroic abstract art and compelled to aggrandize the value of these riches, they have been unreceptive to the idea that new modes of quality cannot arise until the ruling grip of an old mode has been loosened. New ages do not come easy. The march down Fifth Avenue is not over yet.

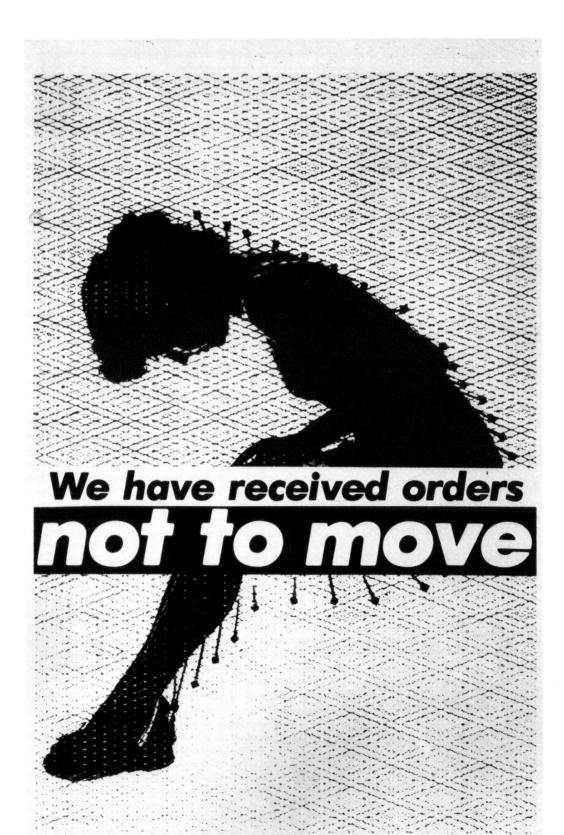

Marcia Tucker

Women Artists Today: Revolution or Regression?

A criticism combining feminist, socialist and anti-racist perspectives is likely to assume that women are not universally the same, that their relations are also determined by race, class and sexual identification; that social change cannot be conceived of in terms only of women who are white and privileged; that integration into existing social structures is not likely to liberate even white middle-class women; and that unequal relations of power in general must be reconstructed, not only for women but for all the oppressed.[1]

183
Barbara Kruger
Untitled (We Have Received Orders Not to Move),
1982
Black-and-white photograph, 71 x 49 in. (framed)
Carol and Arthur A. Goldberg

The commonly held assumption that women artists have moved from a marginal position in American art prior to 1970 into the mainstream as a result of the women's movement strikes me as highly problematic. From my own perspective this sixteen-year period of 1970–85 has been one of struggle, a struggle that is just as vital, and no more resolved, than it was in its early years.[2] A basic question I'd like to pose from the outset, therefore, is in what ways the arena for feminist activity in the arts has changed, for what reasons, and to what end.

The 1970s was certainly a period of growing awareness of the discrimination women faced in the wake of a post-1950s retrenchment of the patriarchal system. Artists who are now well known and highly respected— such as Jennifer Bartlett, Lynda Benglis, Nancy Graves, Elizabeth Murray, Pat Steir, and Joan Jonas—were beginning their careers at the same time that the women's movement took root in New York and California. Graves's first solo museum exhibition (of three life-size camels) was held in 1969, to startled and often hostile critical response.[3] Bartlett, Murray, and Steir all showed in a number of museum exhibitions from 1970 on, but their work was often overshadowed by that of men, many of whom were working in far less adventurous ways. Lynda Benglis

and Eva Hesse, for example, while doing decidedly unorthodox and intellectual work that was part of a new predilection toward process rather than product, were marginalized even within the loosely knit group of artists that constituted that "movement."[4]

Others, such as Ree Morton and Judy Pfaff, were still graduate students working in an almost exclusively male domain. Those who were older (Clyde Connell, Nancy Spero, and Betye Saar, among them) were already marginalized because of their age, political beliefs, or race. And for those on the West Coast, recognition was even slower, California being seen (as captured in Saul Steinberg's famous drawing) as a distant land somewhere on the other side of New Jersey.

Younger artists who are in the vanguard today—among them Jenny Holzer, Barbara Kruger, Louise Lawler, Sherrie Levine, Martha Rosler, Cindy Sherman, Laurie Simmons—are now mostly in their late thirties. They have worked outside the mainstream from the beginning, bypassing formal high-art concerns entirely by employing strategies associated with advertising, architecture, design, and the media (broadcasting, photojournalism, television) rather than with painting and sculpture. Their work has a specifically theoretical and political base somewhat

different from the interests of other women who have been accepted into the mainstream. It seems to me that this is partly a reaction to the nearly exclusive focus on practice (consciousness-raising, action, protest, hands-on political activity of all kinds) rather than on theory that dominated the women's movement of the late 1960s and early '70s.

Activist women who were art critics or museum curators, like myself, found that problems and attitudes similar to those experienced by many of these artists made it difficult to put our views into practice. Despite our efforts, unconscious (or conscious) sexism and racism on the part of editors and directors often worked to limit the numbers of women artists represented in major articles or exhibitions, although there was some improvement made compared to the situation in the 1950s and '60s. Another difficulty was that the community of artists, feeling powerless, sometimes attacked—in the press, in trade journals, in public exchanges such as lectures or symposia—those women who were working from within institutions to promote change, on the assumption that they weren't feminists. This created a serious rift in the movement, one that still exists today.

Thus feminists were divided, and I think remained so through most of the period under discussion. In addition to divisiveness among professional women in the field of art—those who were seen as wielding power from within the system versus women who felt themselves victimized by that power—there was also a fundamental difference of opinion over the nature of the art women were making. For example, many lesbian artists felt isolated from heterosexual women both politically and by virtue of the separate concerns reflected in their work, which often addressed the particular marginality of women-identified women.[5] The situation for female artists of color was even more critical; since

they were far outnumbered by men even in those exhibitions that focused on black (or Hispanic or Asian) artists, there was little, if any, forum for them, their work, or their ideas.[6]

As for the art itself, any discussion of women's aesthetic concerns today, I think, also has to proceed from an understanding of how those concerns evolved from or broke with earlier ones (if, in fact, they did so at all). Throughout the period in question, divisiveness existed between those who advocated a separatist view[7]—seeing central imagery; round, open, fluid forms; soft colors; obsessive and repetitive patterning; craft skills, etc., as inherently female (and their opposite as inherently masculine)—and those who insisted that art itself had no gender.

As artists, some women felt a need to claim a different voice,[8] one that was from their point of view equally valid if not more so than the dominant aesthetic, which had left no room for any other. Others felt that the most profound experiences, those most suited to artistic exploration, were intrinsic to humanity at large and not gender based. Unfortunately, from the mainstream's viewpoint a different voice meant an inferior one, while from the margin's viewpoint it meant that the difference was bound to be co-opted. To the extent that small scale, intimacy, autobiographical and diaristic concerns, or an involvement with patterning and decoration (to name only a few elements) characterized the work of women, those characteristics were easily dismissed; in the hands of men, those same concerns were heralded as important, even "radical," and became eminently marketable.

The artistic canon of the period—modernism—embodied the (masculine) values of the culture at large and virtually eliminated not only women but all artists of color.[9] It upheld the value of a single standard of qual-

ity, against which all works could be objectively measured and which was formed by "a consensus of educated opinion"—consisting largely of those who wished to perpetuate the values of their own kind. (That canon is, in the words of Paul Lauter, "a means by which culture validates social power."[10]) While most men were hardly interested in challenging the canon, due to a vested interest in it, many women who might have been in a position to do so—including critics, curators, dealers, and the rare female artist who was famous—instead generally adapted the methods and goals of the mainstream in order to achieve and maintain visibility or success.

That so many did not work actively toward social change was partly due to the fact that until the early 1970s there was no support system for women, who either joined the "boys' club" or went their solitary ways, working without benefit of dialogue with their peers about common political *or* aesthetic concerns. There were few jobs for women in art schools or university art departments, which might have provided younger women with much-needed role models. And it has always been more difficult for women to make art because it costs money to make, and grants were (and still are, for the most part) available to men more readily than to women.

Strange as it may seem today, in the early 1970s women were divided as to whether or not discrimination even existed. Artists' answers to questions on the topic, published in 1971, ranged from the statement by one (now obscure) painter that "as far as I am concerned, the problem of the sexes in art has never existed, and if it still exists for some women painters, they must look into themselves for the reasons, not into the society that surrounds them," to Lee Krasner's tart response that "any woman artist who says there is no discrimination against women

should have her face slapped."[11]

By 1976, however, the women's movement had "taken," and Lucy Lippard was able to write: "Feminism, or at least the self-consciousness of femaleness, has opened the way for a new context within which to think about art by women."[12] That same year Lawrence Alloway asserted: "The women's movement in art can be considered as an avant-garde because its members are united by a desire to change the existing social forms of the art world."[13]

By 1980 earlier differences dissolved in a wave of optimism; the battle was won. Or so it seemed to many. Kay Larson, writing in *Artnews*, credited "most of the interesting and important stylistic developments of the decade" to feminism. She wrote that "for the first time in Western art, women are leading, not following. And far from displacing men, female leadership has opened up new freedom for everyone."[14] Women were touted as having pioneered the use of a subjective, personal voice; overtly political content; the diaristic mode and performance as autobiography; pattern and decoration; dream images, mythic, and ritual practices; and the dissolution of differences between low and high art. Certainly it seemed as though women had defied the canon and diffused the mainstream by providing men with new stylistic arenas. Unfortunately, it was the men who became famous and reaped the economic rewards of those changes.

By 1980 the consciousness-raising groups that were a mainstay of feminism, both in and out of the art community, had dissolved, and a backlash was beginning to be felt. In the world of museum professionals, for instance, very little had changed for any of us; in fact, those of us who were able to live according to our convictions had to create organizations in order to do so.[15]

In 1983 Kate Linker (indicating at the outset that she was "not known for a specifically feminist criticism") stated that she felt compelled to address women's gross lack of representation in virtually every major group exhibition in Europe and America that season, as well as in most of the commercial galleries in New York. In terms of criticism, she noted that attempts to redress the suppression of women in art history and to subvert the construction of a patriarchal avant-garde were only in their earliest stages; she also specifically pointed to what she saw as a reversal, "One doubly heinous in that it is conducted as if a decade's demystification, politicization, and general expansion of discourse into the consideration of social issues had never occurred . . . as if we lived, then, in a state of amnesia about significant issues."[16]

In the same article Linker took these issues a step further, noting that they were not simply germane to the art community but also "mirror reflections of the more generalized practices of a society that rushes, with astonishing rapidity, into conservatism and into the resurrection of traditional roles." Removing these problems from the alleged disinterestedness of art history and placing them squarely in the world at large (as Linda Nochlin had done over a decade earlier) provided artists and critics of the 1980s with a broader theoretical approach to feminist issues, one that participated actively in other kinds of discourse (including the politics of the Left, new psychoanalytic investigations abroad, philosophical debates on the nature of postmodernist culture, and a large and recent body of literary theory and criticism from France and England).

One of the earliest practical attempts to locate art within the arena of theoretical discourse at large was a 1983 exhibition entitled *The Revolutionary Power of Women's Laughter*, organized by Jo-Anna Isaak. The show explored the aspect of women's work

that addressed not our exclusion from the world but our difference, our position as "Other"—that is, "an identity negatively defined."[17] In a critique of the exhibition, Jane Weinstock discussed the dangers of celebrating Otherness, one of which is to reinforce the stereotypes of male-female imagery, sensibilities, or biological determinations, creating myths rather than exposing them.[18]

However, the intention of the exhibition was also to provide an analysis of how meaning itself is constructed. It did so by focusing on specifically feminist strategies in the work, while Weinstock's critique of the show analyzed the work in terms of its ability to subvert gender identification itself. Much of the work in the exhibition, for example, resisted stereotypical female-male identity by emphasizing instead the importance of the viewer's relationship to the image (who is the image addressing, how, and why?); by proposing a self that is neither basic nor fixed, but constituted through the images that re-present it; by seeing language itself, into which we are born, as crucial in the formation of our identity; and by using images in a literal, unambiguous way as a deconstructive and ultimately subversive device.

Changing the focus from women artists' marginalization to the underlying meaning of images themselves and the ways in which that meaning can be reconstituted provided a very different vantage point for feminists; it eliminated much of the "male-hating" stereotype previously used to denigrate feminists and substituted a broader and more sophisticated theoretical approach that reverberated in the prevalent cultural and political discourse of postmodernism. Thus the debates centering on feminist issues, formerly seen as being of concern only to women, became of potential interest to men as well, making them viable to an intellectual community at large. (So much so that the danger of feminism becoming yet

another arena in which men are the experts seems real enough!)

The choices available earlier to women artists, feminists or not, seem to me to have been limited by the comparative newness of collective action at that time. Most of these artists either bore the brunt of discriminatory practices silently (at least in public) or engaged in overt and disruptive public protest of all kinds; the former were criticized for their silence, which was taken as acceptance of the status quo by default, while the latter were seen as hostile, counterproductive, and separatist.

Today's options are certainly broader, although the terrain on which they need be exercised is no less hazardous. Rather than making work with imagery based on what was thought to be specifically female experience—childbearing and rearing, domestic work, or the iconography of physical and emotional difference—images (whether taken from the media and transformed or made as "originals") are now being examined for the ways in which meaning is constructed through visual representation in the culture at large. Today, so-called female experience is construed by most feminists to be culturally determined, and the concept of a uniquely female sensibility or female nature is considered an enforcement of stereotypes symptomatic of the political repression of women in general. What we think of as "natural" is generally whatever the culture is accustomed to and needs, so that the idea of a female "nature," even more profoundly than the idea of experience, supports the status quo. As Peter Wollen points out in a discussion of "counter-cinema," "the natural can only be expressed, not changed," whereas "culture" is unstable, changing, and changeable.[19]

Similarly, meaning in works of art, as in representation in general, is no longer thought of as singular or absolute, a concept that en-

forced the artistic canon's ability to be exclusive (i.e., there is only one meaning possible; either you get it or you don't, and most of you don't). Meaning today is construed as being situated both within the work itself and outside it, in the context in which it is presented and in the multiplicity of experiences and viewpoints brought to bear on the work by those who see it.

In recent years contemporary critical analysis, in the visual arts as well as in other fields, has also relied heavily on psychoanalytic studies, such as Jacques Lacan's radical rereading of Sigmund Freud, in which traditional concepts of masculine and feminine are replaced by an understanding of sexuality in terms of the "active" or "passive" positioning of the subject. Moreover, the purposeful difficulty of Lacan's writing has prompted an alternative view of criticism itself, one that does not attempt a definitive interpretation of the text but one that is creatively prompted by the points at which a reader *fails to understand* it. The multiplicity of meaning in a given text (or work of art) allows for a constantly shifting series of interpretations, leading to other interpretations, and so on, rather than to a single "correct" reading. Similarly, difference between genders, rather than being a reason for substituting one set of aesthetics or standards for another—women's for men's —is seen as a tool in the process of analysis and ultimately of change, so that, in Gayatri Spivak's words, "to uncover the undertone is to undo the overtone."[20] It is the awareness of and interest in difference that prompts this kind of analysis in the first place.

The question of what constitutes feminist art practice itself is still very much debated, and the possibilities range from the use of critical and subversive elements in the making of work to questions of how it might be possible to use a specifically feminist history (or art history) in attempting to rupture the damag-

ing (i.e., "ideologically repressive") cultural myths that have kept women's work marginal for so long.[21]

What is certain is that there is at present no agreement even as to what constitutes feminism itself; there is certainly no way of seeing women "as an unalloyed force for good or as a unified sisterhood or nature. Women, like men, appear divided from each other, enmeshed not in a simple polarity with males but in a complex and contradictory web of relationships and loyalties."[22] Contemporary feminists' refutation of the notion of an essential female nature, as well as of a unified practice or ideology, has encouraged in the art community as well as among feminists in general a tolerance—if not an active support—of contradiction as an essential aspect of discourse. History, and art history, are interpreted "not as an assortment of facts in a linear arrangement, not as a static tale of the unrelieved oppression of women or of their unalleviated triumphs, but as a process of transformation."[23]

Any attempt to represent the history of women artists in the past sixteen years is, I feel, situated on the shifting sands of the discourse it is part of. There is no single history, no one attitude that these artists have in common, no one vision of themselves or the context in which they live and work that defines them. Any history of that period is determined by those who are constructing it, and the purpose for which they're doing so, and each of us brings a different agenda to the telling.

From my own point of view, not much has changed since those early days. Women are still discriminated against in virtually every area of contemporary American society: we earn less than two-thirds as much as men do, we own less than one percent of the property in the country, and we constitute the smallest minority in the government at large.[24] Even

in the arts, we haven't done as well as we think we have. The statistics still tell the same story: in terms of museum and gallery representation, sales, major articles, important grants, commissions, and tenured teaching positions, women artists are hardly better off today than in 1970.

Part of the reason that so little substantive change has taken place is that once again we are living in a politically conservative climate, one that has in recent years nurtured the defeat of the Equal Rights Amendment, taken a forceful stand against women's control of our own bodies in terms of abortion rights, encouraged homophobia, promoted heterosexuality and family life as "natural" in the face of the AIDS epidemic, and in general nurtured a determined backlash to feminist attitudes and strategies.

In the 1970s many women "cleaned house," reordering priorities and relationships in a struggle to achieve power and autonomy in the home, the workplace, and the political sphere. Early feminists felt victimized by the authority and power of an entrenched patriarchy and reacted against "the enemy" with a moral fervor reminiscent of the civil rights and antiwar activities of the 1960s. The women's movement was all practice and no theory. Today, with the exception of a few individuals and an occasional group effort (like that of the Guerrilla Girls[25]), most feminist efforts are taking place in the arena of criticism and theory. Postmodernism, with its emphasis on the problems of marginalization in general, has helped us to think not in simple dichotomies of right and wrong, male and female, dominant and dominated, but in terms of discourse, whose very nature precludes such polarization and instead raises issues of hegemony and difference—cultural, racial, and sexual, among others. However, today there is no real community of women, no collective action against repressive

attitudes (many of which have become law), and there is a general paralysis when it comes to establishing an equal division of labor in the areas of homemaking and child care.

While more women are visible now than in 1970, and while the rare woman artist (without exception white) may even be highly visible, practice and theory—in the arts as elsewhere—have yet to meet in our century to provide the equity that might lead to real social change.

Notes

Thanks to Eunice Lipton, Phil Mariani, and Tim Yohn for reading and editing this essay.

1. *Feminist Criticism and Social Change: Sex, Class and Race in Literature and Culture*, ed. Judith Newton and Deborah Rosenfelt (New York and London: Methuen, 1985), p. xxvii.

2. This view is informed by my activities both as a feminist and as curator of painting and sculpture at the Whitney Museum of American Art, New York, from 1968 to 1976 and as director of the New Museum of Contemporary Art, New York, from 1977 to the present.

3. *Nancy Graves, Camels*, exhibition and essay by the author, Whitney Museum of American Art, New York, March 24–April 30, 1969. For a review, see Anita Feldman, "Nancy Graves," *Arts Magazine* 43 (May 1969): 58.

4. Eva Hesse felt strongly that although her work participated in every way in the prevalent aesthetic (and, in fact, most likely predated it), she nonetheless had a difficult time being considered on an equal footing. She indicated often, in conversation with me throughout the two years prior to her death, that she felt very much isolated from other artists, especially those with similar concerns. The group being focused on at that time was loosely composed of Rafael Ferrer, Barry LeVa, Robert Morris, Richard Serra, Bruce Nauman, and Keith Sonnier, among others.

5. Several exhibitions of lesbian art were held during the 1970s; the largest and most controversial of these took place at 112 Greene Street.

6. For example, an exhibition mounted at the Whitney Museum entitled *Contemporary Black Artists in America*, April–May 1971, organized by Robert Doty, included only eleven women out of fifty-eight artists.

7. Notable among the proponents of the separatist idea were Judy Chicago and Miriam Schapiro, who founded and ran the Feminist Art Program at the California Institute of the Arts, Valencia. Lucy Lippard at this time was also concerned with defining a uniquely female sensibility (see her *From The Center: Feminist Essays on Women's Art* [New York: E. P. Dutton, 1976]). For a discussion of widely differing views, see

Cindy Nemser, "Forum: Women in Art," *Arts Magazine* 45 (February 1971): 18.

8. This "different voice" has been brilliantly defined by Carol Gilligan, who examines the ways in which differences between men and women have led psychologists to assume the male experience as "normal" and the female one as inferior or "abnormal." See Gilligan's *In a Different Voice: Psychological Theory and Women's Development* (Cambridge, Mass., and London: Harvard University Press, 1982).

9. For a discussion of the modernist debate, see Francis Frascina, ed., *Pollock and After: The Critical Debate* (New York: Harper and Row, 1986) and *Modernism and Modernity* (The Vancouver Conference Papers, 1981), eds. Benjamin Buchloh, Serge Guilbaut, and David Solkin (Halifax: Press of the Nova Scotia College of Art and Design, 1983).

10. Paul Lauter, "Race and Gender in the Shaping of the American Literary Canon: A Case Study from the Twenties," in Elizabeth A. Flynn and Patrocinio P. Schweickart, ed., *Gender and Reading* (Baltimore: Johns Hopkins University Press, 1986), p. 19.

11. Nemser, "Forum: Women in Art," p. 18.

12. Lucy Lippard, "Projecting a Feminist Criticism," *Art Journal* 35 (Summer 1976): 337.

13. Lawrence Alloway, "Women's Art in the '70s," *Art in America* 64 (May–June 1976): 72.

14. Kay Larson, "For the First Time Women Are Leading Not Following," *Artnews* 79 (October 1980): 64.

15. Among them were Alanna Heiss, founder and director of the Institute for Art and Urban Resources; Linda Goode Bryant, founder and director of Just Above Midtown; and other women whose leadership transformed smaller alternative spaces into cultural forces to be reckoned with, like Helene Weiner (succeeded by Linda Shearer) of Artists Space and Anita Contini of Creative Time. The representation of women among museum directors in America is increasing slowly. However, in 1986 only 20 of the 175 members of the Association of Art Museum Directors were women.

16. Kate Linker, "Forum," *Artforum* 21 (April 1983): 2.

17. See Jane Weinstock's article on the exhibition, entitled "A Lass, A Laugh and a Lad," in the Issues and Commentary section of *Art in America* 71 (Summer 1983): 7–11.

18. Ibid., p. 7.

19. *Difference: On Representation and Sexuality* (New York: New Museum of Contemporary Art, 1984), p. 39.

20. "Gayatri Chakravorty Spivak: Interview," by Elizabeth Gross, *ArtNetwork* (Sydney, Australia) 16 (Winter 1985): 26.

21. "Feminist Film Practice and Pleasure: A Discussion," with Griselda Pollock, Judith Williamson, Laura Mulvey, and DeeDee Glass, in *Formations of Pleasure* (London, 1983), pp. 164–65.

22. Introduction, *Feminist Criticism and Social Change*, p. xxvi.

23. Ibid., p. xxiii.

24. A Guerrilla Girls sticker cited in *Artnews* 86 (Summer 1987): 144.

25. An anonymous group of artists working in New York, whose videotapes and posters sardonically address inequities by citing names and statistics.

Ferris Olin and Catherine C. Brawer

Career Markers

In order to gauge the visibility of women artists within the mainstream from 1970 through 1985, we selected eight barometers to measure certain changes that might have occurred during that period. From the start we realized that no definitive conclusions could be drawn because there was no way for us to identify the total number of women or men artists working, exhibiting, or applying for grants, etc. Without such specific information regarding the parameters of the universe we were studying, we could not determine how women's access to the mainstream compared to men's. We suspected, however, that the material we planned to compile would be of sufficient interest to warrant its presentation even without those conclusions—and so we have let the information speak for itself.

We began by developing a survey and convening a team of researchers to obtain necessary information from institutions across the country.[1] Realizing that artists gain visibility primarily through exhibitions, we looked at the numbers of solo exhibitions given to women artists at galleries, alternative spaces, and museums, as well as the representation of women in two major recurring group exhibitions.[2] Next we tabulated reviews and feature articles in four major art periodicals. We then looked at records for contemporary art sales at two major auction houses and researched the inclusion of work by women artists in selected corporate collections. Finally, we traced two prominent funding sources, one private and one public, to ascertain the percentage of women artists receiving their awards. The results of these findings are presented in sections 1 through 8.

Methodology In general, the figures were derived from information provided by individuals associated with the relevant institutions: see the specific sources accompanying each Career Markers chart. All information is based on calendar-year activities. We included artists working in a variety of media—painting, sculpture, photography, video, and performance. Solo exhibitions are here defined as including work by no more than two artists. Every attempt was made to determine the gender of each artist. However, if that proved impossible, the data related to artists of undetermined gender were counted separately and were not included in these figures. Percentages were rounded to the nearest whole number and do not necessarily total 100.

Notes

1. This study evolved from a body of information developed by numerous individuals and art groups representing a variety of viewpoints. Among them are the Tamarind Lithography Workshop, the Women and Art Documentation Group of the Art Libraries Society of North America, individual chapters of the Women's Caucus for Art, the Women in the Arts Foundation, the Guerrilla Girls, and individual artists. See, in particular, *Art Documentation* (October 1982), in which a special supplement edited by Paula Chiaramonte is devoted to resources and research on women artists.

2. It should be noted that museum curators and gallery directors frequently stated in response to our questions that they selected artists for exhibition according to the quality of the artist's work, not the artist's gender. Although several curators also underlined the importance of group exhibitions to the visibility of women artists between 1970 and 1985, a complete survey of women's inclusion in the numerous group shows over this period is beyond the scope of our research. One indication of the role played by group shows in establishing the careers of a selected group of women artists can be found as part of Individual Milestones (see pages 231–36). In addition, a selection of major group exhibitions held from 1970 through 1985, annotated with the names of all the artists in *Making Their Mark* who participated in each show, is listed on pages 266–69.

1. Representation of Women Artists in the Whitney Biennial and Corcoran Biennial

Several American museums host recurring invitational exhibitions. These exhibitions afford living artists an opportunity to have their work viewed in the context of what influential curators select as important currents in contemporary art. Two such recurring exhibitions are held at the Whitney Museum of American Art, New York, and the Corcoran Gallery of Art, Washington, D.C.

Participation in the Whitney Biennial (which evolved in 1973 from the Whitney Annual) can be particularly instrumental in establishing an artist's national reputation. For this reason, the 1969 Whitney Annual's inclusion of only 8 women among the total of 143 artists led concerned artists to picket the museum for greater representation of women in future Whitney shows. In Washington, D.C., where the Corcoran Biennial included no women in 1971, the inclusion of two women in 1973 (representing 17% of the artists exhibiting) may have been due, in part, to protests and to an increased awareness resulting from the first National Conference of Women Artists, held at the museum in 1972.

The accompanying charts present the percentage of women artists in each of these two recurring exhibitions from 1970 through 1985. The percentages are based on the total number of artists in each exhibition; the totals are indicated below each date.

Sources The figures were derived from the catalogs for each exhibition.

Special Considerations Because the period under consideration began three years before the Whitney Annual developed into the Whitney Biennial, percentages for the 1970 and 1972 Whitney Annuals are included (no Annual was held in 1971).

Highlights The lowest percentage occurred at the Corcoran Biennial in 1971 and 1979, when no women were included. The highest percentage occurred at the Corcoran Biennial in 1981, when the percentage rose to 40%. This figure may be somewhat misleading, however, in that it represents the inclusion of two women in the total number of only five artists. The highest percentage at the Whitney Biennial, 32%, occurred in 1979 and represents the inclusion of twenty-eight women out of eighty-eight artists. During this period the representation of women artists at the Whitney Biennial remained between 20% and 32%; at the Corcoran Biennial, with the exception of 40% in 1981, it did not exceed 17%.

At the Carnegie International, a recurring exhibition of international scope held at the Carnegie Museum of Art, Pittsburgh, the percentage of women peaked at 10% of 58 artists in 1982 (the exhibition was suspended from 1971 to 1976). Of the 101 artists included in 1970, 7% were women; no women were included in 1977 or 1979; and in 1985 women constituted 9% of a total of 43 artists.

**1A. Percentage of Women Artists:
Corcoran Gallery of Art Biennial**

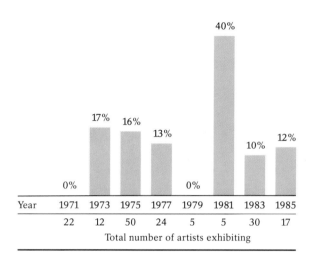

Year	1971	1973	1975	1977	1979	1981	1983	1985
	22	12	50	24	5	5	30	17

Total number of artists exhibiting

**1B. Percentage of Women Artists:
Whitney Museum of American Art Biennial**

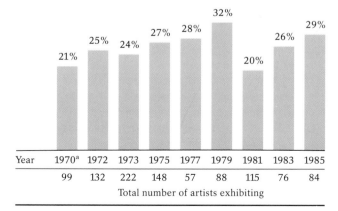

Year	1970[a]	1972	1973	1975	1977	1979	1981	1983	1985
	99	132	222	148	57	88	115	76	84

Total number of artists exhibiting

a. In 1969 the percentage of women artists was 6%.

2. Solo Exhibitions by Women Artists at Selected Galleries

Individual exhibitions or performances at commercial galleries often constitute an important step up the career ladder for an artist, attracting the attention of art critics, museum curators, and collectors, as well as the general public.

The accompanying charts present the percentage of solo exhibitions by women artists at forty-six galleries in four cities with major gallery systems—Chicago, Los Angeles, New York, and San Francisco—for the years 1970, 1973, 1975, 1978, 1980, 1983, and 1985. The percentages are based on the total number of solo exhibitions presented by these galleries each year; the totals are indicated below each date.

Any selection of galleries is subjective. Since the marketplace provides a clear measure of visibility, we focused upon traditional commercial galleries representing contemporary American artists, both men and women. Therefore, nationally recognized single-gender exhibition spaces, such as the cooperative gallery A.I.R. in New York, were not included, however important. The galleries that are included were chosen because of their perceived importance to the mainstream of contemporary art during all or most of this period.

Chicago
Dart, Marianne Deson, Frumkin-Struve, Richard Gray, Rhona Hoffman, Phyllis Kind, Klein, Donald Young, and Zolla-Lieberman

Los Angeles
Asher/Faure, Jan Baum, James Corcoran, Gagosian, LA Louver, and Margo Leavin

New York
Brooke Alexander, Blum Helman, Mary Boone, Grace Borgenicht, Leo Castelli, Paula Cooper, André Emmerich, Ronald Feldman Fine Arts, Xavier Fourcade, Gracie Mansion,

Pat Hearn, Nancy Hoffman, Sidney Janis, Knoedler and Company, Inc., and Marlborough (at both these galleries, only exhibitions by contemporary American artists were surveyed), David McKee, Metro Pictures, Robert Miller, Pace, Max Protetch, Tony Shafrazi, Sharpe Gallery, Holly Solomon, Sonnabend, Tibor de Nagy, John Weber, and Willard

San Francisco

John Berggruen, Braunstein Quay, Fuller-Goldeen, and Stephen Wirtz

Sources Each gallery was sent a questionnaire, and telephone calls were made to obtain missing information. For the following galleries it was necessary to obtain information exclusively from secondary sources: in New York—Blum Helman, Grace Borgenicht, Leo Castelli, Pat Hearn, Sidney Janis, Max Protetch, and John Weber; in San Francisco—John Berggruen. The secondary sources included local and regional magazines and newspapers, *The Art Now Gallery Guide*, and other local art publications.

Special Considerations Unlike museums, which may offer an artist a solo exhibition only a few times during the artist's career, galleries offer the artists they represent periodic opportunities to exhibit their work individually. We believed that the extent to which women artists were visible through solo exhibitions at galleries in each city from 1970 through 1985 would become evident if we tracked information for alternating years. This method was in contrast to our presentation of solo exhibitions at museums, which includes each year from 1970 through 1985.

There are no 1970 figures for Los Angeles because the galleries in the survey had not yet opened.

Highlights According to the composite chart, the percentage of solo exhibitions by women at galleries rose from 12% in 1970 to 19% in 1985, with representation peaking in

1983 at 26%. In each city surveyed, women were given more solo exhibitions in 1985 than in 1970, although the 1985 percentage consistently represents a drop from 1983.

In Chicago, women artists were given the greatest percentage of solo exhibitions in 1978, when the figure rose to 46%. (The year 1983 was a close second with 44%.) The percentage dropped to 22% in 1985.

In New York the total number of solo exhibitions increased from 58 in 1970, when the percentage of women included was 9%, to 260 in 1985, when the percentage was 16%. In 1975, when 168 artists were given solo exhibitions, the percentage was 15%. The greatest percentage occurred in 1978, when it reached 24%. Even when the number of artists given solo shows increased by 55% from 1975 to 1985, the percentage of solos given to women artists rose by only 1%.

The most dramatic changes occurred in California. In Los Angeles no women were represented in solo exhibitions at the galleries surveyed until 1978; that year, 13% of the solo exhibitions were devoted to women artists. The percentage of women given solo shows peaked in 1983 at 29% before dropping to 25% in 1985. At the galleries in San Francisco, exhibitions by individual women artists went from 15% in 1970 to a peak of 26% in 1978, before dropping to 21% in 1985.

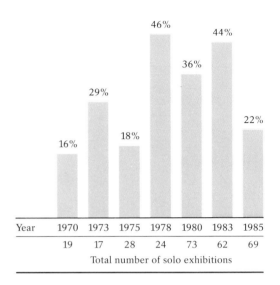

2C. **Percentage of Solo Exhibitions by Women Artists: Selected New York Galleries**

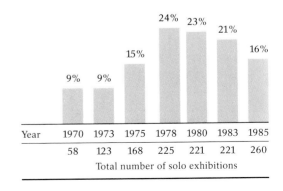

2B. **Percentage of Solo Exhibitions by Women Artists: Selected Los Angeles Galleries**

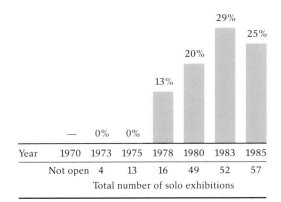

Year	1970	1973	1975	1978	1980	1983	1985
	—	0%	0%	13%	20%	29%	25%
	Not open	4	13	16	49	52	57

Total number of solo exhibitions

2E. **Percentage of Solo Exhibitions by Women Artists: Composite of Chicago, Los Angeles, New York, and San Francisco Galleries**

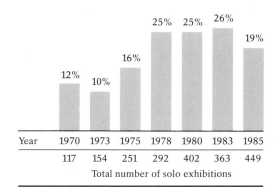

Year	1970	1973	1975	1978	1980	1983	1985
	12%	10%	16%	25%	25%	26%	19%
	117	154	251	292	402	363	449

Total number of solo exhibitions

2D. **Percentage of Solo Exhibitions by Women Artists: Selected San Francisco Galleries**

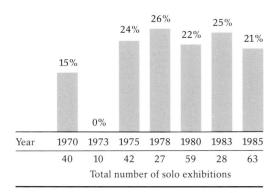

Year	1970	1973	1975	1978	1980	1983	1985
	15%	0%	24%	26%	22%	25%	21%
	40	10	42	27	59	28	63

Total number of solo exhibitions

3. Solo Exhibitions by Women Artists at Selected Alternative Spaces

Beginning in the 1970s men and women artists working in traditional media as well as those involved with performance, dance, and music composition found in alternative spaces new opportunities to exhibit their work. To many women artists who had found the gallery structure unreceptive, the newly forming alternative spaces, many of which were established as not-for-profit organizations, provided new exhibition space and access to broader audiences than they would otherwise have been able to reach.

This limited sample could not include all the alternative spaces that were active in the 1970s and '80s; instead, a selection was made of those that proved especially influential during this period. For example, Artists Space in New York was selected because since 1973 it has maintained an exhibition policy of giving artists their first shows. As with the gallery survey, we did not include alternative spaces that concentrated primarily on showing work by women artists. The Alternative Museum (opened 1973) and P.S. 1 (opened 1976, as an exhibition space for the Institute for Art and Urban Resources, founded in 1970) in New York were not included because they held mainly group exhibitions during this period.

The accompanying charts present the percentage of solo exhibitions and performances by women artists at the following eight alternative spaces in Chicago, Los Angeles, New York, and San Francisco for the years 1970, 1973, 1975, 1978, 1980, 1983, and 1985. The percentages are based on the total number of solo exhibitions presented by these alternative spaces each year; the totals are indicated below each date.

Chicago
NAME (opened 1973)
Los Angeles
LACE (opened 1978)
LAICA (opened 1974)
New York
Artists Space (opened 1973)
The Clocktower (opened 1973)
Franklin Furnace (opened 1976)
The Kitchen (opened 1971)
San Francisco
Art Com/La Mamelle (opened 1975)

Sources Each alternative space was sent a questionnaire, and telephone calls were made to obtain missing information.

Special Considerations The Clocktower, a second exhibition space for the Institute for Art and Urban Resources that opened in 1976, held group shows rather than individual exhibitions in 1983 and 1985; figures for those two years are therefore not included. Art Com/La Mamelle in San Francisco was included even though it exhibits groups of artists more frequently than individuals.

Highlights At NAME, in Chicago, where the total number of artists having solo exhibitions and performances was very small, women were given 50% of the total number in 1973 and 1975. No women were shown in 1980; in 1983 the percentage rose to 33% before dropping to 17% in 1985.

When LAICA opened in Los Angeles in 1974, all of the four individual exhibitions and performances were by men. When the total number of solo exhibitions and performances peaked at forty-nine in 1980, the percentage by women rose to 37%, before dropping to 29% in 1983. In 1985 the percentage rose to 40%, in sharp contrast to the 0% of ten years before. At LACE, also in Los Angeles, the movement was in the opposite direction. When the gallery opened in 1978, 50% of the eight solo exhibitions and

performances were by women. This figure progressively declined to 20% in 1985 (representing one exhibition by a woman artist out of a total of five).

In 1978 the percentage of solo exhibitions and performances by women at Artists Space in New York peaked at 56%; the lowest percentage was in 1983, when 20% of the artists exhibiting were women. In 1985 the percentage rose again to 38%. At The Clocktower the percentage of individual exhibitions and performances by women reached 55% in 1973 and 1978. By 1980 the percentage had declined to 29%. At Franklin Furnace the highest percentage of solo exhibitions and performances by women occurred in 1980, when the figure rose to 62%. By 1985 the figure had dropped back to the 1978 figure of 47%. Figures for The Kitchen are not available until 1978, when women were given 37% of the solo exhibitions and performances. This number dropped to 0% by 1983, where it remained in 1985.

The percentage of solo exhibitions and performances by women artists at the New York alternative spaces surveyed for this period averaged 38%; in the New York commercial galleries the average was 17%, with a peak percentage of 24% in 1978. The higher percentages at alternative spaces may reflect their emphasis on performance, a medium in which women were highly active in 1970–85.

When Art Com/La Mamelle opened in San Francisco in 1975 women were given 55% of the total number of individual exhibitions and performances. This figure declined in the years 1978, 1980, and 1983, but it rose in 1985 to 62%.

3A. **Percentage of Solo Exhibitions by Women Artists: NAME, Chicago**

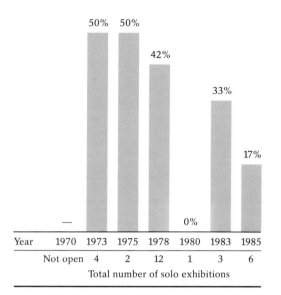

Year	1970	1973	1975	1978	1980	1983	1985
Not open		4	2	12	1	3	6

Total number of solo exhibitions

3B. **Percentage of Solo Exhibitions by Women Artists: LACE, Los Angeles**

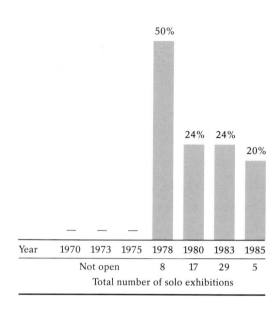

Year	1970	1973	1975	1978	1980	1983	1985
Not open				8	17	29	5

Total number of solo exhibitions

3C. **Percentage of Solo Exhibitions by Women Artists: LAICA, Los Angeles**

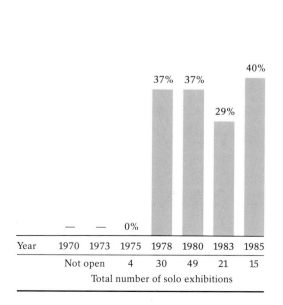

Year	1970	1973	1975	1978	1980	1983	1985
Not open			4	30	49	21	15

Total number of solo exhibitions

3D. **Percentage of Solo Exhibitions by Women Artists: Artists Space, New York**

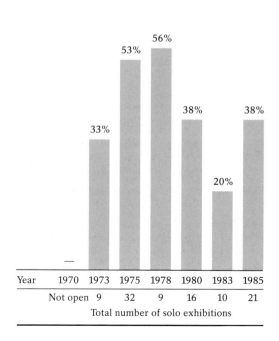

Year	1970	1973	1975	1978	1980	1983	1985
Not open	9	32	9	16	10	21	

Total number of solo exhibitions

3E. **Percentage of Solo Exhibitions by Women Artists: The Clocktower, New York**

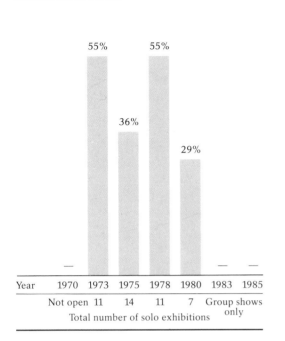

Year	1970	1973	1975	1978	1980	1983	1985
	Not open	11	14	11	7	Group shows only	

Total number of solo exhibitions

3F. **Percentage of Solo Exhibitions by Women Artists: Franklin Furnace, New York**

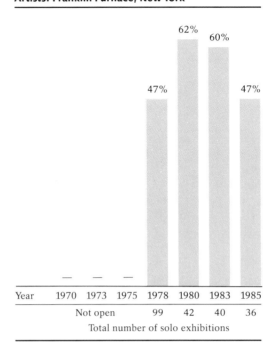

Year	1970	1973	1975	1978	1980	1983	1985
	Not open			99	42	40	36

Total number of solo exhibitions

3G. **Percentage of Solo Exhibitions by Women Artists: The Kitchen, New York**

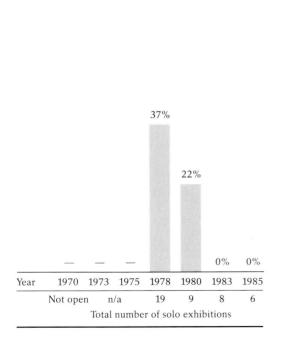

Year	1970	1973	1975	1978	1980	1983	1985
	Not open	n/a		19	9	8	6

Total number of solo exhibitions

3H. **Percentage of Solo Exhibitions by Women Artists: Art Com/La Mamelle, San Francisco**

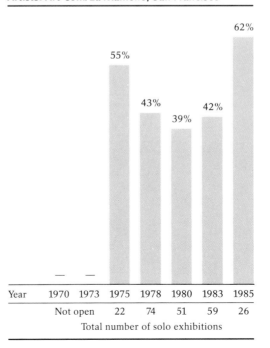

Year	1970	1973	1975	1978	1980	1983	1985
	Not open		22	74	51	59	26

Total number of solo exhibitions

4. Solo Exhibitions by Women Artists at Selected Museums

A solo museum exhibition at a prestigious institution not only recognizes an artist's achievement, it also helps secure an artist's place in the mainstream.

The accompanying table lists the twentieth-century women artists given solo exhibitions at the following twenty-four museums each year from 1970 through 1985. Five of the cities were chosen because they are recognized as primary art centers with major museums; four were chosen because an institution in each of those cities is participating in the tour of *Making Their Mark*. Providing a table of names rather than percentages seemed preferable in this case because it allowed us to identify those women artists who gained visibility in this way.

Chicago
Art Institute of Chicago
Museum of Contemporary Art

Cincinnati
Cincinnati Art Museum
Contemporary Arts Center

Denver
Denver Art Museum

Los Angeles
Los Angeles County Museum of Art
Museum of Contemporary Art (opened 1984)

New Orleans
Contemporary Arts Center (opened 1976)
New Orleans Museum of Art

New York
The Brooklyn Museum
Solomon R. Guggenheim Museum
Metropolitan Museum of Art
Museum of Modern Art
New Museum of Contemporary Art
 (opened 1977)
Whitney Museum of American Art

Philadelphia
Institute of Contemporary Art
Pennsylvania Academy of the Fine Arts
Philadelphia Museum of Art

San Francisco
San Francisco Museum of Modern Art

Washington, D.C.
Corcoran Gallery of Art
Hirshhorn Museum and Sculpture Garden,
 Smithsonian Institution
National Gallery of Art
National Museum of American Art,
 Smithsonian Institution
Phillips Collection

Sources The information on solo exhibitions of work by painters, sculptors, photographers, video artists, performance artists, and those working in other media was obtained from each institution through the assistance of curatorial, archival, and library staff. When a solo exhibition traveled to more than one venue, each stop is cited here to reflect the interest of each museum in presenting that artist's work.

Special Considerations The collections of some of these museums encompass the entire history of art; others specialize in contemporary art. This variation in focus is, of course, reflected in the proportion of the exhibition schedule devoted to twentieth-century art and should be kept in mind while reviewing the accompanying table. Other aspects of exhibition policy vary from institution to institution. Some present frequent exhibitions of work by individual artists; others, like the National Museum of American Art, emphasize group and theme shows. The number of solo exhibitions by women artists must be considered in the context of the museum's exhibition program as a whole.

External circumstances often affect a museum's exhibition program as well. Funding sources may increase or diminish; more or less space may be available due to renovation or construction. One example of this occurred in California in 1978, when Proposition 13 decimated state support for the arts, forcing the Los Angeles County Museum of Art not only to charge admission and freeze hiring but also to reevaluate all exhibitions then being planned. When the same institution later expanded its facility, exhibition space was severely limited during the five-year construction period that began in 1981. Consequently, the number of exhibitions of twentieth-century art decreased, vying for a place on the schedule with exhibitions proposed by nine other curatorial departments.

Highlights From 1970 through 1985, 248 women artists generally associated with twentieth-century art were given a total of 321 solo exhibitions at the twenty-four museums surveyed (this number counts separately each stop of a touring show). Twenty-four artists were given two solo shows each. Thirteen artists were given three solo exhibitions each: Diane Arbus, Alice Aycock, Jennifer Bartlett, Romaine Brooks, Nancy Graves, Sheila Isham, Agnes Martin, Ree Morton, Marjorie Phillips, Susan Rothenberg, Anne Ryan, Betye Saar, and Pat Steir. Georgia O'Keeffe and Alma W. Thomas were each given four solo exhibitions; and Laurie Anderson, Helen Frankenthaler, and Louise Nevelson each had five. Lee Krasner was given six. Whereas these artists and several others listed in the table have national and international reputations, a great many of the artists featured in individual exhibitions at the twenty-four museums surveyed are best known regionally.

4A. Solo Exhibitions by Women Artists at Selected Museums

Museum	1970	1971	1972	1973	1974	1975	1976
Chicago							
Art Institute of Chicago		Georgia O'Keeffe		Claire Trotter		Margaret Fisher	Martyl
Museum of Contemporary Art			Lee Bontecou	Diane Arbus Eva Hesse			
Cincinnati							
Cincinnati Art Museum					Louise Nevelson		
Contemporary Arts Center				Nancy Graves Salli LoveLarkin Constance McClure	Hilla Becher Anne Wilson		Jennifer Bartlett Aka Peremya Jackie Winsor
Denver							
Denver Art Museum							
Los Angeles							
Los Angeles County Museum of Art						Helena Hernmarck	
Museum of Contemporary Art, Los Angeles (opened 1984)							
New Orleans							
Contemporary Arts Center (opened 1976)							
New Orleans Museum of Art				Merle Greene Robertson Cheryl Savoy	Diane Arbus Pat Colville Stephanie Dinkins Ida Kohlmeyer		
New York							
Brooklyn Museum		Miriam Beerman			Anne Ryan Marguerite Zorach		Grace Albee
Solomon R. Guggenheim Museum						Helen Frankenthaler	
Metropolitan Museum of Art				Imogen Cunningham Helen Frankenthaler			
Museum of Modern Art	Berenice Abbott	Nancy Graves	Diane Arbus Barbara Morgan	Helena Hernmarck Agnes Martin	Helen Levitt Marlene Scott Sonia Sheridan	Barbara Hepworth	Mary Miss

1977	1978	1979	1980	1981	1982	1983	1984	1985
Charlotte Hart		Joyce Treiman Claire Zeisler	Marie Cosindas	Joyce Baronio Sonia Delaunay Ruth Thorne-Thomsen	Olivia Parker	Nancy Hemingway		
	Frida Kahlo June Leaf	Elyn Zimmerman		Jane Wenger Margaret Wharton	Magdalena Abakanowicz Laurie Anderson Sophie Taeuber-Arp	Alice Aycock Louise Bourgeois Gabriele Münter	Rebecca Horn	Jo Anne Carson Nancy Reddin-Kienholz
				Marie Cosindas				
	Mildred Fischer Patricia Renick Sandy Underwood	Alice Aycock Sandy Rosen		Stephanie Cooper Lisa Jamison Ming Murray	Ruby Wilkinson	Jo Ann Callis Connie Sullivan	Pat Steir	
			Agnes Martin					
Maureen Lambray				Elaine Carhartt Maren Hassinger Ritzi Jacobi		Susan Rankaitus Susan Rothenberg	Wendy MacNeil	
							Betye Saar (2 shows) Maria Nordman	
		Adrienne Anderson Carol Kapelow Brown Mary Chachere Judy Dater Ellen Mobley Gwen Norsworthy Charlotte Rosshandler Jimmie Williams	Debbie Fleming Caffrey Rosi Urbine	Liza Bear Lin Emery Helen Escobedo Hera Norie Sato Karen Truax	Carol Hurst Judy Peiser	Laurie Anderson Susan Austin Susan Dakin Gisele Freund Josephine Sacabo Linda Thurlow	Lenora Champagne Shirley Clark Mary Luft Pat Oleszko	Emily Hubley Kathy Rose Ilene Segalove
Sheila Isham	Janis Provisor		Betty Gold	Elena Karina Lisette Model		Elizabeth Catlett		Ilse Bing Imogen Cunningham Sandra Garrard Clementine Hunter Ida Kohlmeyer
Consuelo Kanaga Anni Albers			Judy Chicago Martha Zeit	Eve Arnold		Nancy Lawton	Pat Steir	Lee Krasner Jennifer Bartlett
								Helen Frankenthaler Ree Morton
								Marie Zimmerman
Alice Aycock Tina Modotti	Laurie Anderson Anne Poirier Reeva Potoff	Anne Ryan Jackie Winsor	Eileen Gray Nan Hoover	Wendy Clarke Dorothea Rockburne		Louise Bourgeois Lisette Model	Lee Krasner (2 shows)	

Museum	1970	1971	1972	1973	1974	1975	1976
New Museum of Contemporary Art (opened 1977)							
Whitney Museum of American Art	Louise Nevelson Georgia O'Keeffe	Romaine Brooks Jane Kaufman	Chryssa Susan Hall Dorothea Lange Alma W. Thomas	Vija Celmins Lee Krasner Gladys Nilsson	Joan Mitchell Joan Moment Ree Morton Alice Neel	Jo Baer Isabel Bishop Minnie Evans Branda Miller Betye Saar Alexis Smith	
Philadelphia University of Pennsylvania, Institute of Contemporary Art			Nancy Graves	Agnes Martin		Anne Wilson	Joan Jonas
Pennsylvania Academy of the Fine Arts					(closed for remodeling May 31, 1974–April 22, 1976)		
Philadelphia Museum of Art							
San Francisco San Francisco Museum of Modern Art	Nell Sinton	Joan Brown Jeanne East Jan Evans Georgia O'Keeffe		Ruth Asawa Judith Linhares Margaret Peterson Barbara Rogers	Louise Nevelson	Lottie Funduus Nina Raginsky	Mimi Jacobs Beverly Pepper
Washington, D.C. Corcoran Gallery of Art	Eleanor Dickinson		Sonia Delaunay Sally Hazelet Enid Sanford Alma W. Thomas Joan Thorne	Joyce Tenneson Cohen Eleanor Dickinson Ellen Gelman Sheila Isham Margo Lang Nancy Rexroth Pat Steir Anne Truitt	Joan Danziger Agnes Denes Helen Frankenthaler Jo Hanson Lee Krasner Louise Nevelson	Mimi Herbert	Jan Groover Louise Herreshoff
Hirshhorn Museum and Sculpture Garden, Smithsonian Institution (opened 1974)							
National Gallery of Art	Käthe Kollwitz						
National Museum of American Art, Smithsonian Institution		Romaine Brooks	Jennie Cell Edith Greger Halpert Ellen Lanyon	Marguerite Zorach	Anne Ryan	Peggy Bacon	Ethel Mohammed
Phillips Collection				Jennie Lea Knight Eleanor Lyman	Carla Lavatelli Marjorie Phillips	Susan Crile Hilda Thorpe	Catherine Murphy

1977	1978	1979	1980	1981	1982	1983	1984	1985
			Ree Morton		Candace Hill-Montgomery Mary Stoppert			Mia Westerlund-Roosen
	Jan Groover		Louise Nevelson	Margia C. Kramer Mary Lucier Georgia O'Keeffe Catalina Parra		Joan Jonas		Dara Birnbaum Viola Frey Margia C. Kramer Claire Zeisler
Meredith Monk			Tina Girouard Pat Oleszko	Laurie Anderson		Jenny Holzer Joyce Kozloff Laurie Anderson (2 shows)	Jody Pinto	Cindy Sherman
								Alice Neel
	Beatrice Woods					Suzanne Duchamp	Dorothy Norman	
Julia A. Hoffman Marie Johnson Ella Kohler Betye Saar	Jennifer Bartlett Lawrie Brown Wanda Hammerbeck Ellen Land-Weber Margery Mann	Judy Chicago Mary L. O'Neal	Margo Humphrey Carmen Lomas Helen Lundeberg Anne Noggle	Judith Golden Joanne Leonard Annette Messanger Liz Phillips	Barbara Kasten	Susan Rothenberg Doris Ulmann	Lee Krasner	
Aline Fruhauf Sally Mann	Janica Yoder	Helen Levitt Rosalind Solomon	Vija Celmins		Linda Connor	Constance Stuart Larrabee	Gladys Nelson Smith	
				Barbara Hepworth				
		Anna Mary Robertson Moses (Grandma Moses)						
	Maria Martinez	Irene Brynner	Neda Al-Hilali Lia Cook Joyce Kozloff	Sheila Isham Alma W. Thomas	Berenice Abbott		Eugenie Gershoy	Anni Albers Romaine Brooks
Natalie Alper Sarah Baker Constance Costigan	Annette Kaplan	Lois Mailou Jones	Helen Frankenthaler Joyce Tenneson		Margaret O. McBride Marjorie Phillips Cita Scott		Marjorie Phillips	Susan Rothenberg

5A. Percentage of Reviews of Solo Exhibitions by Women Artists and Percentage of Feature Articles on Individual Women Artists: *Artforum*

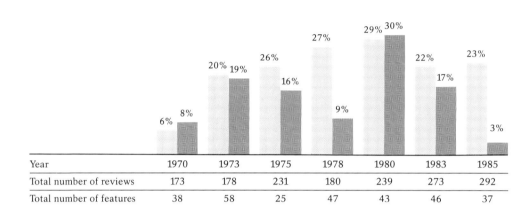

Review

Feature

Year	1970	1973	1975	1978	1980	1983	1985
Total number of reviews	173	178	231	180	239	273	292
Total number of features	38	58	25	47	43	46	37

5. Magazine Reviews of Solo Exhibitions by Women Artists and Feature Articles on Individual Women Artists

Magazine reviews of exhibitions and feature articles on individual artists help to establish an artist's reputation among collectors, museum curators, and the public.

The accompanying charts present the percentage of reviews of solo exhibitions by women artists as well as the percentage of feature articles on them in each of four widely circulated art periodicals: *Artforum, Art in America, Artnews*, and *Arts Magazine*. The charts deal with the years 1970, 1973, 1975, 1978, 1980, 1983, and 1985, the same years surveyed for solo exhibitions at galleries and alternative spaces. The percentages are based on the total number of reviews and features in these magazines; the totals are indicated below each date.

Sources Reviews and features were tal-

lied for every issue of the four journals in each year cited above.

Special Considerations In one instance, *Art in America* for 1970, solo exhibition reviews were woven into essays without a breakdown of the exhibitions covered. The 1970 figures for this magazine have therefore been excluded.

Highlights The highest composite percentage of reviews, 29%, occurred in 1980; the figure declined slightly to 26% in 1985. Of the 131 women artists who were the subject of individual features in these magazines, 72 appeared only once; 36 were featured twice; and 17 artists were featured three times. Three women—Agnes Martin, Georgia O'Keeffe, and Barbara Zucker—were written about four times; and Louise Bourgeois and Nancy Graves were each the subject of five features.

Reviews relate more directly than features to gallery exposure. The following table compares the composite percentage of magazine

reviews of solo exhibitions by women artists with the percentage of solo gallery exhibitions by women. In comparing the number of reviews with the number of exhibitions, it is important to remember that the same show sometimes had multiple reviews in the four magazines.

Year	Percentage of Solo Exhibitions by Women Artists at Galleries	Percentage of Magazine Reviews of Solo Exhibitions by Women Artists
1970	12	20
1973	10	22
1975	16	20
1978	25	26
1980	25	29
1983	26	23
1985	19	26

Neither the percentage of solo exhibitions nor the percentage of reviews exceeded 29% during the 1970–85 period.

5B. Percentage of Reviews of Solo Exhibitions by Women Artists and Percentage of Feature Articles on Individual Women Artists: *Art in America*

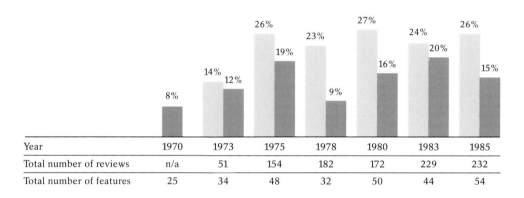

Year	1970	1973	1975	1978	1980	1983	1985
Total number of reviews	n/a	51	154	182	172	229	232
Total number of features	25	34	48	32	50	44	54

5C. Percentage of Reviews of Solo Exhibitions by Women Artists and Percentage of Feature Articles on Individual Women Artists: *Artnews*

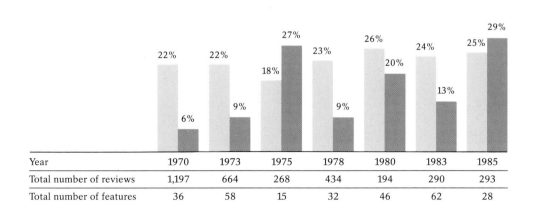

Year	1970	1973	1975	1978	1980	1983	1985
Total number of reviews	1,197	664	268	434	194	290	293
Total number of features	36	58	15	32	46	62	28

5D. **Percentage of Reviews of Solo Exhibitions by Women Artists and Percentage of Feature Articles on Individual Women Artists:** *Arts Magazine*

Review

Feature

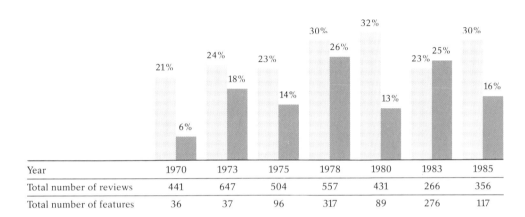

Year	1970	1973	1975	1978	1980	1983	1985
Total number of reviews	441	647	504	557	431	266	356
Total number of features	36	37	96	317	89	276	117

5E. **Percentage of Reviews of Solo Exhibitions by Women Artists: Composite of** *Artforum*, *Art in America*, *Artnews*, **and** *Arts Magazine*

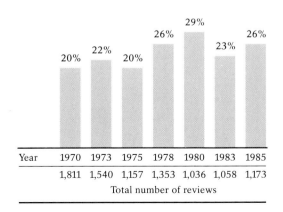

Year	1970	1973	1975	1978	1980	1983	1985
	1,811	1,540	1,157	1,353	1,036	1,058	1,173

Total number of reviews

6A. Percentage of Lots by Women Artists for Sale at Contemporary Auctions: Sotheby's and Christie's, New York

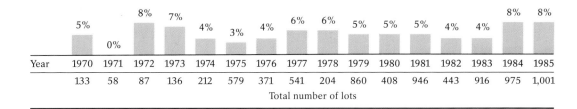

Year	1970	1971	1972	1973	1974	1975	1976	1977	1978	1979	1980	1981	1982	1983	1984	1985
	5%	0%	8%	7%	4%	3%	4%	6%	6%	5%	5%	5%	4%	4%	8%	8%
	133	58	87	136	212	579	371	541	204	860	408	946	443	916	975	1,001

Total number of lots

6. Representation of Work by Women Artists at Auction

The auction market acknowledges a sustained demand for an artist's work that extends beyond its primary purchase from a gallery. Success in this secondary market relates to an artist's ability to command high prices for works sold through his or her gallery. The three works by women that fetched the highest prices in contemporary sales in New York during the 1970–85 period were Helen Frankenthaler's 1962 painting *Approach*, which sold for $88,000 in 1982; Lee Krasner's 1964 painting *Bird's Parasol*, which sold for $71,000 in 1985; and Louise Nevelson's 1978 sculpture *Rain Garden Zag VI*, which sold for $61,000 in 1984.

The accompanying chart presents the percentage of lots of contemporary art by women artists that came up at auction in New York at Sotheby's (formerly Sotheby Parke Bernet) and Christie's (formerly Christie, Manson & Woods International) from 1970 through 1985. The percentages are based on the total number of lots sold annually by each firm; the totals are indicated below each date.

Sources The figures were derived from the catalogs for New York sales of contemporary painting, sculpture, graphic art, collage, mixed media, drawing, and works on paper. Sotheby's held sales throughout the 1970s; Christie's held its first New York sale in 1977. Therefore, percentages for 1970–76 represent Sotheby's; those for 1977–85 represent combined figures for Sotheby's and Christie's.

Special Considerations Certain artists often associated with contemporary art were not included in these sales. For example, Georgia O'Keeffe's work is listed in the catalogs of American art rather than in those of contemporary art, so her work is not represented in this survey.

Highlights Seventy women had lots offered in either Christie's or Sotheby's sales of contemporary art from 1970 through 1985. (Each lot equals an individual work of art.) Of these artists, twenty-eight had only one lot up for auction; another twenty-six had between two and five lots each; and eight had between eight and ten lots each. Those who had more than ten lots were Mary Bauermeister, Lynda Benglis, Helen Frankenthaler, Agnes Martin, Joan Mitchell, Louise Nevelson, Beverly Pepper, and Niki de Saint-Phalle.

The highest percentage of lots by women during the period was 8%. In 1972, when only Sotheby's was open, 7 of the 87 lots for sale were works by women, representing 8%; in 1985, when 77 of the 1,001 lots for sale at Sotheby's and Christie's were works by women, they remained 8% of the total.

7. Representation of Women Artists in Corporate Collections

The number of corporations collecting art increased significantly from 1970 through 1985. In addition, during this period many corporations with collections that had been established before 1970 hired a curator or an outside art advisor to help them expand their holdings. Some corporate collections contain thousands of works of art and are more extensive than the permanent collections of some small museums. Acquisitions by corporate collectors therefore provide yet another possible point of visibility for women artists.

We surveyed a small sample of corporate collections across the country to determine the year the collection was begun, the size of the total collection, the number of women artists represented, the total number of their works owned, and the year the corporation first acquired a work by a woman artist. All of this information is provided in the accompanying table, which is arranged in chronological order, with the oldest collections first.

Sources Questionnaires were sent to eighty-five companies, and calls were made to twelve additional ones; each has an art collection that includes contemporary art and contains at least one hundred works in total. All were selected from the *1986 Artnews Directory of Corporate Art Collections*, edited by Shirley Reiff Howarth. Questionnaires were also sent to twenty-one members of the Association of Professional Art Advisors who were known to have curatorial responsibilities for large corporate collections. Follow-up calls were made to obtain and clarify information.

The thirty-nine corporations cited here provided the information we requested to the best of their ability, although many did not have information about their collections computerized or categorized according to gender. In several instances, the numbers supplied by a corporation were approximated or given as "rough" percentages. We have omitted ballpark figures from the chart and have included the approximations with the following notations: "±" preceding a number means "approximately" and "+" following a number indicates "more than."

Special Considerations In some instances there were discrepancies between the information provided by a corporation and that in the *Artnews Directory*. For example, there are variations in the year chosen as the starting date for certain collections that had been in existence for many years prior to the formal hiring of a curator or art advisor, a step often taken in preparation for a move to new offices—Northern Pacific Bell provides one such example. In the case of Equitable Life Assurance Co., however, the official start of the collection, given as 1984, postdated by five years the corporation's first acquisition of a work by a woman artist (a sculpture by Louise Nevelson). We have therefore given the more recent collection date as well as the acquisition date, allowing the discrepancy to remain. In looking at the table, it is important to keep in mind that collections are not static; most continue to expand each year.

Highlights Since many of the numbers on the following chart are approximations, we did not calculate percentages. However, the chart does provide some interesting profiles of the thirty-nine corporate collections. About half the collections listed on the chart contain more than five hundred pieces; thirteen of these collections have over one thousand, again demonstrating the magnitude of corporate collecting. Within this small sample, eleven collections were begun prior to 1970; twenty-eight were started from 1970 on. In just over half of the collections formed earlier, the first purchase of a work by a woman artist occurred well after the inception of the collection. Among the collections formed later, work by a woman artist was generally purchased within the first year or two. Although the number of collections sampled is too small for us to draw any conclusions, the consistency with which the later collections made their first purchase of a work by a woman artist the same year the collection began appears to parallel the greater visibility of women artists in the marketplace at the time.

7A. **Representation of Women Artists in Corporate Collections**

Name	Year Collection Began	Number of Works in Collection	Number of Women Artists Represented	Total Number of Pieces by Women Artists	Year First Work by Woman Artist Acquired
International Business Machines Corporation Armonk, New York	1937	several hundred	7	8	1941
International Minerals & Chemical Corporation Northbrook, Illinois	1954	750	107	180	1957
CIBA-GEIGY Corporation Ardsley, New York	1959	565	65	148	1960
Honolulu Advertiser[a] Honolulu, Hawaii	1961	1,000+	±70	±200	1981–82
First Federal of Michigan Detroit, Michigan	1965	500+	64	260	1965
Johnson & Johnson New Brunswick, New Jersey	1965	1,100	±100	±350	1973
Exchange National Bank of Chicago Chicago, Illinois[b]	1967	±2,000	39	132	1968
PaineWebber Group, Inc. New York, New York	1967	359	20	45	1978
European American Bank New York, New York	1969	±225	±8	±18	n/a
The Port Authority of New York/New Jersey New York, New York	1969	1,500	158	158	1970
Seafirst Corporation Seattle, Washington	1969	1,700	15% (±225)	15% (±225)	1969
United States Steel Corporation Pittsburgh, Pennsylvania	1970	100+	15	16	1970
Hospital Corporation of America Nashville, Tennessee	1971	1,661	175	360	1972
Cleary, Gottlieb, Steen & Hamilton New York, New York	1972	500	42	80	1972
Blount, Inc. Montgomery, Alabama	1973	300	n/a	70	1974
Kemper Group Long Grove, Illinois	1973	558	188	194	1973
The Progressive Corporation Mayfield Village, Ohio	1974	1,000	±350	±350	1979
Pacific Northwestern Bell Seattle, Washington	1976	125	46	46	1984
Shearman & Sterling New York, New York	1978	109	41	45	n/a[c]
Columbia Savings & Loan Los Angeles, California	1979	163	24	31	1981
Metropolitan Life Insurance Company New York, New York	1979	1,969+	27% (±45)	33% (±55)	n/a
Northern Telecom Inc. Nashville, Tennessee	1979	500+	250	250	1979
Xerox Corporation Stamford, Connecticut	1979	200	30	40	1979
First Bank System, Inc. Minneapolis, Minnesota	1980	2,800+	133	539	1980

7A. **Representation of Women Artists in Corporate Collections** (cont'd.)

Name	Year Collection Began	Number of Works in Collection	Number of Women Artists Represented	Total Number of Pieces by Women Artists	Year First Work by Woman Artist Acquired
National City Bank Cleveland, Ohio	1980	298	38	101	1980
Philip Morris Company, Inc. New York, New York	1980	227	43	66	1980
Smithkline Beckman Corporation Philadelphia, Pennsylvania	1980	219	46	46	1980
The Southland Corporation Dallas, Texas	1980	±2,300	15	102	1982
Texas Commerce Bancshares Houston, Texas	1980	2,000	90	100	1980
Chemical Bank New York, New York	1981	1,700+	190+	n/a	1983
Consolidated Freightwaysd San Francisco, California	1981	395	31	±75	1982
Fried, Frank, Schriver & Jacobsen New York, New York	1981	300+	17	40	1981
General Electric Company Fairfield, Connecticut	1981	850+	128	262	1981
Kaye, Scholer, Fierman Hays & Handler New York, New York	1981	186	26	37	1981
Mellon Bank Pittsburgh, Pennsylvania	1981	1,900	73	205+	1981
Minnesota Mutal Life Insurance Company St. Paul, Minnesota	1981	120	12	12	1981
Steelcase Inc. Grand Rapids, Michigan	1982	±500	5	5	1982
United Bank of Denver Denver, Colorado	1983	119	28	48	1983
Equitable Life Assurance Co. New York, New York	1984	±300	25	25	1979

Notes

a. Most of the collection acquired between 1961 and 1982 was donated to the Contemporary Arts Center, Honolulu. The figure 1,000 was taken from the *Directory*.

b. The emphasis of this collection is on photography.

c. According to the *Directory*, the entire collection was formed at the same time, which would suggest 1978 as the year for the first purchase of a work by a woman artist.

d. Collection includes all media but focuses on photography.

8. Guggenheim and NEA Fellowships Awarded to Women Artists

Two major funding sources that provided support to visual artists during the period 1970 through 1985—the private John Simon Guggenheim Memorial Foundation and the federally funded National Endowment for the Arts (NEA)—were selected for this survey because their prestigious awards have been so important to the development of artistic careers.

John Simon Guggenheim Memorial Fellowships

The 1974 *Reports from the President and the Treasurer*, published by the Guggenheim Foundation, includes the following excerpt from a 1973 letter written in response to questions posed by "an organization advocating women's rights": "The Guggenheim Foundation makes its awards through annual national competitions solely on the basis of demonstrated accomplishment as judged by leading professionals in each field. We do this 'without discrimination . . . on account of sex,' in accordance with Senator Guggenheim's letter of gift. We do not endeavor to increase the participation of women, or of any other group among our applicants [p. xxvi]."

Guggenheim Fellowships "are awarded to men and women of high intellectual and personal qualifications who have already demonstrated unusual capacity for productive scholarship or unusual creative ability in the fine arts."[1] Most recipients are between thirty and forty-five years of age. A Guggenheim Fellowship is awarded according to merit, without consideration of financial need. No budget is submitted with the original application; the amount of each grant is determined after a Fellow has been chosen and varies according to the recipient's circumstances and the project's requirements.

8A. Women Recipients of Guggenheim Fellowships in Fine Arts, Photography, and Video

1970 Imogen Cunningham, Patricia Johanson, Freda Koblick, Anne Truitt

1971 Rosemarie Castoro, Claudia Andujar

1972 Liliane DeCock, Dorothea Rockburne

1973 Chryssa, Mary Frank, Wendy MacNeil, Sonia Sheridan

1974 Sandria Hu, Jane Kaufman

1975 Lynda Benglis, Jackie Ferrara, Laura Gilpin, Michelle Stuart

1976 Virginia Cuppaidge, Joan Jonas, Loren MacIver, Steina Vasulka

1977 Claudia Andujar, Joan Brown, Mary Heilmann, Miyoko Ito, Sylvia Plachy, Marlene Scott, Susan Weil

1978 Judy Dater, Claire Falkenstein, Jan Groover, Nancy Holt, Branda Miller, Jackie Winsor

1979 Linda Connor, Barbara Crane, Donna Dennis, Louise Fishman, Phoebe Helman, Maria Nordman, Rosalind Solomon

1980 Beverly Buchanan, Deborah Butterfield, Vija Celmins, Susan Jane Felter, Patricia Johanson, Pamela Levy, Ana Mendieta, Susan Rothenberg

1981 Alice Adams, Karen A. Carson, Vera Kliment, Helen Levitt, Laura Newman, Joanna Pousette-Dart, Meridel Rubenstein, Arden Scott

1982 Laurie Anderson, Marilyn Bridges, Barbara Kasten, Catherine Murphy, Anne Noggle, Joan Snyder, Pat Steir, Hannah Wilke, Susan Wilmarth

1983 Mary Frank, Gillian Jagger, Judy Pfaff, Ursula von Rydingsvard, Tomiyo Sasaki, Cindy Sherman, Anne Tabachnick

1984 Lois Conner, Stephanie Frank, Mary Frey, Nancy Hellebrand, Deanna Kamiel, Joyce Kohl, Barbara Pugh Norfleet, Deborah Remington, Sage Sohier

1985 Helene Brandt, Linda Francis, Tami Gold, Candace Hill-Montgomery, Mary Lucier, Judith Joy Ross, Mierle Laderman Ukeles, JoAnn Walters

8B. Percentage of John Simon Guggenheim Memorial Fellowships Awarded to Women Artists

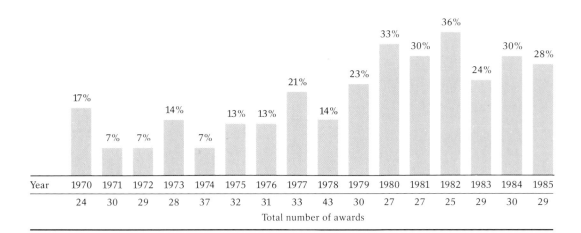

Year	1970	1971	1972	1973	1974	1975	1976	1977	1978	1979	1980	1981	1982	1983	1984	1985
	24	30	29	28	37	32	31	33	43	30	27	27	25	29	30	29

Total number of awards

Stephen Schlesinger, secretary of the John Simon Guggenheim Memorial Foundation, pointed out that the Foundation's process of granting awards to artists well-established in their careers remained constant during 1970–85, so that any increase in the percentage of women Fellows can be interpreted as reflecting greater numbers of qualified women in the pool of applicants.[2]

The accompanying table lists the names of the women who received Guggenheim Fellowships for fine arts, photography, and video each year during the 1970–85 period.The accompanying chart indicates what percentage of the total number of awards each year went to women artists; the total number of awards is indicated below each date.

Sources The figures were derived from lists obtained from the Foundation.

Highlights Of the ninety-one women who received Guggenheim Fellowships from 1970 through 1985 three artists—Patricia Johanson, Mary Frank, and Claudia Andujar—received

two. In 1970 women received 17% of the total number of Guggenheim Fellowships awarded in fine arts, photography, and video. In 1985 the percentage was 28%. During the years 1971, 1972, and 1974, the percentage of women recipients went as low as 7% before increasing gradually to a high of 36% in 1982.

NEA Visual Artists Fellowships

The National Endowment for the Arts was created in 1965 to "foster the excellence, diversity, and vitality of the arts in the United States and to help broaden the availability and appreciation of such excellence, diversity, and vitality."[3] According to Diana Crane, during the 1970s individual artists received only 3% percent of the total amount that the NEA awarded in the arts.[4] As small as this percentage was, it nevertheless provided a crucial source of funding for visual artists.

Approximately 5,000 applications for Visual Artists Fellowships are received each year, of which only about 5% are successful.

According to the *Visual Artists Fellowships Application Guidelines,* "Visual Artists Fellowships are available to practicing professional artists working in a wide variety of visual media: painting, sculpture, photography, crafts, printmaking, drawing, artists' books, video, performance, conceptual, and new genres."[5]

Applications are reviewed by a panel considering the following:

Quality of applicant's work as demonstrated by visual documentation submitted. . . . Record of professional activity and achievement as reflected on the application form and/or accompanying materials submitted. Evidence, based on the two factors cited above, that the applicant's work reflects continued serious and exceptional aesthetic investigation and will be at a critical point of development during the proposed fellowship period.[6]

The accompanying table presents the number and dollar amount of grants awarded each year in selected categories listed under Visual Arts in the NEA *Annual Reports*. It includes a breakdown, with percentages, of the representation of women artists within each of the categories selected for this survey. The percentages are based on the total number of grants and the total dollar amounts.

Sources The figures were derived from the NEA's *Annual Reports*.

Special Considerations When the gender of a name was unclear, or when a nonprofit arts organization received a grant along with individual artists, they were cited as "unclassified." If this unclassified group were factored into the percentages, it could slightly affect the number of grants allotted to women as well as the percentage of funding they received.

The NEA's grant classifications have varied, especially in the early 1970s, and the format of the *Annual Reports* has continued to evolve, making it difficult to track specific information over a period of time. For example, the *Annual Reports* list the total dollar amounts of the grants given for each year of our survey. Beginning in 1973 the amounts awarded for each type of grant (such as Photography or Visual Artists' Fellowships) are consistently listed as well. Beginning in 1981 the total number of recipients for each type of grant and the total dollar amounts awarded are listed consistently. However, the totals are not always separated into the same categories that we have used here; when necessary we have extrapolated this information. The pre-1981 data cited here was determined, whenever possible, by counting the names listed in the *Reports* under each type of grant and by adding up the dollar amounts they received. Our extrapolations do not always add up to the exact amount of the original total number of recipients and dollar amounts listed under each type of grant. We have noted any such discrepancies on the accompanying table; they are too small to affect the percentages given. Shared grants are counted as one in the totals columns, since the monies were allotted as one; the dollar amounts have been appropriately adjusted.

The twenty fellowships listed in the 1971 *Annual Report* that were followed by "(1970)" have been tallied here as part of the 1970 figures. For 1972 only three artists were listed as recipients under "Short-Term Activities"; the remaining eight grants that year were to nonprofit arts organizations. In 1973 "Short-Term Activities" was again listed as a separate category and included two nonprofit arts organizations as well. The 1978 *Annual Report* listed two photography recipients for 1979, who have been included in our figures for that year. In 1980 a video subcategory appeared for the first time under Visual Arts, although all of the money awarded did not come from Visual Arts funds. In 1981 additional grants were made to video artists under the Media Arts Program. Finally, crafts were included under Visual Arts for the years 1982 and 1984.

Highlights The grants in the Visual Artists Fellowships increased from a total of $150,000 awarded to 20 artists in 1970 to a total of $2,930,000 awarded to 260 artists in 1985. The lowest total amount occurred in 1971, when just $47,000 was awarded to 24 artists; the highest total was $3,425,000, awarded to 337 artists in 1982. Except in the years 1982, 1984, and 1985, there was a close relationship during this period between the percentage of grants that went to women and the percentage of the dollar amounts they received. The highest percentage of grants over $10,000 awarded to women was 35%. This figure, which occurred in 1985, is only slightly higher than the highest percentage of grants that went to women, which peaked at 33% in 1979 and 1983.

Notes

1. John Simon Guggenheim Memorial Foundation, *Fellowships United States of America and Canada 1971* (New York: John Simon Guggenheim Memorial Foundation, 1971), p. 4.

2. Stephen Schlesinger, conversation with Catherine C. Brawer, January 1988, New York.

3. *1987–88 Visual Artists Fellowships Application Guidelines Fiscal Years 1987 and 1988* (Washington, D.C.: National Endowment for the Arts), p. 1.

4. See Diana Crane, *The Transformation of the Avant Garde: The New York Art World, 1940–1985* (Chicago: University of Chicago Press, 1987), p. 160 n. 10. Crane points out that NEA support for the arts in 1966, one year after its founding, was at $1.8 million; by 1983 it had risen to $131 million. Matching funds awarded by the NEA were instrumental in increasing state, corporate, and foundation support for the arts; however, these funds went primarily to museums, not to individual artists (see pp. 6–7).

5. *1987–88 Visual Artists Fellowships Application Guidelines*, p. 5.

6. Ibid.

8C. **NEA Grants and Dollar Amounts**

Type of Grant	Total Number of Grants	Number of Grants to Women	Number of Grants to Men	Number of Grants to Unclassified Artists and to Organizations	Percentage of Grants to Women	Total $ Granted	Total $ Granted to Women	Percentage of $ Granted to Women
1970								
Artists' Fellowships: $7,500	20[a]	2	18	0	10%	$150,000	$15,000	10%
Grand Totals	**20**	**2**	**18**	**0**	**10%**	**$150,000**	**$15,000**	**10%**
1971								
Photographers' Fellowships[a]	24	4	20	0	17%	$47,000	$7,000	15%
Grand Totals	**24**	**4**	**20**	**0**	**17%**	**$47,000**	**$7,000**	**15%**
1972								
Visual Arts: "Short-Term" Activities	11	0	3	8[a]	0%	$73,977	$0	0%
Grand Totals	**11**	**0**	**3**	**8**	**0%**	**$73,977**	**$0**	**0%**
1973								
Artists' Fellowships: $7,500	45	11	33	1	24%	$337,500	$82,500	24%
Photographers' Fellowships[a]	60	9	51	0	15%	$217,700	$29,200	13%
Short-Term Activities[b]	54	11	41	2[c]	20%	$160,000	$33,000	21%
Grand Totals	**159**	**31**	**125**	**3**	**19%**	**$715,200**	**$144,700**	**20%**
1974								
Artists' Fellowship Program:	145	37	108	0	26%	$680,000	$167,500	25%
$7,500	60	14	46	0	23%	$450,000	$105,000	23%
$3,000	73	20	53	0	27%	$219,000	$60,000	27%
$1,000	11[a]	3	9	0	25%	$11,000	$2,500	23%
Printmakers' Fellowships: $3,000	30	8	20	2	27%	$90,000	$24,000	27%
Grand Totals	**175**	**45**	**128**	**2**	**26%**	**$770,000**	**$191,500**	**25%**

Type of Grant	Total Number of Grants	Number of Grants to Women	Number of Grants to Men	Number of Grants to Unclassified Artists and to Organizations	Percentage of Grants to Women	Total $ Granted	Total $ Granted to Women	Percentage of $ Granted to Women
1975								
Visual Artists' Fellowships:	135[a]	33	101	2	24%	$595,000	$143,000	37%
$8,000	31	7	23	1	23%	$248,000	$56,000	23%
$4,000 and $3,000	71	19	51	1	26%	$283,000	$76,000	27%
$2,000	33[a]	6	27	0	19%	$64,000	$11,000	17%
Printmakers' Fellowships: $3,000	25	12	12	1	50%	$75,000	$36,000	48%
Photographers' Fellowships: $5,000	50	8	42	0	16%	$250,000	$40,000	16%
Grand Totals	**210**	**53**	**155**	**3**	**25%**	**$920,000**	**$219,000**	**23%**
1976								
Visual Artists' Fellowships:	152	39	111	2	26%	$571,000	$114,000	20%
$10,000	12	0	12	0	0%	$120,000	$0	0%
$5,000	57	12	44	1	21%	$285,000	$60,000	21%
$2,000	83	27	55	1	33%	$166,000	$54,000	33%
Printmakers Fellowships: $3,000	8	4	4	0	50%	$24,000	$12,000	50%
Photographers Fellowships: $7,500	41	8	33	0	19%	$307,500	$60,000	20%
Grand Totals	**201**	**51**	**148**	**2**	**25%**	**$902,500**	**$186,000**	**21%**
1977								
Artists' Fellowships:	98	33	64	1	34%	$663,500	$198,000	30%
$10,000	2	0	2	0	0%	$20,000	$0	0%
$7,500	79	22	56	1	28%	$592,500	$165,000	28%
$3,000	17	11	6	0	65%	$51,000	$33,000	65%
Photographers' Fellowships: $1,500	40[a]	9	31	1	23%	$300,000	$63,750	23%
Printmakers' Fellowships: $5,000	12	8	4	0	67%	$60,000	$40,000	67%
Grand Totals	**150**	**50**	**99**	**2**	**33%**	**$1,023,500**	**$301,750**	**29%**

Type of Grant	Total Number of Grants	Number of Grants to Women	Number of Grants to Men	Number of Grants to Unclassified Artists and to Organizations	Percentage of Grants to Women	Total $ Granted	Total $ Granted to Women	Percentage of $ Granted to Women
1978								
Visual Artists' Fellowships:	127	42	85	1	33%	$764,000	$234,750	31%
$10,000	2	0	2	0	0%	$20,000	$0	0%
$7,500	82[a]	25	57	1	30%	$615,000	$183,750	30%
$3,000	43	17	26	0	40%	$129,000	$51,000	40%
Photographers' Fellowships: $7,500[b]	40	11	27	2	28%	$300,000	$82,500	28%
Grand Totals	**167**	**53**	**112**	**3**	**32%**	**$1,064,000**	**$317,250**	**30%**
1979								
Artists' Fellowships:	160	58	102	0	36%	$1,047,000	$384,000	37%
$10,000	81	30	51	0	37%	$810,000	$300,000	37%
$3,000	79	28	51	0	35%	$237,000	$84,000	35%
Photographers' Fellowships:	57	15	41	1	26%	$430,000	$115,000	27%
$10,000	37	10	27	0	27%	$370,000	$100,000	27%
$3,000	20	5	14	1	25%	$60,000	$15,000	25%
Art in Public Spaces	11	2	9	0	18%	$22,000	$4,000	18%
Grand Totals	**228**	**75**	**152**	**1**	**33%**	**$1,499,000**	**$503,000**	**33%**
1980								
Artists' Fellowships:	272	79	193	2	29%	$1,558,000	$423,000	27%
$10,000	106	27	79	0	25%	$1,060,000	$270,000	25%
$3,000	166[a]	52	114	2	31%	$498,000	$153,000	31%
Video Arts:[b]	51	20	30	1	39%	$265,000	$88,000	33%
$10,000	16	4	12	0	25%	$160,000	$40,000	25%
$3,000	35	16	18	1	46%	$105,000	$48,000	46%
Photographers' Fellowships:	98	19	80	0	19%	$637,000	$106,000	17%
$10,000	49[c]	7	43	0	14%	$490,000	$70,000	14%
$3,000	49	12	37	0	24%	$147,000	$36,000	24%
Grand Totals	**421**	**118**	**303**	**3**	**28%**	**$2,460,000**	**$617,000**	**25%**

Type of Grant	Total Number of Grants	Number of Grants to Women	Number of Grants to Men	Number of Grants to Unclassified Artists and to Organizations	Percentage of Grants to Women	Total $ Granted	Total $ Granted to Women	Percentage of $ Granted to Women
1981								
Artists' Fellowships:	168	47	117	4	28%	$1,519,500	$362,000	24%
$12,500	98	19	77	2	19%	$1,225,000	$237,500	20%
$6,250	10	6	4	0	60%	$62,500	$37,500	60%
$4,000	56	22	32	2	36%	$224,000	$88,000	36%
$2,000	4	0	4	0	0%	$8,000	$0	0%
Photographers' Fellowships:	51	10	39	2	20%	$484,500	$91,000	19%
$12,500	33[a]	6	26	1	18%	$412,500	$75,000	18%
$4,000	18	4	13	1	22%	$72,000	$16,000	22%
Media Arts/ Visual Arts:[b]	14	6	7	1	43%	$73,000	$39,000	53%
$6,500	10	6	3	1	60%	$65,000	$39,000	60%
$2,000	4	0	4	0	0%	$8,000	$0	0%
Grand Totals	**233**	**63**	**163**	**7**	**27%**	**$2,077,000**	**$492,000**	**24%**
1982								
Visual Artists' Fellowships:	337	114	218	6	34%	$3,425,000	$1,010,000	29%
$25,000	87[a]	22	65	1	25%	$2,175,000	$550,000	25%
$5,000	250	92	153	5	37%	$1,250,000	$460,000	37%
Grand Totals	**337**	**114**	**218**	**6**	**34%**	**$3,425,000**	**$1,010,000**	**29%**
1983								
Visual Artists' Fellowships:	218	74	145	0	34%	$2,320,000	$760,000	33%
$25,000	12	4	8	0	33%	$300,000	$100,000	33%
$15,000	99	31	68	0	31%	$1,485,000	$465,000	31%
$5,000	107[a]	39	69	0	36%	$535,000	$195,000	36%
Grand Totals	**218**	**74**	**145**	**0**	**34%**	**$2,320,000**	**$760,000**	**33%**
1984								
Visual Artists' Fellowships:[a]	270	100	169	1	37%	$2,730,000	$870,000	32%
$25,000	9	2	6	1	22%	$225,000	$50,000	22%
$15,000	120	33	87	0	28%	$1,800,000	$495,000	28%
$5,000	141	65	76	0	46%	$705,000	$325,000	46%
Grand Totals	**270**	**100**	**169**	**1**	**37%**	**$2,730,000**	**$870,000**	**32%**

8C. **NEA Grants and Dollar Amounts** (cont'd.)

Type of Grant	Total Number of Grants	Number of Grants to Women	Number of Grants to Men	Number of Grants to Unclassified Artists and to Organizations	Percentage of Grants to Women	Total $ Granted	Total $ Granted to Women	Percentage of $ Granted to Women
1985								
Visual Artists' Fellowships:	260	94	164	3[a]	36%	$2,930,000	$932,500	32%
$100,000	2	0	0	2	0%	$200,000	$0	0%
$50,000	1	0	0	1	0%	$50,000	$0	0%
$25,000	5	0	5	0	0%	$125,000	$0	0%
$15,000	131[c]	47	85[b]	0	35%	$1,965,000	$697,500	35%
$5,000	121	47	74	0	39%	$605,000	$235,000	39%
Grand Totals	**260**	**94**	**164**	**3**	**36%**	**$2,930,000**	**$932,500**	**32%**

Notes

1970a. This information comes from the 1971 *Annual Report.*

1971a. Dollar amounts of grants varied. Women received either $1,000 or $2,000.

1972a. Arts organizations.

1973a. Dollar amounts of grants varied from $1,500 to $5,000.

1973b. Dollar amounts of grants varied; most were $3,000.

1973c. Arts organizations.

1974a. Includes one grant shared by man and woman.

1975a. Includes one grant shared by man and woman.

1977a. Includes one grant shared by man and woman.

1978a. Includes one grant shared by man and woman.

1978b. Photographers' Fellowships were grouped together in the 1978 *Annual Report.* We have extracted the 1979 recipients and listed them under that year.

1980a. Includes two grants shared by man and woman.

1980b. This subcategory was funded jointly by the Visual Arts and the Media Arts programs; therefore the totals for this subcategory do not reconcile with the grand totals for the year.

1980c. Includes one grant shared by two men.

1981a. Two of the 1981 fellowships of this amount were designated from 1980 funds. We have extracted them for inclusion under 1981.

1981b. This information comes from the Media Arts section of the *Annual Report.*

1982a. Includes one grant shared by two men.

1983a. Includes one grant shared by two men.

1984a. Creative Writing and Regional Fellowships listed under this category in 1984 have not been included here.

1985a. Regional arts organizations.

1985b. One grant to a man was funded with fiscal-year 1986 funds and is not reflected in dollar amounts for 1985.

1985c. Includes one grant shared by man and woman.

Catherine C. Brawer

Individual Milestones

The progress of an artist's career can be gauged, at its simplest level, as a succession of fairly standard milestones—each of which marks another step into the mainstream. One of our assumptions regarding changes in the art world from 1970 through 1985 was that the pace of individual careers had quickened and that younger women artists achieved visibility more rapidly than had those of a preceding generation. To test that assumption, we selected a small group of women artists, who are either included in *Making Their Mark* or are among the pioneers discussed in Ellen G. Landau's essay, and charted a series of career firsts for each of them—group exhibitions, solo exhibitions, etc. No attempt was made to create a statistical sample, and any observations are limited to the small selection of artists' careers presented here.

We chose twenty-four artists working in various styles and media, who represent three generations: an older group born before 1920 (five artists); a middle group born between 1920 and 1939 (nine artists); and a younger group born after 1940 (ten artists). The age of these artists in 1970 (when the period under consideration began) ranged from seventy—the age of Alice Neel and Louise Nevelson—to sixteen—the age of Cindy Sherman. Two of the artists, Neel and Lee Krasner, died in 1984; Nevelson died in 1988. We tracked the ages at which each artist in this small sample reached the following eight milestones:

First group exhibition at a gallery
First group exhibition at an alternative space
First group exhibition at an American museum
First inclusion in one of six prestigious recurring exhibitions: the Carnegie International, Corcoran Biennial, Documenta, Venice Biennale, Whitney Annual (through 1972), and Whitney Biennial (beginning 1973)
First solo exhibition at a gallery
First solo exhibition at an alternative space
First solo exhibition at an American museum or cultural institution
First solo exhibition at a foreign museum

The information presented was culled from biographies provided by the artists or their galleries, supplemented in a few instances by chronologies in monographs on the artists. The tables are, of course, only as accurate as their sources.

Individual Milestones

Born	Artist	Age in 1970	Age at First Group Gallery Exhibition	Age at First Group Alternative Space Exhibition	Age at First Group Museum Exhibition
Older					
1900	Alice Neel (d. 1984)	70	33	78	64
1900	Louise Nevelson (d. 1988)	70	34		35
1908	Lee Krasner (d. 1984)	62	29	69	32
1911	Louise Bourgeois	59	34	68	32
1912	Agnes Martin	58			50[a]
Middle					
1920	Elaine de Kooning	50	30		36[b]
1922	Grace Hartigan	48	28		34
1926	Joan Mitchell	44			24
1926	Betye Saar	44			42
1928	Helen Frankenthaler	42	22		25
1931	Audrey Flack	39	32		41
1933	Mary Frank	37			39[c]
1938	Agnes Denes	34	32	35	32
1938	Sylvia Plimack Mangold	34	31	37	30[d]
Younger					
1940	Elizabeth Murray	30	34[e]	36	33[f]
1940	Hannah Wilke	30	26	27	32[g]
1941	Jennifer Bartlett	29	31	32	30
1942	Joyce Kozloff	28	34	35	30[i]
1943	Howardena Pindell	27	31	27	26
1945	Susan Rothenberg	25	29		32
1947	Sherrie Levine	23	32	30	36
1949	Alexis Smith	21	31		23
1951	Melissa Miller	19	29		23
1954	Cindy Sherman	16	25	22	22

Age at First Recurring Exhibition	First Recurring Exhibition	Age at First Solo Gallery Exhibition	Age at First Solo Alternative Space Exhibition	Age at First Solo American Museum Exhibition	Age at First Solo Foreign Museum Exhibition
72	Whitney Annual	38		62	81
46	Whitney Annual	41		67	61
48	Whitney Annual	43		59	57
34	Whitney Annual	36	63	48	
49	Carnegie International	46		59	61
36	Carnegie International	32		38	
53	Corcoran Biennial	29		33	
25	Whitney Annual	25		35	56
44	Whitney Annual	50		47	
27	Carnegie International	23		32	
		28		33	
39	Whitney Annual	25		41	
39	Documenta	29	34	36	40
34	Whitney Annual	36		42	
32	Whitney Annual	35		38	
32	Documenta	32	38	36	
31	Whitney Annual	31h	29	34	41
30	Whitney Annual	28	35	32	
29	Whitney Annual	33	29	28	33
34	Whitney Biennial	31	30	31	27
35	Documenta	34	30	27	
26	Whitney Biennial	25	26	26	
32	Whitney Biennial	32		27	
28j	Documenta & Venice Biennale	26	25	26	28j

Notes

a. Martin stopped painting between 1967 and 1974. Her first recurring exhibition was the Carnegie International at age forty-nine. *Geometric Abstraction* at the Whitney, in which she participated at age fifty, has been listed as her first group exhibition at a museum.

b. If an artist's first group exhibition at a museum was one of the six major recurring exhibitions that have been singled out for separate discussion here, it is cited only in the recurring exhibition column; her age at the time of her first group museum exhibition that is not one of those recurring shows is cited in the group museum column. At age twenty-six de Kooning participated in the Museum of Modern Art's *Young American Painters* in 1956, the same year she was included in her first major recurring exhibition, the Carnegie International.

c. At age thirty-nine Frank appeared in the Guggenheim Museum's *10 Independents* in 1972, the same year she was included in the Whitney Annual, her first major recurring exhibition.

d. At age thirty Mangold was included in three group shows in 1968, each at a university museum.

e. At age thirty-four Murray was given a two-person show with Joseph Zucker at Jacob's Ladder Gallery, Washington, D.C., in 1974.

f. Murray's first recurring exhibition was the Whitney Annual in 1972; her second was the Whitney Biennial in 1973, the same year she participated in *Contemporary American Drawings* at the Whitney, at age thirty-three.

g. At age thirty-two Wilke was included in Documenta in 1972, the same year she was in three additional group shows: *American Women Artists* at the Kunsthaus in Hamburg, West Germany; *Painting or Sculpture* at the Newark Museum, Newark, New Jersey; and the *Summer Drawing Show* at the Akron Institute of Art, Akron, Ohio.

h. At age twenty-five Bartlett was given a two-person show with James Dearing at Jacob's Ladder Gallery in Washington, D.C., in 1966.

i. At age thirty Kozloff was included in the Whitney Annual in 1972, the same year she appeared in four additional group shows at the University of Texas, Austin; Suffolk Museum, Stony Brook, New York; Kent State, Kent, Ohio; and Kunsthaus, Hamburg, West Germany.

j. Sherman is the only artist in this sample to have participated in her first two recurring exhibitions the same year: Documenta and the Venice Biennale, at age twenty-eight. The following year she was included in the Whitney Biennial.

Highlights

1. Age at Time of First Group Exhibition at a Gallery

	20s	30s	40s	50s	60s	70s
Older	1	3				
Middle	2	4				
Younger	4	6				

One artist from the older group—Martin—and three artists from the middle group—Frank, Mitchell, and Saar—did not include information about group gallery exhibitions in their biographies. Among the remaining twenty artists, more in each age group participated in their first group gallery shows while in their thirties than in their twenties. The oldest age for any artist to be included in a group gallery show for the first time was thirty-four (Bourgeois and Nevelson from the older group; Murray and Kozloff from the younger). At twenty-two, Frankenthaler was the youngest to pass this milestone.

2. Age at Time of First Group Exhibition at an Alternative Space

	20s	30s	40s	50s	60s	70s
Older					2	1
Middle		2				
Younger	3	4				

Few alternative spaces existed before the 1970s, but as they proliferated during the 1970s and '80s, they began to play a part in career development. Artists who participated in group exhibitions at alternative spaces were mostly from the younger age group and

were in their twenties or thirties at the time of their first shows of this type. Two artists from the middle group—Denes and Mangold—first participated while in their thirties. And three artists from the older group—Bourgeois, Krasner, and Neel—first participated at ages sixty-eight, sixty-nine, and seventy-eight, respectively.

3. Age at Time of First Group Exhibition at an American Museum

	20s	30s	40s	50s	60s	70s
Older		3		1	1	
Middle	2	5	2			
Younger	4	6				

Artists are generally included in a group exhibition at a museum before they are given a solo museum show. Most of the artists from each age group were in their thirties when they first participated in a group museum exhibition. Among the older artists, those who participated in their first group museum exhibitions while in their thirties—Nevelson at age thirty-five and both Bourgeois and Krasner at age thirty-two—waited for their first solo museum exhibitions until they were sixty-seven, forty-eight, and fifty-nine, respectively. Both Frankenthaler and Mitchell, from the middle group, were in their twenties at the time of their first museum group exhibitions. They then waited seven and eleven years, respectively, before being given their first individual exhibitions at a museum. Four younger women—Miller, Pindell, Sherman, and Smith—were also in their twenties when they participated for the first time in a group museum show. Unlike Frankenthaler and Mitchell, however, they were still in their twenties when given their first solo museum shows, which followed their first group shows within two to four years.

4. Age at Time of First Inclusion in Major Recurring Exhibition

	20s	30s	40s	50s	60s	70s
Older		1	3			1
Middle	2	4	1	1		
Younger	3	7				

By 1985 all but one artist in the sample, Flack, a Super-realist from the middle group, had participated in one of the following recurring exhibitions for the first time: the Carnegie International, Corcoran Biennial, Documenta, Venice Biennale, Whitney Annual, and Whitney Biennial.

Many of the artists in the middle and younger groups first participated in one of these exhibitions while in their thirties, although the middle group tended to be in their mid- to late thirties and the younger group in their early to mid- thirties. Most of the artists from the older group were in their forties, with the exception of Neel, who was seventy-two. Several artists from the middle and younger groups participated for the first time while in their twenties—Frankenthaler and Mitchell from the middle group, and Pindell, Smith, and Sherman from the younger group; these are among the same artists who were given their first group museum exhibitions while in their twenties.

Recognition in one of the international exhibitions sometimes preceded one limited to American artists, as was the case with Wilke, who was first included in Documenta; Martin, who was seen first in the Carnegie International; and Sherman, who participated in both the Venice Biennale and Documenta before being included in the Whitney Biennial for the first time the following year. For three artists—Frank, Kozloff, and Murray—the Whitney Annual was also the first group exhibition at a museum in which each participated. Most of the artists in the sample have

continued to be included in major recurring exhibitions throughout their careers.

5. Age at Time of First Solo Exhibition at a Gallery

	20s	30s	40s	50s	60s	70s
Older		2	3			
Middle	6	2		1		
Younger	3	7				

The younger the age at which an artist has her first solo gallery show, the earlier her entry into mainstream visibility. All of the artists in the older group were in their late thirties to mid-forties when they had their first solo gallery shows. By contrast, most of the artists in the middle group were in their twenties. Within this small sample, the tendency to show earlier in an artist's career that began with the artists in the middle group did not continue among the younger generation of artists, most of whom had their first solo gallery show while in their early thirties.

6. Age at Time of First Solo Exhibition at an Alternative Space

	20s	30s	40s	50s	60s	70s
Older					1	
Middle		1				
Younger	4	4				

Alternative spaces were most important to the visibility of those artists born after 1940. All but two artists in the younger group, Miller and Murray, had at least one solo

exhibition at an alternative space while in their twenties or thirties. In the middle group just one artist, Denes, had a solo show at an alternative space; she was thirty-four at the time. Among the older artists, only Bourgeois had a solo show at an alternative space, at age sixty-three.

Among the younger artists, a first solo exhibition at an alternative space generally occurred within a few years of an artist's first solo gallery and museum exhibitions. The order in which each artist was given her first solo show varied. Three had a solo show at an alternative space before having one at a gallery: Bartlett, Sherman, and Rothenberg. Pindell and Levine each had a solo show first at a museum, next at an alternative space, and then at a gallery. Kozloff, Smith, and Wilke each had a solo exhibition at a gallery before having one at either a museum or an alternative space.

7. Age at Time of First Solo Exhibition at an American Museum

	20s	30s	40s	50s	60s	70s
Older			1	2	2	
Middle			6	3		
Younger	5	5				

Nineteen of the twenty-four artists in the sample had their first solo exhibitions at a university art museum. These were not student exhibitions but curated shows. In the case of Nevelson, she was sixty-seven and was teaching at Brandeis University the year that her first solo show was held at the Rose Art Museum there. This was the same year as the Whitney retrospective of her work.

There was a gradual lowering of the age at which the artists in the different age groups

were given their first solo museum exhibitions. Artists in the older group had their first museum solo shows while in their forties, fifties, and sixties. In the middle group, twice as many artists had their first solo while in their thirties as in their forties; and the younger group had as many solo shows while in their twenties as in their thirties. Artists from the younger age group were the only ones to receive a museum solo show while still in their twenties.

8. Age at Time of First Solo Exhibition at a Foreign Museum

	20s	30s	40s	50s	60s	70s	80s
Older				1	2		1
Middle			1	1			
Younger	2	1	1				

Ten artists in the sample had solo exhibitions at a foreign institution. (This figure includes Neel's 1981 exhibition at the Artists' Union in the USSR.) Those ten represent all three age groups. Only artists from the younger age group had their first foreign museum solo shows while in their twenties, thirties, and forties; the artists in the middle group were in their forties and fifties; and the older artists ranged in age from their fifties to their eighties.

Foreign recognition sometimes preceded a solo museum exhibition at an American institution. Krasner's retrospective at the Whitechapel Gallery in London was held when she was fifty-seven, two years before she received her first individual exhibition at an American museum, at the University of Alabama in Tuscaloosa. Her American retrospective began its tour in 1983, when she was seventy-five.

Conclusion

Although no two artists follow exactly the same path to success, there do seem to be parallels among the careers of artists of the same age group. A comparison of the ages at which women artists achieved their first gallery and museum exposure suggests that little change occurred in the age at which artists in the younger, middle, and older groups were given their first group gallery exhibitions. Artists in the middle group, however, were given their first solo gallery exhibitions at an earlier age than either the older or younger artists. In the case of group museum exhibitions, the younger artists showed slightly earlier than those from the middle and older groups. This is even more pronounced in the case of solo museum exhibitions. Whereas the earliest age for an artist from the older group to have a solo museum show was forty-eight and for the middle group was thirty-two, several artists from the younger group had their first solo museum shows while in their late twenties. This suggests, within this small, nonstatistical sample, that women artists have begun attaining visibility through solo museum exhibitions at an earlier age.

Artists' Biographies

The biography of each artist has been divided into the following categories: birth date and place (when determinable); education; major awards, honors, and grants; public commissions; a selection of no more than one dozen solo exhibitions, installations, performances, major television broadcasts, or screenings at a museum or not-for-profit institution; gallery or distributor; and a brief individual bibliography with no more than six books, reviews, or feature articles (solo exhibition catalogs are noted in the exhibition list). CAPS is an abbreviation for the Creative Artists Public Service award, which was administered by the New York State Council on the Arts; NEA stands for the National Endowment for the Arts. The information has been derived from the biographies supplied by the artists or their galleries. All entries are limited to the years 1970–85, except gallery or distributor.

Each artist's participation in major group exhibitions from 1970 through 1985 is noted under Selected Group Exhibitions (see pages 266–69). The public collections in which the artists' work is represented are listed alphabetically by city on pages 270–74.

Max Almy

Born 1948, Omaha

Education

University of Nebraska, Lincoln, B.F.A., 1970. University of Minnesota, St. Paul. California College of Arts and Crafts, Oakland, M.F.A., 1978.

Awards, Honors, and Grants

First Prize—Video, San Francisco Art Festival, 1975, 1976.
NEA Performance Award, Video Free America, San Francisco, 1979.
First Honorable Mention, United States Film and Video Festival, 1982.
NEA, 1983.
Western States Regional Media Arts Fellowship, 1984.

Selected Solo Installations, Presentations, and Broadcasts

1977 Video installation. San Francisco Museum of Modern Art.
1978 Presentation. Woman's Building, Los Angeles.
1981 Video presentation. Art Com/La Mamelle, San Francisco.
1982 Video installation. Long Beach Museum of Art, Long Beach, Calif.
1984 Presentation. School of the Art Institute of Chicago.
 Screening. Institute of Contemporary Art, Boston.

Video presentation. American Center, Paris.
Nightflight, broadcast. USA Cable Network.
Haute Tension, broadcast. Channel 2, Paris.
1985 Video installation. Utah Arts Festival, Utah Media Center.
 Independent Focus and *New Television*, broadcast. WNET, New York.
 Ghosts in the Machine, broadcast. Channel Four, London.
Distributed by Electronic Arts Intermix, New York, and Video Data Bank, Chicago.

Bibliography

Damsker, Matt. "Embracing the Issues." *Los Angeles Times*, March 15, 1985.
Etra, Louise. "Future Video, Max Almy." *LAICA*, Winter 1983.
Mann, Denise. Interview and article. *Camera Obscura* 12 (1984).
"San Francisco Art Festival." *Artweek*, September 25, 1976.
Stodder, John F. "Video Future Shock." *Artweek*, December 18, 1982.
Video 80/81, Fall 1981, Artist's page.

Laurie Anderson

Born 1947, Chicago

Education

Barnard College, New York, B.A., 1969. Columbia University, New York, M.F.A., 1972.

Awards, Honors, and Grants

CAPS, 1974, 1977.
NEA, 1974–75, 1977, 1979.
Gallery Association of New York, 1976.
Honorary Doctorate, San Francisco Art Institute, 1980.
Villager Award, 1981.
Guggenheim Fellowship, 1982.

Selected Solo Exhibitions and Performances

1970 Barnard College, New York.
1974 *O-Range*. Artists Space, New York, and tour.
1976 Performance. Museum of Modern Art, New York.
 Performance. Whitney Museum of American Art, New York.
1977 *Disco-pictures*. Hopkins Center, Dartmouth College, Hanover, N.H., and tour.
1978 Performance. Walker Art Center, Minneapolis.
 Contemporary Arts Museum, Houston.
 When You We're Here. Museum of Modern Art, New York.
 Matrix 46. Wadsworth Atheneum, Hartford, Conn.
1980 Performance. Kunstmuseum, Zurich.
1982 *Laurie Anderson: Artworks*.

Institute of Contemporary Arts, London, and tour.

1983 *Laurie Anderson: Works from 1969 to 1983.* Institute of Contemporary Art, University of Pennsylvania, Philadelphia, and tour.

Represented by Holly Solomon Gallery, New York. Distributed by The Kitchen, New York.

Bibliography

Levin, Kim. "O Superwoman." *Village Voice*, July 24, 1984.

Owens, Craig. "Amplifications: Laurie Anderson." *Art in America* 69 (March 1981): 120–23.

Pincus-Witten, Robert. "Laurie Anderson." *Art Rite*, April 1974.

Rickey, Carrie. Review. *Artforum* 18 (September 1979): 74–75.

Rockwell, John. "Laurie Anderson: American Music Unbound." *Esquire* 98 (December 1982): 136–39.

Shewey, Don. "The Performing Artistry of Laurie Anderson." *New York Times Magazine*, February 1983.

Eleanor Antin

Born 1935, New York

Education

New School for Social Research, New York. City College, New York, B.A., 1958.

Awards, Honors, and Grants

NEA, 1978.
Vesta Award for Performing Arts, 1985.

Selected Solo Exhibitions and Performances

1971 *Portraits of Eight New York Women.* Chelsea Hotel, New York.
 Library Science. Brand Library Art Center, Los Angeles.

1973 *Part of an Autobiography.* Portland Center for the Visual Arts, Portland, Oreg.

100 Boots. Museum of Modern Art, New York.

1974 *Several Selves.* Everson Museum, Syracuse, N.Y.

1977 *The Angel of Mercy*, performance. La Jolla Museum of Contemporary Art, La Jolla, Calif. Catalog.

1978 *The Ballerina.* Whitney Museum of American Art, New York.
 The Nurse and the Hijackers. Long Beach Museum of Art, Long Beach, Calif.

1979 *100 Boots: Transmission and Reception.* Franklin Furnace, New York.

1981 *Angel of Mercy*, performance. LAICA, Los Angeles.
 Early Works. Palomar College, San Marcos, Calif.

1981 *Recollections of My Life with Diaghilev*, performance.
–84 Contemporary Arts Museum, Houston, and tour.

Represented by Ronald Feldman Fine Arts, New York. Distributed by Video Data Bank, Chicago.

Bibliography

Baker, Elizabeth. "Los Angeles 1971." *Artnews* 70 (September 1971): 27–39.

Bowen, Nancy. "Eleanor Antin." *Profile* 1 (May 1981). Published by Video Data Bank, School of the Art Institute of Chicago, in conjunction with the videotape on Antin made by Lyn Blumenthal and Nancy Bowen.

Crary, Jonathan. "Eleanor Antin." *Arts Magazine* 59 (November 1984): 19.

Frank, Peter. "Eleanor Antin: Wishes, Lies and Dreams." *Soho Evening News*, February 19, 1976.

Goldin, Amy. "The Post-Perceptual Portrait." *Art in America* 63 (January 1975): 79–82.

Johnston, Laurie. "100 Boots End Cross-Country March." *New York Times*, May 16, 1973.

Jacki Apple

Born New York

Education

Syracuse University, Syracuse, N.Y. Otis Art Institute of Parsons School of Design, Los Angeles, graduated 1963.

Awards, Honors, and Grants

NEA, 1979, 1981, 1984.
CAPS, 1981.

Selected Solo Exhibitions, Screenings, and Performances

1973 *Transformation: Claudia*, performance in collaboration with Martha Wilson (with Anne Blevens) (with Anne Blevens). Plaza Hotel, Soho streets and galleries, New York.

1975 *Trunk Pieces.* 112 Greene Street, New York.

1977 *Tracings.* Franklin Furnace, New York.
 Black Holes/Blue Sky Dreams. C Space Gallery, New York.

1978 *Heart of Palms*, performance. P.S. 1, Institute for Art and Urban Resources, Long Island City, N.Y.
 Bedtime Stories, Lullabies, and Other Lies, performance. Whitney Museum of American Art, Downtown Branch at Federal Reserve Plaza, New York, and Kansas Art Institute, Kansas City, Mo.
 Heart of Palms II, performance. Museum of Modern Art, New York.

1979 *The Mexican Tapes*, screening. Franklin Furnace, New York and tour.

1980 *Free Fire Zone*, screening.
–81 University of Michigan, Ann Arbor, and tour.

1982 *The Garden Planet Revisited (Version II)*, performance. Washington Project for the Arts, Washington, D.C.

1985 *The Amazon, the Mekong, the Missouri, and the Nile*, performance. Los Angeles Area

Dance Alliance, John Anson Ford Theater, Hollywood.

Public Commissions

1984 *Last Rites after Angkor Wat.* Museum of Contemporary Art, Los Angeles, for *Territory of Art* radio series. Broadcast on American Public Radio and Canadian Broadcasting Company.

Represented by Cactus Foundation, Los Angeles.

Bibliography

Burnham, Linda Frye. "Reviews." *Artforum* 24 (November 1985): 113.

Durland, Steven. "Sound Philosophies: The Audio Art of Jacki Apple." *High Performance* 28 (1984).

Gardner, Colin. "Colonialism and Postmodernism." *Artweek*, September 7, 1985.

Vickland, Saibra. "The Garden Planet Revisited." *Images and Issues*, September–October 1982.

Writings by Apple

Partitions. New York: self-published, 1976. Edition: 250.

Trunk Pieces. Rochester, N.Y.: Visual Studies Workshop, 1978. Edition: 100 hard cover, 300 soft cover, signed and numbered.

"Correspondence [Jacki Apple and Martha Wilson] 1973–74." *Heresies* 2 (May 1977).

Ida Applebroog

Born 1929, Bronx, N.Y.

Education

New York State Institute of Applied Arts and Sciences, 1947–50. School of the Art Institute of Chicago, 1966–68.

Awards, Honors, and Grants

NEA, 1980, 1985.
CAPS, 1983.

Selected Solo Exhibitions

1971 Boehm Gallery, Palomar College, San Marcos, Calif.

1973 Newport Harbor Art Museum, Newport Beach, Calif.

1976 Women's Interart Center, New York.

1977 P.S. 1, Institute for Art and Urban Resources, Long Island City, N.Y.

1978 Whitney Museum of American Art, New York.

1979 Franklin Furnace, New York.

1980 Rotterdam Arts Foundation, Rotterdam, Holland.

 Apropos, Lucerne, Switzerland.

1981 Mabel Smith Douglass Library, Rutgers University, New Brunswick, N.J.

1982 Bowdoin College Museum of Art, Brunswick, Maine.

1984 Chrysler Museum, Norfolk, Va.

Represented by Ronald Feldman Fine Arts, New York.

Bibliography

Cohen, Ronny. "Ida Applebroog: Her Books." *Print Collector's Newsletter* 15 (May–June 1984): 49–51.

Gambrell, Jamey. "Ida Applebroog at Feldman." *Art in America* 73 (January 1985): 141–42.

"Ida Applebroog: Printed Matter Windows." *Artforum* 18 (March 1980): 75.

Linker, Kate. Review. *Artforum* 21 (February 1983): 80.

Rickey, Carrie. "Ida Applebroog at Franklin Furnace." *Flash Art*, no. 90–91 (June–July 1979): 46.

Smith, Roberta. "Exercises for the Figure." *Village Voice*, November 20, 1984.

Alice Aycock

Born 1946, Harrisburg, Pa.

Education

Douglass College, Rutgers University, New Brunswick, N.J., B.A., 1968.

Hunter College, New York, M.A., 1971.

Awards, Honors, and Grants

NEA, 1975–76, 1980.
CAPS, 1976.
City University of New York Research Award, 1983.

Selected Solo Exhibitions and Installations

1972 *Maze.* Gibney Farm, New Kingston, Pa.

1973 *Low Building with Dirt Roof.* Gibney Farm, New Kingston, Pa.

1974 *Williams College Project.* Williams College, Williamstown, Mass.

1976 *Circular Building with Narrow Ledges for Walking.* Fry Farm, Silver Springs, Pa.

1977 *Studies for a Town.* Project Room, Museum of Modern Art, New York.

1978 *The Happy Birthday Coronation Piece* in *Projects and Proposals.* Muhlenberg College Center for the Arts, Allentown, Pa. Catalog.

1979 *The Rotary Lightning Express.* P.S. 1, Institute for Art and Urban Resources, Long Island City, N.Y.

 Explanation, An, of Spring and the Weight of Air. Contemporary Arts Center, Cincinnati.

1980 *Collected Ghost Stories from the Workhouse.* University of South Florida, Tampa. Catalog.

1983 *Retrospective of Projects and Ideas 1972–1983: The Thousand and One Nights in a Mountain of Bliss Part II, The Fortress of Utopia.* Württembergischer Kunstverein, Württemberg, West Germany, and European tour. Catalog.

 The Nets of Solomon, Phase II. Museum of Contemporary Art, Chicago.

1985 Serpentine Gallery, London. Catalog.

Represented by John Weber Gallery, New York.

Bibliography

Aycock, Alice. *Project Entitled "The Beginnings of a Complex," 1976–1977.* New York: Lapp Princess Press in association with Printed Matter, 1977.

Fox, Howard N. *Metaphor—New Projects by Contemporary Sculptors.* Hirshhorn Museum and Sculpture Garden, Smithsonian Institution. Washington, D.C.: Smithsonian Institution Press, 1982.

Kardon, Janet, and Kay Larson. *Machineworks: Vito Acconci, Alice Aycock, Dennis Oppenheim.* Philadelphia: Institute of Contemporary Art, University of Pennsylvania, 1981.

Kuspit, Donald. "Alice Aycock's Dream Houses." *Art in America* 68 (September 1980): 84–87.

Sheffield, Margaret. "Alice Aycock: Mystery under Construction." *Artforum* 16 (September 1977): 63–65.

Tsai, Eugenie. "A Tale of (at Least) Two Cities: Alice Aycock's 'Large Scale Dis/Integration of Microelectric Memories (A Newly Revised Shantytown).'" *Arts Magazine* 54 (June 1980): 134–41.

Jennifer Bartlett

Born 1941, Long Beach, Calif.

Education

Mills College, Oakland, Calif., B.A., 1963. Yale University, New Haven, Conn., B.F.A., 1964. Yale University School of Art and Architecture, M.F.A., 1965.

Awards, Honors, and Grants

CAPS, 1974.

Harris Prize, Art Institute of Chicago, 1976.

Lucas Visiting Lecture Award, Carleton College, Northfield, Minn., 1979.

Brandeis University Creative Arts Award, 1983.

American Academy and Institute of Arts and Letters, 1983.

Selected Solo Exhibitions

1975 Contemporary Arts Center, Cincinnati.

 Dartmouth College, Hanover, N.H.

1977 Wadsworth Atheneum, Hartford, Conn.

1978 Baltimore Art Museum.

 San Francisco Museum of Modern Art.

1980 Albright-Knox Art Gallery and Hallwalls, Buffalo. Catalog.

1982 Tate Gallery, London. Catalog.

 Joslyn Art Museum, Omaha. Catalog.

1984 Rose Art Museum, Brandeis University, Waltham, Mass. Catalog.

 Matrix/Berkeley 73. University Art Museum, University of California, Berkeley. Brochure.

1985 Walker Art Center, Minneapolis, and tour. Catalog.

Represented by Paula Cooper Gallery, New York.

Bibliography

Amaya, Mario. "Artist's Dialogue: A Conversation with Jennifer Bartlett." *Architectural Digest* 38 (December 1981): 50–60.

Field, Richard S. "Jennifer Bartlett: Prints 1978–83." *Print Collector's Newsletter* 15 (March–April 1984): 1–6.

Galligan, Gregory. "Jennifer Bartlett: In and Out of the Garden." *Arts Magazine* 60 (November 1985): 89–91.

Russell, John. "On Finding a Bold New Work." *New York Times*, May 16, 1976.

Smith, Roberta. "Bartlett's Swimmers." *Art in America* 67 (November 1979): 93–97.

Tomkins, Calvin. "Getting Everything In." *New Yorker*, April 15, 1985, pp. 50–68.

Writings by Bartlett

History of the Universe. New York: Moyer Bell Ltd.; Nimbus Books, 1985.

Lynda Benglis

Born 1941, Lake Charles, La.

Education

Newcomb College, New Orleans, B.F.A., 1964.

Awards, Honors, and Grants

Guggenheim Fellowship, 1975.
Australian Art Council Award, 1976.
Artpark Grant, 1976.
NEA, 1979.

Selected Solo Exhibitions

1971 Kansas State University, Manhattan.

Hayden Gallery, Massachusetts Institute of Technology, Cambridge.

1973 Portland Center for the Visual Arts, Portland, Oreg.

The Clocktower, New York.

1975 The Kitchen, New York.

1979 Real Art Ways, New Haven, Conn.

Georgia State University, Atlanta.

1980 *Lynda Benglis: 1968–1979.* University of South Florida, Tampa, and Miami-Dade Community College. Catalog.

Lowe Art Museum, University of Miami, Coral Gables, Fla.

Chatham College, Pittsburgh.

1981 University of Arizona, Tucson.

Jacksonville Art Museum, Jacksonville, Fla.

Represented by Paula Cooper Gallery, New York. Distributed by Video Data Bank, Chicago.

Bibliography

Bell, Tiffany. "Lynda Benglis." *Arts Magazine* 58 (Summer 1984): 2.

"Interview: Lynda Benglis." *Ocular* 4 (Summer 1979): 30–43.

Kertess, Klaus. "Foam Structures." *Art and Artists* 7 (May 1972): 32–37.

Pincus-Witten, Robert. "Lynda Benglis: The Frozen Gesture." *Artforum* 13 (November 1974): 54–59.

Schjeldahl, Peter. "Updated Data on the Adventure of Being Human." *New York Times*, May 26, 1974.

Williams, Tennessee. "Lynda Benglis." *Parachute*, Spring 1977, pp. 7–11.

Dara Birnbaum

Born 1946, New York

Education

Carnegie Institute of Technology, Pittsburgh, B. Architecture, 1969. San Francisco Art Institute, B.F.A., 1973. Video Study Center, New School for Social Research, New York, certification, 1976.

Awards, Honors, and Grants

CAPS, 1981.

Norman Waite Harris Prize, Art Institute of Chicago, 1982.

New York State Council on the Arts Grant, 1983.

Louis B. Mayer Grant, Dartmouth College, 1983.

NEA, 1984.

Contemporary Art and Television Fund, 1985.

Selected Solo Exhibitions, Installations, and Screenings

1977 Installation. Artists Space, New York.

1978 Installation. The Kitchen, New York.

1979 *Multidisciplinary Program,* installation. P.S. 1, Institute for Art and Urban Resources, Long Island City, N.Y.

1980 London Video Arts. A.I.R. Gallery, London.

1981 *Video Viewpoints.* Museum of Modern Art, New York.

Hallwalls, Buffalo.

1982 Retrospective. Institute of Contemporary Arts Videoteque, London.

1983 Videotape retrospective. Musée d'Art Contemporain, Montreal.

1984 Museum of Art, Carnegie Institute, Pittsburgh.

Women and the Media, New Video, installation in the New American Filmmakers series. Whitney Museum of American Art, New York.

Retrospective screening. Institute of Contemporary Arts Videoteque, London.

1985 Retrospective. Internationale Videobiennale, Venice. Catalog.

Distributed by Electronic Arts Intermix, New York, and Video Data Bank, Chicago.

Bibliography

Brooks, Rosetta. "TV Transformations: An Examination of the Videotapes of New York Artist Dara Birnbaum." *ZG* (London), no. 1.

Buchloh, Benjamin H. D. "Allegorical Procedures: Appropriation and Montage in Contemporary Art." *Artforum* 21 (September 1982): 43ff.

Frank, Peter. "Dara Birnbaum: Artists Space." *Artnews* 76 (October 1977): 139.

Klein, Norman M. "The Audience Culture." In *Theories of Contemporary Art.* Edited by Richard Hertz. Englewood Cliffs, N.J.: Prentice-Hall, 1984.

Owens, Craig. "Phantasmagoria of the Media." *Art in America* 70 (May 1982): 98ff.

Reidy, Robin. "Pop-Pop Video: Dara Birnbaum Alters Familiar Images with Advanced Technology." *American Film* 10 (January–February 1985): 61ff. Reprinted in *Performance Art and Video Installation*, pp. 7–9. London: Tate Gallery, 1985.

Lyn Blumenthal

Born 1949, Chicago
Died 1988, New York

Education

School of the Art Institute of Chicago, M.F.A., 1976.

Awards, Honors, and Grants

NEA, 1977.

New York State Council on the Arts Grant, 1983, 1985.

Production Loan, Producers Initiative, 1984.

New York Foundation for the Arts Fellowship, 1985.

Selected Solo Exhibitions, Installations, and Screenings

1976 *Ice Piece* (Parts I, II, III), video installation. Museum of Contemporary Art, Chicago.

1977 *Surveillance* (Parts I, II, III), video installation. Krannert Museum, Champaign, Ill.

1978 *Clean Slate* (Parts I, II), video environment. Detroit Institute of Arts.

1983 *The Pleasure of His Company*, video environment. The Kitchen, New York.

LACE, Los Angeles.

1985 *The Fiction of Science/The Science of Fiction*, premiere screening of *Arcade*, in collaboration with Carole Ann Klonarides. Grant Park, Chicago.

Video Feature, screening of *Arcade*. International Center of Photography, New York.

1984 *Social Studies* (Parts 1, 2). Hallwalls, Buffalo, and tour.

Institute of Contemporary Art, Boston.

Monte Video, Amsterdam.

Distributed by Video Data Bank, Chicago.

Bibliography

Kirshner, Judith Russi. "The Science of Fiction/The Fiction of Science." *Artforum* 23 (December 1984): 92–93.

Wooster, Ann-Sargent. "Lyn Blumenthal." *Village Voice*, June 7, 1983.

———. "P.S. 1 Reopens the Sixties." *Village Voice*, February 2, 1983.

Zeichner, Arlene. "Re(Tele)visionists." *Village Voice*, December 20, 1983.

Writings by Blumenthal

"Doublecross." In *Resolution: A Critique of Video Art*, pp. 43–47. Edited by Patti Podesta. Los Angeles: LACE, 1985.

"Re: Guarding Video Preservation." *Afterimage* 13, no. 7 (1985): 11–15.

Joan Brown

Born 1938, San Francisco

Education

San Francisco Art Institute, B.F.A., 1959; M.A., 1960.

Awards, Honors, and Grants

NEA, 1976, 1980.
Guggenheim Fellowship, 1977.

Selected Solo Exhibitions

1970 Sacramento State College, Sacramento, Calif.

1971 San Francisco Museum of Modern Art. Catalog.

1973 *Joan Brown: The Dancers Series.* San Francisco Art Institute. Catalog.

1974 University Art Museum, University of California, Berkeley. Catalog.

1977 *Joan Brown: Drawings.* Richard L. Nelson Gallery, University of California, Davis.

 Joan Brown: Matrix 30. Wadsworth Atheneum, Hartford, Conn. Catalog.

1978 Emily H. Davis Art Gallery, University of Akron, Akron, Ohio, and tour. Catalog.

 Fine Arts Center, University of Colorado, Boulder.

Joan Brown: The Acrobat Series. Newport Harbor Art Museum, Newport Beach, Calif. Catalog.

1979 *Joan Brown's Joan Brown.* San Jose Museum of Art, San Jose, Calif.

1983 Mills College, Oakland, Calif. Catalog.

1984 Art Museum of Santa Cruz County, Santa Cruz, Calif.

Public Commissions

1985 Art in Public Places Program, San Francisco Arts Commission, for the Performing Arts Garage, San Francisco.

1985 Washington Arts Commission, for Mattson Junior High School, Kent, Wash.

Represented by Allan Frumkin Gallery, New York.

Bibliography

Berlind, Robert. "'Focus on the Figure: Twenty Years' at the Whitney." *Art in America* 70 (October 1982): 133–34.

Glueck, Grace. "Outline, Cutout, Silhouette." *New York Times*, July 19, 1985.

Horsfield, Kate. "Joan Brown." *Profile* 2 (May 1982).

Kramer, Hilton. "Art: Joan Brown." *New York Times*, October 5, 1974, p. 21.

Perrone, Jeff. "Reviews: Joan Brown." *Artforum* 17 (Summer 1979): 71–72.

Tucker, Marcia. "An Iconography of Recent Figurative Painting: Sex, Death, Violence, and the Apocalypse." *Artforum* 20 (Summer 1982): 70–75.

Nancy Buchanan

Born 1946, Boston

Education

University of California, Irvine, B.A., 1969; M.F.A., 1971.

Awards, Honors, and Grants

NEA, 1978, 1980, 1983.
Research Grant, University of Wisconsin–Madison, 1983.
Residency, Experimental Television Center, Owego, N.Y., 1983, 1984.

Selected Solo Exhibitions, Screenings, and Performances

1974 *Pie Piece*, performance. Woman's Building, Los Angeles.

1976 *Tar Baby*, performance. Mills College, Oakland, Calif.

1977 *Meager Expectations*, performance. LAICA, Los Angeles, and Art Com/La Mamelle, San Francisco.

1979 *Around and about Purity*, performance. Kansas City Art Institute, Kansas City, Mo., and California State University, Long Beach.

1980 *Glossing the Text*, performance. Franklin Furnace, New York.

1981 *Fallout from the Nuclear Family*, performance. University of California, San Diego, and Berkeley Art Center, Berkeley, Calif.

 If I Could Only Tell You How Much I Really Love You, performance. Museum of Contemporary Art, Chicago, and Renaissance Society, University of Chicago.

1982 *It's Been Asked Before*, performance. Washington State University, Pullman.

1985 *Freedom Suites*, performance. Sponsored by California Institute of the Arts, Valencia; Museum of Contemporary Art, Los Angeles; and Japan-America Theater, Los Angeles. Screening. University of Arizona Museum, Tucson.

Distributed by Video Data Bank, Chicago.

Awards, Honors, and Grants

NEA, 1978, 1980, 1983.
Research Grant, University of Wisconsin–Madison, 1983.
Residency, Experimental Television Center, Owego, N.Y., 1983, 1984.

Bibliography

Aber, Buchanan, Holste. Newport Beach, Calif.: Newport Harbor Art Museum, 1976.

Apple, Jacki. "Taking Liberties." *Artweek*, April 1985.

Burnham, Linda, and Steven Durlan. "It's All I Can Think About; An Interview with Nancy Buchanan." *High Performance* 18, no. 25 (1984).

Harrison, Helen A. "Trying to Express the Outrage of War." *New York Times*, April 24, 1983.

Roth, Moira. "Performance Art in 1980: A Turn of Events." *Studio International* 195 (June 1982): 16–24.

Sturken, Marita. "Feminist Video: Reiterating the Difference." *Afterimage* 12 (April 1985).

Barbara Buckner

Born 1950, Chicago

Education

Institute of Film and Technology, New York University, B.F.A., 1972.

Awards, Honors, and Grants

Second Prize, Yale Film Festival, 1972.
NEA, 1977, 1978, 1980.
New York State Council on the Arts Grant, 1979.
CAPS, 1979.
WNET Channel Thirteen Individual Artist Grant, New York, 1981.

Selected Solo Exhibitions

1973 The Kitchen, New York.

1975 Anthology Film Archives, New York.

1977 Collective for Living Cinema, New York.

 Experimental Television Center, Binghamton, N.Y.

 Museum of Modern Art, New York.

1978 School of the Art Institute of Chicago.

1979 Women's Interart Center, New York.

Video Free America, San Francisco.

1980 Whitney Museum of American Art, New York.

Visual Studies Workshop, Rochester, N.Y.

1981 Boston Film/Video Foundation.

Anthology Film Archives, New York.

Distributed by Electronic Arts Intermix, New York.

Selected Bibliography

Sturken, Marita. "An Interview with Barbara Buckner." *Afterimage*, May 1985.

Deborah Butterfield

Born 1949, San Diego, Calif.

Education

San Diego State College, 1966–68. University of California, San Diego, 1969. University of California, Davis, B.A., 1972; M.F.A., 1973.

Awards, Honors, and Grants

Purchase Award for Sculpture, Skowhegan School of Painting and Sculpture, 1972.

Summer Session Grant, University of Wisconsin, 1976.

NEA, 1977, 1980.

Guggenheim Fellowship, 1980.

Selected Solo Exhibitions

1976 Madison Art Center, Madison, Wis.

Israel Museum, Jerusalem.

1981 Museum of Art, Rhode Island School of Design, Providence, Catalog.

1981 ARCO Center for the Visual
–82 Arts, Los Angeles, and tour.

1983 New Mexico State University, Las Cruces, and tour.

Southeastern Center for Contemporary Art, Winston-Salem, N.C. Catalog.

San Antonio Art Institute, San Antonio, Tex.

Oakland Museum, Oakland, Calif.

1984 University Gallery, Reno, Nev.

1985 University Gallery, Ohio State University, Columbus.

Represented by Zolla/Lieberman Gallery, Chicago.

Bibliography

Artner, Alan G. "New Emotion Rides on Butterfield's Horse Sculptures." *Chicago Tribune*, May 27, 1983.

Crowe, Ann Glenn. "Deborah Butterfield." *Artspace*, Fall 1982, pp. 13–15 and cover.

Gedo, Mary Mathews. "Deborah Butterfield." *Arts Magazine* 58 (November 1983): 9.

Guenther, Bruce. "Deborah Butterfield." In *Fifty Northwest Artists*. San Francisco: Chronicle Books, 1983.

Larson, Kay. "Behold a Pale Horse (or Two)." *Village Voice*, November 26, 1979, p. 100.

Muchnic, Suzanne. "Galleries: Giving Life to Metal Horses." *Los Angeles Times*, September 17, 1982.

Cynthia Carlson

Born 1942, Chicago

Education

School of the Art Institute of Chicago, B.F.A., 1965. Pratt Institute, Brooklyn, N.Y., M.F.A., 1967.

Awards, Honors, and Grants

NEA, 1975, 1978, 1980.

MacDowell Colony Fellowship, 1976.

Artpark Grant, 1977.

CAPS, 1978.

Faculty Venture Fund Grants, Philadelphia Colleges of the Arts, 1983.

Selected Solo Exhibitions

1978 University of Colorado, Boulder.

1979 Pennsylvania Academy of the Fine Arts, Philadelphia.

1980 Allen Memorial Art Museum, Oberlin College, Oberlin, Ohio. Catalog.

1981 Hudson River Museum, Yonkers, N.Y.

Herron Art Gallery, University of Indiana, Indianapolis.

Southeastern Center for Contemporary Art, Winston-Salem, N.C. Catalog.

1982 Lowe Art Museum, University of Miami, Coral Gables, Fla.

Rhode Island University, Kingston.

Milwaukee Art Museum. Catalog.

1983 Pratt Institute, Brooklyn, N.Y.

1985 Hallwalls, Buffalo.

Albright-Knox Art Gallery, Buffalo. Catalog.

Public Commissions

1985 *B.W.I. Express.* Maryland Arts Council for Baltimore-Washington International Airport.

Bibliography

Heartney, Eleanor. "Cynthia Carlson." *Arts Magazine* 57 (June 1983): 11.

Jensen, Robert, and Patricia Conway. *Ornamentalism*, pp. 240–41, 258–61. New York: Clarkson N. Potter, 1982.

Johnson, Ellen H., ed. *American Artists on Art from 1940–1980*, pp. 245, 249–51. New York: Harper and Row, 1982.

Kingsley, April. "Cynthia Carlson: The Subversive Intent of the Decorative Impulse." *Arts Magazine* 54 (March 1980): 90–91.

Stewart, Patricia. "High Decoration in Low Relief." *Art in America* 68 (February 1980): 97–101.

Vija Celmins

Born 1939, Riga, Latvia

Education

John Herron Institute, Indianapolis, B.F.A., 1962. University of California, Los Angeles, M.F.A., 1965.

Awards, Honors, and Grants

NEA, 1971, 1976.

Guggenheim Fellowship, 1980.

Selected Solo Exhibitions

1973 Whitney Museum of American Art, New York.

1980 Newport Harbor Art Museum, Newport Beach, Calif., and tour. Catalog.

Represented by David McKee Gallery, New York.

Bibliography

Armstrong, Richard. "Of Earthly Objects and Stellar Sights: Vija Celmins." *Art in America* 69 (May 1981): 100–107.

Baker, Kenneth. "Vija Celmins: Drawing without Withdrawing." *Artforum* 22 (November 1983): 64–65.

Kozloff, Max. "Vija Celmins." *Artforum* 12 (March 1974): 52–53.

Larsen, Susan. "A Conversation with Vija Celmins." *LAICA Journal*, October–November 1978.

Ratcliff, Carter. "Vija Celmins: An Art of Reclamation." *Print Collector's Newsletter* 14 (January–February 1984): 193–96.

Russell, John. "A Remarkable Museum Debut." *New York Times*, July 28, 1980.

Doris Chase

Born 1923, Seattle

Education

University of Washington, Pullman, 1941–43.

Awards, Honors, and Grants

NEA, 1976.

New York State Council on the Arts Grant, 1981.

First Prize, National Women's Film Festival, 1985.

Selected Solo Exhibitions and Broadcasts

1971 Henry Gallery, University of Washington, Pullman.

1973 Wadsworth Atheneum, Hartford, Conn.

1975 Anthology Film Archives, New York.

1985 *Table for One*, broadcast. WNYC-TV, Channel 31, New York.

Public Commissions (monumental kinetic sculpture)

1970 Expo '70, Osaka, Japan.

1972 Seattle Opera.

1974 Museum of Art, Montgomery, Ala.

1975 Open Eye Theater, New York.

1976 Lakeside Park, Anderson, Ind.

Distributed by Museum of Modern Art, New York, and Video Data Bank, Chicago.

Bibliography

Ancona, Victor. "Doris Chase: Painter/Sculptor/Video Artist." *Videography*, June 1978.

Bobrow, Andy. "VideoDance." *Filmmakers Newsletter*, April 1977.

Lorber, Richard. "Doris Chase." *Arts Magazine* 51 (September 1976): 10.

Sturken, Marita. "Video as a Performance Medium." *Sightlines*, Spring 1983.

Weisman, Celia. "Doris Chase: Video and the Dramatic Monologue." *Film Quarterly* 17, nos. 2–4 (1984).

White, Katherine. "Beyond the Gilded Cage." *Women and Performance*, Spring–Summer 1983.

Louisa Chase

Born 1951, Panama City

Education

Yale University School of Art, Norfolk, Conn., 1971. Syracuse University, Syracuse, N.Y., B.F.A., 1973. Yale University School of Art, New Haven, Conn., M.F.A., 1975.

Awards, Honors, and Grants

NEA, 1978–79.

CAPS, 1979–80.

Selected Solo Exhibitions

1975 Artists Space, New York.

1985 *New Currents: Louisa Chase*. Institute of Contemporary Art, Boston. Catalog.

Represented by Harcus Krakow Gallery, Boston.

Bibliography

Flood, Richard. "Louisa Chase." *Artforum* 19 (April 1981): 66.

Henry, Gerrit. "New York Review: Louisa Chase." *Artnews* 80 (Summer 1981): 233.

Logan, Susan, and Allan Schwartzman. *New Work/New York*. New York: New Museum of Contemporary Art, 1980.

Rose, Barbara. *American Painting: The Eighties. A Critical Interpretation*. New York: Vista Press, 1979.

Schwartz, Ellen. "Louisa Chase: I Want Everything at Once." *Artnews* 80 (May 1981): 81–82.

Schwartz, Sheila, and James Leggio. *The American Landscape: Recent Developments*. Fairfield, Conn.: Whitney Museum of American Art, 1981.

Cecilia Condit

Born 1947, Philadelphia

Education

Pennsylvania Academy of the Fine Arts, Philadelphia, 1967–69. Philadelphia College of Art, B.F.A., 1971. Tyler School of Art, Temple University, Philadelphia, M.F.A., 1978.

Awards, Honors, and Grants

Fellowship Award, Tyler School of Art, 1977.

Faculty Summer Incentive Grant, Cleveland Institute of Art, 1981.

Ohio Arts Council Grant, 1981, 1983, 1984.

NEA, 1983, 1985.

First Place—Video Award, Atlanta Film and Video Festival, 1984.

Selected Solo Exhibitions and Screenings

1981 Woodmere Museum of Art, Philadelphia.

Michigan State University, East Lansing.

1985 Screening. Museum of Art, Carnegie Institute, Pittsburgh.

Distributed by Electronic Arts Intermix, New York, and Video Data Bank, Chicago.

Bibliography

Dubler, Linda. "Just like Romeo and Juliet." *Spiral Magazine*, January 1985.

Husler, Kathleen. "Love Stories." *American Film* 11 (November 1985): 63–65.

Killinger, Amy. *New Art Examiner*, February 1985.

Sturken, Marita. "Difference: On Representation and Sexuality." *Afterimage* 12 (April 1985): 10.

White, Mimi. "Resimulation, Video Art and Narrativity." *Wide Angle*, Fall 1985.

Clyde Connell

Born 1901, Belcher, La.

Education

Breneau College, Gainsville, Ga., 1918–19. Vanderbilt University, Nashville, 1919–20.

Awards, Honors, and Grants

Creative Visual Artist Award, Gottlieb Foundation, 1982.

Honor Award, Women's Caucus for Art, 1985.

Selected Solo Exhibitions

1973 Louisiana State University, Alexandria. Catalog.

1979 *Totems and Swamp Songs*. Tyler Museum of Art, Tyler, Tex. Catalog.

Meadows Museum, Shreveport, La. Catalog.

1981 The Clocktower, New York.

Louisiana State University, Shreveport.

1982 *Collage and Assemblage*. Mississippi Museum of Arts, Jackson. Catalog.

Alexandria Museum of Art, Alexandria, La. Catalog.

Clyde Connell—A Sense of Spirit. Sarah Campbell Blaffer Gallery, University of Houston. Catalog.

1984 Celebration of the Arts, World's Fair, New Orleans.

1985 *Recent Works*. Union Gallery, Louisiana State University, Baton Rouge. Catalog.

LSUS Celebrates Clyde Connell. University Center Gallery, Louisiana State University, Shreveport. Catalog.

Represented by Barry Whistler Gallery, Dallas, and Hiram Butler Gallery, Houston.

Bibliography

Harlan, Calvin. "Clyde Connell in Lafayette." *New Orleans Art Review* 5 (October–November 1985).

Hill, Ed, and Suzanne Bloom. Review. *Artforum* 24 (December 1985): 97.

Kalil, Susie. "Clyde Connell: Rain Place." *Artweek* 10 (November 1979): 16.

Lee, Jana Vander. "Clyde Connell: Hinged on Time." *Artspace*, Fall 1983.

Moser, Charlotte. *Clyde Connell: The Art and Life of a Louisiana Woman*. Austin: University of Texas, 1988.

Raynor, Vivien. Review. *New York Times*, June 15, 1984.

Agnes Denes

Born 1938, Budapest

Education

New School for Social Research, New York, 1959–63. City University of New York, 1961–62. Columbia University, New York, 1964–66.

Awards, Honors, and Grants

CAPS, 1972, 1974, 1980.
NEA, 1974, 1975, 1981.
Museum of Modern Art Purchase (matching CAPS grant), 1976.
DAAD Fellowship, 1978.
International Print Competition Awards, Print Club, Philadelphia, 1980, 1982.
New York State Council on the Arts Grant, 1984.

Selected Solo Exhibitions

1972 A.I.R. Gallery, New York.

1974 *Sculptures of the Mind.* Ohio State University, Columbus.

1975 *Agnes Denes: Perspectives.* Corcoran Gallery of Art, Washington, D.C.

1976 Newport Harbor Art Museum, Newport Beach, Calif.

1977 Tyler School of Art, Temple University, Philadelphia.

1978 *Philosophical Drawings.* Amerika Haus, Berlin.
Sculptures of the Mind. Centre Cultural Américain, Paris.

1979 *Agnes Denes Work: 1968–78.* Institute of Contemporary Arts, London.

1980 *Agnes Denes 1968–1980.* Hayden Gallery, Massachusetts Institute of Technology, Cambridge.

1982 *Master of Drawing Invitational.* Kunsthalle, Nuremburg, West Germany.

1985 University of Hawaii Art Gallery, Honolulu.
Northern Illinois University Art Gallery, Chicago.

Public Commissions

1977 *Rice/Tree/Burial.* Artpark, Lewiston, N.Y.

1979 *Time Capsule I.* Artpark, Lewiston, N.Y.

1982 *Wheatfield—A Confrontation.* Public Art Fund, downtown Manhattan.

Represented by Elise Meyer, New York; Ricardo Barreto Contemporary Art, Boston; and Galleriet, Sweden.

Bibliography

Cohen, Ronny. "Agnes Denes: The Triumph of the Will." *Print Collector's Newsletter* 13 (November–December 1982): 159–61.

Kuspit, Donald. "Agnes Denes: The Ironies of Comprehension." *Arts Magazine* 56 (December 1981): 152–53.

Reise, Barbara. "Analytical Works." *Studio International* 188 (December 1974): 235–38.

Selz, Peter. "Agnes Denes: A Visual Presentation of Meaning." *Art in America* 63 (March 1975): 72–74.

Mary Beth Edelson

Born East Chicago, Indiana

Education

School of the Art Institute of Chicago. DePauw University, Greencastle, Ind., B.A. New York University, M.A.

Awards, Honors, and Grants

NEA, 1973.

Selected Solo Exhibitions

1973 *Passage Environment.* Corcoran Gallery of Art, Washington, D.C. Catalog.

1977 *Your 5,000 Years Are Up!* Mandeville Art Gallery, University of California, San Diego.
Proposals for: Memorials to the 9,000,000 Women Burned as Witches in the Christian Era. A.I.R. Gallery, New York.

1978 *Story Gathering Boxes.* Franklin Furnace, New York.

1980 *Mary Beth Edelson: Recent Work.* Albright-Knox Art Gallery, Buffalo.

1981 *A Survey of Photographic*
–82 *Works by Mary Beth Edelson.* Wright State University Galleries, Dayton, Ohio, and tour.

1983 *Pollyanna Perverse.* A.I.R. Gallery, New York.
Mary Beth Edelson: Recent Paintings. Hewlett Gallery, Carnegie-Mellon University, Pittsburgh. Catalog.

1984 *To Dance: Paintings and*
–85 *Drawings by Mary Beth Edelson with Performance in Mind.* Purdue University, Indianapolis, and tour. Catalog.

Bibliography

Burnham, Jack. "Mary Beth Edelson's Great Goddess." *Arts Magazine* 50 (November 1975): 75–78.

Kuspit, Donald, Elaine King, and Mary Beth Edelson. *Mary Beth Edelson, Recent Work: An Ancient Thirst and a Future Vision.* Pittsburgh: Carnegie-Mellon University, 1983.

Lippard, Lucy R. *Overlay: Contemporary Art and the Art of Prehistory.* New York: Pantheon Books, 1983.

Silverthorne, Jeanne. Review. *Artforum* 22 (January 1984): 74.

Zelevansky, Lynn. "Is There Life after Performance?" *Flash Art,* no. 105 (December–January 1982): 38–42.

Writings by Edelson

Seven Cycles: Public Rituals. Introduction by Lucy R. Lippard.

Heide Fasnacht

Born 1951, Cleveland

Education

Rhode Island School of Design, B.F.A., 1973. New York University, M.A. (studio art), 1982.

Awards, Honors, and Grants

NEA, 1979.
Yaddo Fellowship, 1980, 1985.
MacDowell Colony Fellowship, 1981, 1983.
Athena Foundation, 1983.
Hand Hollow Foundation Fellowship, 1983.
Edward Albee Foundation Fellowship, 1984.

Selected Solo Exhibitions

1979 P.S. 1, Institute for Art and Urban Resources, Long Island City, N.Y.

Represented by Germans van Eck, New York.

Bibliography

Brenson, Michael. "A Sculpture Revival All around Town." *New York Times,* November 2, 1985.

Klein, Ellen Lee. "Heide Fasnacht." *Arts Magazine* 58 (December 1983): 35.

———. "Heide Fasnacht." *Arts Magazine* 60 (December 1985): 113.

Russell, John. "Sculpture on the Beach at the Battery." *New York Times,* July 4, 1980.

Smith, Roberta. "Irregulars." *Village Voice,* December 18, 1984.

Jackie Ferrara

Born Detroit

Awards, Honors, and Grants

CAPS, 1971, 1975.
NEA, 1973, 1977.
Guggenheim Fellowship, 1976.

Selected Solo Exhibitions

1977 Ohio State University, Columbus.

1978 Minneapolis College of Art and Design.

1980 University of Southern California, Los Angeles.
University of Massachusetts, Amherst. Catalog.

San Francisco Art Institute.

1981 Laumeier Sculpture Park,
St. Louis.

1982 Lowe Art Museum, University
of Miami, Coral Gables, Fla.
Catalog.

1983 Ackland Art Museum, University of North Carolina, Chapel
Hill.

Represented by Max Protetch Gallery, New York.

Bibliography

Bourdon, David. "Jackie Ferrara: On
the Cutting Edge of a New Sensibility." *Arts Magazine* 50 (January
1976): 90–91.

DeAk, Edit. "Review of Exhibitions."
Art in America 63 (March–April
1975): 87–88.

Heartney, Eleanor. "Jackie Ferrara."
Arts Magazine 57 (March 1983): 9.

Linker, Kate. "Jackie Ferrara's
Illusions." *Artforum* 18 (November
1979): 57–61.

Patton, Phil. "Jackie Ferrara:
Sculpture the Mind Can Use."
Artnews 81 (March 1982): 108–12.

Storr, Robert. "Review of Exhibitions." *Art in America* 70 (May
1982): 140.

Janet Fish

Born 1938, Boston

Education

Smith College, Northampton, Mass.,
B.A., 1960. Skowhegan School of
Painting and Sculpture, Skowhegan,
Maine, 1961. Yale University, New
Haven, Conn., B.F.A., 1963. Yale University School of Art and Architecture, M.F.A., 1963.

Awards, Honors, and Grants

MacDowell Colony Fellowship, 1968,
1969, 1972.

Harris Award, Seventy-first Chicago
Biennial, 1974.

Travel and Lecture Grant, Australian
Council for the Arts, 1975.

Selected Solo Exhibitions

1972 Pace College, New York.

1976 State University of New York,
Stony Brook.

1978 State University of New York,
Stony Brook.

1981 Tomasulo Gallery, Union College, Cranford, N.J.

1982 Delaware Art Museum, Wilmington, Del.

1983 Columbus College, Columbus,
Ga.

1984 Columbia Museum of Art,
Columbia, S.C.

Represented by Robert Miller Gallery, New York.

Bibliography

Arthur, John. *Realists at Work*. New
York: Watson-Guptill Publications,
1983.

Cohen, Ronny. "Large-Scale Close-up
Drawings." *Drawing* 7 (November–
December 1985): 78–80.

Kramer, Hilton. "Stealing the Modernist Fire." *New York Times*,
December 26, 1971, p. 25.

Kuspit, Donald B. "What's Real in
Realism." *Art in America* 69 (September 1981): 84–85.

Nemser, Cindy. "Conversation with
Janet Fish." *Feminist Art Journal* 5
(Fall 1976): 4–10.

Russell, John. "Not So Much the
Glasses as the Light." *New York
Times*, February 22, 1975, p. 23.

Audrey Flack

Born 1931, New York

Education

Cooper Union, New York, 1951. Yale
University, New Haven, Conn.,
B.F.A., 1952. Institute of Fine Arts,
New York University, 1953.

Awards, Honors, and Grants

Award of Merit, Butler Institute of
Art, 1974.

Citation and Honorary Doctorate,
Cooper Union, 1977.

St. Gaudens' Medal, Cooper Union,
1982.

Artist of the Year Award, New York
City Art Teachers Association, 1985.

Selected Solo Exhibitions

1974 University of Hartford,
Hartford, Conn.

1975 University of Bridgeport,
Bridgeport, Conn.

1981 *Audrey Flack: Works on Paper,
1950–1980*. University of
South Florida, Tampa, and Art
and Culture Center, Hollywood, Fla.

1984 Carnegie-Mellon University,
Pittsburgh.

Represented by Louis K. Meisel Gallery, New York.

Bibliography

Alloway, Lawrence. Introduction to
Audrey Flack on Painting. Foreword
by Ann Sutherland Harris. New York:
Harry N. Abrams, 1981.

Glaser, Bruce. Introduction to *Audrey
Flack: The Gray Border Series*. Preface by Louis K. Meisel. New York:
Louis K. Meisel Gallery, 1976.

Gouma-Peterson, Thalia. "Icons of
Healing Energy: The Recent Work of
Audrey Flack." *Arts Magazine* 58
(November 1983): 136–41 and cover.

Henry, Gerrit. "The Real Thing." *Art
International* 16 (Summer 1972):
87–91.

Perreault, John. "A Painting That Is
Difficult to Forget." *Artnews* 77
(April 1978): 150–51.

Siegel, Jeanne. "Audrey Flack's
Objects." *Arts Magazine* 50 (June
1976): 103–5.

Mary Frank

Born 1933, London

Awards, Honors, and Grants

American Academy of Arts and Letters, 1972.

CAPS, 1973.

Guggenheim Fellowship, 1973, 1983.

Brandeis University Creative Arts
Awards, 1977.

Elected to American Academy of Arts
and Letters, 1984.

Selected Solo Exhibitions

1974 Procter Art Center, Bard College, Annandale-on-Hudson,
N.Y.

1975 University of Connecticut,
Storrs.

1976 Cummings Art Center, Connecticut College, New London.
Arts Club of Chicago.
Hobart College, Geneva, N.Y.

1978 *Mary Frank: Sculpture, Drawings, Prints*. Neuberger
Museum, Purchase, N.Y.
Catalog.

Represented by Zabriskie Gallery,
New York.

Bibliography

Henry, Gerrit. "The Clay Landscapes
of Mary Frank." *Craft Horizons* 31
(December 1971): 18–21.

———. "Mary Frank." *Artnews* 82
(May 1983): 160.

Herrera, Hayden. "Myth and
Metamorphosis: The Work of Mary
Frank." *Artscanada* 35 (April 1978):
15–26.

Kingsley, April. "Mary Frank: A
Sense of Timelessness." *Artnews* 72
(Summer 1973).

Ratcliff, Carter. "Mary Frank's
Monotypes." *Print Collector's Newsletter* 9 (November–December 1978):
151–54.

Tina Girouard

Born 1946, De Quincy, La.

Education

University of Southwestern
Louisiana, Lafayette, B.F.A., 1968.

Awards, Honors, and Grants

CAPS, 1973.

NEA, 1976, 1983.

Louisiana Department of the Arts, 1984.

Selected Solo Exhibitions, Installations, and Performances

1973 *Lay on Lie No.* University Art Museum, University of Southwestern Louisiana, Lafayette.

1974 *Juxtaposed, Contained, Revealed*, performance. The Kitchen, New York.

1976 *Maintenance.* Anthology Film Archives, New York.

 Swiss Self, performance. Centre d'Art Contemporain, Geneva.

1977 *Pinwheel*, performance. New Orleans Museum of Art.

1978 *Revival.* The Clocktower, New York.

 Spread, performance. Museum of Contemporary Art, Chicago.

1979 *Even Odd.* Forum Stadtpark Museum, Graz, Austria.

 W.A.W.A. (Worker Aristocrat Witness Ancient), performance. Palais des Beaux-Arts, Brussels.

1982 *Remoat/Remote.* De Vleeshal, Middelburg, Netherlands. Catalog.

1983 *Vamonos.* Museo Tamayo, Mexico City, Catalog.

1985 *Tasting the Blaze*, performance. Austin Opera House, Austin, Tex. Catalog.

Distributed by Video Data Bank, Chicago, and Castelli-Sonnabend, New York.

Bibliography

Bear, Liza, with Tina Girouard. "If I'm Lyin' I'm Dyin'." *Avalanche* 8 (Fall 1973).

Lippard, Lucy R. "Gardens: Some Metaphors for a Public Art." *Art in America* 69 (November 1981): 136–50.

———. "You Can Go Home Again: Five from Louisiana." *Art in America* 65 (July 1977): 22–23.

Russell, John. "Art: American Finds of a Great Collector." *New York Times*, June 26, 1981.

Silverthorne, Jeanne. "Review: Alternatives in Retrospect." *Artforum* 21 (October 1982): 78–79.

Tomkins, Calvin. "Matisse's Armchair." *New Yorker*, February 25, 1980, p. 108.

Nancy Graves

Born 1940, Pittsfield, Mass.

Education

Vassar College, Poughkeepsie, N.Y., B.A., 1961. Yale University, New Haven, Conn., B.F.A., 1964. Yale University School of Art and Architecture, M.F.A., 1964.

Awards, Honors, and Grants

Paris Biennale Grant, 1971.

Vassar College Fellowship, 1971.

NEA, 1972.

CAPS, 1974.

Skowhegan Medal, 1980.

Yale Arts Award for Distinguished Artistic Achievement, 1985.

Selected Solo Exhibitions

1971 *Shaman.* National Gallery of Canada, Ottawa.

 Nancy Graves: Sculpture/ Drawing/Films 1969–1971. Neue Galerie im Alten Kurhaus, Aachen, West Germany. Catalog.

 Vassar College Art Gallery, Poughkeepsie, N.Y.

1971 *Projects: Nancy Graves.*
–72 Museum of Modern Art, New York.

1972 *Nancy Graves: Sculpture and Drawings 1970–72.* Institute of Contemporary Art, University of Pennsylvania, Philadelphia.

1973 La Jolla Museum of Contemporary Art, La Jolla, Calif.

 Recent Works by Nancy Graves. Berkshire Museum, Pittsfield, Mass.

Variability and Repetition of Variable Forms by Nancy Graves. National Gallery of Canada, Ottawa.

1974 *Nancy Graves: Drawings.* Albright-Knox Art Gallery, Buffalo.

1980 *Nancy Graves: A Survey 1969/ 80.* Albright-Knox Art Gallery, Buffalo, and tour. Catalog.

Represented by M. Knoedler and Company, Inc., New York.

Bibliography

Hughes, Robert. "Intensification of Nature." *Time*, April 2, 1984, pp. 80–81.

Lippard, Lucy. *Strata: Nancy Graves, Eva Hesse, Michelle Stuart, Jackie Winsor.* Vancouver: Vancouver Art Gallery, 1977.

Richardson, Brenda. "Nancy Graves: A New Way of Seeing." *Arts Magazine* 46 (April 1972): 57–61.

Shapiro, Michael Edward. "Nature into Sculpture: Nancy Graves and the Tradition of Direct Casting." *Arts Magazine* 59 (November 1984): 92–96.

Storr, Robert. "Natural Fictions." *Art in America* 71 (March 1983): 118–21.

Wasserman, Emily. "A Conversation with Nancy Graves." *Artforum* 9 (October 1970): 42–47.

Eva Hesse

Born 1936, Hamburg, Germany
Died 1970, New York

Education

Pratt Institute, Brooklyn, N.Y., 1952–53. Cooper Union, New York, 1954–57. Yale University, New Haven, Conn., B.F.A., 1959.

Awards, Honors, and Grants

NEA (announced posthumously), 1970.

Selected Solo Exhibitions

1971 Visual Arts Gallery, School of Visual Arts, New York.

1972 Detroit Institute of Arts.

1972 *Eva Hesse: A Memorial Exhibition.* Solomon R. Guggenheim Museum, New York, and tour. Catalog.

1979 *Eva Hesse, 1936–1970: A Retrospective of Works on Paper* and *Eva Hesse: Sculpture.* Mayor Gallery, London, and Whitechapel Art Gallery, London; exhibitions combined for tour. Catalog.

1982 *Eva Hesse: A Retrospective of the Drawings.* Allen Memorial Art Museum, Oberlin College, Oberlin, Ohio. Catalog.

Estate represented by Robert Miller Gallery, New York.

Bibliography

Lippard, Lucy R. *Eva Hesse.* New York: New York University Press, 1976.

———. *Strata: Nancy Graves, Eva Hesse, Michelle Stuart, Jackie Winsor.* Vancouver: Vancouver Art Gallery, 1977.

Nemser, Cindy. "An Interview with Eva Hesse." *Artforum* 8 (May 1970): 59–63.

———. "My Memories of Eva Hesse." *Feminist Art Journal* 2 (Winter 1973): 12–13.

Pincus-Witten, Robert. "Eva Hesse: Post-Minimalism into Sublime." *Artforum* 10 (November 1971): 32–44.

Shapiro, David. "The Random Forms in Soft Materials and String by the Late Young Innovator Eva Hesse." *Craft Horizons* 33 (February 1973): 40–45, 77.

Nancy Holt

Born 1938, Worcester, Mass.

Education

Tufts University, Medford, Mass., B.S., 1960.

Awards, Honors, and Grants

CAPS, 1975, 1978.

NEA, 1975, 1978, 1983, 1985.

WNET Channel Thirteen Artist-in-Residence Grant, New York, 1977.

Guggenheim Fellowship, 1978.

Selected Solo Exhibitions

1972　University of Montana, Missoula.

　　　University of Rhode Island, Kingston.

1974　The Clocktower, New York.

1977　Young Filmmakers series. Whitney Museum of American Art, New York

　　　Franklin Furnace, New York.

1978　Video Theater, Halifax, Nova Scotia.

　　　And/Or Gallery, Seattle.

1979　Museum of Modern Art, New York.

　　　Miami University Art Museum, Oxford, Ohio.

1980　Museum of Art, Carnegie Institute, Pittsburgh.

1981　Saginaw Art Museum, Saginaw, Mich.

1983　Trinity College, Dublin.

Selected Public Commissions (outdoor sculpture)

1972　*Use through a Sand Dune.* Narragansett Beach, R.I.

1974　*Hydra's Head.* Along the Niagara River, Lewiston, N.Y.

1977　*Rock Rings.* Western Washing-
-78　ton University, Bellingham, Wash.

1979　*30 Below.* For the 1980 Winter Olympics, Lake Placid, N.Y.

1979　*Star-Crossed.* Miami Univer-
-80　sity, Oxford, Ohio.

1979　*Dark Star Park.* Rosslyn,
-84　Arlington, Va.

1980　*Annual Ring.* GSA Commis-
-81　sion, for Federal Building, Saginaw, Mich.

1982　*Catch Basin.* St. James Park, Toronto.

1983　*Waterwork.* Gallaudet College,
-84　Washington, D.C.

Represented by John Weber Gallery, New York. Distributed by Video Data Bank, Chicago.

Bibliography

Castle, Ted. "Nancy Holt: Siteseer." *Art in America* 70 (March 1982): 84–91.

Fox, Judy. *Aspects of the '70s: Sitework.* Wellesley, Mass.: Wellesley College Museum, 1980, pp. 2, 4, 8–10.

LeVeque, Terry Ryan. "Nancy Holt's Dark Star Park, Rosslyn, Va." *Landscape Architecture* 75 (July–August 1985): 80–82.

Marter, Joan. "Nancy Holt's Dark Star Park." *Arts Magazine* 59 (October 1984): 137–39.

Saad-Cook, Janet. "Touching the Sky: Conversations with Four Contemporary Artists." *Archaeoastronomy* 8 (April 1985): 124–31.

Shaffer, Diana. "Nancy Holt: Spaces for Reflections Projections." In *Art in the Land*, edited by Alan Sonfist, pp. 169–77. New York: E. P. Dutton, 1983.

Writings by Holt

"Hydra's Head." *Arts Magazine* 49 (January 1975): 57–59.

"Pine Barrens." *Avalanche* 10 (Summer 1975): 6.

"Stone Enclosure: Rock Rings, 1977–78." *Arts Magazine* 53 (June 1979): 152–55.

"Sun Tunnels." *Artforum* 15 (April 1977): 32–37 and cover.

Jenny Holzer

Born 1950, Gallipolis, Ohio

Education

Ohio State University, Columbus, B.F.A., 1972. Rhode Island School of Design, Providence, M.F.A., 1977.

Selected Solo Exhibitions and Installations

1981　*Living.* Nouveau Musée, Lyons, France.

　　　Museum für (sub) Kultur, Berlin.

1982　Artists Space, New York.

1983　Institute of Contemporary Arts, London.

　　　Investigations. Institute of Contemporary Art, University of Pennsylvania, Philadelphia. Catalog.

1984　Cranbrook Museum, Bloomfield Hills, Mich.

　　　University Gallery, University of Massachusetts, Amherst.

　　　Dallas Museum of Art.

　　　Kunsthalle Basel, Basel, Switzerland.

　　　Poster Project. Seattle Art Museum.

　　　State University of New York, Old Westbury.

　　　Sign on a Truck, installation. Grand Army Plaza, Brooklyn, N.Y.

Represented by Barbara Gladstone Gallery, New York. Distributed by Video Data Bank, Chicago.

Bibliography

Bernard, April, and Mimi Thompson. "The Writing on the Walls." *Vanity Fair* 47 (March 1984): 116.

Olander, William. *Holzer/Kruger/Prince.* Charlotte, N.C.: Knight Art Gallery, 1984.

Ratcliff, Carter. "Jenny Holzer." *Print Collector's Newsletter* 13 (November–December 1982): 149–52.

Siegel, Jeanne. "Jenny Holzer's Language Games." *Arts Magazine* 60 (December 1985): 64–68.

Town, Elke. "Jenny Holzer." *Parachute*, Summer 1983.

Zimmer, William. "Art Goes to Rock World on Fire." *Soho News*, September 27, 1979.

Writings by Holzer

Truisms and Essays. Halifax: Nova Scotia College of Art and Design Press.

Sara Hornbacher

Raised in Minnesota

Education

Moorhead State University, Moorhead, Minn., 1975. Graduate Fellow, Center for Media Studies, State University of New York, Buffalo, 1975–78.

Awards, Honors, and Grants

CAPS, 1980.

Completion Fund Award, Media Bureau, The Kitchen, 1983.

Selected Installations, Screenings, and Broadcasts

1980　Film and video retrospective. Hallwalls, Buffalo. Catalog.

　　　Machine Age, broadcast. Manhattan Cable Television, New York.

1982　Installation. Hudson River Museum, Yonkers, N.Y.

1983　Screening. Oakland Museum, Oakland, Calif.

1984　*Videoville 1984*, broadcast. WNYC-TV, Channel 31, New York.

1985　*Videoville 1985*, broadcast. WNYC-TV, Channel 31, New York.

　　　Tomorrow's Television Tonight, broadcast. Manhattan Cable Television, New York.

Bibliography

Hagen, Charles. Review. *Artforum* 21 (April 1983): 74.

Installation: Video. Buffalo: Hallwalls, 1980.

Kijkhuis World-Wide Video Festival. The Hague, Netherlands, 1982, 1984.

Slaton, Amy. Review. *East Village Eye*, April 1985.

Video 80, Winter 1983, p. 53.

Video Music: New Correlations. New York: Whitney Museum of American Art, 1982.

Writings by Hornbacher

"Video: The Reflexive Medium." *Art Journal* 45 (Fall 1985). Hornbacher also served as guest editor for this issue.

Yvonne Jacquette

Born 1934, Pittsburgh

Education

Rhode Island School of Design, Providence, 1952–56.

Awards, Honors, and Grants

Ingram Merrill Grant, 1974.
CAPS, 1979.
New York Foundation for the Arts Fellowship, 1985.

Selected Solo Exhibitions

1972 Tyler School of Art, Temple University, Philadelphia.
1983 *Currents 22: Yvonne Jac-*
-84 *quette.* St. Louis Art Museum.
1985 Yurakucho Seibu/Takanawa Art, Tokyo.

Represented by Brooke Alexander, New York.

Bibliography

Berlind, Robert. "Yvonne Jacquette at Brooke Alexander." *Art in America* 70 (October 1982): 135–36.
Brody, Leslie. "Yvonne Jacquette: Aerial Art." *Tokyo Journal,* July 1985.
Kramer, Hilton. "Art: Yvonne Jacquette." *New York Times,* April 27, 1979.
Lippard, Lucy. "A New Landscape Art: Four Contemporary Artists Go Back to Nature." *Ms.* 5 (April 1977): 68–73.

Ratcliff, Carter. "Yvonne Jacquette: American Visionary." *Print Collector's Newsletter* 12 (July–August 1981): 65–68.
Russell, John. "Yvonne Jacquette." *New York Times,* February 20, 1981.

Valerie Jaudon

Born 1945, Mississippi

Education

Mississippi State College for Women, Columbus, 1963–65. Memphis Academy of Art, Memphis, Tenn., 1965. University of the Americas, Mexico City, 1966–67. St. Martin's School of Art, London, 1968–69.

Awards, Honors, and Grants

CAPS, 1980.
Mississippi Institute of Arts and Letters Art Award, 1981.

Selected Solo Exhibitions

1977 Pennsylvania Academy of the Fine Arts, Philadelphia.
1981 Corcoran Gallery, Los Angeles, Calif.
1983 Quadrat Museum, Bottrop, West Germany. Catalog.
 Amerika Haus, Berlin. Catalog.

Represented by Sidney Janis Gallery, New York.

Bibliography

Goldin, Amy. "The Body Language of Pictures." *Artforum* 16 (March 1978): 54–59.
Larson, Kay. "Freezing Expressionism." *New York,* April 25, 1983, p. 95.
Perreault, John. "Allusive Depths: Valerie Jaudon." *Art in America* 71 (October 1983): 162–65.
———. "Issues in Pattern Painting." *Artforum* 16 (November 1977): 32–36.
Rickey, Carrie. Review. *Artforum* 17 (January 1979): 61–62.
Westfall, Stephen. Review. *Arts Magazine* 60 (December 1985): 125.

Writings by Jaudon

"Art Hysterical Notions of Progress and Culture." *Heresies* 4 (Winter 1977–78): 38–42. With Joyce Kozloff.

Joan Jonas

Born 1936, New York

Education

Mount Holyoke College, South Hadley, Mass., B.F.A., 1958. School of the Museum of Fine Arts, Boston, 1958–61. Columbia University, New York, M.F.A., 1964.

Awards, Honors, and Grants

CAPS, 1971, 1974.
NEA, 1973, 1975, 1978, 1980, 1983.
Guggenheim Fellowship, 1976.
Rockefeller Foundation Grant, 1981.
DAAD Fellowship, 1982.

Selected Solo Exhibitions, Installations, and Performances

1976 *Stage Sets*, installation. Institute of Contemporary Art, University of Pennsylvania, Philadelphia.
1977 *Drawing Room*, installation. School of Visual Arts, New York.
1979 *The Juniper Tree*, installation. Van Abbemuseum, Eindhoven, Netherlands.
1980 Retrospective, including premiere of *Double Lunar Dogs.* University Art Museum, University of California, Berkeley.
 Upside Down and Backwards and retrospective of drawings. Kunstmuseum Bern, Bern, Switzerland.
 Vignettes from Four Works. Solomon R. Guggenheim Museum, New York.
1981 *Double Lunar Dogs*, installation. Contemporary Arts Museum, Houston.

1982 *Upside Down and Backwards.* Stedelijk Museum, Amsterdam.
1983 *He Saw Her Burning.* Whitney Museum of American Art, New York, and international tour.
1984 *Mirage.* Museum of Modern Art, New York.
 Big Market. Whitney Museum at Philip Morris, New York.
1985 *Volcano Saga*, performance. De Appel, Amsterdam.

Distributed by Electronic Arts Intermix, New York; The Kitchen, New York; Video Data Bank, Chicago; Museum of Modern Art, New York; and Castelli-Sonnabend, New York.

Bibliography

Crimp, Douglas. "Joan Jonas's Performance Works." *Studio International* 192 (July–August 1976): 10–12.
de Jong, Constance. "Joan Jonas: Organic Honey's Vertical Roll." *Arts Magazine* 47 (March 1973): 27–29.
———. "Organic Honey's Visual Telepathy." *Drama Review* 16 (June 1972): 63–65.
Jonas, Joan, with Rosalind Krauss. "Seven Years." *Drama Review* 19 (March 1975): 13–16.
Junker, Howard. "Joan Jonas: The Mirror Staged." *Art in America* 69 (February 1981): 86–95.
Silverthorne, Jeanne. "Performance as Metamorphosis: The Art of Joan Jonas." *Philadelphia Arts Exchange* 1 (March–April 1977): 11–14.

Writings by Jonas

Joan Jonas Scripts and Descriptions 1968–1982. Edited by Douglas Crimp. Berkeley: University Art Museum, University of California, Berkeley; Eindhoven: Stedelijk Van Abbemuseum, 1983.

"Organic Honey's Visual Telepathy" (script). *Drama Review* 16 (June 1972): 66–74.

Carole Ann Klonarides

Born Washington, D.C., 1951

Education

Virginia Commonwealth University, Richmond, B.F.A., 1973. Whitney Independent Study Program, New York, 1972–73. New School for Social Research, New York, M.A., 1983.

Awards, Honors, and Grants

Media Bureau, The Kitchen, 1983. Production Grant, Illinois Arts Council, 1984. NEA, 1984.

Selected Screenings and Broadcasts

1982 Hallwalls, Buffalo.

SoHo TV Presents, broadcast. Manhattan Cable Television, New York.

1984 Broadcast. Station VPRO, Schiedam, Netherlands.

1985 *The Fiction of Science/The Science of Fiction*, premiere screening of *Arcade*, in collaboration with Lyn Blumenthal. Grant Park, Chicago.

Video Feature, screening of *Arcade*. International Center of Photography, New York.

New Television, broadcast. WNET, New York.

Distributed by Electronic Arts Intermix, New York.

Bibliography

Brewin, Bob. "The Mega-Satellite Art Event." *Village Voice*, October 26, 1982, p. 114.

Gardner, Paul. "The Electronic Palette." *Artnews* 84 (February 1985): 67–73.

———. "Thinking of Leonardo Wielding a Pixel and a Mouse." *New York Times*, April 22, 1984, p. 1.

Kirshner, Judith Russi. "The Science of Fiction/The Fiction of Science." *Artforum* 23 (December 1984): 92–93.

Pelfrey, Robert H., with Mary Hall-Pelfrey. *Art and Mass Media*, pp. 339–42. New York: Harper and Row, 1985.

Joyce Kozloff

Born 1942, Somerville, N.J.

Education

Carnegie Institute of Technology, Pittsburgh, B.F.A., 1964. Columbia University, New York, M.F.A., 1967.

Awards, Honors, and Grants

CAPS, 1972–73, 1975–76. AAUW Grant in Painting, 1975. NEA, 1977, 1985. Yaddo Fellowship, 1984.

Selected Solo Exhibitions

1973 Mabel Smith Douglass Library, Rutgers University, New Brunswick, N.J.

1974 University of Rhode Island Fine Arts Center, Kingston.

1975 Atholl McBean Gallery, San Francisco Art Institute.

1976 Woman's Building, Los Angeles.

1977 Wilcox Gallery, Swarthmore College, Swarthmore, Pa.

1979 Everson Museum, Syracuse, N.Y.

1980 Mint Museum, Charlotte, N.C.

1980 Renwick Gallery, Smithsonian
–81 Institution, Washington, D.C.

1982 Joslyn Art Museum, Omaha.

1983 *Investigations* series. Institute of Contemporary Art, University of Pennsylvania, Philadelphia.

Lincoln Center for the Performing Arts, New York.

1984 Delaware Art Museum, Wilmington, Del.

Public Commissions

1979 *New England Decorative Arts.*
–85 Cambridge Arts Council, Massachusetts Bay Transportation Authority, for Harvard Square subway station, Cambridge, Mass.

1980 *Homage to Frank Furness.*
–84 Federal Railroad Administration's Northeast Corridor Improvement Project, for train station in Wilmington, Del.

1982 *Bay Area Victorian, Bay Area*
–83 *Deco, Bay Area Funk.* San Francisco Arts Commission, for International Arrivals Building, San Francisco Airport.

1983 Niagara Frontier Transporta-
–84 tion Authority, Humboldt Hospital subway station, Buffalo.

1985 *Galla Placidia in Philadelphia and Topkapi Pullman.* One Penn Plaza, Conrail suburban station, Philadelphia.

Represented by Barbara Gladstone Gallery, New York.

Bibliography

Foote, Nancy. "Joyce Kozloff at de Nagy." *Art in America* 63 (May 1975): 88.

Goldin, Amy. "Pattern and Print." *Print Collector's Newsletter* 9 (March–April 1978): 10–13.

Masheck, Joseph. "Joyce Kozloff." *Artforum* 12 (September 1973): 76.

Perrone, Jeff. "Joyce Kozloff." *Artforum* 18 (November 1979): 78–79.

———. "Two Ethnics Sitting Around Talking about Wasp Culture." *Arts Magazine* 59 (March 1985): 78–83.

Rickey, Carrie. "Joyce Kozloff." *Arts Magazine* 52 (January 1978): 2, 29.

Writings by Kozloff

"Art Hysterical Notions of Progress and Culture." *Heresies* 4 (Winter 1977–78): 38–42. With Valerie Jaudon.

"The Women's Movement: Still a 'Source of Strength' or 'One Big Bore'?" With Barbara Zucker. *Artnews* 75 (April 1976): 49–50.

Margia C. Kramer

Born Brooklyn, N.Y.

Education

Brooklyn College, Brooklyn, N.Y., B.A. New York University, Institute of Fine Arts, M.A.

Awards, Honors, and Grants

NEA, 1976, 1982. Completion Grant, Illinois Arts Council Project, 1981. New York State Council on the Arts Grant, 1981. MacDowell Colony Fellowship, 1982, 1984, 1985. Jerome Foundation Grant, 1985.

Selected Solo Exhibitions and Installations

1977 *New Paintings.* Sarah Lawrence College Art Gallery, Bronxville, N.Y.

1980 *Secret I*, installation with pamphlet. Artists Space, New York.

Ten Year Retrospective. Duke University Art Gallery, Durham, N.C.

Secret III and *Secret IV*, installations with pamphlets. Installed simultaneously at Printed Matter and Franklin Furnace, New York.

Secret VI, installation with pamphlets. Institute of Contemporary Arts, London.

1981 *Left and Right*, installation with books. A Space Gallery, Toronto.

Jean Seberg/The FBI/The Media, installation with pamphlet. Museum of Modern Art, New York.

1983 *Progress (Memory) I*, installation. Visual Studies Workshop, Rochester, N.Y.

1984 *Progress and Access*, installation. Vassar College Art Gallery, Poughkeepsie, N.Y.

Progress (Memory), installation in the New American Filmmakers series. Whitney Museum of American Art, New York. Catalog.

Public Commissions

1983 Video installation for Visual Studies Workshop.

Distributed by Video Data Bank, Chicago.

Bibliography

Hanhardt, John. "The Whitney Museum of American Art New American Filmmakers Series #15, Margia Kramer, *Progress (Memory)*." New York, 1984.

Linker, Kate. "Margia Kramer, *Progress (Memory)*." *Artforum* 22 (Summer 1984): 89.

Lippard, Lucy R. *Get the Message? A Decade of Art for Social Change*, p. 140. New York: E. P. Dutton, 1984.

Lippard, Lucy R. "They've Got FBEyes for You." *Village Voice*, November 1981.

Whitfield, Tony. "Three Books—Three Lives." *Fuse* (Toronto), March 1980, p. 170ff.

Wooster, Ann-Sargent. "Manhattan Short Cuts." *Afterimage* 9 (February 1982): 19.

Writings by Kramer

"Notes on Expression/Repression." *Wedge: An Aesthetic Inquiry*, no. 1 (Summer 1982): 30ff.

Barbara Kruger

Born 1945, Newark, N.J.

Education

Syracuse University, Syracuse, N.Y., 1965. Parsons School of Design, New York, 1966.

Awards, Honors, and Grants

CAPS, 1976.
NEA, 1982.
New York Foundation for the Arts Fellowship, 1985.

Selected Solo Exhibitions

1974 Artists Space, New York.

1979 Franklin Furnace, New York.
Printed Matter, New York.

1980 P.S. 1, Institute for Art and Urban Resources, Long Island City, N.Y.

1983 Institute of Contemporary Arts, London.

1984 Kunsthalle Basel, Basel, Switzerland.
Nouveau Musée, Lyons, France.

1985 Contemporary Arts Museum, Houston.
Los Angeles County Museum of Art.
Wadsworth Atheneum, Hartford, Conn.

Represented by Mary Boone Gallery, New York.

Bibliography

Foster, Hal. "Subversive Signs." *Art in America* 70 (November 1982): 88–92.

Lichtenstein, Terese. "Barbara Kruger." *Arts Magazine* 57 (May 1983): 4.

Linker, Kate. "Barbara Kruger Interview." *Flash Art*, no. 121 (March 1985): 36–37.

Lippard, Lucy. "One Liner after Another." *Village Voice*, April 11, 1984, p. 73.

Owens, Craig. "The Medusa Effect on the Specular Ruse." *Art in America* 72 (January 1984): 97–105.

Rose, Barbara. "Art in Discoland." *Vogue*, September 1985, pp. 668–72, 747.

Shigeko Kubota

Born 1937, Niigata, Japan

Education

Tokyo University, 1960. New York University, 1965–66. New School for Social Research, New York, 1966–67. Art School of the Brooklyn Museum, Brooklyn, N.Y., 1967–68.

Awards, Honors, and Grants

CAPS, 1975.
NEA, 1975, 1978, 1980.
DAAD Fellowship, 1979.
New York State Council on the Arts Grant, 1980, 1982, 1984.
Indie Award, Association of Independent Video and Filmmakers, New York, 1977.

Selected Solo Exhibitions

1972 The Kitchen, New York.

1973 Wabash Transit Gallery, School of the Art Institute of Chicago.

1975 Everson Museum of Art, Syracuse, N.Y.

1976 And/Or Gallery, Seattle.

1978 *Projects*. Museum of Modern Art, New York.
Art Gallery of Ontario, Toronto.

1981 San Francisco Art Institute.
Museum of Contemporary Art, Chicago.

1982 *Video Sculptures*. Kunsthaus Zurich, and tour. Catalog.

1983 Japanese-American Cultural and Community Center, Los Angeles.
University Art Museum, University of California, Berkeley.

1985 The Kitchen, New York.

Distributed by Electronic Arts Intermix, New York, and Video Data Bank, Chicago.

Bibliography

Adams, Brooks. "Profile." *Art in America* 72 (February 1984): 122–24.

Allen, James Addams. "Japanese Tradition Woven into Video Installation." *Washington Times*, December 1983.

Bourdon, David. "Women Paint Portraits on Canvas and Off." *Village Voice*, February 16, 1976.

Frank, Peter. "Shigeko Kubota at Rene Block." *Artnews* 75 (April 1976): 121–22.

Glueck, Grace. "Shigeko Kubota (White Columns)." *New York Times*, November 18, 1983.

Wooster, Ann-Sargent. "New York Reviews." *Artnews* 76 (April 1977): 127–28.

Leslie Labowitz

Born 1946, Uniontown, Pa.

Education

Otis Art Institute of Parsons School of Design, Los Angeles, B.F.A., M.F.A., 1972. Art Academy, Düsseldorf, West Germany, 1972–73.

Awards, Honors, and Grants

DAAD/Fulbright Scholarship, 1972–73.
Scholarship, Goethe Institute, 1972.
NEA, 1982.

Selected Solo Exhibitions, Installations, Screenings, and Performances

1971 *Time Waste*, performance. Otis Art Institute, Los Angeles.

1973 *Recycled*, performance. Art Academy, Düsseldorf, West Germany.
To Please a Man, performance. Art Academy, Düsseldorf, West Germany.

1977 *In Mourning and in Rage*, performance, in collaboration with Suzanne Lacy. Los Angeles City Hall.
Three Weeks in May, performance, in collaboration with Suzanne Lacy. Los Angeles City Hall.

1978 *Global Space Invasion*. San Francisco Museum of Modern Art.
In Mourning and in Rage, screening. Video Free America, San Francisco.

1979 *Political Art and Popular Culture*, installation, in collaboration with Suzanne Lacy. Santa Barbara Museum of Art, Santa Barbara, Calif.
Record Companies Drag Their Feet and *In Mourning and in Rage*. Woman's Building, Los Angeles, and tour.

1980 *The Secret Garden*, Sproutime L.A., installation and performance. Venice, Calif.

1981 *A Business Opportunity*, Sproutime N.Y., installation and performance. Franklin Furnace, New York.

Bibliography

Askey, Ruth. "In Mourning and in Rage." *Artweek*, January 14, 1978.

———. "Social Criticism in Feminist Art." *Artweek*, October 14, 1978.

Lacy, Suzanne. "Greening of California Performance: Art for Social Change—A Case Study." *Images and Issues*, Spring 1982.

"Moving Out: An Interview with Leslie Labowitz and Ruth Iskin on Social, Feminist, and Performance Art." *Spinning Off*, April 1979.

Writings by Labowitz

"Feminist Art: Public Forms and Social Issues." *Heresies* 3 (Spring 1978).

"In Mourning and in Rage." *Frontiers: A Journal of Women's Studies* 3 (Spring 1978).

Suzanne Lacy

Born 1945, Wasco, Calif.

Education

Bakersfield College, Bakersfield, Calif., A.A., 1963–65. University of California, Santa Barbara, B.A., 1968. Fresno State College, Fresno, Calif., 1969–71. California Institute of the Arts, Valencia, M.F.A., 1973.

Awards, Honors, and Grants

CETA Grant, Artists for Economic Action, 1977.
NEA, 1979, 1981, 1985.
California Arts Council Grant, 1982, 1985.

Western Regional Film Fellowship, 1984.
McKnight Fellowship, 1985.

Selected Solo Exhibitions, Installations, and Performances

1975 *Monster Series: Construction of a Novel Frankenstein*, performance. Woman's Building, Los Angeles.

1976 *Inevitable Associations.* American Theater Association Conference, Los Angeles.

Cinderella in a Dragster. Dominguez Hills College, Los Angeles.

1977 *The Bag Lady*, performance. De Young Museum Downtown Center, San Francisco.

In Mourning and in Rage, performance, in collaboration with Leslie Labowitz. Los Angeles City Hall.

Three Weeks in May, performance, in collaboration with Leslie Labowitz. Los Angeles City Hall.

1978 *The Lady and the Lamb.* Mills College, Oakland, Calif.

1980 *Evalina and I*, installation. Woman's Building, Los Angeles.

Tree: A Performance with Women of Ithaca. Cornell University, Ithaca, N.Y.

River Meetings: Lives of Women in the Delta, performance. College Art Association Conference, New Orleans.

1982 *Freeze Frame: Room for Living Room*, performance. International Theater Festival, San Francisco.

1983 Montgomery Gallery, Pomona College, Claremont, Calif.

Distributed by Video Data Bank, Chicago.

Bibliography

Arnold, Stephanie. "Whisper, the Waves, the Wind." *Drama Review*, Spring 1985.

Glueck, Grace. "Women Artists '80: A Matter of Redefining the Whole Relationship between Art and Society." *Artnews* 79 (October 1980): 58–63.

Raven, Arlene. "Commemoration, Public Sculpture and Performance." *High Performance* 8, no. 3 (1985): 36–40.

Rosler, Martha. "The Private and the Public: Feminist Art in California." *Artforum* 16 (September 1977): 66–74.

Roth, Moira. "Suzanne Lacy's Dinner Parties." *Art in America* 68 (April 1980): 126.

———. "Visions and Re-visions." *Artforum* 19 (November 1980): 36–45.

Cheryl Laemmle

Born 1947, Minneapolis

Education

Humboldt State University, Arcata, Calif., B.A., 1974. Washington State University, Pullman, M.F.A., 1978.

Awards, Honors, and Grants

CAPS, 1980.
Vera G. List Award, 1984.
NEA, 1985.

Selected Solo Exhibitions

1980 Special Projects Room, P.S. 1, Institute for Art and Urban Resources, Long Island City, N.Y.

Represented by Sharpe Gallery, New York.

Bibliography

Armstrong, Richard. Review. *Artforum* 21 (Summer 1983): 82–83.

Cotter, Holland. *Arts Magazine* 58 (June 1984): 41.

Drier, Deborah J. "Artists the Critics Are Watching." *Artnews* 83 (November 1984): 79–81.

Russell, John. *New York Times*, March 11, 1983.

Vettese, Angela. "Europe and America: Two Aspects of the New Surreal." *Flash Art*, no. 122 (April–May 1985): 20–25.

Waite, John. "Cheryl Laemmle." *Metropolis M*, July–August 1984, pp. 42–45.

Lois Lane

Born 1948, Philadelphia

Education

Philadelphia Colleges of the Arts, B.F.A., 1969. Yale University School of Art and Architecture, New Haven, Conn., M.F.A., 1971.

Awards, Honors, and Grants

CAPS, 1977.
NEA, 1978.

Selected Solo Exhibitions

1974 Artists Space, New York.

1980 *Lois Lane Paintings and Collages.* Akron Art Museum, Akron, Ohio.

1982 Pennsylvania Academy of the Fine Arts, Philadelphia.

Represented by Barbara Mathes Gallery, New York.

Bibliography

Carr, Carolyn Kinder. Introduction to *The Image in American Painting and Sculpture 1950–1980.* Akron, Ohio: Akron Art Institute, 1981.

———. "Lois Lane: An Interview with the Painter." *Dialogue, The Ohio Arts Journal*, January–February 1981.

Kramer, Hilton. Review. *New York Times*, October 21, 1977.

PostMinimalism. Ridgefield, Conn.: Aldrich Museum of Contemporary Art, 1982.

Smith, Roberta. "The Abstract Image." *Art in America* 67 (March 1979): 103.

Wallis, Brian. "Lois Lane." *Arts Magazine* 55 (January 1981): 19.

Sherrie Levine

Born 1947, Hazleton, Pa.

Education

University of Wisconsin–Madison, B.A., 1969; M.F.A., 1973.

Awards, Honors, and Grants

NEA, 1985.

Selected Solo Exhibitions

1974 De Saisset Museum, Santa Clara University, Santa Clara, Calif.
1978 Hallwalls, Buffalo.
1979 The Kitchen, New York.
1984 Ace, Montreal.
1985 Northwestern University, Evanston, Ill.

Represented by Mary Boone Gallery, New York.

Bibliography

Buchloh, Benjamin H. D. "Allegorical Procedures: Appropriation and Montage in Contemporary Art." *Artforum* 21 (September 1982): 43–56.

Cameron, Dan. "Absence and Allure: Sherrie Levine's Recent Work." *Arts Magazine* 58 (December 1983): 84–87.

Krauss, Rosalind. "The Originality of the Avant-Garde: A Post-Modernist Repetition." *October* 18 (1981): 47–66.

Lawson, Thomas. "Last Exit: Painting." *Artforum* 20 (October 1981): 40–47.

Owens, Craig. "The Allegorical Impulse: Toward a Theory of Post-Modernism." *October* 13 (1980): 58–80.

Smith, Paul. "Difference in America." *Art in America* 73 (April 1985): 190–99.

Joan Logue

Born 1942, McKeesport, Pa.

Education

Mount St. Mary's College, Los Angeles, B.F.A., 1970.

Awards, Honors, and Grants

NEA, 1977, 1979, 1980–81, 1982, 1983, 1984.
New York State Council on the Arts Grant, 1980–81.
CAPS, 1983.
DAAD Fellowship, 1983.
San Francisco Video Festival Award, 1984.

Selected Solo Exhibitions, Installations, and Broadcasts

1978 *Video Portraits from California.* Museum of Modern Art, New York.
 Selected Works. Anthology Film Archives, New York.
1979 *Willem de Kooning Portrait.* Contemporary Arts Center, Cincinnati.
 Robert Rauschenberg Portrait, broadcast. WGBH-TV, Boston.
1980 *M. Alvarez Bravo Video Portrait.* Long Beach Museum of Art, Long Beach, Calif.
 Robert Rauschenberg Portrait. Whitney Museum of American Art, Downtown Branch at Federal Reserve Plaza, New York.
 John Cage Portrait. Walker Art Center, Minneapolis.
1981 *Video Portrait Gallery,* installation. Centre Georges Pompidou, Paris.
 Video Portraits. And/Or Gallery, Seattle.
1985 *30 Second Spots.* University Art Museum, University of California, Berkeley, and International Center of Photography, New York.
 Selected 30 Second Spots. Broadcast on the PBS national series "Alive from Off Center."

Distributed by Electronic Arts Intermix, New York, and Video Data Bank, Chicago.

Mary Lucier

Born 1944, Bucyrus, Ohio

Education

Brandeis University, Waltham, Mass., B.A., 1965.

Awards, Honors, and Grants

CAPS, 1975, 1979.
Project Grant, Gallery Association of New York State, 1977.
NEA, 1978, 1980, 1981, 1983.
New York State Council on the Arts Grant, 1981, 1983.
Jerome Foundation Grant, 1982.
Guggenheim Fellowship, 1985.

Selected Solo Exhibitions and Installations

1975 *Air Writing* and *Fire Writing.* The Kitchen, New York.
1976 *Dawn Burn.* Anthology Film Archives, New York.
1977 *Untitled Display System* and *A Burn for the Bigfoot.* And/Or Gallery, Seattle.
1978 *Paris Dawn Burn* and *Lasering.* The Kitchen, New York.
1979 *Untitled Display System.* Media Study, Buffalo.
 Video Viewpoints. Museum of Modern Art, New York.
1980 *Planet.* Hudson River Museum, Yonkers, N.Y.
1981 *Denman's Col (Geometry).* Whitney Museum of American Art, New York.
1983 *Ohio at Giverny.* Museum of Art, Carnegie Institute, Pittsburgh, and Port Washington Public Library, Port Washington, N.Y.
1985 *Wintergarden.* Whitney Museum at Philip Morris, New York.
 Mary Lucier Video Installations. Norton Gallery and School of Art, West Palm Beach, Fla.

Public Commissions

1979 *Equinox.* City University Graduate Center, New York.
1980 *Planet.* Hudson River Museum, Yonkers, N.Y.
1982 *Wintergarden.* Lower Manhattan Cultural Council, New York.
1984 *Wilderness.* Massachusetts Council on the Arts and Humanities, Boston.

Distributed by Electronic Arts Intermix, New York.

Bibliography

Gever, Martha, and Marita Sturken. "Mary Lucier's Elemental Investigations." *Afterimage* 9 (February 1982): 8–11.

Glueck, Grace. "Equinox/A Color Dawn Burn." *New York Times*, April 13, 1979.

Hagen, Charles. Review. *Artforum* 22 (June 1984): 90.

Lorber, Richard. "Mary Lucier, The Kitchen." *Artforum* 17 (September 1978): 81–82.

Rice, Shelley. "Mary Lucier." *Woman's Art Journal*, Fall–Winter 1984–85.

Russell, John. "Why the Latest Whitney Biennial Is More Satisfying." *New York Times*, March 25, 1983.

Writings by Lucier

"Organic." *Art and Cinema*, December 1978.

Sylvia Plimack Mangold

Born 1938, New York

Education

Cooper Union, New York, 1956–59.
Yale University, New Haven, Conn., B.F.A., 1961.

Awards, Honors, and Grants

CAPS, 1973.

Selected Solo Exhibitions

1980 Ohio State University, Columbus, Ohio.

1981 *Perspectives: Sylvia Plimack Mangold: Nocturnal Paintings.* Contemporary Arts Museum, Houston.

Matrix Gallery, Wadsworth Atheneum, Hartford, Conn.

1982 *The Art of Sylvia Plimack Mangold.* Duke University Art Gallery, Durham, N.C.

Sylvia Plimack Mangold: Paintings 1965–1982. Madison Art Center, Madison, Wis., and Grand Rapids Art Museum, Grand Rapids, Mich.

Represented by Brooke Alexander, New York.

Bibliography

Brenson, Michael. "Sylvia Plimack Mangold." *New York Times,* November 22, 1985.

Caldwell, John. "Complex Works Shown at Atheneum." *New York Times,* January 4, 1981.

Florescu, Michael. "Sylvia Plimack Mangold." *Arts Magazine* 58 (March 1984): 6.

Lyons, Lisa. "Sylvia Plimack Mangold." *Design Quarterly* 111/112 (September–November 1979): 35–39. Exhibition catalog for *Elusive Image,* Walker Art Center, Minneapolis.

Paoletti, John T. "Sylvia Plimack Mangold: Uses of the Past." *Arts Magazine* 57 (May 1983): 90–93.

Ravenal, John B. "Sylvia Plimack Mangold: Framework." *Arts Magazine* 57 (May 1983): 94–96.

Ana Mendieta

Born 1948, Havana
Died 1985, New York

Education

University of Iowa, Iowa City, B.A., 1969; M.A., M.F.A., 1972.

Awards, Honors, and Grants

Iowa Arts Council, 1977.
NEA, 1978, 1980, 1982, 1983.
CAPS, 1979.
Guggenheim Fellowship, 1980.
New York State Council on the Arts Grant, 1982.
American Academy in Rome Fellowship, 1983, 1984.

Selected Solo Exhibitions and Performances

1972 Performance. Center for the New Performing Arts, University of Iowa, Iowa City.

1973 *Freeze,* performance. Center for the New Performing Arts, University of Iowa, Iowa City.

1974 *Esculturas Corporal, Unidad Profesional Zacatenco,* performance. Mexico City.

1976 *Nañigo Burial and Filmwork.* 112 Greene Street, New York.

Body Tracks, performance. Internationaal Cultureel Centtrum, Antwerp, Belgium, and Studenski Kulturni Center, Belgrade, Yugoslavia.

1977 *Silueta Series* in *Corroboree.* Gallery of New Concepts, University of Iowa, Iowa City.

1978 *La Noche, Yemaya,* performance. Franklin Furnace, New York.

1980 Museu de Arte Contemporanea, São Paulo, Brazil.

1981 *Esculturas Rupestres/ Rupestrian Sculptures.* A.I.R. Gallery, New York. Catalog.

1982 *Earth/Body Sculptures.* Douglass College, Rutgers University, New Brunswick, N.J. Catalog.

Body Tracks, performance. Franklin Furnace, New York.

1983 *Geo-Image.* Museo Nacional de Bellas Artes, Havana.

Public Commissions

1980 Two outdoor sculptures, for Kean College, Union, N.J.

Bibliography

"Ana Mendieta 1948–1985." *Heresies* 5, no. 2, issue 18 (1985): frontispiece. Issue dedicated to Mendieta's memory.

Buckberrough, Sherry. "Real Art Ways/Hartford—Ana Mendieta." *Art New England,* June 1982, p. 7.

Gray, Channing. "Earth Art: Ana Mendieta Looks into the Past to Find Our Relationship with Nature." *Providence Journal Bulletin,* April 21, 1984.

Heit, Janet. "Ana Mendieta." *Arts Magazine* 54 (January 1980): 5.

Lippard, Lucy. *Overlay: Contemporary Art and the Art of Prehistory.* New York: Pantheon Books, 1983.

———. "Quite Contrary: Body, Nature, Ritual in Women's Art." *Chrysalis,* no. 2 (1977): 31–47.

Melissa Miller

Born 1951, Houston

Education

University of Texas, Austin, 1969–71. Museum of Fine Arts School, Houston, 1971. University of New Mexico, Albuquerque, B.F.A., 1974.

Awards, Honors, and Grants

Scholarship, Yale University Summer School of Music and Art, 1974.
NEA, 1979, 1982, 1985.
Anne Giles Kimbrough Fund, Dallas Museum of Art, 1982.

Selected Solo Exhibitions

1978 *Young Texas Artist Series: Melissa Miller Paintings and Drawings.* Amarillo Art Center, Amarillo, Tex. Catalog.

1981 Art Museum of South Texas, Corpus Christi.

Perspectives Gallery, Contemporary Arts Museum, Houston. Catalog.

Represented by Texas Gallery, Houston.

Bibliography

Cathcart, Linda L. *Texas Fine Arts 1980 Annual National Exhibition.* Austin, Tex.: Laguna Gloria Art Museum, 1980.

Fagaly, William A., and Monroe K. Spears. *Southern Fictions.* Houston: Contemporary Arts Museum, 1983.

Hauser, Reine. "Melissa Miller." *Artnews* 83 (May 1984): 134.

Kalil, Susie, and Barbara Rose. *Fresh Paint: The Houston School.* Houston: Museum of Fine Arts, 1985.

Strel, D. O. *1974 Southwest Fine Arts Biennial.* Santa Fe, N. Mex.: Museum of Fine Arts, 1974.

Tucker, Marcia, and Rita Starpattern. *Women-in-Sight: New Art in Texas.* Austin, Tex.: Dougherty Cultural Arts Center, 1979.

Mary Miss

Born 1944, New York

Education

University of California, Santa Barbara, B.A., 1966. Rinehart School of Sculpture, College of Art, Maryland Institute, Baltimore, M.F.A., 1968.

Awards, Honors, and Grants

CAPS, 1973, 1976.
Project Grant, Mott Community College, Flint, Mich., 1974.
NEA, 1974, 1975, 1984.
Brandeis University Creative Arts Award, 1982.

Selected Solo Exhibitions

1976 *Projects.* Museum of Modern Art, New York.

1978 *Perimeters/Pavilions/Decoys.* Nassau County Museum of Fine Arts, Roslyn, N.Y.

1979 *Screened Court.* Minneapolis College of Art and Design.

1980 *Mirror Way.* Fogg Art Museum, Harvard University, Cambridge, Mass.

1981 Brown University, Providence, R.I., and University of Rhode Island, Kingston.

1982 Laumeier Sculpture Park, St. Louis.

1983 *Art and Architecture*. Institute of Contemporary Arts, London. Catalog.

San Diego State University.

University of California, Santa Barbara.

Public Commissions

1973 *Untitled*. Allen Memorial Art Museum, Oberlin College, Oberlin, Ohio. Permanently installed in 1975.

1981 *Field Rotation*. Governors State University, Park Forest South, Ill.

1984 *Pool Complex: Orchard Valley*. Laumeier Sculpture Park, St. Louis.

Represented by Max Protetch Gallery, New York.

Bibliography

Kardon, Janet. *Connections: Bridges/Ladders/Staircases/Tunnels*. Philadelphia: Institute of Contemporary Art, University of Pennsylvania, 1983.

Krauss, Rosalind. "Sculpture in the Expanded Field." *October* 8 (Spring 1979).

Linker, Kate. "Public Sculpture." *Artforum* 19 (March 1981): 64–73; (Summer 1981): 37–42.

Lippard, Lucy. "Mary Miss: An Extremely Clear Situation." *Art in America* 62 (March–April 1974): 76–77. Reprinted in Lucy Lippard, *From the Center: Feminist Essays on Women's Art*. New York: E. P. Dutton, 1976.

Nevins, Deborah. "An Interview with Mary Miss." *Princeton Journal* 2 (1985): 96–104.

Onorato, Ronald. "Illusive Spaces: The Art of Mary Miss." *Artforum* 17 (December 1978): 28–33.

Writings by Miss

"From Autocracy to Integration: Redefining the Objectives of Public Art." In *Insights/On Sites—Partners for Livable Spaces*, 1984, pp. 61–71.

"On a Redefinition of Public Sculpture." *Perspecta 21, Yale Architectural Journal*, 1984, pp. 52–70.

Linda Montano

Born 1942, Kingston, N.Y.

Education

College of New Rochelle, New Rochelle, N.Y., B.A., 1965. Villa Schifanoia, Florence, M.A., 1966. University of Wisconsin, Madison, M.F.A., 1969.

Awards, Honors, and Grants

NEA, 1977.

Collaboration Grant, Women's Studio Workshop, 1983.

Selected Screenings and Performances

1972 *The Chicken Woman*, performance. Streets of San Francisco.

1973 *Handcuffed to Tom Marioni for Three Days*, performance. Museum of Conceptual Art, San Francisco.

The Story of My Life, performance. San Francisco Art Institute.

1974 *Three Day Blindfold*, performance. Woman's Building, Los Angeles.

1975 *Trance Dance*, performance. Art Institute of Chicago.

Hypnosis, Dream, Sleep, performance. University Art Museum, University of California, Berkeley.

1977 *Learning to Talk*, performance. University of California, San Diego.

1978 *Mitchell's Death*, performance. Center for Music Experiment, University of California, San Diego.

1979 *Learning to Pay Attention*, performance. LACE, Los Angeles.

1980 *Learning to Talk* and *Pauline Oliveros*, screenings. And/Or Gallery, Seattle.

1981 *Mitchell's Death*, screening. Museum of Modern Art, New York.

1984 *Presentation of One Year Performance*, performance. Fleming Museum, Burlington, Vt.

Distributed by Video Data Bank, Chicago, and Stidfold-Pratt, New York.

Bibliography

Burgess, M. "Linda Montano at the New Museum." *Stroll* 1 (Summer 1985).

Burnham, Linda. Review. *Artforum* 22 (October 1983): 75.

Hays, Doris. "Linda Montano's Video." *Ear* 6 (May 1981).

Johnson, Jill. "Hardship Art." *Art in America* 72 (September 1984): 176.

Roth, Moira. "Matters of Life and Death: Linda Montano Interviewed by Moira Roth." *High Performance* 1 (December 1978).

Shank, Theodore. "Mitchell's Death." *Drama Review* 23 (March 1979).

Ree Morton

Born 1936, Ossining, N.Y.
Died 1977, Chicago

Education

University of Rhode Island, Kingston, B.F.A., 1968. Tyler School of Art, Temple University, Philadelphia, M.F.A., 1970.

Awards, Honors, and Grants

CAPS, 1974.
NEA, 1975.

Selected Solo Exhibitions and Installations

1973 Artists Space, New York.

1974 Whitney Museum of American Art, New York.

1975 *Something in the Wind*, installation. South Street Seaport, New York.

1976 University of Rhode Island, Kingston.

1977 *Ree Morton, 1936–77*. Grey Art Gallery, New York University.

1980 *Ree Morton: Retrospective, 1971–1977*. New Museum of Contemporary Art, New York, and tour. Catalog.

Estate represented by Michael Klein, Inc., New York.

Catherine Murphy

Born 1946, Lexington, Mass.

Education

Pratt Institute, Brooklyn, N.Y., B.F.A., 1967. Skowhegan School of Painting and Sculpture, Skowhegan, Maine.

Awards, Honors, and Grants

NEA, 1979.

Guggenheim Fellowship, 1982.

Selected Solo Exhibitions

1976 Retrospective. Phillips Collection, Washington, D.C., and Institute of Contemporary Art, Boston. Catalog.

Bibliography

Bourdon, David. "Art: Cityscapes." *Architectural Digest*, September 1978, p. 139.

"Catherine Murphy: Art Is My Lifestyle." *Art and Man* 5 (November 1974). This was a special issue, entitled *The Woman Artist*, published under the direction of the National Gallery of Art, Washington, D.C.

Gruen, John. "Catherine Murphy: The Rise of a Cult Figure." *Artnews* 77 (December 1978): 54–57.

Kramer, Hilton. "An Uncommon Painter of the Commonplace." *New York Times*, March 9, 1975, p. 35.

Larson, Kay. "Catherine Murphy." *New York*, December 16, 1985, p. 96.

Raynor, Vivien. "Images of New Jersey." *New Jersey Monthly*, November 1981, pp. 64–65.

Elizabeth Murray

Born 1940, Chicago

Education

School of the Art Institute of Chicago, B.F.A., 1962. Mills College, Oakland, Calif., M.F.A., 1964.

Awards, Honors, and Grants

Walter M. Campana Award, Art Institute of Chicago, 1982.

American Academy and Institute of Arts and Letters, 1984.

Selected Solo Exhibitions

1978 Ohio State University, Columbus.

1980 Galerie Mukai, Tokyo.

1982 Smith College Art Gallery, Northampton, Mass.

1983 Portland Center for the Visual Arts, Portland, Oreg. Catalog.

1984 *Elizabeth Murray: Paintings and Drawings.* Knight Gallery, Charlotte, N.C. Catalog.

1985 *Elizabeth Murray: Lithographs.* University Art Museum, University of New Mexico, Albuquerque.

Represented by Paula Cooper, New York.

Bibliography

Gardner, Paul. "Elizabeth Murray Shapes Up." *Artnews* 83 (September 1984): 46–55.

Kuspit, Donald B. "Elizabeth Murray's Dandyish Abstraction." *Artforum* 16 (February 1978): 28–31.

Murry, Jesse. "Quintet: The Romance of Order and Tension in Five Paintings by Elizabeth Murray." *Arts Magazine* 55 (May 1981): 102–5.

Simon, Joan. "Mixing Metaphors: Elizabeth Murray." *Art in America* 72 (April 1984): 140–47.

Smith, Roberta. "A Three-Sided Argument." *Village Voice*, October 30, 1984, p. 107.

Tucker, Marcia. *Early Works by Five Contemporary Artists.* New York: New Museum of Contemporary Art, 1977. Includes interview by Allan Schwartzman.

Writings by Murray

Notes for Fire and Rain. New York: Lapp Princess Press, 1981.

Rita Myers

Born 1947, Hammonton, N.J.

Education

Douglass College, Rutgers University, New Brunswick, N.J., B.A., 1969.

Hunter College, New York, M.A., 1974.

Awards, Honors, and Grants

CAPS, 1976, 1981.

NEA, 1976, 1980, 1984.

Artists Cable Project Grant, Center for Non-Broadcast Television, 1979.

New York State Council on the Arts Grant, 1983, 1985.

Jerome Foundation Grant, 1984.

Selected Solo Exhibitions

1975 *Investigation/Observations. "We Are Alone Here."* Walters Hall Art Gallery, Douglass College, Rutgers University, New Brunswick, N.J.

1976 *Once before You.* The Kitchen, New York.

Line-up/with and against Them. University of Colorado, Boulder.

Forward. Hallwalls, Buffalo.

1977 *Barricade to Blue.* The Kitchen, New York.

Line-up/with and against Them (second version). Williams College, Williamstown, Mass.

1978 *Forward* (second version). University of Massachusetts, Amherst.

1980 *The Points of a Star.* Whitney Museum of American Art, New York.

1981 *Dancing in the Land Where Children Are the Light.* The Kitchen, New York, and Art Gallery of Ontario, Toronto.

1983 *The Forms That Begin at the Outer Rim.* Real Art Ways, Hartford, Conn., and Media Study, Buffalo.

1985 *Gate.* Anderson Gallery, Virginia Commonwealth University, Richmond.

The Allure of the Concentric. Whitney Museum of American Art, New York.

Distributed by Electronic Arts Intermix, New York.

Bibliography

Bear, Liza. "Rita Myers, A Remote Intimacy." *Avalanche* 10 (Winter 1975).

Rice, Shelley. Review. *Artforum* 19 (May 1981): 78.

——. "Mythic Space: The Video Installations of Rita Myers." *Afterimage* 9 (January 1982): 8–11.

Sturken, Marita. "The Circle Game." *Afterimage* 13 (December 1985).

Wooster, Ann-Sargent. "Video and Ritual." *Afterimage* 12 (February 1985): 19.

——. Review. *Artnews* 75 (October 1976): 125.

Pat Oleszko

Born 1947, Detroit

Education

University of Michigan, Ann Arbor, B.F.A., 1970.

Awards, Honors, and Grants

CAPS, 1973, 1980.

NEA, 1978, 1985.

DAAD Fellowship, 1984.

Ann Arbor Film Festival Award, 1980.

Art Matters Inc. Award, 1985.

Selected Performances

1971 *New Yuck Womun.* Museum of Contemporary Crafts, New York.

1972 *Pat and the Guise Comes to Collegetown USA.* University of Kentucky, Lexington, and tour.

1973 *Fat Tuesday.* Museum of Contemporary Crafts, New York.

1976 *De Nature Takes a Bough Grasp Roots Variety Show.* Artpark, Lewiston, N.Y.

Pat Oleszko—Sew What. Museum of Modern Art, New York.

Taxidermiss. Museum of Modern Art, New York.

1977 *Pats Picasso.* Museum of Modern Art, New York.

1978 *Clothe Your Eyes (Revue).* The Kitchen, New York.

1980 *Spray-Play Pic's—Nic's* plus *The Pats to Sucksess* and *All the World's a Stooge.* Center for Creative Studies, Detroit.

1983 *The Soirée of O.* 80 Langdon
–84 Street, San Francisco, and tour.

1984 *The Tool Jest.* Contemporary Arts Center, New Orleans.

1985 *Where Fools Russian.* P.S. 122, New York.

Bibliography

Conner, Maureen. "Pat Oleszko, the Kitchen." *Artforum* 18 (March 1980): 33.

Larson, Kay. "Caws Anne Defect." *Village Voice*, December 31, 1979, p. 66.

Levin, Maude. "Dressing Up (and Down), Transformation Pat Oleszko." *Art Express*, April 1982.

McNiff, Veronica. "Cold Turkey and Other Larger-than-Life City Birds." *Nova*, April 1974, pp. 73–74.

Trebay, Guy. "Pat Oleszko Puts Her Art On." *Village Voice*, October 11, 1976.

Weisberg, Ruth. "Personification of Myth." *Artweek*, May 19, 1984, p. 6.

Judy Pfaff

Born 1946, London

Education

Wayne State University, Detroit, 1965. Southern Illinois University, Edwardsville, Ill., 1968. Washington University, St. Louis, B.F.A., 1971. Yale University School of Art, New Haven, Conn., M.F.A., 1973.

Awards, Honors, and Grants

CAPS, 1976.
NEA, 1979.
Guggenheim Fellowship, 1983.
Bessie Award for Set Design, 1984.

Selected Solo Exhibitions and Installations

1975 Artists Space, New York.
1977 *The World Is Flat.* Theater Gallery, University of South Florida, Tampa.
1978 *Prototypes.* LACE, Los Angeles.
1981 *Rorschach.* John and Mabel Ringling Museum of Art, Sarasota, Fla. Catalog.
1982 *Rock/Paper/Scissors,* special installation. Albright-Knox Art Gallery, Buffalo.
 Four-Minute Mile. Bennington College Art Gallery, Bennington, Vt.
 Collages and Constructions. Hallwalls, Buffalo.
 Boa. University of Massachusetts, Amherst.
1985 Permanent installation. Spokane City Hall, Spokane, Wash.
Represented by Holly Solomon Gallery, New York.

Bibliography

Perreault, John. "Pfaff Made Pfathomable." *Soho Weekly News,* September 24, 1980, p. 25.
Ratcliff, Carter. "Portrait of the Artist as a Survivor." *New York,* November 27, 1978.

Saunders, Wade. "Talking Objects: Interviews with Ten Younger Sculptors." *Art in America* 73 (November 1985): 130–31.
Schwartz, Ellen. "Artists the Critics Are Watching." *Artnews* 80 (May 1981): 79–80 and cover.
Smith, Roberta. "Judy Pfaff: Undone and Done." *Village Voice,* February 1, 1983, p. 93.
Tucker, Marcia. "An Iconography of Recent Figurative Painting: Sex, Death, Violence, and the Apocalypse." *Artforum* 20 (Summer 1982): 70–75.

Howardena Pindell

Born 1943, Philadelphia

Education

Boston University, B.F.A., 1965. Yale University School of Art and Architecture, New Haven, Conn., M.F.A., 1967.

Awards, Honors, and Grants

NEA, 1972–73, 1983–84.
U.S.-Japan Friendship Commission Artist Exchange Program, 1981–82.
Boston University Alumni Award, 1983.
Ariana Foundation for the Arts, 1984–85.

Selected Solo Exhibitions

1971 Spellman College, Atlanta.
1973 Douglass College, Rutgers University, New Brunswick, N.J.
1974 *Pindell: Paintings and Drawings.* State University of New York, College at Fredonia.
1976 *Pindell: Video Drawings.* Kunstforeningen, Copenhagen, and tour.
1978 *Howardena Pindell: Video Drawings.* Art Academy of Cincinnati.
1979 *Howardena Pindell: Works on Paper, Canvas and Video Drawings.* State University of New York, Stony Brook.

1980 Trenton State College, Trenton, N.J.
1981 *Howardena Pindell: Free, White and 21.* Franklin Furnace, New York.
1983 *Howardena Pindell, Memory Series: Japan.* A.I.R. Gallery, New York.
1985 *Howardena Pindell, Travelers Memories: Japan.* Birmingham Museum of Art, Birmingham, Ala.
1986 Miami-Dade Community College, Miami.

Bibliography

Andrews, Benny. *Blacks: USA: 1973,* p. 21. New York: New York Cultural Center, 1973.
Kingsley, April. *Afro-American Abstraction,* pp. 34–35. Syracuse, N.Y.: Everson Museum, 1981.
Lippard, Lucy, and Mary Schmidt Campbell. *Tradition and Conflict,* p. 65. New York: Studio Museum in Harlem, 1985.
Ratcliff, Carter. *Thick Paint,* p. 13. Chicago: Renaissance Society, University of Chicago, 1978.
Rifkin, Ned. *Stay Tuned,* pp. 16-17. New York: New Museum of Contemporary Art, 1981.
Wilson, Judith. "Howardena Pindell." *Ms.* 8 (May 1980): 66–70.

Adrian Piper

Born 1948, New York

Education

School of Visual Arts, New York, A.A., 1966–69. City College, New York, B.A., 1974. Harvard University, Cambridge, Mass., M.A., 1977; Ph.D., 1981.

Awards, Honors, and Grants

NEA, 1979, 1982.

Selected Solo Exhibitions and Performances

1971 *One Man (sic), One Work.* New York Cultural Center.
1973 *Untitled Streetwork,* performance. Rhode Island School of Design, Providence.
1976 *Some Reflective Surfaces,* performance. Whitney Museum of American Art, New York.
 Gallery One, Montclair State College, Montclair, N.J.
1980 *Adrian Piper at Matrix 56.* Wadsworth Atheneum, Hartford, Conn.
 It's Just Art, performance. Allen Memorial Art Museum, Oberlin College, Oberlin, Ohio.
1981 And/Or Gallery, Seattle.
1983 *Funk Lessons,* performance. University of California, Berkeley, and tour.
1985 *What's Cooking VI,* performance. Center for Music Experiment, University of California, San Diego.

Bibliography

Borger, Irene. "Funk Lessons: A Guerilla Performance." *L.A. Weekly,* March 28, 1984, pp. 63–64.
Goldberg, Roselee. "Public Performance, Private Memory." *Studio International* 192 (July–August 1976): 19–23.
Lippard, Lucy R. *Get the Message? A Decade of Art for Social Change.* New York: E. P. Dutton, 1984.
Mayer, Rosemary. "Performance and Experience." *Arts Magazine* 47 (December 1972): 33–36.
Miller-Keller, Andrea. "Adrian Piper." *Matrix 56.* Hartford, Conn.: Wadsworth Atheneum Press, 1980.
Phillpot, Clive. "Talking to Myself." *Art Journal* 39 (Spring 1980): 213–17.

Katherine Porter

Born 1941, Iowa

Education

Colorado College, Colorado Springs, 1959–61. Boston University, B.A., 1963.

Awards, Honors, and Grants

NEA, 1972.

Honorary Doctorate, Colby College, Waterville, Maine, 1984.

Selected Solo Exhibitions

1971 University of Rhode Island, Kingston.

1973 Worcester Museum of Art, Worcester, Mass.

1974 Hayden Gallery, Massachusetts Institute of Technology, Cambridge. Catalog.

1980 *Katherine Porter: Works on Paper 1969–1979*. Organized by Achenbach Foundation for Graphic Arts, Fine Arts Museums of San Francisco.

1981 *Drawings*. Dartmouth College, Hanover, N.H.

1983 Beaver College, Glenside, Pa. Arts Club of Chicago.

1985 Retrospective. Rose Art Museum, Brandeis University, Waltham, Mass. Catalog.

Represented by André Emmerich Gallery, New York.

Bibliography

Arthyros, Nan. "Katherine Porter, Painter." *New Boston Review*, June 1975.

Brenson, Michael. "Katherine Porter." *New York Times*, October 12, 1984.

Russell, John. "Juicy Abstractions by Katherine Porter." *New York Times*, February 27, 1981.

Schjeldahl, Peter. Review. *Artforum* 17 (Summer 1979): 63–64.

Simon, Joan. "Expressionism Today: An Artists' Symposium." Interview. *Art in America* 70 (December 1982): 73–74.

Storr, Robert. "Katherine Porter." *Art in America* 71 (May 1983): 165–66.

Judy Rifka

Born 1945, New York

Education

Hunter College, New York, 1963–66. New York Studio School, 1966. Skowhegan School of Painting and Sculpture, Skowhegan, Maine.

Selected Solo Exhibitions and Installations

1975 Artists Space, New York.

1977 Franklin Furnace, New York.

1980 Printed Matter, New York.

1981 Museum für (sub) Kultur, Berlin and Hamburg.

1984 *Judy Rifka: Major Works 1981–84*. Knight Gallery, Charlotte, N.C., and Anderson Gallery, Virginia. Commonwealth University, Richmond.

1985 *Judy Rifka: Installation*. Gracie Mansion Gallery, New York.

Represented by Brooke Alexander, New York.

Bibliography

Brenson, Michael. "Judy Rifka." *New York Times*, January 25, 1985.

Cohen, Ronny. "Judy Rifka." *Artforum* 23 (September 1984): 113.

Collings, Betty. "Judy Rifka's Wall (1983)." *Arts Magazine* 57 (May 1983): 116–17.

Howe, Katherine. "Judy Rifka at Brooke Alexander." *Images and Issues*, July–August 1983.

Linker, Kate. "Judy Rifka." *Artforum* 20 (Summer 1982): 80–81.

Smith, Roberta. "Intermural Painting." *Village Voice*, February 23, 1982.

Writings by Rifka

"The Billiardettes." *Art Rite*, no. 21 (special issue, 1979).

"Judy Rifka's Polaroid Album of Premieren." *Kunstforum*, May–June 1985.

Faith Ringgold

Born 1930, New York

Education

City College, New York, B.S. (fine arts), 1955; M.A. (art), 1959.

Awards, Honors, and Grants

CAPS, 1971.

Found Woman Award, *Ms.* Magazine, 1973.

AAUW, 1976.

NEA, 1978.

Dreyfus/MacDowell Colony Fellowship, 1982.

Wonder Woman Award, Warner Communications, 1983.

Selected Solo Exhibitions

1972 Louisiana State University, Baton Rouge.

1973 *Faith Ringgold: 10-Year Retrospective*. Jane Voorhees Zimmerli Art Museum, Rutgers University, New Brunswick, N.J. Catalog.

1973 *Paintings and Masks*. Wellesley College, Wellesley, Mass., and tour.

1974 *Paintings, Sculpture and Masks*. University of Tennessee, Chattanooga, and tour.

1976 *The Wake and Resurrection of the Bicentennial Negro*, tableau. Wilson College, Chambersburg, Pa., and tour.

1978 *Harlem '78*. Hampton Institute, Hampton, Va.

1978 *Woman on a Pedestal*. Douglass College, Rutgers University, New Brunswick, N.J., and tour.

1980 *Faith Ringgold: Soft Sculpture*. Museum of African and African-American Art, Buffalo. Catalog.

1982 Youngstown State University, Youngstown, Ohio.

1983 *Faith Ringgold: Black and Feminist Art*. Lehigh University, Bethlehem, Pa.

1984 *Faith Ringgold: Twenty Years of Painting, Sculpture and Performance, 1963–1984*. Studio Museum in Harlem, New York.

1985 *Faith Ringgold: Painting, Sculpture and Performance*. Art Museum, College of Wooster, Wooster, Ohio. Catalog.

Represented by Bernice Steinbaum Gallery, New York.

Bibliography

Glueck, Grace. "An Artist Who Turns Cloth into Social Commentary." *New York Times*, July 29, 1984.

Lippard, Lucy. "Faith Ringgold Flying Her Own Flag." *Ms.* 5 (July 1976): 34–39.

Rose, Barbara. "Black Art in America." *Art in America* 58 (September 1970): 63.

Sims, Lowery S. "Black Americans in the Visual Arts." *Artforum* 11 (April 1973): 66–70.

Stokes, Stephanie. "Faith Ringgold Makes Dolls an Art." *Essence*, July 1979.

Wallace, Michele. "Black Macho and the Myth of the Superwoman." *Ms.* 7 (January 1979): 45–48, 87–91.

Writings by Ringgold

"Being My Own Woman." In *Confirmation: An Anthology of African American Women Writers*. Edited by Amiri and Amina Baraka. New York: William Morrow, 1983.

"Black Art: What Is It?" *Art Gallery Guide*, April 1970, pp. 35–36.

"The Politics of Culture: Black, White, Male, Female." *Women Artists' News*, Summer 1980.

"What's More Important to Me Is Art for People." *Arts Magazine* 45 (September–October 1970): 28.

"Women's Traditional Arts." *Heresies* 4 (Winter 1977–78): 84.

Dorothea Rockburne

Born 1934, Verdun, Quebec

Education

Ecole des Beaux-Arts, Montreal. Black Mountain College, Beria, N.C.

Awards, Honors, and Grants

Painting Award, School of the Art Institute of Chicago, 1972.

Guggenheim Fellowship, 1972.

NEA, 1974.

Brandeis University Creative Arts Award, 1985.

Selected Solo Exhibitions

1972 Galleria d'Arte, Bari, Italy.
 University of Rochester Art Gallery, Rochester, N.Y.

1973 Hartford College of Art, Hartford, Conn.

Represented by André Emmerich Gallery, New York.

Bibliography

Baker, Kenneth. "Dorothea Rockburne's Egyptian Paintings." *Artforum* 19 (April 1981): 24–25.

Brenson, Michael. "Dorothea Rockburne." *New York Times*, March 1, 1985.

Hess, Thomas B. "Rules of the Game, Part II: Marden and Rockburne." *New York*, November 11, 1974, p. 101.

Licht, Jennifer. "Interview with Dorothea Rockburne." *Artforum* 10 (March 1972): 34–36.

———. "Work and Method." Interview. *Art and Artists* 6 (March 1972): 32–35.

Olson, Roberta. "An Interview with Dorothea Rockburne." *Art in America* 66 (November–December 1978).

Writings by Rockburne

"Notes to Myself on Drawing." *Flash Art*, April 1974, p. 66.

Rachel Rosenthal

Born 1926, Paris

Education

New School for Social Research, New York. Sorbonne, Paris.

Awards, Honors, and Grants

California Arts Council Grant, 1982.

Vesta Award for Performing Arts, 1983.

NEA, 1983.

Selected Performances

1977 *The Head of O.K.* Center for Music Experiment, University of California, San Diego.

1978 *Grand Canyon.* University Art Gallery, California State University, Dominguez Hills.

1979 *The Arousing (Shock Thunder).* LAICA, Los Angeles.

1980 *Bonsoir, Docteur Schon!* LACE, Los Angeles.
 My Brazil. La Jolla Museum of Contemporary Art, La Jolla, Calif.

1981 *Leave Her in Naxos.* University of California, Santa Barbara.
 Soldier of Fortune. Art Institute of Chicago.
 Taboo Subjects. Vehicule Art, Montreal.

1982 *Traps.* Women in Focus,
–83 Vancouver, and tour.

1983 *Gaia, Mon Amour.* The House,
–84 Santa Monica, Calif., and tour.

1984 *The Others.* Japan-America Theater, Los Angeles.
 Shamanic Ritual. Woman's Building, Los Angeles.

Represented by Cactus Foundation, Los Angeles.

Selected Bibliography

Lampe, Eelka. "Rachel Rosenthal: Creating Her Selves." *Drama Review* 32 (Spring 1988).

Moisan, Jim. "Rachel Rosenthal." *LAICA Journal*, January 1979.

Martha Rosler

Born 1943, New York

Education

Brooklyn College, City University of New York, B.A., 1965. University of California, San Diego, M.F.A., 1974.

Awards, Honors, and Grants

NEA, 1979.

Selected Solo Exhibitions and Performances

1973 *Monumental Garage Sale*, performance. University of California, San Diego.
 Vital Statistics of a Citizen, Simply Obtained, performance. University of California, San Diego.

1974 *Gourmet Experience*, performance. University of California, San Diego.

1977 *Foul Play in the Chicken House.* Long Beach Museum of Art, Long Beach, Calif.

1978 *Against the Mythology of Everyday Life.* And/Or Gallery, Seattle.
 Domination and the Everyday, performance. LAICA, Los Angeles.

1979 Performance. Alberta College of Arts, Calgary, Canada.
 Exhibition and performance. University of California, Berkeley.

1980 *Sketch for a Ritual of Mutual Atonement: For Alice,* performance. Interaction Arts, New York.

1981 *Optimism/Pessimism: Constructing Life.* Franklin Furnace, New York.

1982 Performance. Banff Centre for Advanced Education, Banff, Canada.
 Performance. Dance Theater Workshop, New York.

Distributed by Electronic Arts Intermix, New York, and Video Data Bank, Chicago.

Bibliography

Askey, Ruth. "Martha Rosler's Video." *Artweek*, June 4, 1977.

Buchloh, Benjamin H. D. "Allegorical Procedures: Appropriation and Montage in Contemporary Art." *Artforum* 21 (September 1982): 43–56.

Gever, Martha. "An Interview with Martha Rosler." *Afterimage* 9 (October 1981): 10–17.

Owens, Craig. "The Discourse of Others: Feminism and Postmodernism." In *The Anti-Aesthetic: Essays on Postmodernism and Culture,* edited by Hal Foster. Port Townsend, Wash.: Bay Press, 1983.

Rickey, Carrie. "Return to Sender." *Village Voice*, August 14, 1978.

Taubin, Amy. "And What Is a Fact Anyway? (On a Tape by Martha Rosler)." *Millennium Film Journal,* nos. 4–5 (Summer–Fall 1979).

Susan Rothenberg

Born 1945, Buffalo

Education

Cornell University, Ithaca, N.Y., B.F.A., 1966. George Washington University, Washington, D.C., 1967. Corcoran Museum School, Washington, D.C.

Selected Solo Exhibitions

1978 *Susan Rothenberg, Matrix/Berkeley 3.* University Art Museum, University of California, Berkeley. Catalog.

Susan Rothenberg, Recent Work. Walker Art Center, Minneapolis.

1981 Akron Art Museum, Akron, Ohio.

1982 *Susan Rothenberg: Recent Paintings.* Stedelijk Museum, Amsterdam. Catalog.

1983 Los Angeles County Museum of Art, and tour. Catalog.

1984 *Susan Rothenberg Prints, 1977–84.* Davison Art Center Gallery, Wesleyan University, Middletown, Conn.

 Currents. Institute of Contemporary Art, Boston.

1985 *Centric 13: Susan Rothenberg.* University Art Museum, California State Center, Long Beach. Catalog.

 Susan Rothenberg, 1982–85. Virginia Museum of Fine Arts, Richmond. Catalog.

 Phillips Collection, Washington, D.C., and Portland Visual Arts Center, Portland, Oreg. Catalog.

Represented by Sperone Westwater, New York.

Bibliography

Curiger, Bice. "Robert Moskowitz, Susan Rothenberg, Julian Schnabel." *Flash Art*, no. 106 (February–March 1982): 60.

Glueck, Grace. "Susan Rothenberg: New Outlook for a Visionary Artist." *New York Times Magazine*, July 22, 1984, pp. 16ff and cover.

Herrera, Hayden. "Expressionism Today: An Artists' Symposium." *Art in America* 70 (December 1982): 65–139.

———. "In a Class by Herself." *Connoisseur* 214 (April 1984): 112–17.

Smith, Roberta. "The Abstract Image." *Art in America* 67 (March–April 1979): 102–5.

Betye Saar

Born 1926, Pasadena, Calif.

Education

University of California, Los Angeles, B.A., 1949. California State University, Long Beach, 1958–62. University of Southern California, Los Angeles, 1962. California State University, Northridge, 1966.

Awards, Honors, and Grants

NEA, 1974, 1984.

Selected Solo Exhibitions and Installations

1973 Fine Arts Gallery, California State University, Los Angeles.

1975 Whitney Museum of American Art, New York. Catalog.

1976 Wadsworth Atheneum, Hartford, Conn.

1977 San Francisco Museum of Modern Art.

1979 Mandeville Art Gallery, University of California, San Diego.

1980 *Rituals: The Art of Betye Saar.* Studio Museum in Harlem, New York. Catalog.

1983 Canberra School of Art, Canberra, Australia.

 Women's Art Movement, Adelaide, Australia.

1984 Georgia State University Art Gallery, Atlanta.

 Museum of Contemporary Art, Los Angeles. Catalog.

1985 *Spiritcatcher.* Lang Gallery, Scripps College, Claremont, Calif.

 Wood and Shadow, installation. Skowhegan School of Painting and Sculpture, Skowhegan, Maine.

Public Commissions

1983 *L.A. Energy.* Mural for Fifth Street, Los Angeles.

1984 *Fast Trax.* Mural for Newark Station, Newark, N.J.

1985 *On Our Way.* Mural for Metrorail Station, Miami.

Bibliography

Behens, Tim. "Betye Saar Turns Old Articles into Art." *Spokesman Review*, February 10, 1985.

Britton, Crystal. "Interview with Betye Saar." *Art Papers*, September–October 1981, pp. 8–9.

Glueck, Grace. "Betye Saar, Artist Inspired by Occult." *New York Times*, February 16, 1978.

Muchnic, Suzanne. "Saar: Assembling a Positive Vision." *Los Angeles Times*, July 22, 1984.

Nemser, Cindy. "Conversation with Betye Saar." *Feminist Art Journal* 4 (Winter 1976): 19–24.

Woelfle, Gretchen Erskine. "On the Edge: Betye Saar, Personal Time Travels." *Fiberarts* 9 (July–August 1982): 56–60.

Tomiyo Sasaki

Born 1943, Vernon, British Columbia

Education

Alberta College of Art, Calgary, Canada, 1962–65. San Francisco Art Institute, B.F.A., 1967. California College of Arts and Crafts, Oakland, M.A., 1969.

Awards, Honors, and Grants

CAPS, 1972, 1976.

Canada Council Grant, 1969–74, 1976, 1981–82.

NEA, 1982.

Guggenheim Fellowship, 1983.

New York Foundation for the Arts Fellowship, 1985.

Selected Solo Exhibitions and Installations

1975 Jane Voorhees Zimmerli Art Museum, Rutgers University, New Brunswick, N.J.

1976 Media Studies Center, Buffalo.

1977 Museum of Modern Art, New York.

 Port Washington Public Library, Port Washington, N.Y.

 Columbia Teacher's College, New York.

 Jamestown Public Library, Jamestown, N.Y.

1980 Donnell Library, New York. Anthology Film and Video Archives, New York.

1985 *Spawning Sockeyes*, installation. P.S. 1, Institute for Art and Urban Resources, Long Island City, N.Y.

Distributed by Art Metropole, Toronto, and Monte Video, Amsterdam.

Bibliography

Art Video: Retrospectives and Perspectives. Charleroi, Belgium: Palais des Beaux-Arts, 1983.

Goldberg, Michael. "Tokyo Video Festival 2." *Video Guide* (Vancouver) 2 (December 1975).

Hitt, Jack. "From the Somber to the Hilarious in Video." *Villager*, June 9, 1983.

Lord, Barry. "The Eleven O'Clock News in Colour." *Artscanada* 27 (June 1970): 4–20.

Videothek Catalogus. The Hague, Netherlands: Kijkhuis, 1981.

Wooster, Ann-Sargent. "What Is Happening Here?" *Soho News*, March 1976.

Miriam Schapiro

Born 1923, Toronto

Education

State University of Iowa, Iowa City, B.A., 1945; M.A., 1946; M.F.A., 1949.

Awards, Honors, and Grants

NEA, 1976.

Yaddo Fellowship, 1981.

Skowhegan Medal, 1982.

Honorary Doctorate, College of Wooster, Wooster, Ohio, 1983.

Selected Solo Exhibitions

1976 *Selected Paintings.* Mabel Smith Douglass Library, Rutgers University, New Brunswick, N.J.

The Shrine, the Computer and the Dollhouse. Mills College, Oakland, Calif., and tour.

1977 Fairbanks Gallery, University of Oregon, Eugene.

1977 *Femmages.* Allen Memorial
-79 Art Museum, Oberlin College, Oberlin, Ohio, and tour.

Anatomy of a Kimono. Reed College, Portland, Oreg.

1980 *Miriam Schapiro: A Retrospec-
-82 tive, 1953-1980.* College of Wooster Art Museum, Wooster, Ohio, and tour. Catalog.

1983 Kent State University, Kent, Ohio.

1984 Atlanta Center for the Arts, New Smyrna Beach, Fla.

1985 Appalachian State University, Boone, N.C.

Public Commissions

1980 *4 Matriarchs*, stained-glass windows. Temple Shalom, Chicago.

1984 *Three Kimonos.* Orlando Airport, Orlando, Fla.

Represented by Bernice Steinbaum Gallery, New York.

Bibliography

Broude, Norma. "Miriam Schapiro and 'Femmage': Reflections on the Conflict between Decoration and Abstraction in Twentieth-Century Art." In *Feminism and Art History— Questioning the Litany*, edited by Norma Broude and Mary D. Garrard, pp. 315-29. New York: Harper and Row, 1982.

Great American Artists: The Skowhegan Medal Recipients. New York: Alpine Fine Arts; Skowhegan, Maine: Skowhegan School of Painting and Sculpture, 1984.

Nochlin, Linda. "Miriam Schapiro: Recent Work." *Arts Magazine* 48 (November 1973): 38-41.

Perreault, John. "The New Decorativeness." *Portfolio*, June-July 1979, pp. 46-51.

Perrone, Jeff. "Approaching the Decorative." *Artforum* 15 (December 1976): 26-30.

Robinson, Charlotte, ed. *The Artist and the Quilt.* New York: Alfred A. Knopf, 1983.

Judith Shea

Born 1948, Philadelphia

Education

Parsons School of Design, New York, B.F.A., 1969.

Awards, Honors, and Grants

NEA, 1984.

Selected Solo Exhibitions

1976 *Studio Project.* The Clocktower, New York.

1978 Women's Center Gallery, New Haven, Conn.

1981 *Judith Shea: Sculpture as Clothing.* Washington Square East Galleries, New York University.

1984 Walker Art Center, Minneapolis.

1985 Hayden Gallery, Massachusetts Institute of Technology, Cambridge. Catalog.

Knight Gallery, Charlotte, N.C.

Represented by Curt Marcus Gallery, New York.

Bibliography

Cohen, Ronny H. "Judith Shea at Willard Gallery." *Art in America* 68 (October 1980): 129-30.

Klein, Katie. "Judith Shea: Recent Sculpture." In *Robert Moskowitz and Judith Shea.* Cambridge, Mass.: Hayden Gallery, Massachusetts Institute of Technology, 1985.

Rickey, Carrie. "Art of the Whole Cloth." *Art in America* 67 (November 1979): 72-83.

Saunders, Wade. "Talking Objects: Interviews with Ten Younger Sculptors." *Art in America* 73 (November 1985): 134-35.

Rosenzweig, Phyllis D. "From the Model." In *Directions, 1983*, p. 56. Washington, D.C.: Hirshhorn Museum and Sculpture Garden, Smithsonian Institution, 1983.

Westfall, Stephen. "Judith Shea at Willard." *Art in America* 73 (March 1985): 158.

Cindy Sherman

Born 1954, Glen Ridge, N.J.

Education

State University of New York, Buffalo, B.A., 1976.

Awards, Honors, and Grants

NEA, 1977, 1979.
Guggenheim Fellowship, 1983.

Selected Solo Exhibitions

1979 Hallwalls, Buffalo.

1980 Contemporary Arts Museum, Houston. Catalog.

The Kitchen, New York.

1982 Stedelijk Museum, Amsterdam,
-84 and tour. Catalog.

1983 St. Louis Art Museum. Catalog.

State University of New York, Stony Brook, and Wesleyan University, Middletown, Conn. Catalog.

Musée d'Art et d'Industrie de Saint-Etienne, France. Catalog.

1984 Laforet Museum, Tokyo. Catalog.

Seibu Gallery of Contemporary Art, Tokyo. Catalog.

1984 Akron Art Museum, Akron, Ohio, and tour. Catalog.

1985 Westfälischer Kunstverein, Münster, West Germany. Catalog.

Represented by Metro Pictures, New York.

Bibliography

Gambrell, Jamey. "Marginal Acts." *Art in America* 72 (March 1984): 114-19.

Grundberg, Andy. "Cindy Sherman's Dark Fantasies Evoke a Primitive Past." *New York Times*, October 20, 1985.

———. "Cindy Sherman: A Playful and Political Post-Modernist." *New York Times*, November 22, 1981.

Klein, Michael. "Cindy Sherman." *Arts Magazine* 55 (March 1981): 5.

Marzorati, Gerald. "Imitation of Life." *Artnews* 82 (September 1983): 78-87.

Schjeldahl, Peter. "Shermanettes." *Art in America* 70 (March 1982): 110-11.

Laurie Simmons

Born 1949, Great Neck, N.Y.

Education

Tyler School of Art, Temple University, Philadelphia, B.F.A., 1971.

Awards, Honors, and Grants

NEA, 1984.

Selected Solo Exhibitions

1979 Artists Space, New York.

P.S. 1, Institute for Art and Urban Resources, Long Island City, N.Y.

University of Rhode Island, Kingston.

1985 Tyler School of Art, Temple University, Philadelphia.

Weatherspoon Art Gallery, University of North Carolina, Greensboro.

Represented by Metro Pictures, New York.

Bibliography

Grundberg, Andy. "Seeing the World as Artificial." *New York Times*, March 27, 1983.

Klein, Michael "Laurie Simmons." *Arts Magazine* 55 (May 1981): 4.

Linker, Kate. "Ex-posing the Female Model." *Parachute*, September–November 1985, pp. 15–17.

Onorato, Ronald J. "The Photography of Laurie Simmons." *Arts Magazine* 57 (April 1983): 122–23.

Solomon-Godeau, Abigail. "Conventional Pictures." *Print Collector's Newsletter* 12 (November–December 1981): 138–40.

Squiers, Carol. "Undressing the Issues." *Village Voice*, April 5, 1983.

Sandy Skoglund

Born 1946, Boston

Education

Smith College, Northampton, Mass., B.A., 1968. University of Iowa, Iowa City, M.A., M.F.A., 1972.

Awards, Honors, and Grants

NEA, 1980.

Selected Solo Exhibitions and Installations

1973 Joseloff Gallery, Hartford Art School, Hartford, Conn.

1974 University of Connecticut, Torrington.

1980 *Radioactive Cats*, installation. Real Art Ways, Hartford, Conn.

1981 *Revenge of the Goldfish*, installation. Fort Worth Art Museum. Brochure.

 Radioactive Cats, installation. Addison Gallery of American Art, Phillips Academy, Andover, Mass.

1982 *Revenge of the Goldfish* and *Radioactive Cats*, installations. Minneapolis Institute of Art.

Revenge of the Goldfish, installation. Wadsworth Atheneum, Hartford, Conn. Brochure.

1984 Galerie Watari, Tokyo.

Bibliography

Di Grappa, Carol. "Close Quarters." *Camera Arts* 1 (May–June 1981): 86ff. Reprinted in *Fotografi*, no. 11 (November 1981).

Glueck, Grace. "Art That Comments on the Fate of the Earth." *New York Times*, March 13, 1983.

Grundberg, Andy. "Artbreakers: New York's Emerging Artist." *Soho News*, September 17, 1980, pp. 33ff.

Hagen, Charles. "Reviews." *Artforum* 21 (May 1983): 95.

Rice, Shelley. Review. *Artforum* 19 (March 1981): 88.

Tully, Judd. "Reviews of Exhibitions: New York." *Flash Art*, no. 103 (Summer 1981): 55.

Sylvia Sleigh

Born Llandudno, Wales

Education

Brighton School of Art, Sussex, England. London University, diploma, art history.

Awards, Honors, and Grants

NEA, 1982.

Selected Solo Exhibitions

1973 Soho 20, New York. Catalog.

1974 Fine Arts Center, University of Rhode Island, Kingston.

 Mabel Smith Douglass Library, Rutgers University, New Brunswick, N.J.

1976 Kirkland Art Center, Clinton, N.Y., and tour.

 Matrix 23. Wadsworth Atheneum, Hartford, Conn.

1977 *Stones and Flowers*. Paul Klapper Library, Queens College, City University of New York.

Northwestern University, Evanston, Ill. Catalog.

1978 *Portraits*. Housatonic Community College, Bridgeport, Conn.

 A.I.R. Gallery, New York. Catalog.

1980 *Paintings 1970–79*. Canton Art Institute, Canton, Ohio, and tour.

1981 Gallery 210, State University of Missouri, St. Louis.

1982 *Portraits at the New School*. Associates Gallery, New School for Social Research, New York.

Represented by G. W. Einstein, New York, and Zaks Gallery, Chicago.

Bibliography

Chesler, Phyllis. *About Men*, pp. 106–7. New York: Simon and Schuster, 1978.

Comini, Alessandra. "Art History, Revisionism, and Some Holy Cows." *Arts Magazine* 54 (June 1980): 96–100.

Henry, Gerrit. "The Artist and the Face: A Modern American Sampling." *Art in America* 63 (January 1975): 34, 38–39.

Hess, Thomas B. "Sitting Prettier." *New York*, February 23, 1976, p. 62.

Nochlin, Linda. "Some Women Realists: Painters of the Figure." *Arts Magazine* 48, no. 8 (1974): 29–33.

Tickner, Lisa. "The Body Politic: Female Sexuality and Women Artists since 1970." *Art History* 1, no. 2 (1978): 240–44.

Alexis Smith

Born 1949, Los Angeles

Education

University of California, Irvine, B.A., 1970.

Awards, Honors, and Grants

New Talent Award, Los Angeles County Museum of Art, 1974. NEA, 1976.

Key to the City, Grand Rapids, Mich., 1983.

Selected Solo Exhibitions, Installations, and Performances

1975 *Anteroom*, installation. CARP, Los Angeles.

 Rapido, installation. University of California, Santa Barbara.

 Whitney Museum of American Art, New York.

 Long Beach Museum of Art, Long Beach, Calif.

1976 San Jose State University, San Jose, Calif.

 Mandeville Art Gallery, University of California, San Diego.

 Scheherazade the Storyteller, performance. CARP, Los Angeles.

1978 *The Art of Magic, Close-up*, performance. Baxter Art Gallery, California Institute of Technology, Pasadena.

1979 Installation. De Appel, Amsterdam.

1980 *Stardust*, performance. LACE, Los Angeles.

1981 *Stardust*, performance. Los Angeles County Museum of Art and La Jolla Museum of Contemporary Art, La Jolla, Calif.

Public Commissions

1983 *The Grand*. NEA and Michigan State Council for the Arts, for Grand Center, Grand Rapids, Mich.

1984 *California*. California Arts Council, for California State Office Building, Santa Rosa.

 Niagara, granite monument. Artpark, Lewiston, N.Y.

Represented by Margo Leavin Gallery, Los Angeles.

Bibliography

Filler, Martin. "Rediscovering America." *House and Garden* 153 (February 1981): 114–15.

Gardner, Colin. Review. *Artforum* 24 (November 1985): 113–14.

Knight, Christopher. "Los Angeles: Art on the Move." *Artnews* 82 (January 1983): 74–75.

Livingston, Jane. "Ms. L.A.: 3 Women in the City of Angels." *Art in America* 61 (January 1973): 98–101.

Marmer, Nancy. "Alexis Smith: The Narrative Act." *Artforum* 15 (December 1976): 31–33.

Quinn, Joan. "All American Art: Alexis Smith." *Interview* 11 (March 1981): 56–58.

Barbara T. Smith

Born 1931, Pasadena, Calif.

Education

Pomona College, Claremont, Calif., B.A., 1953. Chouinard Art Institute, Los Angeles, 1965. University of California, Irvine, M.F.A., 1971.

Awards, Honors, and Grants

NEA, 1974, 1979, 1985.

Xerox Corporation Grant, 1975.

Edinburgh Arts Festival Fellowship, 1976.

Menninger Foundation Fellowship, Council Groves, Kansas, 1982.

Vesta Award for Performing Arts, 1983.

Selected Solo Exhibitions, Installations, and Performances

1970 *Homage for Mark Rothko*, installation. University of California, Irvine.

1971 *Celebration of the Holy Squash*, installation and performance. University of California, Irvine.

 Field Piece, environmental sculpture. F-Space Gallery, Santa Ana, Calif.

 Photography exhibition. F-Space Gallery, Santa Ana, Calif.

1972 *The Fisherman Is the Fish*, performance. F-Space Gallery, Santa Ana, Calif., sponsored by the Newport Harbor Art Museum, Newport Beach, Calif.

1974 Retrospective. Mandeville Gallery, University of California, San Diego. Catalog.

 Full Jar, Empty Jar. University of California, San Diego.

1976 *Scan I*, performance. Woman's Building, Los Angeles.

1978 *Nada, Nada, Nada*, performance. Franklin Furnace, New York.

1981 *The Perpetual Napkin*, performance. Museum of Contemporary Art, Chicago, and Renaissance Society, University of Chicago.

1983 *Vera and Victoria*, performance. Long Beach Museum of Art, Long Beach, Calif.

 Conjuring the Crone, performance. Contemporary Arts Forum, Santa Barbara, Calif.

Bibliography

Burnham, Linda. "Live Sex Acts." *Franklin Furnace/The Flue: Sex, Performance and the '80s* 2, no. 3 (1982).

———. "Performance Art in Southern California: An Overview." *High Performance* 2, no. 3 (1979).

Levy, Leah. *The Capp St. Project, Inaugural Exhibition and 1984 Residencies.* New York: Capp St. Project, 1984.

Roth, Moira. *Barbara Smith.* San Diego: University of California, San Diego, 1974.

———. "Toward a History of California Performance." *Arts Magazine* 52 (June 1978): 114–23.

Shannon, Mark. "Undefeated Meaning." *Muse* (Denver), February–March 1984.

Joan Snyder

Born 1940, Highland Park, N.J.

Education

Douglass College, Rutgers University, New Brunswick, N.J., B.A., 1962; M.F.A., 1966.

Awards, Honors, and Grants

NEA, 1974.

Guggenheim Fellowship, 1981.

Selected Solo Exhibitions

1972 Initial show of annual Woman Artists series, established by Joan Snyder. Mabel Smith Douglass Library, Rutgers University, New Brunswick, N.J.

1976 LAICA, Los Angeles. Catalog.

 Recent Paintings. Portland Center for the Visual Arts, Portland, Oreg.

 Douglass College, Rutgers University, New Brunswick, N.J. Catalog.

1977 Wake Forest University, Winston-Salem, N.C.

1978 *Seven Years of Work.* Neuberger Museum, Purchase, N.Y. Catalog.

 Women's Art Registry of Minneapolis.

1979 San Francisco Art Institute and tour.

1981 *Resurrection and Studies.* Matrix Gallery, Wadsworth Atheneum, Hartford, Conn.

Represented by Hirschl and Adler Modern, New York.

Bibliography

Elderfield, John. "Grids." *Artforum* 10 (May 1972): 52–59.

"Expressionism Today: An Artists' Symposium." *Art in America* 70 (December 1982): 58.

Herrera, Hayden. "Joan Snyder at Carl Solway." *Art in America* 64 (May–June 1976): 103–4.

Hughes, Robert. "Myths of 'Sensibility.'" *Time*, March 20, 1972, pp. 72–77.

Tucker, Marcia. "The Anatomy of a Stroke: Recent Paintings by Joan Snyder." *Artforum* 9 (May 1971): 42–45.

Webster, Sally. "Fury and Fugue, Politics of the Inside." *Feminist Art Journal*, Summer 1976, p. 5.

Writings by Snyder

"Painter's Reply." *Artforum* 14 (September 1975): 34.

Untitled statement in *Studio International Journal of Modern Art*, July–August 1974.

Nancy Spero

Born 1926, Cleveland

Education

School of the Art Institute of Chicago, B.F.A., 1949. Ecole des Beaux-Arts, Paris, 1949–50.

Awards, Honors, and Grants

CAPS, 1976–77.

NEA, 1977–78.

Selected Solo Exhibitions

1971 *The Artaud Paintings.* University of California, San Diego.

1974 Women's Center, Williams College, Williamstown, Mass.

 Mabel Smith Douglass Library, Rutgers University, New Brunswick, N.J.

1978 Woman's Building, Los Angeles.

1979 *Torture of Women.* Hampshire College Art Gallery, Amherst, Mass.

1980 Livingston Gallery, Rutgers University, New Brunswick, N.J.

1982 Florence Wilcox Gallery, Swarthmore College, Swarthmore, Pa.

1983 *Notes in Time on Women.* Matrix Gallery, Wadsworth Atheneum, Hartford, Conn.

*Art Couples III, Nancy Spero/
Leon Golub.* P.S. 1, Institute
for Art and Urban Resources,
Long Island City, N.Y.

1984 *The Black Paintings.* Bergman
Gallery, Renaissance Society,
University of Chicago.

The First Language. Matrix
Gallery, University of California, Berkeley.

1985 *Nancy Spero: The Black Paris
Paintings 1959–1966.* Hewlett
Gallery, Carnegie-Mellon University, Pittsburgh. Catalog.

Represented by Josh Baer Gallery,
New York.

Bibliography

Alloway, Lawrence. "Nancy Spero."
Artforum 14 (May 1976): 52–53.

Blumenthal, Lyn, and Kate Horsfield.
"Interview with Nancy Spero." *Profile* 3 (January 1983).

de Pasquale, Carol. "Dialogues with
Nancy Spero." *Womanart*, Winter–
Spring 1977, p. 8.

Jolicoeur, Nicole, and Nell Tenhaaf.
"Defying the Death Machine." Interview. *Parachute*, no. 39 (June–August 1985): 50–55.

Lippard, Lucy. "Nancy Spero's 30-
Years War." *Village Voice*, April 19,
1983, p. 101.

Robins, Corinne. "Nancy Spero,
'Political' Artist of Poetry and Nightmare." *Feminist Art Journal*, Spring
1975, p. 19.

Writings by Spero

"Ende." In *Women's Studies*, vol. 6,
pp. 3–11. London: Gordon and
Breach Science Publishers, 1978.

"The Whitney Museum and Women."
Art Gallery Magazine, January 1971.

"Women's Speakout." *New York
Element*, February–March 1972.

Michelle Stuart

Born Los Angeles

Education

Chouinard Art Institute, Los Angeles,
1954–55. Instituto de Bellas Artes,
Mexico City, 1955–56. New School
for Social Research, New York,
1958–60.

Awards, Honors, and Grants

MacDowell Colony Fellowship, 1974.
Ford Foundation–Tamarind Institute
Grant, 1974.
Guggenheim Fellowship, 1975.
CAPS, 1975.
NEA, 1975, 1977, 1980.

Selected Solo Exhibitions

1973 Douglass College, Rutgers University, New Brunswick, N.J.

1975 Fine Arts Center, State University of New York, Oneonta.
Catalog.

1976 Gallery of Fine Arts, State University of New York, Stony
Brook.

1977 Hayden Gallery, Massachusetts
Institute of Technology, Cambridge. Catalog.

Williams College Museum of
Art, Williamstown, Mass.
Catalog.

1978 *A Complete Folk History of
the United States at the End of
the Century.* Fine Arts Gallery,
Wright State University, Dayton, Ohio. Catalog.

Centre des Arts Plastiques
Contemporaines de Bordeaux,
Bordeaux, France. Catalog.

1979 Institute of Contemporary
Arts, London. Catalog.

1983 Haags Gemeentemuseum, The
Hague, Netherlands. Catalog.

*Michelle Stuart: Place and
Time.* Walker Art Center, Minneapolis. Catalog.

1984 *Sacred Precincts: From Dreamtime to the South China Sea.*
Neuberger Museum, Purchase,
N.Y. Catalog.

1985 *Michelle Stuart: Voyages.*
C. W. Post Campus, Long
Island University, Greenvale,
N.Y., and tour. Catalog.

Public Commissions

1979 *Stone/Alignments/Solstice
Cairns.* P.C.V.A., for Columbia
River Gorge, Oreg.

1985 *Night Passage Signaling Two
Suns.* Finnish Art Association,
for Noto Island, Finland.

Represented by Max Protetch, New
York.

Bibliography

Alloway, Lawrence. "Michelle Stuart:
A Fabric of Significations." *Artforum*
12 (January 1974): 64–65.

Beal, Graham. "On Art and Artists:
Michelle Stuart." *Profile*, 1983
(Video Data Bank, School of the Art
Institute of Chicago).

Lippard, Lucy. *Strata: Nancy Graves,
Eva Hesse, Michelle Stuart, Jackie
Winsor.* Vancouver: Vancouver Art
Gallery, 1977.

Lubell, Ellen. "Michelle Stuart: Icons
from the Archives of Time." *Arts
Magazine* 53 (June 1979): 122–24.

Robins, Corinne. "Michelle Stuart:
The Mapping of Myth and Time."
Arts Magazine 51 (December 1976):
83–85.

Wilson, William. "Michelle Stuart's
Green River, Massachusetts Variations: The Mapping of Time, Place,
and Season in Books without Words."
Print Collector's Newsletter 8
(November–December 1977):
135–36.

Writings by Stuart

From the Silent Garden.
Williamstown, Mass.: Williams
College, 1979. Introduction by Lucy
Lippard.

Alma W. Thomas

Born 1891, Columbus, Ga.
Died 1978

Education

Miner Teachers Normal School,
Washington, D.C., teaching certificate, 1913. Howard University, Washington, D.C., B.S. (fine arts), 1924.
Teachers College, Columbia University, New York, M.A., 1934.

Awards, Honors, and Grants

Two Thousand Women of Achievement Award, 1972.
International Women's Year Award,
1976.

Selected Solo Exhibitions

1971 *Recent Paintings by Alma W.
Thomas, Earth and Space
Series, 1961–1971.* Fisk University, Nashville. Catalog.

1972 *Alma W. Thomas Retrospective
Exhibition.* Whitney Museum
of American Art, New York,
and Corcoran Gallery of Art,
Washington, D.C. Catalog.

1975 *Alma W. Thomas: Recent Paintings.* Gallery of Art, Howard
University, Washington, D.C.
Catalog.

1976 *Alma W. Thomas: Recent Paintings.* North Carolina Agricultural and Technical State
University, Greensboro.

1981 *A Life in Art: Alma Thomas,
1891–1978.* National Museum
of American Art, Smithsonian
Institution, Washington, D.C.
Catalog.

Bibliography

*Afro-American Artists, New York and
Boston.* Introduction by Edmund B.
Gaither. Boston: Museum of the
National Center of Afro-American
Artists, 1970.

Doty, Robert. *Contemporary Black
Artists in America.* New York: Whitney Museum of American Art, 1971.

Washington: Twenty Years. Baltimore: Baltimore Museum of Art, 1970. Essays by Diana F. Johnson and Ellen Hope Gross.

Wilson, J. "Alma Thomas: A One-Woman Art Movement." *Ms.* 7 (February 1979): 59–61.

Steina Vasulka

Born 1940, Reykjavik, Iceland

Education

State Conservatory of Music, Prague, 1959–63.

Awards, Honors, and Grants

Guggenheim Fellowship, 1976.
NEA.
New York State Council on the Arts Grant.
Southwest Independent Production Fund, Houston, 1982.

Selected Solo Exhibitions and Installations

1971 *Jackie Curtis' First and Second Television Special,* in collaboration with Woody Vasulka. Global Village, New York.
Transmitted Environment, in collaboration with Woody Vasulka. Experimental Television Center, Binghamton, N.Y.

1974 *Video Environment.* Norton Hall, State University of New York, Buffalo.

1975 *Environment.* Cathedral Park, Buffalo.
Video by the Vasulkas, in collaboration with Woody Vasulka. The Kitchen, New York.

1978 *Video by Videomakers: Recent Work by Steina.* Experimental Television Center, Binghamton, N.Y.

Vasulka: Steina—Machine Vision/Woody—Descriptions, in collaboration with Woody Vasulka. Albright-Knox Art Gallery, Buffalo. Catalog.
Allvision No. 2. The Kitchen, New York.

1982 *Allvision.* Museum of Art, Carnegie Institute, Pittsburgh.

1983 *The West.* The Kitchen, New
–84 York, and Centre Georges Pompidou, Paris.

1984 *Allvision.* Science Museum, St. Paul, Minn.
Steina et Woody Vasulka: Videastes, retrospective. MBXA/Cinédoc, Paris. Catalog.

Distributed by Electronic Arts Intermix, New York, and Video Data Bank, Chicago.

Bibliography

Furlong, Lucinda. "Notes toward a History of Image-Processed Video: Steina and Woody Vasulka." *Afterimage* 11 (December 1983): 12–17.

Haller, Robert. "Interview with Steina." *Video Texts: 1983,* pp. 14–15.

Lalanne, Dorothée. "Promenade Electronique." *Vogue* (Paris), June–July 1984, pp. 178–83.

Margaret Wharton

Born 1943, Portsmouth, Va.

Education

University of Maryland, B.S., 1965. School of the Art Institute of Chicago, M.F.A., 1975.

Awards, Honors, and Grants

NEA, 1980.
Awards in the Visual Arts, 1984.

Selected Solo Exhibitions

1981 Museum of Contemporary Art, Chicago, and tour. Catalog.

Public Commissions

1985 *Pala.* Museum of Contemporary Art, Chicago.

Represented by Phyllis Kind Gallery, Chicago.

Bibliography

Artner, Alan G. "Quality Comes Out of Wharton Wood Work." *Chicago Tribune,* January 11, 1980.

Glauber, Robin. "Chairs as Metaphor: The Sculpture of Margaret Wharton." *Arts Magazine* 56 (September 1981): 84.

Kirshner, Judith Russi. "Margaret Wharton." *Artforum* 20 (January 1982): 85–86.

Rickey, Carrie. "Chicago." *Art in America* 67 (July–August 1979): 47–54.

Schjeldahl, Peter. "Letter from Chicago." *Art in America* 64 (July–August 1976): 52–58.

Tully, Judd. "Vita Breva, Chaise Longue: The Art of Margaret Wharton." *Arts Magazine* 57 (June 1983): 111–15.

Hannah Wilke

Born 1940, New York

Education

Tyler School of Art, Temple University, Philadelphia, B.F.A., B.S., 1961.

Awards, Honors, and Grants

CAPS, 1973–74.
NEA, 1976–77, 1979, 1980.
Alaska Council for the Arts and University of Alaska, Fairbanks, 1980.
Guggenheim Fellowship, 1982–83.

Selected Solo Exhibitions, Installations, and Performances

1974 *Hannah Wilke, Super-T-Art,* performance. The Kitchen, New York.

1976 *Starification.* Fine Arts Gallery, University of California, Irvine.

1977 *Intercourse with . . . ,* performance. London Art Museum, London, Ontario.

1978 *So Help Me Hannah,* installation. P.S. 1, Institute for Art and Urban Resources, Long Island City, N.Y.

1979 *Performalist Self-Portraits 1942–79.* Washington Project for the Arts, Washington, D.C.

1984 Gross Gallery, University of Arizona, Tucson.

Represented by Ronald Feldman Fine Arts, New York.

Bibliography

"Artist Hannah Wilke Talks with Ernst." *Oasis d'Neon* 1, nos. 1 and 3 (1978).

Hess, Thomas B. "Hannah Wilke." *New York,* October 13, 1975, p. 83.

Jones, Marvin. "Hannah Wilke's Art, Politics, Religion and Feminism." Interview. *The New Common Good,* May 1985, pp. 1, 9–11.

Russell, John. "Hannah Wilke." *New York Times,* March 24, 1978, p. 20.

Savitt, Mark. "Hannah Wilke: The Pleasure Principle." *Arts Magazine* 49 (September 1975): 56–57.

Sims, Lowery. "Body Politics: Hannah Wilke and Kaylynn Sullivan." In *Art and Ideology,* pp. 45–56. New York: New Museum of Contemporary Art, 1984.

Martha Wilson

Born 1947, Philadelphia

Education

Wilmington College, Wilmington, Ohio, B.A., 1969. Dalhousie University, Halifax, Nova Scotia, M.A., 1971.

Awards, Honors, and Grants

NEA, 1978, 1983.

Selected Performances

1973 *Transformance: Claudia*, in collaboration with Jacki Apple (with Anne Blevens). Plaza Hotel, Soho streets and galleries, New York.

1975 *De-formation*. Whitney Museum of American Art, Downtown Branch at Federal Reserve Plaza, New York.

1976 *Queen*. Whitney Museum of American Art, New York, and Oberlin College, Oberlin, Ohio.

Rose. Artists Space, New York.

Mudpie. LAICA, Los Angeles, and tour.

Ditto. Fine Arts Building, New York, and tour.

1977 *Beast*. University of Iowa, Iowa City.

1978 *Story Lines*. Whitney Museum of American Art, Downtown Branch at Federal Reserve Plaza, New York.

1981 *Disband*. Museum of Contemporary Art, Chicago.

1983 *Alexander M. Plague, Jr.* Princeton University, Princeton, N.J.

1984 *Nancy Reagan Runs for Office.* Franklin Furnace and The Kitchen, New York.

1985 *Nancy Reagan at the Inauguration.* P.S. 122, New York.

Bibliography

Lippard, Lucy R. "Making Up: Role-Playing and Transformation in Women's Conceptual Art." *Ms.*, October 1975.

———. "The Pains and Pleasures of Rebirth: Women's Body Art." *Art in America* 64 (May 1976): 73–81.

Writings by Wilson

"Correspondence [Jacki Apple and Martha Wilson] 1973–74." *Heresies* 2 (May 1977).

"Story Lines: Stuck in Buffalo '77." *Tracks*, December 1977. Text to performance.

Jackie Winsor

Born 1941, Newfoundland, Canada

Education

Massachusetts College of Art, Boston, B.F.A., 1965. Rutgers University, New Brunswick, N.J., M.F.A., 1967.

Awards, Honors, and Grants

New York State Council on the Arts, 1973.

Mather Award, 1974.

NEA, 1974, 1977, 1984.

Lewis Comfort Tiffany Award, 1977.

Guggenheim Fellowship, 1978.

Brandeis University Creative Artists Award, 1984.

Selected Solo Exhibitions

1971 Nova Scotia College of Art and Design, Halifax.

1977 Museum of Modern Art, San Francisco.

1978 Wadsworth Atheneum, Hartford, Conn.

1979 Museum of Modern Art, New York.

Art Gallery of Ontario, Toronto.

Fort Worth Art Museum.

1981 Virginia Museum of Fine Arts, Richmond, Va.

1982 Akron Art Museum, Akron, Ohio.

1983 Hayden Gallery, Massachusetts Institute of Technology, Cambridge.

Represented by Paula Cooper, New York.

Bibliography

Bear, Liza. "An Interview with Jackie Winsor." *Avalanche* 7 (Spring 1972): 10–17.

Gholson, Craig. "More than Minimal Jackie Winsor." *Interview* 9 (April 1979): 62–64.

Gruen, John. "Jackie Winsor: Eloquence of a 'Yankee Pioneer.'" *Artnews* 78 (March 1979): 57–60.

Lippard, Lucy. "Jackie Winsor." *Artforum* 12 (February 1974): 56–58 and cover.

———. *Strata: Nancy Graves, Eva Hesse, Michelle Stuart, Jackie Winsor.* Vancouver: Vancouver Art Gallery, 1977.

Smith, Roberta. "Winsor-Built." *Art in America* 65 (January–February 1977): 118–20.

Selected Group Exhibitions

This chronological list of group exhibitions held from 1970 through 1985 is annotated with the names of all the artists in *Making Their Mark* who participated in each show. The information has been derived from the biographies provided by the artists or their galleries. Not every exhibition listed on the artists' biographies has been included, and no exhibition is cited unless at least one of these artists participated in it.

1970

Drawing Annual. Whitney Museum of American Art, New York. Catalog.
Ree Morton

Sculpture Annual. Whitney Museum of American Art, New York. Catalog.
Vija Celmins, Jackie Ferrara, Nancy Graves, Mary Miss, Dorothea Rockburne, Betye Saar, Jackie Winsor

1971

Contemporary Black Artists in America. Whitney Museum of American Art, New York. Catalog.
Alma W. Thomas

Documenta 5. Kassel, West Germany. Catalog.
Nancy Graves, Eva Hesse, Joan Jonas, Faith Ringgold, Dorothea Rockburne, Hannah Wilke

Envois, Biennale de Paris. Parc Floral, Paris. Catalog.
Eleanor Antin, Nancy Graves, Adrian Piper

26 Contemporary Women Artists. Aldrich Museum of Contemporary Art, Ridgefield, Conn. Catalog.
Alice Aycock, Sylvia Plimack Mangold, Mary Miss, Howardena Pindell, Adrian Piper, Jackie Winsor

1972

Gedok: American Women Artists. Kunsthaus Hamburg, Hamburg, West Germany. Catalog.
Lynda Benglis, Jackie Ferrara, Janet Fish, Mary Frank, Nancy Graves, Joyce Kozloff, Mary Miss, Howardena Pindell, Sylvia Sleigh, Joan Snyder, Nancy Spero, Hannah Wilke, Jackie Winsor

Painting and Sculpture Today, 1972. Indianapolis Museum of Art. Catalog.
Lynda Benglis, Audrey Flack, Nancy Graves

Painting Annual. Whitney Museum of American Art, New York. Catalog.
Jennifer Bartlett, Joan Brown, Audrey Flack, Nancy Graves, Yvonne Jacquette, Joyce Kozloff, Sylvia Plimack Mangold, Catherine Murphy, Elizabeth Murray, Howardena Pindell, Joan Snyder

Sculpture Annual. Whitney Museum of American Art, New York. Catalog.
Mary Frank

Thirty-second Annual. Art Institute of Chicago. Catalog.
Lynda Benglis, Janet Fish

Twenty-two Realists. Whitney Museum of American Art, New York.
Audrey Flack

1973

Biennale de Paris. Paris. Catalog.
Jackie Winsor

Biennial Exhibition. Whitney Museum of American Art, New York. Catalog.
Lynda Benglis, Cynthia Carlson, Jackie Ferrara, Mary Frank, Nancy Graves, Joyce Kozloff, Mary Miss, Ree Morton, Catherine Murphy, Elizabeth Murray, Katherine Porter, Joan Snyder, Hannah Wilke, Jackie Winsor

Whitney Annual. Whitney Museum of American Art, New York. Catalog.
Dorothea Rockburne

Women Choose Women. New York Cultural Center. Catalog.
Audrey Flack, Yvonne Jacquette, Joyce Kozloff, Faith Ringgold, Sylvia Sleigh, Joan Snyder, Michelle Stuart, Hannah Wilke

1974

American Abstract Painting Today. Whitney Museum of American Art, Downtown Branch at Federal Reserve Plaza, New York.
Elizabeth Murray

Circa 7500. California Institute of the Arts, Valencia, and tour. Catalog.
Laurie Anderson, Eleanor Antin, Jacki Apple, Alice Aycock, Jennifer Bartlett, Nancy Holt, Rita Myers, Adrian Piper

Painting and Sculpture Today, 1974. Indianapolis Museum of Art. Catalog.
Mary Beth Edelson, Jackie Ferrara, Catherine Murphy, Howardena Pindell, Sylvia Sleigh, Michelle Stuart, Alma W. Thomas, Hannah Wilke, Jackie Winsor

Seventy-first American Exhibition. Art Institute of Chicago. Catalog.
Vija Celmins, Janet Fish, Nancy Graves, Dorothea Rockburne, Jackie Winsor

1975

Biennale de Paris. Musée National d'Art Moderne, Paris. Catalog.

Alice Aycock, Jennifer Bartlett, Howardena Pindell

Biennial Exhibition. Whitney Museum of American Art, New York. Catalog.

Judy Pfaff, Judy Rifka, Alexis Smith

Southland Video Anthology. Long Beach Museum of Art, Long Beach, Calif. Catalog.

Martha Rosler

37th Corcoran Biennial. Corcoran Gallery of Art, Washington, D.C. Catalog.

Jennifer Bartlett, Dorothea Rockburne, Alexis Smith

Video Art U.S. São Paulo Bienal. São Paulo. Catalog.

Eleanor Antin, Steina Vasulka

The Year of the Woman. Bronx Museum of the Arts, Bronx, N.Y.

Lynda Benglis, Janet Fish, Sylvia Sleigh, Hannah Wilke

1976

Internationaler Forum des Jungen Films. Berlin Film Festival.

Steina Vasulka

Painting and Sculpture Today, 1976. Indianapolis Museum of Art. Catalog.

Sylvia Plimack Mangold

Seventy-second American Exhibition. Art Institute of Chicago. Catalog.

Jennifer Bartlett, Dorothea Rockburne

Sydney Biennale. Art Gallery of New South Wales, Sydney, Australia.

Lynda Benglis, Agnes Denes

Two Centuries of Black American Art. Los Angeles County Museum of Art, and tour. Catalog.

Alma W. Thomas

200 Years of American Sculpture. Whitney Museum of American Art, New York. Catalog.

Nancy Graves, Eva Hesse

The Year of the Woman: Reprise. Bronx Museum of the Arts, Bronx, N.Y. Catalog.

Yvonne Jacquette

1977

American Narrative/Story Art: 1967–1977. Contemporary Arts Museum, Houston, and tour. Catalog.

Laurie Anderson, Eleanor Antin, Jacki Apple, Suzanne Lacy, Martha Rosler, Alexis Smith

Biennale de Paris. Musée National d'Art Moderne, Paris. Catalog.

Tina Girouard, Mary Lucier, Adrian Piper, Alexis Smith

Biennial Exhibition. Whitney Museum of American Art, New York. Catalog.

Jennifer Bartlett, Joan Brown, Vija Celmins, Nancy Holt, Ree Morton, Elizabeth Murray, Dorothea Rockburne, Steina Vasulka, Jackie Winsor

Contemporary Women: Consciousness and Content. Brooklyn Museum, Brooklyn, N.Y.

Eleanor Antin, Lynda Benglis, Mary Frank, Joyce Kozloff, Ree Morton, Miriam Schapiro, Sylvia Sleigh, Joan Snyder, Michelle Stuart

Documenta 6. Kassel, West Germany. Catalog.

Alice Aycock, Jennifer Bartlett, Agnes Denes, Heide Fasnacht, Tina Girouard, Nancy Graves, Eva Hesse, Joan Jonas, Shigeko Kubota, Sylvia Plimack Mangold, Dorothea Rockburne, Michelle Stuart

Feminist Statements. Woman's Building, Los Angeles.

Ana Mendieta

Patterning and Decoration. Museum of the American Foundation for the Arts, Miami. Catalog.

Valerie Jaudon, Joyce Kozloff, Howardena Pindell, Miriam Schapiro

Pattern Painting. P.S. 1, Institute for Art and Urban Resources, Long Island City, N.Y.

Cynthia Carlson, Valerie Jaudon, Joyce Kozloff, Miriam Schapiro

Representations of America. Fine Arts Museums of San Francisco, and tour.

Joan Brown

1978

America 1976: A Bicentennial Exhibition. Brooklyn Museum, Brooklyn, N.Y.

Janet Fish

Art about Art. Whitney Museum of American Art, New York. Catalog.

Audrey Flack

"Bad" Painting. New Museum of Contemporary Art, New York. Catalog.

Joan Brown

New Image Painting. Whitney Museum of American Art, New York. Catalog.

Jennifer Bartlett, Lois Lane, Susan Rothenberg

Painting and Sculpture Today, 1978. Indianapolis Museum of Art. Catalog.

Eleanor Antin, Cynthia Carlson

Performance Festival. Beursschouwberg, Brussels. Catalog.

Martha Rosler

The Sense of Self: From Self-Portrait to Autobiography. Independent Curators, Washington, D.C., and tour. Catalog.

Laurie Anderson, Eleanor Antin, Joan Brown, Adrian Piper

37th Biennale. Venice. Catalog.

Alice Aycock, Agnes Denes

1979

American Painting of the Seventies. Albright-Knox Art Gallery, Buffalo, and tour. Catalog.

Joan Brown, Audrey Flack, Nancy Graves, Sylvia Plimack Mangold, Susan Rothenberg

American Painting: The Eighties. Grey Art Gallery, New York University. Catalog.

Louisa Chase, Nancy Graves, Lois Lane, Elizabeth Murray, Susan Rothenberg

Biennial Exhibition. Whitney Museum of American Art, New York. Catalog.

Alice Aycock, Jennifer Bartlett, Barbara Buckner, Deborah Butterfield, Mary Frank, Nancy Holt, Joyce Kozloff, Lois Lane, Rita Myers, Dorothea Rockburne, Martha Rosler, Susan Rothenberg, Alexis Smith, Jackie Winsor

By the Sea: 20th-Century Americans at the Shore. Queens Museum, Flushing, N.Y. Catalog.

Joan Brown, Mary Frank, Ana Mendieta

Contemporary Feminist Art. Haags Gemeentemuseum, The Hague, Netherlands, and tour.

Mary Beth Edelson, Joyce Kozloff, Miriam Schapiro, Nancy Spero

The Decade in Review: Selections for the 1970s. Whitney Museum of American Art, New York.

Alice Aycock, Jennifer Bartlett, Deborah Butterfield, Vija Celmins, Elizabeth Murray, Susan Rothenberg, Alexis Smith, Jackie Winsor

The Decorative Impulse. Institute of Contemporary Art, University of Pennsylvania, Philadelphia, and tour. Catalog.

Cynthia Carlson, Joyce Kozloff, Miriam Schapiro

Directions 1979. Hirshhorn Museum and Sculpture Garden, Smithsonian Institution, Washington, D.C. Catalog.

Eleanor Antin

Five American Painters, 36th Corcoran Biennial. Corcoran Gallery of Art, Washington, D.C.

Joan Logue

A Great Big Drawing Show. P.S. 1, Institute for Art and Urban Resources, Long Island City, N.Y.

Alice Aycock, Michelle Stuart

Social Works. LAICA, Los Angeles. Catalog.

Martha Rosler

Storytelling in Art. Museum of the American Foundation for the Arts, Miami.

Eleanor Antin, Joan Brown, Alexis Smith

1980

A Decade of Women's Performance Art. Contemporary Arts Center, New Orleans.

Jacki Apple, Nancy Buchanan, Suzanne Lacy, Adrian Piper, Martha Rosler, Barbara T. Smith

Decorative Fabricators. Virginia Museum of Fine Arts, Richmond. Catalog.

Cynthia Carlson, Joyce Kozloff, Miriam Schapiro

Drawings: The Pluralist Decade. 38th Biennale, Venice, and tour. Catalog.

Laurie Anderson, Alice Aycock, Jennifer Bartlett, Lynda Benglis, Agnes Denes, Jackie Ferrara, Tina Girouard, Nancy Graves, Joyce Kozloff, Sylvia Plimack Mangold, Mary Miss, Dorothea Rockburne, Susan Rothenberg

The Figurative Tradition and the Whitney Museum of American Art. Whitney Museum of American Art, New York. Catalog.

Mary Frank

The 1970s: New American Painting. New Museum of Contemporary Art, New York, and tour.

Ree Morton, Dorothea Rockburne, Joan Snyder

Painting and Sculpture Today, 1980. Indianapolis Museum of Art. Catalog.

Ida Applebroog, Deborah Butterfield, Louisa Chase, Jackie Ferrara, Joyce Kozloff, Lois Lane, Mary Miss, Susan Rothenberg, Miriam Schapiro, Margaret Wharton

Sculpture in the '70s: The Figure. Pratt Manhattan Center Gallery, New York.

Mary Frank

Times Square Show. New York.

Jenny Holzer, Judy Rifka

1981

Biennial Exhibition. Whitney Museum of American Art, New York. Catalog.

Alice Aycock, Jennifer Bartlett, Lynda Benglis, Barbara Buckner, Louisa Chase, Nancy Holt, Mary Miss, Elizabeth Murray, Judy Pfaff, Katherine Porter, Judith Shea, Sandy Skoglund, Alexis Smith, Joan Snyder

Body Language: Figurative Aspects of Recent Art. Hayden Gallery, Massachusetts Institute of Technology, Cambridge.

Jennifer Bartlett, Judy Pfaff, Cindy Sherman, Laurie Simmons

Contemporary American Realism since 1960. Pennsylvania Academy of the Fine Arts, Philadelphia, and tour. Catalog.

Audrey Flack, Sylvia Plimack Mangold, Catherine Murphy

Directions 1981. Hirshhorn Museum and Sculpture Garden, Smithsonian Institution, Washington, D.C., and tour. Catalog.

Judy Pfaff, Michelle Stuart

Inside Out: Self beyond Likeness. Newport Harbor Art Museum, Newport Beach, Calif. Catalog.

Eleanor Antin, Joan Brown

Nineteen Emerging Artists. Solomon R. Guggenheim Museum, New York.

Barbara Kruger

The Pattern Principle. Ohio Foundation for the Arts; toured Ohio.

Cynthia Carlson, Valerie Jaudon, Miriam Schapiro

Real, Really Real, Super Real: Directions in Contemporary American Realism. San Antonio Museum of Art, and tour. Catalog.

Janet Fish, Audrey Flack, Sylvia Plimack Mangold, Catherine Murphy

Tracking the Marvelous. Grey Art Gallery, New York University.

Mary Frank

Transformations: Women in Art, 1970–80. New York Feminist Art Institute, New York Coliseum.

Lois Lane, Ana Mendieta, Judith Shea, Nancy Spero, Hannah Wilke

1982

Afro-American Abstraction. Los Angeles Municipal Art Gallery, and tour.

Howardena Pindell

Biennale de Paris. Grand Palais, Paris. Catalog.

Lyn Blumenthal, Cecilia Condit

Documenta 7. Kassel, West Germany. Catalog.

Dara Birnbaum, Jenny Holzer, Joan Jonas, Barbara Kruger, Sherrie Levine, Judy Rifka, Cindy Sherman

The Image Scavengers. Institute of Contemporary Art, University of Pennsylvania, Philadelphia. Catalog.

Barbara Kruger, Sherrie Levine, Judy Rifka, Cindy Sherman, Laurie Simmons

Mill Valley Film and Video Festival. Mill Valley, Calif. Catalog.

Lyn Blumenthal

National Video Festival. Kennedy Center for the Performing Arts, Washington, D.C.

Shigeko Kubota

New Work/New York. New Museum of Contemporary Art, New York. Catalog.

Louisa Chase, Cheryl Laemmle

New York Now. Kestner-Gesellschaft, Hanover, West Germany, and tour. Catalog.

Lynda Benglis, Louisa Chase, Judy Pfaff, Judy Rifka

Painting and Sculpture Today, 1982. Indianapolis Museum of Art. Catalog.

Louisa Chase, Judith Shea

Seventy-fourth American Exhibition. Art Institute of Chicago. Catalog.

Lynda Benglis, Dara Birnbaum, Joan Brown, Jenny Holzer, Barbara Kruger, Sherrie Levine, Elizabeth Murray, Katherine Porter, Martha Rosler, Susan Rothenberg

Sydney Biennale. Art Gallery of New South Wales, Sydney, Australia.

Jacki Apple, Susan Rothenberg, Miriam Schapiro

39th Biennale. Venice. Catalog.

Alice Aycock, Barbara Kruger, Judy Pfaff, Cindy Sherman, Steina Vasulka

Videodanse. Centre Georges Pompidou, Paris.

Doris Chase

Women's Video and Film Festival. Rome.

Tomiyo Sasaki

1983

American Still Life, 1945–1983. Contemporary Arts Museum, Houston, and tour. Catalog.

Vija Celmins, Janet Fish, Catherine Murphy

Back to the U.S.A. Kunstmuseum, Lucerne, Switzerland, and tour. Catalog.

Jennifer Bartlett, Lynda Benglis, Louisa Chase, Joyce Kozloff, Lois Lane, Judy Pfaff, Judy Rifka, Susan Rothenberg, Miriam Schapiro, Cindy Sherman

Biennial Exhibition. Whitney Museum of American Art, New York. Catalog.

Nancy Graves, Jenny Holzer, Shigeko Kubota, Mary Lucier, Melissa Miller, Judy Rifka, Martha Rosler, Susan Rothenberg, Cindy Sherman, Jackie Winsor

Contemporary Latin American Art. Chrysler Museum, Norfolk, Va.

Ana Mendieta

Directions 1983. Hirshhorn Museum and Sculpture Garden, Smithsonian Institution, Washington, D.C. Catalog.

Ida Applebroog, Elizabeth Murray, Judith Shea, Cindy Sherman, Alexis Smith

The End of the World: Contemporary Visions of the Apocalypse. New Museum of Contemporary Art, New York. Catalog.

Melissa Miller, Katherine Porter, Nancy Spero

Festival Andere Avant-garde. Brucknerhaus Linz, Linz, Austria. Catalog.

Martha Rosler

Images fabriquées. Centre Georges Pompidou, Paris, and tour. Catalog.

Laurie Simmons, Sandy Skoglund

Mill Valley Film and Video Festival. Mill Valley, Calif. Catalog.

Max Almy, Lyn Blumenthal

National Video Festival. American Film Institute, Los Angeles.

Max Almy

Ornamentalism: The New Decorativeness in Architectural Design. Hudson River Museum, Yonkers, N.Y. Catalog.

Cynthia Carlson, Valerie Jaudon, Joyce Kozloff, Miriam Schapiro

38th Corcoran Biennial Exhibition of American Painting. Corcoran Gallery of Art, Washington, D.C., and tour. Catalog.

Joan Brown

Video Art: A History. Museum of Modern Art, New York.

Eleanor Antin, Dara Birnbaum, Martha Rosler

1984

Content: A Contemporary Focus, 1974–84. Hirshhorn Museum and Sculpture Garden, Smithsonian Institution, Washington, D.C. Catalog.

Eleanor Antin, Alice Aycock, Lynda Benglis, Dara Birnbaum, Joan Brown, Louisa Chase, Nancy Holt, Jenny Holzer, Barbara Kruger, Sherrie Levine, Ree Morton, Martha Rosler, Susan Rothenberg, Cindy Sherman, Nancy Spero, Jackie Winsor

Currents. Institute of Contemporary Art, Boston.

Louisa Chase, Jenny Holzer, Barbara Kruger, Elizabeth Murray, Katherine Porter

Difference: On Representation and Sexuality. New Museum of Contemporary Art, New York, and tour. Catalog.

Dara Birnbaum, Cecilia Condit, Barbara Kruger, Sherrie Levine, Martha Rosler

Disarming Images: Art for Nuclear Disarmament, organized by the Art Museum Association of America.

Contemporary Arts Center, Cincinnati, and tour. Catalog.

Joan Brown, Jenny Holzer, Adrian Piper, Laurie Simmons, Sandy Skoglund, Nancy Spero

The East Village Scene. Institute of Contemporary Art, University of Pennsylvania, Philadelphia.

Cheryl Laemmle

Fifth Sydney Biennale. Art Gallery of New South Wales, Sydney, Australia.

Jenny Holzer, Barbara Kruger, Cindy Sherman

The Human Condition: Biennial III. San Francisco Museum of Modern Art. Catalog.

Joan Brown, Louisa Chase, Jenny Holzer, Melissa Miller, Judy Rifka

International Narrative Exhibition. Museum of Modern Art, New York, and tour.

Cecilia Condit

An International Survey of Recent Painting and Sculpture. Museum of Modern Art, New York. Catalog.

Ida Applebroog, Louisa Chase, Yvonne Jacquette, Cheryl Laemmle, Elizabeth Murray, Judy Pfaff, Katherine Porter, Susan Rothenberg, Alexis Smith

New American Video: A Historical Survey, 1968–1980. Whitney Museum of American Art, New York, and tour. Catalog.

Dara Birnbaum, Martha Rosler, Steina Vasulka

Painting and Sculpture Today, 1984. Indianapolis Museum of Art, Catalog.

Jenny Holzer, Elizabeth Murray, Judy Rifka, Laurie Simmons

Paradise Lost, Paradise Regained: American Visions of the New Decade. 40th Biennale, Venice, and tour. Catalog.

Max Almy, Dara Birnbaum, Louisa Chase, Cheryl Laemmle, Melissa Miller, Judy Pfaff

"Primitivism" in 20th-Century Art: Affinity of the Tribal and the Modern. Museum of Modern Art, New York, and tour. Catalog.

Nancy Graves, Eva Hesse, Michelle Stuart, Jackie Winsor

Rencontres Video internationales de Montreal, Video 84. Montreal, Quebec. Catalog.

Dara Birnbaum, Lyn Blumenthal

Revising Romance: New Feminist Video. Institute of Contemporary Art, Boston, and tour.

Eleanor Antin, Nancy Buchanan, Cecilia Condit, Barbara T. Smith

Sexuality and Representation. Institute of Contemporary Arts, London.

Barbara Kruger

Tenth Anniversary Exhibition. Artists Space, New York.

Dara Birnbaum, Jenny Holzer, Sherrie Levine

Video: A Retrospective, 1974–1984. Long Beach Museum of Art, Long Beach, Calif. Catalog.

Eleanor Antin, Dara Birnbaum, Nancy Buchanan

1985

The Artist and the Computer. Bronx Museum of the Arts, Bronx, N.Y. Catalog.

Sara Hornbacher

Biennale de Paris. Grand Palais, Paris. Catalog.

Jenny Holzer

Biennial Exhibition. Whitney Museum of American Art, New York. Catalog.

Dara Birnbaum, Lyn Blumenthal, Jenny Holzer, Barbara Kruger, Sherrie Levine, Elizabeth Murray, Faith Ringgold, Susan Rothenberg, Cindy Sherman, Laurie Simmons, Nancy Spero

Carnegie International. Museum of Art, Carnegie Institute, Pittsburgh. Catalog.

Dara Birnbaum, Jenny Holzer, Susan Rothenberg, Cindy Sherman

18th Bienal. São Paulo, Brazil.

Alice Aycock, Rita Myers, Steina Vasulka

In Three Dimensions: Recent Sculpture by Women. Pratt Manhattan Center, New York.

Lynda Benglis, Heide Fasnacht, Jackie Ferrara

New Video. International Center of Photography, New York.

Lyn Blumenthal

Painters in the Anchorage. Creative Time, Brooklyn Bridge, New York. Catalog.

Cynthia Carlson, Judy Rifka, Nancy Spero

San Francisco Video Festival. San Francisco.

Lyn Blumenthal

Sculpture by Women in the Eighties. University of Pittsburgh Art Gallery.

Jackie Ferrara, Nancy Graves, Mary Miss, Jackie Winsor

Tradition and Conflict: Images of a Turbulent Decade, 1963–1973. Studio Museum in Harlem, New York, and tour. Catalog.

Howardena Pindell, Adrian Piper, Faith Ringgold, Betye Saar, Nancy Spero

Videodanse. Centre Georges Pompidou, Paris.

Doris Chase

Women Artists at the Palladium, curated by the Guerrilla Girls. Palladium, New York.

Ida Applebroog, Lynda Benglis, Lyn Blumenthal, Cynthia Carlson, Jackie Ferrara, Valerie Jaudon, Cheryl Laemmle, Elizabeth Murray, Judy Rifka, Nancy Spero, Michelle Stuart, Hannah Wilke

World-Wide Video Festival. The Hague, Netherlands.

Lyn Blumenthal

Public Collections

Representation in a museum collection means, ideally, that an artist's work will be displayed at that institution, published as part of the collection, and made available for other museums to borrow. This list of museums that own work by the artists included in *Making Their Mark* has been culled from the biographies provided by the artists and their galleries; it has not been confirmed by the institutions. There is no indication of whether a work entered a collection as a gift or as a purchase. However, an asterisk after an artist's name indicates that the institution was the first major collection to purchase a work by the artist. A double asterisk indicates that the artist had a first purchase by more than one major collection in the same year.

Aachen, West Germany, Neue Galerie Sammlung Ludwig
 Alice Aycock, Nancy Graves, Valerie Jaudon, Joyce Kozloff, Judy Pfaff

Aarhus, Denmark, Aarhus Kunstmuseum
 Steina Vasulka

Adelaide, Australia, Art Gallery of South Australia
 Jennifer Bartlett*

Akron, Ohio, Akron Art Institute
 Audrey Flack, Mary Frank, Nancy Graves, Lois Lane, Susan Rothenberg, Cindy Sherman,* Sandy Skoglund, Steina Vasulka, Jackie Winsor

Albany, New York, New York State Museum
 Joan Logue

Albion, Michigan, Albion College
 Agnes Denes, Miriam Schapiro

Albuquerque, New Mexico, University of New Mexico
 Michelle Stuart

Alexandria, Louisiana, Alexandria Museum of Art
 Lynda Benglis, Clyde Connell*

Alexandria, Louisiana, Louisiana State University
 Clyde Connell

Amherst, Massachusetts, University of Massachusetts
 Alice Aycock, Agnes Denes, Jackie

Ferrara, Martha Rosler, Sandy Skoglund

Amsterdam, Netherlands, Stedelijk Museum
 Max Almy, Dara Birnbaum, Jenny Holzer, Susan Rothenberg, Cindy Sherman, Jackie Winsor

Andover, Massachusetts, Addison Gallery of American Art, Phillips Academy
 Katherine Porter, Sandy Skoglund

Ann Arbor, Michigan, University of Michigan Art Museum
 Dorothea Rockburne

Athens, Ohio, Ohio University
 Yvonne Jacquette, Nancy Spero

Atlanta, Georgia, High Museum of Art
 Lynda Benglis, Jackie Ferrara, Sherrie Levine,* Elizabeth Murray, Howardena Pindell, Katherine Porter, Dorothea Rockburne, Betye Saar, Cindy Sherman, Laurie Simmons, Sandy Skoglund, Joan Snyder, Jackie Winsor

Austin, Texas, Huntington Art Gallery, University of Texas
 Judy Rifka

Austin, Texas, Laguna Gloria Art Museum
 Clyde Connell, Nancy Holt

Baltimore, Maryland, Baltimore Museum of Art
 Jennifer Bartlett, Lynda Benglis,

Jackie Ferrara,* Barbara Kruger, Cindy Sherman, Sandy Skoglund

Baltimore, Maryland, Goucher College
 Jennifer Bartlett

Basel, Switzerland, Offentliche Kunstsammlung Basel Kunstmuseum
 Alice Aycock

Bellingham, Washington, Western Washington University
 Nancy Holt

Berkeley, California, University Art Museum, University of California, Berkeley
 Joan Brown, Nancy Graves, Betye Saar, Miriam Schapiro

Berlin, West Germany, Staatliche Museen
 Yvonne Jacquette, Judy Rifka

Bern, Switzerland, Kunstmuseum Bern
 Jenny Holzer, Adrian Piper

Bloomington, Illinois, Merwin Gallery, Illinois Wesleyan University
 Miriam Schapiro

Bloomington, Indiana, Indiana University Art Museum
 Janet Fish, Valerie Jaudon, Martha Rosler

Boise, Idaho, Boise Gallery of Art
 Sandy Skoglund

Boston, Massachusetts, Institute of Contemporary Art
 Lyn Blumenthal

Boston, Massachusetts, Museum of Fine Arts
Joan Brown, Doris Chase, Elizabeth Murray, Judy Rifka, Miriam Schapiro, Joan Snyder, Jackie Winsor

Boulder, Colorado, University of Colorado Art Galleries
Joan Brown, Cynthia Carlson, Jackie Winsor

Bridgeport, Connecticut, University of Bridgeport
Mary Frank

Bronx, New York, Bronx Museum of the Arts
Ida Applebroog, Sara Hornbacher

Brooklyn, New York, Brooklyn Museum
Alice Aycock, Mary Frank, Yvonne Jacquette, Joyce Kozloff,* Judy Pfaff, Howardena Pindell, Judith Shea, Cindy Sherman, Michelle Stuart

Brunswick, Maine, Bowdoin College Museum of Art
Yvonne Jacquette

Buffalo, New York, Albright-Knox Art Gallery
Joan Brown, Cynthia Carlson, Louisa Chase, Janet Fish, Nancy Graves, Joyce Kozloff, Lois Lane, Sylvia Plimack Mangold, Melissa Miller, Judy Pfaff,* Susan Rothenberg, Cindy Sherman, Laurie Simmons, Michelle Stuart, Hannah Wilke, Jackie Winsor

Cambridge, Massachusetts, Fogg Art Museum, Harvard University
Valerie Jaudon, Mary Miss, Howardena Pindell, Katherine Porter, Dorothea Rockburne, Laurie Simmons, Joan Snyder

Cambridge, Massachusetts, Hayden Gallery, Massachusetts Institute of Technology
Joyce Kozloff, Elizabeth Murray, Katherine Porter, Cindy Sherman, Nancy Spero

Canberra, Australia, Australian National Gallery

Ida Applebroog, Alice Aycock, Lynda Benglis, Audrey Flack, Eva Hesse, Martha Rosler, Cindy Sherman, Nancy Spero, Michelle Stuart,* Jackie Winsor**

Canton, New York, Richard F. Brush Art Gallery, St. Lawrence University
Jackie Ferrara

Chapel Hill, North Carolina, Ackland Art Museum, University of North Carolina
Elizabeth Murray

Charlotte, North Carolina, Mint Museum of Art
Joyce Kozloff

Chattanooga, Tennessee, Hunter Museum of Art
Janet Fish

Chicago, Illinois, Art Institute of Chicago
Doris Chase, Janet Fish, Mary Frank, Nancy Graves, Sherrie Levine, Elizabeth Murray

Chicago, Illinois, Museum of Contemporary Art
Alice Aycock, Jennifer Bartlett, Dara Birnbaum, Deborah Butterfield, Cynthia Carlson, Mary Beth Edelson, Howardena Pindell, Cindy Sherman, Michelle Stuart, Margaret Wharton

Chicago, Illinois, University of Illinois
Max Almy, Martha Rosler

Cincinnati, Ohio, Cincinnati Art Museum
Alice Aycock, Deborah Butterfield, Heide Fasnacht, Jackie Ferrara, Mary Miss, Elizabeth Murray, Michelle Stuart

Cleveland, Ohio, Cleveland Museum of Art
Jennifer Bartlett, Janet Fish

Columbia, Missouri, Stephens College Art Gallery
Miriam Schapiro

Columbus, Ohio, Columbus Museum of Art
Heide Fasnacht,** Jackie Ferrara

Columbus, Ohio, Orton Museum, Ohio State University
Eleanor Antin, Agnes Denes, Elizabeth Murray, Adrian Piper,* Dorothea Rockburne, Jackie Winsor

Copenhagen, Denmark, Tranegarden Gentofte Kunstbibliotek
Howardena Pindell

Coral Gables, Florida, Lowe Art Museum, University of Miami
Jackie Ferrara

Corpus Christi, Texas, Art Museum of South Texas
Jennifer Bartlett, Janet Fish, Nancy Graves, Lois Lane, Susan Rothenberg

Dallas, Texas, Dallas Museum of Art
Jennifer Bartlett, Deborah Butterfield, Jackie Ferrara, Janet Fish,* Nancy Graves, Sylvia Plimack Mangold, Elizabeth Murray, Judy Rifka, Susan Rothenberg, Judith Shea, Cindy Sherman, Sandy Skoglund, Joan Snyder, Margaret Wharton

Dayton, Ohio, Dayton Art Institute
Valerie Jaudon

Denver, Colorado, Denver Art Museum
Cynthia Carlson, Louisa Chase,* Katherine Porter

Des Moines, Iowa, Des Moines Art Center
Jackie Ferrara, Mary Frank, Nancy Graves, Lois Lane, Susan Rothenberg

Detroit, Michigan, Detroit Institute of Arts
Lynda Benglis, Mary Beth Edelson, Sylvia Plimack Mangold, Elizabeth Murray, Judy Pfaff, Jackie Winsor

East Islip, New York, Islip Museum of Art
Nancy Holt

Eindhoven, Netherlands, Van Abbemuseum
Jenny Holzer**

Elmira, New York, Arnot Art Museum
Mary Frank

Essen, West Germany, Museum Folkwang
Cindy Sherman

Flushing, New York, Queens Museum
Cynthia Carlson

Fort Worth, Texas, Fort Worth Art Museum
Lynda Benglis, Vija Celmins, Nancy Graves, Melissa Miller

Grand Rapids, Michigan, Grand Rapids Art Museum
Joan Snyder

Greensboro, North Carolina, Weatherspoon Art Gallery, University of North Carolina
Heide Fasnacht,** Jackie Ferrara, Nancy Graves, Yvonne Jacquette, Joyce Kozloff, Sylvia Plimack Mangold, Catherine Murphy, Judy Rifka,* Michelle Stuart

Greensburg, Pennsylvania, Westmoreland County Museum of Art
Janet Fish

Greenville, South Carolina, Greenville County Museum of Art
Joan Snyder, Nancy Spero*

The Hague, Netherlands, Haags Gemeentemuseum
Alice Aycock, Jenny Holzer, Michelle Stuart

Hamburg, West Germany, Hamburger Kunsthalle
Michelle Stuart

Hartford, Connecticut, Wadsworth Atheneum
Eleanor Antin, Jackie Ferrara, Sylvia Plimack Mangold, Adrian Piper, Cindy Sherman

Honolulu, Hawaii, Contemporary Arts Center of Hawaii
Katherine Porter

Honolulu, Hawaii, Honolulu Academy of Arts
Agnes Denes

Houston, Texas, Contemporary Arts Museum

271

Tina Girouard, Suzanne Lacy,*
Martha Rosler

Houston, Texas, Museum of Fine Arts
Lynda Benglis, Doris Chase, Clyde
Connell, Janet Fish, Nancy Graves,
Lois Lane, Sylvia Plimack Mangold,
Melissa Miller,* Susan Rothenberg,
Cindy Sherman, Laurie Simmons

Houston, Texas, Sarah Campbell
Blaffer Gallery, University of
Houston
Michelle Stuart

Humboldt, Iowa, Humboldt State
University
Eleanor Antin

Humlebaek, Denmark, Louisiana
Museum
Alice Aycock, Jennifer Bartlett,
Jackie Ferrara, Valerie Jaudon,
Howardena Pindell, Cindy
Sherman

Indianapolis, Indiana, Indianapolis
Museum of Art
Deborah Butterfield, Mary Beth
Edelson, Jackie Ferrara, Sylvia
Plimack Mangold

Iowa City, Iowa, University of Iowa
Museum of Art
Yvonne Jacquette, Howardena
Pindell, Miriam Schapiro

Ithaca, New York, Herbert F. Johnson
Museum of Art, Cornell University
Jackie Ferrara, Barbara T. Smith,
Michelle Stuart

Jerusalem, Israel, Israel Museum
Jennifer Bartlett, Lynda Benglis,
Deborah Butterfield, Agnes Denes

Kalamazoo, Michigan, Kalamazoo
Institute of Arts
Mary Frank, Miriam Schapiro

Kansas City, Missouri, Nelson-Atkins
Museum of Art
Jennifer Bartlett, Lynda Benglis,
Agnes Denes, Susan Rothenberg

Krefeld, West Germany, Kaiser
Wilhelm Museum
Eva Hesse, Michelle Stuart

Kyoto, Japan, National Museum of
Modern Art
Doris Chase

La Jolla, California, La Jolla Museum
of Contemporary Art
Alice Aycock, Jennifer Bartlett,
Nancy Buchanan, Nancy Graves,
Mary Miss, Judy Pfaff, Miriam
Schapiro

La Jolla, California, Mandeville Art
Gallery, University of California,
San Diego
Margia C. Kramer, Martha Rosler

Las Cruces, New Mexico, New
Mexico State University Museum
Lynda Benglis

Lexington, Kentucky, University of
Kentucky Art Museum
Cindy Sherman

Little Rock, Arkansas, Arkansas Arts
Center
Katherine Porter

London, England, Tate Gallery
Jennifer Bartlett, Jenny Holzer,
Cindy Sherman

Long Beach, California, Long Beach
Museum of Art
Max Almy, Eleanor Antin, Jennifer
Bartlett, Lyn Blumenthal, Nancy
Buchanan,* Joan Brown, Cecilia
Condit, Joan Logue, Mary Lucier,
Martha Rosler

Los Angeles, California, Los Angeles
County Museum of Art
Joan Brown, Vija Celmins, Nancy
Graves, Susan Rothenberg, Alexis
Smith

Los Angeles, California, Museum of
Contemporary Art
Sherrie Levine, Elizabeth Murray,
Susan Rothenberg, Cindy Sherman,
Alexis Smith

Louisville, Kentucky, J. B. Speed Art
Museum
Deborah Butterfield, Joan Snyder*

Lyons, France, Nouveau Musée
Jenny Holzer

Madison, Wisconsin, Madison Art
Center

Sylvia Plimack Mangold, Margaret
Wharton

Malmö, Sweden, Malmö Museum
Michelle Stuart

Marl, West Germany, Skulpturen-
museum Glastasten
Alice Aycock

Melbourne, Australia, National Gal-
lery of Victoria
Lynda Benglis, Janet Fish, Audrey
Flack

Mexico City, Mexico, Centro Cultural
de Arte Contemporaneo
Jenny Holzer

Mexico City, Mexico, Museo Rufino
Tamayo
Tina Girouard, Cindy Sherman

Milwaukee, Wisconsin, Milwaukee
Art Museum
Alice Aycock, Deborah Butterfield,
Cynthia Carlson, Doris Chase, Eva
Hesse, Carole Ann Klonarides,
Barbara Kruger, Sylvia Plimack
Mangold, Elizabeth Murray, Susan
Rothenberg, Miriam Schapiro,
Cindy Sherman

Minneapolis, Minnesota, Minneapolis
College of Art and Design Gallery
Jackie Ferrara

Minneapolis, Minnesota, Minneapolis
Institute of Arts
Janet Fish, Dorothea Rockburne

Minneapolis, Minnesota, Walker Art
Center
Eleanor Antin, Alice Aycock,
Jennifer Bartlett, Lynda Benglis,*
Deborah Butterfield,* Nancy
Graves, Sylvia Plimack Mangold,
Elizabeth Murray, Dorothea
Rockburne, Susan Rothenberg,
Judith Shea,* Cindy Sherman,
Laurie Simmons, Alexis Smith,
Michelle Stuart

Montclair, New Jersey, Montclair Art
Museum
Betye Saar

Montreal, Quebec, Musée d'Art
Contemporain
Cindy Sherman, Sandy Skoglund

Mountainville, New York, Storm King
Art Center
Alice Aycock, Lynda Benglis, Mary
Frank

Newark, New Jersey, Newark
Museum
Janet Fish, Catherine Murphy,
Howardena Pindell, Faith
Ringgold*

New Brunswick, New Jersey, Doug-
lass College, Rutgers University
Alice Aycock

New Brunswick, New Jersey, Jane
Voorhees Zimmerli Art Museum,
Rutgers University
Agnes Denes, Yvonne Jacquette,
Howardena Pindell

New Haven, Connecticut, Southern
Connecticut University
Nancy Holt

New Haven, Connecticut, Yale
University Art Gallery
Jennifer Bartlett, Janet Fish, Mary
Frank, Yvonne Jacquette, Sylvia
Plimack Mangold,* Elizabeth
Murray, Howardena Pindell

New London, Connecticut, Con-
necticut College
Mary Frank

New Orleans, Louisiana, New
Orleans Museum of Art
Lynda Benglis, Cynthia Carlson,
Tina Girouard

Newport Beach, California, Newport
Harbor Art Museum
Joan Brown, Vija Celmins, Miriam
Schapiro, Alexis Smith, Barbara T.
Smith

New York, New York, American
Academy and Institute of Arts and
Letters
Janet Fish, Yvonne Jacquette

New York, New York, Anthology Film
Archives
Sara Hornbacher

New York, New York, Grey Art Gal-
lery, New York University
Lynda Benglis, Barbara Buckner,
Doris Chase, Audrey Flack, Miriam
Schapiro

New York, New York, Solomon R. Guggenheim Museum
Alice Aycock, Lynda Benglis, Cynthia Carlson, Mary Beth Edelson, Jackie Ferrara, Audrey Flack, Nancy Graves, Barbara Kruger, Mary Miss, Ree Morton,* Elizabeth Murray, Katherine Porter

New York, New York, The Kitchen
Sara Hornbacher, Joan Logue

New York, New York, Metropolitan Museum of Art
Ida Applebroog, Alice Aycock, Jennifer Bartlett, Deborah Butterfield, Cynthia Carlson, Louisa Chase, Clyde Connell, Agnes Denes, Jackie Ferrara, Janet Fish, Audrey Flack, Mary Frank, Tina Girouard, Nancy Graves, Yvonne Jacquette, Joyce Kozloff, Cheryl Laemmle, Ana Mendieta,* Howardena Pindell, Dorothea Rockburne, Cindy Sherman, Sandy Skoglund,* Joan Snyder, Alma W. Thomas, Hannah Wilke

New York, New York, Museum of the City of New York
Yvonne Jacquette

New York, New York, Museum of Modern Art
Max Almy, Eleanor Antin,* Ida Applebroog,* Alice Aycock,* Jennifer Bartlett, Lynda Benglis, Dara Birnbaum, Lyn Blumenthal, Joan Brown,* Nancy Buchanan, Barbara Buckner, Vija Celmins,* Doris Chase, Louisa Chase, Cecilia Condit,* Agnes Denes,* Jackie Ferrara, Audrey Flack,* Mary Frank, Nancy Graves, Eva Hesse, Nancy Holt, Jenny Holzer, Yvonne Jacquette, Valerie Jaudon, Carole Ann Klonarides, Joyce Kozloff, Margia C. Kramer,* Barbara Kruger,* Shigeko Kubota,* Suzanne Lacy, Lois Lane, Sylvia Plimack Mangold, Melissa Miller, Elizabeth Murray, Rita Myers,* Judy Pfaff, Howardena Pindell, Katherine Porter, Dorothea Rockburne, Rachel Rosenthal,*

Martha Rosler, Susan Rothenberg, Cindy Sherman, Barbara T. Smith,* Joan Snyder, Nancy Spero, Michelle Stuart, Steina Vasulka, Jackie Winsor

New York, New York, New Museum of Contemporary Art
Nancy Buchanan, Nancy Holt

New York, New York, New York Public Library, Donnell Collection
Barbara Buckner, Louisa Chase, Cecilia Condit, Tina Girouard, Sara Hornbacher,* Margia C. Kramer, Howardena Pindell, Judy Rifka, Martha Rosler, Tomiyo Sasaki, Steina Vasulka

New York, New York, Studio Museum in Harlem
Howardena Pindell, Betye Saar

New York, New York, Whitney Museum of American Art
Alice Aycock, Jennifer Bartlett, Lynda Benglis, Joan Brown, Deborah Butterfield, Vija Celmins, Louisa Chase, Agnes Denes, Jackie Ferrara, Janet Fish, Audrey Flack, Mary Frank, Nancy Graves, Eva Hesse, Jenny Holzer,** Sara Hornbacher, Yvonne Jacquette, Barbara Kruger, Lois Lane,* Mary Lucier,* Sylvia Plimack Mangold, Catherine Murphy,* Elizabeth Murray, Judy Pfaff, Howardena Pindell,* Katherine Porter,* Judy Rifka, Dorothea Rockburne, Susan Rothenberg, Miriam Schapiro,* Alexis Smith,* Joan Snyder, Alma W. Thomas,* Margaret Wharton,* Jackie Winsor**

Norfolk, Virginia, Chrysler Museum
Ida Applebroog

Norman, Oklahoma, Museum of Art, University of Oklahoma
Sandy Skoglund

Nuremberg, West Germany, Kunsthalle Nürnberg
Agnes Denes

Oakland, California, Mills College
Miriam Schapiro

Oakland, California, Oakland Museum
Joan Brown, Deborah Butterfield

Oberlin, Ohio, Allen Memorial Art Museum, Oberlin College
Max Almy, Jennifer Bartlett, Lynda Benglis, Nancy Buchanan, Cynthia Carlson,* Cecilia Condit, Agnes Denes, Janet Fish, Audrey Flack, Nancy Graves, Eva Hesse,* Joyce Kozloff, Sylvia Plimack Mangold, Mary Miss,* Ree Morton, Miriam Schapiro, Cindy Sherman, Laurie Simmons,* Joan Snyder, Nancy Spero, Michelle Stuart, Hannah Wilke, Jackie Winsor**

Oklahoma City, Oklahoma, Oklahoma Art Center
Janet Fish

Omaha, Nebraska, Joslyn Art Museum
Jennifer Bartlett, Joyce Kozloff, Michelle Stuart

Orlando, Florida, Loch Haven Art Center
Jackie Ferrara, Judy Rifka, Miriam Schapiro

Ottawa, Ontario, National Gallery of Canada
Nancy Graves,* Jenny Holzer, Tomiyo Sasaki*

Otterlo, Netherlands, Rijksmuseum Kröller-Müller
Jenny Holzer, Cindy Sherman

Owego, New York, Experimental Television Center
Nancy Buchanan, Barbara Buckner

Oxford, Ohio, Miami University Museum of Art
Nancy Holt

Paris, France, Musée National d'Art Moderne, Centre Georges Pompidou
Dara Birnbaum, Doris Chase, Jenny Holzer, Carole Ann Klonarides, Joan Logue, Adrian Piper, Cindy Sherman, Sandy Skoglund

Pensacola, Florida, Pensacola Museum of Art

Lynda Benglis, Miriam Schapiro

Philadelphia, Pennsylvania, Moore College of Art
Jackie Ferrara

Philadelphia, Pennsylvania, Pennsylvania Academy of the Fine Arts
Cynthia Carlson, Doris Chase, Janet Fish, Nancy Graves, Ree Morton, Betye Saar

Philadelphia, Pennsylvania, Philadelphia Museum of Art
Alice Aycock, Jennifer Bartlett, Lynda Benglis, Cynthia Carlson, Agnes Denes, Yvonne Jacquette, Elizabeth Murray, Howardena Pindell, Katherine Porter, Betye Saar, Cindy Sherman, Michelle Stuart

Philadelphia, Pennsylvania, Tyler School of Art Galleries, Temple University
Margia C. Kramer

Pittsburgh, Pennsylvania, Carnegie Museum of Art
Max Almy, Dara Birnbaum, Cecilia Condit, Jackie Ferrara, Yvonne Jacquette, Katherine Porter, Susan Rothenberg, Cindy Sherman

Pittsfield, Massachusetts, Berkshire Museum
Nancy Graves

Portland, Oregon, Portland Art Museum
Louisa Chase, Katherine Porter, Cindy Sherman

Port Washington, New York, Port Washington Public Library
Mary Lucier

Poughkeepsie, New York, Vassar College Art Gallery
Nancy Graves, Joyce Kozloff

Providence, Rhode Island, David Winton Bell Gallery, Brown University
Mary Frank

Providence, Rhode Island, Museum of Art, Rhode Island School of Design
Max Almy, Jennifer Bartlett, Janet Fish, Carole Ann Klonarides,* Mary Miss, Elizabeth Murray

Purchase, New York, Neuberger Museum, State University of New York
Jennifer Bartlett, Cynthia Carlson, Agnes Denes, Mary Frank, Nancy Graves, Judy Pfaff, Howardena Pindell, Judith Shea, Michelle Stuart

Richmond, Virginia, Richmond Museum of Art
Cynthia Carlson

Richmond, Virginia, Virginia Museum of Fine Arts
Max Almy, Janet Fish, Dorothea Rockburne, Steina Vasulka

Ridgefield, Connecticut, Aldrich Museum of Contemporary Art
Jackie Ferrara, Eva Hesse, Valerie Jaudon, Ree Morton, Michelle Stuart

Rio de Janeiro, Brazil, Museu de Arte Moderna
Martha Rosler

Rotterdam, Netherlands, Museum Boymans-Van Beuningen
Cindy Sherman

Sacramento, California, Crocker Art Museum
Joan Brown

St. Louis, Missouri, Laumeier International Sculpture Park and Gallery
Alice Aycock, Jackie Ferrara, Mary Miss

St. Louis, Missouri, St. Louis Art Museum
Jennifer Bartlett, Jackie Ferrara, Audrey Flack, Nancy Graves, Yvonne Jacquette, Elizabeth Murray, Susan Rothenberg, Cindy Sherman, Sandy Skoglund

St. Paul, Minnesota, Minnesota Museum of Art
Janet Fish

Salt Lake City, Utah, Utah Museum of Fine Arts, University of Utah
Sylvia Plimack Mangold

San Antonio, Texas, Marion Koogler McNay Art Institute
Joyce Kozloff

San Francisco, California, San Francisco Museum of Modern Art
Max Almy, Eleanor Antin, Joan Brown, Vija Celmins, Melissa Miller, Betye Saar, Cindy Sherman, Jackie Winsor

Santa Barbara, California, Santa Barbara Museum of Art
Betye Saar, Alexis Smith

Santa Cruz, California, University of California, Santa Cruz
Martha Rosler, Miriam Schapiro

Seattle, Washington, Seattle Art Museum
Lynda Benglis, Doris Chase,* Margaret Wharton

Seward, Nebraska, Koenig Art Gallery, Concordia College
Yvonne Jacquette

Southampton, New York, Parrish Art Museum
Joan Snyder

South Hadley, Massachusetts, Mount Holyoke Art Museum, Mount Holyoke College
Vija Celmins, Joyce Kozloff

Stanford, California, Stanford University Museum of Art
Martha Rosler, Miriam Schapiro

Stockholm, Sweden, Moderna Museet
Dara Birnbaum, Agnes Denes, Joan Logue, Michelle Stuart

Sydney, Australia, Art Gallery of New South Wales
Cindy Sherman

Syracuse, New York, Everson Museum of Art
Barbara Buckner, Mary Frank, Howardena Pindell

Teheran, Iran, Teheran Museum of Modern Art
Michelle Stuart

Tokyo, Japan, Wacoal Art Center
Judy Pfaff

Toledo, Ohio, Toledo Museum of Art
Judy Rifka

Tougaloo, Mississippi, Tougaloo College Art Collection
Miriam Schapiro

Toulon, France, Musée d'Art et d'Archéologie
Michelle Stuart

Toyama, Japan, Toyama Museum of Modern Art
Shigeko Kubota

Trenton, New Jersey, New Jersey State Museum
Catherine Murphy, Betye Saar*

Utica, New York, Munson-Williams-Proctor Institute
Susan Rothenberg

Valencia, California, California Institute of the Arts
Martha Rosler

Vancouver, British Columbia, Vancouver Art Gallery
Doris Chase

Vienna, Austria, Museum Moderner Kunst
Nancy Graves

Waltham, Massachusetts, Rose Art Museum, Brandeis University
Audrey Flack, Katherine Porter, Cindy Sherman

Washington, D.C., Corcoran Gallery of Art
Louisa Chase, Agnes Denes, Mary Beth Edelson,* Nancy Graves, Cheryl Laemmle, Joan Logue, Alma W. Thomas, Margaret Wharton

Washington, D.C., Hirshhorn Museum and Sculpture Garden, Smithsonian Institution
Joan Brown, Deborah Butterfield, Doris Chase, Mary Frank, Yvonne Jacquette, Valerie Jaudon,* Catherine Murphy, Elizabeth Murray*

Washington, D.C., Library of Congress
Louisa Chase, Mary Frank, Yvonne Jacquette

Washington, D.C., National Air and Space Museum, Smithsonian Institution
Agnes Denes

Washington, D.C., National Gallery of Art
Joyce Kozloff, Lois Lane, Miriam Schapiro

Washington, D.C., National Museum of American Art, Smithsonian Institution
Lynda Benglis, Anges Denes, Nancy Holt, Alma W. Thomas

Washington, D.C., National Museum of Women in the Arts
Alice Aycock, Audrey Flack, Nancy Graves, Eva Hesse, Dorothea Rockburne, Alma W. Thomas

Washington, D.C., Phillips Collection
Catherine Murphy, Alma W. Thomas

Waterville, Maine, Colby College Museum of Art
Janet Fish, Yvonne Jacquette*

Wellesley, Massachusetts, Wellesley College Museum
Jackie Ferrara, Joyce Kozloff

West Palm Beach, Florida, Norton Gallery and School of Art
Heide Fasnacht**

Williamstown, Massachusetts, Williams College Museum of Art
Joan Brown, Miriam Schapiro

Winston-Salem, North Carolina, Wake Forest University
Sandy Skoglund

Worcester, Massachusetts, Worcester Art Museum
Mary Frank, Katherine Porter

Yonkers, New York, Hudson River Museum
Doris Chase

Zurich, Switzerland, Kunsthaus Zurich
Dara Birnbaum, Jenny Holzer, Howardena Pindell

Selected General Bibliography

This bibliography comprises publications in which several of the artists in the exhibition are discussed, as well as a selection of books and articles regarding more general developments in the art of the period and the role of women artists. Most of this material was published in 1970–85, although a few essential references that appeared after that date are also cited.

Books and Catalogs

Agonito, Rosemary. *History of Ideas on Woman.* New York: G. P. Putnam's Sons, Perigree Books, 1977.

American Women: 20th Century. Peoria, Ill.: Lakeview Center for the Arts and Sciences, 1972.

Anonymous Was a Woman. Valencia: California Institute of the Arts, 1974.

Art and Ideology. New York: New Museum of Contemporary Art, 1984.

Art—A Woman's Sensibility: The Collected Works and Writings of Women Artists. Valencia: California Institute of the Arts, 1975.

Battcock, Gregory, ed. *New Artists' Video.* New York: E. P. Dutton, 1978.

Battcock, Gregory, and Robert Nickas, eds. *The Art of Performance: A Critical Anthology.* New York: E. P. Dutton, 1984.

Beardsley, John. *Art in Public Places.* Washington, D.C.: Partners for Livable Places, 1982.

Broude, Norma, and Mary D. Garrard, eds. *Feminism and Art History: Questioning the Litany.* New York: Harper and Row, 1982.

Cathcart, Linda. *American Paintings of the 1970s.* Buffalo: Albright-Knox Art Gallery, 1978.

Collins, J. L. *Women Artists in America.* Knoxville: University of Tennessee Press, 1975.

Difference. New York: New Museum of Contemporary Art, 1984.

Dreyfus, L. Hubert, and Paul Rabinow. *Michel Foucault: Beyond Structuralism and Hermeneutics.* 2d ed., with afterword and interview with Michel Foucault. Chicago: University of Chicago Press, 1983.

Fine, Elsa Honig. *The Afro-American Artist.* New York: Holt, Rinehart and Winston, 1973.

Foster, Hal, ed. *The Anti-Aesthetic: Essays on Postmodern Culture.* Port Townsend, Wash.: Bay Press, 1983.

Frascina, Francis, ed. *Pollock and After: The Critical Debate.* New York: Harper and Row, 1986.

Freeman, Phyllis, Eric Himmel, Edith Pavese, and Anne Yarowsky, eds. *New Art.* New York: Harry N. Abrams, 1984.

Gilligan, Carol. *In a Different Voice: Psychological Theory and Women's Development.* Cambridge, Mass., and London: Harvard University Press, 1982.

Goldberg, Roselee. *Performance: Live Art 1909 to the Present.* New York: Harry N. Abrams, 1979.

Goodyear, Frank H., Jr. *Contemporary American Realism since 1960.* Philadelphia: Pennsylvania Academy of the Fine Arts, 1981.

Greer, Germaine. *The Obstacle Race: The Fortunes of Women Painters and Their Work.* New York: Farrar, Straus and Giroux, 1979.

Guenther, Bruce. *Fifty Northwest Artists.* San Francisco: Chronicle Books, 1983.

Hanhardt, John G., ed. *Video Culture: A Critical Investigation.* Rochester, N.Y.: Visual Studies Press, 1986.

Harris, Ann Sutherland, Mary Jane Jacob, and Tressa R. Miller. *Self-Portraits by Women Artists.* Los Angeles: Gallery at the Plaza, Security Pacific National Bank, 1985.

Harris, Ann Sutherland, and Linda Nochlin. *Women Artists: 1550–1950.* Los Angeles: Los Angeles County Museum of Art; New York: Alfred A. Knopf, 1977.

Hertz, Richard, ed. *Theories of Contemporary Art.* Englewood Cliffs, N.J.: Prentice-Hall, 1985.

Hess, Thomas B., and Elizabeth C. Baker, eds. *Art and Sexual Politics.* New York and London: Collier Books, 1973.

Hopkins, Henry. *Fifty West Coast Artists.* San Francisco: Chronicle Books, 1981.

Hunter, Sam, and John Jacobus. *Modern Art.* 2d ed. New York: Harry N. Abrams, 1985.

Jensen, Robert, and Patricia Conway. *Ornamentalism.* New York: Clarkson N. Potter, 1982.

Johnson, Ellen H., ed. *American Artists on Art from 1940–1980.* New York: Harper and Row, 1982.

Jones, Virginia Watson. *Contemporary American Women Sculptors.* Phoenix: Oryx, 1986.

Kelly, Joan. *Women, History, and Theory: The Essays of Joan Kelly.* Chicago and London: University of Chicago Press, 1984.

Krauss, Rosalind E. *The Originality of the Avant-Garde and Other Modernist Myths.* Cambridge, Mass., and London: MIT Press, 1985.

Lauter, Estella. *Women as Mythmakers: Poetry and Visual Art by Twentieth-Century Women.* Bloomington: Indiana University Press, 1984.

Lippard, Lucy R. *From the Center: Feminist Essays on Women's Art.* New York: E. P. Dutton, 1976.

———. *Get the Message? A Decade of Art for Social Change.* New York: E. P. Dutton, 1984.

———. *Overlay: Contemporary Art and the Art of Prehistory.* New York: Pantheon Press, 1983.

———. *Six Years: The Dematerialization of the Art Object from 1966 to 1972.* New York: Praeger Publishers, 1973.

Loeffler, Carl E., and Darlene Tong, eds. *Performance Anthology: Source Book for a Decade of California Performance Art.* San Francisco: Contemporary Arts Press, 1980.

Lucie-Smith, Edward. *American Art Now.* New York: William Morrow and Co., 1985.

———. *Art in the Seventies.* Ithaca, N.Y.: Cornell University Press, 1980.

Marshall, Richard. *American Art since 1970: Painting, Sculpture, and Drawings from the Collection of the Whitney Museum of American Art, New York.* New York: Whitney Museum of American Art, 1984.

———. *New Image Painting.* New York: Whitney Museum of American Art, 1979.

Mitchell, Margaretta K. *Recollections: Ten Women of Photography.* New York: Viking Press, 1979.

Munro, Eleanor. *Originals: American Women Artists.* New York: Simon and Schuster, 1979.

Nairne, Sandy, with Geoff Dunlop and John Wyver. *State of the Art: Ideas and Images in the 1980s.* London: Chatto and Windus, in collaboration with Channel Four Television Co., 1987.

Nemser, Cindy. *Art Talk: Conversations with Twelve Women Artists.* New York: Charles Scribner's Sons, 1975.

Neumann, Erich. *The Great Mother: An Analysis of the Archetype.* Translated by Ralph Manheim. Bollingen Series, no. 47. Princeton, N.J.: Princeton University Press, 1985.

"On Art and Artists." *Video Data Bank* (School of the Art Institute of Chicago), 1985.

Parker, Rozsika, and Griselda Pollock, eds. *Framing Feminism: Art and the Women's Movement, 1970–85.* London: Pandora, 1987.

Petersen, Karen, and J. J. Wilson. *Recognition and Reappraisal from the Early Middle Ages to the Twentieth Century.* New York: Harper and Row, Colophon Books, 1976.

Plagens, Peter. *Sunshine Muse: Contemporary Art on the West Coast.* New York: Praeger Publishers, 1974.

Real, Really Real, Super Real: Directions in Contemporary American Realism. San Antonio, Tex.: San Antonio Museum of Art, 1981.

Robins, Corinne. *The Pluralist Era: American Art, 1968–1981.* New York: Harper and Row, 1984.

Robinson, Charlotte, ed. *The Artist and the Quilt.* New York: Alfred A. Knopf, 1983.

Rose, Barbara. *American Painting: The Eighties—A Critical Interpretation.* San Rafael, Calif.: Vista Press, 1979.

Rosenthal, Mark. Essay in *Art of Our Time: The Saatchi Collection*, vol. 4. New York: Rizzoli, 1985.

Roth, Moira, ed. *The Amazing Decade: Women and Performance Art in America, 1970–1980.* Los Angeles: Astro Artz, 1983.

Rubinstein, Charlotte Streifer. *American Women Artists: From Early Indian Times to the Present.* New York: Avon, 1982.

Ruddick, Sara, and Pamela Daniels, eds. *Working It Out: Twenty-three Women Writers, Artists, Scientists and Scholars Talk about Their Lives and Work.* New York: Pantheon Books, 1977.

Russo, Alexander. *Profiles on Women Artists.* Frederick, Md.: University Publications of America, 1985.

Schneider, Ira, and Beryl Korot, eds. *Video Art.* New York: Harcourt Brace Jovanovich, 1976.

Selz, Peter. *Art in a Turbulent Era.* Edited by Donald Kuspit. Ann Arbor: University of Michigan Press, 1985.

Sherman, Claire R., and Adele M. Holcomb, eds. *Women as Interpreters of the Visual Arts, 1820–1979.* Contributions in Women's Studies, no. 18. Westport, Conn.: Greenwood Press, 1981.

Slatkin, Wendy. *Women Artists in History: From Antiquity to the Twentieth Century.* Englewood Cliffs, N.J.: Prentice-Hall, 1985.

Stimpson, Catharine R., and Nina Kressner Cobb. *Women's Studies in the United States: A Report to the Ford Foundation.* New York: Ford Foundation, 1986.

Tucker, Marcia. *"Bad" Painting.* New York: New Museum of Contemporary Art, 1978.

Tucker, Marcia, and Lynn Gumpert. *Early Work.* New York: New Museum of Contemporary Art, 1982.

Tucker, William. Essay in *The Condition of Sculpture.* London: Hayward Gallery, 1975.

Tufts, Eleanor. *Our Hidden Heritage: Five Centuries of Women Artists.* London: Paddington Press, 1974.

Van Wagner, Judy K. Collischan. *Women Shaping Art: Profiles in Power.* New York: Praeger Publishers, 1984.

Wallis, Brian, ed. *Art after Modernism: Rethinking Representation.* Foreword by Marcia Tucker. New York: New Museum of Contemporary Art; Boston: David Godine, 1984.

Women of Photography: An Historical Survey. San Francisco: San Francisco Museum of Modern Art, 1975.

Periodicals

Alloway, Lawrence. "Where Were You on the Week of the 23rd?" *Village Voice*, March 2, 1982.

———. "Women's Art in the '70s." *Art in America* 64 (May–June 1976): 64–72.

Berman, Avis. "Women Artists 1980: A Decade of Progress, But Could a Female Chardin Make a Living Today?" *Artnews* 79 (October 1980): 73–79.

Duncan, Carol. "When Greatness Is a Box of Wheaties." *Artforum* 14 (October 1975): 59.

Gabhart, Ann, and Elizabeth Broun. "Old Mistresses: Women Artists of the Past." *Walters Art Gallery Bulletin* 24 (April 1972).

Glueck, Grace. "At the Whitney It's Guerilla Warfare." *New York Times*, November 1, 1970, p. 22.

———. "Women Artists Demonstrate at the Whitney." *New York Times*, December 12, 1970, p. 22.

———. "Women Artists 1980." *Artnews* 79 (October 1980): 58.

Goldin, Amy. "Patterns, Grids, and Painting." *Artforum* 14 (September 1975): 50–54.

Gouma-Peterson, Thalia, and Patricia Mathews. "The Feminist Critique of Art History." *Art Bulletin* 69 (September 1987): 326–57.

"The Great Goddess." *Heresies* 5, special issue (Spring 1978).

Heartney, Eleanor. "How Wide Is the Gender Gap?" *Artnews* 86 (Summer 1987): 139–45.

Jaudon, Valerie, and Joyce Kozloff. "Art Hysterical Notions of Progress and Culture." *Heresies* 4 (Winter 1977–78): 38–42.

Larson, Kay. "For the First Time Women Are Leading Not Following." *Artnews* 79 (October 1980): 64–72.

———. "Keep Your Eye on Art . . . Women in the Vanguard." *Harper's Bazaar*, March 1985, pp. 276–77, 318, 320.

Linker, Kate. "Eluding Definition." *Artforum* 23 (December 1984): 61.

Lippard, Lucy R. "The Pains and Pleasures of Rebirth: Women's Body Art." *Art in America* 64 (May 1976): 73–81.

London, Barbara. "Independent Video: The First Fifteen Years." *Artforum* 9 (September 1980): 38ff.

Lorber, Richard. "Woman Artists on Women in Art." *Portfolio*, February–March 1980, pp. 68–73.

Masheck, Joseph. "The Carpet Paradigm: Critical Prolegomena to a Theory of Flatness." *Arts Magazine* 50 (September 1976): 86–109.

Nemser, Cindy. "Towards a New Sensibility: Contemporary Trends in Women's Art." *Feminist Art Journal*, Summer 1976, p. 22.

Nochlin, Linda. "Some Women Realists: Part I." *Arts Magazine* 48 (February 1974): 46–51.

———. "Why Have There Been No Great Women Artists?" *Artnews* 69 (January 1971): 22–39.

Orenstein, Gloria Feman. "Review Essay Art History." *SIGNS* 1, no. 2 (1975): 505–25.

Perreault, John. "Issues in Pattern Painting." *Artforum* 16 (November 1977): 32–36.

———. "The New Decorativeness." *Portfolio*, June–July 1979.

Perrone, Jeff. "Approaching the Decorative." *Artforum* 15 (December 1976): 26–30.

Pollack, Griselda. "Women, Art and Ideology: Questions for Feminist Art Historians." *Women's Art Journal* 4 (Spring–Summer 1983): 39–47.

Ratcliff, Carter. "The Paint Thickens." *Artforum* 14 (June 1976): 43–47.

Rickey, Carrie. "Art of the Whole Cloth." *Art in America* 67 (November 1979): 72–83.

———. "Decoration, Ornament, Pattern and Utility." *Flash Art*, no. 90–91 (June–July 1979): 19–20.

Robins, Corinne. "Artists in Residence: The First Five Years." *Womanart*, Winter 1977–78, p. 6.

Roth, Moira. "Toward a History of California Performance." *Arts Magazine* 52 (February 1978): 94–103.

Russell, H. Diane. "Review Essay Art History." *SIGNS* 5, no. 3 (1980): 468–81.

Russell, John. "Art: American Women Artists, Part II." *New York Times*, February 24, 1984, p. C19.

———. "It's Not 'Women's Art,' It's Good Art." *New York Times*, July 24, 1983, pp. H1, 25.

———. "Women Artists with Growing Authority." *New York Times*, November 14, 1976.

Sandler, Irving. "Modernism, Revisionism, Pluralism and Post-Modernism." *Art Journal* 40 (Fall–Winter 1980): 345–46.

Smith, Roberta. "Beyond Gender." *Village Voice*, January 22, 1985, p. 103.

———. "Portfolio: A Celebration of Women Artists." *Ambiance*, March 1979, pp. 84–87.

Straayer, Chris. "I Say I Am: Feminist Performance Video in the '70s." *Afterimage*, November 1985, pp. 8–12.

Wooster, Ann-Sargent. "Why Don't They Tell Stories the Way They Used To?" *Art Journal* 45 (Fall 1985): 204–12.

Acknowledgments

Making Their Mark represents Maidenform Inc.'s first sponsorship of a nationally traveling exhibition and book. We want to thank the company for entrusting us with this initial effort and to express our gratitude for their continuing support and encouragement even when the project expanded far beyond the original proposal. Many at Maidenform helped to bring the project to fruition, but three in particular deserve special mention. Steven N. Masket, Vice President–Counsel, often interrupted pressing corporate duties to help with a myriad of details pertaining to the sponsorship of the project. We appreciate his unfailing good nature and excellent advice. Marilyn Bane, Vice President of Advertising, was a creative spark and source of sound judgment throughout. Beatrice Coleman, President, grasped from the outset the importance of bringing the achievements of women artists to public attention, recognizing in those achievements a parallel to the company's own dedication to excellence. Her commitment never waivered, and we are grateful to her for having the imagination to make this project a reality.

As extensive as this project may seem, it is not large enough to encompass all those whose art enriched the period 1970–85. The artists included here are representative of many others whose styles developed during these years and who also deserve recognition for having helped to make this period a turning point for all women artists. We are indebted to those artists who expanded our own perception of the period by sharing with us their memories and varied experiences. To those artists who have loaned works from their personal collections, and in particular to the video artists who facilitated the production of special compilation tapes for use in the exhibition, we are especially grateful. We would also like to thank Ann-Sargent Wooster, whose skillful organization of the video program for *Making Their Mark* reflects her knowledge and love of the medium.

We are indebted to the directors and curatorial staff of the participating museums for recognizing from the beginning the importance of the exhibition and for offering support and advice in a true spirit of collaboration. We were privileged to work at the Cincinnati Art Museum with Millard F. Rogers, Jr., Director; Gretchen Mehring, Assistant Director for Public Affairs; and Genetta Gardner, Assistant Curator of Painting; at the New Orleans Museum of Art with E. John Bullard, Director; William A. Fagaly, Assistant Director for Art; and Valerie Olsen, Chief Curator of Collections and Curator of Prints and Drawings; at the Denver Art Museum with Richard S. Teitz, Director;

Lewis Story, Associate Director; Dianne Perry Vanderlip, Curator of Contemporary Art; and Deborah Jordy, Associate Curator of Contemporary Art; and at the Pennsylvania Academy of the Fine Arts with Linda Bantel, Director, and Judith E. Stein, Associate Curator. We are further indebted to Linda Bantel, whose special assistance helped us secure two major loans for the exhibition, and to Judith E. Stein, who began as an essayist and became both a valued advisor and friend.

There is a delicate balance involved in assembling a group of works for an exhibition as complex as *Making Their Mark*. The result depends half upon the selection, half upon the good will of lenders. We have been fortunate in gaining the cooperation of eighty-seven museum, gallery, private, and corporate lenders. Their belief in the significance and timeliness of *Making Their Mark* made them willing to part with important works for over a year. It was through the generous assistance of the owners and directors of galleries across the country that we were able to obtain key works of art. The staff at each gallery we contacted provided us with countless slides and photographs as well as extensive biographical information, responding promptly to our many requests. We are grateful to all those who took our twentieth phone call as graciously as our first and want to single out the following gallery staff members on whom we relied the most: Will Armeringer, Martina Batan, Douglas Baxter, Ted Bonin, Wendy Brandow, Jim Cohan, David Goldsmith, Sophie Hager Hume, Nathan Kernan, Marilyn Lanfear, Natasha Sigmund, and Ron Warren. For extending themselves on behalf of the exhibition, we would also like to thank Russell Bowman, Director, Milwaukee Art Museum; Graham Beal, Chief Curator, San Francisco Museum of Modern Art; and Susan Graze, Curator of Contemporary Art, Dallas Museum of Art. The enthusiasm and efficiency of the staff members at each lending institution made our task infinitely easier.

The members of the Advisory Council for *Making Their Mark* graciously made themselves available to us over the course of this project. Our thanks go to Marcia Tucker for her essay and for broadening our initial vision of the exhibition; to Patterson Sims for suggesting that we include an essay on the period 1900–1970, thereby providing a historical context; to Robert Rosenblum for encouraging our efforts from the inception of the project and for reading the introductory essay; to John G. Hanhardt for sharing his extensive knowledge of video art; to Ferris Olin, who in addition to guiding the Career Markers research was a valuable resource for information on women's studies; to Henry Hopkins for giving us the benefit of his long experience in the art world; to Kathy Halbreich for helping us in the early stages of developing the exhibition; to Mary Jane Jacob, whose work on performance art provided the basis for that segment of the exhibition; and to the members of the Advisory Council at the participating museums—William A. Fagaly, Gretchen Mehring, Judith E. Stein, and Dianne Perry Vanderlip—for their sensitive guidance in sustaining the balanced viewpoint of the exhibition.

Two people deserving of our greatest thanks are Elizabeth A. Gottshall, whose unerring managerial and organizational capabilities kept the project on course, and Rita M. Gilchrest, whose thoroughness and computer wizardry were invaluable in tracking the innumerable details involved in an undertaking of this scope.

The challenge of designing a consistent installation for the exhibition at four very different sites fell to Arthur Clark; he never tired of reworking the possibilities, for which we thank him.

It was our good fortune to have Nancy Grubb as our editor at Abbeville Press. Her perceptive editing lies at the heart of this book, and many of her good ideas are reflected in the exhibition as well. At Abbeville, Amy Handy cheerfully assumed the burdensome task of compiling the back matter included here. The book's distinctive design is the imaginative work of Marc Zaref.

For the hours spent in the exchange of ideas we thank Richard H. Axsom, Carol Morgan, Pamela Gruninger Perkins, Lynne Sowder, John Weber, and Richard Whelan. Anita Duquette's enthusiastic support was helpful throughout the project. Many others have also given generously of their time, expertise, and assistance over the four years of this project's development. Although we cannot thank everyone by name, we would like to acknowledge the contributions of the following people: Stefan Abrams, David Allison, Linda Ashcraft, Robert Beck, Norma Broude, Laura Catalano, Steven Cohen, Nancy Doll, Grace Eleazar, Mindy Faber, Patricia Hayes, Tom Henson, Jerry Hillhouse, Jon Hutton, Mitch Leon, Louise Martin, Renée McKee, Steven Meyer, Anne Morgan, Cath Murphy, Gail Neeson, Dennis O'Shea, Carole Pesner, Louise Reiss-Rogas, Sam Samore, Stephen Schlesinger, Susan Sollins, Marita Sturken, Sherry Summers, Liane M. Thatcher, Edna Tuttleman, Suzanne Vanderwoude, Martin Vandiver, Christopher Warren, Bill Washington, and Judith Zilczer.

The Career Markers research project was conceived and directed by Ferris Olin in collaboration with us. All of the Career Marker charts were prepared by Ferris Olin, except the table of NEA awards in the visual arts, which was prepared by Jan Abrams. We would like to thank the curators, archivists, librarians, and staff members at the museums surveyed for generously and quickly providing the information we sought. The corporations we contacted were equally courteous

and helpful. We regret that limitations of time and space made it impossible in the end to include the information graciously provided by Abigail Gerdts, Ward Jackson, and Nancy Johnson. Our conversations with Judi Freeman, Associate Curator of Twentieth-Century Art, Los Angeles County Museum of Art, were instrumental in shaping this study. Sharon Gallagher and Stacey Lesser offered many valuable suggestions. We are grateful to Bert Wyle for his assistance with Individual Milestones. We would also like to thank the directors and personnel at galleries and alternative spaces who contributed their time and information.

The Career Markers project would not have been possible without the extraordinary commitment shown by the following team of researchers who spent countless hours compiling the data for this study. Their dedication to the topic is a tribute to all women artists.

California
Edith Crowe, Librarian, San Jose State
 University
Laurel Paley, artist and editor, Los Angeles
Illinois
T. A. Neff Associates, Chicago
Susan Walsh, former Senior Research
 Librarian, Art Institute of Chicago
New Jersey
Beryl Smith, Assistant Director, Art Library
 at Rutgers—The State University of
 New Jersey
New York
Jan Abrams, President, Hart-Abrams,
 Ltd.
Gretchen Adkins, art historian
Janis Ekdahl, Assistant Director,
 Museum of Modern Art Library
Linda Swieskowski, Director, Information
 Exchange at the Municipal Art Society
Valerie Weinberger, Cataloguer, Pierpont
 Morgan Library

Pennsylvania
Ray Anne Lockhard, Head, Frick Fine Arts
 Library, University of Pittsburgh
Washington, D.C.
Roberta Geier, formerly Technical
 Information Specialist, National Museum
 of American Art, Smithsonian Institution
Elizabeth W. Harter, Art Subject Specialist,
 George Washington University Library
Katherine M. Kovacs, Consulting Archivist,
 Corcoran Gallery of Art

Each aspect of *Making Their Mark* reflects a generous sharing of time, thought, and energy by countless people. We hope that everyone involved in the project has found the experience as enlightening as it has been for us.

Randy Rosen, *Curator*

Catherine C. Brawer, *Associate Curator*

National Advisory Council

William A. Fagaly
Assistant Director for Art
New Orleans Museum of Art

Kathy Halbreich
Independent Curator

John G. Hanhardt
Curator, Film and Video
Whitney Museum of American Art, New York

Henry Hopkins
Director
Frederick R. Weisman Foundation of Art
Collection, Los Angeles

Mary Jane Jacob
Chief Curator
Museum of Contemporary Art, Los Angeles

Gretchen Mehring
Assistant Director for Public Affairs
Cincinnati Art Museum

Ferris Olin
Executive Officer
Rutgers Institute for Research on Women and
Laurie New Jersey Chair in Women's Studies,
Douglass College, New Brunswick, New
Jersey

Robert Rosenblum
Professor of Fine Arts
New York University

Patterson Sims
Associate Director and Chief Curator
The Collections and Exhibitions, Seattle Art
Museum

Judith E. Stein
Associate Curator
Pennsylvania Academy of the Fine Arts,
Philadelphia

Marcia Tucker
Director
The New Museum of Contemporary Art,
New York

Dianne Perry Vanderlip
Curator, Contemporary Art
Denver Art Museum

Lenders to the Exhibition

Jack and Maryon Adelaar

Albright-Knox Art Gallery, Buffalo

The Aldrich Museum of Contemporary Art,
 Ridgefield, Connecticut

Brooke Alexander, New York

Alexandria Museum of Art, Alexandria,
 Louisiana

Albert Alhadeff

Max Almy; courtesy Electronic Arts Intermix,
 New York

Michele Amateau

Laurie Anderson; courtesy The Kitchen,
 New York

Eleanor Antin; courtesy Ronald Feldman
 Fine Arts, New York

Jacki Apple

Alice Aycock; courtesy John Weber Gallery,
 New York

J. Barrett Gallery, Toledo, Ohio

Dara Birnbaum; courtesy Electronic Arts
 Intermix, New York

Lyn Blumenthal; courtesy Video Data Bank,
 Chicago

Hans Breder

Eli Broad Family Foundation

Nancy Buchanan

Barbara Buckner; courtesy Electronic Arts
 Intermix, New York

Gayle and Andrew Camden

Vija Celmins

Cincinnati Art Museum

Columbus Museum of Art, Columbus, Ohio

Cecilia Condit; courtesy Electronic Arts
 Intermix, New York

Dallas Museum of Art

Jane and David Davis

Shirley and Thomas J. Davis, Jr.

Agnes Denes

Denver Art Museum

Mr. and Mrs. Charles M. Diker

Stefan T. Edlis

Dr. and Mrs. Jack Eisert

Ronald Feldman Fine Arts, New York

Jackie Ferrara; courtesy Max Protetch
 Gallery, New York

Dr. and Mrs. Robert J. Freedman, Jr.

Allan Frumkin Gallery, New York

Carol and Arthur A. Goldberg

Greenberg Gallery, St. Louis

The Grinstein Family

Solomon R. Guggenheim Museum, New York

Mr. and Mrs. Graham Gund

Raquel Mendieta Harrington

Estate of Eva Hesse; courtesy Robert Miller Gallery, New York

Hirshhorn Museum and Sculpture Garden, Smithsonian Institution, Washington, D.C.

Nancy Holt; courtesy John Weber Gallery, New York, and Video Data Bank, Chicago

Sara Hornbacher

Harvey and Florence Isaacs

Diane and Steven M. Jacobson

Valerie Jaudon

Mr. and Mrs. Alvin P. Johnson

Miani Johnson

Joan Jonas; courtesy Electronic Arts Intermix, New York

Howard Kalka and Steven M. Jacobson

Ellen and Ellis Kern

Mr. and Mrs. Gilbert H. Kinney

Carole Ann Klonarides; courtesy Electronic Arts Intermix, New York

Monique Knowlton

Joyce Kozloff

Margia C. Kramer; courtesy Video Data Bank, Chicago

Shigeko Kubota; courtesy Electronic Arts Intermix, New York

Leslie Labowitz

Suzanne Lacy

Sherrie Levine; courtesy Mary Boone Gallery, New York

Joan Logue

Marianne and Sheldon B. Lubar

Mary Lucier; courtesy Electronic Arts Intermix, New York

Sylvia Plimack Mangold

Michael McCarthy

Louis K. and Susan Pear Meisel

Ignacio C. Mendieta

Raquel Oti Mendieta

Metro Pictures, New York

Milwaukee Art Museum

Mary Miss

Linda Montano

George and Salina Muellich

Museum of Contemporary Art, Chicago

The Museum of Fine Arts, Houston

The Museum of Modern Art, New York

Rita Myers; courtesy Electronic Arts Intermix, New York

Marcia and Marvin Naiman

National Museum of American Art, Smithsonian Institution, Washington, D.C.

Pat Oleszko

PaineWebber Group, Inc., New York

Pennsylvania Academy of the Fine Arts, Philadelphia

Dr. and Mrs. David Peretz

Philadelphia Museum of Art

Howardena Pindell

Private collection; courtesy M. Knoedler and Company, Inc., New York

Private collection; courtesy Louis K. Meisel Gallery, New York

Private collection; courtesy Metro Pictures, New York

Private collection; courtesy Texas Gallery, Houston

Private collection, New York

Private collection, Washington, D.C.

Max Protetch Gallery, New York

Steven Robinson

A. G. Rosen

Rachel Rosenthal

Martha Rosler; courtesy Electronic Arts Intermix, New York

Betye Saar

Sam Samore

Santa Barbara Museum of Art, Santa Barbara, California

Tomiyo Sasaki

Miriam Schapiro; courtesy Bernice Steinbaum Gallery, New York

John H. Scully

Joseph E. Seagram and Sons, Inc., New York

Stanley Shenker

Laurie Simmons; courtesy Metro Pictures, New York

Sandy Skoglund

Sylvia Sleigh

Barbara T. Smith

Suellen Snyder

Holly Solomon Gallery, New York

Nancy Spero; courtesy Josh Baer Gallery, New York

Bernice Steinbaum Gallery, New York

Michelle Stuart; courtesy Max Protetch Gallery, New York

The Studio Museum in Harlem, New York

Suzanne and Maurice Vanderwoude

Steina Vasulka; courtesy Electronic Arts Intermix, New York

Virginia Museum of Fine Arts, Richmond

Wadsworth Atheneum, Hartford, Connecticut

Ethan and Sherry Wagner

John Weber Gallery, New York

Margaret Wharton

Whitney Museum of American Art, New York

Hannah Wilke

Martha Wilson

David Wirtz

Sue and David Workman

Checklist of the Exhibition

Max Almy

Leaving the 20th Century, 1983
Color videotape, 10:40 min.
Collection of the artist; courtesy Electronic Arts Intermix, New York

Perfect Leader, 1983
Color videotape, 4:11 min.
Collection of the artist; courtesy Electronic Arts Intermix, New York

Laurie Anderson

O Superman, 1981
Color videotape, 8 min.
© Warner Bros. Records; courtesy The Kitchen, New York

Sharkey's Day, 1984
Color videotape, 4:25 min.
© Warner Bros. Records; courtesy The Kitchen, New York

Eleanor Antin

100 Boots, 1971–73
51 black-and-white postcards, each card: 4½ x 7 in.
Wadsworth Atheneum, Hartford, Connecticut; The Sol LeWitt Collection

Eleanor Antin as the Ballerina, in the black-and-white videotape *Caught in the Act*, 1973
Black-and-white photograph
Courtesy Ronald Feldman Fine Arts, New York

The Angel of Mercy, 1980
Color videotape, 63 min., from performance premiered at the M.L. D'Arc Gallery, New York, 1977
Courtesy Ronald Feldman Fine Arts, New York

From the Archives of Modern Art, 1987
Black-and-white videotape, 24 min.
Courtesy Ronald Feldman Fine Arts, New York

Jacki Apple

See *Martha Wilson*

Ida Applebroog

I Can't, 1981
Ink and Rhoplex on vellum, 7 parts: 10½ x 9½ in. (6); 9 x 9½ in. (1)
Cincinnati Art Museum; Gift of the RSM Co.

Happy Birthday to Me, 1982
Acrylic and Rhoplex on canvas, 83 x 66½ in.
Ronald Feldman Fine Arts, New York

Alice Aycock

Untitled (Shanty), 1978
Wood, shanty: 54 x 30 x 30 in.; base: 45 x 36 x 42 in.; wheel diameter: 107½ in.
Whitney Museum of American Art, New York; Gift of Raymond J. Learsy

One Hundred Small Rooms (Part II), 1984
Pencil on Mylar, 36 x 54 in.
George and Salina Muellich

A Salutation to the Wonderful Pig of Knowledge,
1984
Steel, copper, brass, aluminum, Formica, wood,
Plexiglas, and motorized LED parts, 82 x 112 x 139 in.
Collection of the artist; courtesy John Weber
Gallery, New York

Jennifer Bartlett

2 Priory Walk, 1977
Baked enamel, silkscreen, and enamel on steel,
64 parts, each 12 x 12 in.; 103 x 103 in. overall
Philadelphia Museum of Art; Purchased, Adele Haas
Turner and Beatrice Pastorius Turner Memorial Fund

In the Garden No. 201, 1983
Oil on canvas, 2 parts, each 84 x 72 in.; 84 x 144 in.
overall
J. Barrett Gallery, Toledo, Ohio

Lynda Benglis

Modern Art No. 1, 1970–74
Bronze and aluminum, 2 parts, each 12 x 43¾ x 30 in.
Collection, The Museum of Modern Art, New York;
Gift of J. Frederic Byers III

Essex, 1985
Bronze wire, zinc, copper, and chrome, 28 x 40 x 9 in.
Dr. and Mrs. Robert J. Freedman, Jr.

Dara Birnbaum

Technology/Transformation: Wonder Woman, 1978
Color videotape, 5:36 min.
Collection of the artist; courtesy Electronic Arts
Intermix, New York

PM Magazine, 1982
Video installation with bromide enlargements,
speed-rail suspension system, painted walls, and
lights; installation: 71 x 95 x 20⅛ in.; single-channel
color videotape, 5:40 min.
Museum of Contemporary Art, Chicago; Gift of
Joseph and Jory Shapiro, Mr. and Mrs. E.A.
Bergman, and Mrs. Robert B. Mayer

Lyn Blumenthal and Carole Ann Klonarides, in collaboration with Ed Paschke

Arcade, 1984
Color videotape, 11:00 min.
Collection of the artists; courtesy Video Data Bank,
Chicago

Joan Brown

New Year's Eve #2, 1973
Enamel and oil on canvas, 72 x 84 in.
Allan Frumkin Gallery, New York

After the Alcatraz Swim #3, 1976
Enamel on canvas, 96 x 78 in. (framed)
Stanley Shenker

Nancy Buchanan and Barbara T. Smith

With Love from A to B, 1977
Color videotape, 10 min., adapted from fixed-
camera performance for video at College Art
Association, Los Angeles, 1976
Collection of the artists

Barbara Buckner

Hearts, 1979–81
Color videotape, 12 min. (silent)
Collection of the artist; courtesy Electronic Arts
Intermix, New York

Deborah Butterfield

Horse #6–82, 1982
Steel, sheet aluminum, wire, and tar, 76 x 108 x 41 in.
Dallas Museum of Art; Foundation for the Arts
Collection, Edward S. Marcus Fund

Horse #9–82, 1982
Aluminum, steel, and tar, 39 x 92 x 60 in.
Ethan and Sherry Wagner

Cynthia Carlson

Cozy Hang, 1976
Oil on canvas, 60 x 48 in.
Denver Art Museum

Untitled, 1983
Bronze, 12 parts, each approximately 15 x 9 x 2½
in.; wall installation: approximately 10 x 8 ft.
Museum of Contemporary Art, Chicago; Promised
gift of Dr. Helen Herrick

Vija Celmins

Ocean: 7 Steps #1, 1972–73
Graphite on acrylic-sprayed paper, 12⅝ x 99¼ in.
(framed)
Whitney Museum of American Art, New York;
Purchase, with funds from Mr. and Mrs. Joshua A.
Gollin

Desert-Galaxy, 1974
Graphite on acrylic-sprayed paper, 17½ x 38 in.
Collection of the artist

Doris Chase

Table for One, 1985
Color videotape, 28 min.
Circulating Film and Video Library, The Museum of
Modern Art, New York

Louisa Chase

Storm, 1981
Oil on canvas, 90 x 120 in.
Denver Art Museum; Purchased with funds from
National Endowment for the Arts Matching Fund
and Alliance for Contemporary Art

White Water, 1983
Oil on canvas, 48 x 60 in.
Marcia and Marvin Naiman

Cecilia Condit

Possibly in Michigan, 1983
Color videotape, 11:40 min.
Collection of the artist; courtesy Electronic Arts
Intermix, New York

Clyde Connell

Guardian Post III, 1976
Wood, paper, metal, and glue, 84 x 14 x 14 in.
Alexandria Museum of Art, Alexandria, Louisiana

Mantis and Man in Time and Space, 1983
Mixed media, 79 x 37 x 45 in.
Gayle and Andrew Camden

Agnes Denes

Systems of Logic/Logic of Systems, Studies for Steel-Cable Structure in Red, Black, and Silver, 1976
Ink on Mylar, 108 x 30½ in.
Collection of the artist

Probability Pyramid in Perspective—Study for Crystal Pyramid, 1982
Silver ink on silk vellum, 36 x 39 in.
Collection of the artist

Teardrop-Monument to Being Earthbound (Top Free Floating), 1984
Ink on Mylar, 46 x 80 in.
Collection of the artist

Mary Beth Edelson

Woman Rising/Spirit, 1974
Black-and-white photograph and drawing from The Woman Rising series
Documentation of private ritual performance in Outer Banks, North Carolina, 1974
Courtesy the artist

Heide Fasnacht

Pell Mell II, 1985
Wood and India ink, 58⅝ x 20¼ x 50½ in.
Columbus Museum of Art, Columbus, Ohio; Purchased with funds made available from the Awards in the Visual Arts Program

Portrait, 1985
Wood and various paints, 27½ x 21 x 30 in.
Diane and Steven M. Jacobson

Jackie Ferrara

A121 Curved Pyramid, 1973
Wolmanized fir, 35 x 60 x 18 in.
Collection of the artist; courtesy Max Protetch Gallery, New York

A207 Recall, 1980
Pencil on paper, 2 sheets, 17 x 44 in. overall
Collection of the artist; courtesy Max Protetch Gallery, New York

A207 Recall, 1980
Pine, 76½ x 37½ x 37½ in.
Max Protetch Gallery, New York

Janet Fish

August and the Red Glass, 1976
Oil on canvas, 72 x 60 in.
Virginia Museum of Fine Arts, Richmond; Gift of The Sydney and Frances Lewis Foundation

Kara, 1983
Oil on canvas, 70¼ x 60½ in.
The Museum of Fine Arts, Houston; Museum purchase with funds provided by the Museum Collectors

Audrey Flack

Queen, 1975–76
Oil over acrylic on canvas, 80 x 80 in.
Private collection; courtesy Louis K. Meisel Gallery, New York

Wheel of Fortune (Vanitas), 1977–78
Oil over acrylic on canvas, 96 x 96 in.
Louis K. and Susan Pear Meisel

Mary Frank

Night-Head, 1971
Clay, 20 x 19 x 19 in.
Suzanne and Maurice Vanderwoude

Woman, 1975
Clay, 22 x 92 x 16 in.
Private collection

Tina Girouard

Pinwheel, 1977
Black-and-white documentary photograph of performance at New Orleans Museum of Art, with Mercedes Deshotel, John Geldersma, and Gerard Murrell, 1977
Courtesy New Orleans Museum of Art

Nancy Graves

Bone Finger, 1971
Steel, acrylic, and gauze, 114 x 60 x 12 in.
Private collection; courtesy M. Knoedler and Company, Inc., New York

Zeeg, 1983
Bronze with polychrome patina, 28½ x 14 x 11 in.
Private collection

Tarot, 1984
Bronze with polychrome patina and enamel, 88 x 49 x 20 in.
Private collection; courtesy M. Knoedler and Company, Inc., New York

Eva Hesse

Untitled, 1968
Latex on wire mesh and plastic clothespin hook, 30 x 9 in.
Estate of the artist; courtesy Robert Miller Gallery, New York

Tori, 1969
Fiberglass on wire mesh, 9 parts, each 30–47 x 12½–17 x 10¼–15 in.
Steven Robinson

Nancy Holt

Sun Tunnels, Great Basin Desert, Utah, 1973–76
4 tunnels, each 18 ft. long x 9 ft. 4 in. diameter; each axis 86 ft. long
8 color photographs, 30 x 40 in. (2); 16 x 20 in. (2); 16 x 24 in. (1); 16 x 16 in. (3)
John Weber Gallery, New York

Underscan, 1974
Black-and-white videotape, 9 min.
Collection of the artist; courtesy Video Data Bank, Chicago

Preliminary Study: Horizon Views from the Center of "Sun Tunnels," 1975
Black-and-white photographs and pencil on paper, 18 x 24 in.
Collection of the artist; courtesy John Weber Gallery, New York

Working Drawing for "Sun Tunnels": Star Hole Positions (Constellation Columba), 1975
Pencil on paper, 18 x 24 in.
Collection of the artist; courtesy John Weber Gallery, New York

Working Drawing for "Sun Tunnels": Star Hole Positions (Constellation Perseus), 1975
Pencil on paper, 18 x 24 in.
Collection of the artist; courtesy John Weber Gallery, New York

Study for "Sun Tunnels," 1976
Pencil and green crayon on paper, 18 x 24 in.
Joseph E. Seagram and Sons, Inc., New York

Jenny Holzer

Inflammatory Essays, 1980–84
Ink on colored paper, 20 parts, each 17 x 17 in.

Untitled, with selections from Truisms, 1984
Electronic LED sign, 5½ x 30½ x 6 in.
Stefan T. Edlis

Sara Hornbacher

Writing Degree Z, 1985
Color videotape, 5 min.
Collection of the artist

Yvonne Jacquette

Ferry near Battery Park, Dusk, 1981
Oil on canvas, 76 x 62 in.
PaineWebber Group, Inc., New York

Telegraph Hill II, 1984
Oil on canvas, 77¾ x 105 in.
John H. Scully

Valerie Jaudon

Yazoo City, 1975
Oil on canvas, 72 x 72 in.
The Aldrich Museum of Contemporary Art, Ridgefield, Connecticut

Pantherburn, 1979
Oil on canvas, 96 x 72 in.
Collection of the artist

Joan Jonas

Vertical Roll, 1972
Black-and-white videotape, 19:38 min.
Collection of the artist; courtesy Electronic Arts Intermix, New York

Double Lunar Dogs, 1984
Color videotape, 25 min., from performance premiered at University Art Museum, University of California, Berkeley, 1980
Collection of the artist; courtesy Electronic Arts Intermix, New York

Carole Ann Klonarides

Cindy Sherman—An Interview, 1981
Color videotape, 10 min.
Collection of the artist; courtesy Electronic Arts Intermix, New York

Laurie Simmons—A Teaser, 1982
Color videotape, 5 min.
Collection of the artist; courtesy Electronic Arts Intermix, New York

See also *Lyn Blumenthal*

Joyce Kozloff

Tent-Roof-Floor-Carpet, Zenmour, 1975
Acrylic on canvas, 78 x 96 in.
Dr. and Mrs. David Peretz

Untitled (Buffalo Architectural Themes): #6: window, Martin House; #7: City Hall lobby, Vars Building; #4: window, Heath House; #9: City Hall auditorium; #2: Calumet Building, City Hall lobby, 1984
Series of 5 watercolors from tiles at Humboldt Hospital subway station, Buffalo. All are from lower level except #9, which is from upper level.
Each 9½ x 6 in.; 14 x 43 in. overall (framed)
Albright-Knox Art Gallery, Buffalo; Charles W. Goodyear Fund, 1984

View from upper level of the Humboldt Hospital subway station, Buffalo, 1984, with hand-painted ceramic-tile-and-glass mosaic (36 x 114 ft.)
Black-and-white documentary photograph, 1984
Collection of the artist

Buffalo Architectural Themes, 1984
12 tile samples for Humboldt Hospital subway station, Buffalo, each 6 x 6 in.; 18 x 24 in. overall
Collection of the artist

Margia C. Kramer

Progress (Memory), 1983–84
3-channel videotapes, 36, 20, and 15 min.
Collection of the artist

Barbara Kruger

Untitled (We Have Received Orders Not to Move), 1982
Black-and-white photograph, 71 x 49 in. (framed)
Carol and Arthur A. Goldberg

Untitled (We Won't Play Nature to Your Culture), 1983
Black-and-white photograph, 73 x 49 in. (framed)
John Weber Gallery, New York

Shigeko Kubota

Video Installations, 1970–86
Color videotape, 11:25 min.
Collection of the artist; courtesy Electronic Arts Intermix, New York

Leslie Labowitz

See *Suzanne Lacy*

Suzanne Lacy and Leslie Labowitz

In Mourning and in Rage, 1977
Black-and-white documentary photograph of performance at City Hall, Los Angeles, 1977
Collection of the artists

Cheryl Laemmle

Two Sisters, 1984
Oil on canvas with painted wood, 73 x 84 in. (framed)
A.G. Rosen

August, 1985, from the American Decoy series
Oil on canvas, 85 x 80 in. (framed)
Eli Broad Family Foundation

Lois Lane

Mardi Gras, 1976
Oil on canvas, 72 x 96 in.
Miani Johnson

Untitled, 1978
Oil, gesso, and graphite on canvas, 84 x 96 in.
Ellen and Ellis Kern

Sherrie Levine

After Walker Evans, 1981
Black-and-white C-print, 20 x 16 in. (framed)
Collection of the artist; courtesy Mary Boone Gallery, New York

After Henri Matisse, 1983
Watercolor on paper, 19½ x 15½ in. (framed)
Harvey and Florence Isaacs

Untitled (Broad Stripe #8), 1985
Casein and wax on wood, 24 x 20 in.
Marianne and Sheldon B. Lubar

Joan Logue

David Hockney, from *30 Second Spots: Paris*, 1984
Color videotape, 12:30 min. (entire tape)
Collection of the artist

Mary Lucier

Ohio to Giverny; Memory of Light, 1983
Single-channel color videotape, 18:25 min.
Collection of the artist; courtesy Electronic Arts Intermix, New York

Wintergarden, 1984
Color videotape, two-channel, split-screen composite, 11:11 min.
Collection of the artist; courtesy Electronic Arts Intermix, New York

Sylvia Plimack Mangold

January 1977, 1977
Acrylic on canvas, 60 x 72 in. (framed)
Collection of the artist

Schunnemunk Mountain, 1979
Oil on canvas, 60 x 80 in.
Dallas Museum of Art; General Acquisitions Fund and a gift of The 500, Inc.

Ana Mendieta

Untitled, no. 259, from the Silueta (Silhouette) series, 1976
Color photograph, 13¼ x 20 in.
Documentation of earth-body sculpture with flowers on sand, Oaxaca, Mexico
Raquel Oti Mendieta

Arbol de la Vida, no. 294, from the Arbol de la Vida/Silueta (Tree of Life/Silhouette) series, 1977
Color photograph, 20 x 13¼ in.
Documentation of earth-body sculpture with artist, tree trunk, and mud, at Old Man's Creek, Iowa City, Iowa
Hans Breder

El Ix-chell Negro, no. 246, from El Ix-chell Negro/Silueta (The Black Ix-chell/Silhouette) series, 1977
Color photograph, 20 x 13¼ in.
Documentation of earth-body sculpture with artist, cloth, and paint, Iowa City, Iowa
Raquel Oti Mendieta

Encantamiento a Olokun-Yemaya (Enchantment at Olokun-Yemaya), no. 244, from the Silueta (Silhouette) series, 1977
Color photograph, 20 x 13¼ in.
Documentation of earth-body sculpture with sand and tempera paint, Iowa
Raquel Oti Mendieta

Encantamiento a Olokun-Yemaya (Enchantment at Olokun-Yemaya), no. 278, from the Silueta (Silhouette) series, 1977
Color photograph, 20 x 13¼ in.
Documentation of earth-body sculpture with sand, grass, and tempera paint, Iowa
Raquel Oti Mendieta

Tumbas (Tombs), no. 261, from the Silueta (Silhouette) series, 1977
Color photograph, 20 x 13¼ in.
Documentation of low relief with cracked earth mounds, Oaxaca, Mexico
Raquel Oti Mendieta

Untitled, no. 401, from the Arbol de la Vida/Silueta (Tree of Life/Silhouette) series, 1977
Color photograph, 13¼ x 20 in.
Documentation of earth-body sculpture with gunpowder and fire on tree trunk, at Old Man's Creek, Iowa City, Iowa
Ignacio C. Mendieta

Untitled, no. 238, from the Fetiches/Silueta (Fetish/Silhouette) series, 1977
Color photograph, 20 x 13¼ in.
Documentation of earth-body sculpture with sand, sticks, and water at Old Man's Creek, Iowa City, Iowa
Raquel Mendieta Harrington

Untitled, no. 211, from the Silueta (Silhouette) series, 1977
Color photograph, 13¼ x 20 in.
Documentation of earth-body sculpture with earth, dried grass, sticks, and fire, Iowa
Raquel Oti Mendieta

Untitled, no. 214, from the Silueta (Silhouette) series, 1977
Color photograph, 20 x 13¼ in.
Documentation of earth-body sculpture burned into landscape, Iowa
Raquel Oti Mendieta

Untitled, no. 285, from the Silueta (Silhouette) series, 1977
Color photograph, 13¼ x 20 in.
Documentation of earth-body sculpture with cracked earth and grass, Iowa
Raquel Oti Mendieta

Untitled, no. 230, from the Silueta (Silhouette) series, 1978
Color photograph, 13¼ x 20 in.
Documentation of earth-body sculpture with grass and fertilizer, Iowa
Raquel Oti Mendieta

Untitled, no. 300, from the Silueta (Silhouette) series, c. 1978
Color photograph, 20 x 13¼ in.
Documentation of earth-body sculpture with mud balls on earth, Iowa
Raquel Oti Mendieta

Isla (Island), no. 227, from the Silueta (Silhouette) series, 1979
Color photograph, 13¼ x 20 in.
Documentation of earth-body sculpture with mud and grass on island, Sharon Center, Iowa
Raquel Oti Mendieta

Untitled, no. 299, from the Silueta (Silhouette) series, 1979
Color photograph, 20 x 13¼ in.
Documentation of earth-body sculpture with stones on grass, Iowa
Raquel Mendieta Harrington

La Concha de Venus (The Conch of Venus), from El Laberinto de Venus (The Labyrinth of Venus) series, 1982
Black-and-white photograph, 60 x 40 in.
Documentation of earth-clay sculpture, Iowa
Raquel Mendieta Harrington

Melissa Miller

Northern Lights, 1982
Oil on linen, 66 x 74 in.
Private collection; courtesy Texas Gallery, Houston

Salmon Run, 1984
Oil on linen, 90 x 60 in.
Shirley and Thomas J. Davis, Jr.

Mary Miss

Untitled, 1977
Wood, 108 x 114 x 12 in.
Solomon R. Guggenheim Museum, New York; Theodoron Purchase Award, through funds contributed by Mr. and Mrs. Irving Rossi, Mr. and Mrs. Sidney Singer, The Theodoron Foundation, and The Walter Foundation, 1977

Field Rotation, Governors State University, Park Forest South, Illinois, 1981
4 color photographs—aerial view; close-up, central structure; angle view of platforms; exterior view of mound with posts—each 16 x 20 in.
Collection of the artist

Linda Montano

Mitchell's Death, 1978
Black-and-white videotape, 22 min., from performance at University of California, San Diego, Center for Music Experiment, 1978
Collection of the artist

Ree Morton

Let Us Celebrate While Youth Lingers and Ideas Flow, 1975
Celastic, wood, and paint on canvas, 96 x 72 in.
Pennsylvania Academy of the Fine Arts, Philadelphia; Academy Purchase Fund, 1988

Regional Piece Number 6, 1976
Oil on Masonite with Celastic drapery, 2 parts, each 16 x 49¾ in.
Private collection, New York

Catherine Murphy

View from the Backyard: Lexington, 1972–73
Oil on canvas, 35 x 40 in. (framed)
Whitney Museum of American Art, New York; Purchase, with funds from the Neysa McMein Purchase Award

Self-Portrait with Pansy, 1975
Oil on canvas, 21 x 26 in.
Mr. and Mrs. Graham Gund

View of the World Trade Center from Rose Garden, 1976
Oil on canvas, 37 x 29 in.
Hirshhorn Museum and Sculpture Garden, Smithsonian Institution, Washington, D.C.; Museum Purchase, 1976

Elizabeth Murray

Duck Foot, 1983
Oil on canvas, 129 x 132 in.
Sue and David Workman

Leg, 1984
Oil on canvas, 2 parts, 117 x 82 in. overall
Mr. and Mrs. Graham Gund

Rita Myers

In the Planet of the Eye, 1984
Color videotape, 5 min.
Collection of the artist; courtesy Electronic Arts Intermix, New York

Pat Oleszko

Pat Oleszko as Tom Saw-yer in *The Tool Jest*, 1984
Color videotape, 8 min., of film used in the performance *The Soirée of O*, at P.S. 122, New York, 1984
Collection of the artist

Judy Pfaff

Voodoo, 1981
Contact-paper collage on Mylar, 98 x 60 in. (framed)
Albright-Knox Art Gallery, Buffalo; Edmund Hayes Fund, 1983

Stage Fright, 1983
Mixed-media wall relief, 85 x 102½ x 29 in.
Holly Solomon Gallery, New York

Howardena Pindell

Untitled (No. 5), 1975
Pen and ink on punched paper, mounted on graph paper, 34 x 44 in.
Collection of the artist

Feast Day of Iemanja II, December 31, 1980
Acrylic, dye, paper, powder, thread, and glitter on sewn canvas, 84 x 102 in.
The Studio Museum in Harlem, New York; Gift of Diane and Steven M. Jacobson

Adrian Piper

Funk Lessons, 1983
Color videotape, 18:30 min., from performance at University of California, Berkeley, 1983
Sam Samore

Katherine Porter

When Alexander the Great Wept by the River Bank Because There Were No More Worlds to Conquer, His Distress Rested on Nothing More Substantial Than the Ignorance of His Map Maker, 1977
Oil on canvas, 84 x 92½ in. (framed)
Denver Art Museum; Purchase with funds from National Endowment for the Arts Purchase Fund, Dayton Hudson Foundation, and Target Stores

El Salvador, 1981
Oil on canvas, 90 x 90 in. (framed)
Jane and David Davis

Judy Rifka

Square Dress, 1982
Oil on linen, 51 x 64½ in.
Dr. and Mrs. Jack Eisert

Beach II, 1984
Oil on linen and wood, 74½ x 89 in.
Brooke Alexander, New York

Faith Ringgold

Bena and Buba, from *The Wake and Resurrection of the Bicentennial Negro*, 1976
Mixed media, *Bena*: 65 x 14 x 7 in.; *Buba*: 71 x 16 x 7 in.; flowers and vase: 18 x 12 x 12 in.; cooling pad: 70 x 36 x 2 in.
Bernice Steinbaum Gallery, New York

Nana and Moma, from *The Wake and Resurrection of the Bicentennial Negro*, 1976
Mixed media, *Nana*: 67 x 16 x 11 in.; *Moma*: 62 x 16 x 11 in.
Bernice Steinbaum Gallery, New York

Dorothea Rockburne

Arena IV, 1978
Vellum, colored pencil, varnish, glue, and ragboard, 54½ x 47 in.
Michael McCarthy

White Angel #2, 1981
Rives BFK paper on mattboard with glue and blue pencil, 70 x 46 in.
Virginia Museum of Fine Arts, Richmond; Gift of The Sydney and Frances Lewis Foundation

Rachel Rosenthal

The Performance World of Rachel Rosenthal, 1987
Color videotape, 15:38 min.
Collection of the artist

Martha Rosler

Semiotics of the Kitchen, 1975
Black-and-white videotape, 6 min.
Collection of the artist; courtesy Electronic Arts Intermix, New York

Vital Statistics of a Citizen, Simply Obtained, 1977
Color videotape, 39:20 min., from performance premiered at University of California, San Diego, 1973
Collection of the artist; courtesy Electronic Arts Intermix, New York

Susan Rothenberg

Diagonal, 1975
Acrylic and tempera on canvas, 46 x 60 in.
Stefan T. Edlis

Mist from the Chest, 1983
Oil on canvas, 78 x 89 in. (framed)
Milwaukee Art Museum; Gift of Friends of Art

Betye Saar

Bessie Smith Box, 1974
Assemblage, 14¾ x 20 x 2½ in. (open)
Monique Knowlton

Imitation of Life, 1975
Assemblage, 8¼ x 7 x 4 in.
Collection of the artist

Indigo Mercy, 1975
Assemblage, 41¾ x 18½ x 17½ in.
The Studio Museum in Harlem, New York; Gift of Nzingha Society, Inc.

Veil of Tears, 1976
Assemblage, 9½ x 13½ x 9½ in. (open)
Mr. and Mrs. Alvin P. Johnson

Tomiyo Sasaki

The Creatures of the Enchanted Isles, 1984
Single-channel study for 5-channel video installation with 20 monitors; color videotape, 25 min.
Collection of the artist

Miriam Schapiro, in collaboration with Sherry Brody

The Doll House, 1972
Mixed media, 48 x 41½ x 8 in.
Miriam Schapiro; courtesy Bernice Steinbaum Gallery, New York

Miriam Schapiro

Barcelona Fan, 1979
Acrylic and fabric collage on canvas, 72 x 144 in.
Howard Kalka and Steven M. Jacobson

Wonderland, 1983
Acrylic and fabric collage on canvas, 90 x 144 in.
(framed)
Bernice Steinbaum Gallery, New York

Judith Shea

Inaugural Ball, 1980
Cotton organdy, 67 x 24 x 1½ in.
Jack and Maryon Adelaar

The Young One, 1981
Wool felt, 19 x 28 x 8½ in.
Private collection, Washington, D.C.

Untitled, 1985
Graphite on paper, 19 x 26 in.
Greenberg Gallery, St. Louis

Cindy Sherman

Untitled, 1975
Black-and-white photograph, 20 x 16 in.
Metro Pictures, New York

Untitled, 1975
Black-and-white photograph, 20 x 16 in.
Metro Pictures, New York

Untitled Film Still, 1978
Black-and-white photograph, 10 x 8 in.
David Wirtz

Untitled Film Still, 1978
Black-and-white photograph, 8 x 10 in.
Carol and Arthur A. Goldberg

Untitled Film Still, 1979
Black-and-white photograph, 10 x 8 in.
Carol and Arthur A. Goldberg

Untitled, 1984
Color photograph, 71 x 48½ in.
Metro Pictures, New York

Laurie Simmons

Arms Up/Pyramid, 1982
Color photograph, 39 x 29 in.
Private collection; courtesy Metro Pictures, New York

Red Library #2, 1983
Color photograph, 48½ x 38¼ in.
Collection of the artist; courtesy Metro Pictures, New York

Sandy Skoglund

Radioactive Cats, 1980
Cibachrome, 30 x 40 in.
Collection of the artist

Radioactive Cats, 1980
Painted wooden table, 2 chairs, and 4 plaster cats, table: 26 x 26 x 48 in.; each chair: 36 x 22 x 22 in.; cats: 10–13 x 18–32 x 8 in.
Collection of the artist

Revenge of the Goldfish, 1981
Cibachrome, 30 x 40 in.
Collection of the artist

Sylvia Sleigh

The Turkish Bath, 1973
Oil on canvas, 76½ x 102½ in. (framed)
Collection of the artist

A.I.R. Group Portrait, 1977
Oil on canvas, 75½ x 82½ in. (framed)
Collection of the artist

Alexis Smith

The Red Shoes, 1975
Mixed-media collage, 2 parts: left: 7 sheets, each 11 x 8½ in.; 13½ x 63 in. overall (framed); right: 6 sheets, each 11 x 8½ in.; 13½ x 54½ in. overall (framed)
The Grinstein Family

Wild Life, 1985
Mixed-media collage, 11 x 9¼ in.
Santa Barbara Museum of Art, Santa Barbara, California; Gift of Bruce Murkoff

Barbara T. Smith

See *Nancy Buchanan*

Joan Snyder

Small Symphony for Women #1, 1974
Oil and acrylic on canvas, 3 parts, each 24 x 24 in.; 24 x 72 in. overall
Suellen Snyder

Sweet Cathy's Song (for Cathy Elzea), 1978
Mixed media, including children's drawings, papier-mâché, chalk, and oil on canvas, 77¾ x 144 in.
Collection, The Museum of Modern Art, New York; Gift of the Louis and Bessie Adler Foundation, Inc., Seymour M. Klein, President

Nancy Spero

Codex Artaud XXIII, 1972
Painting, typewriting, and collage on paper, 24½ x 116 in.
Collection of the artist; courtesy Josh Baer Gallery, New York

Codex Artaud XXIV, 1972
Painting, typewriting, and collage on paper, 24½ x 114¼ in.
Collection of the artist; courtesy Josh Baer Gallery, New York

Michelle Stuart

Passages: Mesa Verde, 1977–79
Scroll: earth from Mesa Verde, Colorado, on rag paper mounted on muslin; stacks: earth from Mesa Verde on handmade paper; and 2 Kodacolor C-prints Scroll: 108 x 59 in.; 11 stacks of varying sizes; C-prints: 14 x 17 in.
Collection of the artist; courtesy Max Protetch Gallery, New York

Islas Incantadas: Seymour Island Cycle (for C.D.) (Charles Darwin), 1981–82
6 black-and-white photographs, earth from Seymour Island, Galapagos Islands, Ecuador, mounted on rag paper, 121 x 176 in.
Collection of the artist; courtesy Max Protetch Gallery, New York

Alma W. Thomas

Antares, 1972
Acrylic on canvas, 65¾ x 56½ in.
National Museum of American Art, Smithsonian Institution, Washington, D.C.; Bequest of Alma W. Thomas

Babbling Brook and Whistling Poplar Trees Symphony, 1976
Acrylic on canvas, 72 x 52 in.
Mr. and Mrs. Gilbert H. Kinney

Steina Vasulka

Somersault, 1982
Color videotape, 5 min.
Collection of the artist; courtesy Electronic Arts Intermix, New York

Rest, 1982
Color videotape, 5 min.
Collection of the artist; courtesy Electronic Arts Intermix, New York

Margaret Wharton

Eiffel Tower, 1979
Partial stained wooden high chair, epoxy glue, and wooden dowels on concrete base, 98 x 17 x 17 in.
Mr. and Mrs. Charles M. Diker

Mocking Bird, 1981
Partial stained wooden chair, epoxy glue, paint, and wooden dowels, 60 x 60 x 13 in.
Collection of the artist

Hannah Wilke

S.O.S.—Starification Object Series, 1974–82
10 black-and-white photographs with 15 chewing-gum sculptures in Plexiglas cases mounted on ragboard, from a series originally made for *S.O.S. Mastication Box* and used in an exhibition-performance at The Clocktower, January 1, 1975
41 x 58 in. overall (framed)
Collection of the artist

Rosebud, 1976
Latex, rubber, and snaps, 24 x 92 x 8 in.
Collection of the artist

Martha Wilson and Jacki Apple

Transformation: Claudia, 1973
Black-and-white documentary photograph of performance with Anne Blevens at various locations in New York, December 1973
Collection of the artists

Jackie Winsor

Chunk Piece, 1970
Hemp, diameter: 28 in.; length: 36 in.
Michele Amateau and Albert Alhadeff

Burnt Piece, 1977–88
Concrete, burnt wood, and wire, 36 x 36 x 36 in.
Private collection, New York

Index

Photography Credits

The photographers and the sources of photographic material other than those indicated in the captions are as follows: Courtesy Brooke Alexander, New York: plate 158; Michael Alexander: plate 107; David Allison: plates 75, 104 (courtesy Whitney Museum of American Art, New York), 112, 123, 134, 147, 149, 159, 160, 162–64; David R. Allison: plate 60; Courtesy Josh Baer Gallery, New York: plate 141; Basia: plate 69; Karen Bell: plate 49; William H. Bengtson, courtesy Phyllis Kind Gallery, Chicago: plates 42, 43; Dawoud Bey: plate 157; Breger and Associates: plates 167, 168; Courtesy Cynthia Carlson: plate 151; Courtesy Castelli Graphics: plates 64, 65; Geoffrey Clements: frontispiece, plates 11, 14, 17, 18, 20, 26, 33, 39, 56, 95, 96, 120, 121; Ken Cohen: plate 38; Sheldan Comfort Collins: plates 41, 59, 76, 146; Courtesy Paula Cooper Gallery, New York: plate 32; Paula Court: plate 139; Ivan dalla Tana: plates 58, 92 (courtesy Brooke Alexander, New York); James Dee: plates 9, 108, 155, 156, 179; © 1975 Mary Beth Edelson: plate 4; Richard Eells Photography: plate 135; eeva-inkeri, courtesy Allan Frumkin Gallery, New York: plate 51; Elaine Galasso: plate 7; Al Giese: plate 180; Ernest Gisella, © 1984 Tomiyo Sasaki: plate 106; Courtesy Barbara Gladstone Gallery, New York: plates 109, 132; Leslie Harris: plate 86; Greg Heins: plate 55; Biff Henrich: plate 22; Courtesy Rhona Hoffman Gallery, Chicago: plate 182; Nancy Holt, courtesy John Weber Gallery, New York: plate 83; Jim Jardine: plate 61; Bruce C. Jones: plate 47; Lisa Kahane: plates 131 (courtesy Barbara Gladstone Gallery, New York), 172; Bill Kennedy: plates 99, 100 (courtesy Texas Gallery, Houston); Margia C. Kramer: plate 137; Richard Landry: plate 6; David Lubarsky, courtesy Sharpe Gallery, New York: plate 67; Paul M. Macapia: plate 30; George MacDonald: plate 84; Robert E. Mates: plates 28 (courtesy Paula Cooper Gallery, New York), 79; Allen Mewbourn: plate 53; Courtesy Metro Pictures, New York: plates 127, 128; Susan R. Mogul: plate 5; Montana State University Photo Services, courtesy Deborah Butterfield: plate 89; Peter Moore, courtesy Shigeko Kubota: plate 101; Gerard Murrell: plate 46; Robert Natowitz: plate 142; Douglas M. Parker Studio, courtesy Margo Leavin Gallery, Los Angeles: plates 115, 116; Pollitzer, Strong and Meyer, courtesy Brooke Alexander, New York: plate 93; David Reynolds: plates 117, 118; Lloyd Rule: plate 97; Lezley Saar: plates 111, 113; William E. Sauro, courtesy *New York Times*: plate 178; Fred Scruton: plates 169 (courtesy John Weber Gallery, New York), 170, 177; Neil Selkirk: plate 3; Rik Sferra, courtesy Adrian Piper: plate 71; Courtesy Sharpe Gallery, New York: plate 66; Courtesy Bernice Steinbaum Gallery, New York: plate 48; Philip Steinmetz: plates 124, 125; Jamey Stillings, courtesy Barbara Gladstone Gallery, New York: plate 23; Marita Sturken: plates 44, 143; Gwenn Thomas: plate 72; Courtesy Tilden-Foley Gallery, New Orleans: plate 34; Martin Vandiver: plate 78; Video Data Bank, courtesy Linda Montano; Willard Associates Photography: plate 31; Ellen Page Wilson: plate 122; Jackie Winsor and Lisa Bromberg: plate 35; Graydon Wood: plate 1; Zindman/Fremont: plate 8; Courtesy Zolla/Lieberman Gallery, Chicago: plate 90.